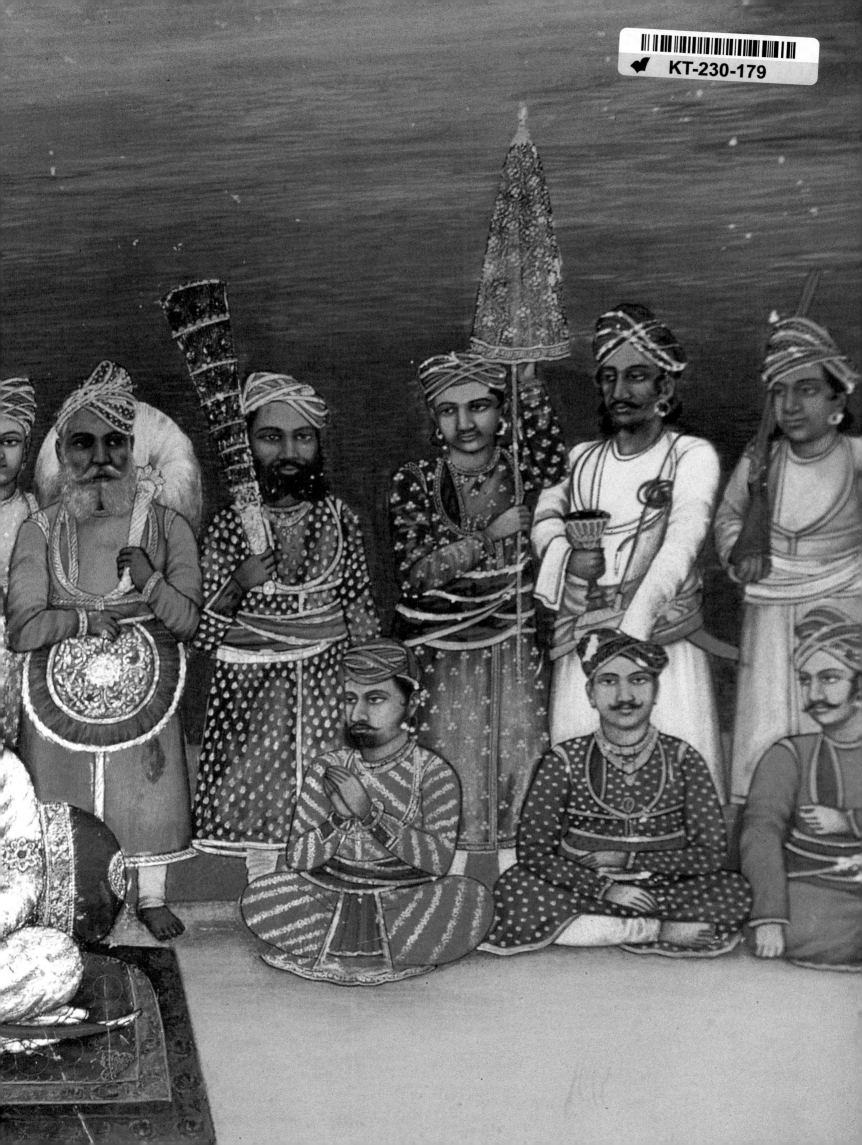

Intérieurs de l'Inde
Indian Interiors
Indien Interieurs

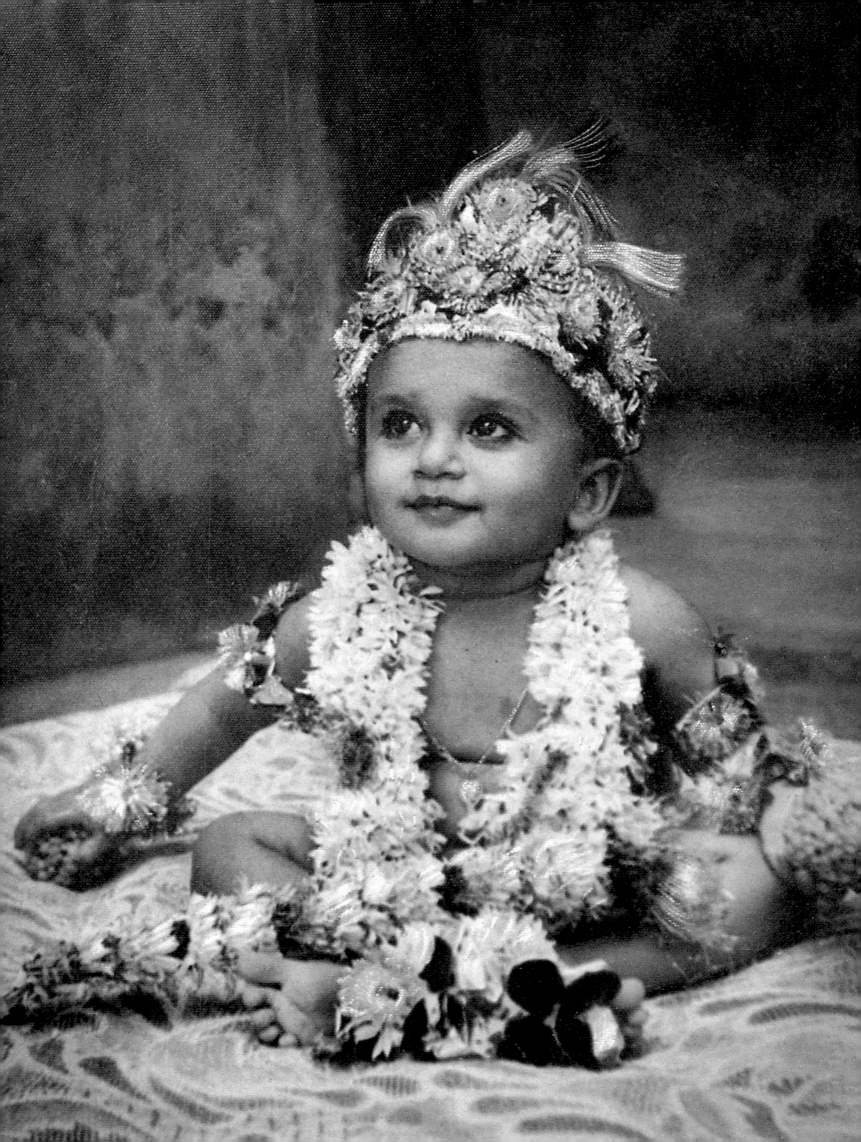

Intérieurs de l'Inde
Indian Interiors
Indien Interieurs

Photos: Deidi von Schaewen

Text: Sunil Sethi

Edited by Angelika Taschen

TASCHEN

KÖLN LONDON MADRID NEW YORK PARIS TOKYO

Endpapers | Pages de garde | Vorsatzpapier:
A fresco in the Juna Mahal in Dungarpur, Rajasthan (see page 156)
Une fresque du Juna Mahal à Dungarpur, Rajasthan (voir page 156)
Ein Fresko im Juna Mahal in Dungarpur, Rajasthan (siehe Seite 156)

Illustration page 2 | Reproduction page 2 | Abbildung Seite 2:
Devendra Deshprabhu as child (see page 236)
Devendra Deshprabhu enfant (voir page 236)
Devendra Deshprabhu als Kind (siehe Seite 236)

Illustration page 7 | Reproduction page 7 | Abbildung Seite 7:
Drawing by | Dessin par | Zeichnung von Tilmann Lohse, Darmstadt

Portrait of the Maharaja of Jodhpur page 111
Portrait du maharaja de Jodhpur page 111
Porträt des Maharajas von Jodhpur Seite 111:
Photo by Sumio Uchiyama

© Benedikt Taschen Verlag GmbH
Hohenzollernring 53, D–50672 Köln
Edited by Angelika Taschen, Cologne
Text edited by Ursula Fethke, Nazire Ergün, Cologne
Production by Ute Wachendorf, Cologne
French translation by Philippe Safavi, Paris
German translation by Dorothee Merkel, Cologne

Printed in Austria
ISBN 3–8228–7076–5 (English cover)
ISBN 3–8228–7105–2 (French cover)
ISBN 3–8228–7139–7 (German cover)

Contents
Sommaire
Inhalt

Living in India

Vivre en Inde aujourd'hui

Indische Wohnwelten

Growing up in a provincial town in the Punjab, in a rambling colonial brick bungalow of Twenties design, it never struck me that there was any other way of living than in a large extended family. Several uncles and their families, aunts estranged from husbands, cousins on home leave and innumerable servants, all lived under the same roof, or rather, in various sections of the house, connected by corridors, courtyards, verandas and rooftop terraces. As many as 20 people sat down to meals together. On hot summer nights, beds with mosquito nets like ships' sails formed a fluttering armada up and down the driveway. Distant relatives, or friends of friends, came for a few nights and stayed on for weeks, sometimes months.

As the composite "joint" family disintegrated into nuclear units and people moved out of the old house, I thought a way of life had evaporated forever. But in India there are no vanishing points. Many of the houses featured in this book replicate the life of a small town that I knew as a boy. For example, few of the old family members still live in the turn-of-the-century "haveli" or mansion in Churu (page 86) but when I set about tracking down its rightful inheritors I found them, after many weeks of effort, living not far from me in Delhi. Similarly, the owners of the magnificent Kothari Haveli in Bikaner (page 92), unoccupied except for a mindful watchman, live far away in Calcutta, while the man who will one day inherit the impressive "tharawad" plantation house in Kerala (page 274) runs a restaurant in Cochin.

Visitors to India or those Indians who bemoan the speed at which their country is changing – fearing it will soon be consumed by "Maharaja McBurgers", digital technology and the advancing tide of urban sprawl – may be surprised to find in the pages of this book how much of it remains unchanged.

George Michell, an authority on Indian architectural history, who has lately documented many of the hundreds of scenes of Indian life, including monuments, landscapes and temple sites, that the intrepid Englishmen Thomas and William Daniell painted in the last decades of the 18th century, says that more old buildings survive in India today than in any European country. True, some may be in a decrepit state, and others damaged or encroached upon,

J'ai passé mon enfance dans un immense bungalow colonial en briques construit dans les années 20, dans une ville provinciale du Pendjab. Plusieurs oncles et leur famille, des tantes séparées de leur mari, des cousins en visite et une armée de domestiques vivaient sous le même toit, ou plutôt dans diverses parties de la maison reliées par des couloirs, des cours, des vérandas ou des terrasses. Aux repas, nous étions toujours une vingtaine à manger ensemble. Les chaudes nuits d'été, nos lits formaient une armada de voiles blanches le long de l'allée du jardin, les moustiquaires oscillant doucement dans la brise. Des parents éloignés, ou des amis d'amis, venaient passer quelques nuits et restaient des semaines, parfois des mois.

Lorsque chacun partit vivre de son côté, je crus que c'était tout un mode de vie qui s'était évanoui à jamais. Un grand nombre des maisons présentées dans ce livre reflètent la vie provinciale que j'ai connue enfant. Peu de gens habitent encore dans le «haveli», ou grande demeure, de Churu (page 86), datant du début du siècle, mais après de nombreuses semaines de recherches, j'ai fini par retrouver ses héritiers vivant non loin de chez moi à Delhi. De même, les propriétaires du magnifique haveli Kothari à Bikaner (page 92), qui n'est plus habité que par un fidèle gardien, vivent désormais à des milliers de kilomètres, à Calcutta, alors que celui qui héritera un jour de l'impressionnante «tharawad» du Kerala (page 274) dirige un restaurant à Cochin.

Les visiteurs étrangers et les Indiens qui sont persuadés que le pays sera bientôt consumé par les «McBurgers Maharaja», la technologie numérique et l'urbanisation anarchique, seront surpris de constater l'ampleur de la part demeurée intacte.

George Michell a récemment répertorié l'œuvre de l'intrépide duo anglais Thomas et William Daniell, oncle et neveu, qui, au cours des dernières décennies du 18e siècle, ont peint des centaines de scènes de la vie indienne, incluant des monuments, des paysages et des temples. Certains sont bien sûr aujourd'hui à l'état de ruines, d'autres endommagés ou remaniés, mais, au cours des deux siècles qui se sont écoulés depuis que les Daniell ont publié leurs images, seule une poignée a définitivement disparu.

Ich wuchs auf in einer Provinzstadt im Punjab, in einer weitläufigen Backsteinvilla aus den zwanziger Jahren, und es kam mir nie in den Sinn, daß es eine andere Lebensweise geben könnte als die inmitten einer großen, weitverzweigten Familie. Mehrere Onkel und deren Familien, Tanten, die sich von ihren Männern entfremdet hatten, Cousins auf Besuch und zahllose Bedienstete lebten alle unter einem Dach oder vielmehr in verschiedenen Teilen des Hauses, die durch Flure, Innenhöfe, Veranden und Dachterrassen miteinander verbunden waren. Zu den Mahlzeiten kamen nie weniger als 20 Personen zusammen. Während der heißen Sommernächte ähnelten die in die Auffahrt gestellten Betten mit ihren wallenden Moskitonetzen einer Armada von Schiffen mit flatternden Segeln. Entfernte Verwandte oder Freunde von Freunden kamen für einige Tage zu Besuch, um dann wochen-, manchmal sogar monatelang zu bleiben.

Als diese Großfamilie in ihre Einzelteile zerfiel und die Menschen das alte Haus verließen, dachte ich, daß eine ganz besondere Lebensart für immer verschwunden sei. Aber in Indien gibt es keine endgültigen Verluste. In vielen der Häuser, die in diesem Buch vorgestellt werden, spielte sich ein ganz ähnliches Leben ab wie jenes, das ich als kleiner Junge kannte. In Churu zum Beispiel, in dem »Haveli« oder Herrenhaus von der Jahrhundertwende (Seite 86), leben heute nur noch einige wenige Familienmitglieder, aber als ich mich auf die Suche nach den rechtmäßigen Erben machte, entdeckte ich nach einer mehrwöchigen intensiven Suche, daß sie in Delhi wohnten, ganz in meiner Nähe. Ganz ähnlich verhält es sich mit dem herrlichen Kothari Haveli in Bikaner (Seite 92). Abgesehen von einem Wachmann ist es unbewohnt, denn die Besitzer wohnen Tausende von Kilometern entfernt in Kalkutta. Und der Mann, der eines Tages das »Tharawad«-Plantagenhaus in Kerala (Seite 274) erben wird, führt heute ein Restaurant in Cochin.

Indienreisende, aber auch jene Inder, die die Geschwindigkeit beklagen, mit der sich das Land verändert, und die glauben, es sei bald vom »Maharaja McBurger«, digitaler Technologie und dem ungebremsten Wachstum der Städte gänzlich verein-

but less than a handful have disappeared altogether in the 200 years since the Daniells produced the volumes containing their celebrated views.

Among the more splendid interiors presented here, and rarely photographed in such refined detail, are rooms that have remained untouched since they were decorated more than two centuries ago. The sumptuously frescoed and mirrored chambers of the Juna Mahal (page 156), or the maharani's personal sitting room in the palace at Jasdan (page 208), with its swing and bed of solid silver, its panels of Kutch beadwork embroidery and rows of dowry chests have survived in excellent condition, chiefly because they have remained in private hands. They are valued symbols of family pride. And if some of the scattered treasures of royal splendour, cherished by fond, preserving hands over the centuries are still to be found the way they were, then why should the circular huts of the Rabari nomads in the desolate wasteland of the Rann of Kutch (page 168), embellished with elaborate mirror-encrusted decoration, succumb to sudden change – except in the mere token exchange of a few discarded light bulbs for mirrors or the placing of health posters advocating breast-feeding alongside images of religious heroes?

To the percipient observer of Indian interiors occasional unities of form and style will be obvious, like variations on a theme. What the gilded throne room of the maharajas of Jaipur (page 68) has in common with the shepherd's mud-plastered hut is that the occupants of both sit on the floor. It is the preferred, traditional form of seating in India. The rich man's "gaddi", a throne or padded cushion, is only infinitesimally raised above the poor man's grass mat. Symbolically they are equal citizens. Like chilli or cottage cheese, the chair is a European import to India. There are plenty of accounts by early European arrivals of painfully crawling about on all fours at audiences with Indian rulers.

At the heart of most Indian houses is a sacred space. It may be a richly painted prayer room, as in the house in Leh (page 56), a large temple as in the Palacio de Pernem in Goa (page 236) or a private chapel like the one in the Casa de Braganza in Goa (page 254). Or it may be a saffron symbol of blessing

Parmi les intérieurs splendides présentés ici, rarement photographiés avec un tel raffinement de détails, se trouvent des pièces demeurées intactes depuis leur conception il y a de cela deux cents ans. Ils doivent leur parfait état de conservation au fait d'être toujours restés entre les mains de propriétaires privés. C'est le cas notamment des salles somptueusement décorées de fresques et de miroirs du Juna Mahal (page 156), ou du salon privé de la maharani dans le palais de Jasdan (page 208), avec sa balançoire et son lit en argent massif, ses panneaux brodés de perles et les rangées de coffres de trousseau. Ils sont autant de symboles choyés de la fierté familiales. Si ces quelques trésors épars de la splendeur royale d'antan ont été préservés avec amour pendant des siècles, pourquoi en irait-il autrement des huttes rondes que les nomades Rabari construisent dans les terres arides du Rann de Kutch (page 168), les embellissant de motifs sophistiqués incrustés de miroirs? Les seuls changements que l'on observe dans ces dernières sont les vieilles ampoules électriques venues remplacer les miroirs et les affiches de santé publique faisant l'éloge de l'allaitement placées parmi les images de héros religieux.

L'observateur attentif remarquera dans ces intérieurs certaines unités de formes et de styles, telles des variations sur un même thème. Ce qui relie la salle dorée du trône des maharajas de Jaipur (page 68) à la hutte aux murs enduits de plâtre d'un berger, c'est que, dans un cas comme dans l'autre, on s'assoit par terre. C'est la manière favorite et politiquement correcte de s'asseoir en Inde. Le «gaddi» du riche – trône ou coussin rembourré – étant à peine plus haut que la paillasse du pauvre. Symboliquement, ils sont égaux. Comme le piment rouge et le fromage blanc, la chaise est une importation européenne. Il existe des dizaines d'anecdotes au sujet des premiers occidentaux arrivés en Inde et rampant à quatre pattes lors d'audiences avec les souverains.

Au cœur de nombreuses maisons indiennes se trouve un lieu sacré. Il peut s'agir d'une salle de prière richement peinte comme dans une maison de Leh (page 56), d'un grand temple comme dans le palais de Pernem à Goa (page 236), d'une chapelle privée comme dans le palais Braganza à Goa (page

nahmt, werden wohl überrascht sein, in diesem Buch
zu entdecken, wieviel unverändert geblieben ist.

George Michell, eine Autorität auf dem Gebiet
der indischen Architektur, stellte vor kurzem Hun-
derte von Gemälden zusammen, in denen das aus
Onkel und Neffe bestehende Künstlerpaar Thomas
und William Daniell Ende des 18. Jahrhunderts mit
zahlreichen Darstellungen von Gebäuden, Land-
schaften und Tempelanlagen das Leben in Indien do-
kumentierten. Michell vertritt die Ansicht, daß in In-
dien bis heute mehr alte Gebäude erhalten geblieben
sind als in irgendeinem europäischen Land. Manche
davon mögen in einem äußerst schlechten Zustand
sein, andere beschädigt oder baulich verändert wor-
den sein, aber weniger als eine Handvoll sind in den
vergangenen 200 Jahren seit der Entstehung der
Daniell-Gemälde gänzlich verschwunden.

In einigen der prachtvolleren Gebäude, die hier
vorgestellt werden und deren Inneres bislang noch
nie so gelungen und detailliert fotografiert worden
ist, befinden sich Räume, die seit ihrer Einrichtung
vor mehr als 200 Jahren unberührt geblieben sind.
Die verschwenderisch mit Fresken und Spiegelglas
ausgestatteten Gemächer des Juna Mahal (Seite 156)
oder der Salon der Maharani im Jasdan Palace (Seite
208) mit seiner Schaukel und dem Bett aus massi-
vem Silber, den Stickereien mit Perlen aus Kutch und
den Truhen mit der Mitgift der Maharani – all dies hat
in solch einem hervorragenden Zustand überlebt,
weil es in Privatbesitz geblieben ist. Diese Dinge sind
kostbare Symbole des Familienstolzes. Und ähnlich
wie die hier und da verstreuten Schätze herrschaftlicher
Prachtentfaltung unverändert blieben, weil sie über
Jahrhunderte liebevoll gepflegt wurden, so erhielt bei-
spielsweise das Nomadenvolk der Rabari seine Lebens-
weise. Ihre runden Hütten in der kargen Wildnis der
Rann von Kutch (Seite 168), die sie mit kunstvollen,
von Spiegelglas durchsetzten Malereien verziert ha-
ben, wurden kaum verändert – abgesehen von kaput-
ten Glühbirnen, die hier und da anstelle von Spiegel-
glas als Schmuck verwendet werden, oder Plakaten,
die neben religiösen und mythologischen Darstellun-
gen hängen und das Stillen der Kinder propagieren.
Dem aufmerksamen Leser von »Indien Inte-
rieurs« werden gelegentliche Gemeinsamkeiten in

daubed at the entrance of a nomadic home (page 168). Some invocation to God, often manifested as a personal deity, is an essential feature of many Indian dwellings. Even the meandering patterns of the huts in Orissa (page 310) carry symbolic allusions to Lakshmi, the goddess of prosperity.

But Indians are also a fiercely individualistic people, and they abhor the rubber-stamp of homogeneity. They build to express themselves, as a statement of personal identity. I asked the actress Asha Parekh, a leading Bollywood icon of the Sixties, why she commissioned a top Bombay architect to build her extraordinary house (page 226). With touching honesty she replied: "Because I wanted to leave behind something that people would remember me for." Doubtless it was the same feeling that impelled the innumerable ruling dynasties of India to build feverishly and on such a vast scale, leaving for posterity one of the great architectural legacies of the world.

There is an impression nowadays that India is an inward-looking country and that its politics of religious intolerance have bred fundamentalism and xenophobia. Its modern buildings, however, tell a different story. The Thirties palace at Morvi (page 184) is among the best-preserved art deco buildings in the world. The home of writer Patwant Singh (page 22) has strong connections with modern masters of Western design, the Poddar house (page 16) gives free rein to a younger generation of Indian architects and Jimmy Gazdar's villa (page 244) harks back to the golden age of European baroque. Far from being insular, these interiors carry forward the traditions of avid curiosity and an active engagement with the outside world that has marked Indian style down the ages.

This book is neither an architectural survey nor a digest of Indian lifestyles. It seeks to address, in a selective, purely impressionistic way, three questions that may strike visitors to India or Indians themselves: "Who are these people? Where do they come from? And why do they live the way they do?" It offers a whiff of India, a scent of the Indian way of living at the start of the new millennium.

254), ou encore d'un simple symbole de bénédiction dessiné au safran à l'entrée d'une maison nomade (page 168). Même les arabesques en pâte de riz avec lesquelles les villageoises d'Orissa décorent leurs huttes (page 310) sont chargées d'allusions symboliques à Lakshmi, déesse de la prospérité.

Mais les Indiens forment également un peuple profondément individualiste et bâtissent pour s'exprimer, pour afficher leur identité. J'ai demandé à l'actrice Asha Parekh pourquoi elle avait demandé au plus grand architecte de Bombay de lui construire son extraordinaire maison au bord de la plage (page 226). Avec une émouvante sincérité, elle m'a répondu : « Parce que je voulais qu'on se souvienne de moi après ma mort.» C'est certainement inspirées par le même sentiment que d'innombrables dynasties indiennes ont construit autant et à si grande échelle, laissant derrières elles un des patrimoines architecturaux les plus grands du monde.

Aujourd'hui, ou considère souvent l'Inde comme un pays replié sur lui-même, ses bâtiments modernes, toutefois, racontent une autre histoire. Le palais années 30 de Morvi (page 183) est l'un des bâtiments Art Déco les mieux conservés du monde. La demeure de l'écrivain Patwant Singh (page 22) reflète la forte influence des maîtres modernistes de l'Occident. Dans la maison Poddar (page 16), on a donné carte blanche à une nouvelle génération d'architectes indiens. Quant à la villa de Jimmy Gazdar à Goa (page 244), elle nous renvoie à l'âge d'or du baroque européen. Loin d'être insulaires, ces intérieurs témoignent d'une tradition d'une curiosité insatiable et d'une participation active au monde extérieur qui a marqué le style indien au fil des siècles. Ce livre n'est ni une étude d'architecture ni un résumé du mode de vie indien. Il ne cherche qu'à répondre, d'une manière sélective et purement impressionniste, aux trois questions qui viennent souvent à l'esprit des visiteurs de l'Inde et aux Indiens eux-mêmes : «Qui sont ces gens? D'où viennent-ils? Pourquoi vivent-ils ainsi?» Il offre une bouffée d'air indien, un parfum du style indien à l'aube du troisième millénaire.

Form und Stil auffallen, so als handele es sich um Variationen zu ein- und demselben Thema. Was der vergoldete Thronsaal des Maharajas von Jaipur (Seite 68) mit den lehmverputzten Hütten der Hirten gemeinsam hat, ist die Tatsache, daß die Bewohner beider Gebäude auf der Erde sitzen. Es ist die bevorzugte, »politisch korrekte«, traditionelle Art des Sitzens in Indien. Der »Gaddi« des reichen Mannes, sei es nun ein Thron oder ein gepolstertes Kissen, ist nur ein winziges Stück höher als die aus Gras geflochtene Matte des armen Mannes. Auf dieser symbolischen Ebene sind sie gleichberechtigte Bürger. Ähnlich wie Chili oder Hüttenkäse ist auch der Stuhl ein europäischer Import. Zahlreiche Berichte früherer europäischer Besucher schildern, wie sie unter dieser Art des Sitzens während der Empfänge bei indischen Herrschern litten.

Als wichtigstes Element haben viele indische Häuser einen sakralen Bereich. Dabei kann es sich um einen reich verzierten Gebetsraum handeln, wie bei dem Haus in Leh (Seite 56), um einen großen Tempel, wie im Palacio de Pernem in Goa (Seite 236), oder eine Hauskapelle, wie in der Casa de Braganza in Goa (Seite 254). Oder es kann auch einfach nur ein safranfarbenes Segenssymbol sein, das an den Eingang einer Nomadenhütte gemalt wurde (Seite 168). Die Beschwörung eines Gottes in Gestalt verschiedener Manifestationen ist in den Häusern Indiens allgegenwärtig. Selbst die mäanderförmigen Verzierungen an den Hütten in Orissa, die von den Frauen mit Reispaste aufgetragen werden (Seite 310), beinhalten symbolische Anspielungen auf Lakshmi, die Göttin der Fruchtbarkeit.

Aber die Inder sind zugleich auch ein Volk, dessen Angehörige leidenschaftlich auf ihre Individualität bedacht sind und eine alles einebnende Homogenität verabscheuen. Ihre Bauten sind Ausdruck ihres ureigensten Wesens, ihrer persönlichen Identität. Ich habe der Schauspielerin Asha Parekh, einer der großen »Bollywood«-Ikonen der sechziger Jahre, einmal die Frage gestellt, warum sie einen der führenden Architekten Bombays damit beauftragt hatte, ihr außergewöhnliches Strandhaus zu bauen (Seite 226). Mit rührender Aufrichtigkeit antwortete sie: »Weil ich etwas hinterlassen möchte, für das mich die Men-

schen in Erinnerung behalten.« Zweifellos war es derselbe Impuls, der die zahllosen Herrscherdynastien Indiens dazu veranlaßte, geradezu fieberhaft und in monumentalen Ausmaßen zu bauen und auf diese Weise ein architektonisches Erbe zu hinterlassen, das zu den großartigsten der Welt gehört.

Es kursiert heutzutage die Ansicht, Indien sei ein Land, das sehr mit seinen eigenen Angelegenheiten beschäftigt sei. Die Politik der religiösen Intoleranz habe den Nährboden für Fundamentalismus und Fremdenhaß geschaffen. Die modernen Bauten des Landes bezeugen jedoch etwas ganz anderes. Der Palast in Morvi aus den dreißiger Jahren (Seite 184) gehört zu den am besten erhaltenen Art-déco-Bauten der Welt. Das Haus des Schriftstellers Patwant Singh (Seite 22) ist in seiner Gestaltung eng mit westlichen Architekten und Designern verbunden, bei dem Bau des Poddar-Hauses (Seite 16) hatte eine jüngere Generation indischer Architekten Gelegenheit, ihr Talent zu zeigen, und Jimmy Gazdars Villa (Seite 244) erinnert an das goldene Zeitalter des europäischen Barock. Weit davon entfernt, sich vom Rest der Welt zu isolieren, zeigen diese Interieurs vielmehr die Fortführung jener Traditionen von unersättlicher Neugier und tatkräftiger Auseinandersetzung mit den Dingen, die anderswo vor sich gehen und die den indischen Stil bereits seit Urzeiten geprägt haben.

Dieses Buch ist weder ein architektonischer Überblick noch eine Zusammenfassung der indischen Lebensart. Es möchte vielmehr in einer selektiven, rein impressionistischen Weise drei Fragen in den Mittelpunkt stellen, die sich vielleicht den Indienreisenden, aber auch den Indern selbst stellen mögen: »Wer sind diese Menschen? Woher kommen sie? Und warum leben sie auf diese Art und Weise?« Es bietet eine Vorahnung davon, was Indien ist, einen Hauch des indischen Lebensstils zu Beginn eines neuen Jahrtausends.

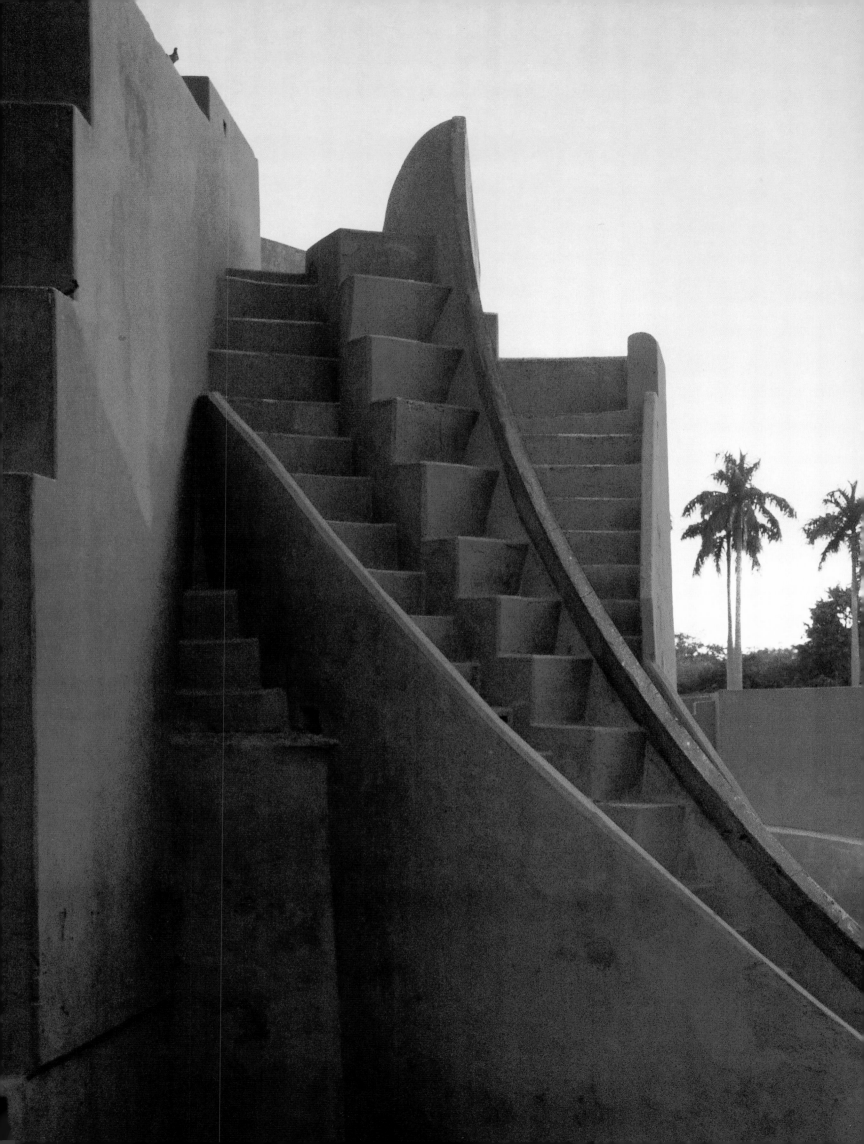

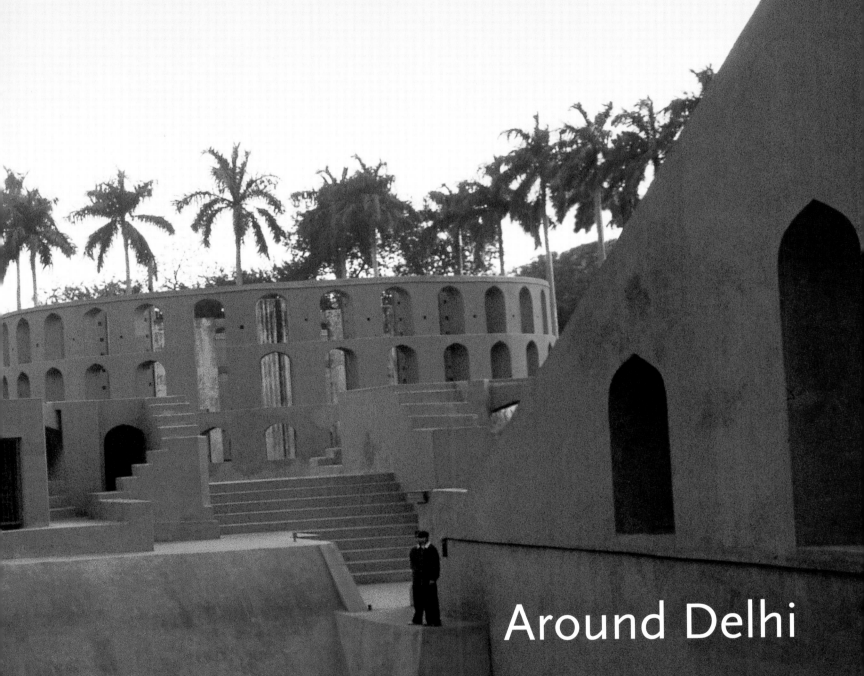

Around Delhi

Si vous cherchez une résidence indienne post-moderne vraiment originale, c'est à Delhi que vous la trouverez. Lekha et Ranjan Poddar, tous deux issus de grandes familles industrielles, ont passé le plus clair de leur vie dans des villes indiennes surpeuplées. Leurs fils devenus grands, ils souhaitaient des habitations séparées pour que chacun puisse mener sa vie tout en restant près des autres. Ils tenaient également à offrir à une nouvelle génération d'architectes la possibilité d'inventer des structures faciles à entretenir. L'architecte Inni Chatterjee et le décorateur Samiir Wheaton ont merveilleusement répondu à leurs attentes. Chatterjee a construit le bâtiment au toit volant sur une colline, de sorte que toutes les pièces aient une vue dégagée. Il a bâti la seconde maison, en forme cubique, avec des blocs de ciment encadrant des baies vitrées, lui donnant, là encore, une allure à la fois robuste et légère. Les Poddar se sentent ici parfaitement dans leur élément!

Lekha and Ranjan Poddar

The search for a truly inspired postmodern Indian residence must end at the Poddar house in Delhi. Lekha and Ranjan Poddar hail from prominent industrial families who had spent much of their lives in crowded Indian cities. With two grown sons they wanted separate dwellings that would provide independent living areas but keep the family unit together. They were also keen to give a new generation of architects the chance to experiment and create maintenance-free buildings. In architect Inni Chatterjee and designer Samiir Wheaton they found the people they were looking for. Chatterjee placed the flying-roof structure on a slope so that all rooms in the house give on to open spaces. He shaped the second house in cubic form, with concrete blocks framing sheets of plateglass to give it the same feeling of fragility yet solidness as the first. Ever since they moved in, the Poddar family have found their design for living an unqualified success.

Ein Musterbeispiel für ein wahrhaft gelungenes indisches Wohnhaus im Stil der Postmoderne ist das Poddar-Haus in Delhi. Lekha und Ranjan Poddar stammen beide aus prominenten Industriellenfamilien, die ihr Leben hauptsächlich in Häusern inmitten dicht bevölkerter indischer Städte zubrachten. Das Paar wollte für sich und seine beiden erwachsenen Söhne zwei voneinander getrennte Häuser schaffen, die den einzelnen Familienmitgliedern ihre Unabhängigkeit bewahren, die Familie als Ganzes jedoch zusammenhalten sollten. Ein weiteres Anliegen war es, einer neuen Generation von Architekten die Gelegenheit zum Experimentieren zu geben. Es sollten Gebäude geschaffen werden, die nach dem Bau keinerlei Instandhaltung mehr bedurften. In dem Architekten Inni Chatterjee und dem Designer Samiir Wheaton fanden sie genau die Leute, die sie suchten. Chatterjee stellte den Bau mit dem »schwebenden Dach« auf einen Hang, so daß man aus allen Räumen des Hauses einen Blick ins Freie hat. Dem zweiten Haus gab er eine kubische Form. Dabei faßte er Flächen aus Glas mit Beton ein, um so dieselbe Mischung aus Zerbrechlichkeit und Dichte zu erzielen wie bei dem ersten Gebäude. Vom ersten Augenblick ihres Einzugs an erlebte die Familie Poddar das Ergebnis als uneingeschränkten Erfolg.

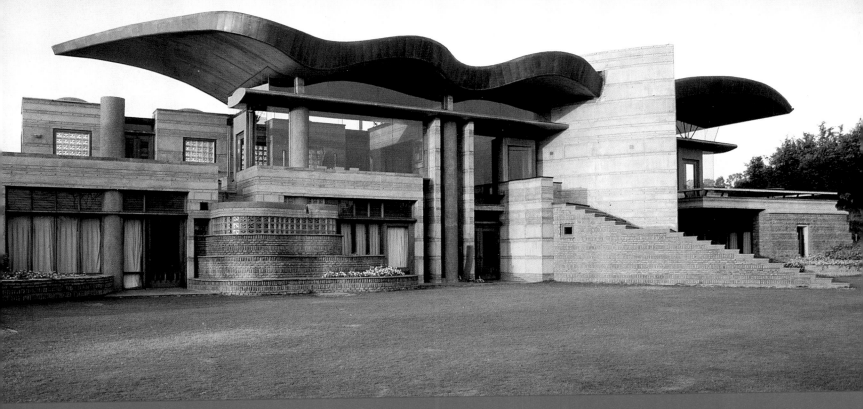

Above: Is it a bird, a wave or an U.F.O.? Sheathed in gleaming copper and underlaid in wood, the undulating roof of the Poddar house is placed on a curved fin, supported on concrete columns. French windows, sheets of plateglass and glass bricks give on to terraces and gardens at every level.
Right: view of the cubic house.

Ci-dessus: Est-ce un oiseau, une vague, ou un ovni? Le toit ondulé de la Poddar House, dont la partie inférieure est en bois et la partie supérieure recouverte de cuivre poli, repose sur un axe vertical incurvé et des colonnes en béton. A tous les niveaux, les baies vitrées et les murs en verre à vitre ou en briques de verre donnent sur des terrasses et des jardins.
A droite: vue sur la maison cubique.

Oben: Ist es ein Vogel, eine Meereswoge, ein UFO? Das wellenförmige Dach des Poddar-Hauses ist mit glänzendem Kupfer verkleidet und Holz unterlegt, und ruht auf einer flossenartigen Wölbung und Säulen aus Beton. Auf jeder Etage gewähren Verandatüren, große Fensterflächen oder Glasbausteine einen Blick auf die Terrassen oder den Garten.
Rechts: ein Blick auf das kubische Haus.

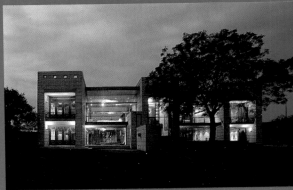

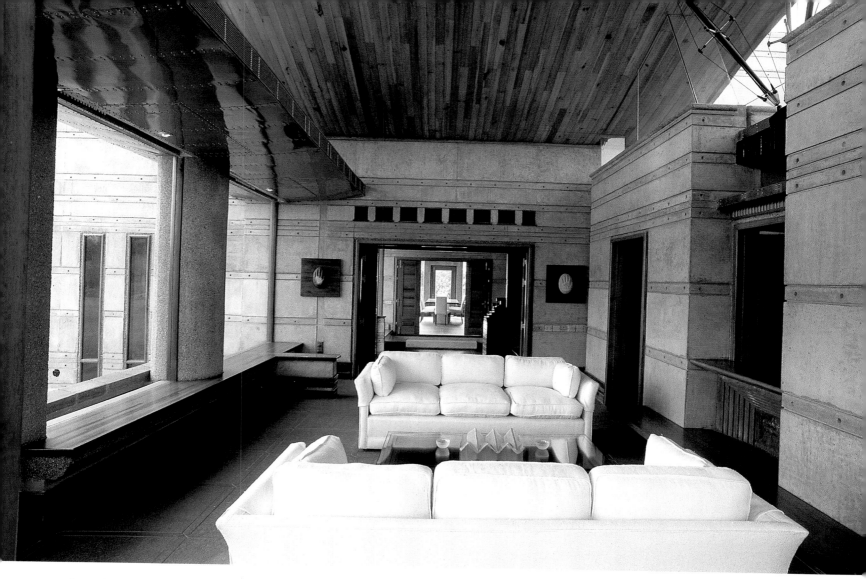

Above: The raised living room has sofas covered in plain white cotton and a long window seat of polished Burma teak on a terrazzo base. The wide air-conditioning duct below the wooden roof is in polished stainless steel. A pair of modern sculptures in granite by British sculptor Stephen Cox flank the entrance door.
Right: The dining room, flooded with light, has a wave-like roof supported by glass sheeting.

Ci-dessus: Dans le salon surélevé, les canapés sont revêtus d'une simple cotonnade blanche. Les longues banquettes en teck birman poli sont soutenues par une base en granito. Le large conduit d'air conditionné sous le toit en bois est en acier inoxydable poli. La porte d'entrée est flanquée d'une paire de sculptures modernes en granit de l'artiste anglais Stephen Cox.
A droite: La salle à manger est inondée par la lumière qui pénètre par les immenses fenêtres et les vitres qui couronnent les murs, donnant l'illusion d'un toit suspendu dans l'air.

Oben: Die Ausstattung des leicht erhöhten Wohnzimmers besteht aus Sofas mit weißen Baumwollbezügen und einer Fensterbank aus poliertem birmanischem Teakholz auf einem Sockel aus Terrazzo. Der breite Air-conditioner unter der Holzdecke ist aus poliertem Edelstahl. Zwei Skulpturen des britischen Künstlers Stephen Cox flankieren die Eingangstür.
Rechts: Licht flutet durch die großen Fensterflächen und eine gläserne Abschlußmauer, die das wellenförmige Dach trägt, in dieses Eßzimmer.

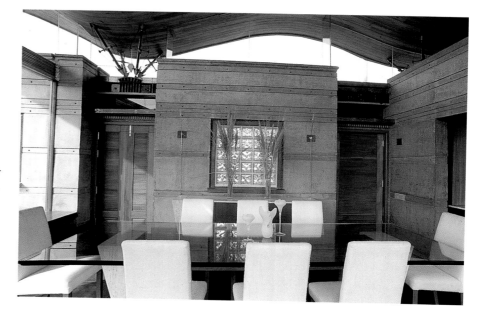

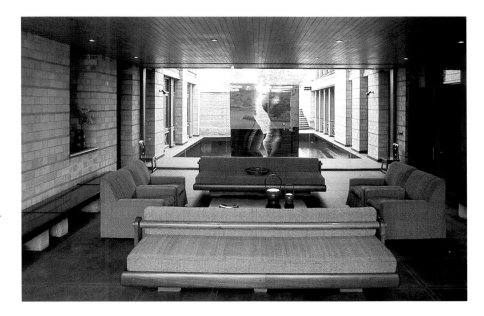

Right: *The ground-floor drawing room, overlooking a glass sculpture by American artist Danny Lane, set in a pool of water, has a Zen-like calm with twin-seater sofas fashioned from Burma teak to Lekha Poddar's design.*
Below: *a view of the dining room. Plate glass windows look out onto a waterbody, with a sheet-glass sculpture by Danny Lane. The main wall of concrete blocks is broken by bands of grit-wash. The square dining table, custom-made in Assam teak, is complemented by simple dining chairs covered in inexpensive grey cotton.*

A droite: *Le salon du rez-de-chaussée, qui s'ouvre sur une sculpture en verre de l'artiste américain Danny Lane placée au milieu d'un bassin, dégage une sérénité zen. Les canapés à deux places ont été réalisés en teck birman d'après un dessin de Lekha Poddar.*
Ci-dessous: *une vue de la salle à manger. Les parois vitrées donnent d'un côté sur un bassin accueillant une sculpture en verre de Danny Lane et, de l'autre, sur un jardin aménagé. Dans le mur principal, les blocs de ciment alternent avec les bandes de grès. La table carrée, réalisée sur mesure en teck d'Assam, est complétée par des chaises aux lignes sobres, houssées d'une simple cotonnade grise.*

Rechts: *Der Salon im Erdgeschoß, mit Aussicht auf eine Glasskulptur des amerikanischen Künstlers Danny Lane inmitten eines Wasserbassins, strahlt eine geradezu meditative Ruhe aus. Er ist mit zweisitzigen Sofas eingerichtet, die nach einem Entwurf von Lekha Poddar aus birmanischem Teakholz gefertigt wurden.*
Unten: *ein Blick in das Eßzimmer. Die Fenster gewähren Aussicht auf eine weitere Glasskulptur von Danny Lane und einen sorgfältig angelegten Garten. Die Wand aus Beton ist strukturiert durch Streifen aus grober Sandstein-Tünche. Der rechteckige Eßtisch, eine Spezialanfertigung aus Assam-Teakholz, wird durch schlichte, mit grauem Baumwollstoff bezogene Stühle ergänzt.*

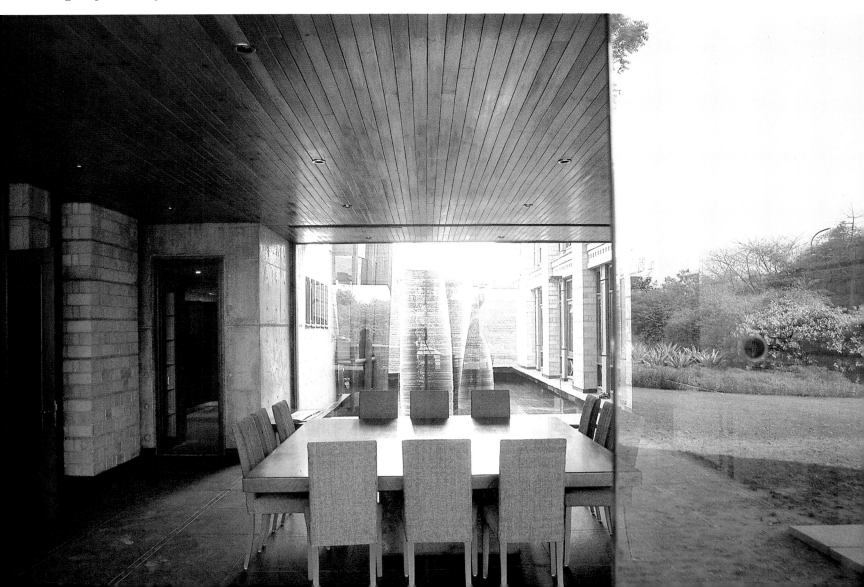

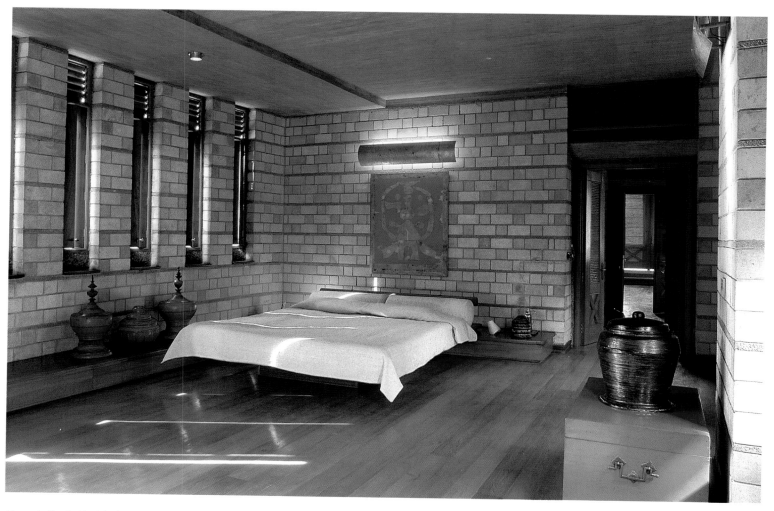

Above: Lekha Poddar's bedroom reverses the use of materials, with a floor in polished wood and a concrete roof. A set of narrow slatted windows modulate natural light. A lacquered chest and pagoda-shaped monks' bowls in red lacquer from Burma echo the colours of a modern painting by V. S. Gaitonde over the bed.
Right: Lekha Poddar's bathroom has a sunken bath with walls of polished grey granite with bands of speckled Italian marble. Wide wooden steps lead to the bathing area.
Facing page: The flowing contours of a long dining table in Burma teak designed by Samiir Wheaton imitates the drape of a rich textile. The red lacquer trays are Burmese and the large urn-shaped vessel in the corner is made of rattan.

Ci-dessus: Dans la chambre de Lekha Poddar, c'est le monde à l'envers, avec un parquet en bois poli et un plafond en ciment. Les volets à lamelles des fenêtres hautes et étroites permettent de moduler la lumière naturelle. Le coffre laqué et les jarres de monastères birmans en laque rouge et en forme de pagode rappellent les couleurs du tableau moderne de V. S Gaitonde au-dessus du lit.
A droite: Dans la salle de bains de Lekha Poddar, la baignoire est enchâssée dans le sol et les murs en granit gris poli sont rehaussés de filets de marbre tacheté d'Italie. De larges marches de bois mènent au bain.
Page de droite: Les contours fluides de la longue table en teck birman, dessinée par Samiir Wheaton, imitent le drapé d'une étoffe précieuse. Les plateaux en laque rouge viennent de Birmanie.

Oben: In Lekha Poddars Schlafzimmer hat man die Verwendung der Materialien umgekehrt: der Boden ist aus poliertem Holz und die Decke aus Beton. Eine Reihe schmaler, mit Holzläden versehener Fenster moduliert das Tageslicht. Die Farben eines über dem Bett hängenden modernen Gemäldes von V. S. Gaitonde korrespondieren mit einer Lacktruhe und roten Lackgefäßen in Pagodenform aus einem birmanischem Kloster.
Unten: Lekha Poddars Badezimmer enthält eine eingelassene Badewanne, die Wände sind aus poliertem grauem Granit, der von gefleckten italienischen Marmorstreifen durchzogen wird. Breite Holzstufen führen zur Badewanne hinauf.
Rechte Seite: Die fließenden Konturen des von Samiir Wheaton entworfenen langgestreckten Eßtischs ahmen die Faltenlegung eines prächtigen Stoffes nach. Die roten Lackschalen stammen aus Birma.

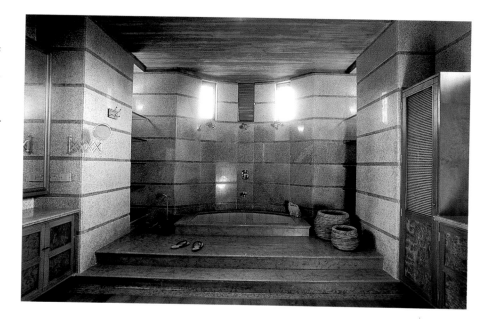

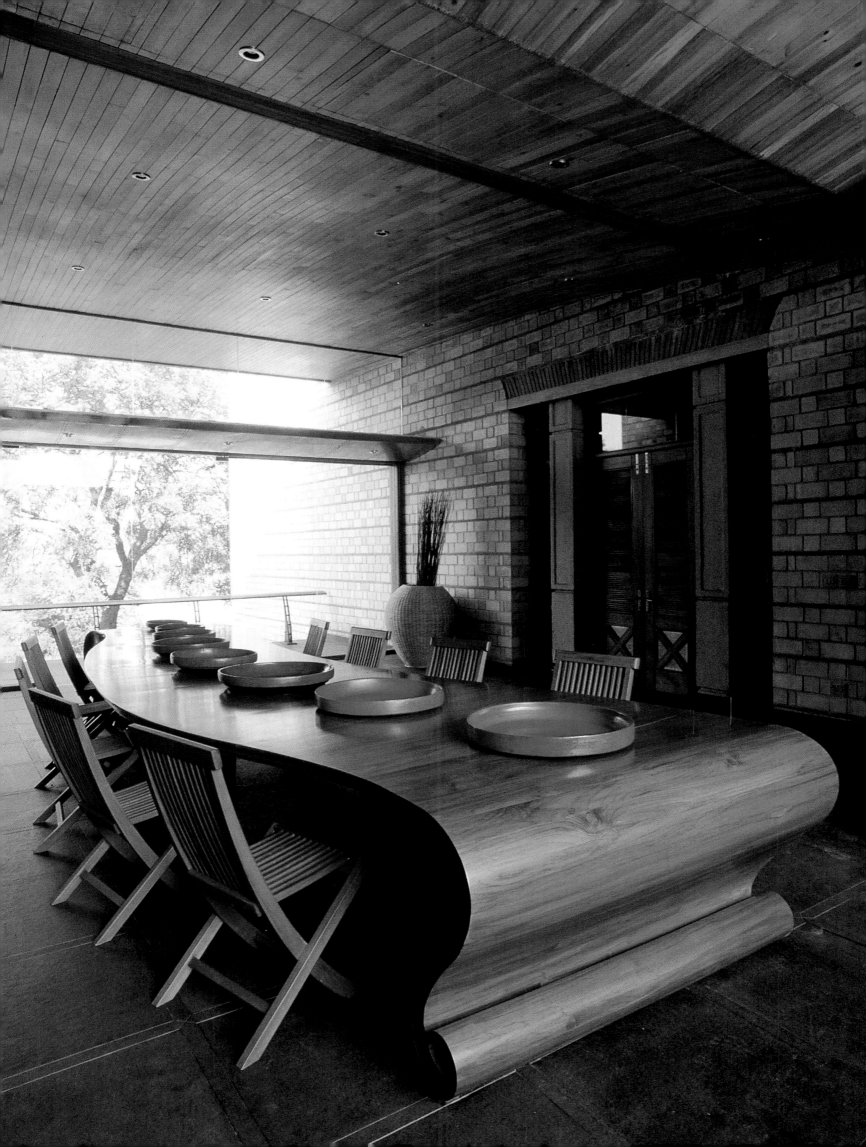

La maison de l'écrivain Patwant Singh jouxte un jardin public créé autour de monuments funéraires du début du 16e siècle. Singh est issu d'une famille de bâtisseurs, des sikhs venus dans le Pendjab dans les années vingt pour aider Sir Edwin Luytens à concrétiser son rêve d'une nouvelle capitale pour l'empire britannique. Son intérêt pour l'architecture et le design, ainsi que sa longue amitié avec des modernistes tels que Walter Gropius, Ludwig Mies van der Rohe et Philip Johnson, l'ont incité à ajouter un étage au bungalow colonial typique de l'ère Lutyens que son père avait acheté en 1937. Avec l'aide de l'architecte canadien Luc Durand, il a conçu une structure curviligne qui souligne les détails Art Déco de la bâtisse originale et dans laquelle les pièces spacieuses et claires contrastent avec la pénombre qui règne au rez-de-chaussée. Un élégant escalier mène à l'étage. Près de 40 ans après sa construction, l'adjonction moderniste de Patwant Singh a brillamment survécu à la succession capricieuse des modes.

Patwant Singh

The home of writer Patwant Singh adjoins a public garden laid out around some early 16th-century funerary monuments. Singh hails from a family of builders, Sikhs who came from the Punjab to help Sir Edwin Lutyens realise his vision of a new capital for the British Empire in the Twenties. An early preoccupation with architecture and design, and abiding friendships with Modernists such as Walter Gropius, Ludwig Mies van der Rohe and Philip Johnson, led Singh to add an upper storey to the typical colonial bungalow of the Lutyens era that his father had purchased in 1937. With the help of French Canadian architect Luc Durand, he conceived a curvilinear structure that emphasised the art deco finish of the old house and large, light-filled rooms in contrast to the dark rooms below. A graceful staircase leads to the first floor. Nearly 40 years after he built it, Patwant Singh's distinct modernist statement has success-fully endured the vagaries of changing fashion.

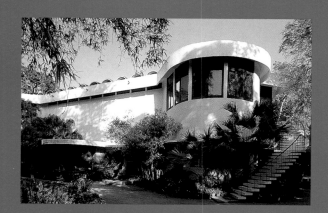

Das Haus des Schriftstellers Patwant Singh grenzt an einen großen öffentlichen Park, in dem Grabstätten aus dem frühen 16. Jahrhundert liegen. Singh stammt aus einer Familie von Baumeistern: Sikhs, die aus dem Punjab kamen, um Sir Edwin Lutyens in den zwanziger Jahren bei der Verwirklichung seiner Vision einer neuen Hauptstadt des britischen Empires zu helfen. Der Autor interessierte sich von jeher für Architektur und Design und pflegte langjährige Freundschaften zu Vertretern der Moderne, wie Walter Gropius, Ludwig Mies van der Rohe und Philip Johnson. Vor diesem Hintergrund entstand der Gedanke, dem aus der Luytens-Ära stammenden Bungalow im typischen Kolonialstil, den sein Vater 1937 gekauft hatte, ein weiteres Stockwerk hinzuzufügen. Mit Hilfe des franko-kanadischen Architekten Luc Durand entwarf Singh eine Konstruktion aus geschwungenen Formen, durch die die Art-déco-Verzierungen des ursprünglichen Gebäudes noch mehr zur Geltung gebracht wurden. Die großen, lichterfüllten Räume im Innern stehen im Kontrast zu den dunklen Räumen im Untergeschoß. Man erreicht den ersten Stock über eine elegant geschwungene Treppe. Auch fast vier Jahrzehnte nach dem Bau des Hauses hat Patwant Singhs Hommage an die Moderne alle Launen des Geschmacks erfolgreich überdauert.

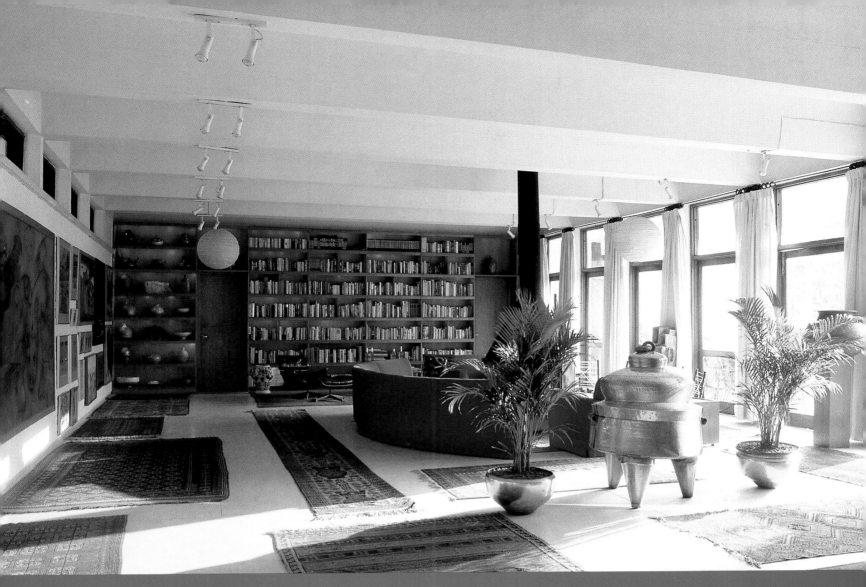

Above and right: *two views of the 60-foot-long living room that houses diverse collections of carpets, books, glass, ceramics and modern Indian painting. The ventilators above one wall provide cross-ventilation and the French windows opposite give on to a wide loggia overlooking the garden. The shell roof in whitewashed concrete and the open cast-iron fireplace are of Singh's design. The three-legged brass vessel from Gujarat was formerly used by villagers to store valuables.*

Ci-dessus et à droite: *deux vues du salon de 18 mètres de long qui accueille plusieurs collections de tapis, de livres, de verreries, de céramiques et de peinture indienne moderne. Les ventilateurs au-dessus d'un des murs assurent une aération croisée. Les baies vitrées en face donnent sur une loggia spacieuse qui domine le jardin. Le toit en béton blanchi à la chaux et la cheminée en fonte ont été dessinés par Singh. Le coffre-trépied en laiton goujarati était autrefois utilisé par les villageois pour ranger leurs objets de valeur.*

Oben und rechts: *zwei Ansichten des 18 Meter langen Wohnzimmers, in dem verschiedene Sammlungen von Teppichen, Büchern, Glas, Keramik und moderner indischer Kunst untergebracht sind. Der Air-conditioner am oberen Ende der Wand sorgt für reichlich Luftzufuhr, und die gegenüberliegenden Verandatüren führen auf eine breite Loggia mit Aussicht auf den Garten. Das Design der weißgetünchten Betondecke und des offenen Kamins aus Gußeisen stammt von Singh selbst. Das dreibeinige Messinggefäß aus Gujarat benutzten Dorfbewohner zur Aufbewahrung von Wertgegenständen.*

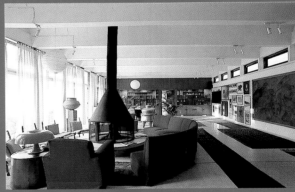

Ce jardin situé dans les faubourgs de Delhi s'appelle «Anandgram»,
village de la béatitude. O. P. Jain, conservateur et philanthrope, l'a
créé dans les années quatre-vingt pour y héberger le Sanskriti Kendra,
un centre culturel indépendant qu'il a fondé pour accueillir sa superbe
collection d'art. Il a commencé par planter une forêt, puis, avec l'aide
des architectes Upal Ghosh et Mohammed Shaheer, a érigé une
série de bâtiments rassemblés autour de cours où sont exposées ses
collections de terres cuites traditionnelles, de tableaux et d'artisanat.
Jain a également fait construire un bâtiment discret abritant des
ateliers d'artistes donnant sur un plan d'eau, un amphithéâtre, un
ensemble d'habitations et une maisonnette aux très belles proportions
qui lui sert de résidence. On ne peut pénétrer dans le Sanskriti Kendra
que sur invitation mais, dans cette oasis de paix et de méditation,
les artistes de passage peuvent travailler en toute quiétude.

O. P. Jain

"Anandgram", Village of Bliss, is the name of a large garden retreat
on the outskirts of Delhi. Conservator and philanthrophist
O. P. Jain built it up gradually through the Eighties as the home of
Sanskriti Kendra, an independent cultural centre that he founded
to house his splendid art collections. Jain first planted a forest.
With the help of architects Upal Ghosh and Mohammed Shaheer,
he then created a series of buildings around courtyards that in-
clude museums to house his collections of traditional terracotta,
painting and traditional art. O. P. Jain also built a low-profile block
of artists' studios overlooking a body of water, an amphitheatre for
performing artists, a residential complex and a small, beautifully-
proportioned cottage for himself. Entrance to the Sanskriti Kendra
is by invitation only but here, in this calm, meditative oasis,
O. P. Jain has created an idyll in which visiting artists and perform-
ers can work undisturbed.

»Anandgram«, der Ort der Glückseligkeit, so heißt eine Garten-
anlage am Stadtrand Delhis. Der Konservator und Philanthrop
O. P. Jain baute sie während der achtziger Jahre allmählich auf und
brachte darin das Sanskriti Kendra unter, ein unabhängiges Kultur-
zentrum, das er gründete, um seiner herrlichen Kunstsammlung ei-
nen Rahmen zu geben. Als erstes pflanzte Jain einen Wald. Mit Hilfe
der Architekten Upal Ghosh und Mohammed Shaheer entwarf er
sodann eine Reihe von Gebäuden, die er um verschiedene Innenhöfe
gruppierte, und die als Museen für seine Sammlungen von traditio-
neller Terrakotta, Gemälden und Gebrauchskunst dienen. Jain baute
darüber hinaus eine Reihe von schlichten Künstlerateliers am Rande
eines kleinen Sees, ein Amphitheater für künstlerische Aufführungen,
einen Komplex von Wohngebäuden und ein kleines, wunderbar aus-
gewogen gestaltetes Cottage für sich selbst. Einlaß in das Sanskriti
Kendra findet man nur aufgrund einer Einladung. Hier, in dieser
friedlichen, meditativen Oase hat O. P. Jain eine Idylle für Besucher
aus dem Bereich der bildenden und darstellenden Kunst geschaffen,
in der sie ungestört arbeiten können.

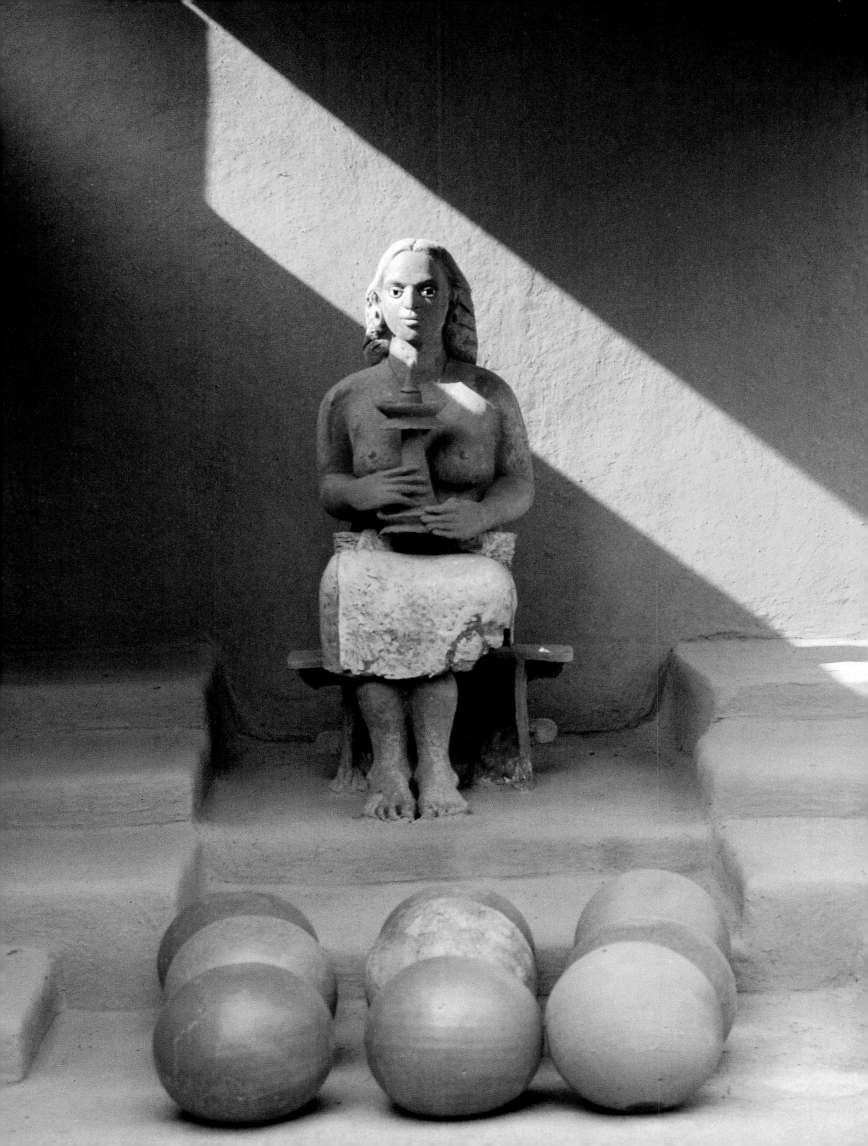

Previous page: A Zen-like cluster of terracotta globes by a Japanese artist, representing the abstract concept of "shunya" or zero, are carefully placed before a larger-than-life, painted clay image of an Earth Mother holding a lamp by Kerala sculptor Asokan Paudwal.
Right: An elaborate 19th-century wooden dovecote from Patan in Gujarat is the centrepiece of one courtyard. Its ornamental brackets support tiers of nesting spaces for birds. An enclosure at the base provides security for fledgings.
Below: A modern fibreglass sculpture of an urn smeared in terracotta wash by Kerala artist N. M. Rimzon is propped up against a wall coated with mud-coloured cement plaster. An old bullock cart wheel blocks a gap in a boundary wall.

Page précédente: devant une statue plus grande que nature en argile peinte figurant la Terre nourricière tenant une lampe, œuvre du sculpteur Asokan Paudwal, originaire du Kerala, un ensemble zen de globes en terre cuite réalisés par un artiste japonais et représentant le concept du «shunya» ou du zéro.
A droite: au centre de cette cour, un colombier ouvragé du 19e siècle provenant de Patan dans le Gujerat. Ses saillies ornementales cachent des étages où les oiseaux peuvent nicher. Une enceinte à sa base assure la sécurité des oisillons.
Ci-dessous: Une urne monumentale en fibre de verre badigeonnée d'ocre rouge, œuvre de N. M. Rimzon, un artiste du Kerala, adossée à un mur enduit de plâtre-ciment couleur terre. La vieille roue de char à bœuf bouche une ouverture dans le muret de la cour.

Vorhergehende Seite: Eine Zen-artige Gruppierung von Terrakotta-Kugeln eines japanischen Künstlers, die die abstrakte Idee des »Shunya« – der Null – darstellen, liegt zu Füßen einer überlebensgroßen, bemalten Tonfigur einer Erdmutter mit Lampe, die der aus Kerala stammende Künstler Asokan Paudwal geschaffen hat.
Rechts: Ein kunstvoll geschnitzter hölzerner Taubenschlag aus dem 19. Jahrhundert, der aus Patan in Gujarat stammt, steht in der Mitte eines der Innenhöfe. Seine reich verzierten Trägerarme stützen eine Reihe von Nistkästen. Eine Einfriedung an seinem unteren Ende bietet Schutz für die Nestlinge.
Unten: Von dem keralischen Künstler N. M. Rimzon stammt die moderne Urnen-Skulptur aus Fiberglas, die mit einer Terrakotta-Tünche überzogen ist und gegen eine mit grauem Zement verputzte Wand gelehnt steht. Das Rad eines alten Ochsenkarren versperrt eine Lücke in der Mauer.

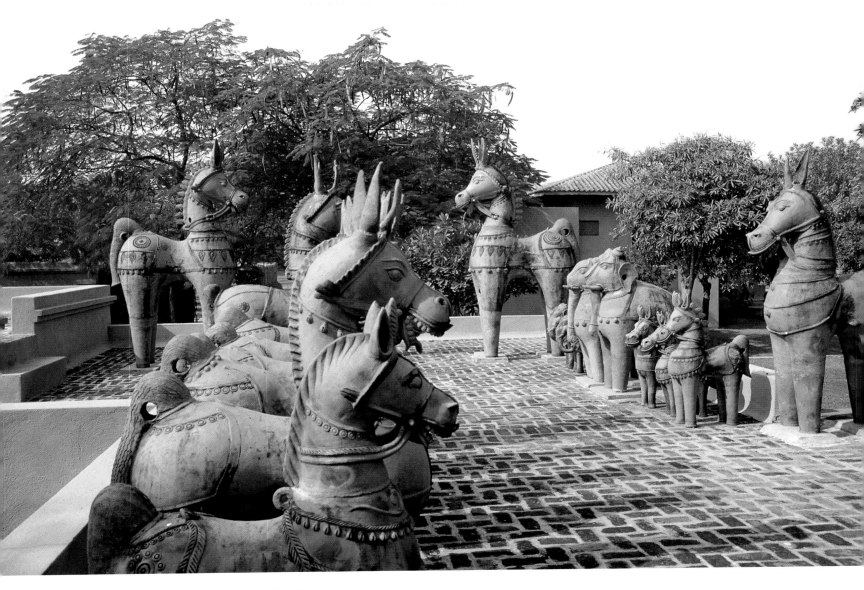

Above: Votive animal sculptures in terracotta, representing the army
of a mythical king, recreate the majesty of traditional Aiyyanar
shrines found in Tamil Nadu. It took half a dozen skilled craftsmen
three months on site to complete the shrine at Sanskriti.
Right: Both the performance and seating areas of the amphitheatre
at Sanskriti were conceived as a series of terraced concentric circles.
For the stage backdrop O. P. Jain salvaged an entire façade of "jaali"
stonework, finely carved screens of pierced sandstone, from a crum-
bling mansion in Rajasthan.

Ci-dessus: Ces sculptures animalières votives en terre cuite, figurant
l'armée d'un roi mythique, recréent la majesté des temples tradition-
nels Aiyyanar que l'on trouve dans le Tamil Nadu. Il a fallu trois mois
à une demi-douzaine d'artisans qualifiés pour achever sur place le
temple de Sanskriti.
A droite: La scène et les tribunes de l'amphithéâtre de Sanskriti ont
été conçues comme une série de cercles concentriques sur plusieurs
niveaux. En guise de toile de fond, O. P. Jain a récupéré toute une
façade de «jaali», des panneaux de grès ajourés et finement sculptés,
dans un palais en ruines du Rajasthan.

Oben: Die Terrakottavotive in Form von Tierskulpturen, die die
Armee eines mythischen Königs darstellen, stammen aus Tamil
Nadu. Sechs versierte Künstler benötigten drei Monate, um den
Schrein von Sanskriti vor Ort fertigzustellen.
Rechts: Sowohl Bühne als auch Publikumsbereich des Amphitheaters
in Sanskriti bestehen aus einer Reihe abgestufter konzentrischer
Kreise. Für den Bühnenhintergrund rettete O. P. Jain eine gesamte
Fassade aus »Jali«-Werk, fein gemeißelte Fenstergitter aus durch-
brochenem Sandstein, von einem dem Verfall preisgegebenen Haus
in Rajasthan.

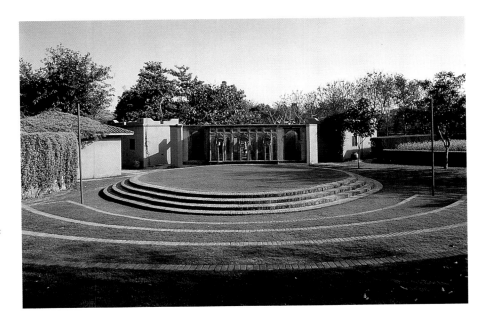

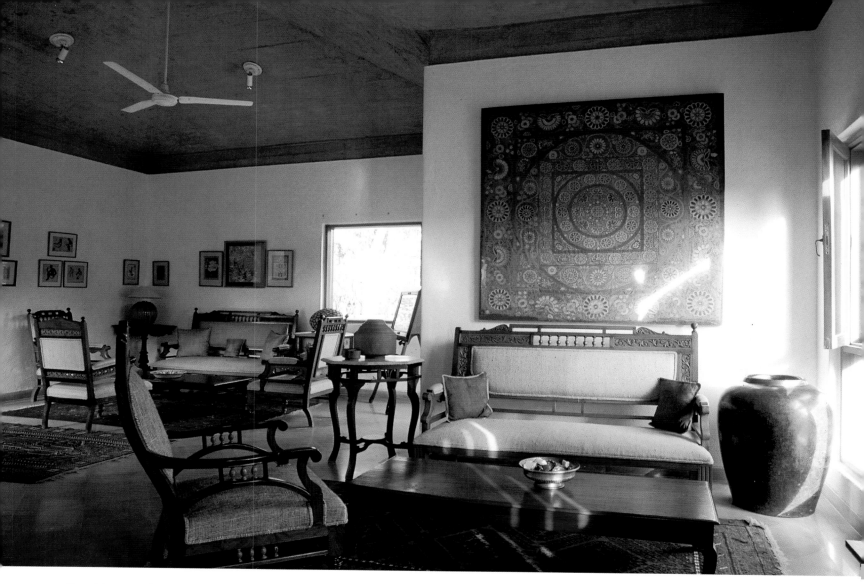

Above: The rooms of O. P. Jain's cottage in Sanskriti are roofed in sloping concrete but a formal arrangement of late 19th-century colonial furniture gives the sitting room a "fin-de-siècle" air. The large silk-embroidered panel above the sofa and the big storage jar are both from coastal Gujarat.
Right: Airy light-filled work spaces, with loft-like living quarters on the upper floors, give artists-in-residence at Sanskriti the independence to pursue their work without distraction.

Ci-dessus: Bien que toutes les pièces de la maisonnette d'O. P. Jain à Sanskriti aient un plafond en béton incliné, la disposition formelle des meubles coloniaux de la fin du 19e siècle confère à ce salon une atmosphère «fin de siècle». Le grand panneau en soie brodé au-dessus du canapé et la grande jarre viennent de la région côtière du Gujerat.
A droite: Les ateliers aérés et clairs, avec leurs appartements-lofts à l'étage, offrent aux artistes séjournant à Sanskriti la possibilité de travailler sans être dérangés.

Oben: Die Räume von O. P. Jains Cottage in Sanskriti sind mit einer schräg abfallenden Betondecke überdacht. Im Gegensatz dazu verleiht das sorgfältige Arrangement von Möbeln aus der Kolonialzeit des späten 19. Jahrhunderts dem Wohnzimmer eine »Fin-de-siècle«-Atmosphäre. Der Wandteppich aus Seidenstickerei über dem Sofa und das große Gefäß daneben stammen beide aus der Küstenregion Gujarats.
Rechts: Luftige, lichterfüllte Arbeitsräume und loftartige Wohnräume geben den zu Besuch weilenden Künstlern die nötige Unabhängigkeit, um sich ohne Ablenkung ihrer Arbeit widmen zu können.

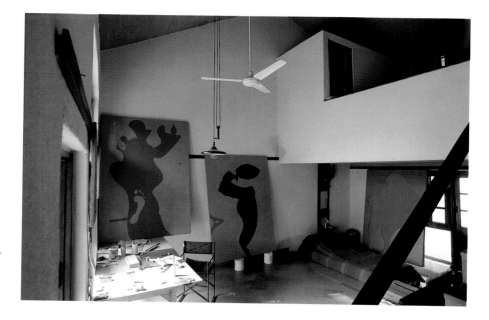

Right: Special chambers of the terracotta museum are dedicated to cults of powerful deities worshipped in various parts of rural India. In this room village artists from the Madhubani region of Bihar have recreated sculpture and wall paintings to commemorate the life of Raja Sailesh, a much-revered local hero.
Below: O. P. Jain's bedroom, which opens on to a private walled garden, is furnished with a refreshingly eclectic mix of the old and new. The rosewood four-poster is from Tamil Nadu and the armoir from Goa. The large mural-like painting of a garlanded priest is by the contemporary painter Anjolie Ela Menon. The bird mobile was made by a visiting Lithuanian artist.

A droite: Dans le musée de terres cuites, des pièces entières sont consacrées aux cultes des puissantes divinités vénérées dans différentes régions rurales de l'Inde. Dans celle-ci, des artistes villageois de la région de Madhubani dans l'Etat de Bihâr ont recréé des sculptures et des fresques commémorant la vie de Raja Sailesh, un héros local très aimé.
Ci-dessous: La chambre à coucher d'O. P. Jain, qui donne sur un jardin privatif, contient un assortiment éclectique et plaisant de meubles anciens et modernes. Le lit à baldaquin en bois de rose vient du Tamil Nadu et l'armoire de Goa. La grande peinture ressemblant à une fresque et représentant un prêtre portant une guirlande est l'œuvre du peintre Anjolie Ela Menon. L'oiseau suspendu a été réalisé par un artiste lithuanien de passage.

Rechts: Einige Bereiche des Terrakotta-Museums sind dem Kult mächtiger Gottheiten geweiht, die in den verschiedenen ländlichen Gebieten Indiens verehrt werden. In diesem Raum haben Künstler aus der Madhubani-Region von Bihar Skulpturen und Wandmalereien nachgeschaffen, die an das Leben des dort hochverehrten Helden Raja Sailesh erinnern.
Unten: Die Einrichtung von O. P. Jains Schlafzimmer, mit Aussicht auf einen privaten, von Mauern umschlossenen Garten, besteht aus einer erfrischenden Mixtur aus alt und neu. Das Himmelbett aus Rosenholz kommt aus Tamil Nadu, und der Schrank ist aus Goa. Das große, wandbildartige Gemälde eines bekränzten Priesters stammt von dem modernen Künstler Anjolie Ela Menon. Das Vogel-Mobile wurde von einem Künstler aus Litauen während seines Aufenthalts angefertigt.

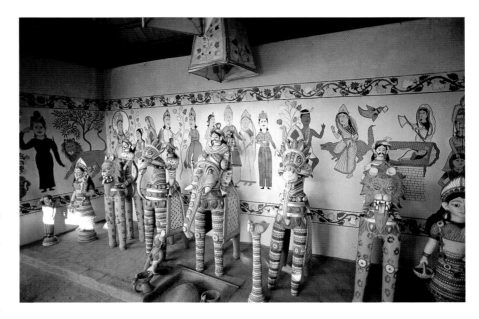

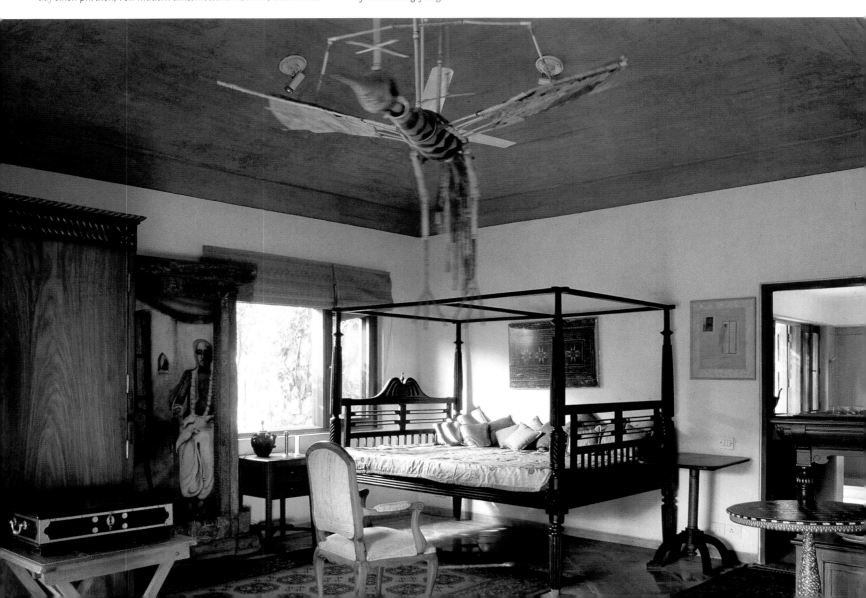

Shahnaz Husain est la reine incontestée des cosmétiques à base de plantes, une sorte d'Helena Rubinstein made in India. Sa maison, son bureau et son salon de beauté, qui occupent plusieurs étages de deux immeubles au sud de Delhi, vibrent de vie, embaument le jasmin et la rose-thé et contiennent plus de trésors que la caverne d'Ali Baba. Sur chaque porte, des lettres en laiton annoncent: «White House» pour un salon tout blanc, «Dance Attack», pour la discothèque, «Hollywood» pour la salle de jeux et «Home Affair» pour la pièce où la famille prend le café. Shahnaz Husain transgresse allègrement les conventions de la décoration. A l'origine, elle avait acheté un appartement pour son père à la retraite puis, lorsqu'il s'est plaint qu'il était devenu trop petit, elle a acheté les 18 autres de l'immeuble et les a tous réaménagés à sa démesure. Comme son amie Barbara Cartland, la reine du roman rose, elle ne se sent chez elle que dans le monde qu'elle s'est créé.

Shahnaz Husain

Shahnaz Husain is India's undisputed queen of herbal cosmetics, a sort of home-grown Helena Rubinstein. Her home, office and beauty salon, spread over several floors of two houses in south Delhi, are humming with life, fragrant with mingling scents of jasmine and tea rose, and laden with more acquisitions than Aladdin's Cave. Each room is a fantasy interior. Brass lettering at each door announces the speciality within: "White House" for an all-white parlour, "Dance Attack" for the discotheque, "Hollywood" for the games room and "Home Affair" for the family café. With characteristic insouciance Shahnaz Husain confesses to violating conventional norms of design. She originally bought one flat in a building of 18 flats for her retired father but when he found it too small, she bought all 18 and recast each in her larger-than-life mould. Like her friend Barbara Cartland, the romantic novelist, she is happiest in the fabulist surroundings of her own creation.

Shahnaz Husain ist Indiens unangefochtene Königin der Kräuterkos-metik – eine Art einheimische Helena Rubinstein. In ihrer Wohnung, ihrem Büro und ihrem Schönheitssalon, die sich über mehrere Etagen zweier Häuser im Süden Delhis ausbreiten, ist es so lebhaft wie in einem Bienenstock. Es duftet nach Jasmin und Teerosen, und es fin-den sich hier mehr Schätze als in Aladins Höhle. Jeder Raum ist eine eigene kleine Fantasiewelt. An jeder Tür verkündet ein Messingschild, welcher besondere Stil im Innern vorherrscht. »White House« heißt ein Salon, der ganz in Weiß gehalten ist, die Diskothek heißt »Dance Attack«, der Freizeitraum wurde »Hollywood« genannt, und der Bereich, den die Familie als Café benutzt, trägt den Titel »Home Affair«. Es ist charakteristisch für Shahnaz Husain, daß sie ganz un-bekümmert zugibt, die herkömmlichen Design-Normen verletzt zu haben. Ursprünglich hatte sie eine der 18 Wohnungen des Gebäudes für ihren pensionierten Vater gekauft. Als er diese jedoch zu klein fand, kaufte sie alle 18, und gestaltete sie vollkommen neu in jenem pompösen Stil um, der ihr Markenzeichen ist. Ähnlich wie ihre Freun-din Barbara Cartland, die Autorin von Liebesromanen, fühlt sie sich in der von ihr selbst geschaffenen, der eigenen Fantasie entsprunge-nen Umgebung am wohlsten.

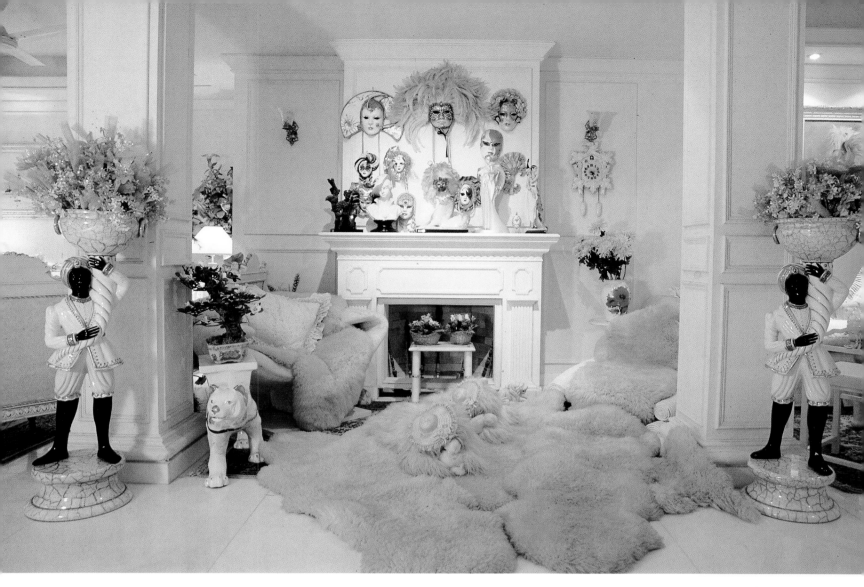

Previous page: *Rows of family photographs in gilt frames are displayed on shelves in the entrance lobby to the "Dream Floor", while porcelain frames with pink china roses are devoted to wedding pictures of Shahnaz Husain's son.*
Above: *An old apartment was completely gutted to create the main drawing room called the "White House". Venetian masks over the plaster fireplace, sheepskin rugs on the floor and porcelain black-amoors complete the decor.*
Right: *Shahnaz Husain's bedroom, a fantasia of pink chintz sofas, salmon pink drapes, wreaths of pink silk flowers and pink-hued chairs was partly inspired by her friend Barbara Cartland's fascination for the colour pink.*

Page précédente: *des rangées de photos de famille dans des cadres en argent sur des étagères dans l'entrée de «l'étage des rêves». Les cadres ornés de roses en porcelaine sont réservés aux photos de mariage du fils de Shahnaz Husain.*
Ci-dessus: *Les murs d'un appartement ont été abattus pour créer ce grand salon baptisé «White House». Des masques vénitiens sur la cheminée en plâtre, des peaux de moutons et des maures en porcelaine constituent le décor.*
A droite: *La chambre à coucher de Shahnaz Husain, avec ses canapés tapissés de chintz rose, ses rideaux saumon, ses énormes bouquets de roses artificielles et ses chaises aux tons roses, a été partiellement inspirée par la fascination de son amie Barbara Cartland pour le rose.*

Vorhergehende Seite: *Mehrere Reihen von Familienfotos in vergoldeten Rahmen sind in der Eingangshalle des sogenannten »Dream Floor« ausgestellt. Die Hochzeitsbilder von Shahnaz Husains Sohn haben Rahmen aus Porzellan, die mit rosafarbenen Porzellanrosen verziert sind.*

Oben: *Um Platz für den »White House« genannten, großen Salon zu schaffen, wurde eine alte Wohnung komplett ausgeräumt. Vervollständigt wird die Einrichtung durch venezianische Masken über dem Kamin, Schafsfellteppiche auf dem Boden und Porzellanfiguren.*
Unten: *Die Inspiration für Shahnaz Husains Schlafzimmer, eine Fantasie aus rosafarbenen Chintz-Sofas, lachsfarbenen Vorhängen, Kränzen von rosafarbenen Seidenblumen und Stühlen in Farbschattierungen aus Rosa stammt zum Teil von ihrer Freundin Barbara Cartland, die ein besonderes Faible für die Farbe Rosa hat.*

Indian Interiors Shahnaz Husain

Right: details of the "Red Room" and "Green Room" with sofas upholstered in red and green velvet with gold braid. Shahnaz Husain's theme interiors are often inspired by the colours of bric-à-brac collected on her travels.
Below: The family entertainment room, called "Hollywood", celebrates movies with a wall of film posters and Disneyland cuddlies. The room also houses a pool table, popcorn machine and giant television set.
Following pages: A small paved patio at the entrance has been transformed into a "China Garden" with a profusion of real and fake plants.

A droite: des détails des salons «rouge» et «vert», avec des canapés tapissés de velours rouge et vert et de filets d'or. Pour choisir les couleurs de ses décors, Shahnaz Husain s'inspire souvent des souvenirs qu'elle rapporte de ses voyages.
Ci-dessous: la salle de détente de la famille, baptisée «Hollywood», avec ses murs tapissés d'affiches de film et ses peluches de Disneyland. Elle accueille également une table de billard, une machine à faire du popcorn, et un écran de télévision géant.
Double page suivante: un petit patio a l'entrée de l'immeuble a été converti en «jardin chinois» avec une profusion de plantes naturelles et artificielles.

Rechts: Detailansichten des »Roten Zimmers« und des »Grünen Zimmers«. Die Sofas sind jeweils mit rotem oder grünem Samt mit goldener Borte bezogen. Shahnaz Husains Einrichtungsstil orientiert sich oft an den Farben der Nippessachen, die sie auf ihren Reisen ansammelt.

Unten: Der Freizeitraum der Familie, der »Hollywood« heißt, ist eine Hommage an den Film: Die Wände sind voller Filmposter, und auf dem Sofa sitzen Stoffpuppen aus Disneyland. In dem Zimmer stehen außerdem noch ein Billardtisch, eine Popcorn-Maschine und ein riesiger Fernseher.
Folgende Doppelseite: Ein kleiner gepflasterter Innenhof am Eingang wurde in einen »Chinesischen Garten« verwandelt. Er quillt geradezu über von echten und künstlichen Pflanzen.

*Dans la restauration d'anciens bâtiments indiens, peu de collabora-
tions ont été aussi fructueuses que celles entre l'écrivain Aman Nath
et l'homme d'affaires d'origine française Francis Wacziarg. Leur projet
le plus acclamé à ce jour est la résurrection d'une forteresse en ruines
du 15e siècle à Neemrama. Parmi leurs projets moins connus ils
comptent la restauration de deux «havelis», des demeures tradition-
nelles datant des 17e et 18e siècles, dénichés dans un village à une
cinquantaine de kilomètres au sud-ouest de Delhi. Lorsqu'Aman
Nath a découvert la première, il s'est retrouvé encerclé par des cen-
taines de chauve-souris furieuses d'être dérangées. De vieilles peaux
de serpent pendaient un peu partout. Le second bâtiment était dans
un état plus pitoyable encore, ayant perdu la majeure partie de son
toit. Quinze ans plus tard, les deux demeures, dont la réfection a
dépassé les notions puristes de la restauration, ont retrouvé enfin tout
leur éclat.*

Aman Nath and Francis Wacziarg

Few partnerships in restoring old Indian buildings have been as
successful as that between writer Aman Nath and French-born
businessman Francis Wacziarg. Their most celebrated endeavour is
the restoration of the ruined 15th century fort at Neemrana. Less
well-known is their revival of two small "havelis", traditional man-
sions, dating from the 17th and 18th centuries that they found hid-
den in a village 50 kilometres southwest of Delhi. On entering the
first, Aman Nath was ringed by hundreds of screeching bats and
found sloughed-off snakeskins hanging everywhere. Mounds of
rubble and bat shit prevented further access. The second building
was in an even more pitiable condition, with only a small portion of
the roof intact. But 15 years after acquisition, the buildings, recon-
structed beyond purist notions of restoration, have found a new
lease of life.

*Nur wenige Partnerschaften, die die Restaurierung alter indischer
Gebäude zum Ziel haben, sind so erfolgreich wie diejenige zwischen
dem Schriftsteller Aman Nath und dem in Frankreich geborenen Ge-
schäftsmann Francis Wacziarg. Ihr meistgefeiertes Projekt war die
Wiederherstellung des in Ruinen liegenden Forts aus dem 15. Jahrhun-
dert in Neemrana. Weniger bekannt ist ihre Restaurierung zweier
kleiner »Havelis«, traditioneller Wohngebäude, die aus dem 17. und
18. Jahrhundert stammen und die sie versteckt in einem Dorf 50 Kilo-
meter südwestlich von Delhi entdeckten. Als er das erste Mal eines
der »Haveli« betrat, sah sich Aman Nath von Hunderten von krei-
schenden Fledermäusen umringt und fand überall abgestreifte
Schlangenhäute. Berge von Trümmern und Fledermauskot hinderten
ihn daran, weiter hineinzugehen. Das zweite Gebäude war in einem
noch bemitleidenswerteren Zustand – nur ein winziger Teil des Da-
ches war instand geblieben. Fünfzehn Jahre nach dem Erwerb jedoch
haben die Gebäude, deren Restaurierung auch die puristischsten An-
sprüche weit übertrifft, zu neuem Leben gefunden.*

Viewed from a rocky hill, the two "havelis" are barely distinguishable
from the cluster of thatched mud huts in the tiny shepherds' village.
A dirt track winds down to the nearest road a kilometre away. It was
spotting the jutting "jharokha", the pillared balcony between the
trees, that led Aman Nath to the abandoned buildings. Twenty years
later a lush garden flourishes in an inner courtyard.

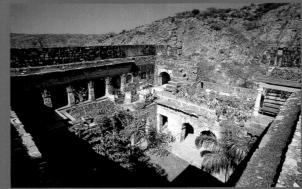

Depuis le sommet de cette colline rocailleuse, on distingue à peine
les deux «havelis» parmi l'amoncellement de chaumières en torchis
du minuscule village de bergers. Un chemin en terre serpente sur
un kilomètre avant de rejoindre la route la plus proche. C'est le
«jharokha», le balcon en saillie agrémenté de colonnes, aperçu à
travers le feuillage, qui a attiré Aman Nath jusqu'aux bâtiments
abandonnés. Vingt ans plus tard, la cour intérieure est devenue un
jardin luxuriant.

Beim Blick von einem felsigen Hügel aus kann man die beiden
»Havelis« kaum von der Gruppe kleiner strohgedeckter Lehmhütten
in dem winzigen Schäferdorf unterscheiden. Ein Feldweg schlängelt
sich zu der nächstgelegenen Straße, die einen Kilometer entfernt ist.
Es war die Entdeckung des hervorspringenden »Jharokha«, des mit
Säulen versehenen Erkers, zwischen den Bäumen, die Aman Nath
zu den verfallenen Gebäuden führte. Zwanzig Jahre später blüht ein
üppiger Garten in einem der Innenhöfe.

Above: A leftover pile of 17th-century bricks was used to pave the entrance hall of the "haveli". Situated at the far end, a second entrance into the interior ensures privacy. A carved wooden mantel, a child's wagon and a baby's cradle provide decoration.
Right: Images in wood, for example, this Christian saint from Goa and a peacock from Tamil Nadu, are strewn around the "haveli".
Facing page: An old painted cupboard from Gujarat, placed under a niche housing earthern water pitchers, is used as a household shrine.
Following pages: Only the stone wall existed previously in this first floor bedroom overlooking the courtyard. The roof is new, and a floor has been laid in honey-coloured Jaisalmer stone. Screens with a Jaipur print of Moghul poppies by Brigitte Singh cover the sliding glass doors. The low chairs with carved backrests were used by village women for churning butter.

Ci-dessus: Le long vestibule a été pavé de briques datant du 17e siècle, récupérées dans un tas abandonné. Au fond de la salle, une seconde porte assure l'intimité du «haveli». Une console en bois sculpté, un chariot d'enfant et un berceau sont les seuls éléments décoratifs.
A droite: Des statues en bois sont disséminées un peu partout dans la maison, ici un saint chrétien provenant de Goa et un paon de Tamil Nadu.
Page de droite: Un vieux bahut en bois peint du Gujerat, placé sous une niche contenant des cruches en faïence, fait office d'autel.
Double page suivante: De cette chambre au premier étage, donnant sur la cour, il ne restait que le mur en pierre. On lui a donné un nouveau toit et un sol en pierres de Jaisalmer, couleur de miel. Les stores, réalisés par Brigitte Singh dans un imprimé de Jaipur représentant des pavots mongols, masquent les baies vitrées. Les chaises basses au dossier sculpté étaient utilisées par les villageoises quand elles battaient le beurre.

Oben: Dadurch daß der zweite Durchgang der Eingangshalle im hinteren Bereich liegt, ist man vor neugierigen Blicken geschützt. Zur Dekoration dienen eine geschnitzte hölzerne Konsole, ein Kinderspielzeug auf Rädern und eine Wiege.
Rechts: Standbilder aus Holz, etwa von einem christlichen Heiligen aus Goa, oder einem Pfau aus Tamil Nadu, sind über das ganze »Haveli« verteilt.
Rechte Seite: Ein alter bemalter Schrank aus Gujarat unter einer Nische mit irdenen Wasserkrügen dient als Schrein für die Gottheiten.
Folgende Doppelseite: Von diesem Schlafzimmer im ersten Stock war nur noch die steinerne Mauer übriggeblieben. Das Dach ist wie der mit honigfarbenen Steinen ausgelegter Boden neu. Die gläsernen Schiebetüren sind mit Vorhängen aus Jaipur verhängt, die mit einem von Brigitte Singh entworfenen Mohnblumen-Muster nach Vorbildern aus dem 17. Jahrhundert bedruckt sind. Die niedrigen Stühle mit den geschnitzten Rückenlehnen wurden von den Dorffrauen beim Buttern benutzt.

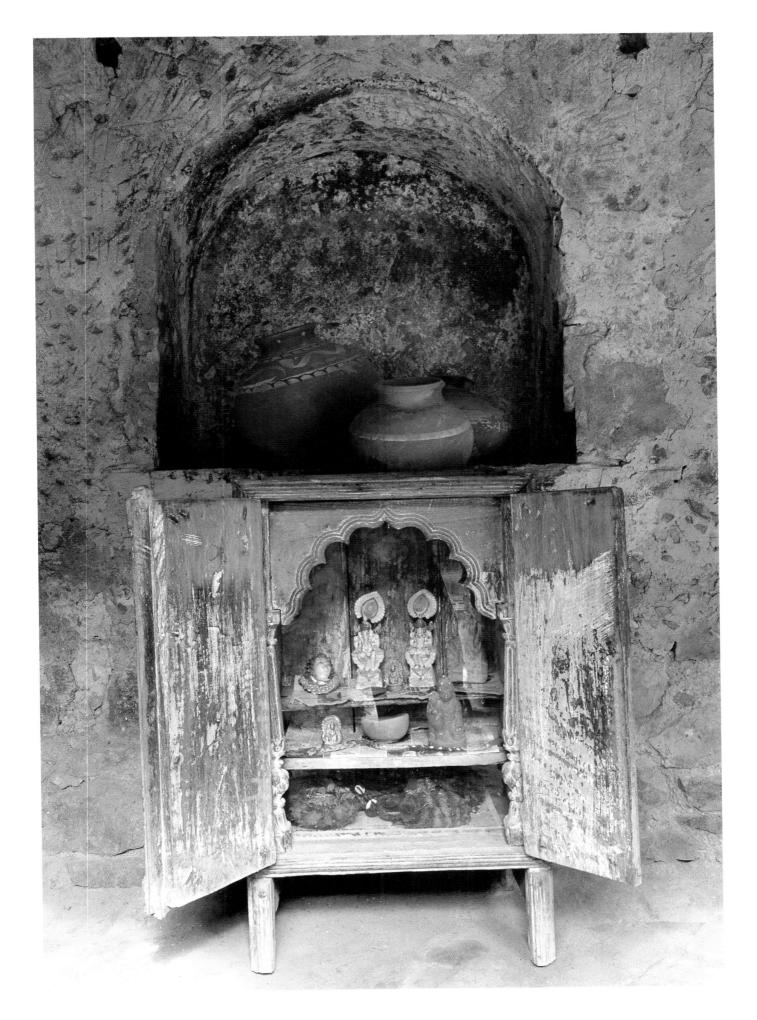

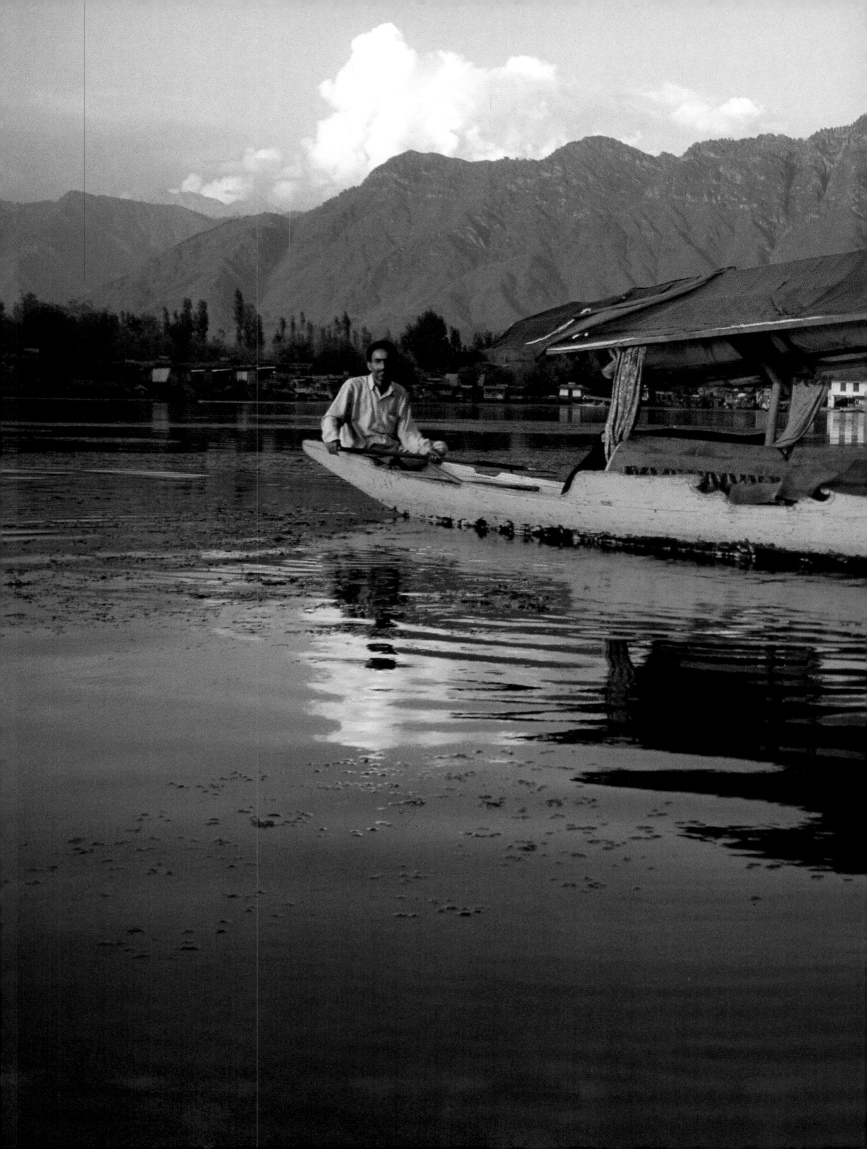

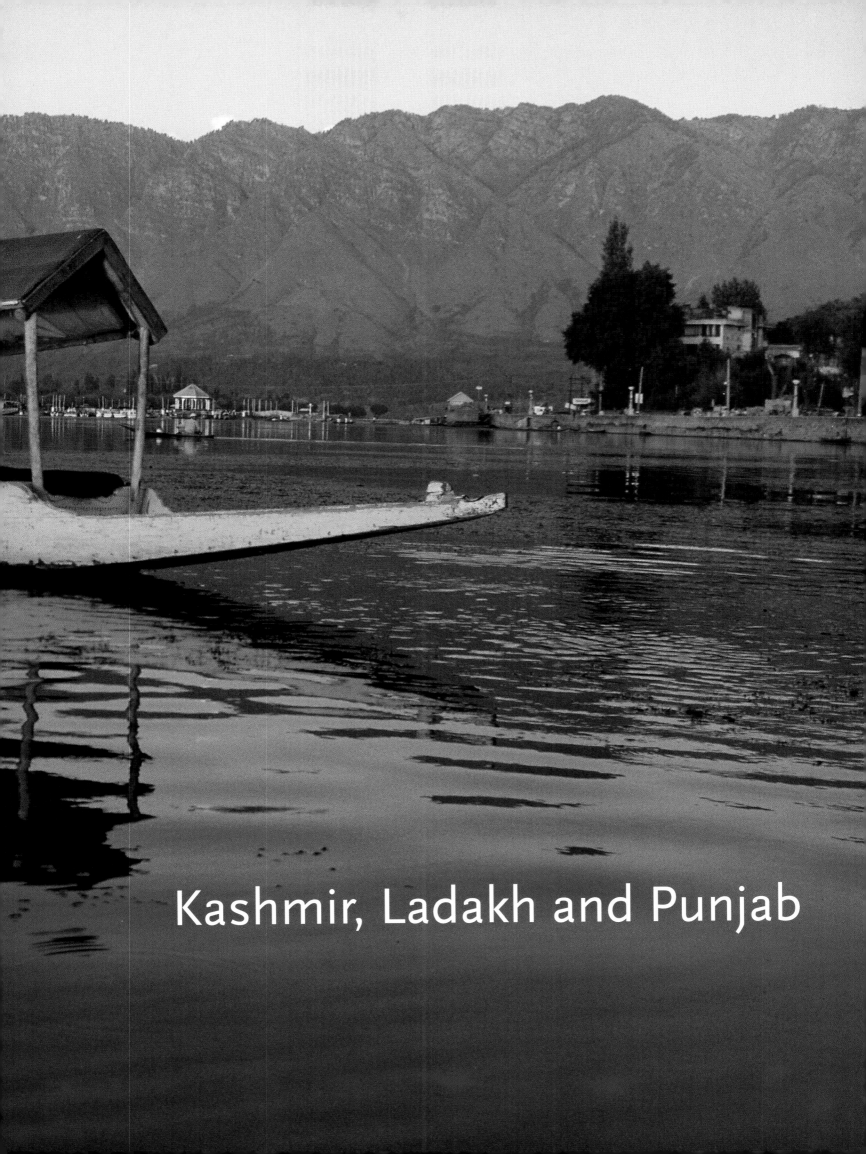

Kashmir, Ladakh and Punjab

Les lacs des montagnes et les canaux bordés de saules du Cachemire
ont toujours été sillonnés par des embarcations, mais les habitations
flottantes y sont relativement récentes. En 1880, un Anglais, M. T.
Kennard, eut l'idée de créer des «maisons-bateaux». Un commer-
çant, Pandit Naraindas, agrandit et aménagea alors sa «doonga»,
la barque traditionnelle qui rappelle la gondole, afin d'acheminer ses
produits jusqu'au domicile des Européens. Il rencontra un tel succès
qu'il se lança bientôt dans la construction de bateaux, plus rentable.
Les habitations flottantes étaient également une solution toute
trouvée aux problèmes de logement des Européens au siècle dernier.
En effet, la maharaja du Cachemire refusait que les étrangers achè-
tent des terres, une règle qui prévaut encore aujourd'hui. Pour les
habitants du Cachemire, rien n'est plus naturel que de vivre sur
l'eau. La maison flottante de ce colporteur, dans le vieux quartier de
Srinagar, n'est qu'une parmi des centaines d'autres amarrées au
bord du Jhelam, la rivière qui serpente à travers la ville.

River Houseboats

Boats have always plied the placid mountain lakes and willow-
lined canals of Kashmir but boats to live in are a comparatively
late development. M. T. Kennard, an Englishman conceived the
idea of "floating houses" in 1880 and Pandit Naraindas, a local
shopkeeper, enlarged and amended the traditional gondola-like
"doonga" as a mobile store to serve Europeans. His venture was
such a success that he got into the more profitable boat-building
business. Houseboats also proved a heaven-sent solution to the
scarcity of accommodation for European arrivals in the last cen-
tury. The Maharaja of Kashmir discouraged outsiders from buying
property, a rule strictly adhered to till this day. But for Kashmiris,
living on the water is a way of life. This working man's boat in the
old quarter of Srinagar is one of several hundred moored on the
river Jhelum that weaves its way through the city.

Schon immer haben Boote die stillen Bergseen und mit Weiden ge-
säumten Kanäle Kashmirs befahren, doch Boote, in denen man woh-
nen kann, sind eine relativ neue Entwicklung. Der Engländer M. T.
Kennard hatte 1880 erstmals den Gedanken, sich ein »schwimmen-
des Haus« zu bauen. Auch Pandit Naraindas, ein einheimischer
Ladenbesitzer, vergrößerte die traditionelle, einer Gondel ähnelnde
»Donga« und baute sie zu einem mobilen Laden für den Handel mit
Europäern um. Seine Idee war ein derartiger Erfolg, daß er in das ein-
trägliche Geschäft des Bootsbaus einstieg. Im vorigen Jahrhundert
waren Hausboote darüber hinaus auch die ideale Lösung für das Pro-
blem mangelnder Unterkünfte für die Neuankömmlinge aus Europa,
denn der Maharaja von Kashmir verbot Fremden, Land zu kaufen,
eine Regel, die bis heute streng eingehalten wird. Für die Menschen in
Kashmir ist das Wohnen auf dem Wasser ein ganz natürlicher Lebens-
stil. Dieses, hier abgebildete Boot eines Arbeiters in der Altstadt von
Srinagar ist nur eines von vielen Hunderten, die auf dem sich durch
die Stadt schlängelnden Fluß Jhelum angetäut liegen.

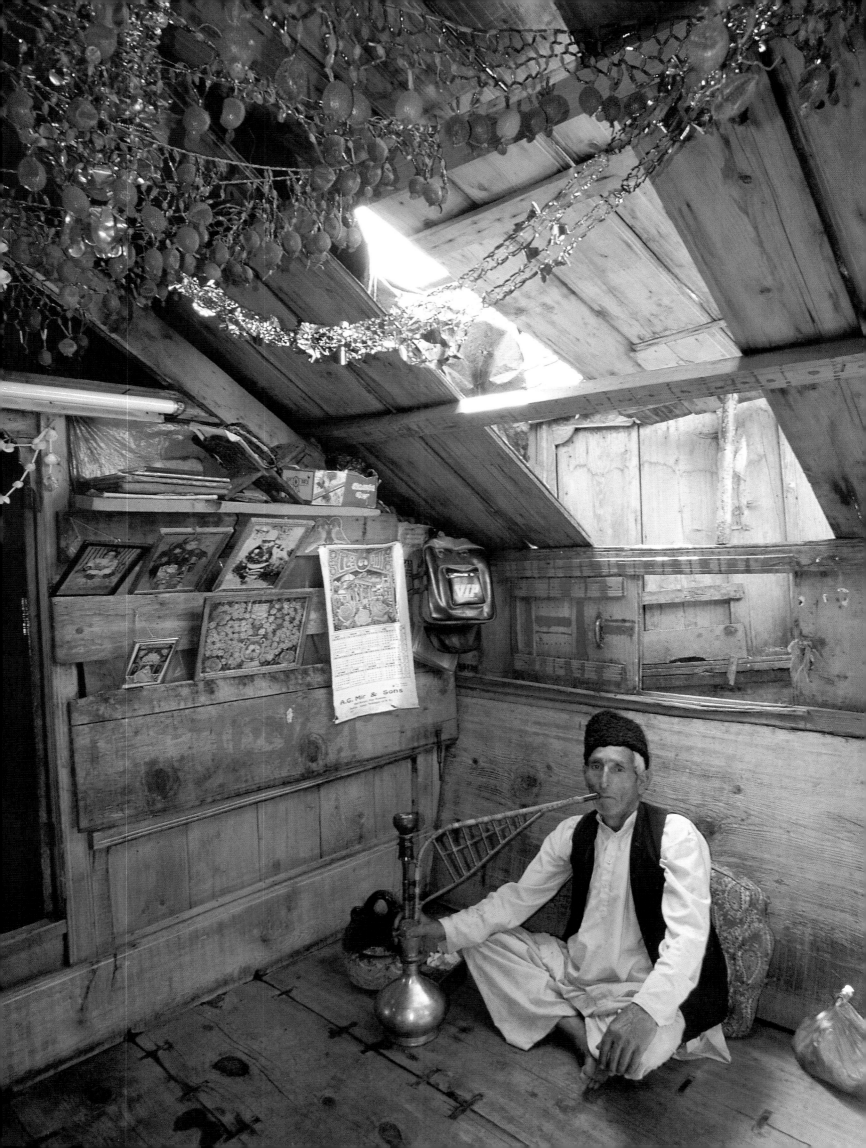

Previous page: *Many of the families on the river have lived in the same houseboat for generations. Made of "deodar", Kashmir's fragrant cedar wood, the boats are about 60 foot long and 14 foot wide and partitioned into three or four rooms. A local hawker in the city relaxes with his "hookah" in his modestly-decorated sitting room after a hard day's work.*

Right: *Once moored on the riverbank the boats are rarely moved. Many families also tend to occupy the patch of land alongside as an extended living area.*

Below: *Clothes, bedding rolls and valuables are stored high up on shelves, in piled-up tin trunks or wicker baskets hung from the roof where they are likely to be safer, protected from damp and seepage through the floorboards.*

Page précédente: *Un grand nombre de familles du Jhelam habitent la même maison flottante depuis plusieurs générations. Construites en «déodar», le cèdre parfumé du Cachemire, ces habitations mesurent environ 18 mètres de long sur quatre mètres de large et sont divisées en trois à quatre pièces. Ce colporteur se détend en fumant son houka dans son salon modestement aménagé après une dure journée de labeur.*

A droite: *Une fois amarrées, les maisons flottantes se déplacent rarement. Il n'est pas rare que les familles occupent également un lopin de terre près de leur embarcation.*

Ci-dessous: *Les vêtements, les matelas et les objets de valeur sont rangés sur de hautes étagères, dans des coffres en fer blanc empilés les uns sur les autres, ou dans des paniers en osier suspendus au plafond afin de les protéger de l'humidité et de l'eau qui filtre entre les lattes du plancher.*

Vorhergehende Seite: *Viele Familien, die auf dem Fluß leben, wohnen bereits seit Generationen in demselben Hausboot. Die Boote sind aus »Deodar« gebaut, einem wohlriechenden Zedernholz aus Kashmir. Sie sind ungefähr 18 Meter lang, vier Meter breit und in drei*

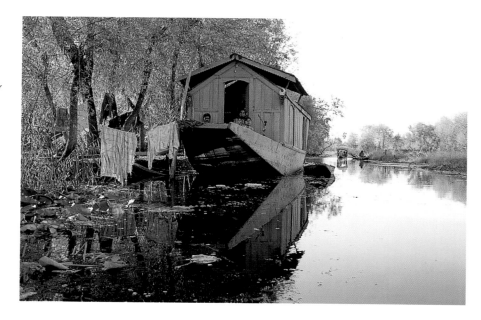

oder vier Räume aufgeteilt. Ein einheimischer Straßenhändler entspannt sich nach einem anstrengenden Tag mit seiner Huka, einer Wasserpfeife, in seinem bescheiden geschmückten Wohnzimmer.

Oben: *Wenn sie einmal am Flußufer angetäut sind, werden die Boote nur selten von der Stelle bewegt. Viele Familien benutzen auch das Stück Land am Ufer als Wohnbereich.*

Unten: *Kleider, Bettwäsche und Wertgegenstände werden auf Regalen, in aufeinandergestapelten Blechkoffern oder in Weidenkörben, die an der Decke hängen, verstaut. Hier sind sie sicher und trocken, und vor Feuchtigkeit und dem durch die Bodendielen sickernden Wasser geschützt.*

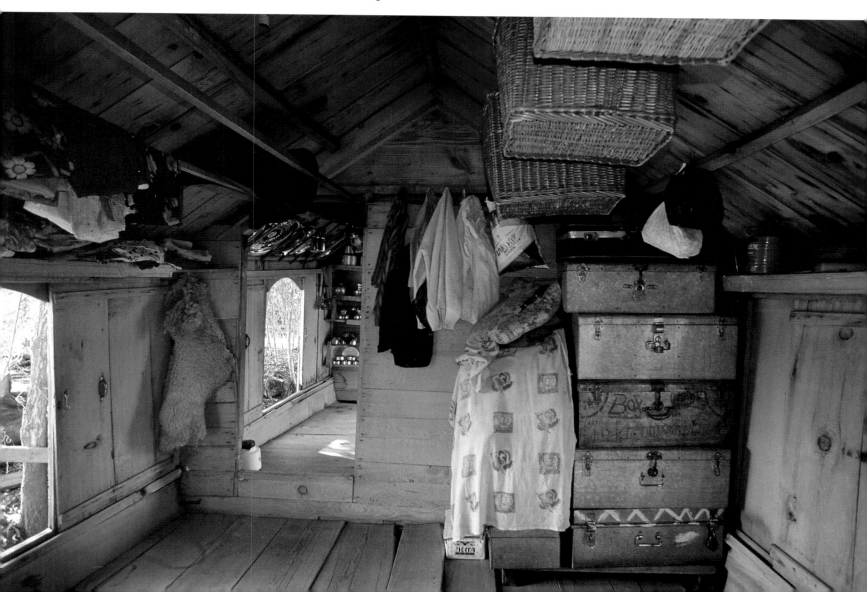

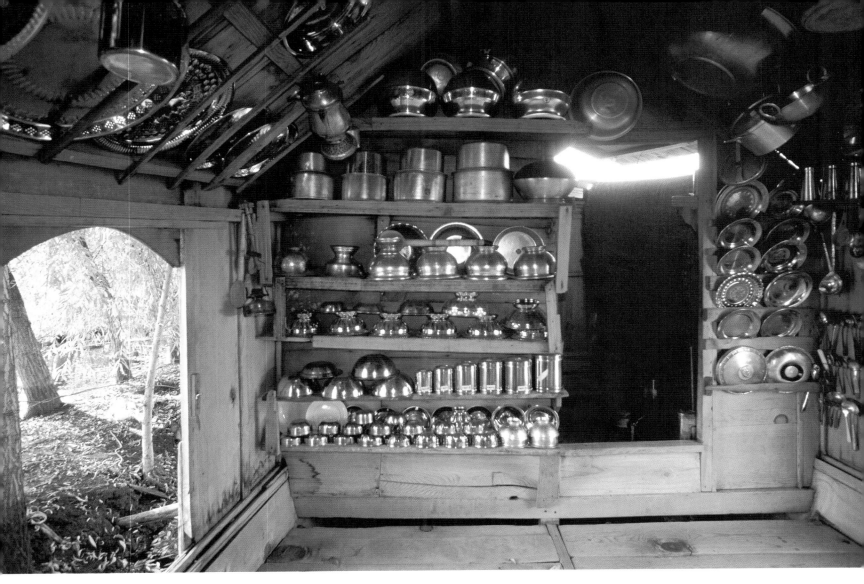

Above: The way to a Kashmiri's heart is indisputably through his kitchen. A staggering variety of rich meat stews are ladled on to mounds of rice in large metal trays known as "traami" from which several people eat at once. "Wazas" or speciality chefs are engaged to produce community feasts or "wazwans". Even in a modest houseboat kitchen the variety of utensils, lovingly displayed, convey how much time and attention is lavished on cooking and eating.
Right: A cheerful houseboat family, delighted to pose for photographs, welcomes visitors at the front door of their floating home.

Ci-dessus: Si vous voulez conquérir le cœur d'un Cachemirien, parlez-lui de sa cuisine! La gastronomie locale compte une étourdissante variété de délicieux ragoûts déversés sur des montagnes de riz dans de grands plats en métal appelés «traami» et dans lesquels plusieurs personnes mangent directement. Pour les banquets communautaires, ou «wazwans», on engage des «wazas», des chefs spécialisés. Même dans une habitation modeste, la cuisine, avec ses ustensiles fièrement exposés, trahit le temps et l'attention consacrés à la préparation et la consommation des repas.
A droite: Une famille joyeuse, ravie de prendre la pose, accueille les visiteurs à la porte de sa maison flottante.

Oben: Der Weg zum Herz eines Einwohners von Kashmir führt unweigerlich durch seine Küche. In den als »Traami« bekannten metallenen Schüsseln, aus denen mehrere Leute gleichzeitig essen, wird eine Vielfalt von Fleischgerichten auf Berge von Reis gehäuft. Für die »Wazwans«, Feste der Gemeinschaft, stellt man eigens einen »Waza«, einen Spezialitätenkoch, ein. Sogar in einer eher bescheidenen Hausboot-Küche kann man an der Vielfalt der liebevoll ausgestellten Kochutensilien erkennen, wieviel Zeit und Aufmerksamkeit auf das Kochen und Essen verwandt werden.

Rechts: Eine fröhliche Hausboot-Familie, die sich begeistert für ein Foto aufstellt, begrüßt die Besucher an der Eingangstür ihres schwimmenden Heims.

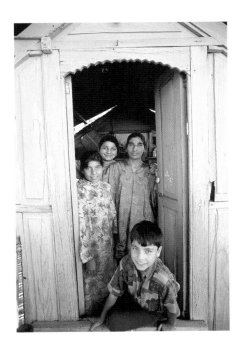

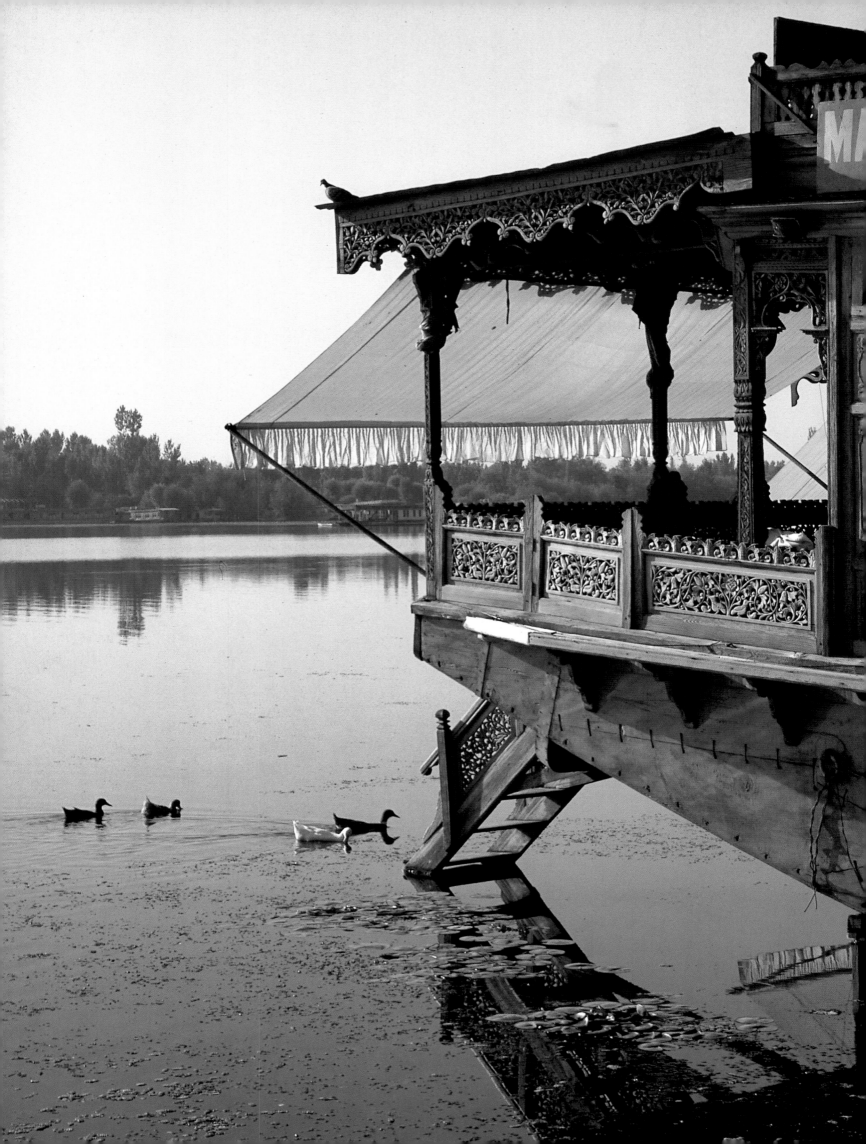

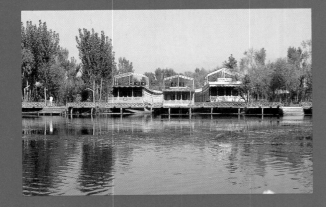

A Lake Houseboat

It was really the Moghuls who put Kashmir on the world map and started a vogue for the enchanted valley. The Emperor Akbar liked to refer to Kashmir as his private garden; he would watch sunsets on the lake with his son Prince Salim by his side. When Salim took over as Emperor Jahangir in 1605 his obsession for Kashmir far surpassed his father's. A connoisseur and sybarite, Jahangir made trips to Kashmir a regular habit. He created ornamental gardens, commissioned albums on Kashmir's flowers and penned besotted verses to his vision of paradise regained. Spurred by the emperor's fancy, a kind of Kashmir-mania gripped the country – and later the world. Naturalist renderings of Kashmir's poppies, daffodils and cypresses began to be woven into carpets, inlaid on marble walls and beaten in gold into metalware. Thus a myth was born, and partly lives on in the fine decoration and luxurious interiors of houseboats moored along the valley's lakeshores.

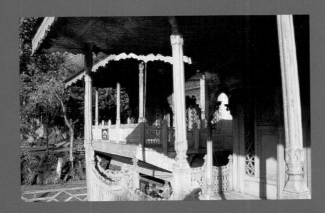

Previous page: A de luxe houseboat's 14-foot deck, with tasselled awning and carved balcony, overlooks a classic Kashmir landscape of poplars and willows mirrored in the lake waters on the far shore. Guests might use the stairs to step into a "shikara", one of the narrow, oared gondolas that glide swiftly over the lake.

Right: a detail of the delicately carved pillared arches that decorate a passageway running around the houseboat.

Below: A formal drawing room in a luxury houseboat. The furniture, of carved walnut, is a great Kashmir speciality but the wooden roof, with its elegant geometric pattern, is made of a local wood known as "kail". The technique of banding tiny wooden strips into complex patterns on ceilings is unique to Kashmir.

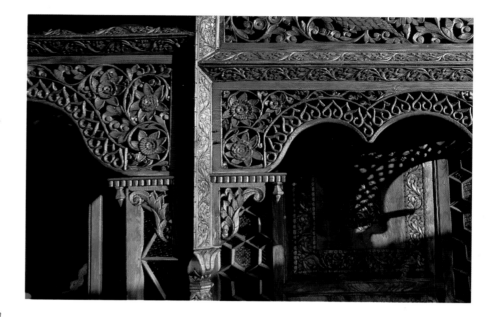

Page précédente: Le pont avant de cette luxueuse maison flottante, long de quatre mètres, avec son auvent à franges et son balcon sculpté, domine un paysage typique du Cachemire, les peupliers et les saules de la rive opposée se reflétant dans le lac. Le petit escalier permet aux invités de grimper dans des «shikaras», des barques à rames, étroites et rapides, qui glissent sur l'eau.

A droite: détail des arches finement ouvragées qui ornent la galerie qui court tout autour de la maison.

Ci-dessous: le salon d'une luxueuse maison flottante. Les meubles en noyer sculpté sont une grande spécialité du Cachemire. Le plafond, avec ses élégants motifs géométriques est travaillé dans un bois local, le «kail». Cette technique qui consiste à entrelacer des bandelettes de bois pour réaliser des dessins complexes sur les plafonds est propre au Cachemire.

Vorhergehende Seite: Das vier Meter große Deck eines Hausboots in Luxusausführung, mit einem Sonnensegel und einer mit Schnitzereien verzierten Veranda bietet einen für Kashmir typischen Ausblick: Pappeln und Weiden, die sich am gegenüberliegenden Ufer im Wasser des Sees spiegeln. Gäste benutzen die Treppe, um in eine »Shikara« einzusteigen, eine jener schmalen Gondeln, die in rascher Fahrt über den See gleiten.

Oben: eine Detailansicht der fein geschnitzten, auf Säulen ruhenden Bögen, die einen der Gänge des Hausboots verzieren.

Unten: der Salon in einem luxuriösen Hausboot. Eine Spezialität aus Kashmir sind die aus Walnußholz geschnitzten Möbel. Die Holzdecke mit den eleganten geometrischen Mustern, ist aus einer einheimischen Holzart namens »Kail«. Die hier angewandte Technik, bei der an einer Zimmerdecke winzige Holzstreifen zu komplexen Mustern zusammengesetzt werden, findet man nur in Kashmir.

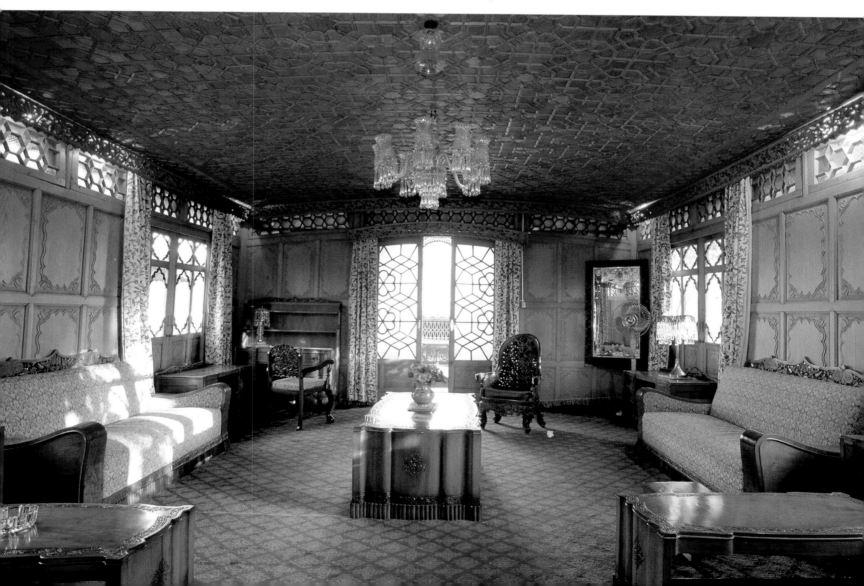

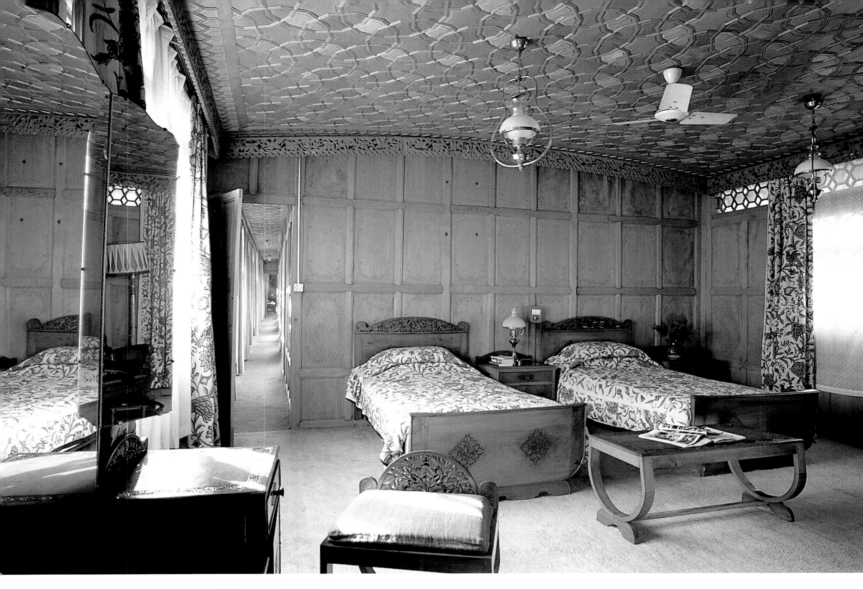

Above: A carpeted side passage opens into the boat's panelled bedroom. The bedroom furniture is in carved walnut and the furnishings are of crewel work, the famous woollen embroidery on cotton fabric special to Kashmir.
Details right: Natural light and ventilation in houseboats comes from glazed windows, often embellished with coloured glass for privacy. The passage to the bedroom is panelled with natural, sweet-smelling local cedar known as "deodar".

Ci-dessus: Un couloir latéral agrémenté d'un long tapis débouche sur une chambre lambrissée. Les meubles sont en noyer sculpté et les tissus en coton rehaussé de broderies en laine, un travail typique du Cachemire.
Détails de droite: Dans les maisons flottantes, l'air et la lumière pénètrent par des fenêtres souvent ornées de vitraux pour préserver l'intimité des occupants. Les lambris du couloir qui mène à la chambre sont en «déodar» naturel, un cèdre local qui dégage un doux parfum.

Oben: Ein mit Teppich ausgelegter Gang an der Seite des Bootes führt in das holzvertäfelte Schlafzimmer. Die Schlafzimmermöbel sind aus Walnußholz und mit Schnitzereien verziert, und der überall im Raum verwandte Stoff ist eine »Crewel«-Arbeit, eine jener berühmten Wollstickereien auf Baumwollgewebe, die es nur in Kashmir gibt.
Details rechts: Für Tageslicht und Belüftung auf Hausbooten sorgen verglaste Fenster, die oft mit Buntglas verziert sind, um vor neugierigen Blicken abzuschirmen. Der holzgetäfelte Gang zum Schlafzimmer ist aus dem einheimischen Zedernholz »Deodar«, das e nen süßlichen Duft ausströmt.

Mulbekh est premier village bouddhiste que l'on rencontre dans le
Ladakh en sortant de la région à prédominance musulmane de Kargil.
De là, une longue route sinueuse traverse les paysages d'une beauté
aride de l'Himalaya et mène jusqu'à Leh, la capitale située à la fron-
tière tibétaine. De vieux monastères aux intérieurs peints et enfumés
sont perchés sur des promontoires rocheux, et le vent incessant fait
chuchoter les milliers de petits drapeaux de prières bouddhistes. La
maison de Rigzin Padma Wazir, enseignant communément appelé
«le maître», est nichée sur une colline de Mulbekh. C'est une bâtisse
en pierre et en bois, au toit plat, avec des murs épais et de petites
fenêtres qui protègent contre le froid pendant les rudes mois d'hiver,
quand la température peut tomber jusqu'à moins 30 degrés. Comme
la plupart des habitations de montagne, elle est bâtie sur une pente et
possède une cour intérieure. Les pièces de réception sont richement dé-
corées mais le vrai cœur de la maison est la cuisine, qui reste toujours
chaude grâce à son grand four équipé d'une cheminée.

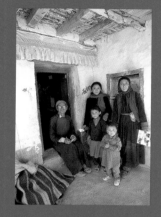

A House in Mulbekh

Mulbekh is the name of the first Buddhist village outside the pre-
dominantly muslim region of Kargil in Ladakh. From here, the long,
winding road, passing through a shimmering trans-Himalayan
landscape of desolate beauty, leads to the capital Leh on the
Tibetan frontier. Ancient monastries, with smoky painted interiors,
perch on rocky crags and a thousand Buddhist prayer flags flutter
in the whistling wind. Nestling against a hill in Mulbekh is the
house of Rigzin Padma Wazir, a teacher, popularly known in the
area as "Master". It is a flat-roofed stone-and-wood structure with
thick walls and small windows that helps to keep the cold out dur-
ing arduous winters when temperatures plunge as low as minus 30
degrees. Like most hill houses, it is built on a gradient and opens
into an inner courtyard. Inside, the formal rooms are elaborately
decorated but the heart of the house remains the kitchen, a room
kept warm by a large stove with a chimney.

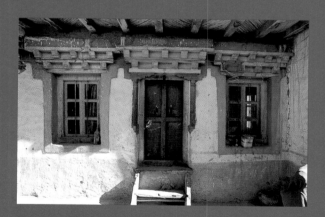

Mulbekh ist der Name des ersten buddhistischen Dorfes außerhalb
der hauptsächlich vom Islam beherrschten Kargil-Region in Ladakh.
Von hier aus führt eine lange gewundene Straße durch die einsame
Schönheit der schimmernden Landschaft des Himalaya zur Haupt-
stadt Leh an der Grenze zu Tibet. Uralte Klöster, deren Wandbema-
lungen im Innern von Rauch überzogen sind, thronen hoch oben auf
den Gipfeln der Felsen, und Tausende von buddhistischen Gebetsfah-
nen flattern im pfeifenden Wind. In Mulbekh steht, eingebettet am
Fuß eines Hügels, das Haus von Rigzin Padma Wazir, eines Lehrers,
der von der einheimischen Bevölkerung nur »der Meister« genannt
wird. Das Haus hat ein Flachdach und ist aus Stein und Holz gebaut,
mit dicken Wänden und kleinen Fenstern, um die Kälte abzuwehren,
die im Winter auf eine Temperatur von bis zu minus 30 Grad sinken
kann. Wie die meisten Häuser an einem Hügel ist es an einem Ab-
hang gebaut und öffnet sich zu einem Innenhof. Die Räume im In-
nern sind mit kunstvollen Verzierungen versehen, aber das Herzstück
des Hauses ist und bleibt die Küche – ein Raum, der von einem riesi-
gen Ofen mit Kamin warm gehalten wird.

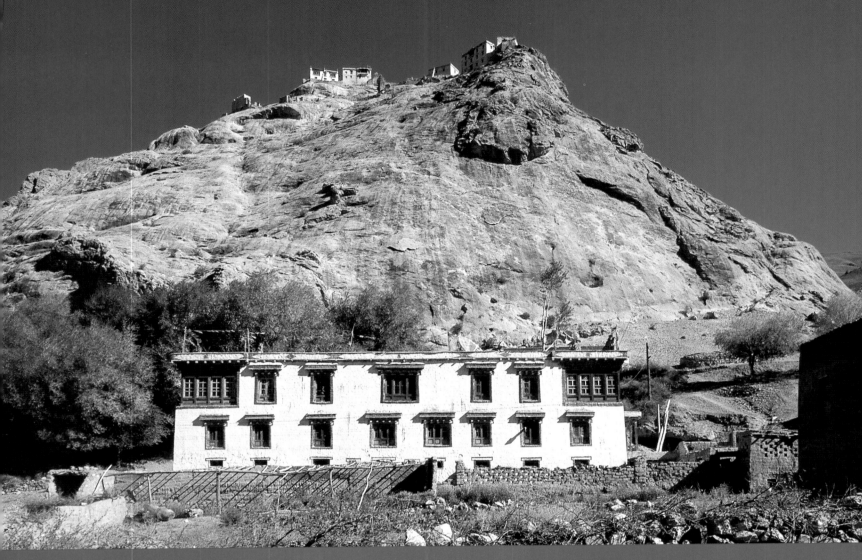

The rooms on the ground floor of the three-storey stone house would
traditionally have been used as cattle pens. The glass-paned windows
on either side of the top storey serve to catch the warmth of the rising
and setting sun. The entrance to the house is through a covered porch
at the side.

Autrefois, les pièces du rez-de-chaussée de cette maison de trois étages
servaient d'étable. Les fenêtres à croisillons, de chaque côté du dernier
étage, permettent de profiter de la chaleur du soleil quand il se
couche et se lève. On entre dans la maison par un porche sur le côté.

Traditionell wurden die Räume im Erdgeschoß des dreistöckigen
Steinhauses früher als Stall für das Vieh benutzt. Die verglasten
Fenster auf beiden Seiten des Obergeschosses sollen die Wärme der
auf- und untergehenden Sonne einfangen. Der Eingang zum Haus
liegt in einer überdachten Veranda auf der Schmalseite.

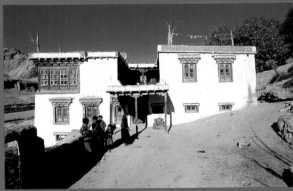

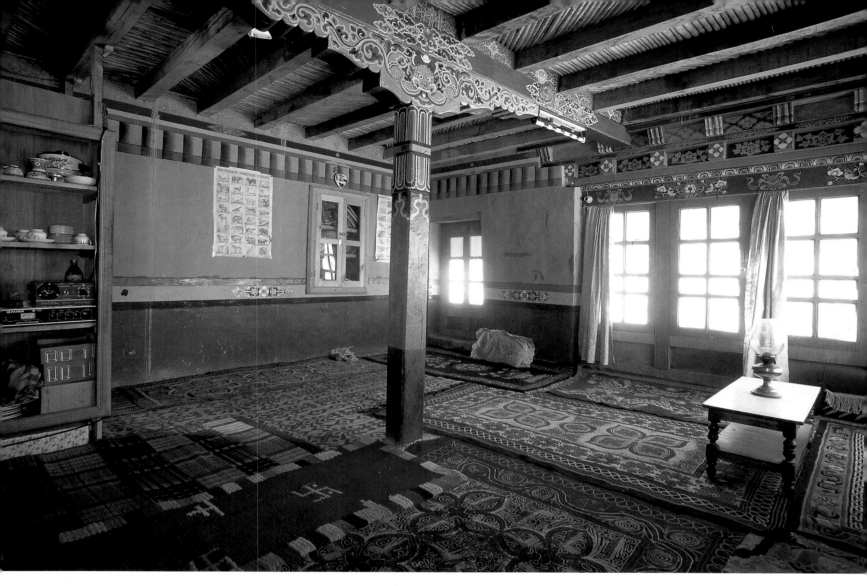

Above: A spacious central area, with richly painted supporting
pillars and beams, serves as the formal drawing room. Guests sit on
thick carpets. The rafters and narrow cross-beams are made of local
willow. The painted walls are fringed with a cornice of colourful cloth.
Right: another view of the same room with auspicious Buddhist
symbols painted on the walls, including a large mural of "Old Man,
Long Life", a symbolic representation of longevity and good health.

Ci-dessus: Cette vaste pièce centrale aux colonnes et au plafond
richement peints, sert de salon de réception. Les invités s'assoient
sur d'épais tapis. Les poutres et les chevrons sont en saule local. Les
murs sont ornés d'une frise en tissu aux vives couleurs.
A droite: dans la même pièce, des symboles bouddhistes de bienve-
nue peints sur les murs, dont une fresque intitulée «Vieil homme,
longue vie», symbole de longévité et de santé.

Oben: Ein großer Raum in der Mitte des Hauses, dessen Stützbalken
mit kunstvollen Verzierungen bemalt sind, dient als Salon für offizielle
Anlässe. Die Gäste sitzen auf dicken Teppichen. Die Dachsparren und
schmalen Querbalken sind aus dem Holz des in dieser Gegend wach-
senden Weidenbaums. Die mit Malereien verzierten Wände werden
am oberen Rand von bunten Stoffbahnen abgeschlossen.
Rechts: eine andere Ansicht desselben Raumes. Auf die Wände sind
glückverheißende buddhistische Symbole gemalt, zu denen auch ein
großes Wandgemälde namens »Alter Mann, langes Leben« gehört –
eine symbolische Darstellung der Langlebigkeit und Gesundheit.

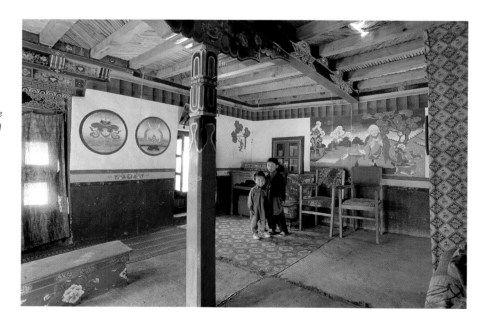

Right: The large kitchen, warmed by a traditional stove and surrounding hearth, is the most lived-in part of the house. The family sit on carpets and eat off low rectangular tables.
Below: An essential feature of most Ladakhi homes, the prayer room, has a painted altar with niches for individual deities. Rows of votive butterlamps and water bowls are lit and replenished every day. Visiting monks sit at the long tables and chant to the accompaniment of the leather drum in the corner.

A droite: La grande cuisine, réchauffée par le four traditionnel et son âtre, est la pièce où l'on vit le plus souvent. La famille s'assoit sur des tapis et mange sur des tables basses rectangulaires.
Ci-dessous: élément incontournable de la plupart des maisons du Ladakh, la salle de prières avec un autel peint où chaque divinité a sa niche. Chaque jour, on allume les rangées de petites lampes votives et on remplit les bols d'eau. Les moines de passage s'assoient derrière les longues tables et récitent des incantations rythmées par le tambour de cuir dans le coin.

Rechts: Die große Küche, die ihre Wärme von einem traditionellen Ofen und einem Herd bezieht, ist der am häufigsten benutzte Raum des Hauses. Die Familie sitzt auf dem Teppich und nimmt ihre Mahlzeiten an den niedrigen, rechteckigen Tischen ein.
Unten: Ein wesentlicher Bestandteil der meisten Häuser in Ladakh ist der Gebetsraum, in dem ein mit Malereien verzierter Altar mit einzelnen Nischen für verschiedene Gottheiten steht. Jeden Tag werden die Gebetslampen neu angezündet und die Wasserkrüge neu gefüllt. Die Mönche, die zu Besuch kommen, sitzen an den langen Tischen und intonieren ihre Sprechgesänge zu der Begleitung der Ledertrommel, die in der Ecke hängt.

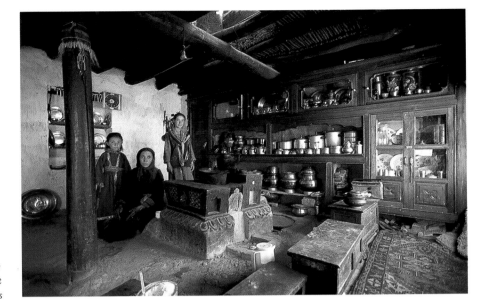

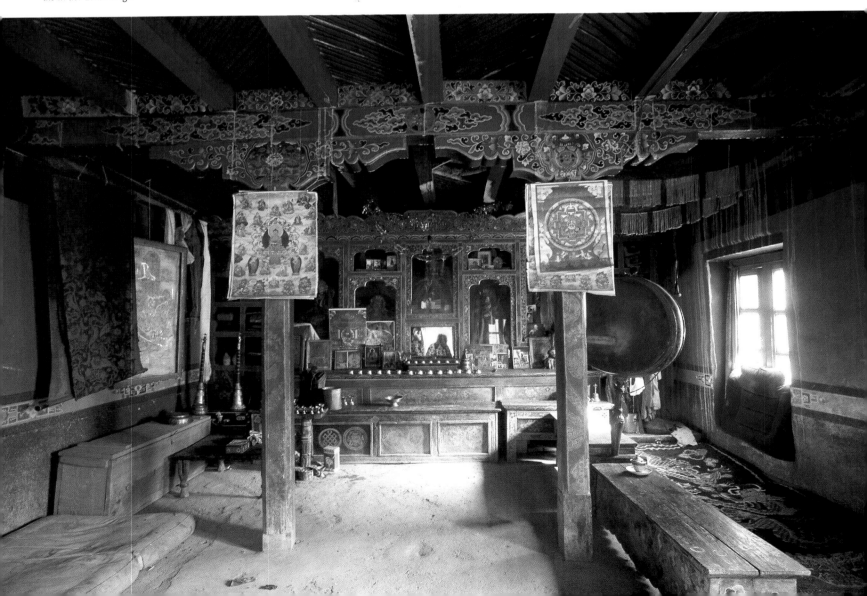

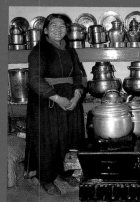

Perchée dans une haute vallée glaciale, non loin des torrents tumultueux de l'Indus, Leh est la capitale du Ladakh depuis le 16e siècle. Elle était autrefois un centre caravanier important au croisement des routes qui reliaient le Cachemire au Tibet et à la Chine. En lisière de la vieille ville se dresse le palais royal, haut de neuf étages, construit au 17e siècle à la même époque que celui, plus connu, de Potala à Lhassa au Tibet. Lakruk Tsewang Rigzin et sa femme, agriculteurs, cultivent des fleurs et des légumes venus d'ailleurs et destinés aux touristes et aux randonneurs qui affluent vers Ladakh pendant l'été. Leur demeure, entourée de champs et de jardins de fleurs, offre une image de prospérité semi-rurale. Ils ont apporté un grand soin à la décoration de leur intérieur, avec des poutres peintes de svastikas stylisées et des équerres embellies de lotus en fleur.

A Domestic Interior in Leh

Set high up in the cold thin air of a valley not far from the gushing torrents of the river Indus, the town of Leh has been capital of Ladakh since the 16th century. It was once an important market town on the trade route that linked Kashmir with Tibet and China. On the periphery of the old town lies the nine-storey Royal Palace, built in the 17th century, at the same time as the better-known Potala Palace at Lhasa in Tibet. Lakruk Tsewang Rigzin and his wife are progressive farmers in Leh who grow flowers and exotic vegetables for the stream of trekkers and tourists who flow into Ladakh during the summer months. Their home, set in fields and flower gardens, is a picture of semi-rural prosperity. Great care has been lavished on the interiors.

Nicht weit von den reißenden Stromschnellen des Indus entfernt, hoch oben in einem Tal in der dünnen Luft des Himalaya liegt die Stadt Leh, die seit dem 16. Jahrhundert die Hauptstadt von Ladakh ist. Früher war Leh eine wichtige Handelsstadt auf dem Karawanenweg, der Kashmir mit Tibet und China verband. Am Rande der Altstadt liegt der neunstöckige königliche Palast, der im 17. Jahrhundert gebaut wurde – zur gleichen Zeit als in Tibet der berühmte Potala-Palace in Lhasa entstand. Lakruk Tsewang Rigzin und seine Frau sind Bauern, die in Leh Blumen und exotisches Gemüse anbauen. Den Ertrag verkaufen sie an die zahlreichen Wanderer und Touristen, die Ladakh während der Sommermonate überfluten. Ihr Haus liegt inmitten von Feldern und Blumengärten und ist der malerische Inbegriff einer halb ländlichen, halb städtischen Lebensweise. Das Innere des Hauses wurde mit verschwenderischer Liebe zum Detail gestaltet.

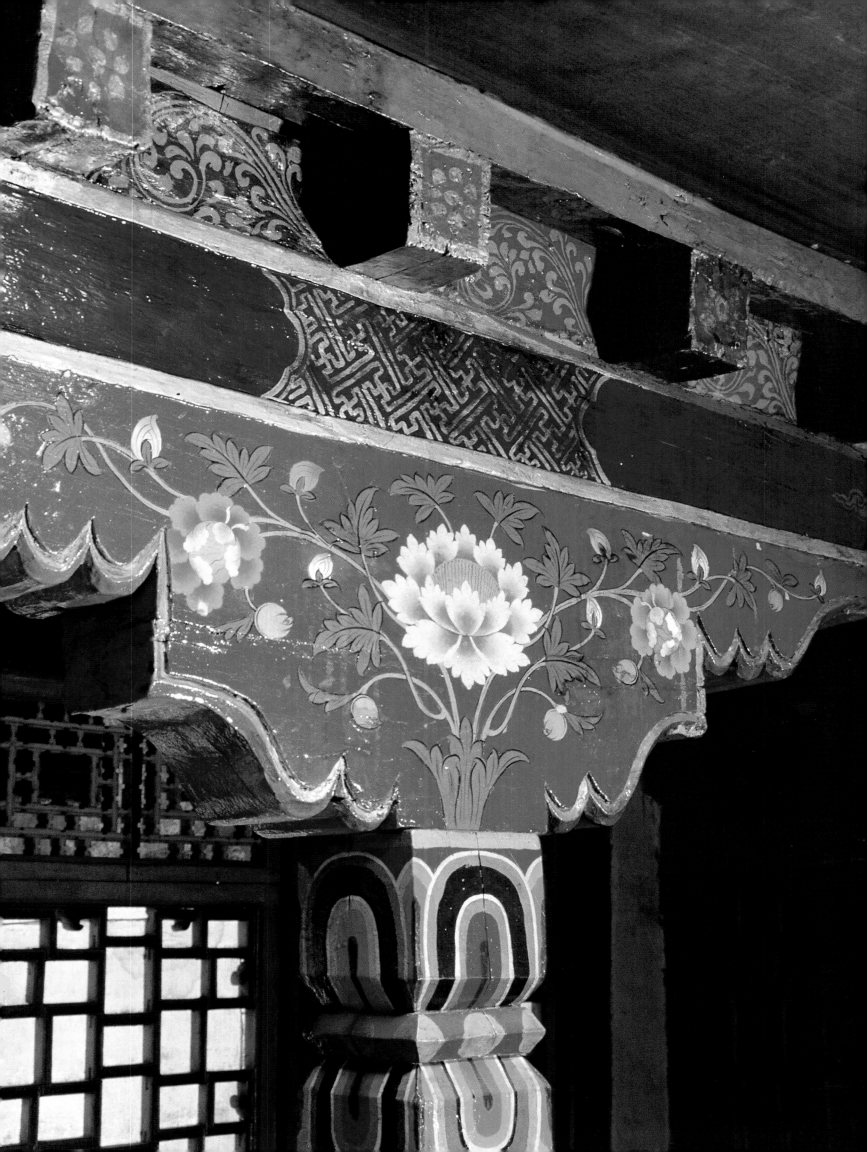

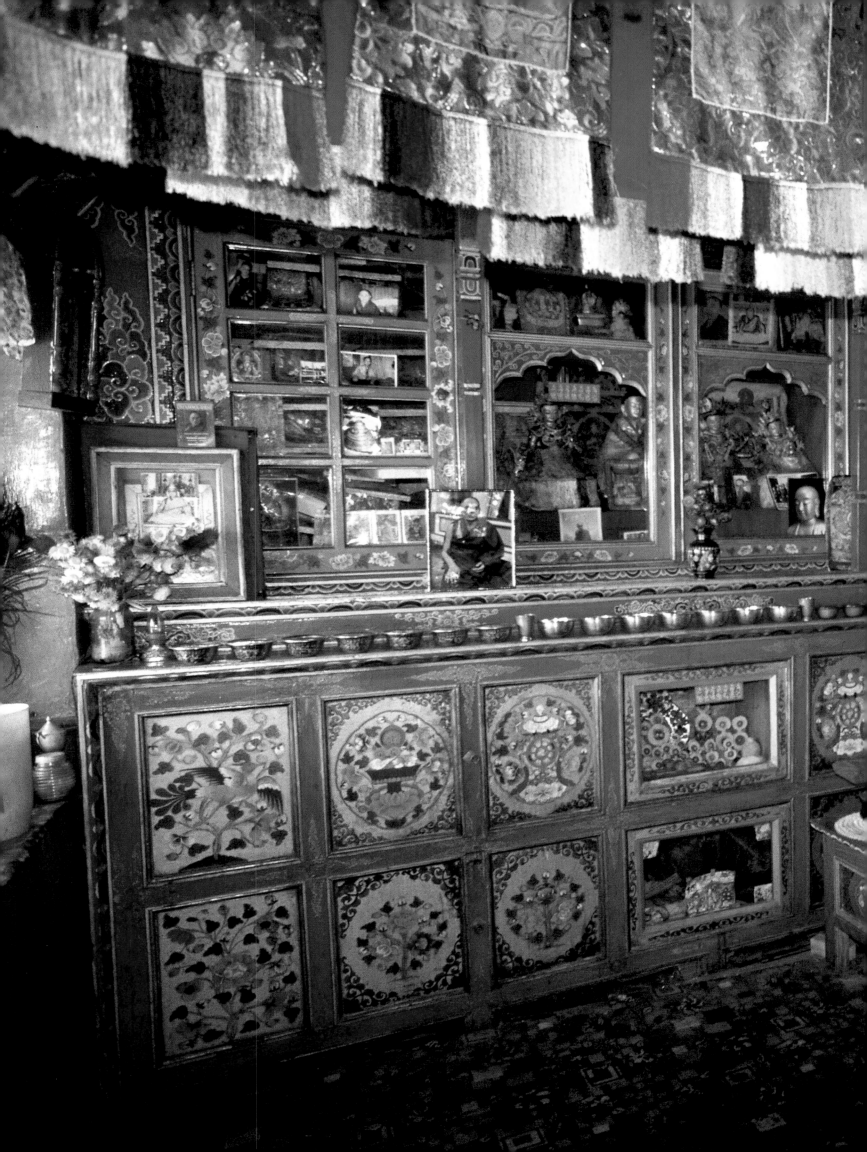

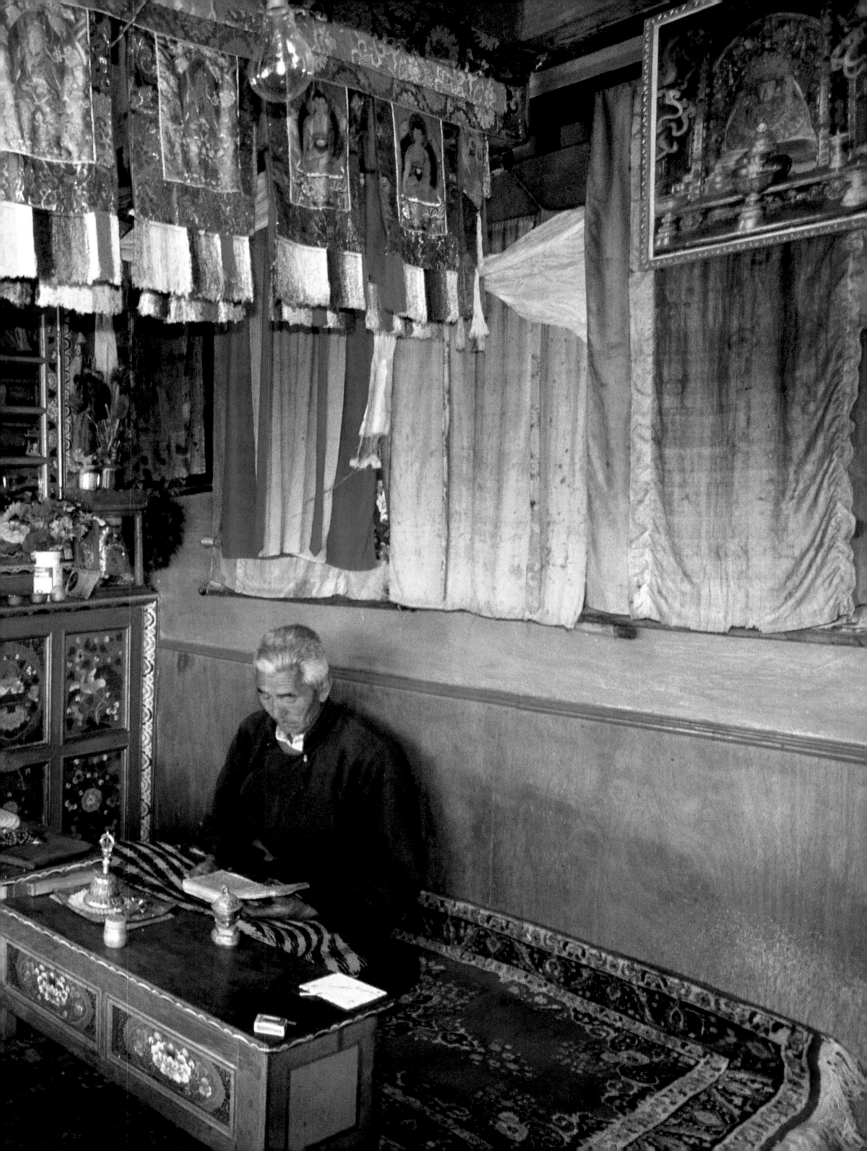

Previous pages: Lakruk Rigzin at prayer in his private temple, a rich tapestry of colours and textures. Buddhist deities occupy the niches in the painted altar, which also holds a picture of the Dalai Lama, the spiritual leader of the Tibetans. The cabinets are decorated with sacred symbol. A curtain of tasselled "thankhas", religious scrolls, hangs above.

Above and facing page: The storeroom of the house, known as a "dzot", is a cool room that houses provisions for the long winter including round wooden casks of "chang", fermented barley beer. The centrepiece of the kitchen is a gleaming iron stove, its surface lovingly sculpted and encrusted with precious corals.

Right: Like deities in an altar, a shining row of copper and brass ewers for tea and barley beer occupy individual niches in a lacquered kitchen wall cabinet.

Double page précédente: Lakruk Rigzin en prière dans son temple privé, riche mélange de couleurs et de textures. Des divinités bouddhistes occupent les niches de l'autel peint, qui accueille également une photo du Dalaï Lama, chef spirituel des Tibétains. Les placards de l'autel sont ornés de symboles sacrés. Au-dessus, un rideau de «thankhas», des bandes de tissus portant des inscriptions religieuses.

Ci-dessus et page de droite: Le grenier, ou «dzot», est une pièce fraîche où l'on entrepose les provisions pour les longs mois d'hiver, y compris les fûts en bois contenant «chang», la bière locale. Au centre de la cuisine, le superbe four, sculpté avec soin et incrusté de coraux précieux.

A droite: Telles des divinités dans un autel, une série d'aiguières en cuivre et en laiton pour le thé et la bière sont disposées dans des niches individuelles dans une étagère laquée de la cuisine.

Vorhergehende Doppelseite: Lakruk Rigzin beim Gebet in seinem an Farben, Mustern und Texturen reichen Haustempel. In den Nischen des reich verzierten Altars stehen buddhistische Gottheiten zusammen mit einem Bild des Dalai Lama, dem geistigen Oberhaupt der Tibeter. Der Schrank ist mit heiligen Symbolen bemalt, und an der Decke hängt ein mit Fransen besetzter Vorhang aus »Thangkas«, religiösen Rollbildern des tibetischen Buddhismus.

Oben und rechte Seite: Der Lagerraum des Hauses, den man als »Dzot« bezeichnet, ist gleichzeitig ein Kühlraum, in dem die Vorräte für den langen Winter gelagert werden. Dazu gehören auch runde hölzerne Fässer mit »Chang«, einem aus Gerste gebrauten Bier. Der Blickfang in der Küche ist ein glänzender Ofen aus Eisen, dessen Oberfläche liebevoll mit kostbaren Korallen besetzt wurde.

Unten: Wie Statuen von Gottheiten stehen glänzende Kupfer- und Messingkrüge in den einzelnen Nischen eines lackierten Küchenregals. Sie sind zum Ausschank von Tee oder Gerstenbier gedacht.

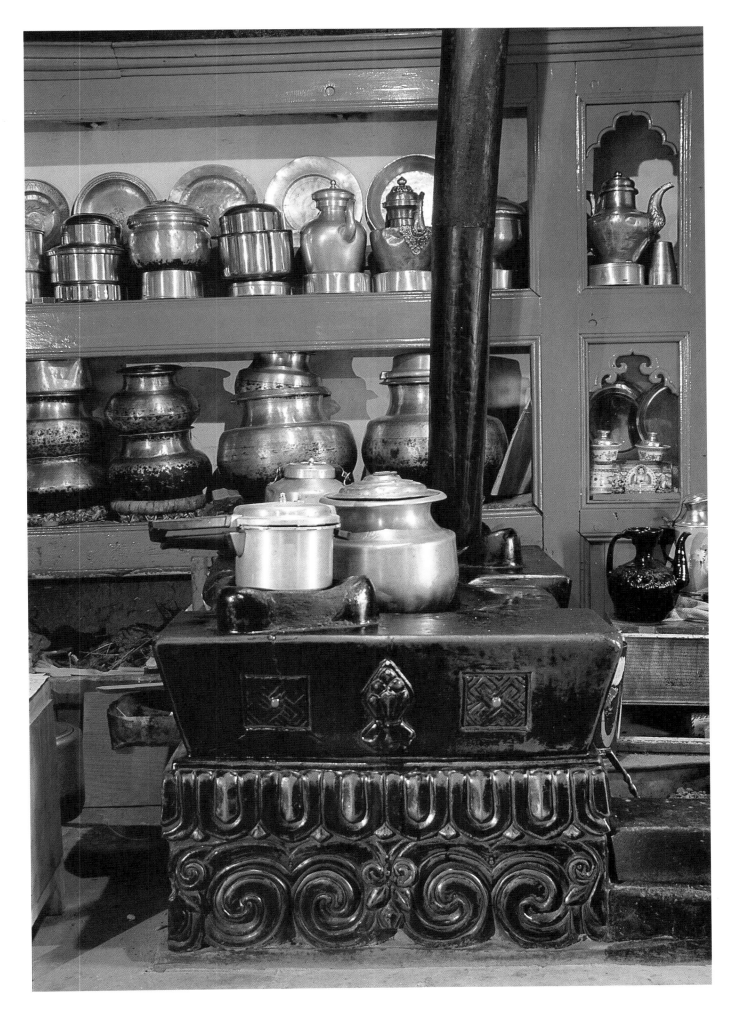



A Chandigarh, la nouvelle capitale du Pendjab dessinée par Le Corbusier dans les années cinquante, le jardin de pierre de Nek Chand, avec ses cascades, ses passages secrets, ses folies et ses terrasses dissimulés dans la verdure, peut rivaliser avec les bâtiments du célèbre architecte. Des armées de poupées, d'oiseaux magiques et d'animaux veillent sur ce jardin enchanté élaboré à partir de déchets industriels et de bric-à-brac récupéré dans des décharges. Des fragments de porcelaine, des scories, des éclats de métal, même des parpaings abandonnés provenant des chantiers de Le Corbusier, ont été recyclés pour construire ce paysage visionnaire. Nek Chand était employé dans les transports publics lorsqu'il a commencé à créer ce jardin secret il y a 40 ans, guidé par sa seule imagination. Des administrateurs municipaux éclairés ont su reconnaître son talent et son œuvre, qui couvre à présent près de dix hectares et accueille 5 000 touristes par jour, soit plus que les créations de Le Corbusier.

Nek Chand

A sight to rival the buildings of Le Corbusier in Chandigarh, the new capital of Punjab that the Swiss architect planned in the Fifties, is Nek Chand's rock garden – a place of waterfalls, hidden passages, pavilions and piazzas set in a jungle landscape that was once a derelict wasteland. Armies of doll-like figures, magical birds and beasts are the sentinels of this enchanted garden, which has been fashioned from industrial waste and throwaway junk. Broken china, slag from foundries, metal scrap, even leftover cement blocks from the city that Le Corbusier built have been recycled in Nek Chand's visionary environment. Untutored in art but driven by his fantasy, Nek Chand was a transport official 40 years ago when he began to build his secret garden. Enlightened city administrators recognised his talent and legitimised the project which now covers an area of 25 acres and receives 5 000 tourists a day – more than Le Corbusier's creations.

In Chandigarh, der neuen Hauptstadt des Punjab, sind nicht nur die in den fünfziger Jahren entworfenen Gebäude des schweizerischen Architekten Le Corbusier sehenswert. Ein Anblick, der es durchaus mit ihnen aufnehmen kann, ist Nek Chands Steingarten – ein mysteriöser Ort mit donnernden Wasserfällen, geheimen Gängen, Pavillons und malerischen Plätzen inmitten einer auf einem verlassenen Grundstück entstandenen Dschungel-Landschaft. Ein Heer von kleinen menschlichen Figuren, magischen Vögeln und Tieren »bewacht« diesen verzauberten Garten, dessen Bestandteile sich zur Gänze aus Industrieabfall und altem Gerümpel zusammensetzen. Porzellanscherben, Schlacke aus den Gießereien, Metallschrott, auseinandergenommene Leitungsmasten, sogar übriggebliebene Zementblöcke der von Le Corbusier gebauten Stadt gelangten in Nek Chands phantasievollem Areal zur Wiederverwendung. Vor 40 Jahren, als er seinen geheimen Garten auf einem leerstehenden Grundstück baute, war Nek Chand ein kleiner Angestellter im Transportwesen, der seine fehlende künstlerische Ausbildung durch Fantasie wettmachte. Weitsichtige Mitglieder der Stadtverwaltung erkannten sein Talent und gaben dem Projekt ihren städtebaulichen Segen. Heute erstreckt sich der Garten über ein Gebiet von zehn Hektar und wird täglich von 5 000 Touristen besucht – weit mehr als die Gebäude Le Corbusiers anziehen.

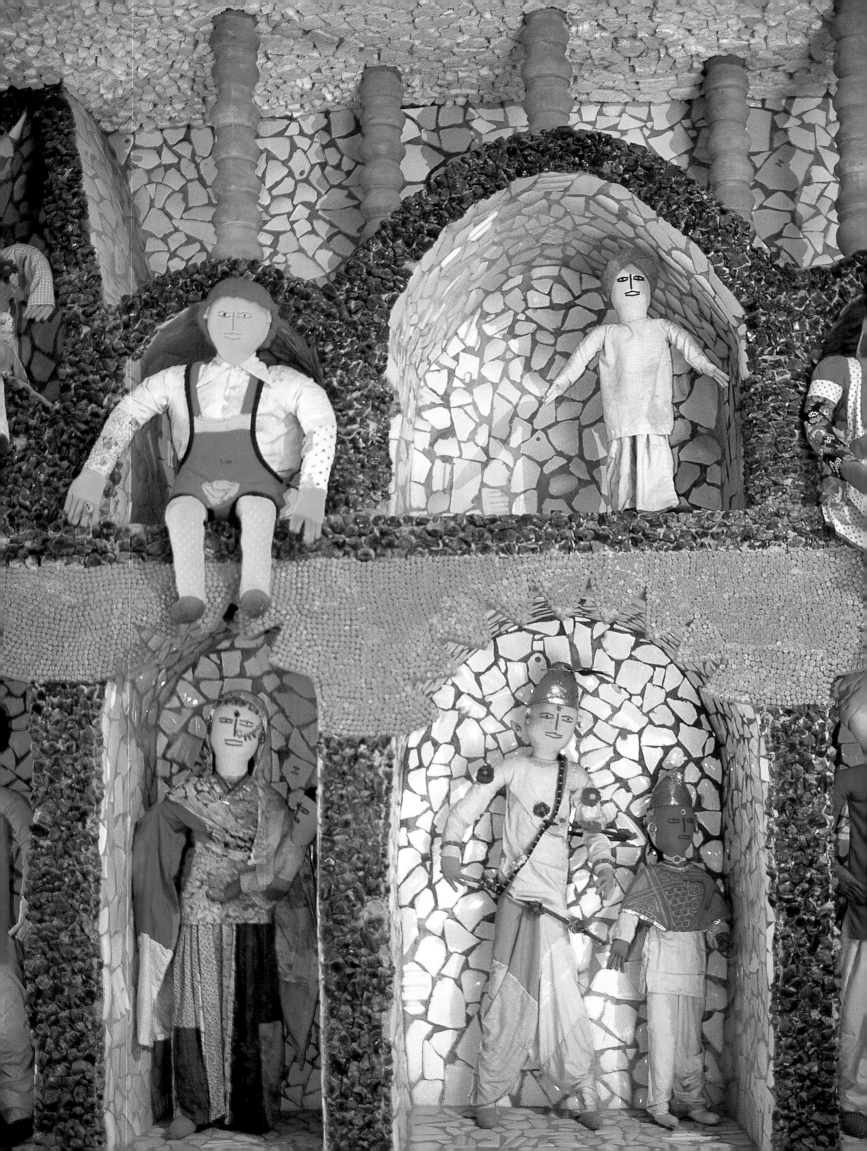

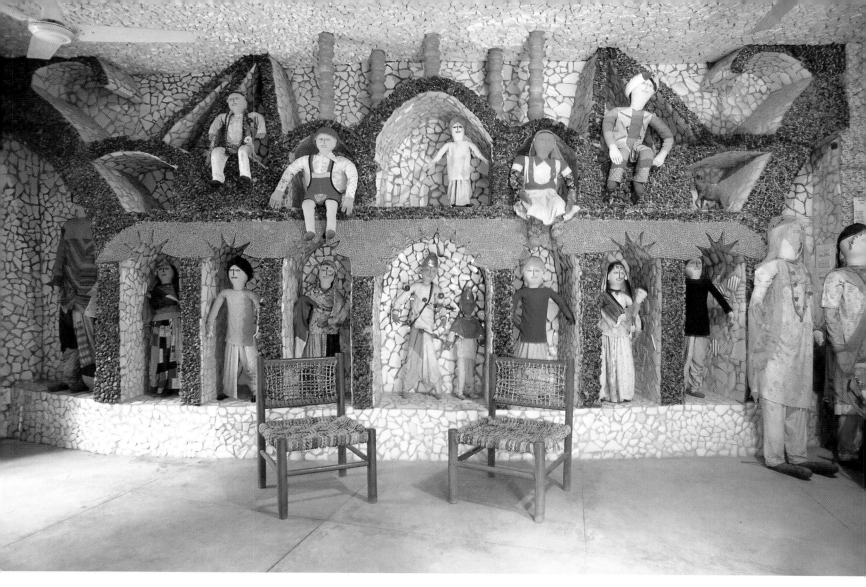

Nek Chand has built a small two-bedroomed house in his rock garden
that captures his unique creative spirit. Rag dolls of mythical figures
sit in niches made of broken tiles, industrial slag and clay beads.

Dans son jardin de pierre, Nek Chand a construit une maisonnette
avec deux chambres à coucher qui reflète parfaitement l'originalité
de son esprit créatif. Les niches, faites de carreaux cassés, de scories
industrielles et de perles d'argile, accueillent des poupées en chiffon
représentant des personnages mythiques.

Nek Chand baute in seinem Steingarten ein kleines Haus mit zwei
Schlafzimmern, das seine einzigartige Kreativität widerspiegelt. In
Nischen, die mit Kachelscherben, Industrieschlacke und Tonperlen
verkleidet sind, sitzen Flickenpuppen, die verschiedene Sagengestalten
darstellen.

Right: Normal tiles in a small area of the spartan bathroom are inventively used to contrast with walls lined with broken tiles.
Below: The main seating area is decorated with Nek Chand's home-grown building models. The old wicker chairs are enlivened with brightly-coloured rags sewn together by hand.

A droite: Dans un angle de la salle de bains spartiate, des carrelages réguliers contrastent de manière inventive avec le mur de carreaux cassés.
Ci-dessous: Le coin salon est décoré avec les maquettes d'architecture de Nek Chand. Les vieux fauteuils en osier sont tapissés de chiffons aux couleurs vives cousus à la main.

Rechts: In dem spartanischen Badezimmer gibt es einen kleinen Bereich, der mit ganzen Kacheln verkleidet ist und in Kontrast zu dem mit Bruchstücken gekachelten Rest der Wände steht.
Unten: Zur Dekoration des Wohnzimmers gehören Nek Chands selbstgemachte Architekturmodelle. Die alten Korbstühle sind mit handgenähten bunten Flicken bezogen.

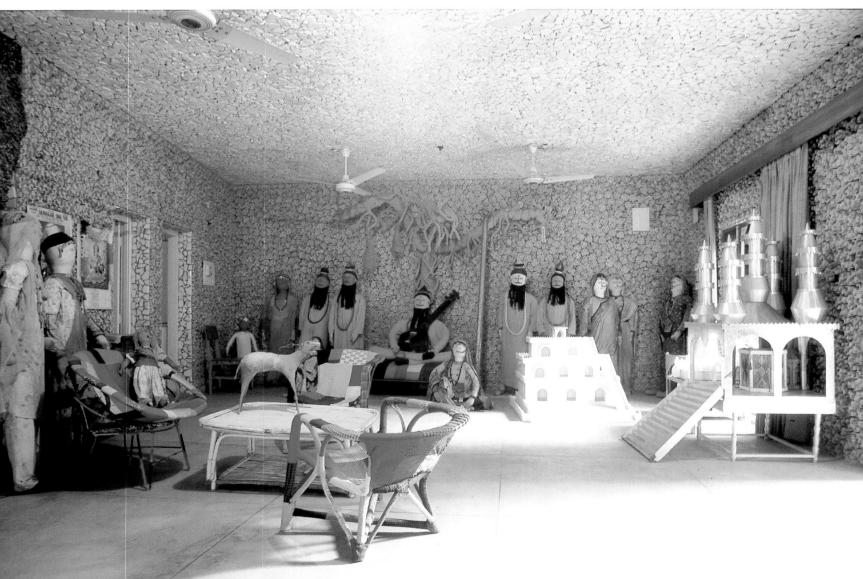

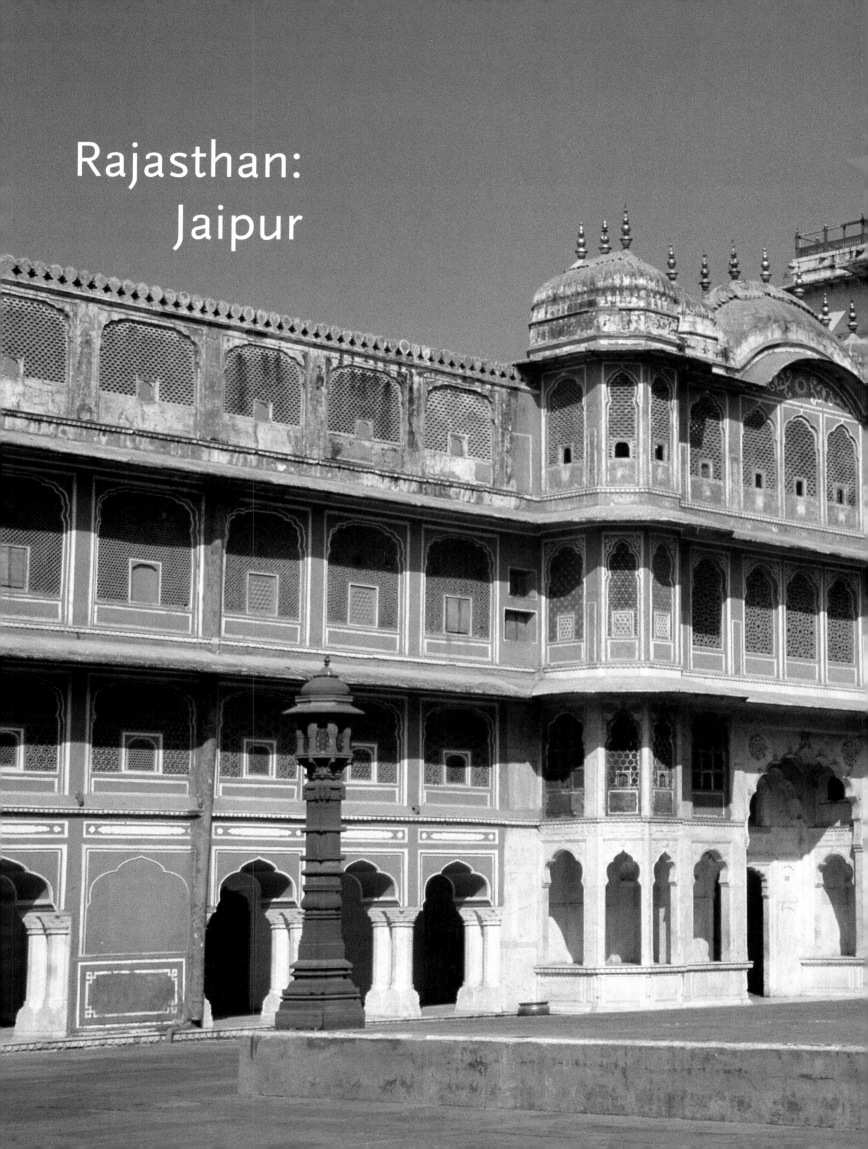

Rajasthan:
Jaipur

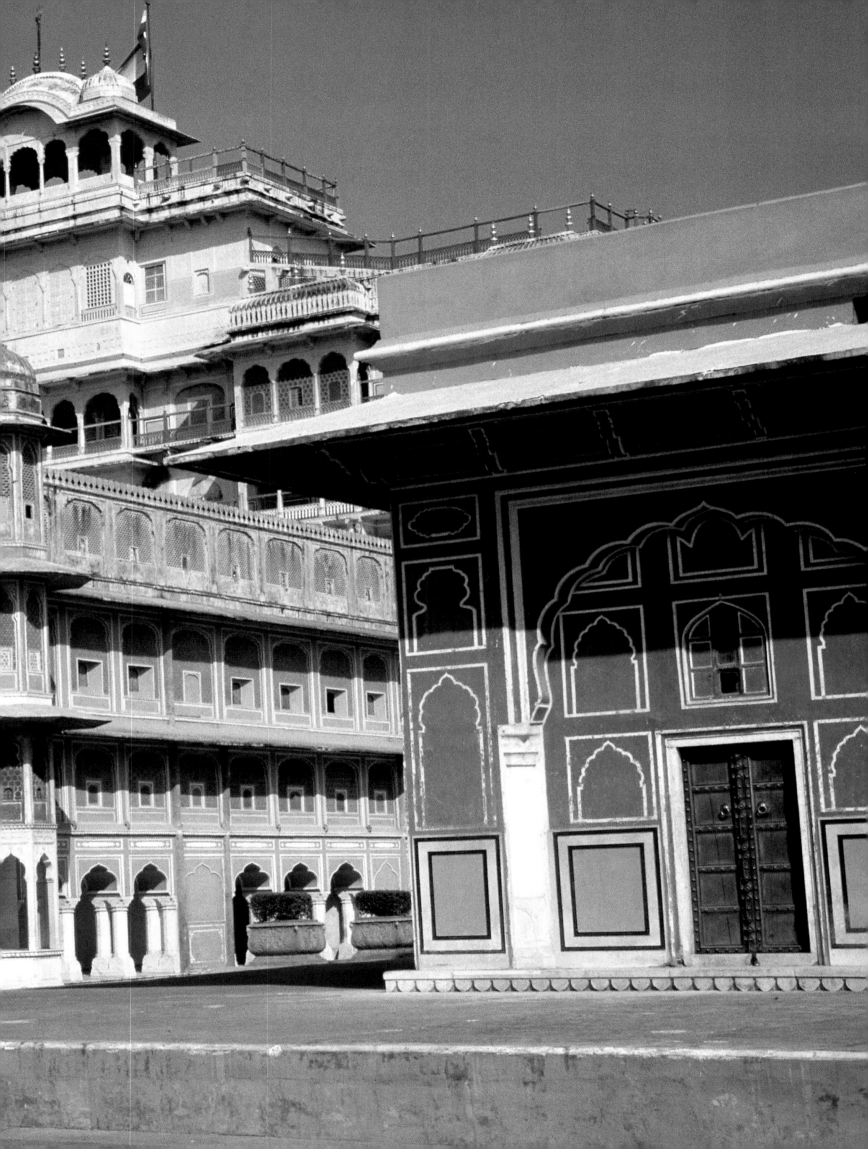

On entre dans Jaipur par des portes enchâssées dans des crevasses et des remparts dentelés perchés sur des crêtes rocheuses qui s'ouvrent brusquement sur le majestueux fort Amber, comme si l'on pénétrait dans une imprenable forteresse de montagne. La légendaire «ville rose» du Rajasthan est sans doute une des destinations touristiques les plus courues mais, à certains égards, c'est également la plus secrète. Si l'avènement des Kachhwaha, le clan régnant, fut inextricablement lié aux puissants Mongols, la Jaipur moderne doit son développement au déclin de ces derniers. Elle fut créée par le maharaja Jai Singh II qui, en 1727, entreprit de bâtir la première ville planifiée d'Inde. Il fit construire de nombreux observatoires, tels que celui que l'on aperçoit depuis les balcons de son palais principal. Mais le joyau de son vaste complexe de palais est le Chandra Mahal, ou «palais de la lune», haut de sept étages et devenu la demeure du maharaja actuel, Bhawani Singh, chacune de ses nombreuses pièces recèle des prouesses architecturales et des détails d'une richesse inouïe.

Maharaja of Jaipur

Entering Jaipur, through gateways set in crags and turreted battlements on high ridges that suddenly open on to the majesty of Amber Fort, is like entering a secret mountain fastness. Rajasthan's fabled Pink City may be the most obvious of tourist destinations but in some ways it is also the most elusive. Although the rise of Jaipur's ruling Kachhwaha clan was inextricably linked to Moghul rule, modern Jaipur developed as a result of declining Moghul power. It was the creation of Maharaja Jai Singh II who, in 1727, set about building the first planned city in India. His interest in astronomy led him to build observatories, seen from the balconies of his main palace. The crowning glory of his vast palace complex is the seven-storeyed Chandra Mahal or Moon Palace. Home to the present Maharaja of Jaipur, Bhawani Singh, it contains room after room of outstanding architectural merit and breathtaking detail.

Wenn man die Stadt Jaipur betritt und durch die zinnen- und turmbekrönten Tore schreitet, die sich über die schmalen Kammlinien der Felsen ziehen und plötzlich den Blick auf die majestätische Festung Amber freigeben, dann fühlt man sich, als betrete man eine geheime Bergfeste. Rajasthans berühmte »Pink City« mag zwar das beliebteste Touristenziel in Indien sein, doch in gewisser Weise ist sie auch der Ort, der sich dem Besucher am meisten entzieht. Obwohl der Aufstieg des Kachhwaha-Geschlechts untrennbar mit der Herrschaft der Moguln verbunden war, entstand das heutige Jaipur als Folge des Niedergangs des Mogul-Reiches. Sein Schöpfer war Maharaja Jai Singh II., der 1727 begann, die erste am Reißbrett entworfene Stadt Indiens zu bauen. Sein Interesse an der Astronomie veranlaßte ihn auch dazu, Observatorien zu errichten; unter anderem jenes, welches man von den Balkonen seines Hauptpalastes sehen kann. Der krönende Höhepunkt seines riesigen Palastkomplexes ist das siebenstöckige Chandra Mahal oder der Palast des Mondes, in dem der heutige Maharaja von Jaipur, Bhawani Singh, residiert. Die Räume im Innern des Palastes übertreffen einander in ihrer architektonischen Kunstfertigkeit und einer atemberaubenden Liebe zum Detail.

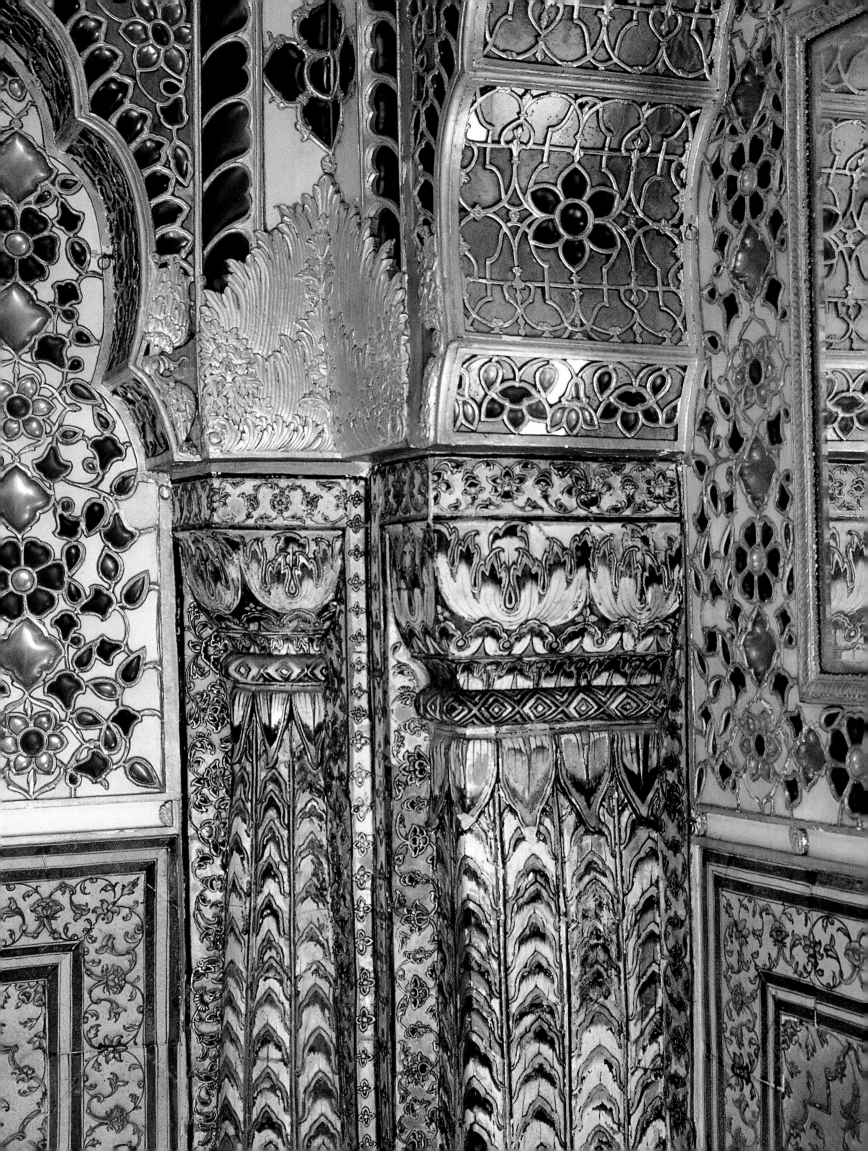

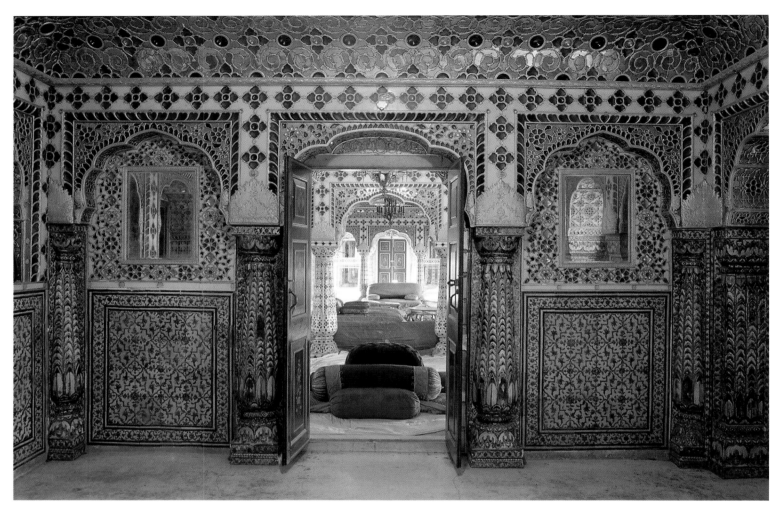

Previous page: detail of the exquisite blue-tiled dadoes and glittering gold leaf-and-mica decoration in the Shobha Niwas, or Hall of Beauty, on the fourth floor of the Chandra Mahal.
Above and facing page: The fascination of maharajas for mirror-encrusted halls led to the redecoration of the sumptuous Shobha Niwas in the mid-19th century. Local art school students executed floral patterns in gypsum and covered them with gold leaf. The hollows between were coated in coloured tinsel, then covered with mica. Reclining on cushions of embroidered velvet, the maharaja and his guests would enjoy the spectacle of the room bursting into a thousand flickering images as the first candles were lit after dark.
Following pages: The Chhavi Niwas, or Hall of Images, is on the fifth floor of Chandra Mahal. Painted a serene blue and white, it has a polished floor of eggshell stucco. It was used as a retreat during the rainy season, once the hot summer had abated.

Page précédente: détail des magnifiques lambris carrelés de bleu et des ornements en mica et à la feuille d'or du Shobha Niwas, ou «salon de la beauté», au quatrième étage du Chandra Mahal.
Ci-dessus et page de droite: La fascination des maharajas pour les pièces tapissées de petits miroirs a inspiré une nouvelle décoration du Shobha Niwas vers le milieu du 19e siècle. Les élèves d'une école d'art locale réalisèrent des motifs floraux en gypse puis les dorèrent à la feuille. Les creux entre les motifs furent comblés par des guirlandes colorées puis recouverts de mica. Au coucher du soleil, couchés sur des coussins en velours brodé, les maharajas et leurs invités admiraient le spectacle des milliers de lueurs dansant sur les murs tandis qu'on allumait les premières chandelles.

Double page suivante: Le Chhavi Niwas, ou «salon des images», se trouve au cinquième étage du Chandra Mahal. Peint en tons sereins bleus et blancs, il a un sol en stuc poli coquille d'œuf. Il servait autre fois de retraite pendant la saison des pluies, une fois passées les chaleurs étouffantes de l'été.

Vorhergehende Seite: eine Detailansicht der exquisiten, mit blauen Kacheln besetzten Paneele und der glitzernden Wandverzierungen aus Muskovit und Blattgold im Shobha Niwas, der Halle der Schönheit, im vierten Stock des Chandra Mahal.
Oben und rechte Seite: Die Begeisterung der Maharajas für spiegelglasbesetzte Oberflächen führte dazu, daß das verschwenderische Shobha Niwas Mitte des 19. Jahrhunderts neu dekoriert wurde. Einheimische Kunststudenten modellierten Blumenmuster aus Gips und überzogen sie dann mit Blattgold. Die Vertiefungen dazwischen wurden mit bunten Metallfäden verkleidet und mit Muskovit besetzt. Wenn sich dann der Maharaja und seine Gäste auf den mit Stickereien verzierten Samtkissen zurücklehnten, genossen sie den Anblick, der sich ihnen bot, sobald nach Einbruch der Dunkelheit die ersten Kerzen angezündet wurden und der Raum plötzlich von Tausenden von flackernden Bildern erfüllt wurde.
Folgende Doppelseite: Das Chhavi Niwas, die Halle der Bilder, liegt im fünften Stock des Chandra Mahal. Der Raum ist in einem heiteren Blauweiß gestrichen und der Boden ist mit Stucco überzogen. Hier hielt man sich für gewöhnlich während der Regenzeit auf, nachdem die Hitze des Sommers nachgelassen hatte.

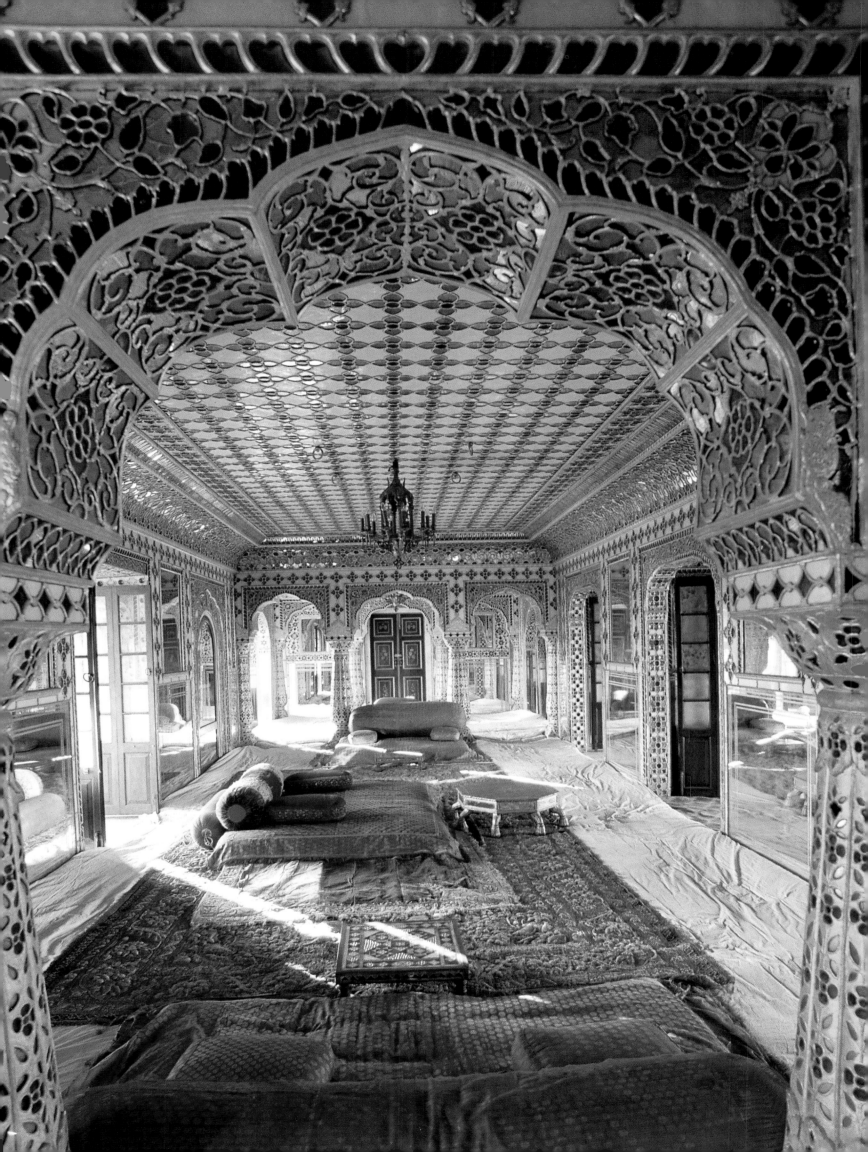

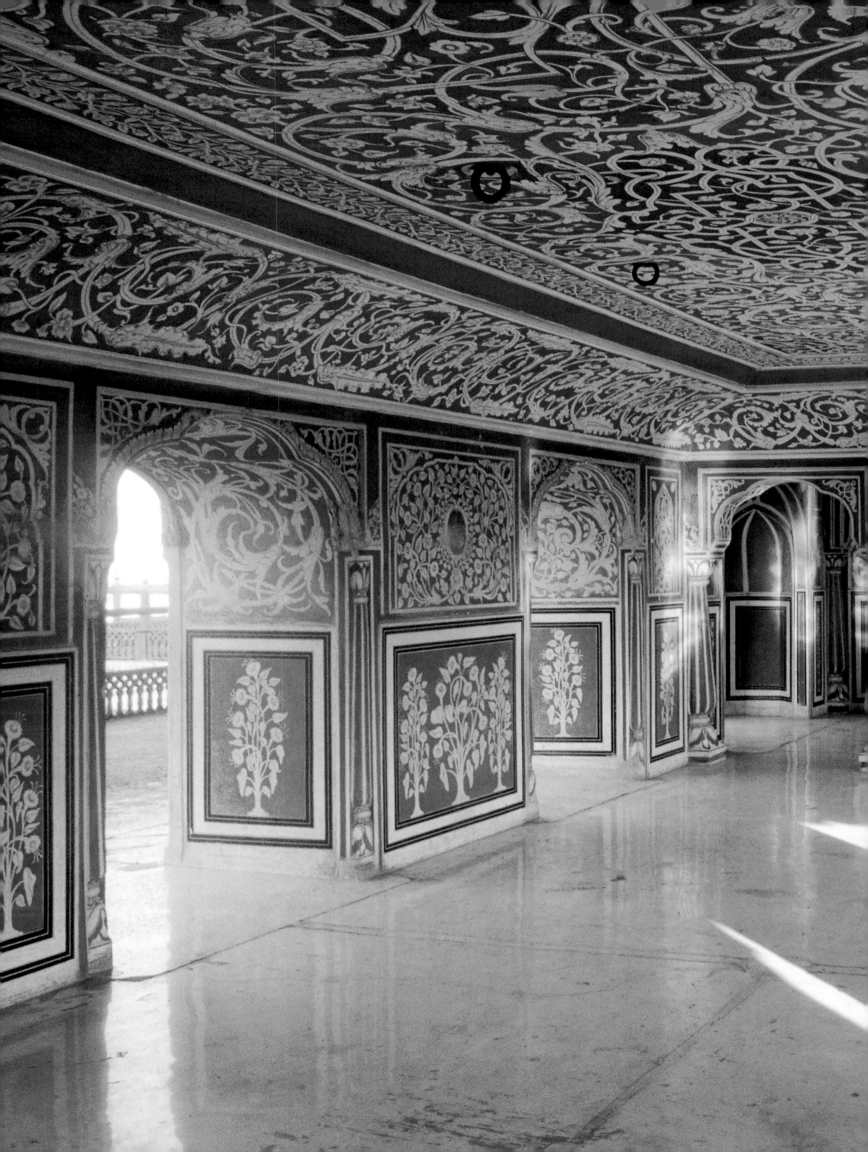

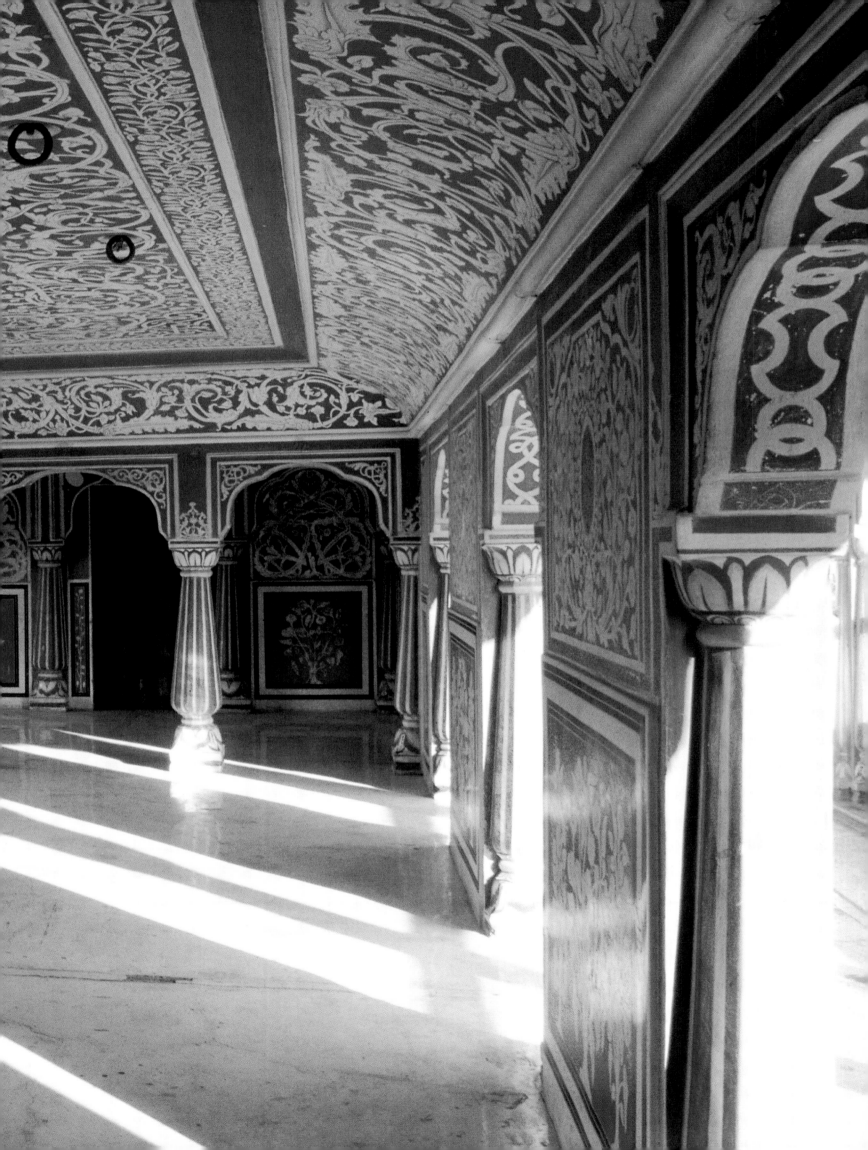

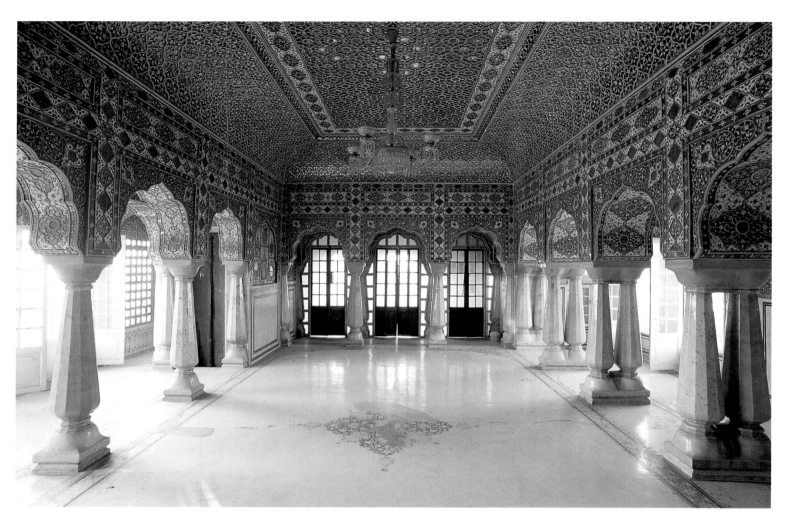

Above: The sixth floor of Chandra Mahal, with its mirrored ceiling and stucco floor, has rows of double columns through which one sees a magnificent vista of rugged hills.
Right and facing page: Sukh Niwas, Hall of Rest, a formal salon of double-height, has peep-holes camouflaged with gold-leaf decorations, for air ventilation. Furnished with Moghul miniatures, European silver and family portraits, it serves as the Maharaja of Jaipur's private drawing room. In the dining room alongside are rare glass dining tables by René Lalique.

Ci-dessus: Le sixième étage du Chandra Mahal, avec son plafond en miroirs et son sol en stuc, est bordé de doubles colonnes qui donnent sur une vue splendide des montagnes escarpées.
A droite et page de droite: Dans le monumental Sukh Niwas, ou «salon du repos», les ouvertures d'aération sont camouflées par des ornements à la feuille d'or. Abritant des miniatures mongoles, des pièces d'orfèvrerie européennes et des portraits de famille, c'est le salon privé du maharaja de Jaipur. Dans la salle à manger qui le jouxte, des tables en cristal de René Lalique, pièces rares.

Oben: Im sechsten Stock des Chandra Mahal ist die Decke mit Spiegelglas besetzt, der Boden ist aus Stucco und durch die Reihe von Doppelsäulen hat man einen herrlichen Blick auf zerklüftete Hügel.
Rechte Seite und rechts: Das Sukh Niwas, die Halle der Ruhe, ein repräsentativer Salon von doppelter Höhe, wird durch kleine Löcher belüftet, die mit einer Dekoration aus Blattgold getarnt sind. Der Raum ist mit Miniaturen aus der Mogulzeit, europäischem Silber und Familienporträts ausgestattet und dient dem Maharaja von Jaipur als privates Wohnzimmer. Das angrenzende Eßzimmer enthält seltene Glastische von René Lalique.

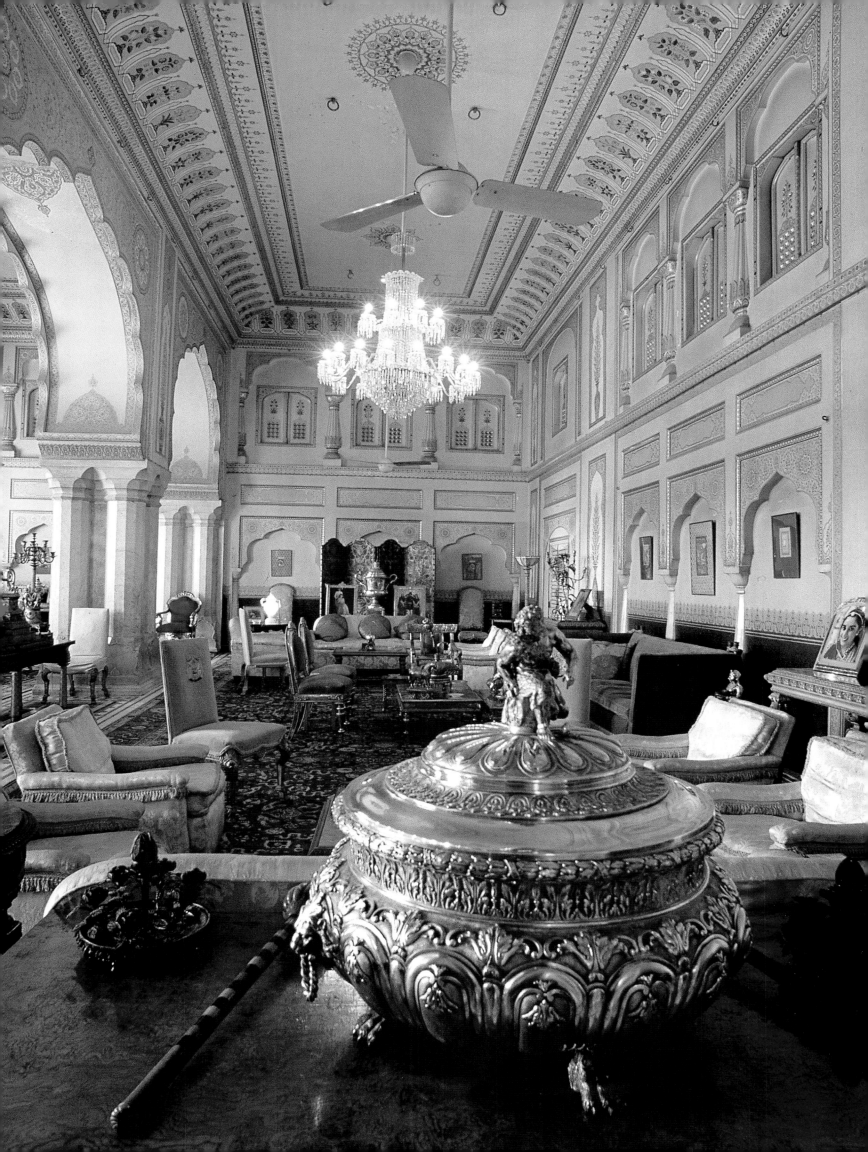

Narain Niwas est le parfait exemple de ces splendides villas indo-européennes qui fleurirent à Jaipur dans les années vingt, lorsque le maharaja Man Singh II, fringant joueur de polo affectueusement monta sur le trône et entreprit une modernisation rapide de la ville. Sa construction coïncida avec l'expansion des forces militaires dans l'Etat de Jaipur. De fait, son commanditaire, le général Amar Singh, n'était autre que le commandant en chef de l'armée et un ami proche du maharaja. Le général avait deux passions: l'armée et son journal intime. Premier officier indien à être mandaté par l'armée britannique, il voyagea en Chine, en Europe et au Moyen-Orient et enregistra ses impressions pendant 44 ans, sans faillir un seul jour, dans 90 gros volumes en vélin aujourd'hui conservés dans la bibliothèque de la famille. Jusqu'à la Seconde Guerre mondiale, Narain Niwas était entourée d'une jungle. Aujourd'hui au cœur de la ville, elle a été convertie en hôtel par le descendant d'Amar Singh, Prithvi Singh Rathore.

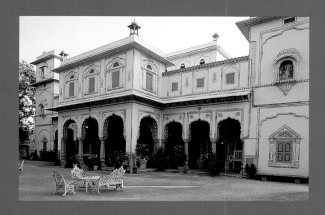

Narain Niwas

Narain Niwas in Jaipur is a fine example of the splendid Indo-European villas that sprung up in the Twenties as the city underwent rapid modernisation after Maharaja Man Singh II, the dashing polo player, came to power. Its building coincided with the expansion of forces in Jaipur state and its builder, General Amar Singh, was commander of forces and a close friend of the maharaja. General Amar Singh had two overriding interests: soldiering and writing diaries. As the first Indian officer to gain a King's commission in the British army, he travelled to China, Europe and the Middle East and recorded his experiences for 44 years, without a day's break, in 90 large vellum-bound volumes which are kept in the family library. Until World War II, Narain Niwas was surrounded by jungle. It is now a hotel in the heart of the city run by Amar Singh's descendant Prithvi Singh Rathore.

Narain Niwas ist ein wunderbares Beispiel für die prachtvollen indo-europäischen Villen, die während der zwanziger Jahre in Jaipur gebaut wurden. Damals wurde die Stadt gerade einer raschen Modernisierung unterzogen, nachdem Maharaja Man Singh II., ein schneidiger Polo-Spieler, an die Macht gekommen war. Der Bau der Villa fiel in eine Zeit, in der der Staat Jaipur seine Streitkräfte vergrößerte. Ihr Erbauer, General Amar Singh, ein Adeliger aus der nahegelegenen Stadt Kanota, war der Kommandant der Truppen und ein enger Freund des Maharajas. General Amar Singh hatte zwei alles beherrschende Interessen: das Soldatenleben und das Schreiben von Tagebüchern. Er war der erste indische Offizier, der in die britische Armee aufgenommen wurde. Er reiste nach China, Europa sowie den Mittleren Osten und schrieb seine Erlebnisse 44 Jahre lang auf, ohne je einen Tag auszulassen. Die 90 großen Bücher mit Pergamenteinband, die er auf diese Weise füllte, werden heute in der Familienbibliothek aufbewahrt. Bis zum Zweiten Weltkrieg war Narain Niwas von einem Dschungel umgeben, heute steht die Villa im Herzen der Stadt und wird von Amar Singhs Nachfahren Prithvi Singh Rathore als Hotel geführt.

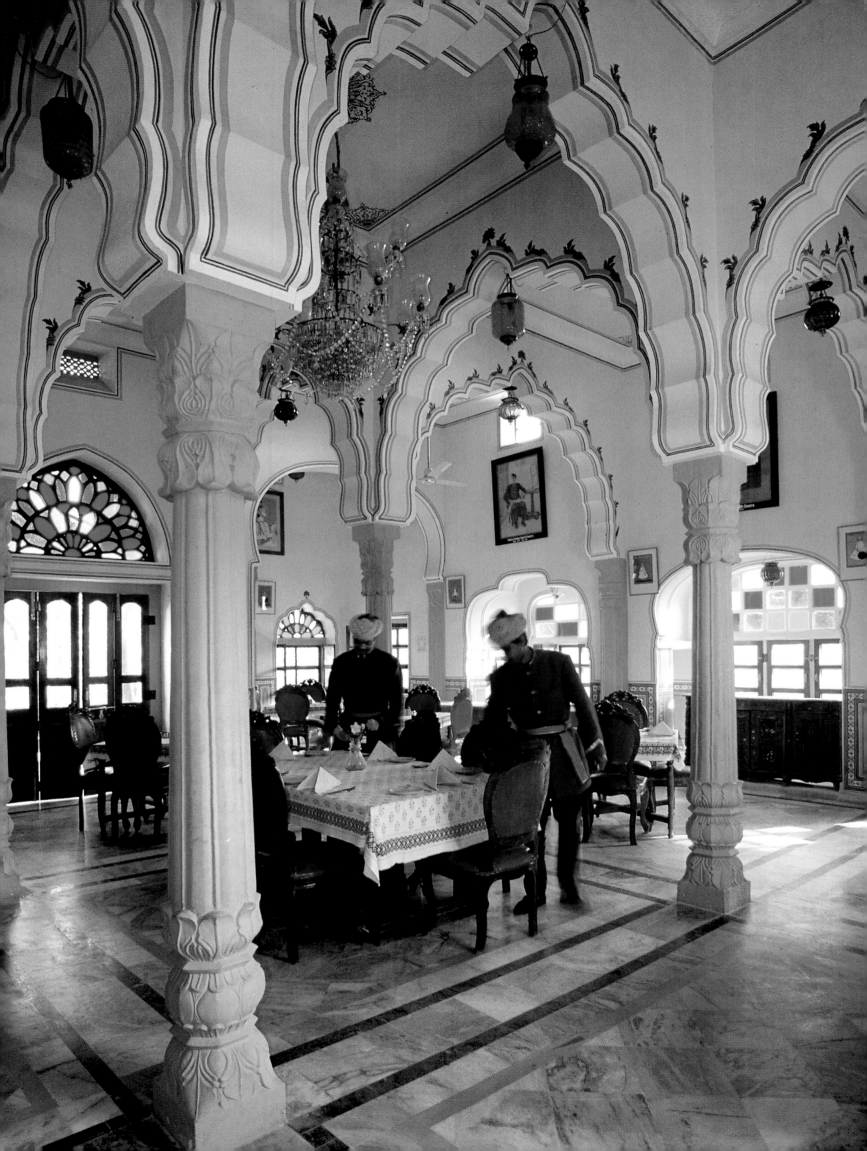

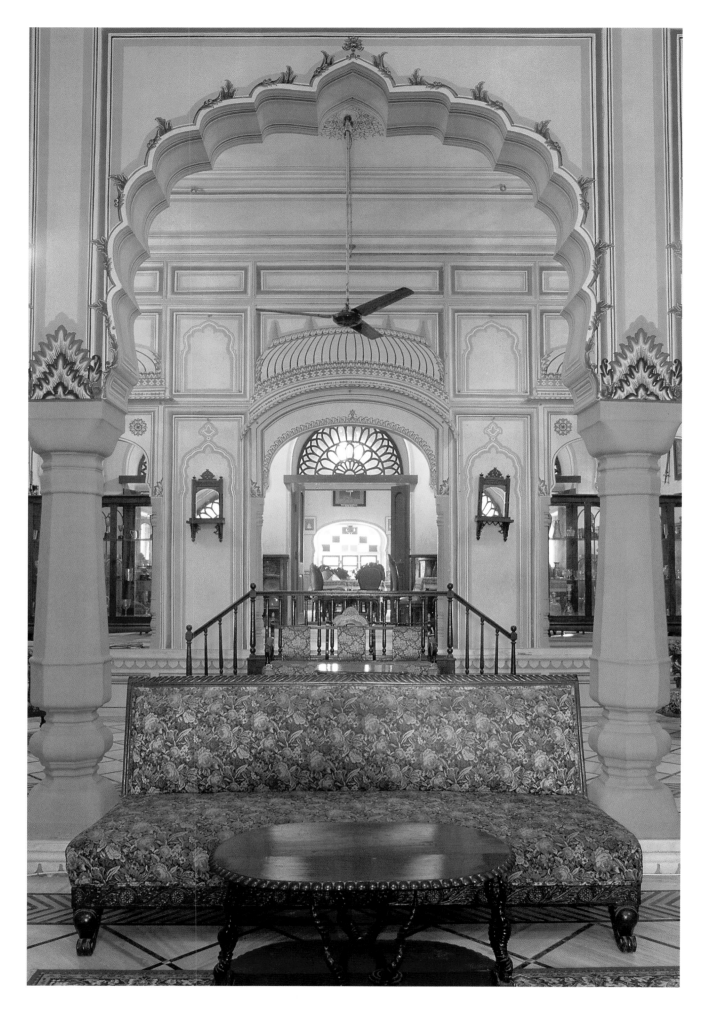

Indian Interiors Narain Niwas

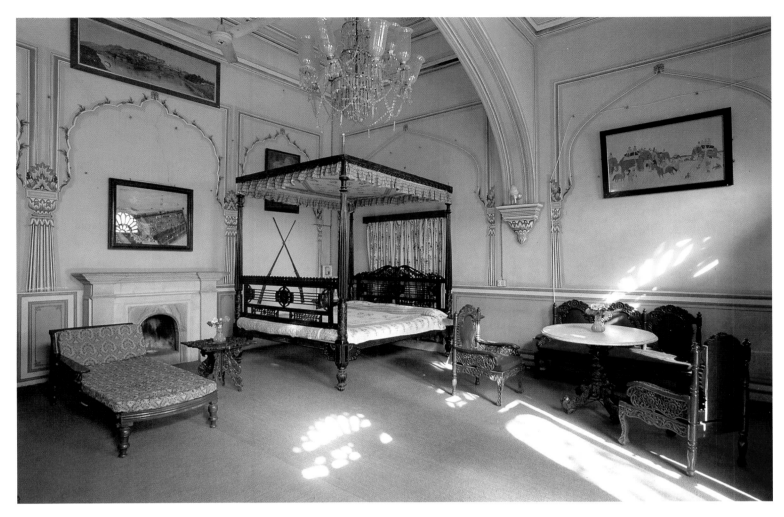

First pages: *A profusion of red sandstone pillars with double-lotus capitals support elegantly painted multifoil arches in the dining room. A detail of a pedimented "trompe l'œil" window on the main facade bears the stamp of European influence.*
Facing page: *Stylised creepers painted along a scalloped arch give on to an elaborate "trompe l'œil" decoration of Moghul-style canopies and niches around a door, thereby enhancing the effect of a succession of rooms leading from the main hall of Narain Niwas.*
Above: *a carved four-poster and ornate furniture in one of the Narain Niwas bedrooms. The European-style marble fireplace is an incongruous addition to the painted arches.*

Premières pages: *Dans la salle à manger, une forêt de colonnes en grès rose, surmontées de chapiteaux en double lotus, soutiennent d'élégantes arches peintes en éventail. Le détail d'une fenêtre à fronton en trompe-l'œil sur la façade principale témoigne de l'influence européenne.*
Page de gauche: *Des plantes grimpantes stylisées courent le long d'une arche donnant sur une porte bordée de trompe-l'œil de dais et de niches de style mongol, accentuant encore l'effet de perspective de l'enfilade des pièces depuis le hall principal.*
Ci-dessus: *une chambre du Narain Niwas, avec un lit à baldaquin et des meubles en bois sculpté. La cheminée en marbre, de style européen, dénote entre des arches peintes.*

Eingangsseiten: *Eine Vielzahl von Säulen aus rotem Sandstein mit doppelten Lotos-Kapitellen stützt im Eßzimmer die Fächerbögen, die mit eleganten Malereien verziert sind. Die Detailansicht des Trompe-l'œil-Fensters mit Giebelaufsatz an der Hauptfassade zeigt den europäischen Einfluß.*
Linke Seite: *Die Bogenöffnung, die mit stilisierten Kletterpflanzen bemalt ist, gibt den Blick frei auf eine kunstvolle Trompe-l'œil-Dekoration an der Umrahmung einer Tür. Sie besteht aus einem Baldachin im Mogul-Stil und einzelnen Nischen. Auf diese Weise wird die räumliche Wirkung der Zimmerfluchten unterstrichen, die von der Empfangshalle des Narain Niwas ihren Ausgang nehmen.*
Oben: *Ein geschnitztes Himmelbett und andere prunkvolle Möbel stellen die Einrichtung eines der Schlafzimmer im Narain Niwas dar. Der Kamin aus Marmor im europäischen Stil wurde nachträglich hinzugefügt und will nicht so recht zu den vorgeblendeten Bögen an der Wand passen.*

Kesri Singh était autrefois un petit propriétaire avec un emploi stable, une tendre épouse et des enfants. Aujourd'hui, après avoir hérité avec ses frères d'un fort datant de la moitié du 18e siècle, c'est un nouveau rajah. Mandawa n'était pourtant guère prometteur. Il se dressait au milieu de nulle part, à près de 300 kilomètres à l'ouest de Delhi. Abandonné depuis des décennies, il menaçait de tomber en ruines. Puis, Aman Nath et Francis Wacziarg convainquirent la famille de le reprendre en main. En 1980, ils y invitèrent un groupe de touristes français, mené par Dominique Lapierre. Bientôt, le Tout-Paris en entendit parler. Depuis, Castle Mandawa a été converti en hôtel et Singh s'est découvert une nouvelle vocation. Il a aussi créé un complexe dans les dunes de sable environnantes avec l'aide des architectes Vasant et Revathi Kamath, pionniers du renouveau de l'architecture en terre. Ces derniers se sont inspirés du style des villages voisins, y compris des murs faits avec des cruches en terre rondes.

Castle Mandawa

Kesri Singh was once a conventional middle-class householder with a safe job, a nice wife and kids. Today he is a born-again rajah. Kesri Singh and his brothers inherited a mid-18th-century fort. However, although Mandawa with its warren of rooms was impressive enough, it stood in the middle of nowhere – nearly 300 kilometres west of Delhi. Decades of neglect had brought it to the brink of ruin, until conservationists Aman Nath and Francis Wacziarg rekindled the family's interest. In 1980 they sent a group of French tourists, led by the writer Dominique Lapierre, to visit Mandawa. Lapierre put the word out in Paris, Castle Mandawa was established as a hotel, and Singh found a profitable vocation. Encouraged by success, he has created a desert complex on the sand dunes with the help of architects Vasant and Revathi Kamath, pioneers in the revival of mud architecture, by simulating the style of nearby villages, down to walls made of round earthen pitchers.

Kesri Singh war früher ein ganz gewöhnlicher Hausbesitzer aus der Mittelschicht, mit einem gesicherten Arbeitsplatz, einer netten Frau und Kindern. In seinem zweiten Leben ist er nun zum Raja geworden. Kesri Singh und seine Brüder erbten ein Fort aus der Mitte des 18. Jahrhunderts. Zwar war Mandawa mit seinem Labyrinth von Räumen eindrucksvoll genug, doch befindet sich der Ort fast 300 Kilometer westlich von Delhi – mitten im Nirgendwo. Durch jahrzehntelange Vernachlässigung drohte das Ganze zu verfallen, bis die Restauratoren Aman Nath und Francis Wacziarg das Interesse der Familie wieder wachriefen. 1980 schickten sie eine Gruppe französischer Touristen nach Mandawa, angeführt von dem Schriftsteller Dominique Lapierre. Lapierre erzählte ganz Paris von dem Ort, Castle Mandawa etablierte sich als Hotel, und Singh entdeckte seine Berufung als Hotelmanager. Vom Erfolg ermutigt schuf er einen Wüstenkomplex auf den Sanddünen, gemeinsam mit den Architekten Vasant und Revathi Kamath, die Pionierarbeit auf dem Gebiet der Lehmarchitektur leisten. Sie ahmten den Stil nahegelegener Dörfer nach, bis zu den aus irdenen Krügen gefertigten Mauern.

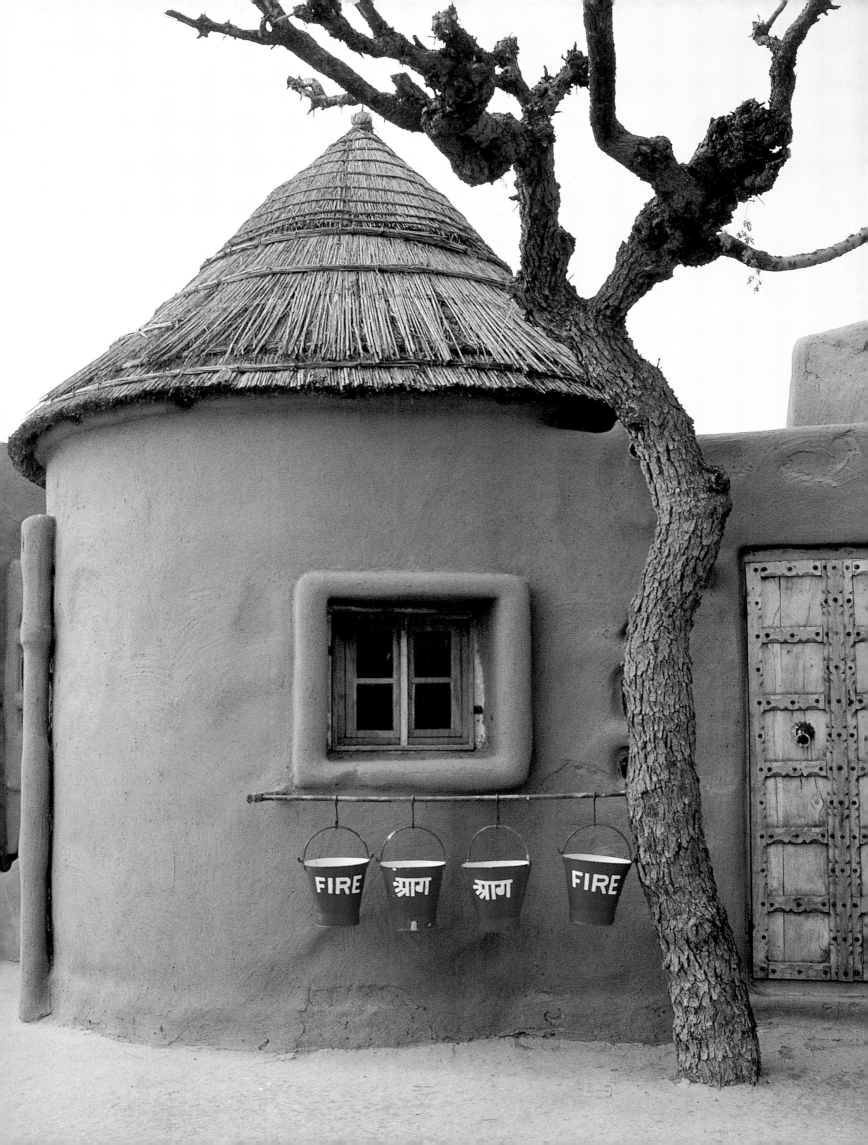

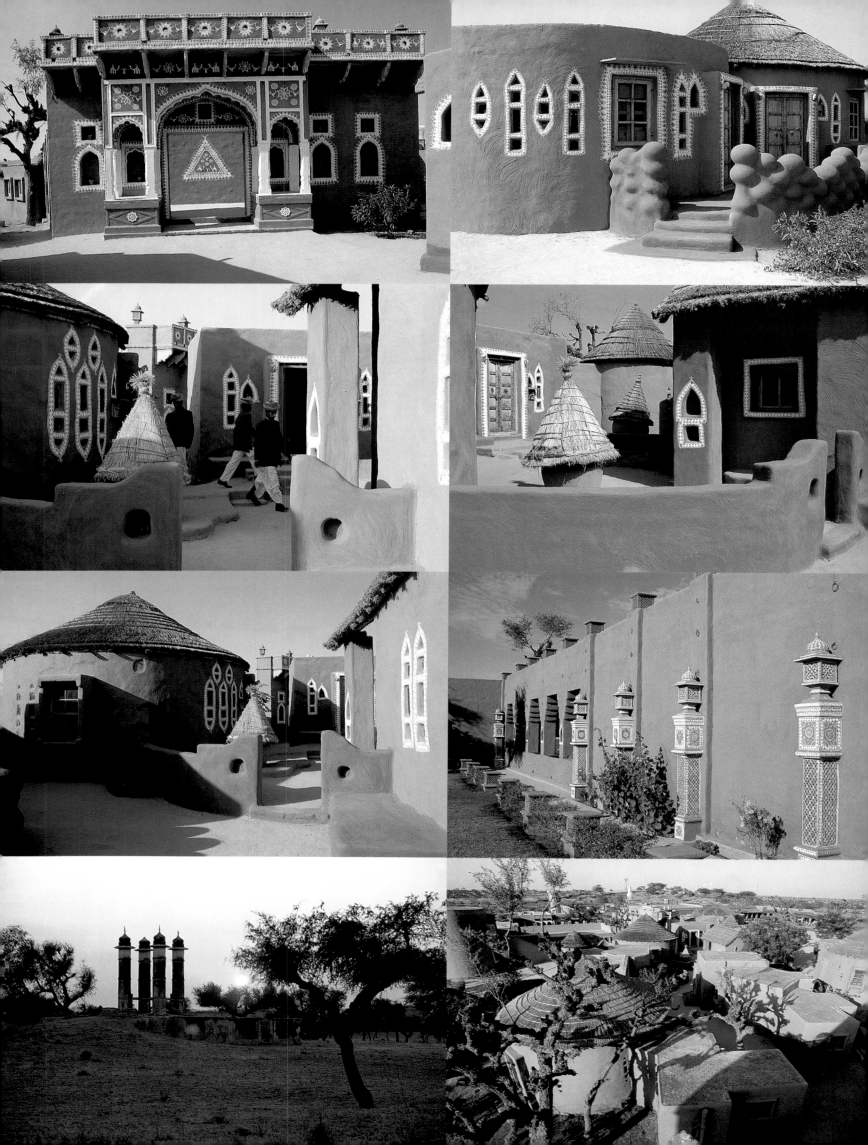

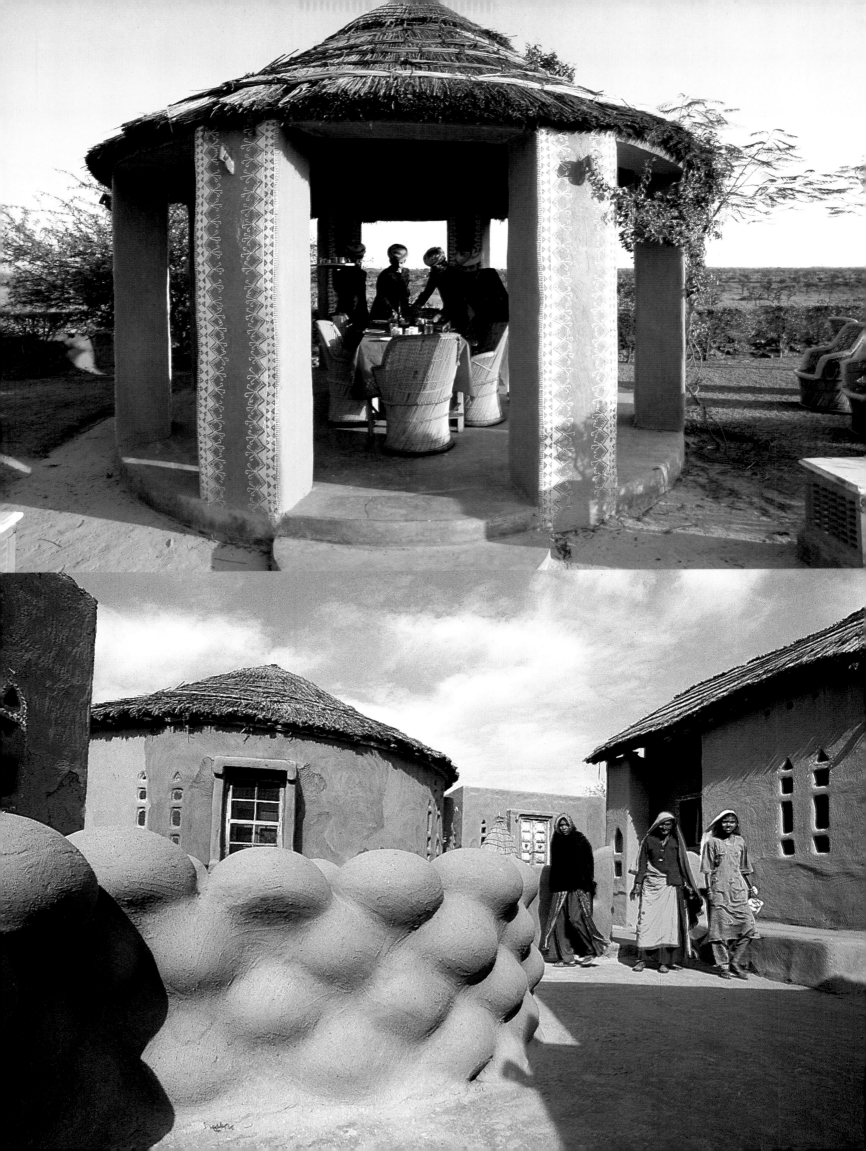

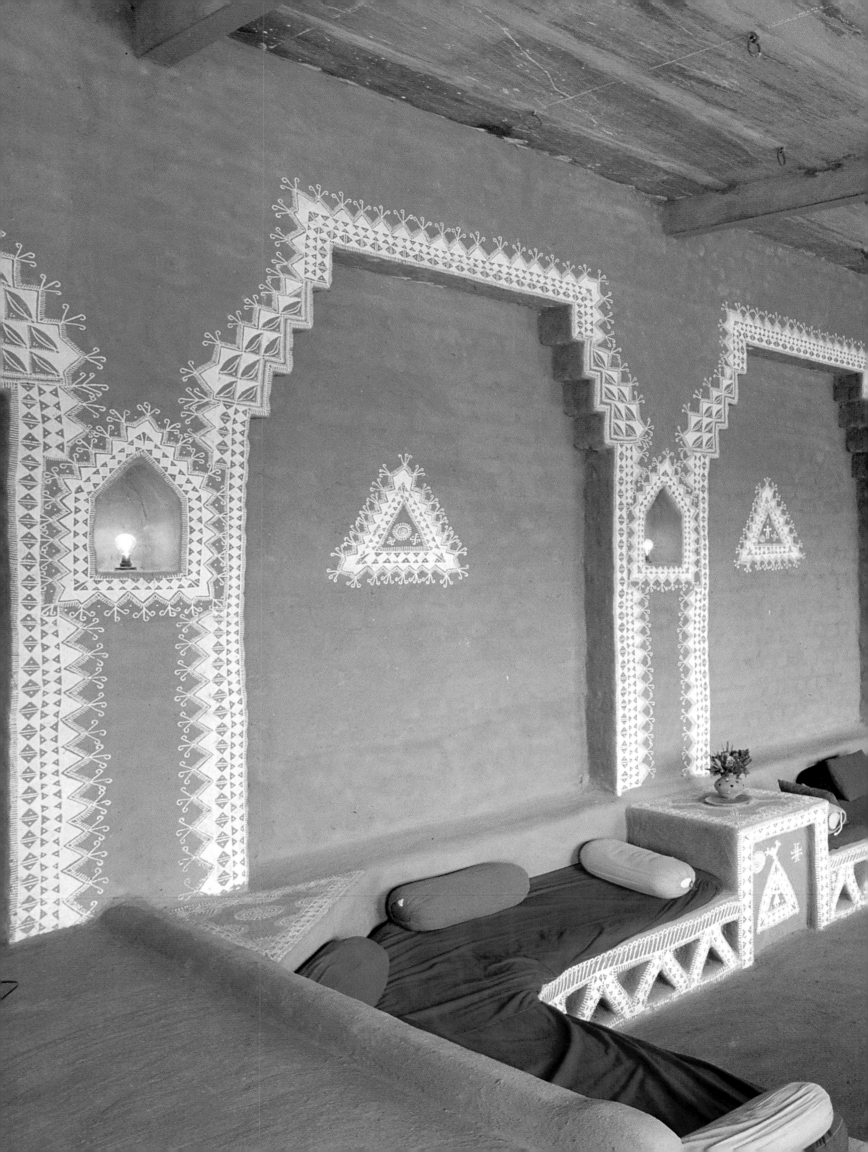

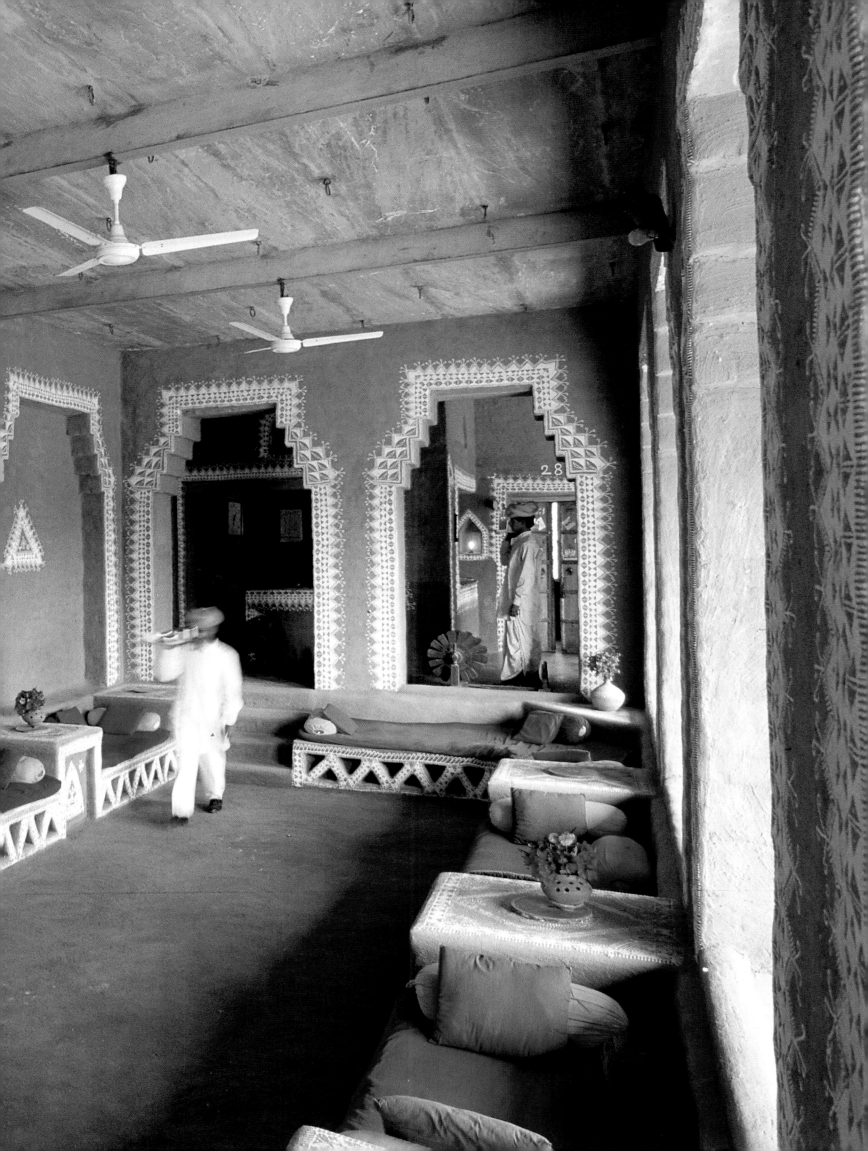

Churu, une petite ville commerçante du Rajasthan, faisait autrefois partie de l'État princier de Bikaner. Elle se situe dans la région du Marwar, qui a vu naître les Marwaris, une puissante communauté qui a dominé le commerce en Inde plusieurs siècles durant. D'abord petits marchands et boutiquiers, l'indomptable esprit d'entreprise des Marwaris les a conduit à traiter dans tout le pays jusqu'à bâtir certains des empires industriels les plus puissants de l'Inde moderne. Au fil des ans, bon nombre d'entre eux ont dépensé des fortunes pour se faire construire de luxueux «havelis» dans leur ville natale. Parmi ces derniers, le Haveli Kothari, datant du début du siècle, avec sa façade surélevée, son toit en avancée soutenu par une colonnade et ses intérieurs peints. Il fut bâti par Madan Chand Kothari, un marchand local dont les nombreuses affaires incluaient une fabrique de pains de glace et un cinéma. Des générations plus tard, une grande partie de sa famille s'est dispersée mais certains de ses descendants, dont Komal Kothari, continuent d'y habiter.

A Haveli in Churu

Churu, a small trading town in Marwar, Rajasthan, was once part of the princely state of Bikaner. The region Marwar spawned the Marwaris, a powerful community that has dominated Indian commerce for several centuries. Although they started out as traders and storekeepers, the indomitable mercantile spirit of the Marwaris ensured their spread throughout the country, and led them to establish some of modern India's most influential industrial empires. Over the years many also spent fortunes in building lavish "havelis" back in their hometowns. The turn-of-the-century Kothari Haveli in Churu is one such residence, with its elevated frontage, its rooftop held aloft by pillars and brackets, and its painted interiors. It was built by Madan Chand Kothari, a local merchant whose various businesses included running an ice factory and a cinema hall. Generations later, much of his family has dispersed but some descendants, such as Komal Kothari, continue to make it their home.

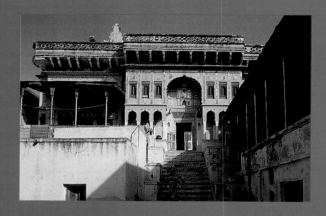

Die kleine Handelsstadt Churu gehörte einst zu dem Herrschaftsbereich des Fürstentums Bikaner. Sie ist Teil eines Gebietes, das man als die Marwar-Region bezeichnet und aus dem die Marwaris hervorgingen, eine mächtige Volksgruppe, die den indischen Handel bereits seit mehreren Jahrhunderten beherrscht. Obwohl sie ursprünglich einfache Händler oder Ladenbesitzer waren, sorgte der unbezwingbare kaufmännische Geist der Marwaris dafür, daß sie sich über das ganze Land verbreiteten. Sie gründeten Industriekonzerne, die zu den mächtigsten in ganz Indien gehören. Viele von ihnen gaben auch über die Jahre ein Vermögen aus, um in ihren Heimatstädten luxuriöse »Havelis« zu bauen. Das aus der Jahrhundertwende stammende Kothari Haveli in Churu mit seiner auf einem Podium errichteten Fassade, seinem von Konsolen und Säulen gestützten Dach und den mit Malereien verzierten Innenräumen ist ein solches Gebäude. Es wurde von Madan Chand Kothari gebaut, einem ortsansässigen Kaufmann, zu dessen zahlreichen Unternehmen auch eine Eisfabrik und ein Kino gehörten. Heute, mehrere Generationen später, hat der Großteil der Familie die Gegend verlassen. Einige seiner Nachkommen jedoch, unter ihnen Komal Kothari, betrachten das Haus nach wie vor als ihr Zuhause.

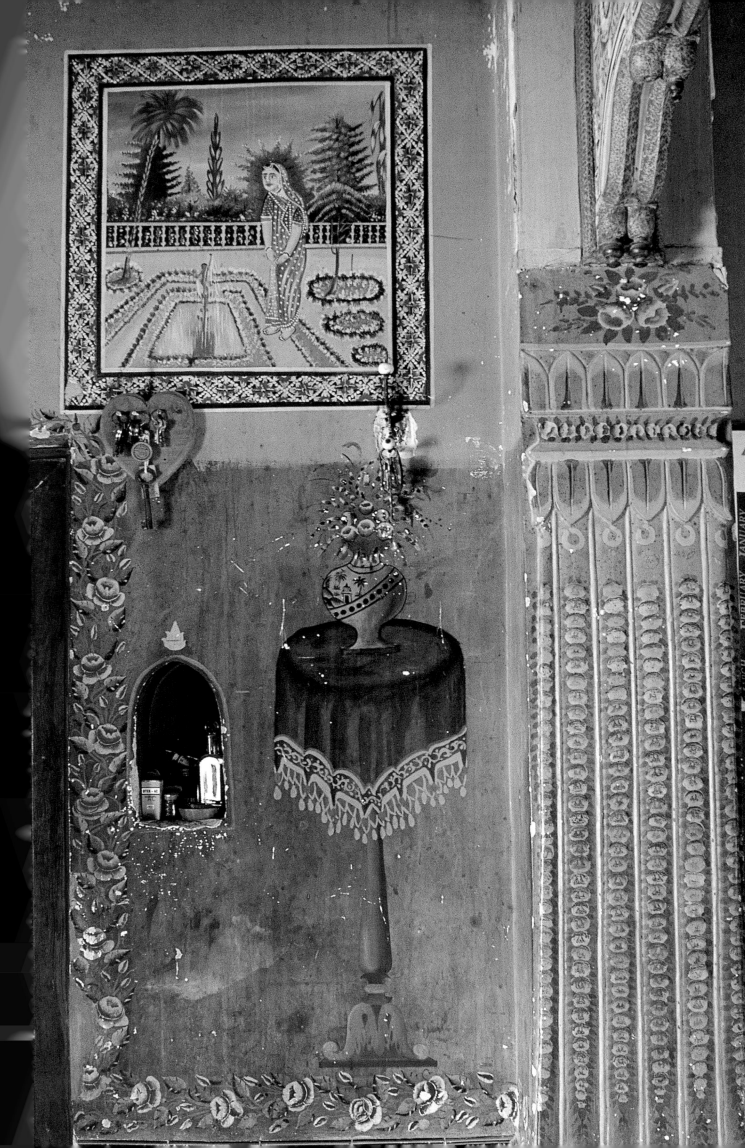

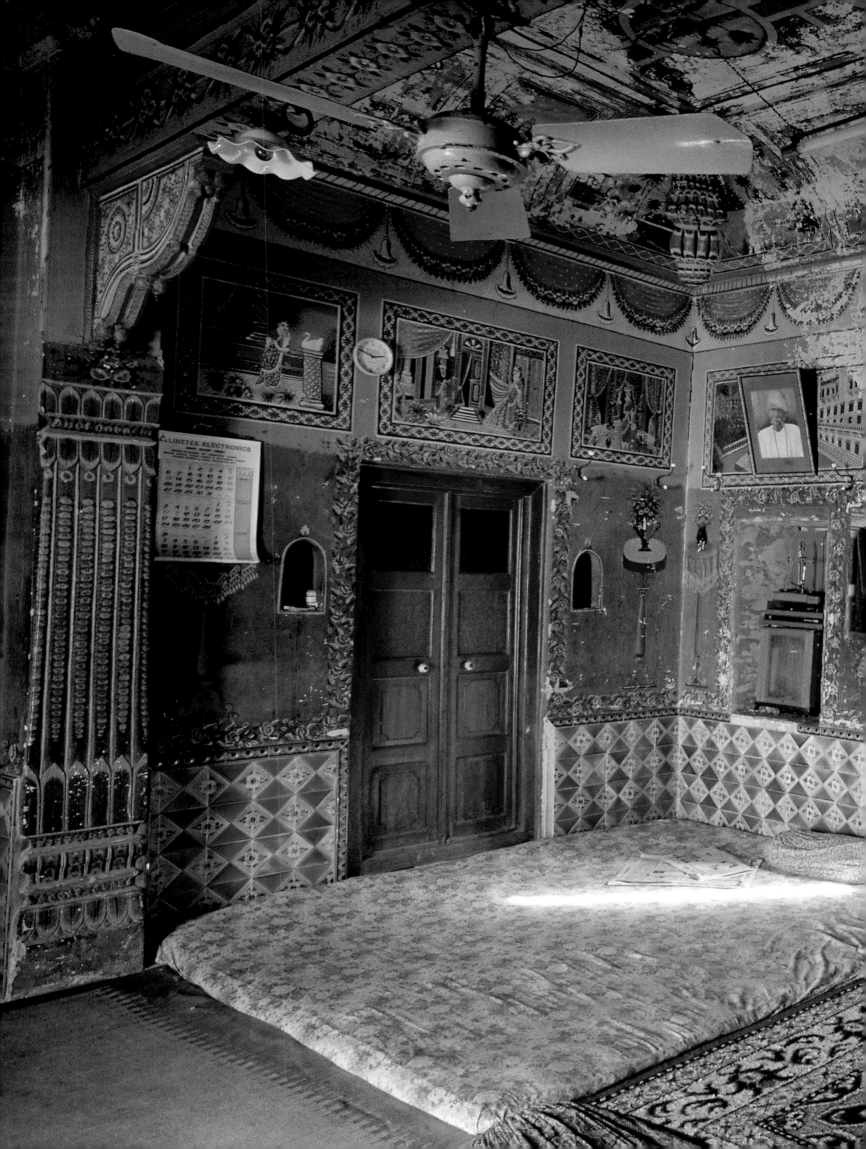

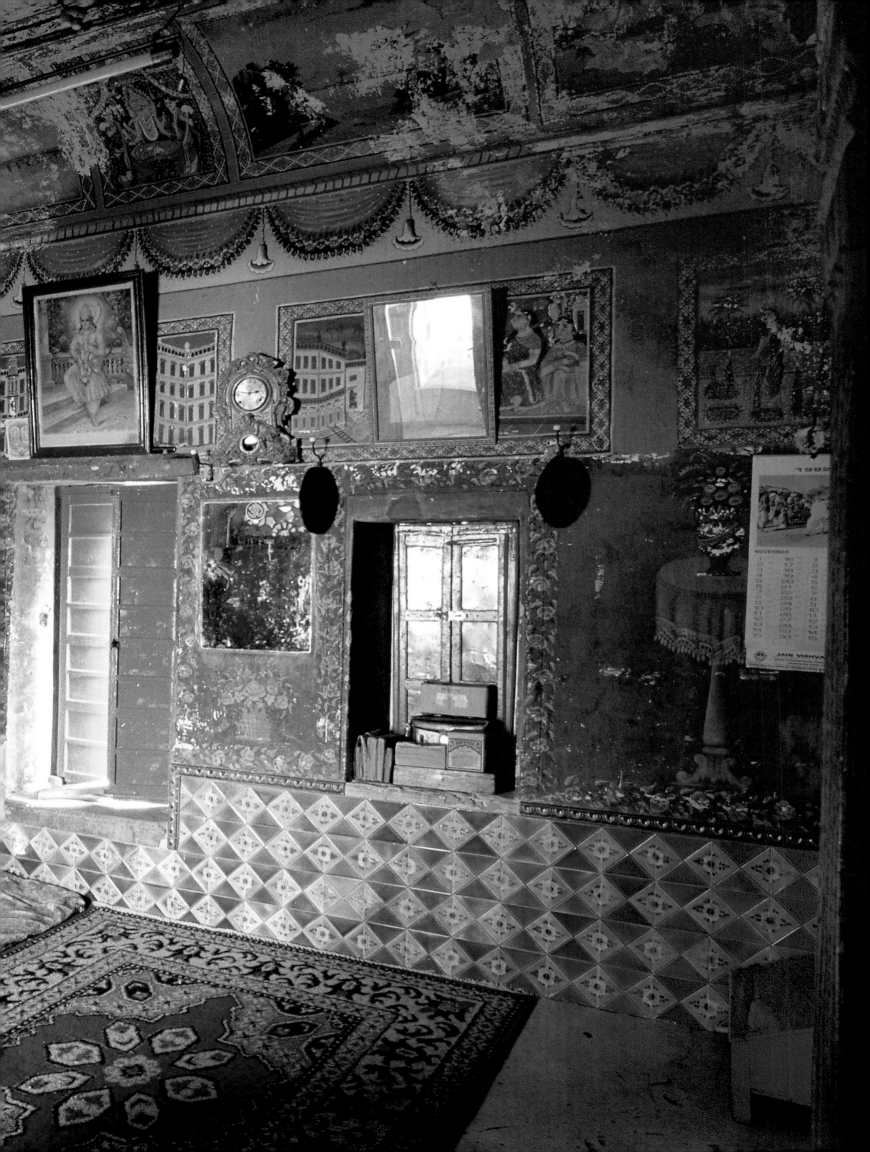

Previous pages: The "baithak", or main reception room, of the Kothari Haveli was strictly the preserve of men and their male guests. Apart from its tiled dado and painted wooden architrave, every inch of the walls is covered with frescoes of pretty women and grand mansions.
Right: The old kitchen, with its raised area under the arches, was where the cooking was done. It now houses a refrigerator and a water storage tank.
Below: A section of the main bedroom is used as a private store, with wooden chests, tin trunks and a steel cupboard holding valuables. The brass containers on the stone shelf hold food rations including expensive spices.

Pages précédentes: Le «baithak», ou principal salon de réception, était le domaine exclusif des hommes de la maison et de leurs invités masculins. Outre ses lambris carrelés et son architrave en bois peint, chaque centimètre carré de mur est couvert de fresques représentant de jolies femmes et de belles demeures.
A droite: la vieille cuisine, avec une partie surélevée sous les arches. Elle ne sert plus à la préparation des repas mais abrite un réfrigérateur et une citerne d'eau pure.
Ci-dessous: Une partie de la chambre principale sert d'espace de rangement, avec des coffres en bois, des malles en fer blanc et des commodes en acier où l'on garde les objets de valeur. Les boîtes en laiton sur l'étagère en pierre contiennent des denrées alimentaires, dont des épices précieuses.

Vorhergehende Seite: Der »Baithak« oder Empfangssalon des Kothari Haveli war ausschließlich für Männer reserviert. Zusätzlich zu dem mit Kacheln verkleideten Wandsockel und den mit Malereien verzierten hölzernen Architraven ist jeder einzelne Zentimeter der Wände mit Fresken bedeckt, auf denen schöne Frauen und herrliche Paläste dargestellt sind.

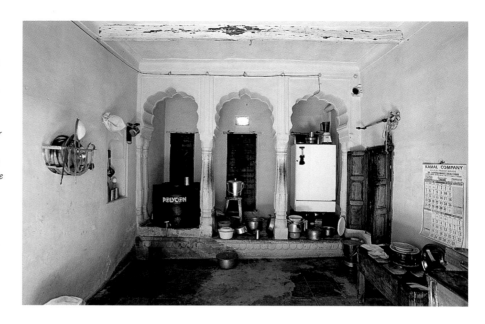

Oben: In der alten Küche, mit einer erhöhten Plattform hinter der Arkade, wurde früher das Essen zubereitet. Heute stehen dort ein Kühlschrank und ein Wasserbehälter.
Unten: Ein Teil des großen Schlafzimmers wird als Stauraum für hölzerne Truhen, Blechkoffer und einen Stahlschrank, in dem Wertsachen aufbewahrt werden, benutzt. Die Messingbehälter auf dem Steinregal sind mit Nahrungsmitteln und kostbaren Gewürzen gefüllt.

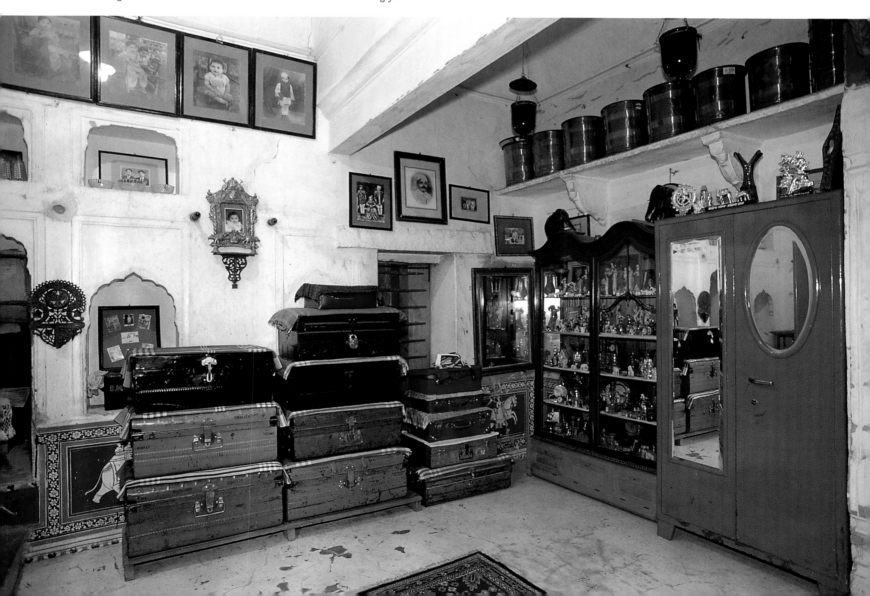

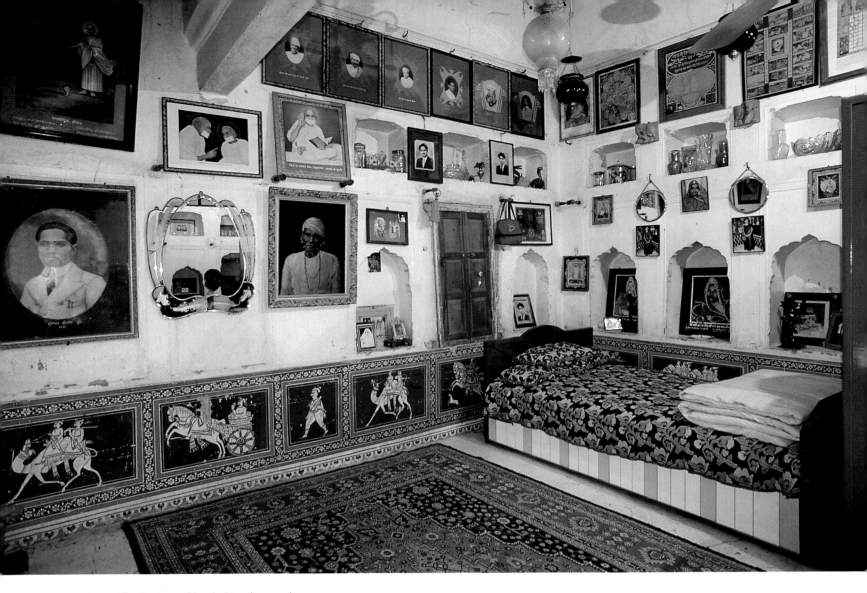

Portraits of revered family priests, elders, looking glasses and mementoes cover the walls of a bedroom. Old hand-painted dadoes of horses and camels contrast with the recent acquisition of a fancy bed.

Des portraits de religieux et d'ancêtres, des miroirs et des souvenirs tapissent les murs de cette chambre. Les lambris peints à la main avec des images de chevaux et de chameaux contrastent avec le lit moderne, acquisition récente.

Porträts von verehrten Priestern und Vorfahren der Familie, Spiegel und diverse Andenken hängen an den Wänden eines Schlafzimmers. Auf alten, handbemalten Paneelen am Sockel der Wand sind Pferde und Kamele dargestellt. Im Kontrast dazu steht das etwas ausgefallene, erst kürzlich gekaufte Bett.

Bikaner est célèbre pour ses palais en grès et son fameux détachement de chameliers. Mais ce qu'elle a de plus extraordinaire encore, ce sont les magnifiques demeures qu'ont laissées derrière eux ses riches marchands. Cette ville fortifiée du désert, qui doit son nom à Bika, un grand guerrier du 15e siècle, a connu une période exceptionnelle de prospérité et de modernisation sous le maharaja Ganga Singh, un favori de la reine Victoria, qui monta sur le trône à l'âge de sept ans et régna jusqu'en 1943. Le Haveli Kothari, resté inachevé, fut commencé au début du siècle par Bhairondan Kothari, un riche drapier. Son style indo-européen fut décrit par un historien de l'architecture victorienne comme «le trait d'union entre Bombay et Birmingham». Des travées en grès sculpté qui ornent sa façade aux colonnes de marbre surmontées de chapiteaux corinthiens et aux ravissants stucs rose et vert de sa décoration intérieure, cette demeure incarne à merveille l'alliance complexe entre le vieux Bikaner et l'empire britannique.

Kothari Haveli

More astonishing than its sandstone palaces or its famous camel corps are the magnificent mansions that the merchant barons of Bikaner left behind. This fortified desert city, named after the 15th-century warrior Bika, passed through a period of exceptional prosperity and modernization under the reign of Maharaja Ganga Singh who ascended the throne in 1887 at the age of seven and ruled until 1943. The Kothari Haveli, an unfinished house built at the turn of the century by Bhairondan Kothari, a wealthy cloth trader, is an uninhibited Indo-European fusion that a historian of Victorian architecture once described as "a mixture of Bombay and Birmingham". From the carved sandstone bays that ornament the exterior to the marble pillars with Corinthian capitals and delicious pink and green festoonery inside, the house is a manifestation of old Bikaner's intricate alliance with the British.

Erstaunlicher noch als die Paläste aus Sandstein oder das berühmte Kamelkorps sind die prachtvollen Herrenhäuser, die die reichen Kaufleute von Bikaner hinterließen. Die Festungsstadt in der Wüste, die ihren Namen von einem Krieger aus dem 15. Jahrhundert namens Bika herleitet, erlebte während der Herrschaft des Maharajas Ganga Singh eine Zeit der Modernisierung und des außerordentlichen Wohlstands. Der Maharaja bestieg den Thron im Alter von sieben Jahren und herrschte bis 1943. Das Kothari Haveli, ein unvollendetes Haus, das von dem wohlhabenden Getreidehändler Bhairondan Kothari um die Jahrhundertwende gebaut wurde, verbindet großzügig indische mit europäischen Elementen. Ein Historiker und Kenner der viktorianischen Architektur hat das Haus einmal als »eine Mischung aus Bombay und Birmingham« bezeichnet. Von den aus Sandstein gemeißelten Erkern an der Fassade bis hin zu den Marmorsäulen mit korinthischen Kapitellen und den wundervollen, grünen und rosafarbenen, girlandenförmigen Verzierungen im Innern legt das gesamte Haus Zeugnis ab von den vielschichtigen Beziehungen, die die Stadt Bikaner früher mit den Briten unterhielt.

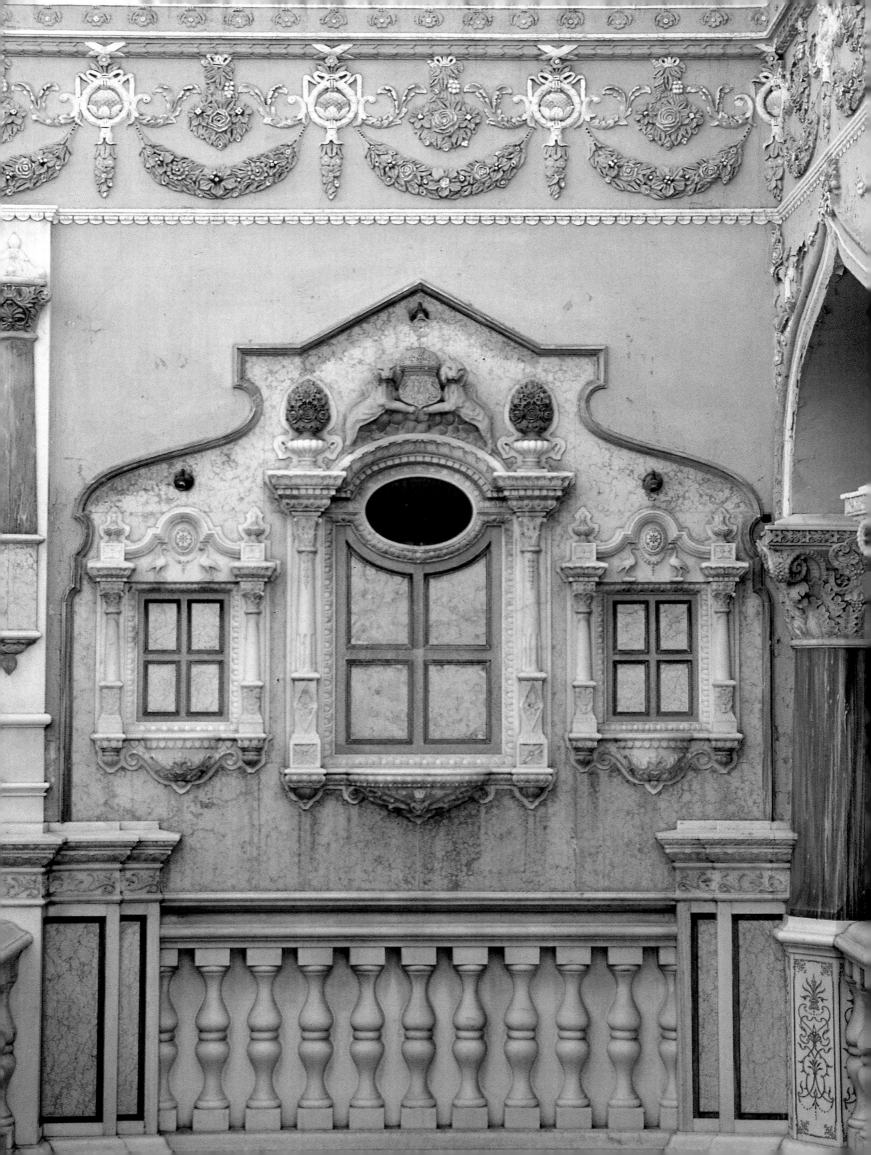

Previous page: The inner court of the three-storeyed house is decorated with Moghul arches, marble balustrades and false windows.
Facing page: Marble is lavished on dadoes in a living room. Oleographs of mythological scenes are hung between mirror-fronted niche.
Above and right: The rooftop, with its elaborate mosaic floor laid in floral patterns, overlooks a crowded part of the inner city.
Following pages: Venetian mirrors and family portraits are hung on the walls of a sitting room. The Art Nouveau tiles contrast with the traditional floor seating of padded mattresses and bolsters.

Page précédente: La cour intérieure de la maison de trois étages est décorée d'arches de style mongol, de balustrades en marbre et de fenêtres en trompe-l'œil.
Page de gauche: dans un des salons, des lambris en marbre italien. Des chromolithographies représentant des scènes mythologiques sont accrochées entre des niches tapissées de miroirs.
Ci-dessus et à droite: La terrasse sur le toit, avec son sol en mosaïques de motifs floraux, surplombe un quartier animé de la vieille ville.
Double page suivante: sur les murs de ce salon, des miroirs vénitiens et des portraits de famille. Le carrelage Art nouveau contraste avec le matelas et les coussins traditionnels.

Vorhergehende Seite: Der Innenhof des Hauses ist mit Bögen im Mogul-Stil, Marmorbalustraden und blinden Fenstern verziert.
Linke Seite: Für die Wandverkleidung eines Salons verwandte man Marmor. Öldrucke mit Darstellungen von mythologischen Szenen hängen zwischen Nischen, die mit Spiegelglas verkleidet sind.
Oben und rechts: Das Dach hat einen kunstvollen Mosaikboden mit Rankenmustern und schwarz-weiß gekachelte Mauern.
Folgende Doppelseite: Die Wände des Salons schmücken venezianische Spiegel und Familienporträts. Die Jugendstil-Kacheln stehen im Kontrast zu der traditionellen Sitzgelegenheit auf der Erde, die aus gepolsterten Matratzen und Kissen besteht.

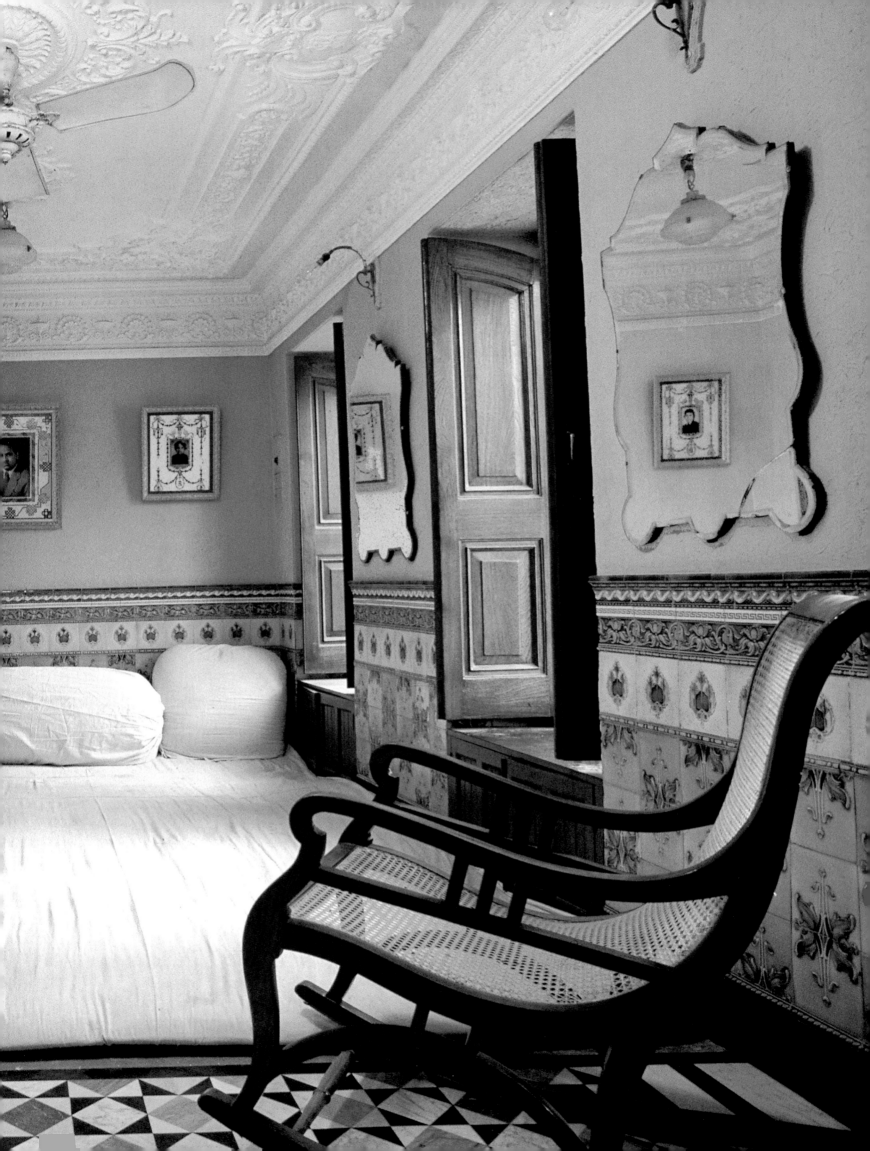

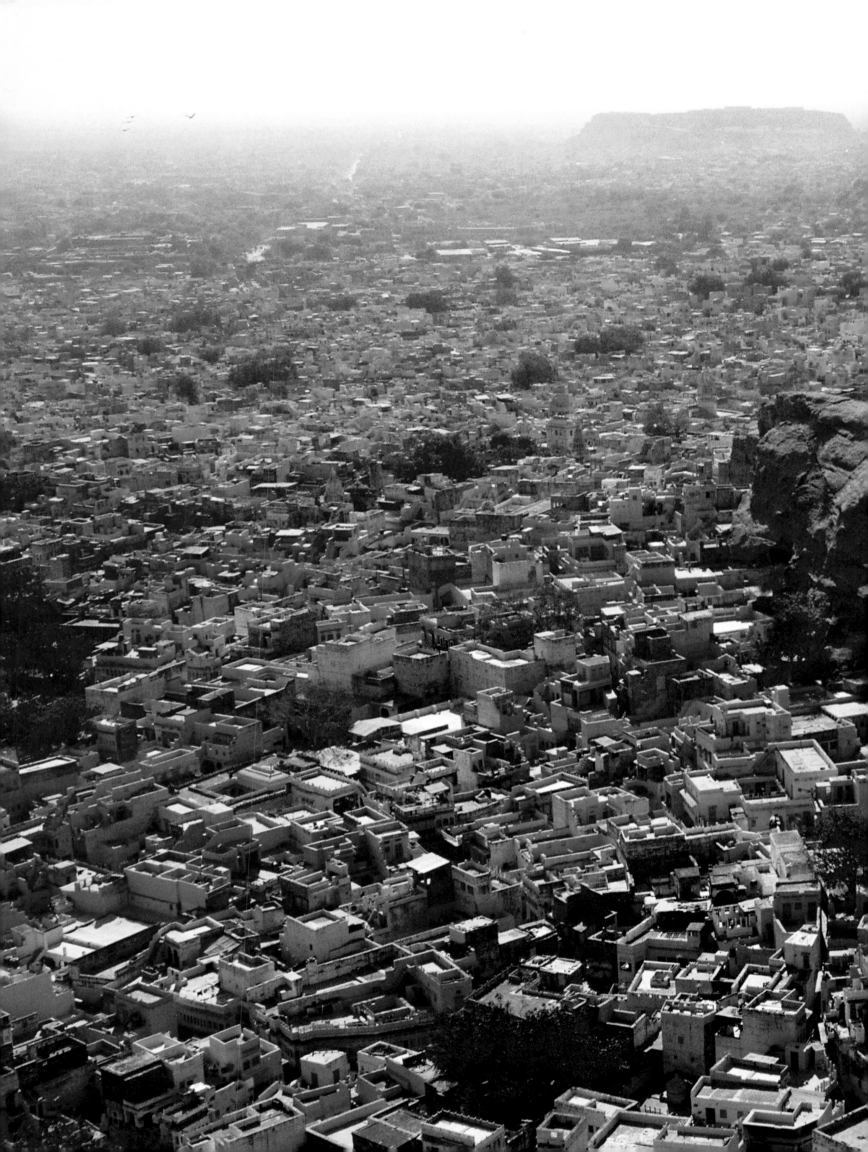

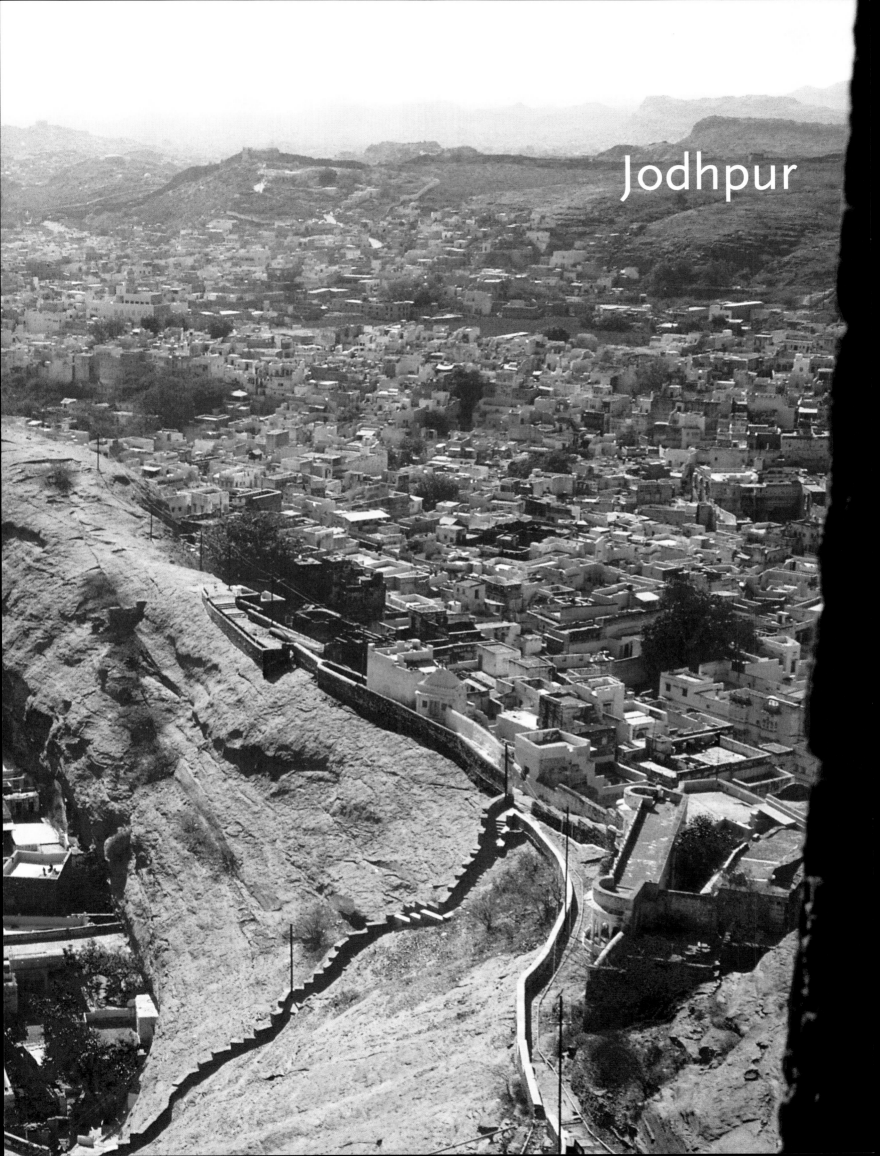

Jodhpur

Du haut du grand promontoire rocheux on voit la vieille ville fortifiée de Jodhpur s'étendre à nos pieds tel un patchwork de nuances bleues. Une porte du 18e siècle s'ouvre sur «Brahmpuri», la cité des Brahmanes, où les façades badigeonnées en bleu étaient autrefois un signe distinctif de cette caste supérieure. Ce code de couleurs pour distinguer les castes a été abandonné depuis longtemps mais, en cette ère plus égalitaire, les habitants continuent de peindre leurs maisons en bleu afin de préserver l'identité de leur ville. Comme Jaipur, la «ville rose», Jodhpur est devenue la «ville bleue». La couleur est obtenue en mélangeant une teinture chimique à l'indigo avec de la chaux blanche. Elle réfléchit la lumière crue du désert et conserve les intérieurs au frais. Dans Anchaliyo Lane, avec son escalier bleu sous une arche dentelée, se trouve la maison d'une famille d'orfèvres, haute de deux étages. Tous les intérieurs du «haveli» ne sont pas bleus. Ici et là, le thème monochromatique est interrompu par un mur blanc ou des meubles peints en vert.

A Blue Haveli

From the vast rocky outcrop the old walled city of Jodhpur is spread below like a patchwork quilt in shades of blue. An 18th-century gate leads into "Brahmpuri", the city of Brahmins, where the bluewashed houses once denoted the upper caste homes of Brahmins. That exclusive colour-coding of the caste system has long been dropped. In a more egalitarian age residents paint their houses blue to give their city a distinct identity. Like Jaipur, the Pink City, Jodhpur has adopted the title of the Blue City. The blue tint is achieved by mixing a chemical indigo dye into white limewash – the colour reflects the harsh desert light and cools the interiors. In Anchaliyo Lane, with its blue flight of steps under a cusped arch, stands the two-storeyed home of a family of goldsmiths. Not all of the "haveli's" interiors are blue; here and there the monochromatic scheme is broken with white walls and green-painted cupboards.

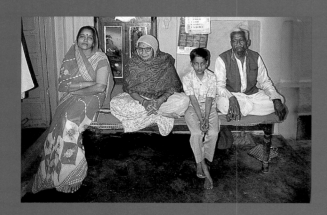

Von der riesigen Felsnase aus gesehen, erscheint die alte, von einer Mauer umgebene Stadt Jodhpur wie eine kunstvolle Flickendecke mit verschiedenen Blauschattierungen. Ein aus dem 18. Jahrhundert stammendes Tor führt in die »Brahmpuri«, die Stadt der Brahmanen, deren blaugetünchte Häuser einst besagten, daß sich hier die Wohnstätten der obersten Kaste, der Brahmanen, befanden. Dieses ausschließlich als Symbol der Kastenzugehörigkeit verwandte Farbschema wurde bereits vor langer Zeit aufgegeben. Heute, in einem Zeitalter größerer Gleichberechtigung, streichen die Einwohner ihre Häuser blau, um der Stadt ihren ganz eigenen Charakter zu verleihen. So wie Jaipur die »Pink City« genannt wird, hat sich Jodhpur den Titel der »Blue City« angeeignet. Der blaue Farbton entsteht, indem man einen chemisch hergestellten Indigo-Farbstoff mit weißer Kalktünche vermischt. Die Farbe reflektiert das grelle Sonnenlicht der Wüstenregion und sorgt dafür, daß es im Innern der Häuser kühl bleibt. In einer der Straßen, der Anchaliyo Lane, steht das zweistöckige Haus einer Familie von Goldschmieden, das man durch einen Fächerbogen und über eine blaugestrichene Treppe erreicht. Die blaue Farbe beherrscht das Innere des »Haveli« nicht ausschließlich, hier und da gibt es weiße Wände und grün gestrichene Schränke.

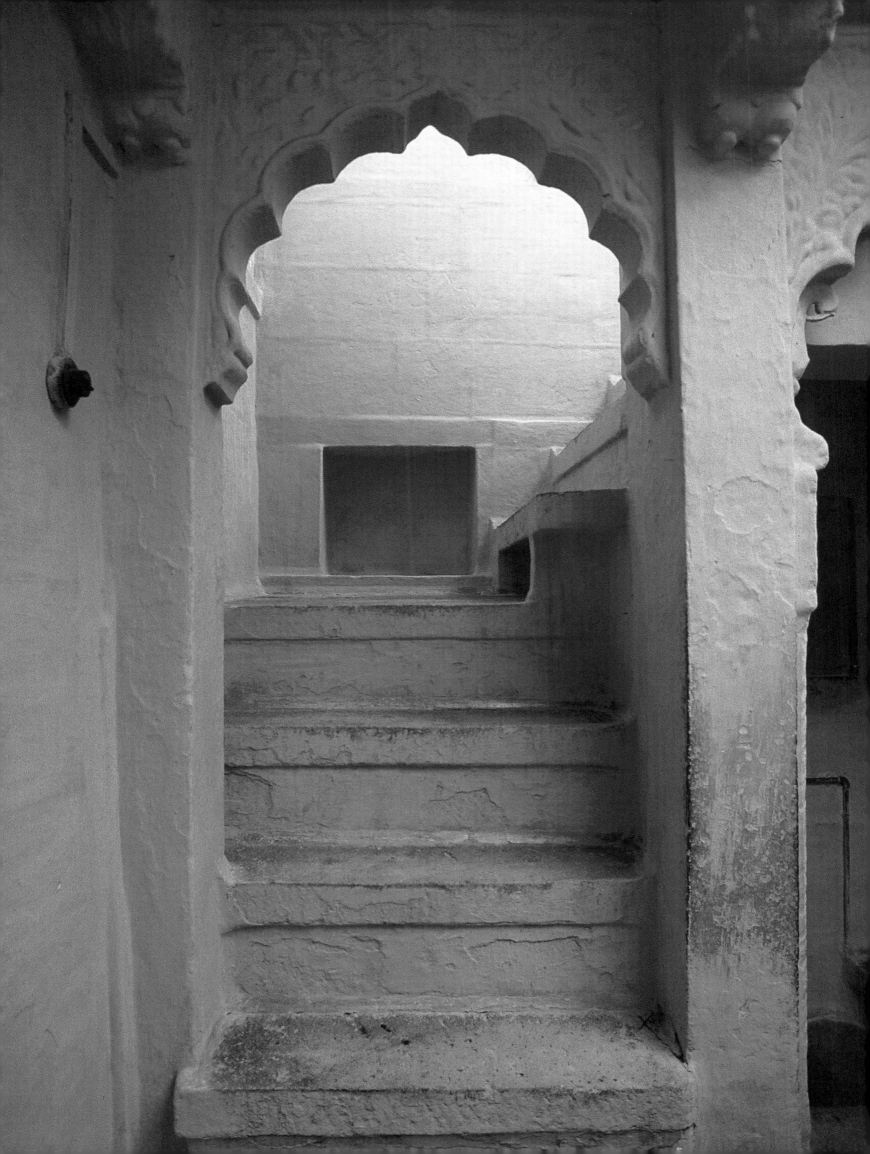

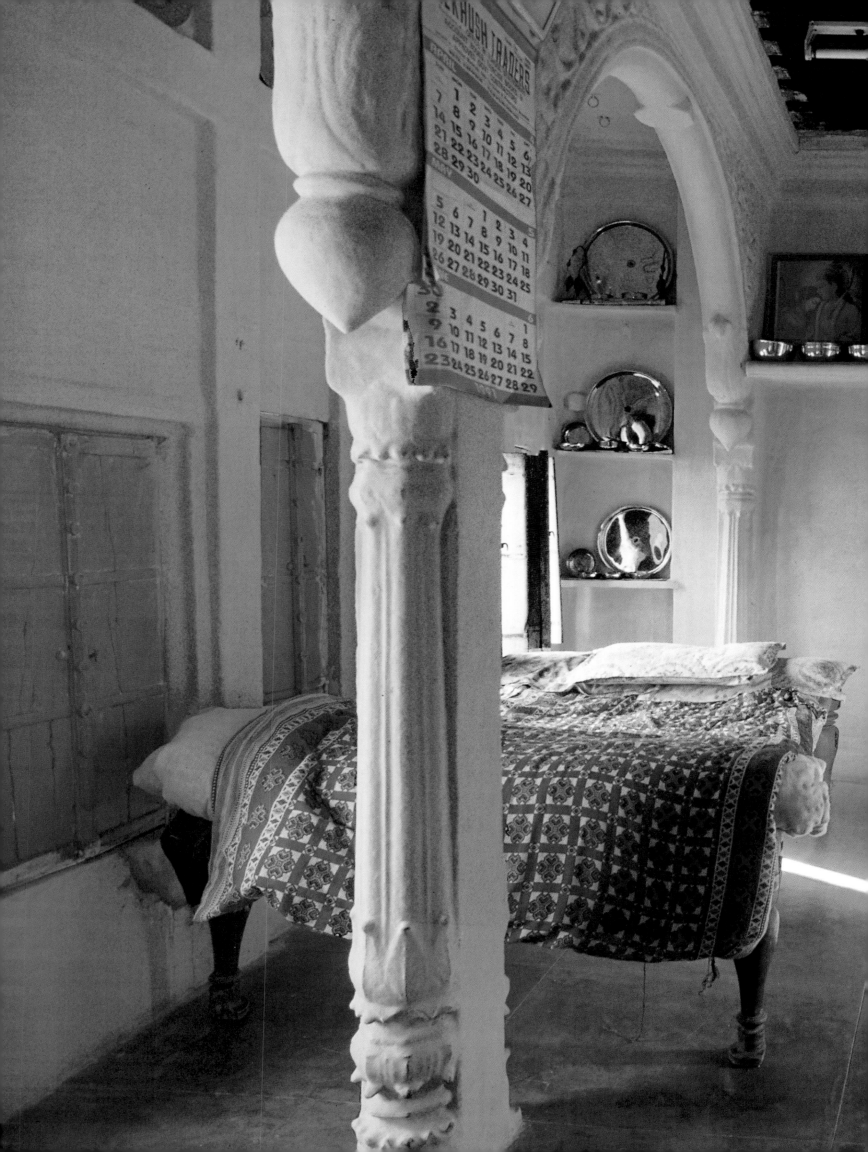

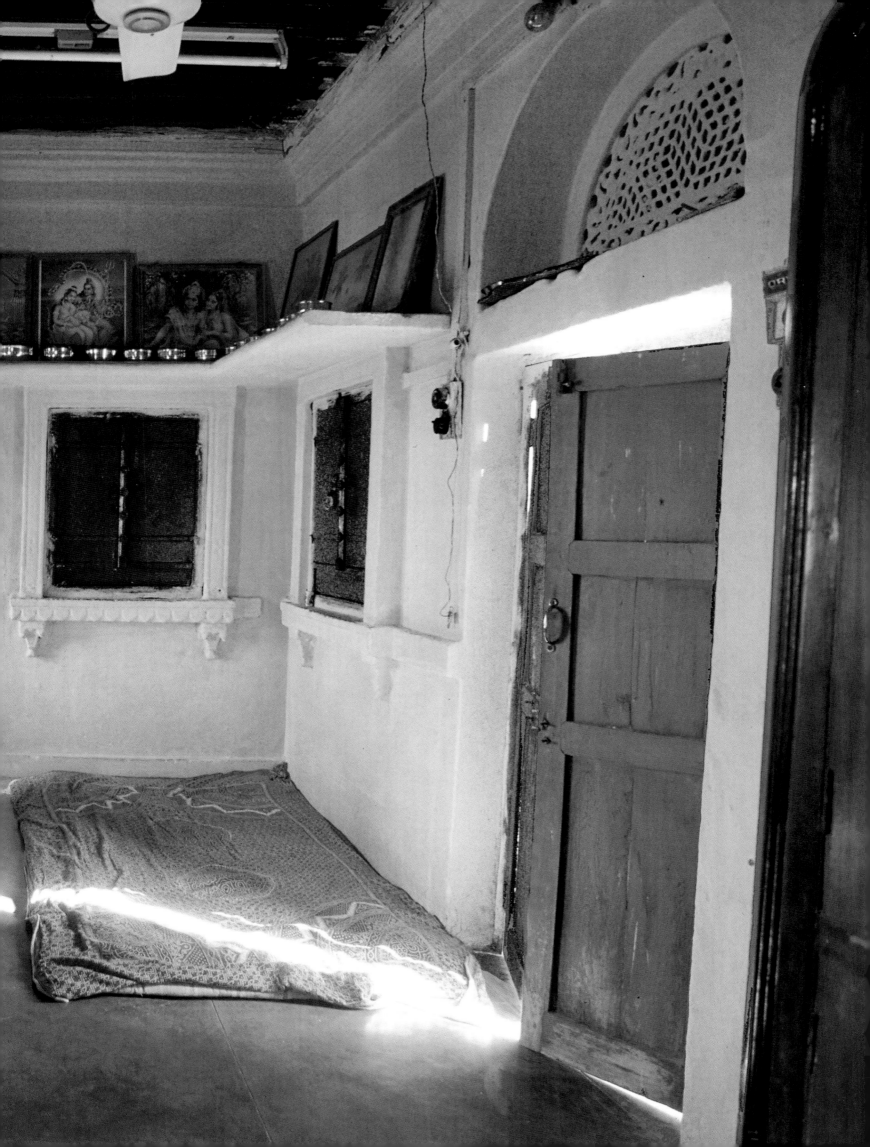

Dans les allées étroites de la vieille ville fortifiée de Jodhpur, un «pol», une porte monumentale, s'ouvre sur le vaste Haveli Nimaj. Nimaj était un vassal de l'ancien Etat princier de Jodhpur et cette maison était l'hôtel particulier de la famille, construit entre la fin du 18e siècle et le début du 19e. Comme de nombreuses maisons de la vieille ville, des parties du Haveli Nimaj ont été morcelées et louées. Sohan Lal Jain, son épouse Kumud et leurs enfants, occupent un triplex dans une partie de l'ancien hôtel. Dans son atelier au rez-de-chaussée, M. Jain fait fondre d'anciens panneaux d'affichage en plastique pour en faire des anneaux en acrylique. Son appartennt avec ses pièces disposées autour d'une cour centrale, est typique des vieilles maisons de Jodhpur. On accède à l'étage supérieur par un escalier en grès dans la cour. De là-haut, on a une vue spectaculaire sur le fort Mehrangarh, datant du 15e siècle.

Nimaj Haveli

In the narrow lanes of the old walled city of Jodhpur stands a "pol", an arched gate, leading into the sprawling Nimaj Haveli. Nimaj was a feudatory of the former princely state of Jodhpur and the mansion, built in the late 18th and early 19th century, was the family's town house. Like many old mansions in the inner city of Jodhpur, parts of Nimaj Haveli have been parcelled out and let to a variety of tenants. Sohan Lal Jain lives with his wife Kumud and their children in a three-storeyed portion of the old house. Mr Jain is a bangle-maker; he lives above his workshop. He remoulds damaged plastic signboards into acrylic bangles. His apartment, with a suite of rooms arranged around an open courtyard, is a typical old-style Jodhpur home. The upper floor is reached by a sandstone staircase from the courtyard. The private rooms above afford a spectacular view of Jodhpur's 15th-century Mehrangarh Fort.

Inmitten der engen Gassen der von einer Mauer umschlossenen Altstadt Jodhpurs steht ein »Pol«, ein Torbogen, der zu dem weitläufigen Nimaj Haveli führt. Nimaj war ein Vasall des früheren Herrschers von Jodhpur, und das Gebäude, das zwischen dem Ende des 18. und Beginn des 19. Jahrhunderts entstand, wurde von der Familie als Stadthaus benutzt. Ähnlich wie bei vielen anderen Häusern der Innenstadt wurden Teile des Nimaj Haveli abgetrennt und an verschiedene Mieter vergeben. Sohan Lal Jain, seine Frau Kumud und seine Kinder bewohnen einen Teil des alten Hauses, der sich über drei Stockwerke ausbreitet. Jain fertigt aus alten, schadhaften Plastikschildern Armreifen. Über der Werkstatt befindet sich seine Wohnung, deren Zimmer sich um einen offenen Innenhof gruppieren und die ein typisches Beispiel für den traditionellen Wohnstil in Jodhpur ist. Das obere Stockwerk erreicht man vom Hof aus über eine Treppe aus Sandstein. Die oben liegenden Privaträume haben eine herrliche Aussicht auf die im 15. Jahrhundert erbaute Festung der Stadt, Fort Mehrangarh.

First page: *The kitchen, on the upper floor of the house, is a study in practical storage. The large bin in the corner holds a month's stock of flour.*
Below: *The open-ended room-cum-verandah in two arched sections is the heart of the apartment. Like most Jodhpur houses, the walls are washed with lime mixed with indigo. The white and blue limewash is inexpensive and soothing while the indigo helps in repelling mosquitoes.*

Première page: *La cuisine, à l'étage, est un modèle de rangement pratique. La grande corbeille dans le coin contient un mois de farine.*
Ci-dessous: *Le salon-véranda, divisé par des arches, occupe le cœur de l'appartement. Comme dans la plupart des maisons de Jodhpur, les murs sont badigeonnés à la chaux teintée à l'indigo. Un revêtement bon marché et rafraîchissant, et l'indigo éloigne les moustiques.*

Eingangsseite: *Die Küche im oberen Stockwerk des Hauses ist ein Musterbeispiel für die optimale Nutzung des vorhandenen Stauraums. Die riesige Tonne in der Ecke enthält eine Monatsration Mehl.*
Unten: *Dieses zum Hof offene Veranda-Zimmer, das von Arkaden in zwei Bereiche unterteilt wird, ist das Herzstück der Wohnung. Wie in den meisten Häusern Jodhpurs wurden die Wände mit einer Mischung aus Kalk und Indigo getüncht. Die weißblaue Kalktünche ist preiswert und schafft eine wohltuende kühle Atmosphäre, und das Indigo hilft beim Abschrecken der Moskitos.*

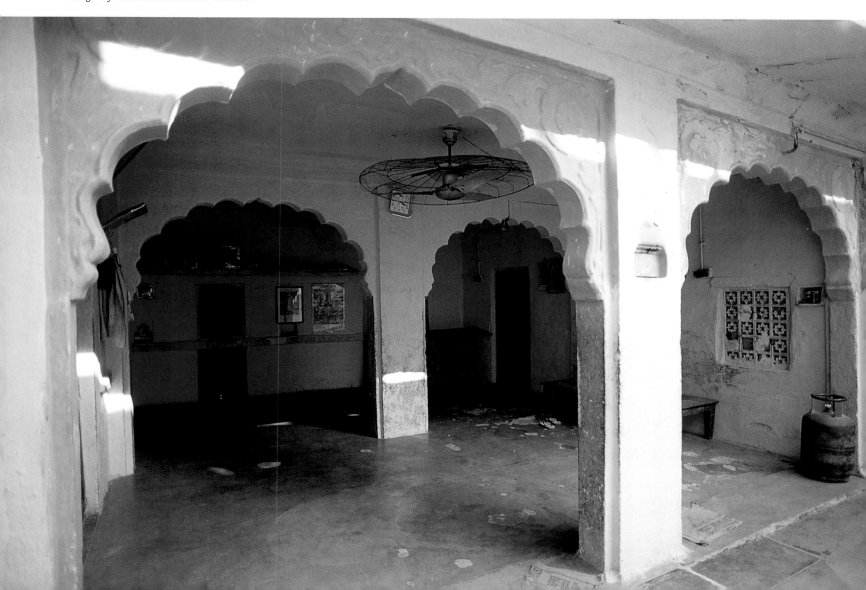

A small blue-washed room suspended between two floors with Indian-style floor seating is used in the monsoon for the wonderful cross-breeze it offers. Mr Jain admits that possessing three phones is a luxury in the bangle business.

Cette petite pièce bleue, entre deux étages, et où l'on s'asssoit par terre à la manière indienne, sert pendant la mousson en raison de l'agréable brise qui y filtre. M. Jain admet que posséder trois téléphones est un luxe dans son métier.

Der kleine, blaugetünchte Raum zwischen zwei Stockwerken, in dem man sich nach indischer Gewohnheit auf den Boden setzt, wird aufgrund seiner wundervollen Durchlüftung zumeist während der Monsunzeit benutzt. Sohan Lal Jain gibt zu, daß der Besitz von drei Telefonen ein Luxus ist, über den durchaus nicht alle Mitglieder seines Gewerbes verfügen.

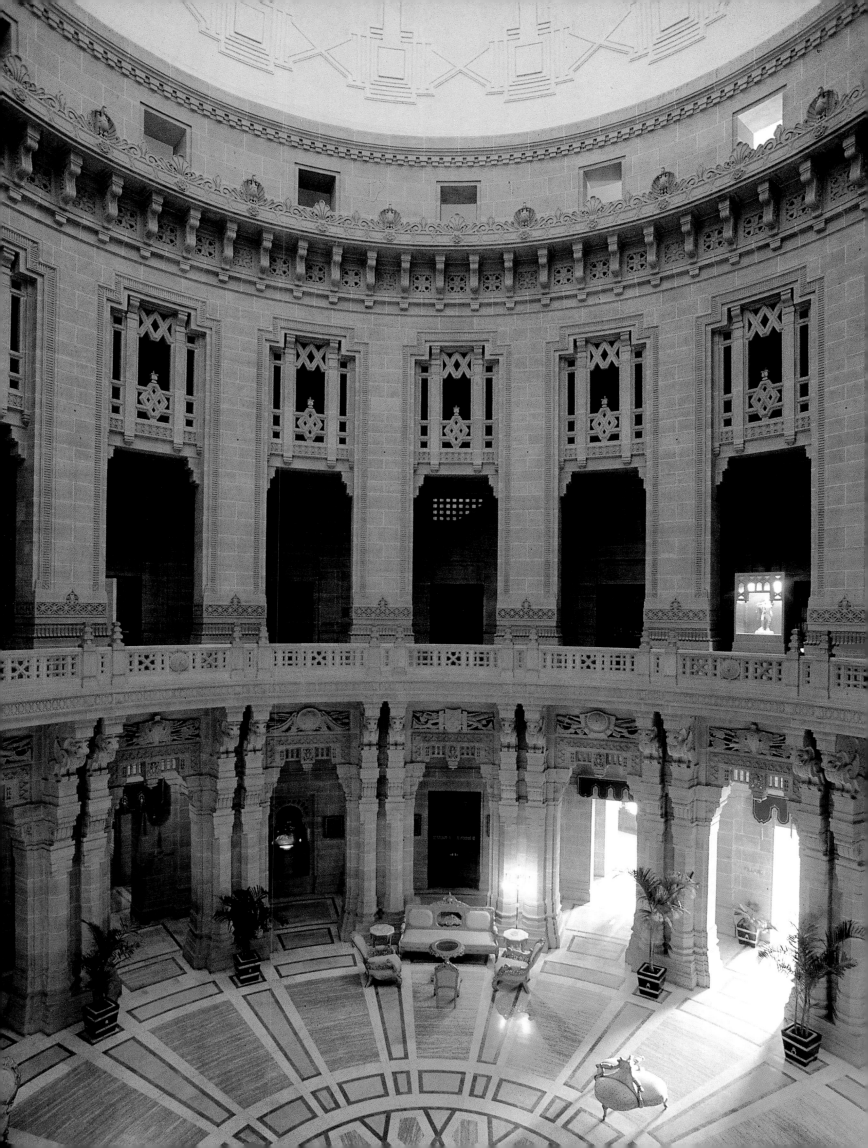

Avec son énorme dôme, ses hautes tourelles et ses vastes dépen-
dances, le palais d'Umaid Bhawan à Jodhpur offre un spectacle saisis-
sant en lisière du désert de Thar. C'est le dernier grand palais à avoir
été construit en Inde, et l'un des plus grands au monde. Il fut com-
mandé en 1929 par le maharaja Umaid Singh dans le cadre d'un pro-
gramme de travail visant à lutter contre la famine qui sévissait à
l'époque. Le chantier fut confié au célèbre architecte anglais H. V.
Lanchester. La construction nécessita 15 ans de travail et plus de 3
000 ouvriers, hommes et femmes. Le palais, entouré de grands jar-
dins, abrite 347 pièces, une piscine intérieure, des courts de squash en
marbre et de somptueux appartements Art Déco. Umaid Singh n'y a
pratiquement pas vécu et son fils, Gaj Singh II, homme d'affaires et
politicien, l'a transformé en grand hôtel. Pour entretenir le palais et
préserver son ambiance spécifique, il en occupe une petite partie.

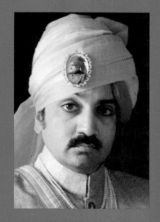

Maharaja of Jodhpur

Viewed from the sky, the Umaid Bhawan Palace in Jodhpur, with its
enormous dome, rising towers and outstretched wings, is one of
the most impressive sights on the edge of the Thar Desert. It is the
last great palace to have been built in India, and one of the largest
in the world. Started in 1929 by Maharaja Umaid Singh, it was
commissioned as a food-for-work programme to avert starvation in
years of famine. H. V. Lanchester, a famous Edwardian architect,
was given the job and 3 000 men and women worked for 15 years
to complete it. No expense was spared: it has vast gardens, 347
rooms, an indoor swimming pool, marble squash courts and
sumptuous art deco suites. Its builder Umaid Singh hardly lived in
it but his grandson, Gaj Singh II, a businessman and politician, has
turned it into a superior hotel. To keep the place up, and its special
atmosphere intact, he also occupies a small part of it.

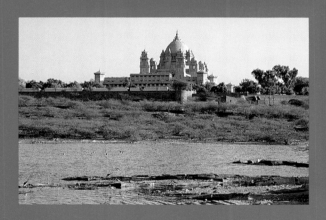

Aus der Luft betrachtet ist der Umaid Bhawan Palace in Jodhpur
mit seiner riesigen Kuppel, den in den Himmel ragenden Türmen und
weitgestreckten Gebäudeflügeln eine der eindrucksvollsten Sehens-
würdigkeiten, die es am Rande der Wüste Thar gibt. Er war der letzte
bedeutende Palast, der in Indien gebaut wurde, und gehört zu den
größten Palästen der Welt. Maharaja Umaid Singh gab den Bau
1929 in Auftrag, als Teil eines Hilfsprogrammes, mit dem der jahre-
lang herrschenden Hungersnot entgegengewirkt werden sollte, indem
man Arbeit mit Nahrung vergalt. Der berühmte englische Architekt
H. V. Lanchester übernahm den Auftrag, und 3 000 Männer und
Frauen arbeiteten 15 Jahre lang an seiner Vollendung. Man scheute
keine Kosten: Der Palast verfügt über riesige Gartenanlagen, 347 Zim-
mer, ein Hallenschwimmbad, Squash-Plätze aus Marmor und luxu-
riöse Art-déco-Suiten. Sein Erbauer Umaid Singh hat ihn kaum be-
wohnt. Dessen Enkel Gaj Singh II., ein Geschäftsmann und Politiker,
verwandelte den Komplex in ein vornehmes Hotel. Um auf das
Ganze ein Auge zu haben und die besondere Atmosphäre des
Palastes zu bewahren, bewohnt er einen kleinen Teil des Gebäudes
selbst.

First page: The impressive central rotunda of the Umaid Bhawan Palace rise to 105 feet and was used by Maharaja Umaid Singh for Christmas lunches.
Right: The bedroom in the Maharani Suite is surmounted by a Stefan Norblin mural of the Goddess Kali astride a tiger.
Below: the sitting room in the Maharaja Suite, with its veneered cabinet, chrome fittings and velvet leopard print sofas. Norblin helped with designing the furniture locally after a ship carrying the originals from Maples of London was torpedoed in 1942.

Première page: L'impressionnante rotonde centrale s'élèvent à 32 mètres du sol et était utilisée par le maharaja Umaid Singh pour ses banquets de Noël.
A droite: La chambre de l'appartement de la maharani est dominée par une fresque de Stefan Norblin représentant la déesse Kali chevauchant un tigre.
Ci-dessous: un des salons de l'appartement du maharaja, avec son cabinet verni, ses appliques chromées et ses canapés tapissés d'imprimés léopard en velours. Norblin fit en partie réaliser les meubles dans la région, le vaisseau transportant ceux commandés chez Maples à Londres ayant été torpillé en 1942.

Eingangsseite: Der Rundbau ist fast 32 Meter hoch und wurde von Maharaja Umaid Singh für das alljährliche Weihnachtsessen benutzt.
Rechts: Das Schlafzimmer in der Suite der Maharani ziert ein Wandgemälde Stefan Norblins, das die Göttin Kali auf einem Tiger reitend darstellt.
Unten: Die Einrichtung des Wohnzimmers in der Suite des Maharajas besteht aus einem Schrank mit poliertem Edelholz, Chromelementen und Sofas mit einem Überzug aus Samt in Leopardenmuster. Norblin war dabei behilflich, die Möbel vor Ort neu zu gestalten, nachdem das Schiff, das die von Maples in London stammenden Originale mit sich führte, 1942 torpediert worden war.

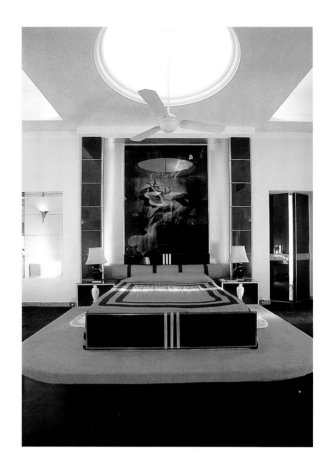

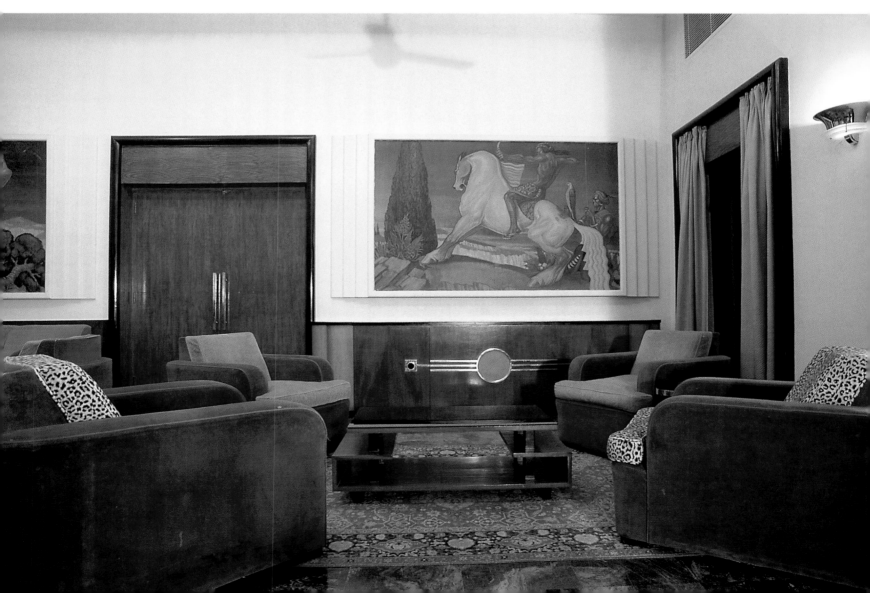

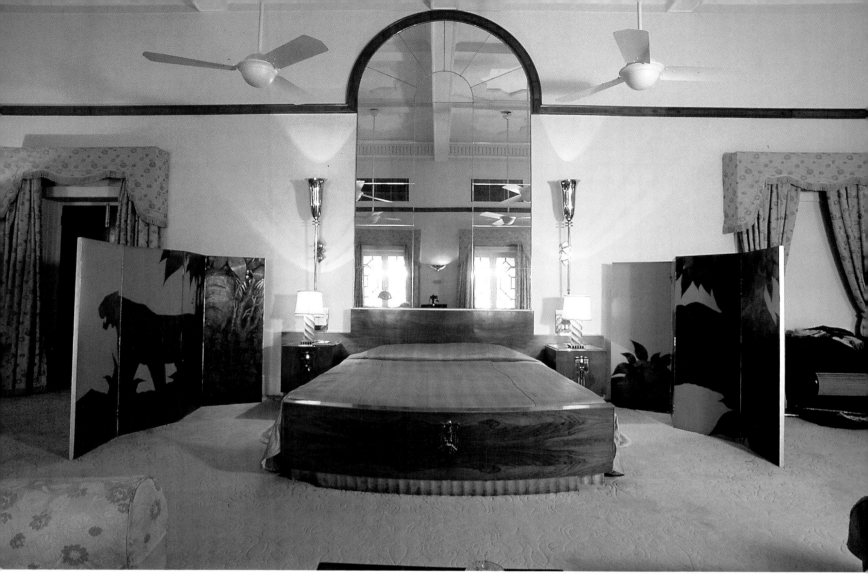

Above: Stefan Norblin, a Polish artist fleeing Europe during World
War II, was commissioned by Maharaja Umaid Singh to design
the main palace suites in the art deco style. The bedroom in the
Maharaja Suite, with its mirrored arch and chrome lamps, is attrib-
uted to Stefan Norblin who also painted the wildlife screens.
Right: Original watercolour drawings in the Umaid Bhawan Palace
archive confirm that the maharani's opulent marble bathroom was
created to Norblin's design.

Ci-dessus: Pendant la Seconde Guerre mondiale, le maharaja Umaid
Singh confia la décoration Art Déco des principaux appartements
du palais à Stefan Norblin, un artiste polonais ayant fui l'Europe. La
chambre de l'appartement du maharaja, avec son arche en miroir et
ses luminaires chromés, est attribuée aussi à Stefan Norblin, qui a
également peint les paysages sauvages.
A droite: Les aquarelles originales conservées dans les archives du
palais confirment que la somptueuse salle de bains en marbre de la
maharani a bien été conçue par Norblin.

Oben: Stefan Norblin, ein polnischer Künstler, der während des
Zweiten Weltkriegs aus Europa geflohen war, wurde von Maharaja
Umaid Singh damit beauftragt, die wichtigsten Suiten des Palastes
im Art-déco-Stil zu gestalten. Das Design des Schlafzimmers der
Maharaja-Suite mit dem Spiegel in Rundbogenform und den ver-
chromten Lampen wird ebenfalls Stefan Norblin zugeschrieben, von
dem auch die mit Tierbildern bemalten Wandschirme stammen.
Rechts: Die Aquarelle im Archiv des Umaid Bhawan Palace
beweisen, daß das opulente marmorne Badezimmer des Maharajas
nach dem Entwurf Norblins entstanden ist.

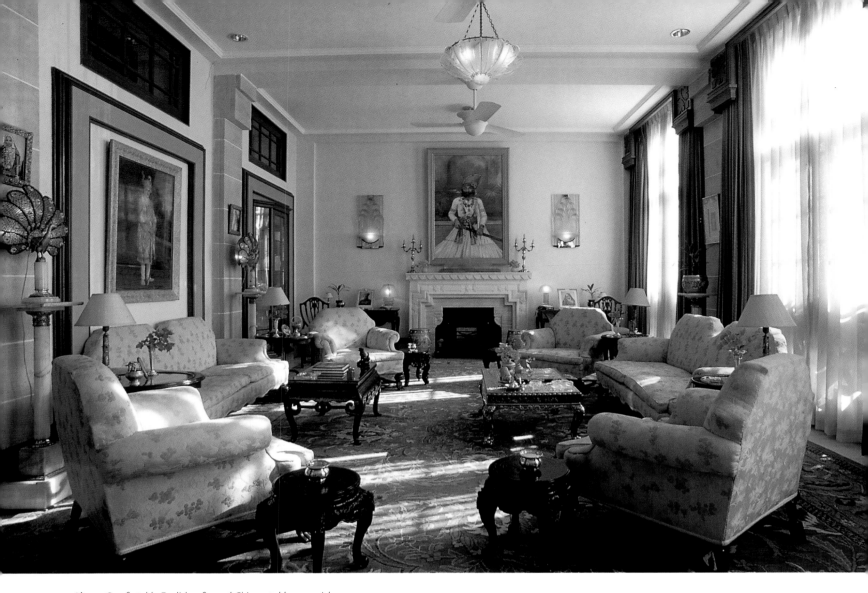

Above: Comfortable English sofas and Chinese tables on a rich
Persian carpet give the Maharaja of Jodhpur's private drawing room
in the south-west wing of Umaid Bhawan Palace a cosmopolitan air.
Portraits of his forbears are the main decoration on the walls.
Right: A new "dal-badal", or lake-and-clouds tent, covers a large
fountain courtyard in the Umaid Bhawan Palace. Painstakingly
constructed from panels of block-printed and embroidered cotton
fabric, it serves as a restaurant in the winter months.

Ci-dessus: Le salon privé du maharaja dans l'aile sud-ouest du
palais Umaid Bhawan, avec ses confortables canapés anglais, ses
tables chinoises et son grand tapis persan, dégage une atmosphère
cosmopolite. Aux murs, des portraits d'ancêtres.
A droite: Une nouvelle «dal-badal», ou tente «lac et nuages», abrite
une grande fontaine dans une des cours du palais. Faite de bandes de
cotonnades imprimées et brodées soigneusement cousues ensemble,
elle sert de restaurant pendant les mois d'hiver.

Oben: Gemütliche englische Sofas und chinesische Tische, die auf
einem kostbaren Perserteppich stehen, verleihen dem privaten
Wohnzimmer des Maharajas von Jodhpur im Südwestflügel des
Palastes eine internationale Atmosphäre. Porträts seiner Vorfahren
schmücken die Wände.
Rechts: Ein neues »Dal-Badal« – was soviel heißt wie See-und-
Wolken-Zelt – überdacht einen großen Innenhof mit Springbrunnen
im Umaid Bhawan Palace. Es wurde mit großer Sorgfalt aus
bedruckten und mit Stickereien verzierten Baumwollstoffbahnen
errichtet und dient während der Wintermonate als Restaurant.

Right: A circular marquee erected on pink marble pedestals and hung with muslin curtains in the maharaja's private apartment overlooks an enclosed garden below, and is used for pre-lunch drinks or cocktails.
Below: The maharaja's informal sitting and dining room, with its painted cane chairs and old polo trophies epitomises the informal English country house look. It is dominated by a portrait of Maharaja Jaswant Singh II (1873–1895), the first ruler of Jodhpur to move out of a medieval fort into a modern residence.

A droite: Sur la terrasse privée du maharaja, un dais rond tendu sur des supports en marbre rose et bordé de voiles en mousseline domine un jardin clos. Aujourd'hui, on aime prendre l'apéritif ici ou savourer un cocktail.
Ci-dessous: Ce salon-salle à manger informel du maharaja, avec ses chaises cannées et peintes et ses trophées de polo, rappelle l'ambiance décontractée d'une maison de campagne anglaise. Il est dominé par le portrait du maharaja Jaswant Singh II (1873–1895), le premier souverain de Jodhpur à avoir abandonné son fort médiéval pour une résidence moderne.

Rechts: Ein kreisrundes Festzelt, das an rosa Marmorsockeln verankert und mit Musselinvorhängen versehen ist, gehört zu den Privatgemächern des Maharajas und gewährt Aussicht auf einen darunterliegenden Garten. Hier werden vor dem Essen die Cocktails serviert.
Unten: Das private Wohn- und Eßzimmer des Maharajas ist mit lackierten Korbstühlen und Polo-Trophäen ausgestattet und spiegelt die typische Atmosphäre eines englischen Landhauses wider. Der Raum wird beherrscht von einem Porträt des Maharaja Jaswant Singh II. (1873–1895), der als erster unter den Herrschern Jodhpurs aus einer mittelalterlichen Festung in einen modernen Palast zog.

En 1929, année où Umaid Singh, maharaja de Jodhpur, fit bâtir son palais Art Déco au sommet d'une colline, son jeune frère Ajit Singh se fit construire une demeure plus modeste au pied de cette même colline. Ajit Bhawan Palace est une grande villa en grès rose qui reflète la double vie des demeures princières dans les années trente. La façade présente une porte cochère monumentale à l'européenne surmontée de dômes et de balcons traditionnels. Au rez-de-chaussée, les salons de réception donnaient sur un hall en marbre qui menait aux chambres des invités. En revanche, l'accès à l'étage, domaine des dames de la maison, était interdit. Ces dernières pouvaient observer sans être vues les banquets à l'européenne qui se donnaient en contrebas. Aujourd'hui, le fils d'Ajit Singh, Swaroop Singh, et sa femme, ont transformé la villa en palace mais ils ont conservé quelques traditions familiales: chacune des quatre chambres situées sous les dômes est occupée par un des quatre petit-fils d'Ajit Singh.

Ajit Bhawan Palace

In 1929, the same year that Maharaja Umaid Singh of Jodhpur built his art deco pile on top of a hill, his younger brother Ajit Singh, ordered himself a smaller building at the foot of that same hill. Ajit Bhawan Palace is a large red sandstone villa that encapsulates the double life of princely households in the Thirties. Many things had changed under European influence but not all. The palace exterior is a hybrid, with a European porte-cochère topped with traditional domes and balconies. On the ground floor, formal reception rooms lead off a marble entrance hall to guest rooms. But upstairs was forbidden territory, the domain of palace ladies. With giddy delight they would observe European-style banquets in the rooms below but remain unseen. Ajit Singh's son Swaroop Singh and his wife run their home today as a hotel, but some family traditions are still upheld: each of the rooms under the four domes is occupied by one of Ajit Singh's four grandsons.

1929, in demselben Jahr, als Maharaja Umaid Singh von Jodhpur seinen Art-déco-Palast auf der Spitze eines Hügels baute, gab sein jüngerer Bruder Ajit Singh einen kleineren Bau am Fuß desselben Hügels in Auftrag. Der Ajit Bhawan Palace ist eine große Villa aus rotem Sandstein, an dem sich gut erkennen läßt, welche Art von Doppelleben in den dreißiger Jahren im Haushalt eines indischen Fürsten geführt wurde. Unter europäischem Einfluß hatten sich viele Dinge geändert, wenn auch längst nicht alle. Das Äußere des Palastes ist eine Mischform: Eine Wagenauffahrt im europäischen Stil wird von traditionellen Kuppeln und Balkonen überragt. Im Erdgeschoß verbinden Empfangsräume eine Eingangshalle aus Marmor mit den Gästezimmern. Das Obergeschoß war für Besucher tabu, denn es war das Reich der Palastdamen. Von dort aus beobachteten sie mit großer Begeisterung die im europäischen Stil gehaltenen Bankette, konnten selbst jedoch nicht gesehen werden. Mittlerweile haben Ajit Singhs Sohn Swaroop Singh und seine Frau Teile ihres Palastes in ein Hotel umgewandelt, doch manche Familientraditionen bestehen immer noch: Jeder der unter einer der vier Kuppeln gelegenen Räume wird von einem der vier Enkel Ajit Singhs bewohnt.

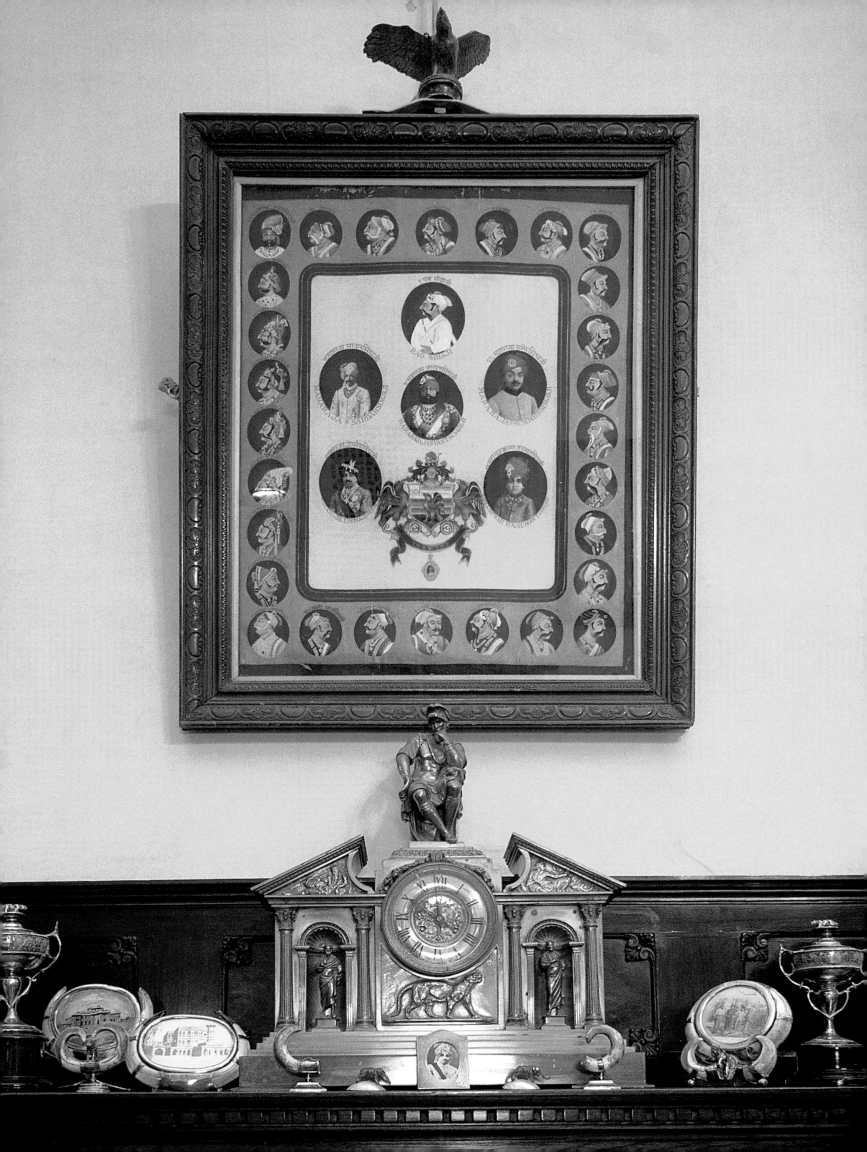

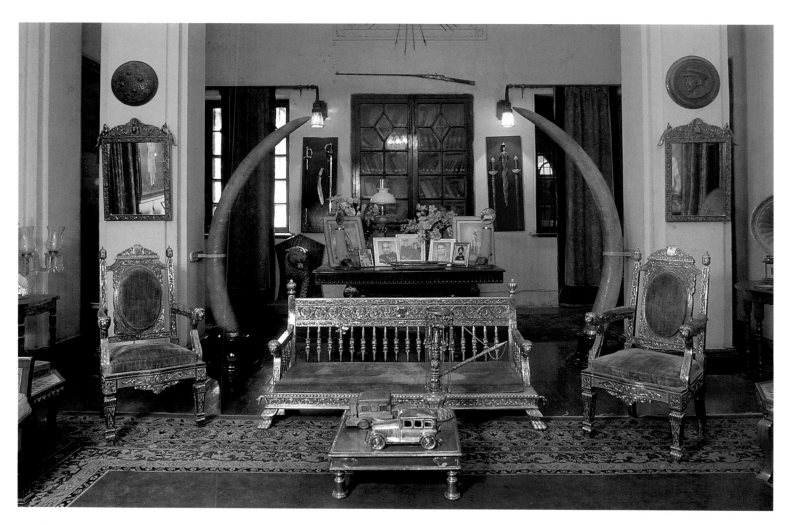

Previous page: A hand-painted chart of Jodhpur's royal lineage hangs above a mantelpiece.
Above and right: A suite of hand-beaten silver furniture is placed in front of a pair of giant elephants' tusks brought back from shooting safaris in Kenya in the Thirties. A hand-tinted photograph of the two brothers Umaid Singh and Ajit Singh commemorates the heyday of big game hunting in Africa.
Facing page: An ornamental hookah and silver cigarette boxes in the shape of vintage cars, on a low traditional table known as a "bajot", evokes the Jazz Age of the maharajas.

Page précédente: au-dessus d'un manteau de cheminée un tableau généalogique de la lignée royale de Jodhpur peint à la main.
Ci-dessus et à droite: des meubles en argent martelé devant une paire de gigantesques défenses d'éléphant rapportées d'un safari au Kenya dans les années trente. La photographie des deux frères Umaid Singh et Ajit Singh, colorée à la main, commémore la grande époque des chasses au gros gibier en Afrique.
Page de droite: Un houka décoratif et une paire de coffrets à cigarettes en forme d'automobiles sur une table basse traditionnelle, ou «bajot», évoque les années folles des maharajas.

Vorhergehende Seite: Über einem Kaminsims hängt ein von Hand gemalter Stammbaum der königlichen Familie Jodhpurs.
Oben und rechts: Handgetriebene Silber-Möbel stehen vor gigantischen Elefantenzähnen, die bei Jagdsafaris in Kenia in den dreißiger Jahren erbeutet wurden. Eine von Hand kolorierte Fotografie der beiden Brüder Umaid Singh und Ajit Singh erinnert an die Zeit, in der die Großwildjagd in Afrika auf ihrem Höhepunkt stand.
Rechte Seite: Eine reich verzierte Wasserpfeife und Zigarettenbehälter in Form von Automodellen stehen auf einem niedrigen, traditionellen, als »Bajot« bezeichneten Tisch.

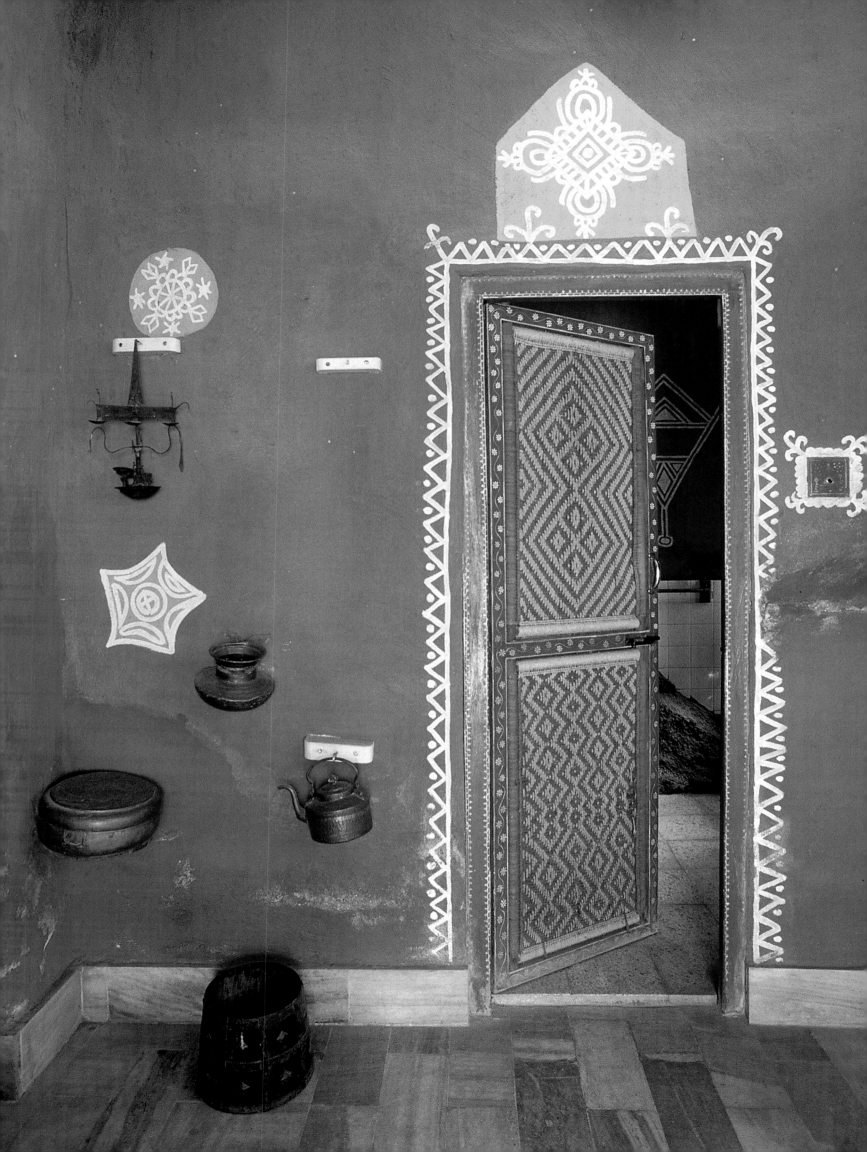

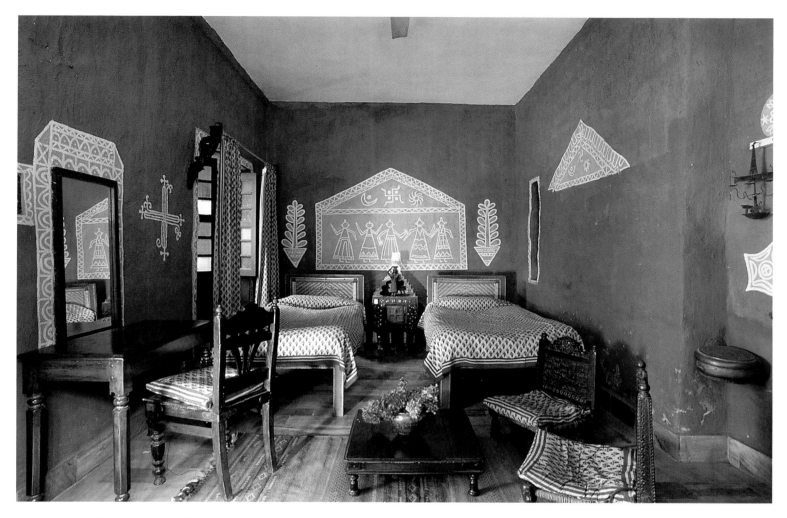

Facing page: Everyday vessels of iron and brass, including an oil lamp, enliven a guest-room wall. The rope-woven bathroom door is in the style of a "charpai", a common string-bed.
Above: Rooms in the recently-built garden resort at Ajit Bhawan are decorated in rustic style, with hand-painted designs on terracotta-coloured walls and hand-blocked furnishings.
Right: The bathroom has been converted into a grotto, using rocks from the rugged hill that rises behind Ajit Bhawan.

Page de gauche: Des objets quotidiens en fer et en laiton, dont une lampe à huile, égayent le mur de cette chambre d'amis. La porte en corde tissée de la salle de bains reprend le style d'un «charpai», un lit en ficelle utilisé un peu partout.
Ci-dessus: Dans le pavillon du jardin, plus récent, les pièces sont décorées dans un style rustique, avec des tissus artisanaux et des ornements peints à la main sur des murs couleur de terre cuite.
A droite: La salle de bains a été transformée en grotte grâce à des pierres extraites de la paroi accidentée de la colline qui s'élève derrière Ajit Bhawan.

Linke Seite: Gebrauchsgegenstände aus Eisen und Messing, zu denen unter anderem eine Öllampe gehört, verzieren die Wand eines Gäste-zimmers. Die Badezimmertür aus geflochtenem Seil ist im Stil eines »Charpai« gehalten, eines in Indien weithin gebräuchlichen, aus Kor-del geknüpften Bettgestells.
Oben: Die Zimmer in dem vor kurzem entstandenen Gartentrakt des Ajit Bhawan Palace sind im rustikalen Stil ausgestattet. Die Verzie-rungen auf den terrakottafarbenen Wänden sind von Hand gemalt und die Möbel mit handbedruckten Stoffen bezogen.
Rechts: Das Badezimmer wurde mit Hilfe von Felsgestein, das von dem zerklüfteten Hügel hinter dem Ajit Bhawan stammt, in eine Art Grotte verwandelt.

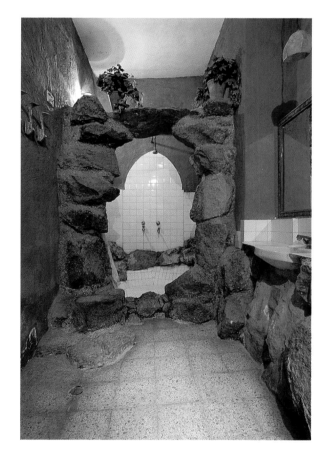

Le petit fort provincial de Narlai se dresse à environ 160 kilomètres au sud de Jodhpur, près des somptueux temples jaina de Ranakpur datant du 15e siècle. Construit pour servir de pavillon de chasse aux maharajas de Jodhpur, il changea de propriétaire à la suite d'un accident: le maharaja Umaid Singh l'offrit à son frère Ajit Singh pour avoir sauvé sa vie lors d'une charge d'éléphant. Le petit-fils d'Ajit Singh, Raghavendra Rathore, célèbre styliste de mode formé à la Parson's School of Design de New York et ayant fait ses classes chez Oscar de la Renta, a entrepris de le restaurer progressivement avec son frère. Ils ont dégagé les pièces sombres et les galeries étroites du bâtiment, nettoyé la crasse accumulée au fil des siècles et mis à jour les fresques délicates peintes sur les murs enduits d'un stuc brillant. Les intérieurs frais qu'ils ont ainsi créés sont en parfaite harmonie avec les sculptures de marbre des temples de Ranakpur.

Narlai Fort

About 160 kilometres southeast of Jodhpur, at Narlai, lies a small provincial fort, near the magnificent 15th-century Jain temples of Ranakpur. It was originally built as a hunting lodge by the maharajas of Jodhpur. The fort's ownership changed hands as a result of a hunting accident: Maharaja Umaid Singh presented it to his brother Ajit Singh for saving his life during an elephant charge. Ajit Singh's grandson Raghavendra Rathore, a well-known fashion designer who studied at the Parson's School of Design in New York and later trained with Oscar de la Renta, has now undertaken a gradual restoration of the family property with his brother. Opening up some of the building's dark rooms and narrow passages, they have removed the grime of centuries to reveal delicately-painted frescoes on lustrous walls of eggshell stucco and created cool interiors in keeping with the gleaming marble sculpture of the Ranakpur temples nearby.

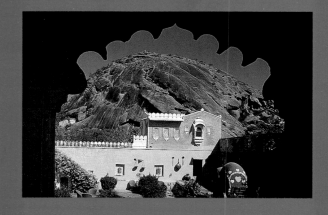

Ungefähr 160 Kilometer südöstlich von Jodhpur steht das kleine ländliche Fort von Narlai, nicht weit von den prachtvollen Jaina-Tempeln aus dem 15. Jahrhundert in Ranakpur. Die Maharajas von Jodhpur hatten es ursprünglich als Jagdschloß gebaut. Nach einem Jagdunfall wechselte das Fort seinen Besitzer: Maharaja Umaid Singh schenkte es seinem Bruder Ajit Singh, weil dieser ihm während eines Elefantenangriffs das Leben gerettet hatte. Ajit Singhs Enkel Raghavendra Rathore, ein bekannter Modedesigner, der an der Parson's School of Design in New York studierte und später bei Oscar de la Renta in die Lehre ging, hat jetzt zusammen mit seinem Bruder damit begonnen, den Familienbesitz allmählich zu restaurieren. Sie öffneten einige der dunklen Gemächer des Gebäudes, reinigten sie von dem Schmutz, der sich während der Jahrhunderte angesammelt hatte und legten kunstvoll gemalte Fresken auf glänzenden Stucco-Wänden frei. Dadurch entstanden Räume von kühler Eleganz, die große Verwandtschaft mit den glänzenden Marmorskulpturen der nahe gelegenen Ranakpur-Tempel aufweisen.

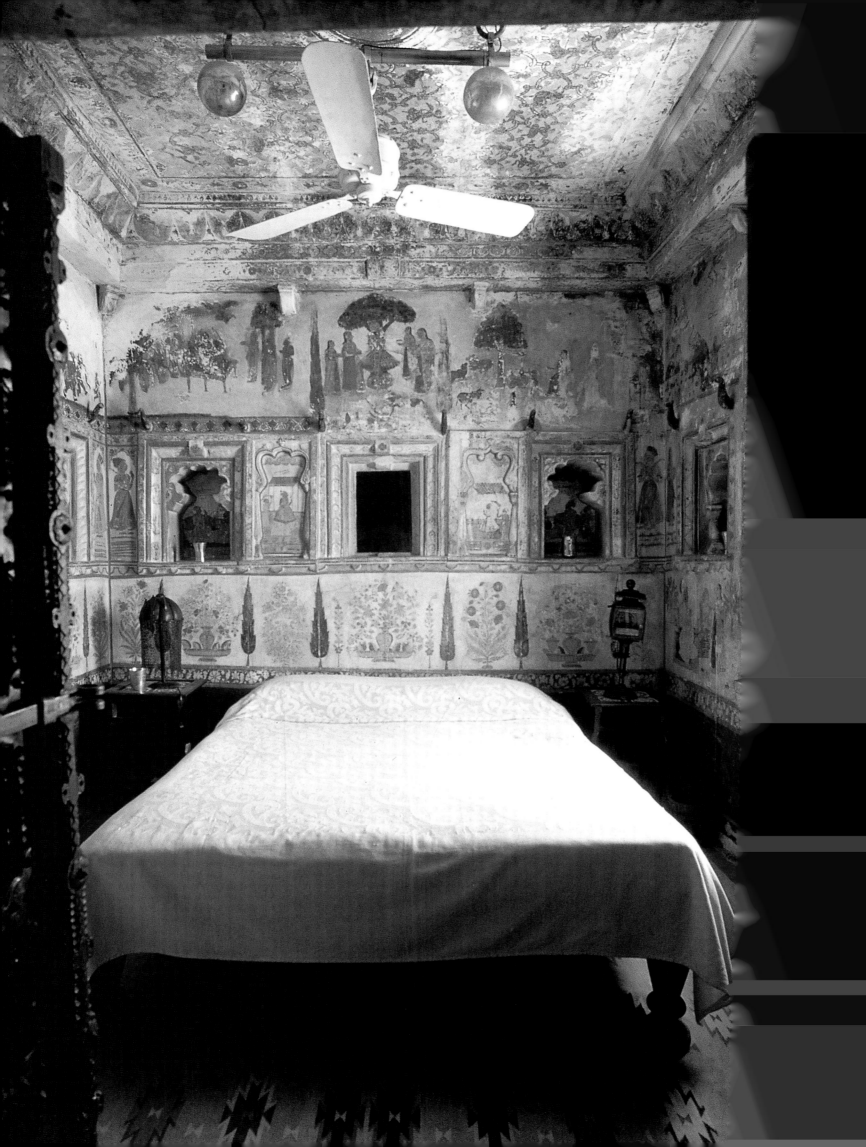

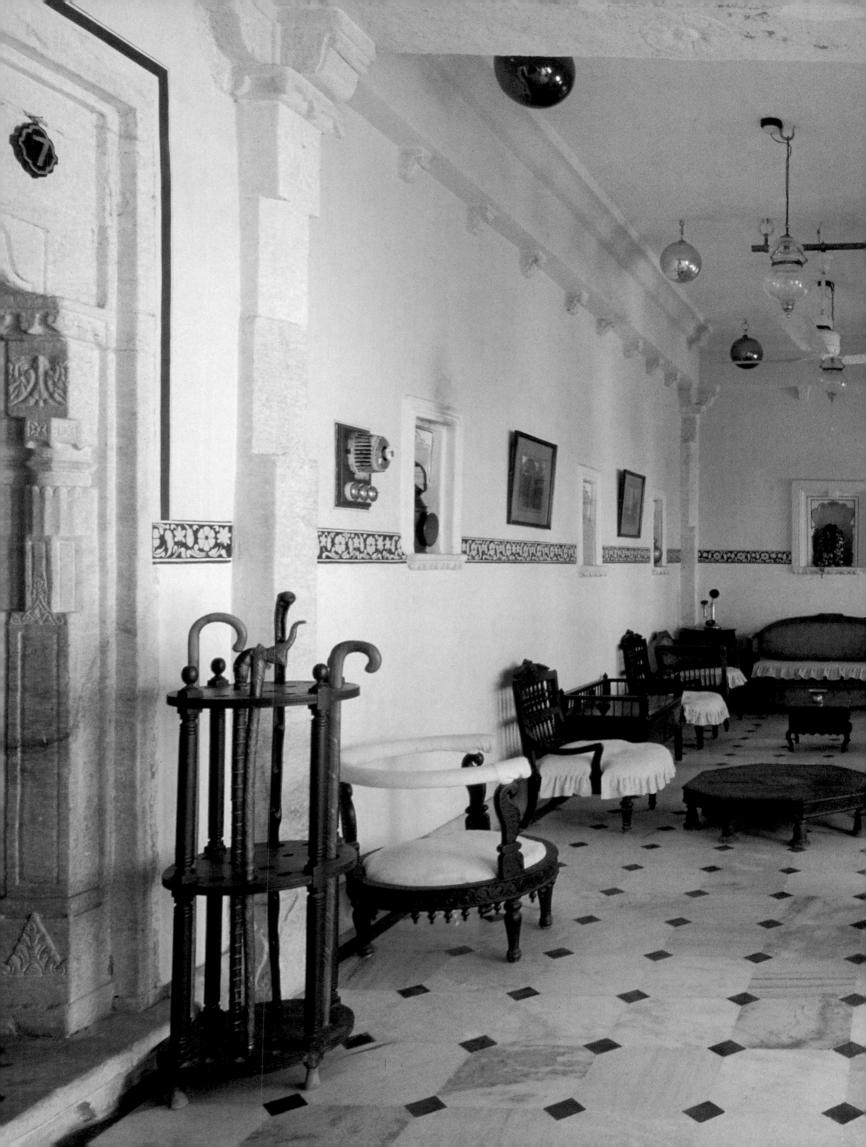

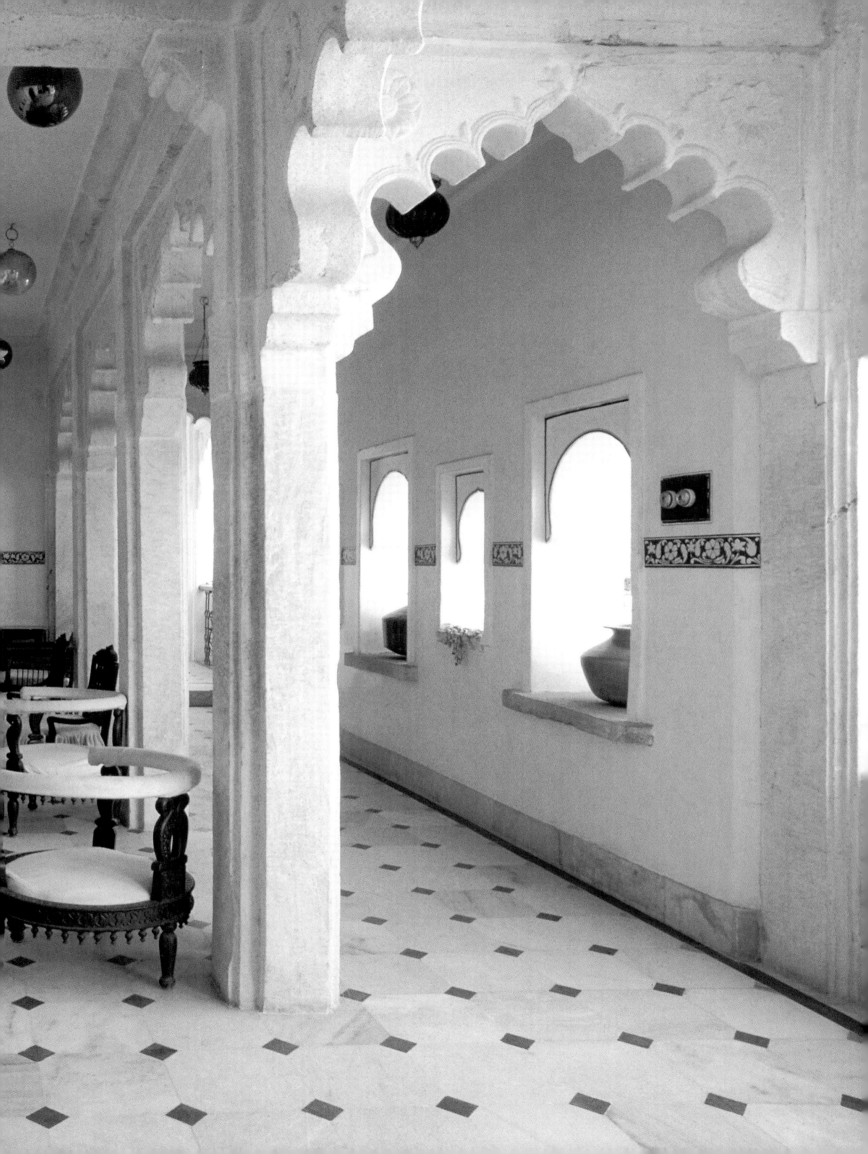

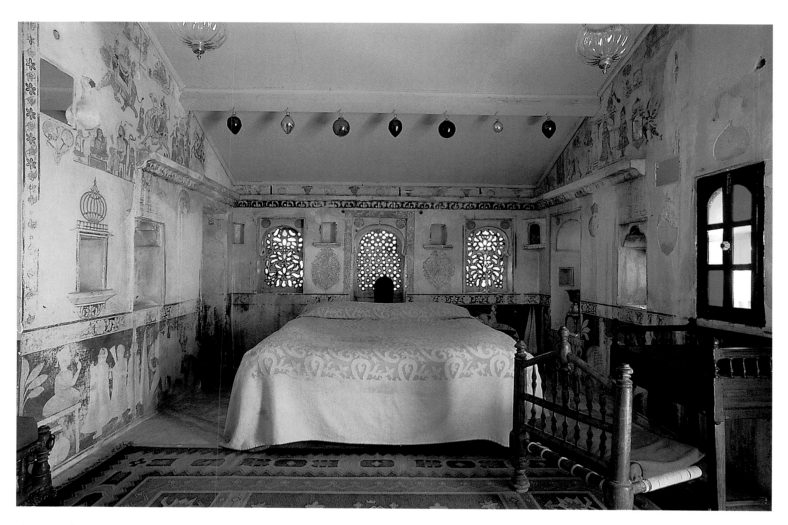

First page: *The oldest bedroom in Narlai has frescoes painted on a lustrous stucco known as "airaish".*
Previous pages: *The cusped arches of the entrance corridor orginally ran along the inside wall but were moved out to create a wide lounge for seating.*
Above and right: *The bedrooms on the upper floors were furnished with pieces from the family storerooms and enlivened with inexpensive, locally-woven bedspreads.*
Facing page: *A family retainer in his traditional turban and dhoti closes a "jharokha", a small window.*

Première page: *La chambre la plus ancienne de Narlai possède des fresques peintes sur un stuc brillant appelé «airaish».*
Double page précédente: *Une partie des arches dentelées du couloir d'entrée a été enlevée pour créer un salon.*
Ci-dessus et à droite: *Les chambres des étages supérieurs ont été aménagées avec des meubles dénichés dans les greniers de la famille. Les sobres couvre-lits ont été tissés dans la région.*
Page de droite: *Un domestique, portant le turban et le dhoti traditionnels, ferme un «jharokha», une petite fenêtre.*

Eingangsseite: *Der älteste Raum in Narlai ist mit Fresken verziert, die auf glänzendem, »Airaish« genanntem Stucco aufgetragen sind.*
Vorhergehende Doppelseite: *Die Fächerbögen des Eingangskorridors waren ursprünglich der inneren Wand vorgeblendet, wurden dann jedoch nach außen versetzt, um Raum für einen breiten Salon mit Sitzgelegenheiten zu schaffen.*
Oben und rechts: *Die Schlafzimmer in den oberen Geschossen richtete man mit Möbeln aus den Lagerräumen der Familie und mit einfachen, in der Umgebung des Forts gewobenen Tagesdecken ein.*
Rechte Seite: *Ein Bediensteter der Familie mit traditionellem Turban und »Dhoti« schließt ein »Jharokha«, ein kleines Erkerfenster.*

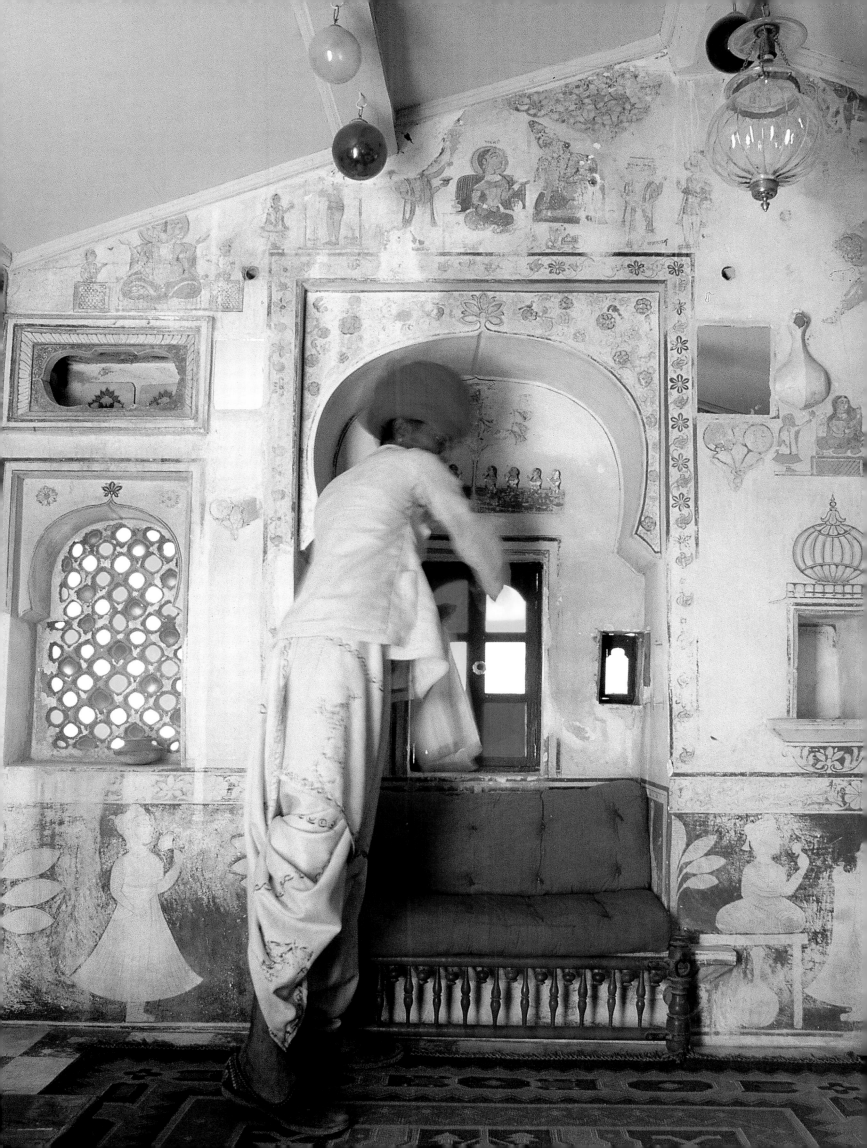

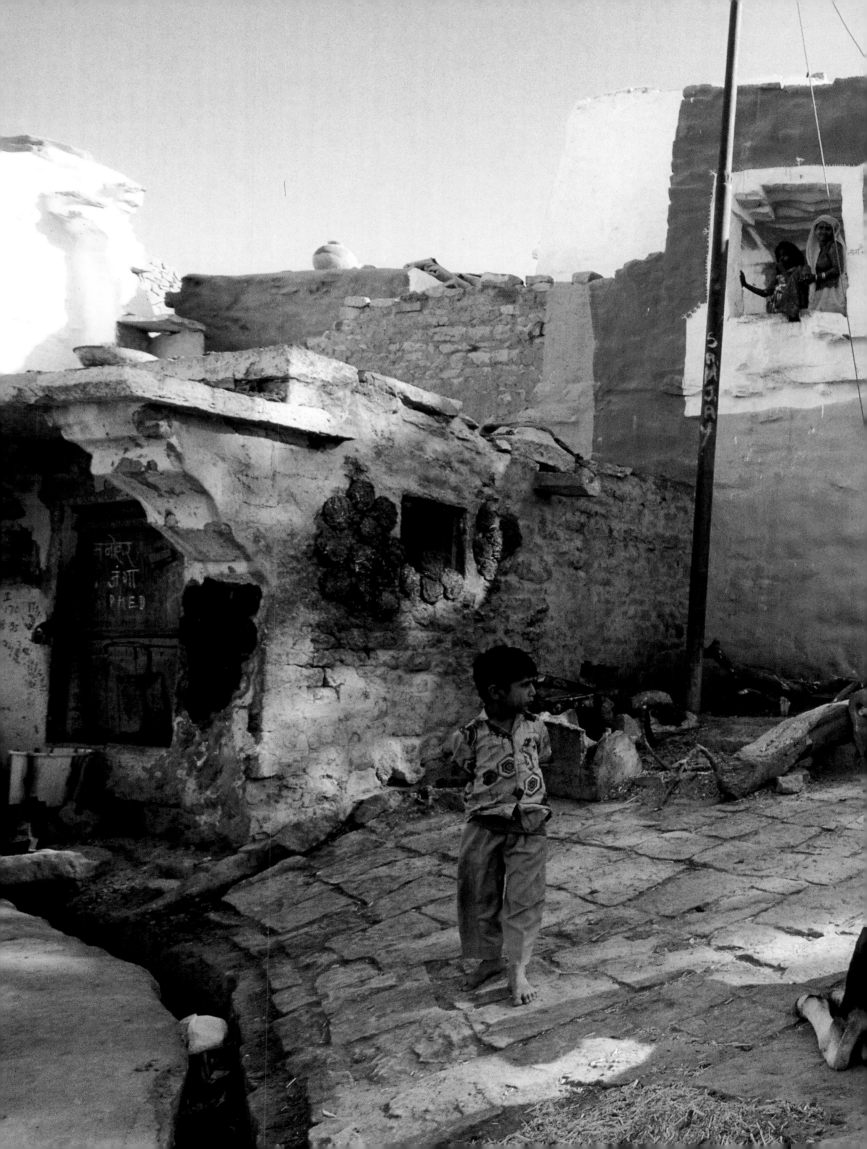

En hindi, le désert se dit «marusthal», pays de la mort. Arides et ba-
layées par les vents, les terres calcinées du Thar, s'étendant sur 800 ki-
lomètres, séparent la vallée de l'Indus de la plaine fertile du Gange.
Cependant, elles sont loin d'être désertes. Les caravanes de chameaux
les traversent depuis des temps immémoriaux, assurant les liaisons
commerciales entre les principales villes de l'Inde, la Perse, l'Arabie,
l'Afrique et l'Europe. Surgissant des sables, la ville fortifiée de Jaisal-
mer, lointaine et étincelante, servait déjà de caravansérail au 12e
siècle. Derrière ses hauts remparts en pierres couleur de miel, ses
riches marchands ont érigé quelques-uns des plus beaux «havelis» ja-
mais construits en Inde. Beaucoup tombent en ruines, comme la ville
du désert elle-même, et ne pourront être sauvés que grâce à la géné-
rosité de l'aide internationale. Toutefois, à l'intérieur et tout autour de
Jaisalmer vivent des communautés sédentarisées de bergers et de cha-
meliers. Ils habitent des demeures moins menacées mais tout aussi
remarquables par leur simplicité, leur fonctionnalité, leur résistance et
leur beauté austère.

Mud Houses in Jaisalmer

In Hindi the word for desert is "marusthal" – Land of Death. Arid
and windswept, the burning wasteland of the Thar Desert, 500
miles wide, separates the Indus valley from the fertile plain of the
Ganges. But it is not empty. Camel trains have wended their way
through this wilderness since ancient times, linking the main cities
of India on the trade routes to Persia, Arabia, Africa and Europe.
Rising out of the sands, the fortified city of Jaisalmer has served as
a caravanserai since at least the 12th century. Within its soaring
walls of honey-coloured stone lie some of the grandest "havelis"
ever built in India, residences of the city's merchant barons. Many
are in a dire state of repair and, like the desert city itself, subject of
an international conservation appeal. But in and around Jaisalmer
there are settled communities of pastoralists and camel-herders,
living in dwellings less-threatened but no less remarkable for their
simplicity, functional endurance and stark beauty.

Das Wort für Wüste in Hindi ist »Marusthal« – das Land des Todes.
Das sonnenverbrannte, dürre und von Winden durchfegte Ödland der
Wüste Thar erstreckt sich über 800 Kilometer und trennt das Tal des
Indus von der fruchtbaren Ganges-Ebene. Dennoch ist die Wüste
nicht menschenleer. Bereits seit Urzeiten haben Karawanen diese
Wildnis durchzogen, auf einem Handelsweg, der die wichtigsten
Städte Indiens mit Persien, Arabien, Afrika und Europa verband. Von
weitem ragt in der Sonne leuchtend das befestigte Jaisalmer aus dem
Sand empor, das spätestens seit dem 12. Jahrhundert als Karawanse-
rei diente. Hinter seinen hochaufragenden Stadtmauern aus honigfar-
benem Sandstein liegen die Paläste der reichen Kaufleute: einige der
prachtvollsten »Havelis«, die je in Indien gebaut wurden. Viele von
ihnen sind in einem überaus schlechten Zustand und – genau wie die
Wüstenstadt selbst – auf internationale Hilfe angewiesen. In und um
Jaisalmer haben sich Hirten und Kameltreiber niedergelassen, deren
Wohnhäuser zwar weniger vom Verfall bedroht, aber ihrer Schlicht-
heit, widerstandskräftigen Bauweise und rauhen Schönheit wegen
nicht weniger bemerkenswert sind.

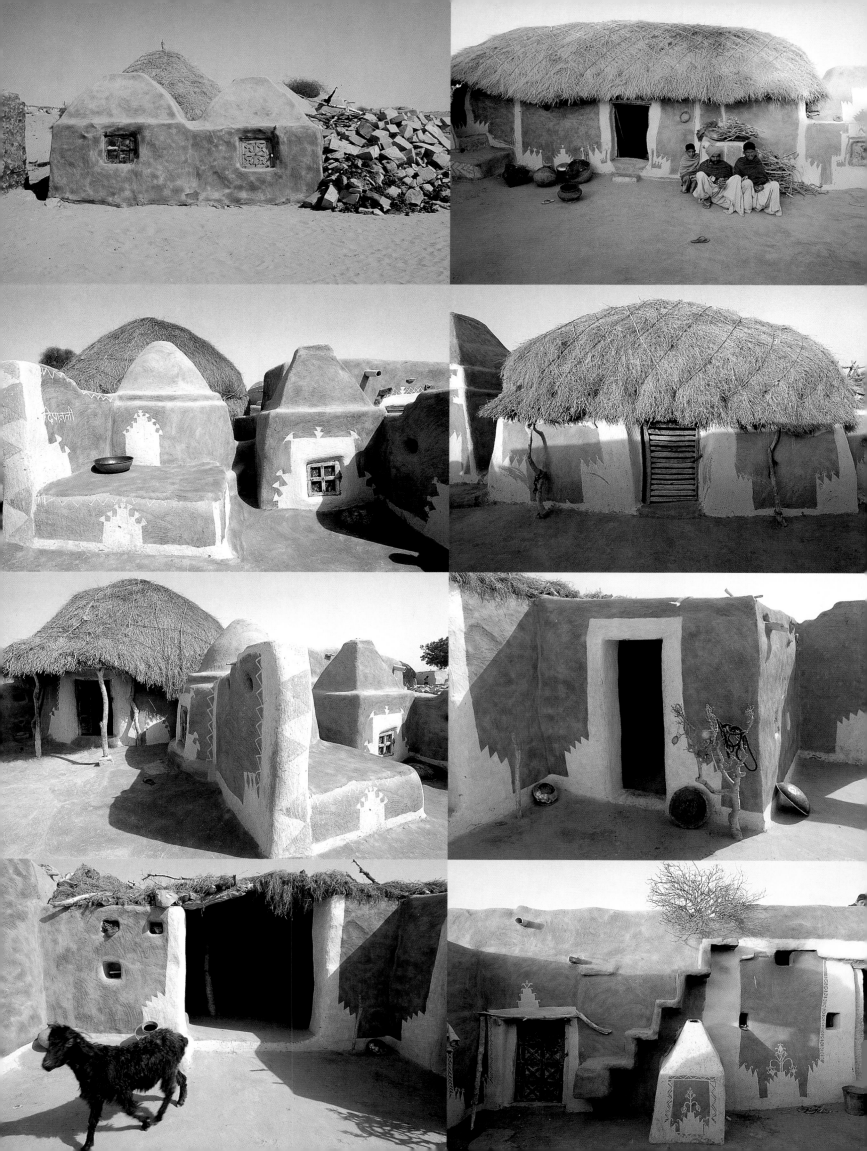

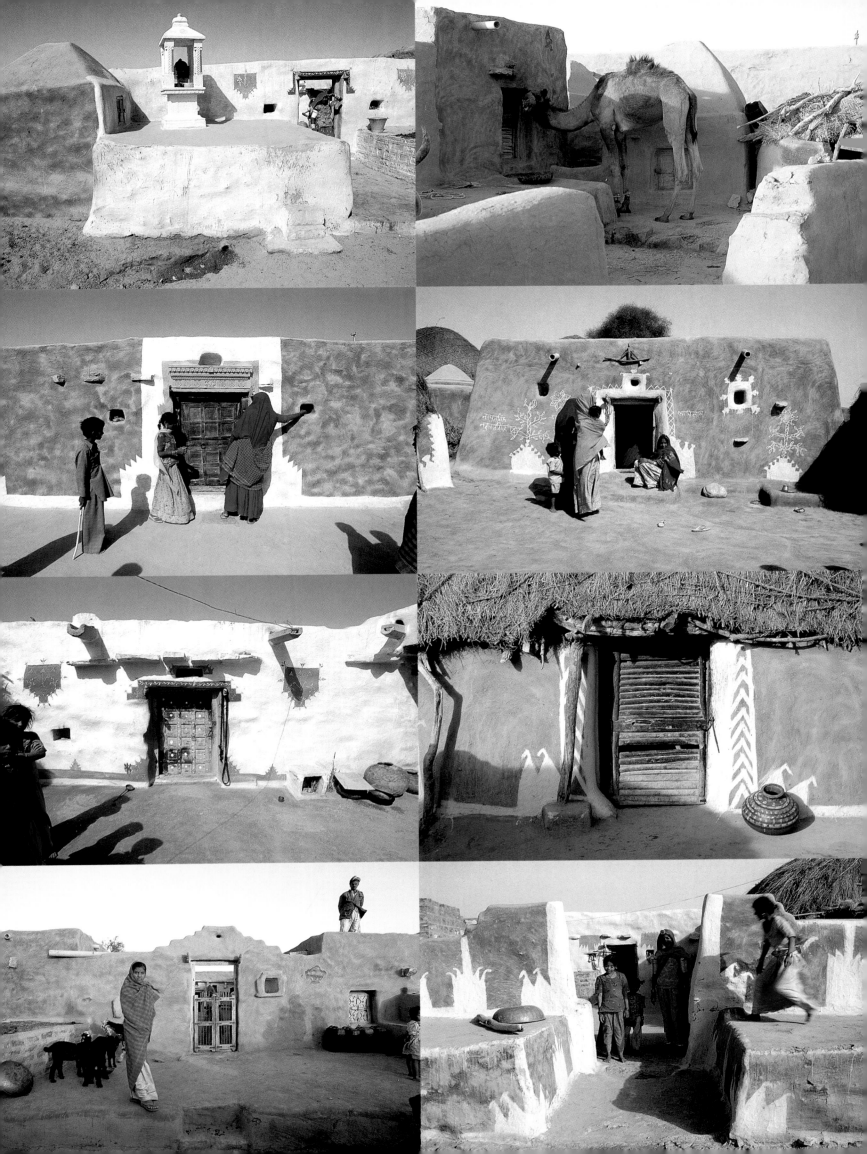

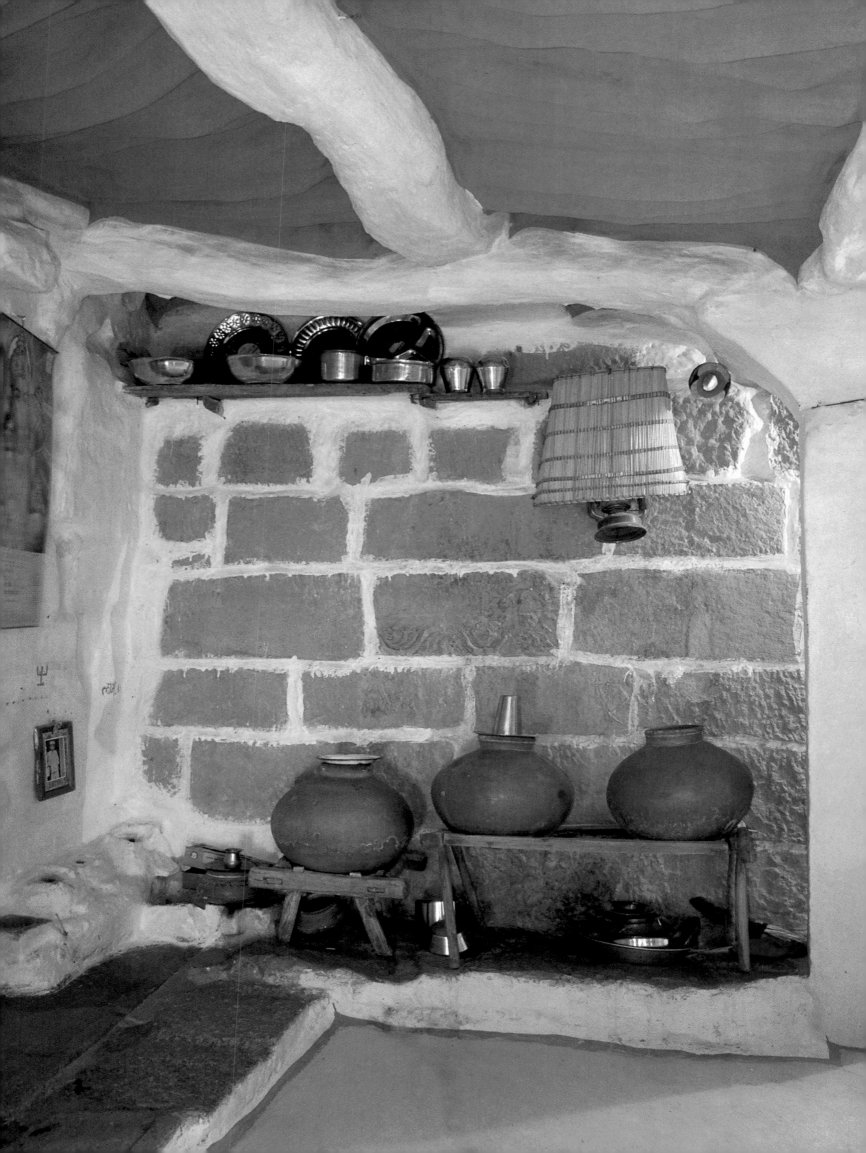

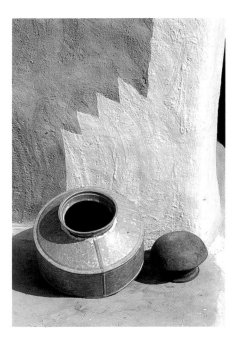

Previous pages: Roofed with dried desert grasses, the homes in a camel-herders' village are made by hand. Most of the mud plastering is done by women who also decorate the exteriors with patterns in white clay. A thorny tree-stump makes a convenient hanger for items of daily use, including a tea-strainer and a camel rope.
Left page: Earthen pitchers in the kitchen are used for storing the most precious commodity in the desert water.
Above: A stone grain mill with a clay base and a sunken stone slab with a hole, for pounding chillies and garlic, are important kitchen implements.

Double pages précédentes: Avec leur toit en broussailles séchées, ces maisons de chameliers sont construites en pierres, en gravats et en boue. La boue séchée est souvent appliquée par les femmes, qui décorent également les intérieurs avec des motifs en argile blanche. Un arbre sec sert à accrocher divers ustensiles de la vie quotidienne, dont une passoire à thé et une corde de chameau.
Page de gauche: Ces jarres en terre posées dans un coin de la cuisine servent à conserver l'eau, le bien le plus précieux dans le désert.
Ci-dessus: un moulin à grains avec un socle en argile et une dalle concave en pierre percée d'un trou pour écraser les piments et l'ail, deux ustensiles de cuisine indispensables.

Vorhergehende Doppelseiten: Die Häuser in dem Dorf der Kameltreiber sind mit getrocknetem Wüstengras gedeckt und von Hand gebaut. Der Großteil des Lehmverputzes wie auch die Wandverzierungen aus weißem Lehm werden von den Frauen angebracht. Ein dorniger Baumstumpf dient als willkommene Ablage für tägliche Gebrauchsgegenstände, zu denen auch ein Teesieb und ein Kamelstrick gehören.

Linke Seite: In der Küche wird in irdenen Krügen das kostbarste Gut aufbewahrt, das es in der Wüste gibt: das Wasser.
Oben: Zu den wichtigsten Küchengeräten gehören eine steinerne Kornmühle und eine in den Boden eingelassene Steinplatte mit einer Vertiefung, die zum Zerstampfen von Chilli und Knoblauch benutzt wird.

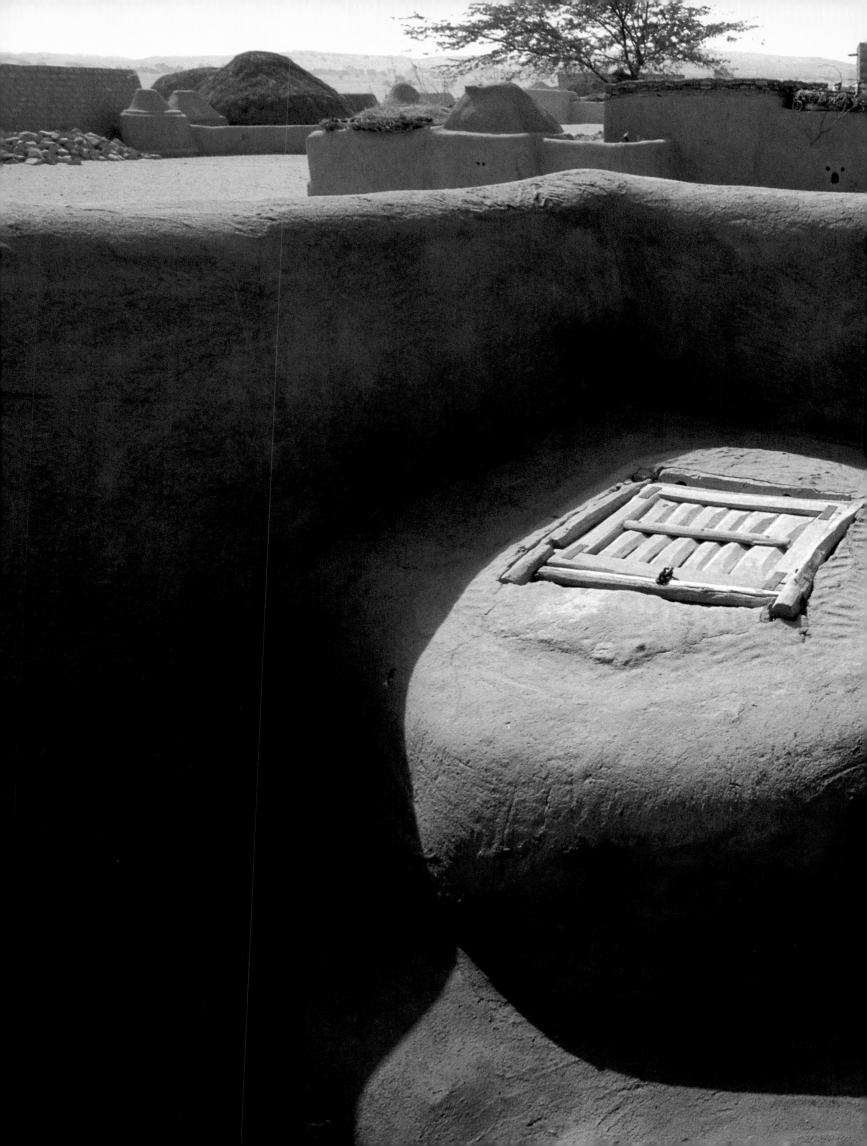

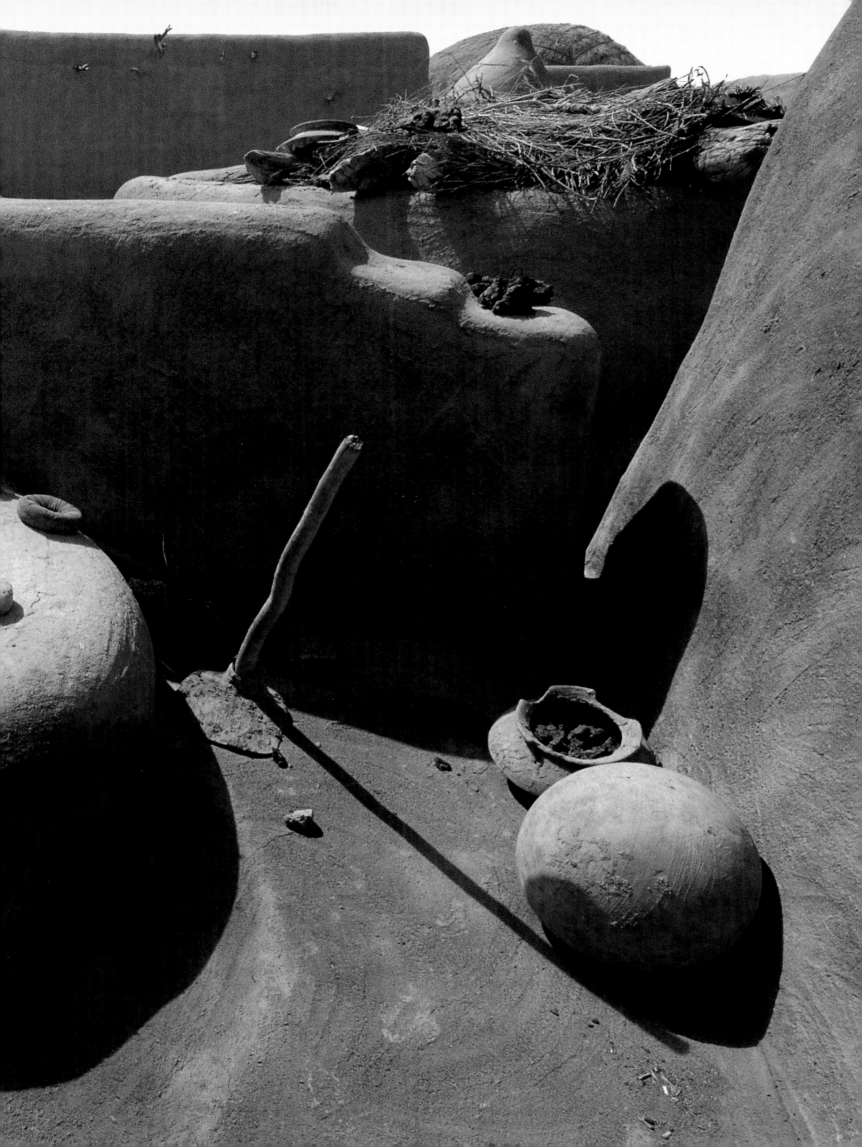

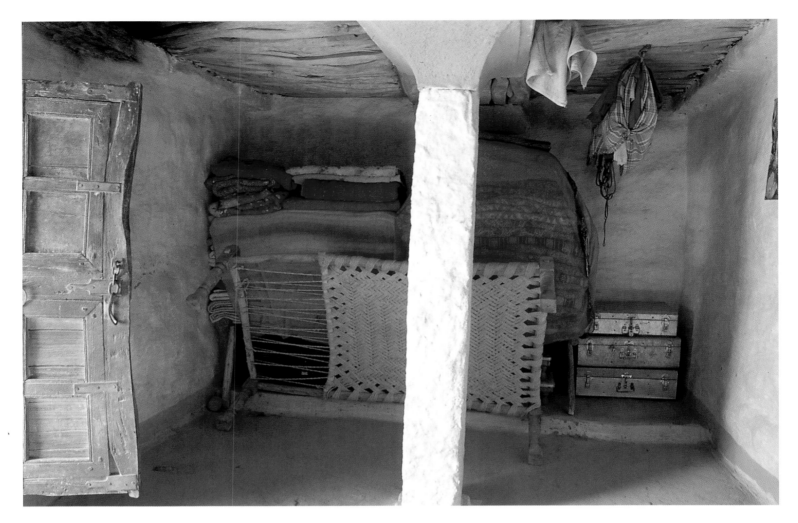

Previous pages: In a freshly mud-plastered courtyard, a large round mud container with a wooden trapdoor is used for storing fodder.
Above: A single supporting pillar of stone with a cheerfully painted capital holds up the bedroom roof. Bedding and "charpai" are neatly stacked away after use.
Right page: a decorated storage unit, hand-made from clay and fitted with a door and latch, for stowing valuable items such as special clothes. Expensive utensils in stainless steel, including buckets and water pitchers, are piled above.

Double page précédente: dans cette cour, fraîchement enduite de boue, une réserve en terre équipée d'une trappe en bois pour stocker le fourrage.
Ci-dessus: Le toit de cette chambre à coucher est soutenu par une seule colonne en pierre au chapiteau égayé de couleurs vives. Le lit et le «charpai» sont soigneusement rangés le matin.
Page de droite: Cette armoire en argile, ornée de motifs géométriques et équipée d'une porte et d'un loquet, sert à ranger les objets de valeur tels que les habits réservés aux grandes occasions. Les objets «précieux» en acier inoxydable, y compris les seaux et les cruches, sont entassés dessus.

Vorhergehende Doppelseite: In einem frisch mit Lehm verputzten Hof steht ein großer runder Lehmbehälter mit einer Falltür aus Holz, der für die Lagerung von Futter benutzt wird.
Oben: Eine einzelne Steinsäule mit einem bunt bemalten Kapitell stützt das Dach des Schlafzimmers. Das Bettzeug und das »Charpai« werden tagsüber sorgfältig in der Ecke verstaut.

Rechte Seite: Ein von Hand gemachtes, mit Verzierungen versehenes Schränkchen aus Lehm, in das eine Tür mit Riegel eingebaut ist, dient der Aufbewahrung von Wertgegenständen, wie zum Beispiel festliche Kleider. Wertvolle Küchengeräte aus Edelstahl, zu denen auch Eimer und Wasserkrüge gehören, stapeln sich darauf.

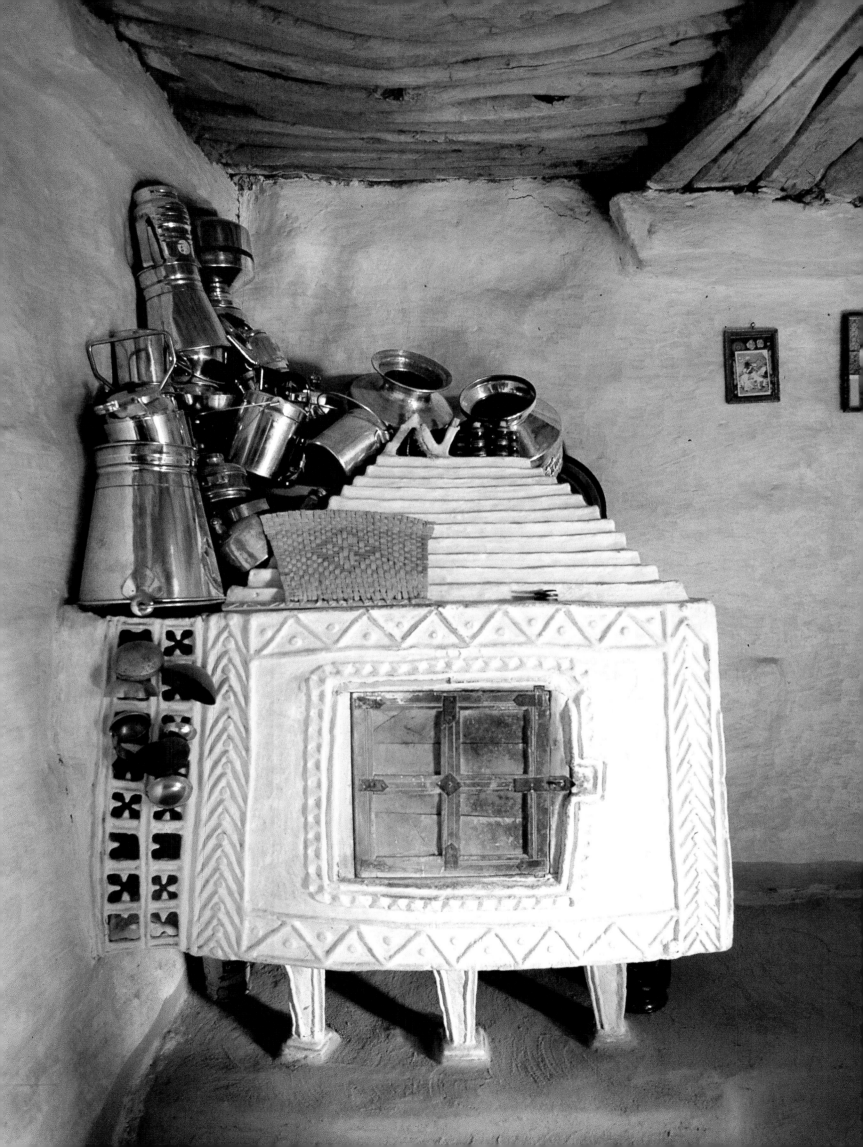

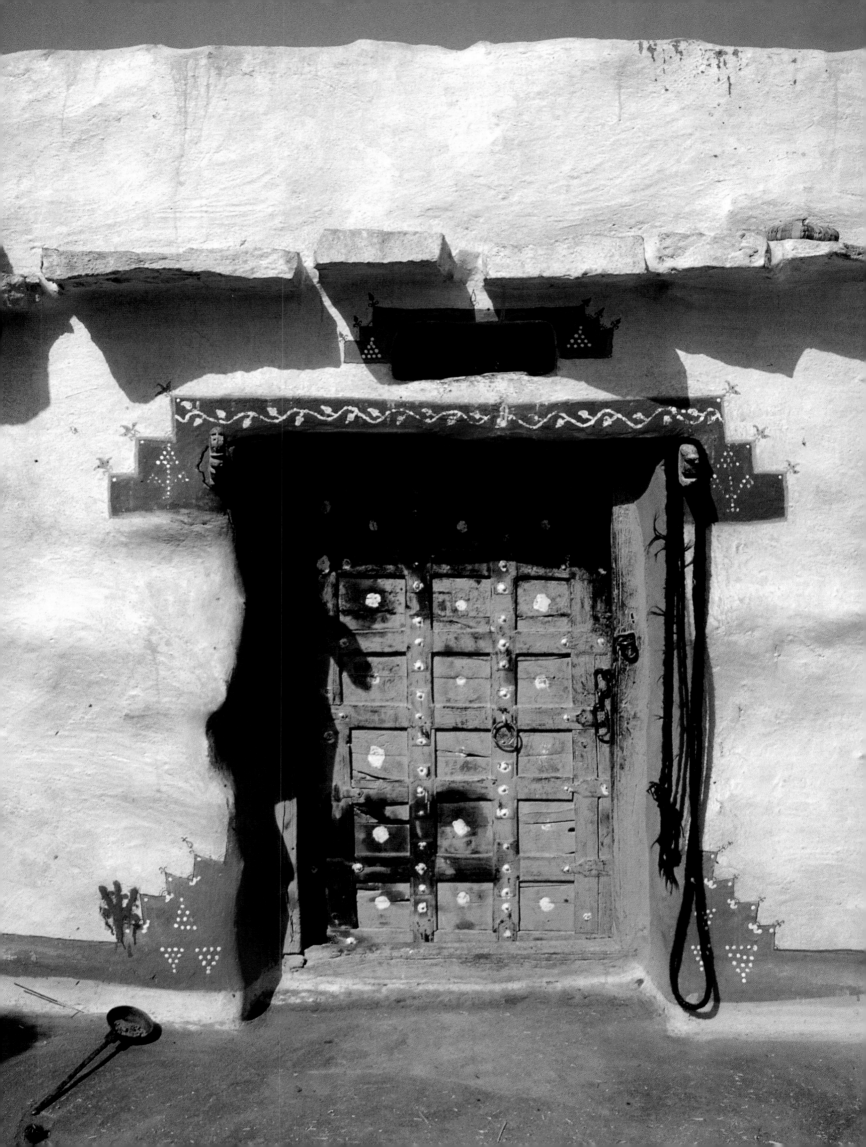

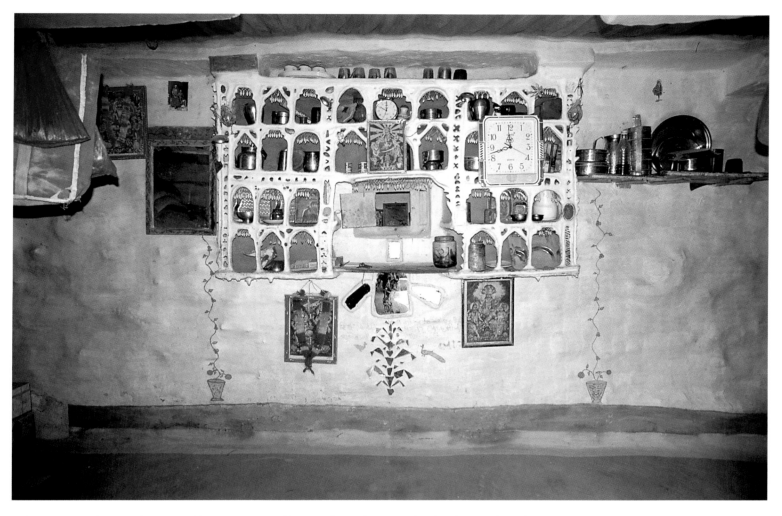

Left page: A painted wooden door to a mud house is surmounted by a hand-drawn pattern of a trailing vine. A thick camel rope, made of goat's hair, hangs on a bracket. Although the decorations generally have no significance, the small vermilion trident at the base of the well means that the house has been blessed. The iron ladle is used for burning incense.
Above and right: Decorative niches, fashioned from white clay and reinforced with twigs, are for displaying utensils and religious images. Women in "purdahs" are framed by a doorway linking the forecourt to the inner courtyard of the house.

Page de gauche: La porte en bois peinte de cette maison en torchis est surmontée d'une frise végétale peinte à la main. Une épaisse corde de chameau, faite en poils de chèvre, est accrochée au linteau. Bien que les décorations n'aient pas de signification en soi, le petit trident vermillon en bas à gauche de la porte signifie que la maison a été bénie. La louche en métal sert à faire brûler de l'encens.
Ci-dessus et à droite: Les niches décoratives en argile blanche renforcée avec des brindilles abritent des ustensiles et des images religieuses. Des femmes voilées devant la porte qui relie l'avant-cour à la cour intérieure de la maison.

Linke Seite: Der Balken über einer bunt gestrichenen Holztür, die in eines der Lehmhäuser führt, wurde von Hand mit einem Rankenmuster bemalt. An einem Kragstein hängt ein dicker Kamelstrick aus Ziegenhaar. Während diese Dekorationen keine besondere Bedeutung haben, besagt der kleine zinnoberrote Dreizack am Sockel der Wand, daß das Haus gesegnet wurde. Die Schöpfkelle aus Eisen wird zum Verbrennen von Weihrauch benutzt.

Oben und unten: In den als Dekoration dienenden Nischen, die aus weißem Lehm geformt und mit kleinen Zweigen verstärkt wurden, stehen verschiedene Gegenstände und religiöse Bildnisse. In einer Tür, die den Vorhof mit dem Innenhof des Hauses verbindet, stehen Frauen, die sich in »Purdahs« oder Schleier gehüllt haben, die sie vor den Blicken Fremder schützen sollen.

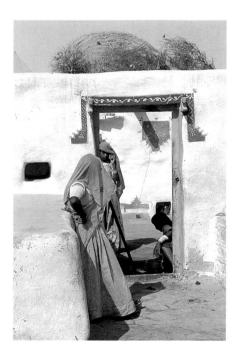

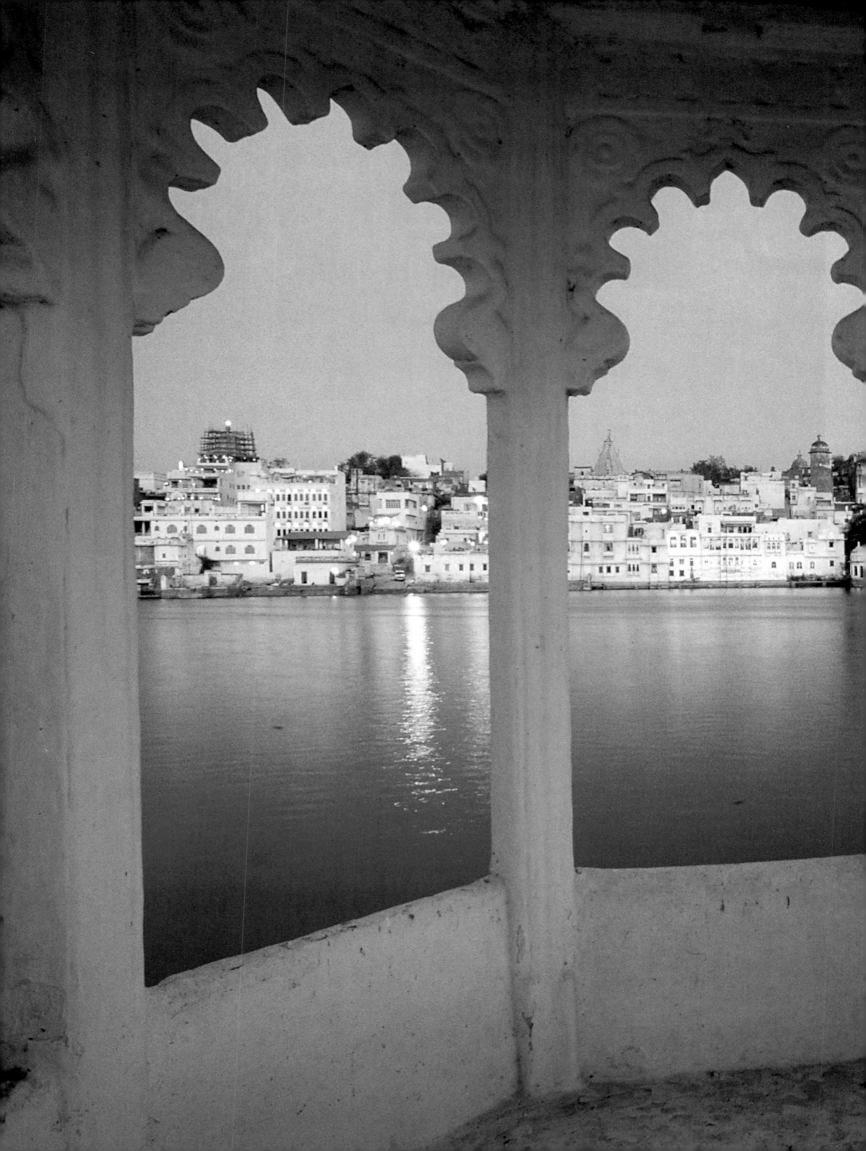

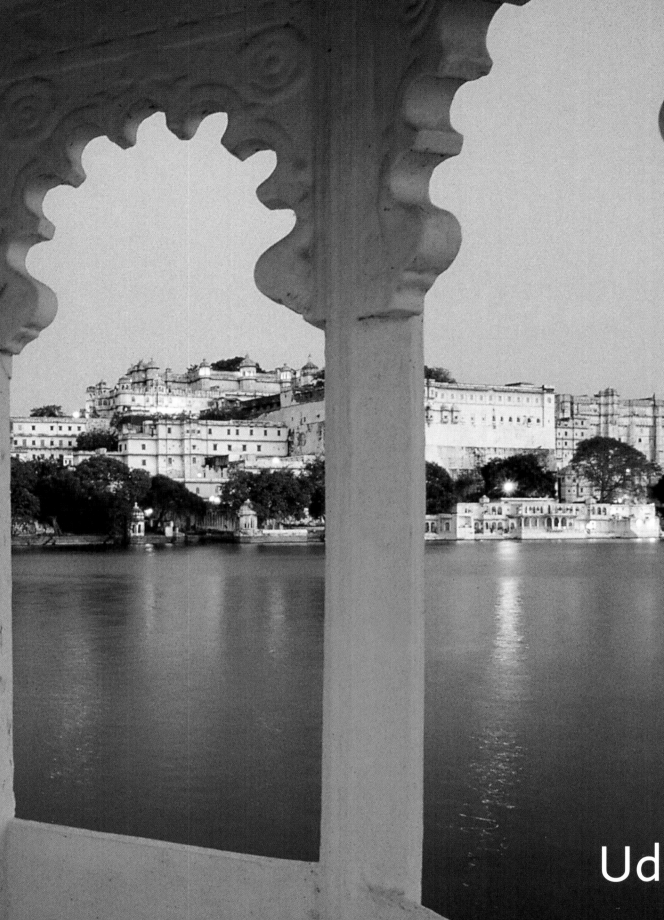

Udaipur

Nichée au cœur d'un décor de rêves, avec ses lacs, ses ruisseaux et ses montagnes escarpées, Udaipur, la «Ville du soleil levant», associe une beauté lumineuse à un passé tumultueux et sanglant. Elle fut fondée en 1567 par Udai Singh après que l'empereur mongol Akbar eut détruit la capitale voisine du Mewar, Chittorgarh. Au cours de ce sac, des milliers de femmes et d'enfants, incités par les reines, préférèrent le suicide collectif à la capture. La famille régnante d'Udaipur, les Sisodia Rajput, au pouvoir depuis le 8e siècle, formèrent le premier clan Rajput, ce qui explique que le souverain d'Udaipur porte le titre de «Maharana», ou grand guerrier. Le joyau central de la ville est le lac Pichola avec ses deux îles-palais et ses rives bordées de collines, de jardins, de temples et de «havelis». Sur sa rive sud, à demi flottant sur l'eau, se dresse le Haveli Amet, ses pavillons aux arches en éventail offrant une vue superbe sur le lac. Il appartient depuis 1680 à une vieille famille féodale originaire du village d'Amet.

Amet Haveli

Set in a dream landscape of lakes, streams and rugged hills, Udaipur, the "City of Sunrise", is one city in Rajasthan that combines luminous beauty with a blood-soaked history. It was founded in 1567 by Udai Singh after the final sack of Chittorgarh, the nearby capital of Mewar, by the Moghul Emperor Akbar during which thousands of women and children led by the royal queens committed ritual suicide to avoid risking capture by the enemy. Udaipur's ruling line of Sisodia Rajputs, unbroken since the 8th century, are the premier Rajput clan, which is why Udaipur's ruler carries the title of "Maharana" or Great Warrior. The city's jewel-like centrepiece is Lake Pichola, studded with two island-palaces and surrounded by hills, gardens, temples and "havelis". Partially afloat on the southern bank of the lake stands Amet Haveli, its pavilions with peacock-tail arches commanding superb views of the distant shore. It belongs to an old feudal family, who hail from the village of Amet, and has been in their possession since 1680.

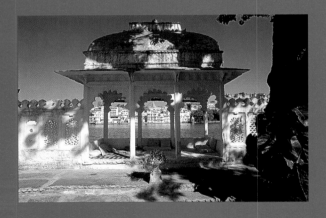

Inmitten einer verträumten Landschaft aus Seen, Flüssen und zerklüfteten Hügeln liegt Udaipur, die »Stadt des Sonnenaufgangs«. Sie ist einer der Orte Rajasthans, deren leuchtende Schönheit sich mit einer weit zurückreichenden, blutgetränkten Geschichte verbindet. Die Stadt wurde 1567 von Udai Singh gegründet, nachdem Chittaurgarh, die nahegelegene Hauptstadt von Mewar, endgültig von dem Mogul-Kaiser Akbar geplündert worden war. Unter der Führung der königlichen Familie begingen während der Eroberung Tausende von Frauen und Kindern Selbstmord, um der Gefangennahme durch den Feind zu entgehen. Udaipurs Herrschergeschlecht der Sisodia-Rajputen, das seit dem 8. Jahrhundert regiert, ist das älteste und vornehmste unter den Rajputen. Daher führen die Herrscher von Udaipur den Titel »Maharana« – großer Krieger. Das einem Juwel gleichende Herzstück der Stadt, der Pichola-See, in dem zwei Inselpaläste liegen, ist von Hügeln, Gärten, Tempeln und »Havelis« umgeben. Am südlichen Ufer des Sees, zum Teil vom Wasser umflutet, steht das Amet Haveli, dessen Pavillons mit ihren Fächerbögen eine herrliche Aussicht auf das entfernte Ufer bieten. Es gehört seit 1680 einer alten Adelsfamilie, die aus dem Dorf Amet stammt.

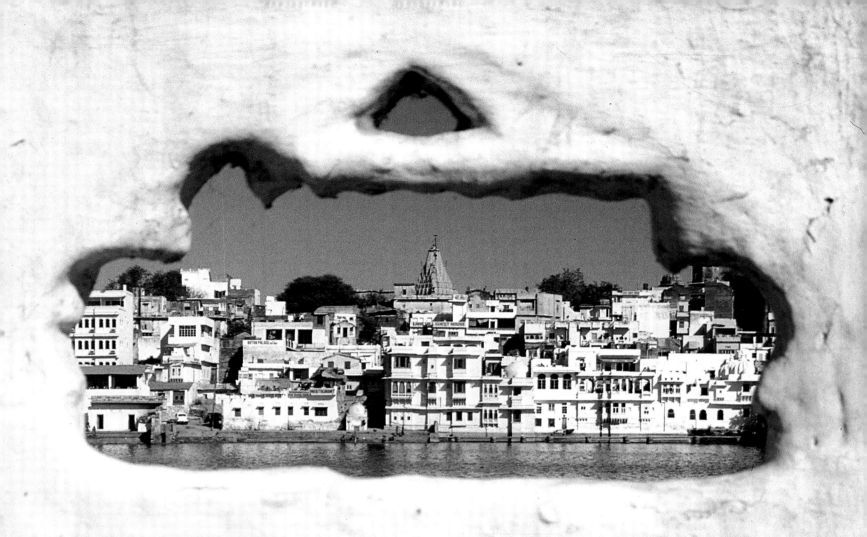

Right: *view into the bedroom through the familiar peacock arches. Small windows with coloured glass panes help reduce the bright glare. The stone floors are covered with cotton "dhurries".*
Below: *Amet Haveli's all-white, limed-washed interiors, built entirely of stone, are supported by pillars connected by peacock-tail arches of varying width. A rough-edged piece of white marble on a painted iron base serves as the dining table.*

A droite: *la chambre à coucher, avec son arche en éventail. Les petites fenêtres aux panneaux de verre colorés permettent de filtrer la lumière trop crue. Les sols en pierre sont recouverts de «dhurries» en coton.*
Ci-dessous: *Les murs en pierre, blanchis à la chaux, sont soutenus par des colonnes reliées entre elles par des arches en éventail d'ampleur variable. La table de la salle à manger est une grande dalle de marbre aux bords bruts, posée sur des pieds en métal peints.*

Rechts: *eine Ansicht des Schlafzimmers durch die bereits vertrauten Fächerbögen. Die kleinen Fenster mit Buntglasscheiben dienen dazu, das grelle Sonnenlicht zu dämpfen. Auf den Steinböden liegen Baumwollteppiche – sogenannte »Dhurries«.*
Unten: *Die Innenräume des Amet Haveli, die alle mit einem weißen Kalkverputz versehen und zur Gänze aus Stein gebaut sind, werden durch Arkaden mit Fächerbögen gegliedert. Eine weiße Marmorplatte mit unregelmäßigem Rand, die auf einem grünen Eisengestell ruht, dient als Eßtisch.*

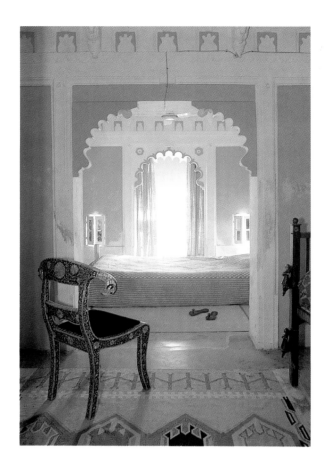

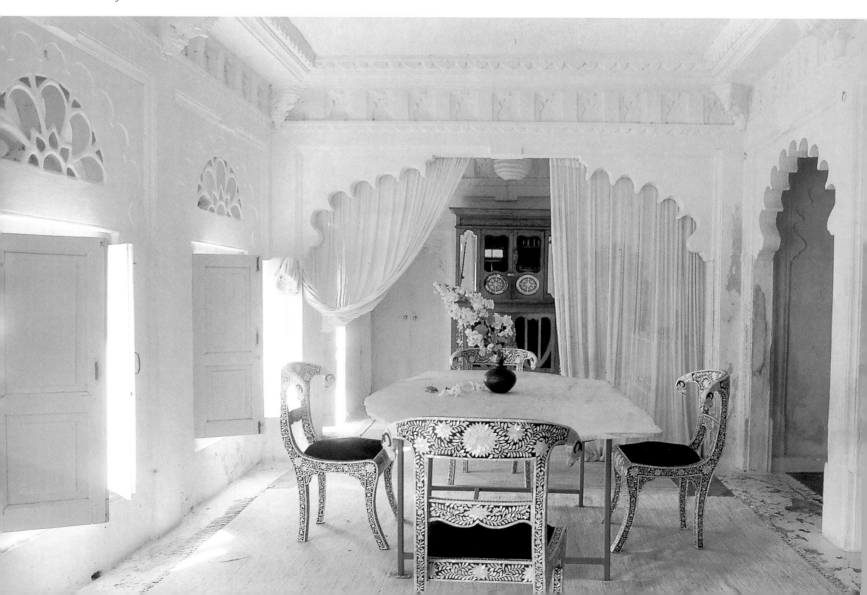

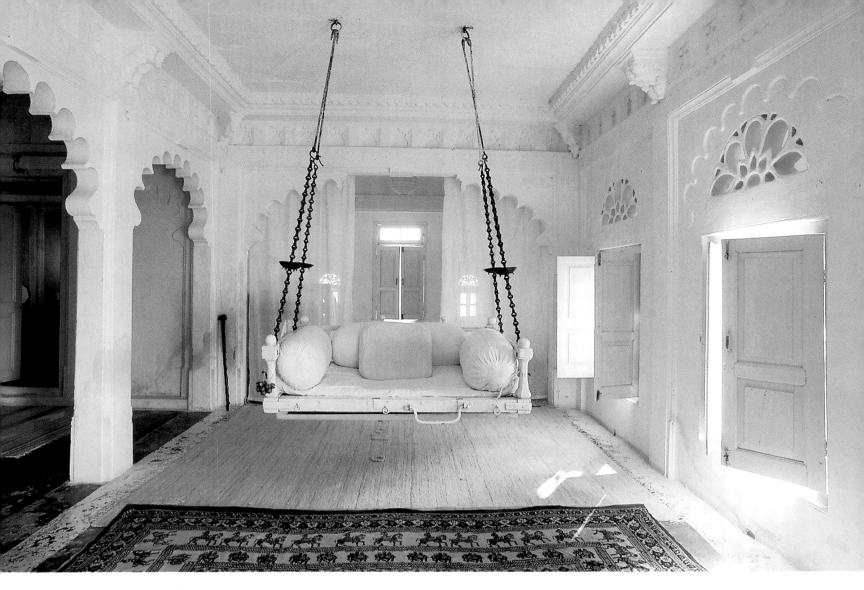

Above: A white-painted swing in the living room, suspended on ornamental chains from the stone ceiling, looks on to views of the lake. The low windows, surmounted with fanlights with panes of amber glass, also open onto lakeviews.
Right: The peacock-arch is repeated on a bricked-in wall of the bedroom, which is furnished with an ornamental bed, a carved wooden screen, painted white, and a couple of old brass water pots.

Ci-dessus: Dans le salon, la balançoire blanche, suspendue au plafond en pierre par des chaînes ornementales, est orientée vers le lac afin de jouir de la vue. Les fenêtres basses, surmontées de panneaux de verre ambré en demi-lune, donnent également sur le lac.
A droite: On retrouve l'arche en éventail dans le mur en briques de la chambre, meublée avec un lit ornemental, un paravent blanc en bois sculpté et des cruches anciennes en cuivre.

Oben: Auf einer weißgestrichenen Schaukel im Wohnzimmer, die an kunstvoll verzierten Ketten von der Steindecke hängt, kann man die Aussicht auf den See genießen. Die niedrigen Fenster, deren Oberlichter mit bernsteinfarbenen Glasscheiben versehen sind, geben ebenfalls die Aussicht auf den See frei.
Rechts: Der Ziegelmauer des Schlafzimmers sind Fächerbögen vorgeblendet. Die Einrichtung besteht aus einem reich verzierten Bett, einem weiß angestrichenen, aus Holz geschnitzten Wandschirm und zwei alten Wasserkrügen aus Messing.

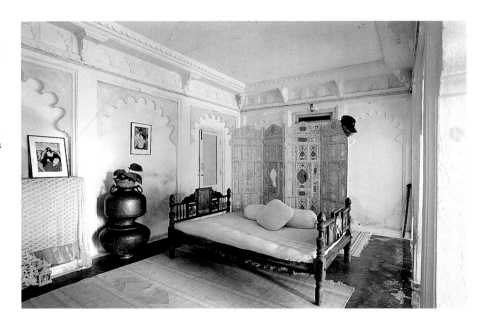

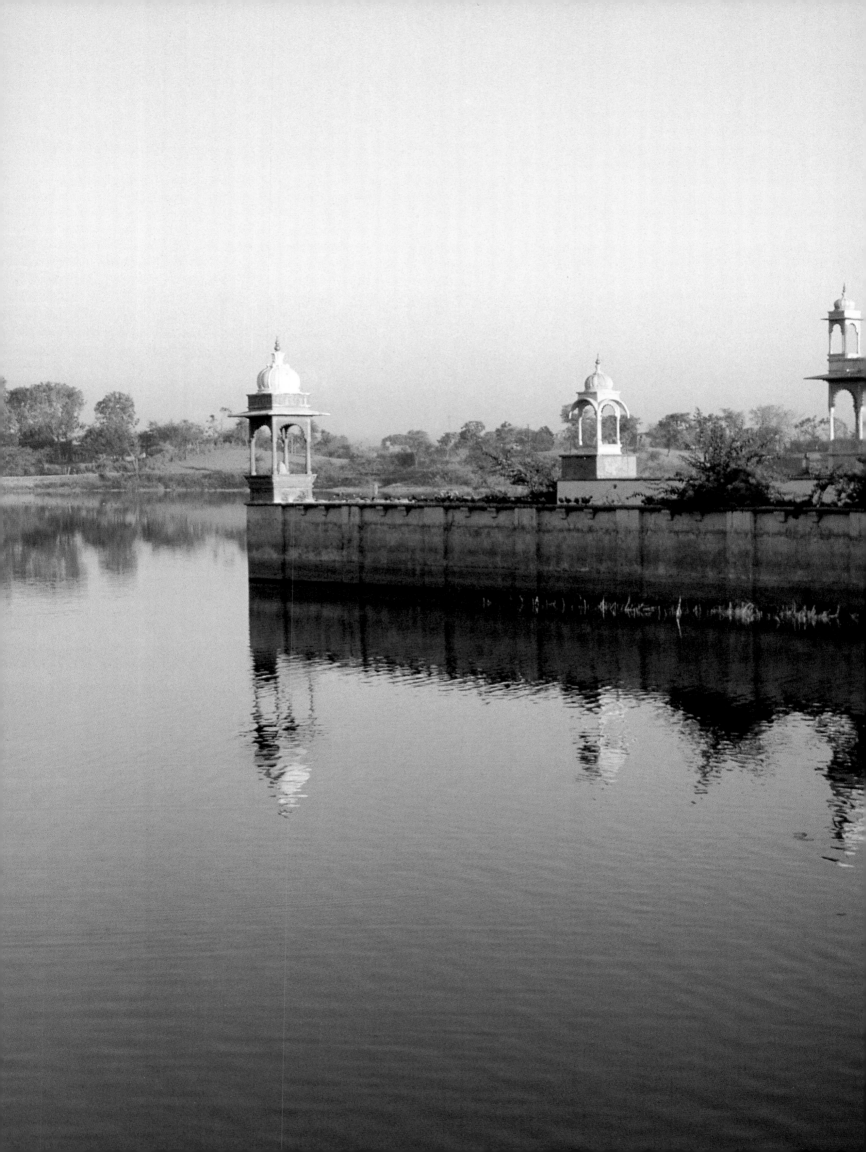

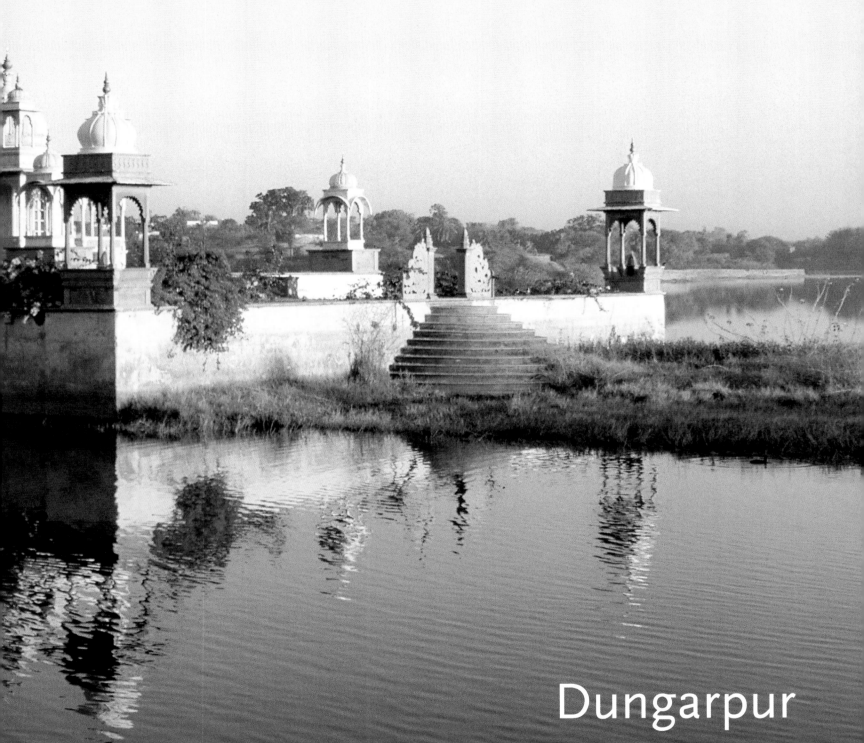

Dungarpur

A deux pas de la grand-route qui relie Udaipur à Ahmadabad se cache un joyau princier du Rajasthan. Baignant dans une lumière ambrée, la ville de Dungarpur est nichée dans un décor immuable de collines escarpées, de temples en ruines, de lacs tranquilles et de forêts mystérieuses. Elle fut fondée au 13e siècle par une branche de la maison régnante d'Udaipur, le clan des Rajput, mais ses principaux palais firent leur apparition bien plus tard. Udai Bilas, construit au bord d'un lac auquel on accède par une route qui traverse la jungle, fut achevé au milieu du 19e siècle lorsque Udai Singh II lui ajouta une somptueuse aile supplémentaire revêtue de la pierre bleu gris locale. Les nouveaux bâtiments furent érigés autour d'une cour au centre de laquelle s'élève une superbe folie suspendue en porte-à-faux sur un pilier unique. L'une des dernières grandes cérémonies qui s'y tint fut le mariage d'une princesse de Dungarpur en 1948. Les invités royaux – ci-contre – furent logés dans des appartements aux plafonds incrustés de miroirs et au sol en verre, tel que celui de la page de droite.

Udai Bilas Palace

Just off the main highway that links the cities of Udaipur and Ahmedabad lies a secret of princely Rajasthan preserved in amber light. The town of Dungarpur is hidden in an unchanged landscape of rugged hills, temple ruins, placid lakes and secluded forests. Dungarpur was founded in the 13th century by a branch of Udaipur's ruling house, the premier clan of Rajputs, but its main palaces were built much later. The lakeside Udai Bilas Palace, approached by a drive through the jungle, was completed in the mid-19th century when Udai Singh II built a sumptuous wing clad in the local bluish-grey stone. The new buildings were added round a courtyard from which rises a glorious folly cantilevered on a single central pillar. One of the last great celebrations held here was the wedding of a Dungarpur princess in 1948 when royal guests, in the picture above, occupied suites with mirrored ceilings and glass floors, such as the one on the facing page.

Ganz in der Nähe der großen Landstraße, die Udaipur mit Ahmedabad verbindet, liegt – von bernsteinfarbenem Licht beschienen – eines jener unberührten Geheimnisse des Fürstentums von Rajasthan. Die Stadt Dungarpur liegt versteckt in einer unverändert gebliebenen Landschaft aus zerklüfteten Hügeln, Tempelruinen, Seen und abgelegenen Wäldern. Dungarpur wurde im 13. Jahrhundert gegründet, von einem Zweig der Herrscherfamilie Udaipurs, dem Hauptstamm der Rajputen-Dynastie. Die bedeutendsten Paläste der Stadt wurden jedoch wesentlich später gebaut. Der Udai Bilas Palace am Ufer des Sees, zu dem man über eine durch den Dschungel führende Straße gelangt, wurde Mitte des 19. Jahrhunderts fertiggestellt. Damals vollendete Udai Singh II. einen luxuriös gestalteten Gebäudeflügel, der mit dem für die Gegend typischen blaugrauen Steinen verkleidet wurde. Die neuen Gebäude wurden um einen Innenhof gruppiert, in dem sich ein prachtvoller Zierbau auf einer einzigen Säule erhebt. Eines der letzten großen Feste im Udai Bilas Palace war die Hochzeit einer Prinzessin von Dungarpur im Jahre 1948. Die königlichen Gäste – hier in der Abbildung oben – wohnten in Suiten mit Decken aus Spiegelglas und Glasböden, die dem auf der rechten Seite abgebildeten Raum glichen.

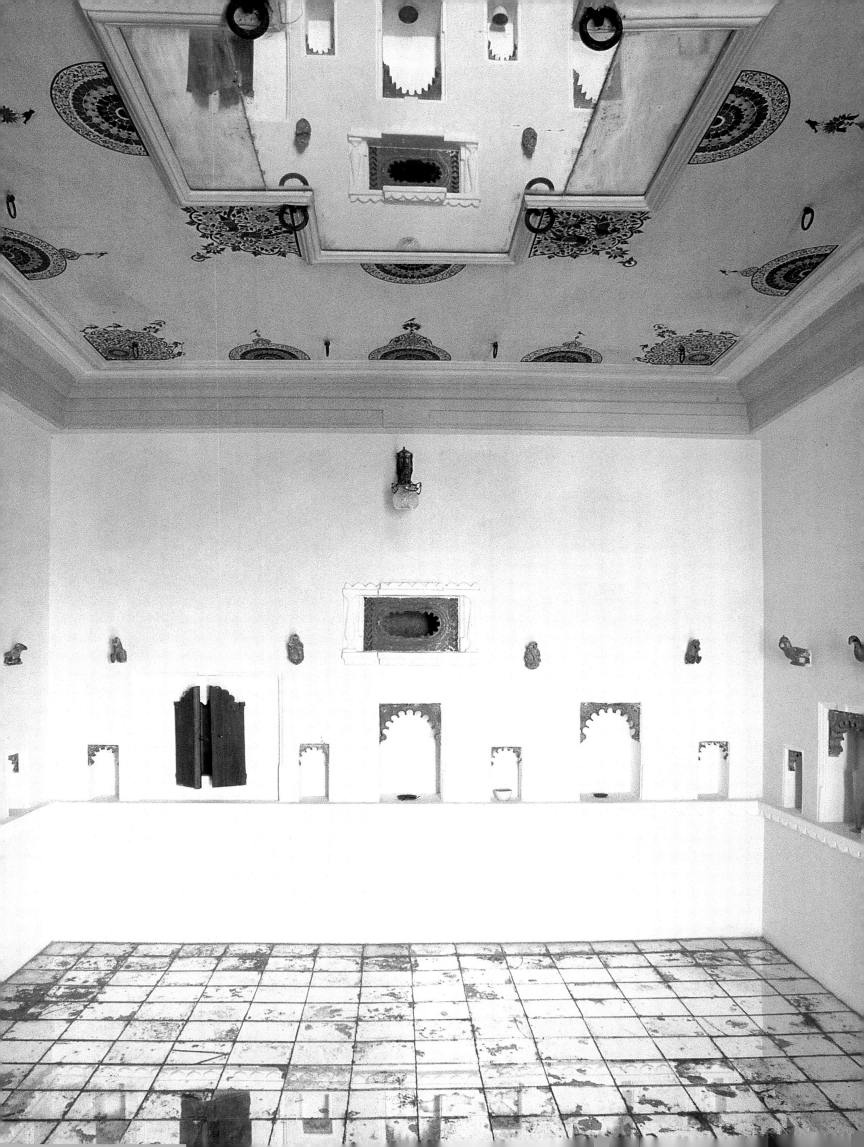

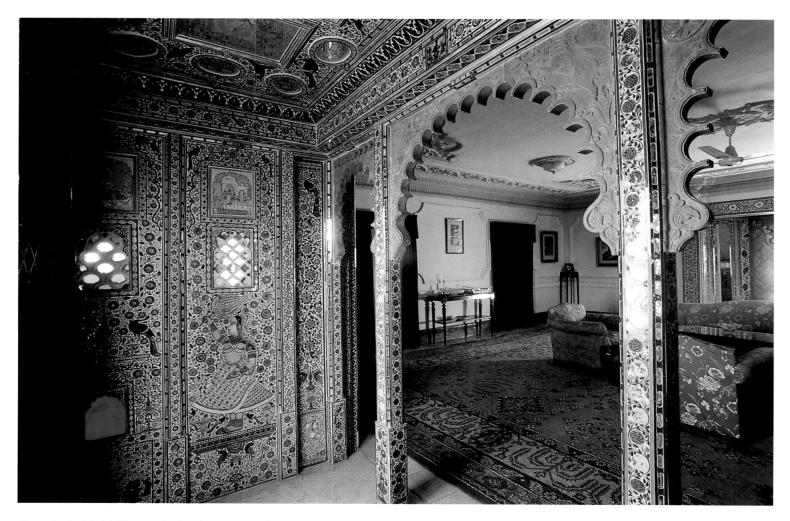

Above: A suite in Udai Bilas, appointed in the European style, nevertheless boasts intricately inlaid mirror-work walls, considered the most exquisite in Rajasthan.
Right: a cool, all-white hexagonal bathroom with a European bathtub.
Facing page: A staircase leading to the Dungarpur family's private apartments is lined with "shikar" specimens and photographs.
Following pages: Unaltered since it was decorated in the 1940s, nothing in the dining room at Udai Bilas has been touched, from the hunting trophies on the walls to the carved roof of Burma teak and the made-to-order carpet woven in Bikaner.

Ci-dessus: un appartement meublé à l'européenne mais conservant néanmoins ses murs incrustés de fines marqueteries en miroirs, sans doute les plus raffinées du Rajasthan.
A droite: la fraîcheur d'une salle de bains hexagonale toute carrelée de blanc, avec une baignoire à l'européenne.
Page de droite: L'escalier qui mène aux appartements privés de la famille royale de Dungarpur est tapissé de spécimens de «shikar» et de photographies.
Double page suivante: Depuis sa dernière décoration au cours des années 40, rien n'a changé dans la salle à manger, ni ses trophées de chasse, ni son toit en teck birman sculpté, ni son tapis tissé sur mesure à Bikaner.

Oben: Diese Suite im Udai Bilas Palace ist zwar im europäischen Stil eingerichtet, ihre Wände prunken jedoch mit feinsten Einlegearbeiten aus Spiegelglas. Diese Intarsien gelten als die vorzüglichste Arbeit dieser Art in ganz Rajasthan.
Rechts: ein kühles, vollkommen weißes, sechseckiges Badezimmer mit einer europäischen Badewanne.

Rechte Seite: In dem Treppenhaus, das zu den Privatgemächern der Familie führt, hängen Fotografien und Trophäen der »Shikar« – der Jagd.
Folgende Doppelseite: Das Eßzimmer im Udai Bilas Palace ist seit den vierziger Jahren unverändert geblieben. Alles blieb unberührt: die Jagdtrophäen an den Wänden, die geschnitzte Decke aus birmanischem Teakholz und die eigens für diesen Raum gewebten Teppiche aus Bikaner.

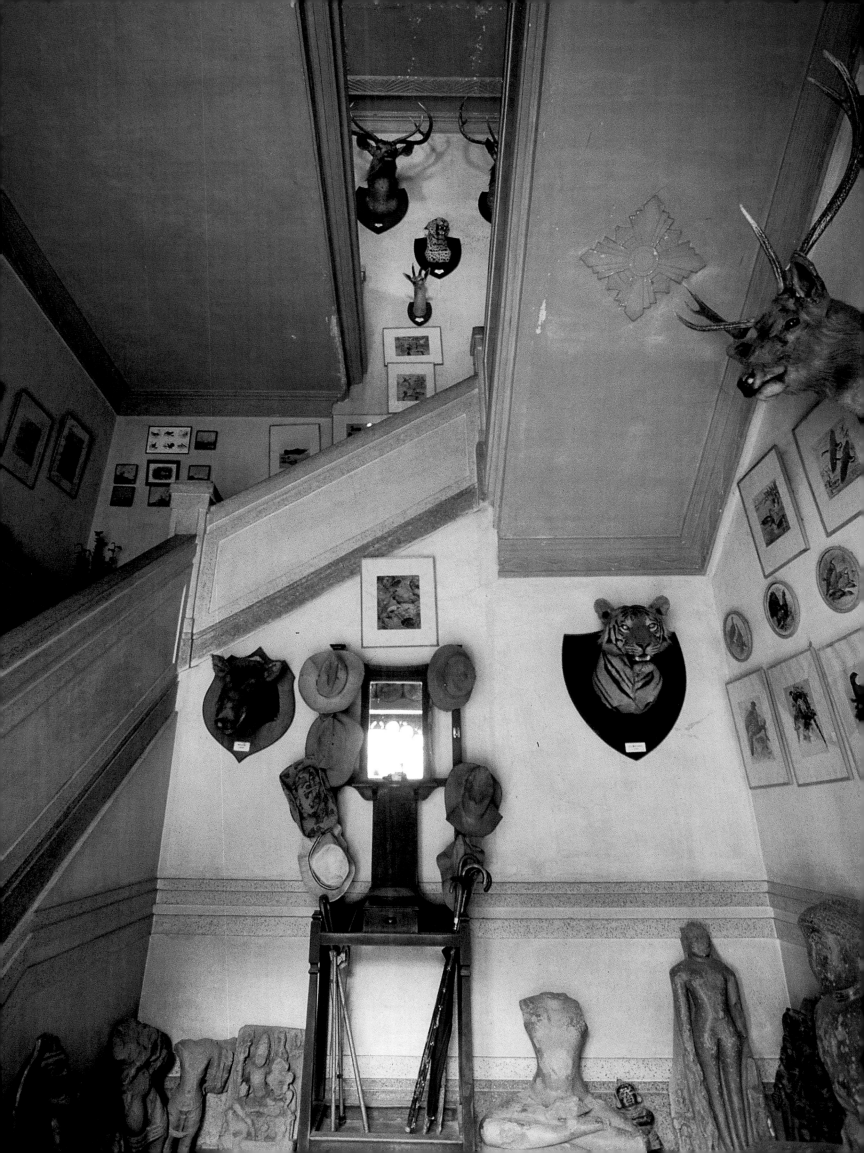

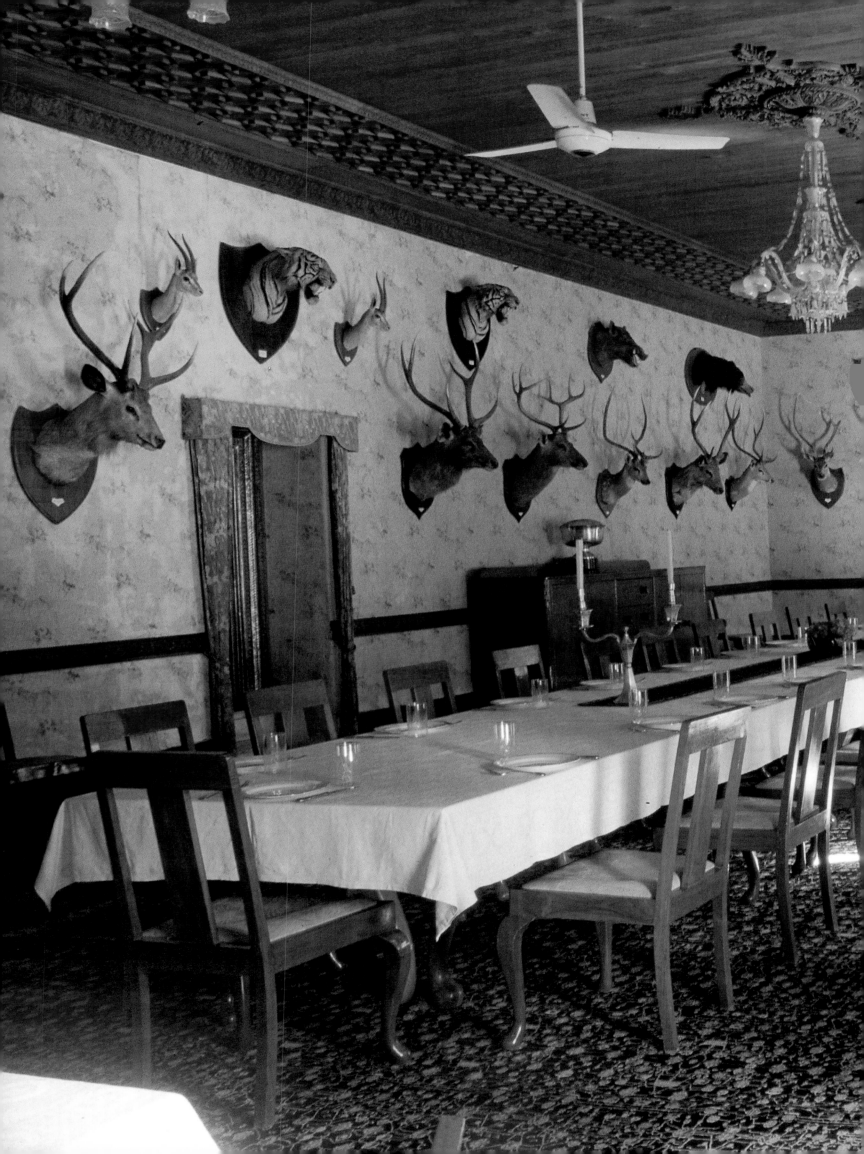

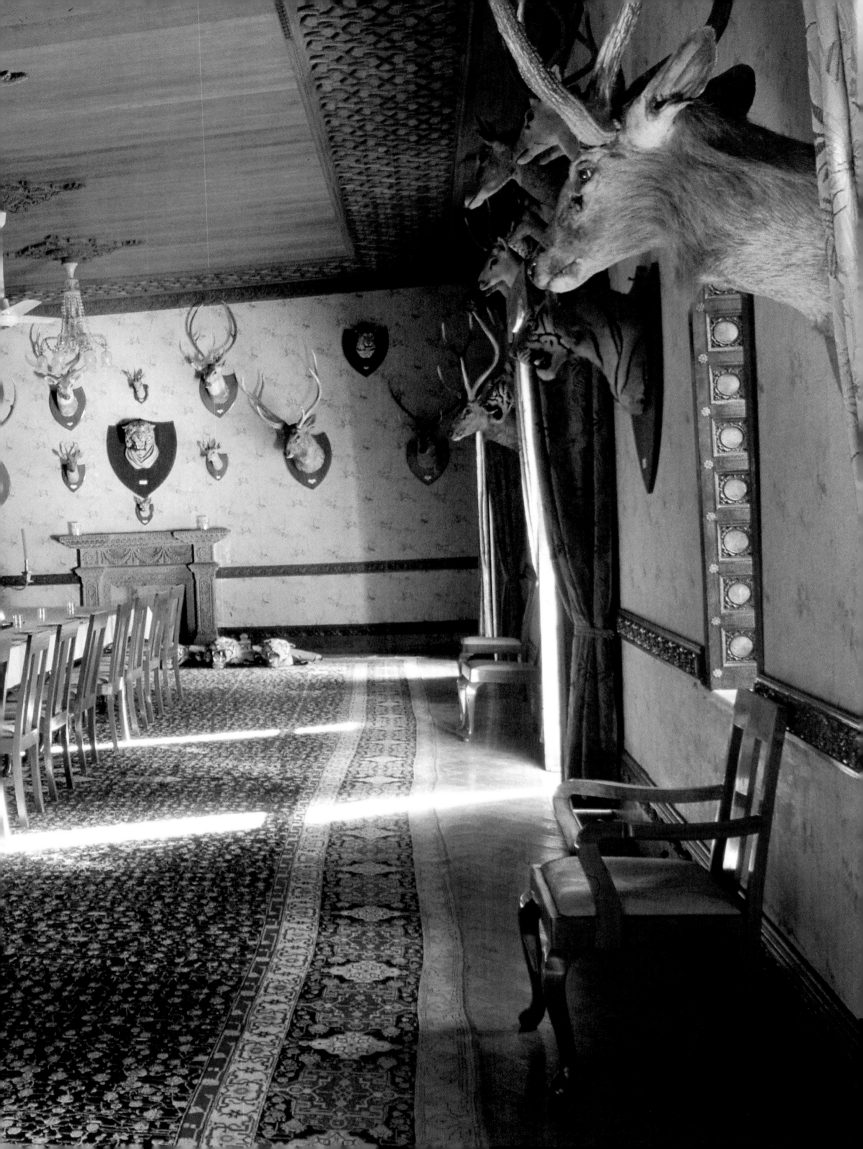

Juna Mahal

The Juna Mahal, or Old Palace, at Dungarpur is a vast fortress-like structure, with crenellated walls, turrets, terraces and overhanging balconies of cream-coloured stucco. Its location at the crest of a rocky hill was chosen as a natural defence against invaders and the warren of narrow passages inside acted as further barriers against intruders. Juna Mahal's earliest foundations date from the 13th century but later additions have resulted in a rambling architectural complex that rings with the sound of medieval romance and adventure. Equally impressive is the quality of craftsmanship in its decoration, such as the exquisite sculptural frieze of dancing women between brackets that support a balcony or the magnificent 19th-century gilded frescoes, showing Udai Singh II in a ceremonial procession, on the walls of his private chambers. One reason for the fine preservation of Juna Mahal's interiors is that it remains in the private possession of the princely family of Dungarpur.

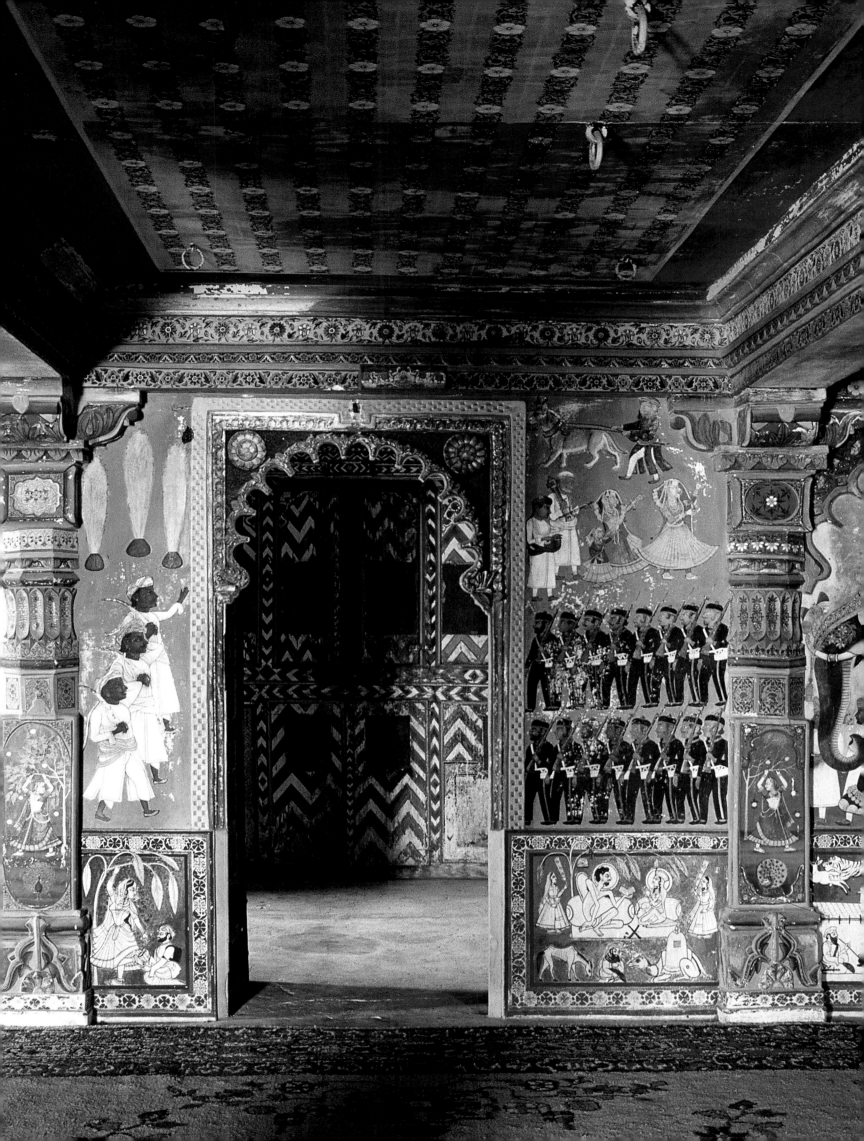

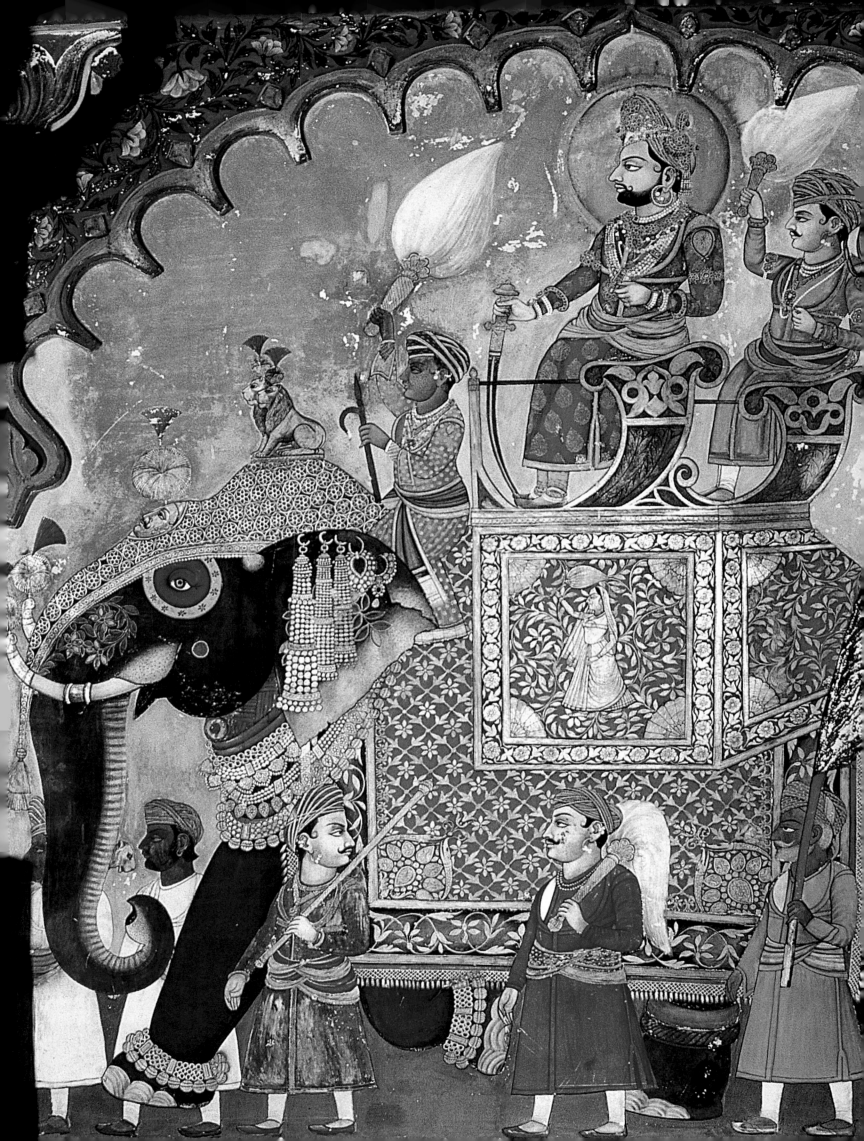

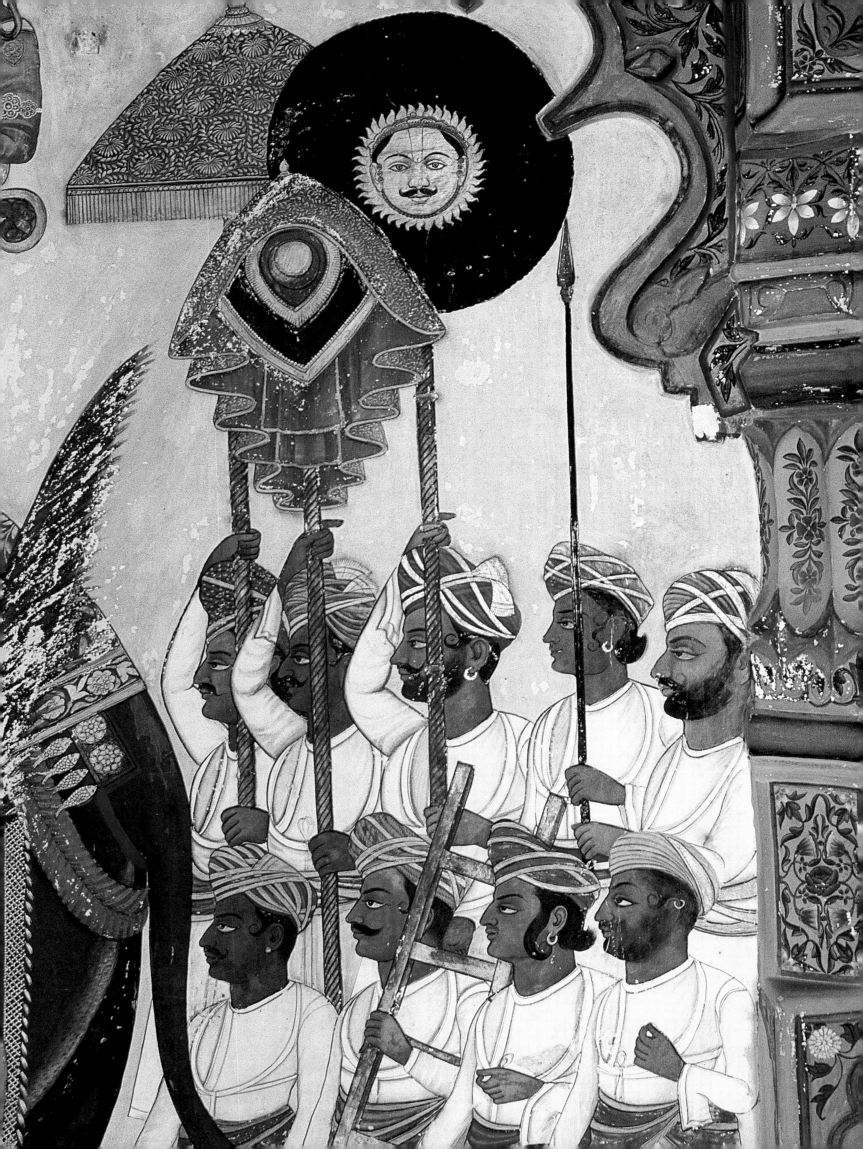

Right: Both sides of a painted cupboard in the "Aam Khas" library are covered in religious icons and paintings of animals.
Below: The main bedroom in the "Aam Khas" is a dazzling fantasy of intricate inlaid mirror-work, incorporating portraits of the ruler, and surrounded by floral and animal motifs. The floor is laid with mirrored and painted tiles.

A droite: Cette armoire peinte dans la bibliothèque de l'«Aam Khas» est flanquée d'images d'animaux et de peintures religieuses.
Ci-dessous: L'étourdissant décor en marqueterie de miroirs de la chambre principale de l'«Aam Khas» inclut des portraits du souverain bordés de motifs animaux et végétaux. Le sol est en miroirs et en carreaux peints.

Rechts: Der reich verzierte Wandschrank in der Bibliothek des »Aam Khas« ist mit Tierbildern und religiösen Szenen bemalt.
Unten: Das große Schlafzimmer im »Aam Khas« ist ein einziger, das Auge blendender Rausch aus filigranen Spiegelglas-Intarsien. Dazu gehört auch ein Herrscherporträt, umgeben von Blumen- und Tiermotiven. Der Boden ist mit verspiegelten und bemalten Fliesen ausgelegt.

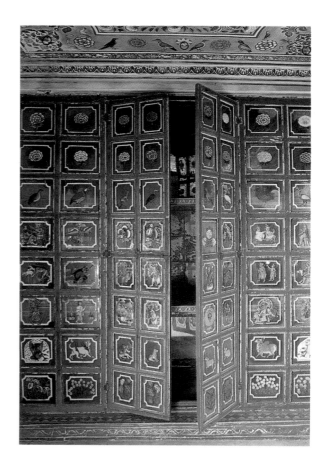

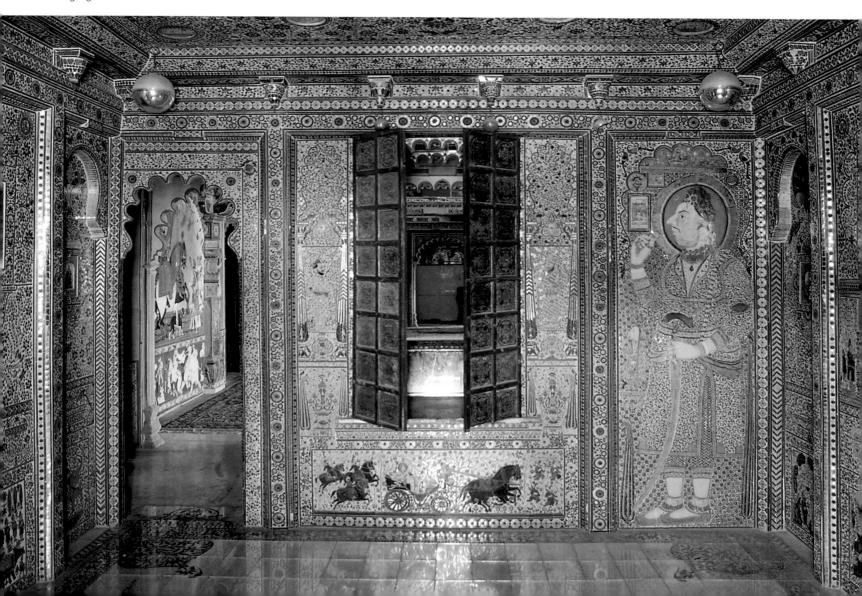

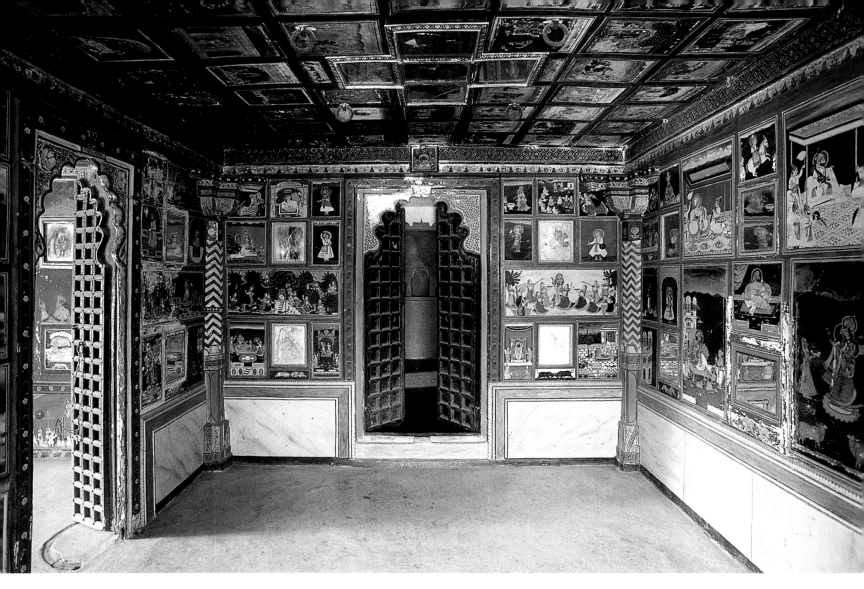

Above: Frescoes of Dungarpur's rulers and scenes from religious epics decorate the walls of a sixth floor chamber in Juna Mahal.
Right: The walls and ceiling of the ruler's private apartment, known as the "Aam Khas", are decorated with mythological sequences, including 365 scenes from the Mahabharata, the famous Indian epic.
Following pages: The "Durbar Hall" or throne room of the Dungarpur rulers is decorated with frescoes of hunting scenes on the walls. The embroidered velvet seat and bolster was the ruler's "gaddi" or throne. Doors to a room in the "Aam Khas" are inlaid with lotus vines in coloured glass alongside a painted panel of the baby Krishna peacefully floating in a lotus pond.

Ci-dessus: Les murs d'une salle au sixième étage du palais sont décorés de fresques représentant les souverains de Dungarpur et des scènes inspirées d'épopées religieuses.
A droite: Les murs et le plafond de l'«Aam Khas», appartement privé du souverain, sont ornés de scènes mythologiques, dont 365 épisodes du Mahabharata, le plus grand récit épique indien.
Doubles pages suivantes: Le «Durbar Hall», ou salle du trône, est décoré avec des fresques représentant des scènes de chasse. Le souverain trônait sur le «gaddi», un coussin et un traversin en velours brodé. Les battants d'une porte de l'«Aam Khas» sont incrustés de fleurs de lotus en verre coloré. A côté, un panneau représentant Krishna bébé, paisiblement endormi sur une feuille de lotus flottant dans une mare.

Oben: Fresken mit Darstellungen von Dungarpurs Herrschern und Szenen aus religiösen Epen verzieren die Wände eines der Räume im sechsten Stock des Juna Mahal.
Rechts: Die Wände und Decken der Privatgemächer des Herrschers, die »Aam Khas« genannt werden, sind mit mythologischen Darstellungen dekoriert, zu denen auch 365 Szenen aus dem wichtigsten indischen Epos, dem Mahabharata, gehören.
Folgende Doppelseiten: Der Thronsaal der Herrscher von Dungarpur – die »Durbar Hall« – ist mit Fresken dekoriert, auf denen Jagdszenen dargestellt sind. Der mit Stickereien verzierte Samtsitz und die Polster dienten als Thron oder »Gaddi«. Eine der Türen im »Aam Khas« ist mit bunten Glas-Intarsien in Form einer sich emporrankenden Lotosblume gestaltet. Die Wand daneben zeigt Krishna als kleines Kind, das in einem Lotosteich treibt.

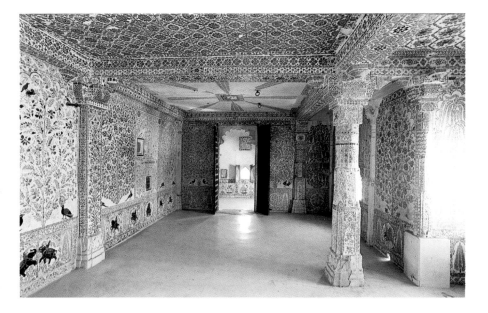

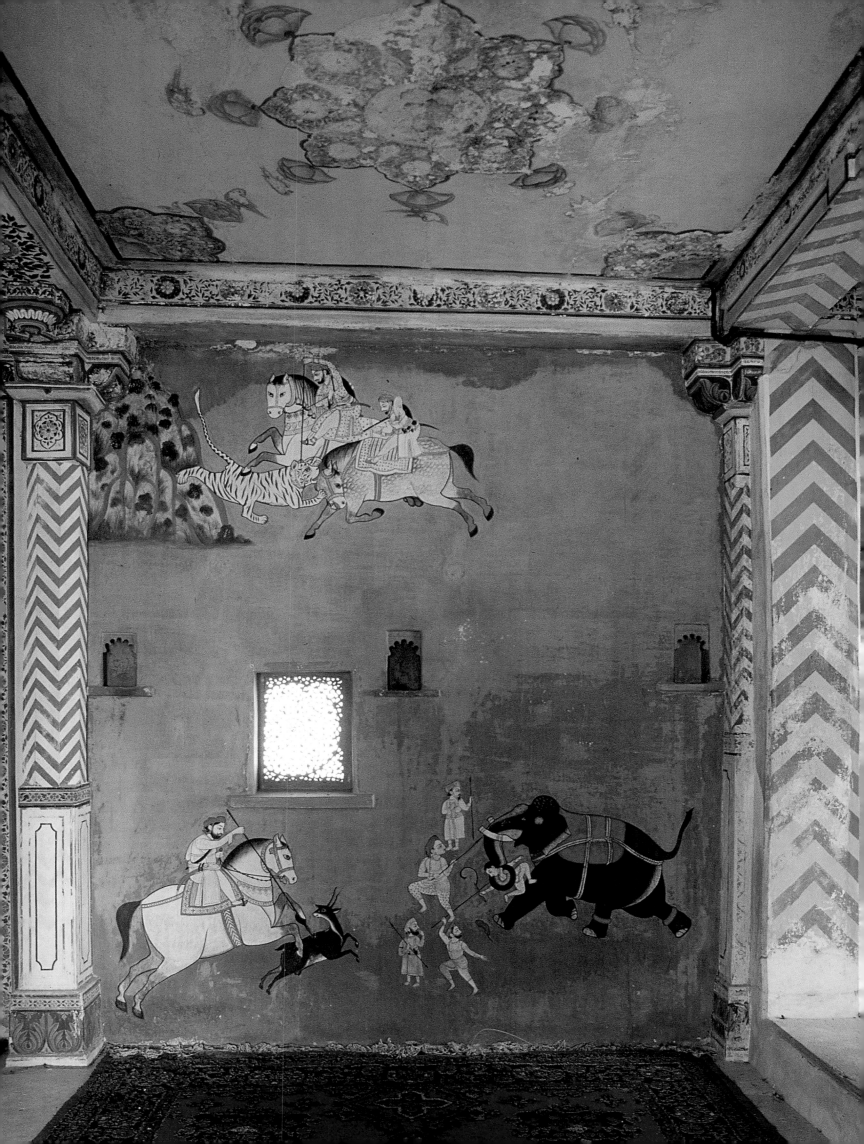

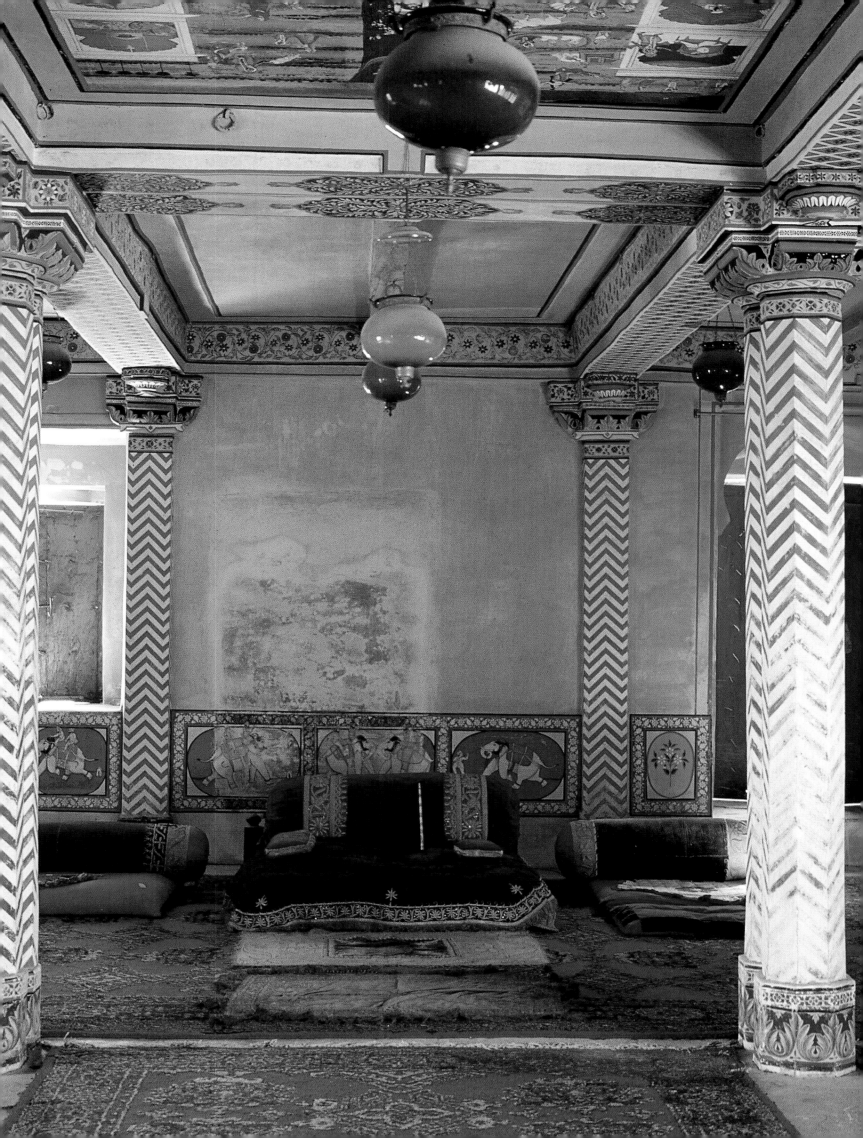

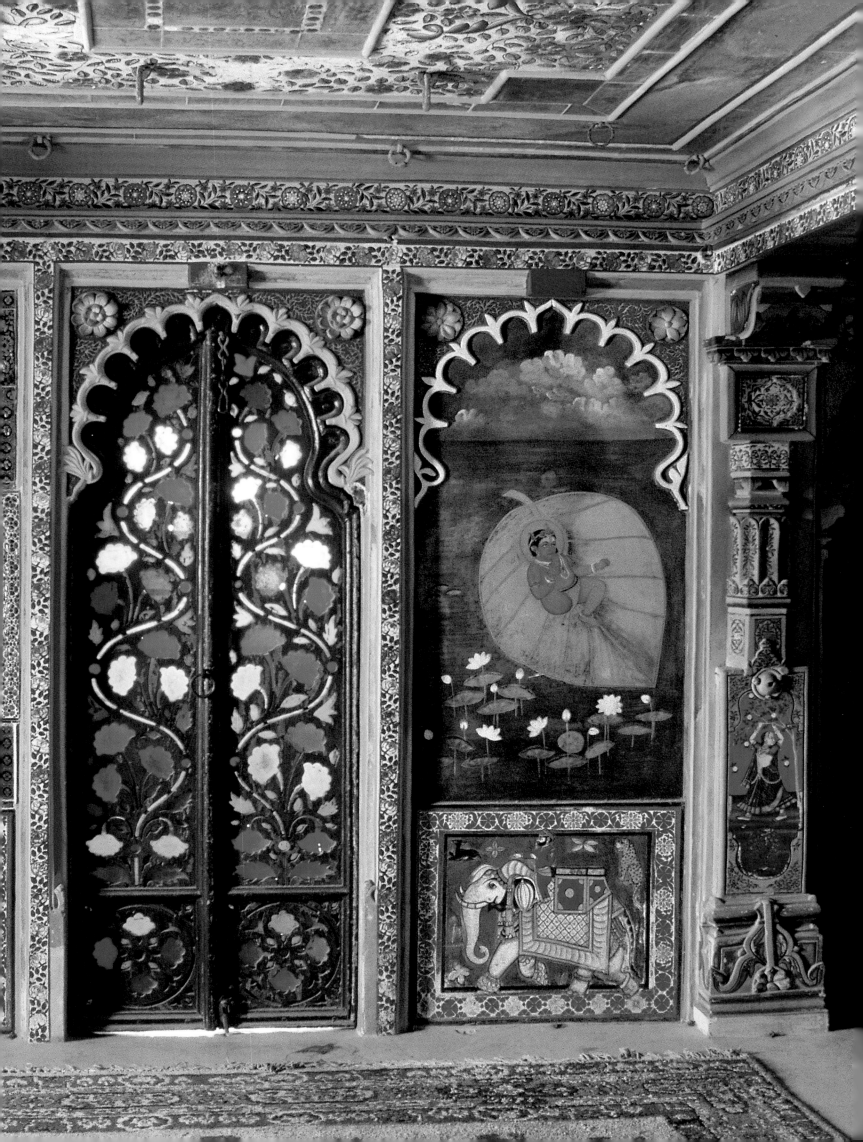

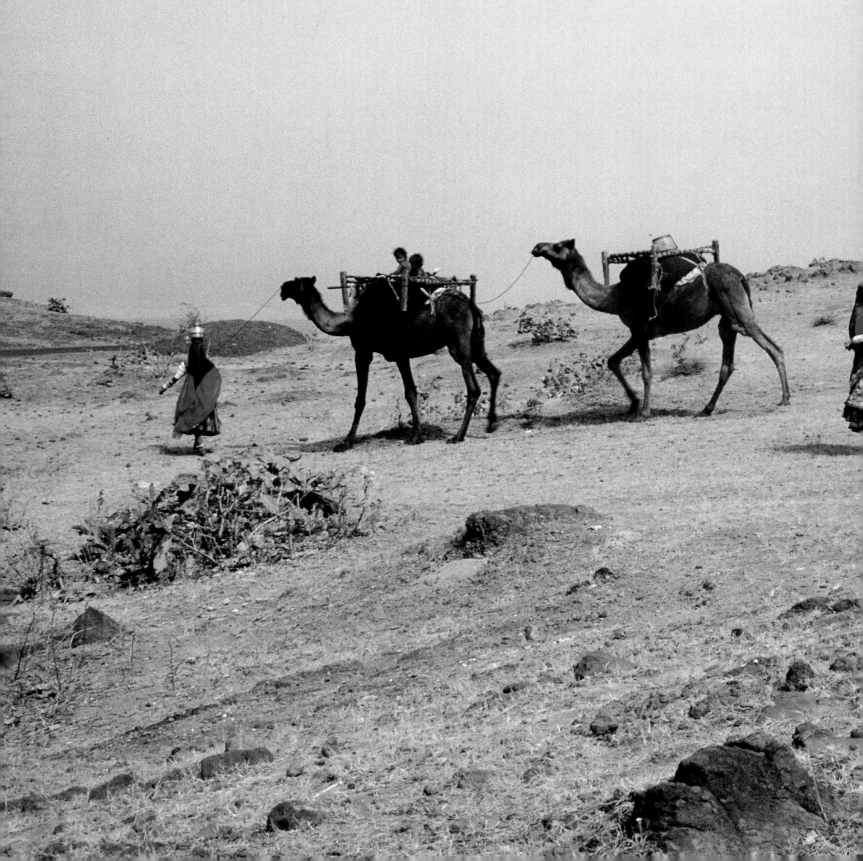

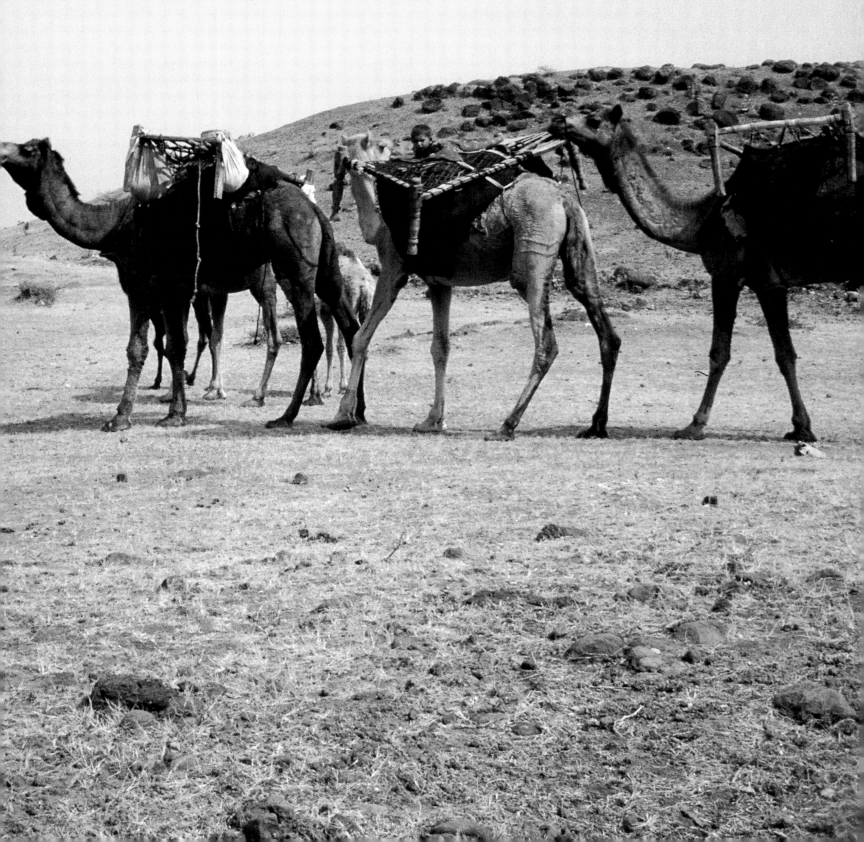

Gujarat

Le Rann de Kutch sur la côte du Gujerat est submergé pendant une partie de l'année puis, lorsque la marée se retire, le ciel prend des teintes bleues de porcelaine et un soleil aveuglant cuit la terre en une croûte dure et étincelante. C'est dans ce paysage austère que vivent les Rabaris, une communauté nomade qui élève des chèvres, des moutons et des chameaux. Chaque année, ils traversent le Gujerat et le Rajasthan en quête de pâturages lors d'une migration. Leur mode de vie et leurs coutumes sont parfaitement adaptés à cette errance saisonnière. De loin, un campement rabari ressemble à un groupe de champignons, chaque hutte ronde étant surmontée d'un toit conique en chaume. Toutefois, ces constructions temporaires, régulièrement enduites de boue et d'argile blanche, sont époustouflantes par leur fonctionnalisme et le raffinement de leur décoration. Non loin des Rabaris vivent les Meghwals, une caste de tanneurs, aux étonnantes maisons font preuve d'un sens aigu de la forme et de la couleur.

Nomadic Huts in Kutch

For part of the year, the Rann of Kutch in coastal Gujarat is submerged in water but once the tides recede the sky turns a porcelain blue and the blinding sun bakes the earth to a glittering, salt-encrusted hardness. The harsh landscape is home to the Rabaris, nomadic communities of goat-, sheep- and camel-herders who wend their way in search of pasture through Gujarat and Rajasthan on annual migrations. Their customs and way of life are set in accordance with their seasonal wanderings. From a distance a Rabari settlement looks like a cluster of toadstools, each circular hut topped by a conical clump of thatch. Yet these dwellings, plastered with mud and clay, are astonishing for their functional design. Not far from the Rabaris live the Meghwals, a caste of leather workers, whose brightly painted homes display a vibrant sense of colour.

Die Rann von Kutch in der Küstenregion von Gujarat steht zu bestimmten Jahreszeiten unter Wasser, aber sobald das Meer sich zurückgezogen hat, nimmt der Himmel eine porzellanblaue Farbe an, und unter der gleißenden Sonne verdorrt die Erde und verhärtet sich zu einer glitzernden, salzverkrusteten Fläche. In dieser kargen Landschaft leben die Rabaris, eine Gemeinschaft nomadisierender Ziegen-, Schaf- und Kamelhirten, die auf ihrer alljährlichen Wanderschaft durch Gujarat und Rajasthan ziehen, immer auf der Suche nach Weideland. Ihre Gebräuche und Lebensart haben sich der jährlichen Wanderschaft angepaßt. Von weitem sieht eine Rabari-Siedlung wie eine Ansammlung von Pilzen aus, denn jede der kreisrunden Hütten ist mit einem kegelförmigen Strohdach gedeckt. Doch überraschen diese Häuser mit ihrem frischen Verputz aus dunklem Lehm und weißem Ton durch ihre zweckmäßige Gestaltung und ihre Dekorationen. Nicht weit von den Rabaris wohnen die Meghwals, eine Volksgruppe, die hauptsächlich Leder verarbeitet und deren bunt gestrichene Häuser einen regen Sinn für Farbe und Form unter Beweis stellen.

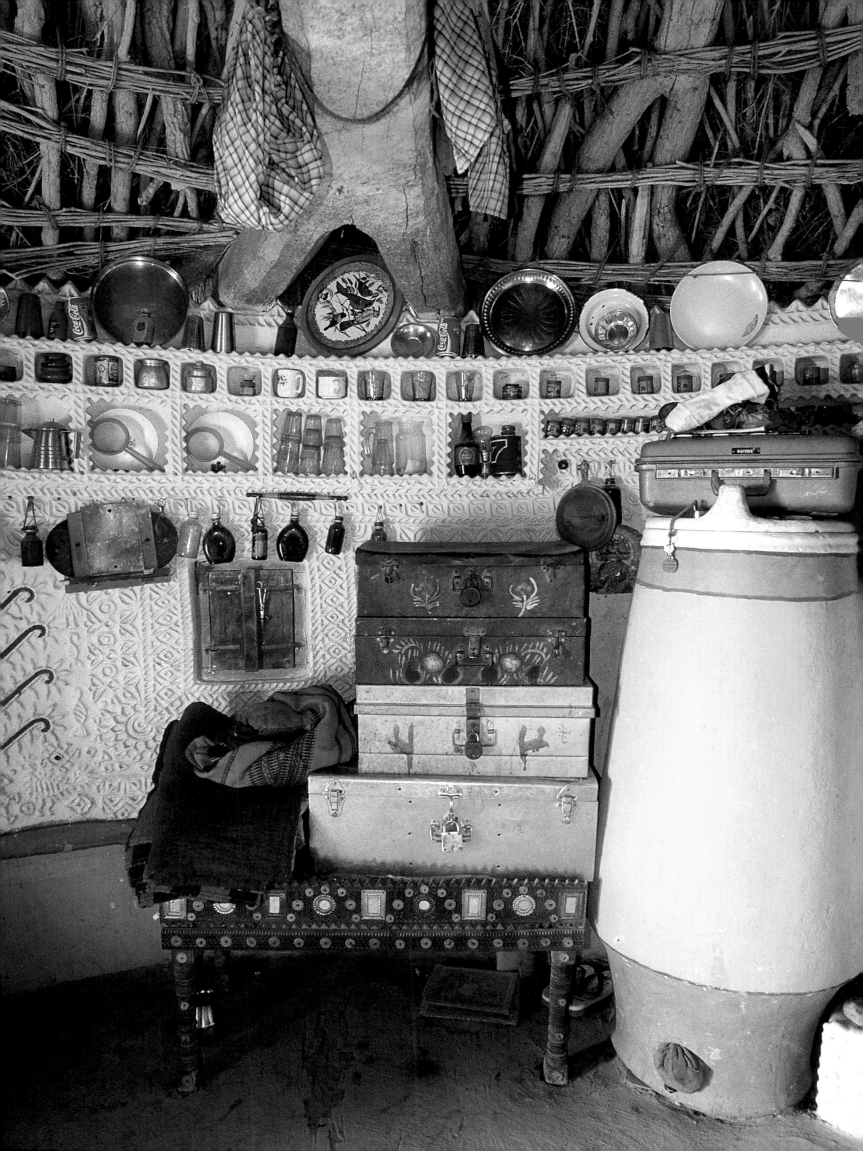

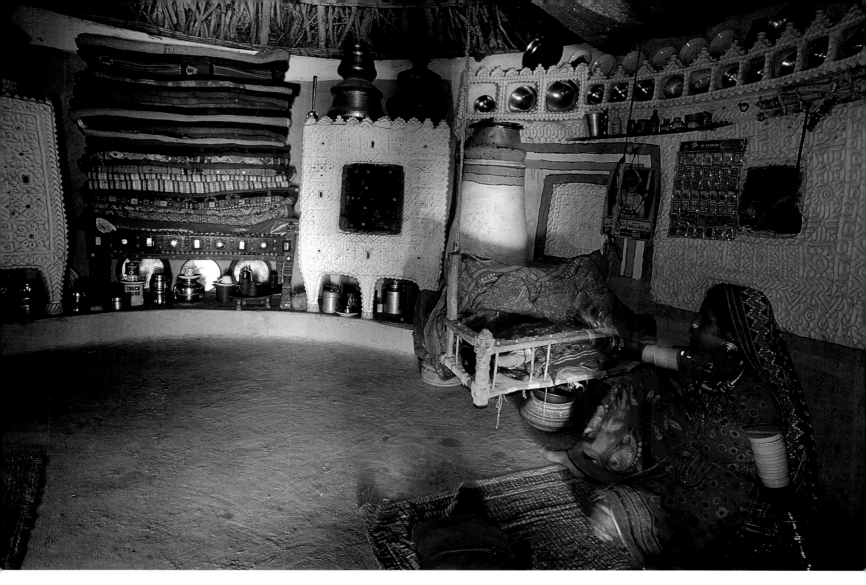

Previous page: A grain storage jar, fashioned by hand from white clay and painted in contrasting colours, dominates a corner of a Rabari hut. Required quantities flow out from the plugged hole at the bottom.
Above: A Rabari woman, minding her baby in a wooden crib slung from the roof, surveys her possessions. Cooking utensils are displayed in niches and patchwork quilts, necessary protection from the cold desert air, are piled up against the wall of the circular hut.
Right: The exterior of Rabari huts, decorated in patterns of coloured clay, give on to verandahs plastered with mud and partially protected by a thatched roof.

Page précédente: dans un coin de cette hutte rabari, une potiche en argile, peinte de couleurs vives, où l'on conserve les céréales. Le trou bouché à sa base permet d'extraire les quantités nécessaires.
Ci-dessus: Une femme rabari veille sur son enfant endormi dans un berceau en bois suspendu au toit. Les ustensiles de cuisine sont rangés dans des niches. Des piles de couvertures en patchwork tapissent les murs arrondis pour protéger du vent froid du désert.
A droite: La façade des huttes rabari, ornée de motifs en argile colorée, est prolongée d'une véranda enduite de boue et partiellement abritée par un toit de chaume.

Vorhergehende Seite: *In der Ecke einer Rabari-Hütte steht ein von Hand aus Lehm geformtes und in kontrastierenden Farben bemaltes Gefäß zur Aufbewahrung des Getreides. Aus dem Loch am unteren Ende, das mit einem Stöpsel verschlossen ist, kann man die jeweils gewünschte Menge herausrinnen lassen.*
Oben: *Eine Rabari-Frau wiegt ihr Kind in einer von der Decke hängenden hölzernen Wiege und betrachtet währenddessen ihre Besitztümer. In mehreren kleinen Nischen steht das Kochgeschirr, und an der*

Wand der kreisrunden Hütte stapeln sich zahlreiche Patchwork-Decken, die zum Schutz vor der kalten Wüstenluft unentbehrlich sind.
Unten: *An die Außenwand der Rabari-Hütten, die mit Mustern aus bunt gefärbtem Lehm verziert sind, schließt sich jeweils eine Veranda mit Lehmboden an, die zum Teil von einem Strohdach geschützt wird.*

Right: *Rabari women embellish their huts with elaborate decorations, embedding small mirrors for special effect. They also renew the floors almost daily with a hand-kneaded coating of mud paste.*
Below: *A much-prized sewing machine testifies to the pleasure Rabari women take in adorning themselves. Flower-printed skirts are matched with richly-patched and beaded blouses and headcoverings. Masses of ivory bangles and silver jewels, worn as a sign of a women's personal wealth, are passed on from mother to daughter.*
Following pages: *Popular symbols of modern life, from street posters of religious heroes to plastic bottles, discarded bulbs and defunct batteries, have changed the rules of Rabari home decoration.*

A droite: *Les femmes rabari décorent leurs huttes de motifs complexes, enchâssant de petits miroirs dans l'argile fraîche pour accentuer les effets. Le sol est renouvelé presque quotidiennement avec une couche de boue pétrie à la main.*
Ci-dessous: *La machine à coudre, un outil des plus précieux, atteste de la coquetterie des femmes rabari. Leurs jupes en imprimés fleuris sont assorties à leurs corsages et leurs voiles brodés de perles. Les bracelets en ivoire et les bijoux en argent, signes extérieurs de la fortune personnelle de chaque femme, se transmettent de mère en fille.*
Double page suivante: *Les icônes de la vie moderne – affichettes de rue, héros religieux, bouteilles en plastique, ampoules grillées ou piles électriques périmées – ont considérablement modifié les critères de décoration d'intérieur des Rabaris.*

Rechts: *Rabari-Frauen dekorieren ihre Hütten mit kunstvollen Ornamenten, wobei sie eine besondere Wirkung durch die kleinen Spiegelglasteilchen erzielen, die sie in die Muster einfügen. Darüber hinaus erneuern sie den Boden nahezu jeden Tag mit einer von Hand gekneteten Schicht aus Lehmmasse.*
Unten: *Eine Nähmaschine, die als ein besonders wertvoller Besitz empfunden wird, legt Zeugnis ab von der Freude, die die Rabari-Frauen daran haben, sich mit schönen Dingen zu schmücken. Mit*

Blumenmustern bedruckte Röcke werden durch Blusen und Kopfschleier ergänzt, die aus zahlreichen Stoffteilen zusammengenäht und mit Perlen verziert sind. Silberschmuck und zahllose Armbänder aus Elfenbein, die die Frauen als Zeichen ihres persönlichen Reichtums tragen, werden von Mutter zu Tochter weitervererbt.
Folgende Doppelseite: *Weitverbreitete Symbole des modernen Lebens, von Plakaten mit religiösen Helden bis hin zu Plastikflaschen, weggeworfenen Glühbirnen und kaputten Batterien, haben die Regeln, nach denen für gewöhnlich ein Rabari-Haus geschmückt wird, auf den Kopf gestellt.*

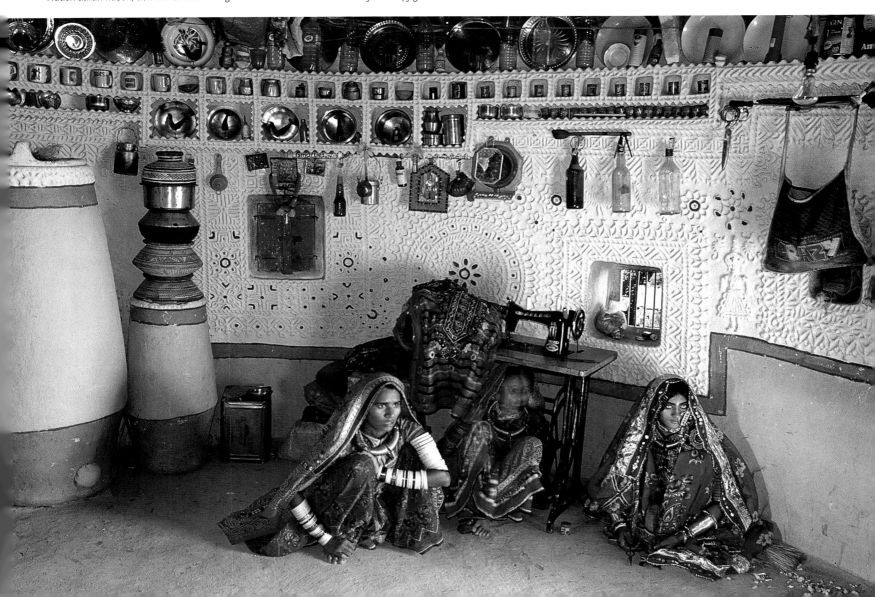

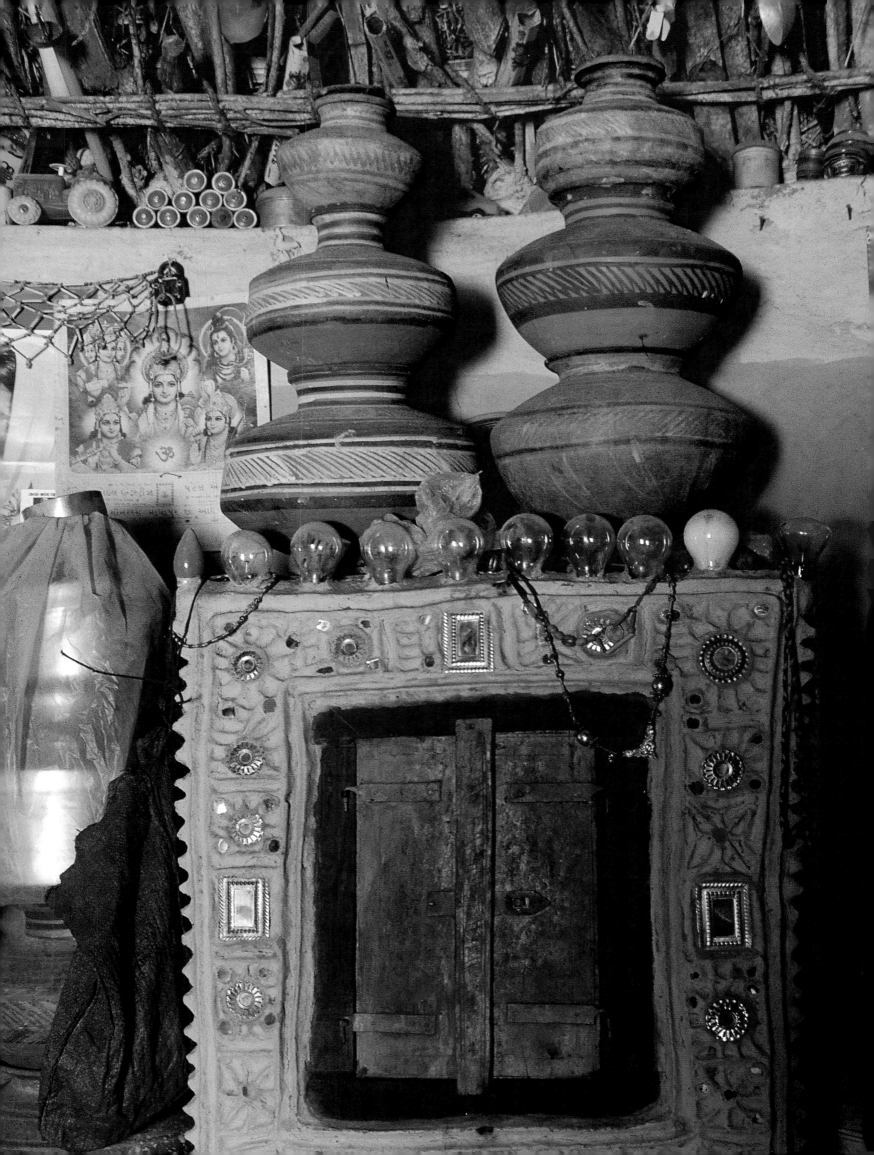

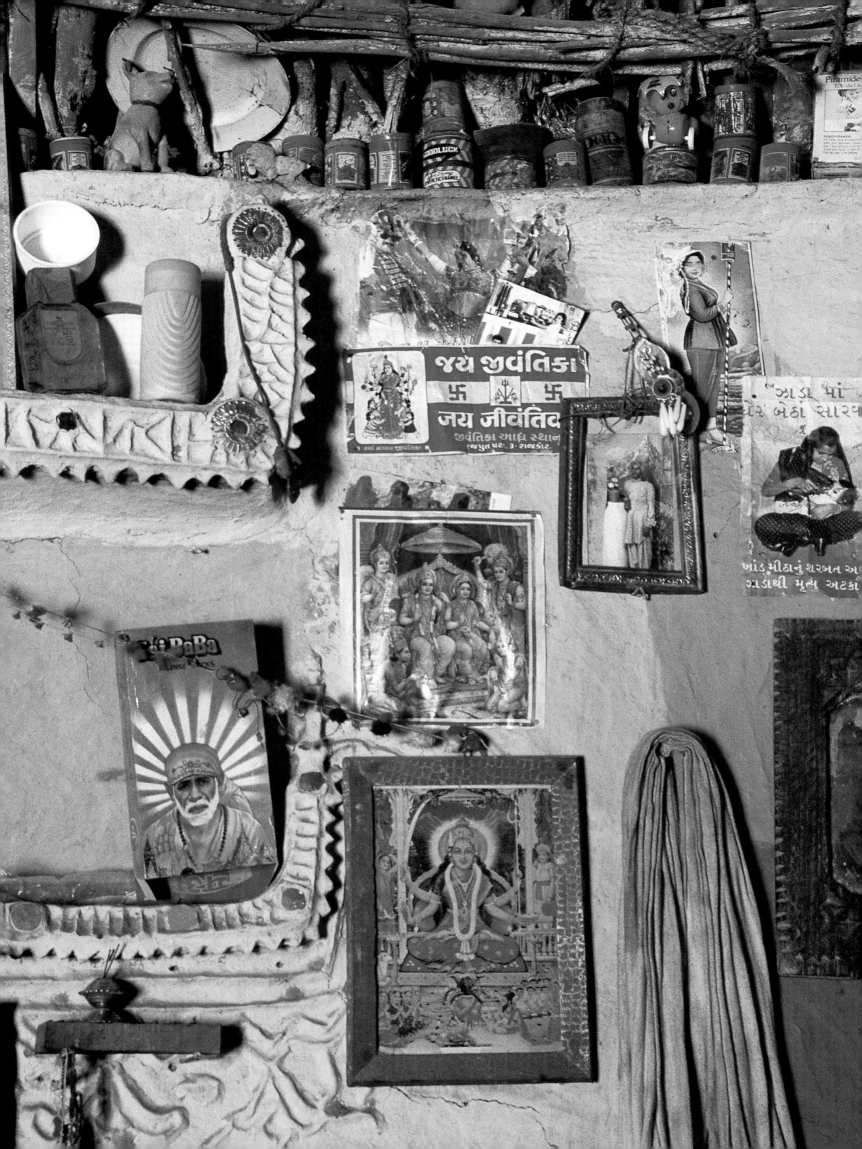

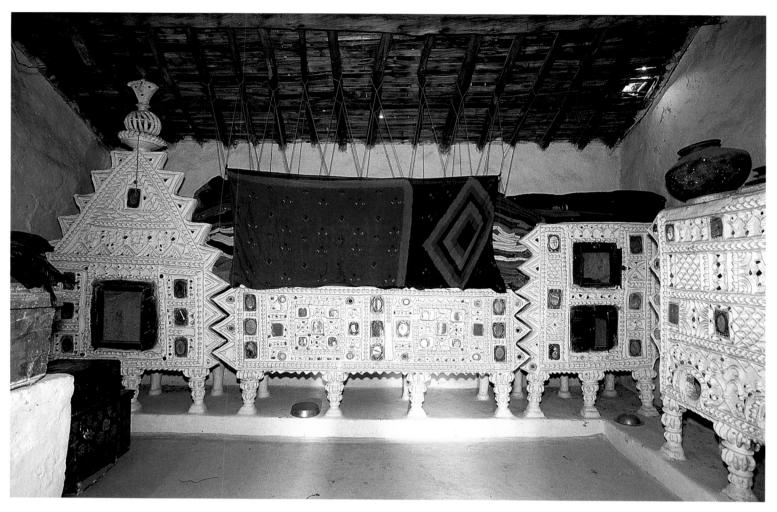

Above: Interlocking storage units in a Rabari hut are fashioned in a variety of shapes to serve the diverse functions of storing food, clothing or valuables. Created by women out of "khadi", a local white clay, they are raised on legs to keep the floors clean.

Facing page: A decorated home-made clay seat for a lovingly decorated baby serves the function of teaching a child how to sit. Variations of this seat include clay walkers with clay wheels for toddlers.

Following pages: The dictates of function and design are perfectly balanced in Rabari interiors. Utility areas, such as the kitchen corner, with its clay stove and low-level chimney to funnel out the smoke, or the mirror-encrusted storage units, decorated with geometric, animal and bird motifs, are placed against the walls, to leave the central area of the hut free for work or rest.

Ci-dessus: Ces modules de rangement qui s'emboîtent les uns dans les autres peuvent prendre différentes formes et servent à conserver la nourriture, les vêtements ou les objets de valeur. Façonnés par les femmes avec du «khadi», une argile blanche locale, ils sont surélevés sur des pieds afin qu'elles puissent entretenir le sol.

Page de droite: ce petit siège en argile décoré avec amour sert à apprendre à l'enfant à s'asseoir correctement. Il existe également en version «trotteur» équipée de roulettes en argile.

Doubles pages suivantes: Dans les intérieurs rabari, l'équilibre entre la fonction et la forme répond à des critères bien étudiés. Les parties utilitaires telles que le coin cuisine, avec son four en argile et son conduit de cheminée bas pour évacuer la fumée, ou les espaces de rangements incrustés de miroirs et décorés d'animaux et de fleurs stylisés, sont placés contre les murs afin de laisser le plus de place possible au centre, consacré au travail et au repos.

Oben: Die zum Teil ineinander übergehenden Schränke in einer Rabari-Hütte wurden in den verschiedensten Formen gebaut. In ihnen werden so unterschiedliche Dinge wie Essen, Kleider und Wertgegenstände aufbewahrt. Sie wurden von den Frauen der Rabari aus dem für die Gegend typischen weißem Lehm namens »Khadi« geformt und sind auf Füße gestellt, damit sich der Boden leichter sauber halten läßt.

Rechte Seite: Ein reich verziertes, selbstgemachtes Stühlchen aus Lehm, in dem ein liebevoll geschmücktes Baby sitzt, soll dazu dienen, den Kindern das Sitzen beizubringen. Zu den verschiedenen Variationen, in denen dieses Stühlchen auftaucht, gehören auch Laufstühle für Kleinkinder, die einschließlich der Räder ganz aus Lehm geformt sind.

Folgende Doppelseiten: Zweckmäßigkeit und kunstvolle Gestaltung halten sich im Innern einer Rabari-Hütte auf perfekte Weise die Waage. Funktionsbereiche, wie zum Beispiel die Kochecke mit dem Herd aus Lehm und dem niedrig gebauten Kamin oder der mit Spiegelglas besetzte Schrank, der sowohl mit geometrischen als auch mit Tier- und Vogelmotiven verziert ist, sind an die Wand gestellt, um in der Mitte der Hütte genug Platz zum Arbeiten und Ruhen zu lassen.

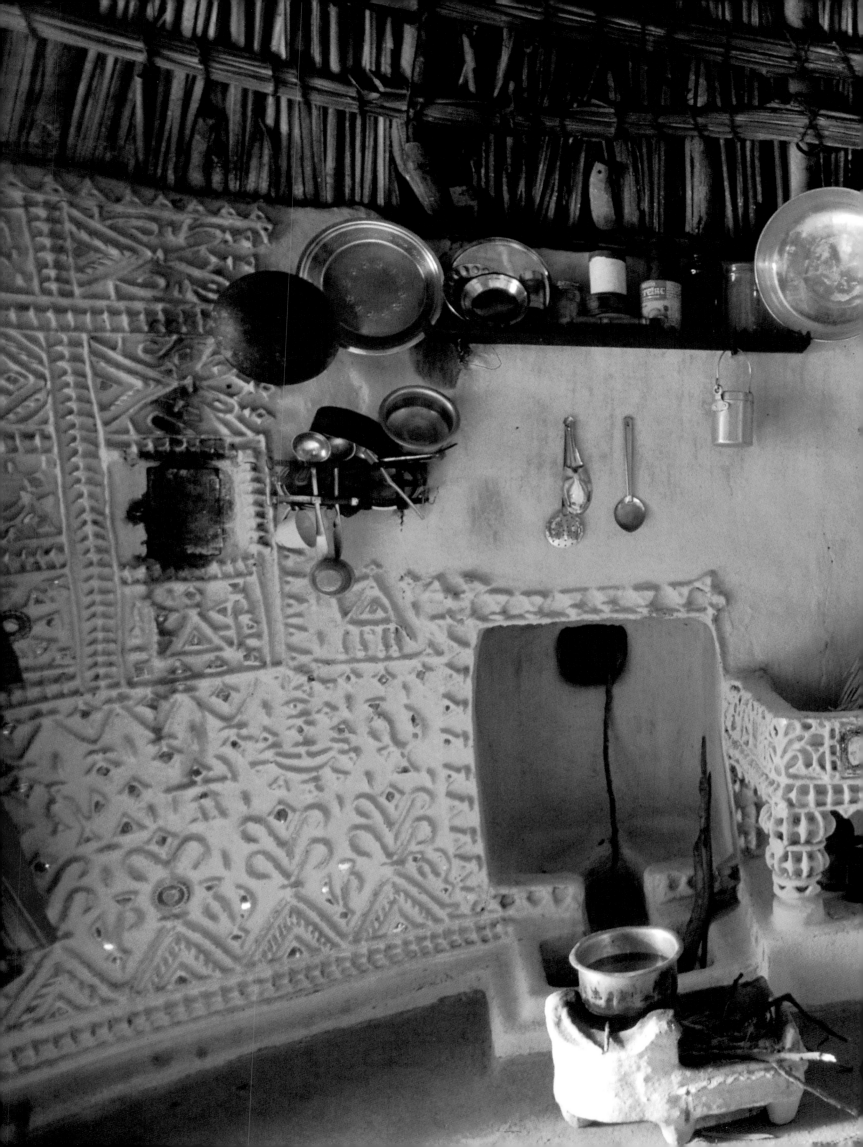

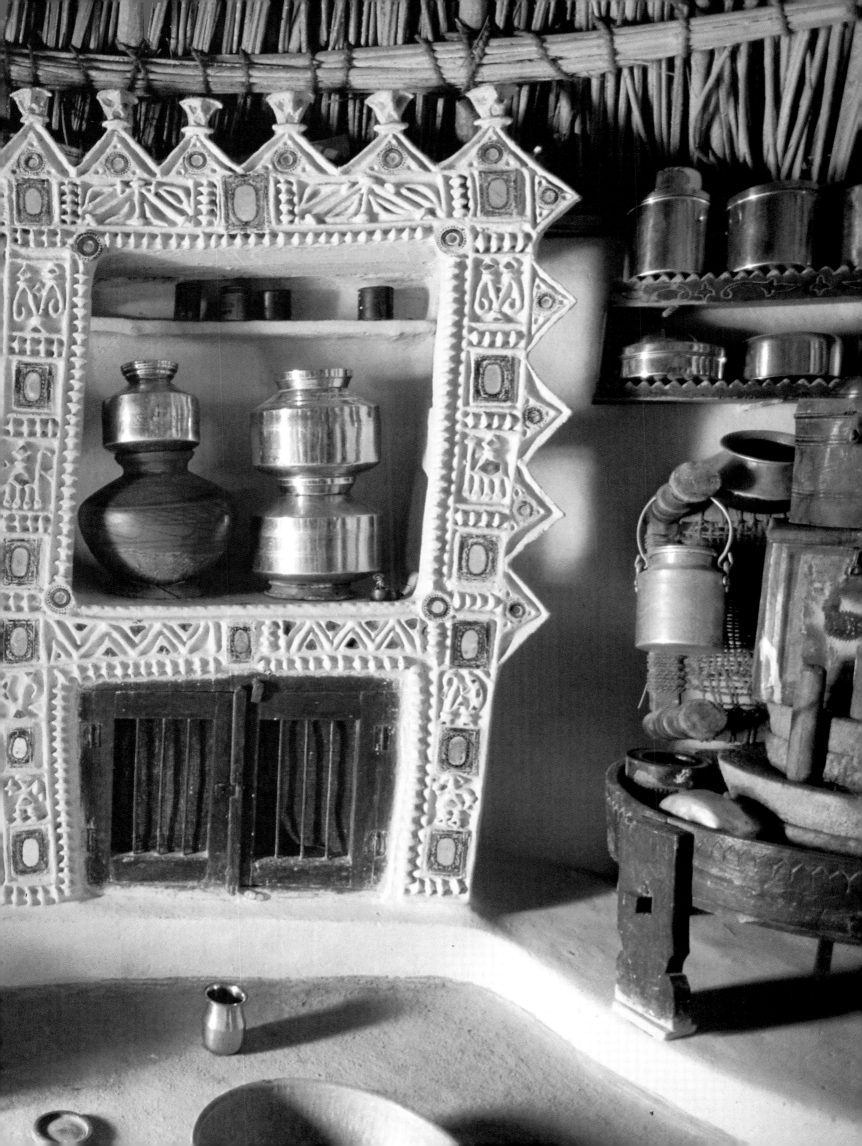

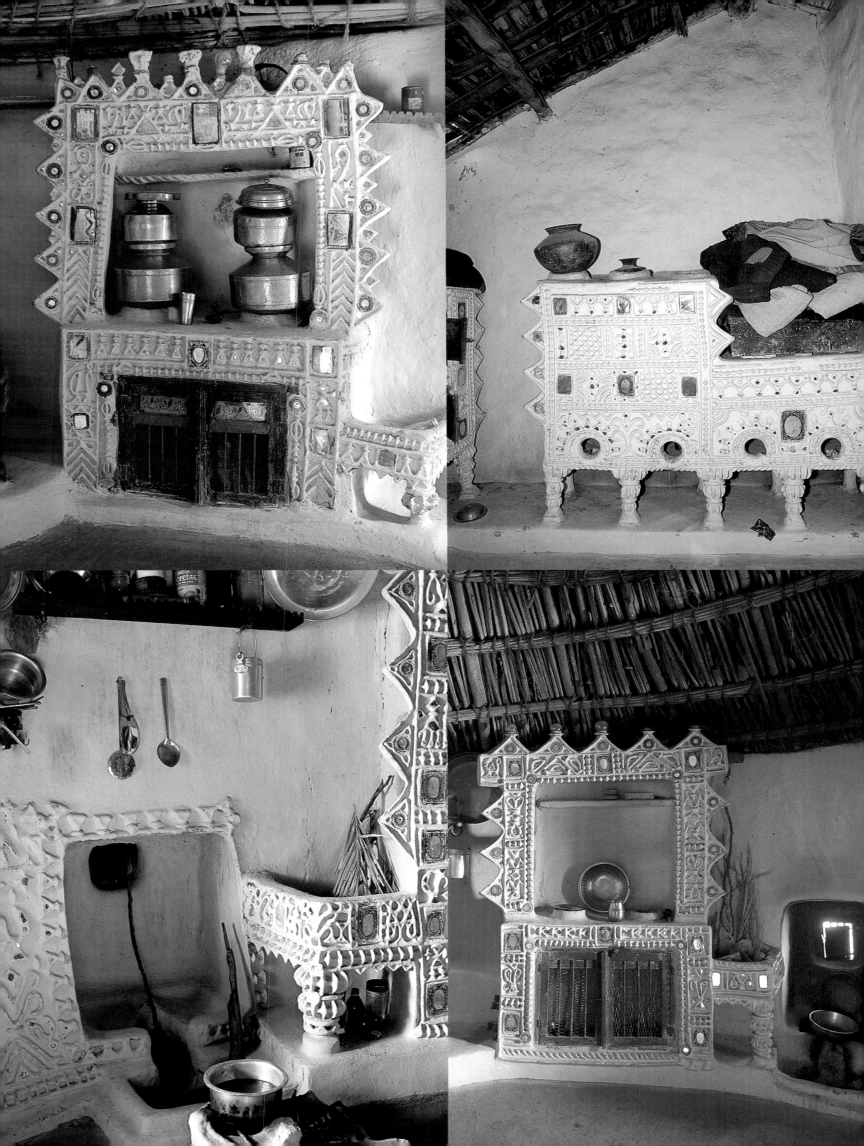

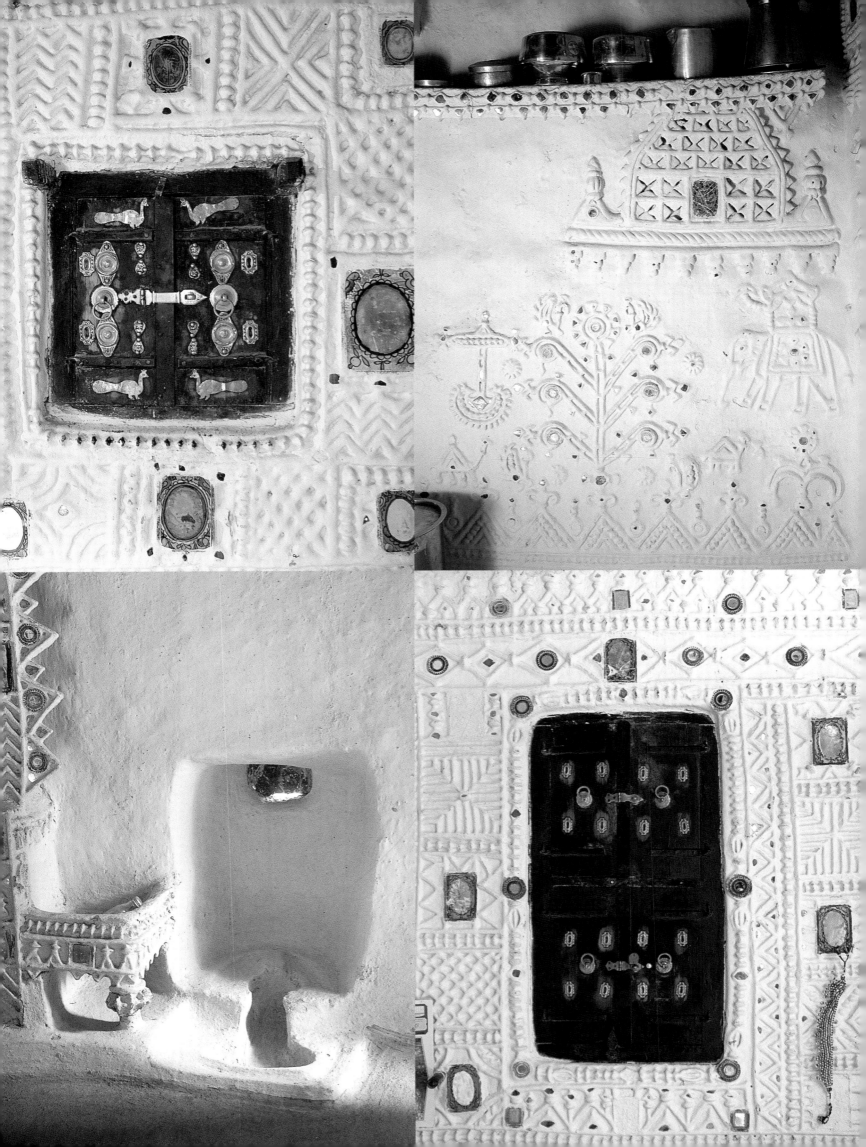

Facing page: The Meghwals, a community of leather workers more settled than the nomadic Rabari, use conventional building materials like brick, wooden beams and rafters for their homes.
Above and right: Like the Rabari, the Meghwals also keep sheep and goats. However the mirror-work, painted decoration and pillared verandahs of their homes clearly spell the transition from a pastoral to a semi-urban environment.
Following pages: Access to a new range of paints and appurtenances like doors and windows have not curbed the exuberant feeling for colour and decoration, as it is visible in this coordinated interior and exterior of a Meghwal home.

Page de gauche: Les Meghwals, une communauté de tanneurs plus sédentarisée que les Rabaris, utilisent des matériaux de construction plus traditionnels comme la brique et les poutres en bois.
Ci-dessus et à droite: Comme les Rabaris, les Meghwals élèvent des chèvres et des moutons. Cependant, leurs marqueteries de miroirs, leurs fresques et leurs vérandas à colonnes reflètent nettement la transition d'une vie pastorale à un environnement semi-urbain.
Double page suivante: L'apparition de nouvelles gammes de peintures et d'accessoires tels que les portes et les fenêtres n'a diminué en rien le sens des couleurs fortes et de la décoration des Meghwals, comme on peut le constater dans cette maison, dont la façade s'harmonise parfaitement avec l'intérieur.

Linke Seite: Die Meghwals, ein Volk, das sich auf die Verarbeitung von Leder spezialisiert hat und das seßhafter ist als die nomadischen Rabaris, benutzen für den Bau ihrer Häuser herkömmliche Materialien wie Ziegelsteine, Holzbalken und Dachsparren.

Oben und rechts: Ähnlich wie die Rabaris halten sich auch die Meghwals Schafe und Ziegen. Aber die Verzierungen aus Spiegelglas und Farbe und die von Säulen getragene Überdachung ihrer Veranden zeigten deutlich, daß hier ein Übergang von der ländlichen zur halburbanen Lebensweise stattgefunden hat.
Folgende Doppelseite: Die Verwendung neuer Farben und Bauelementen wie Fenster und Türen haben das ausgeprägte Gespür für lebendige Dekoration in keinster Weise beschnitten, wie man an der Art und Weise erkennen kann, in der hier das Innere und Äußere eines Meghwal-Hauses aufeinander abgestimmt sind.

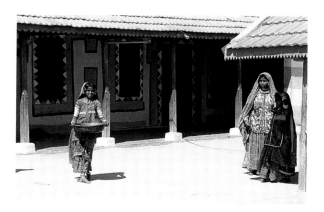

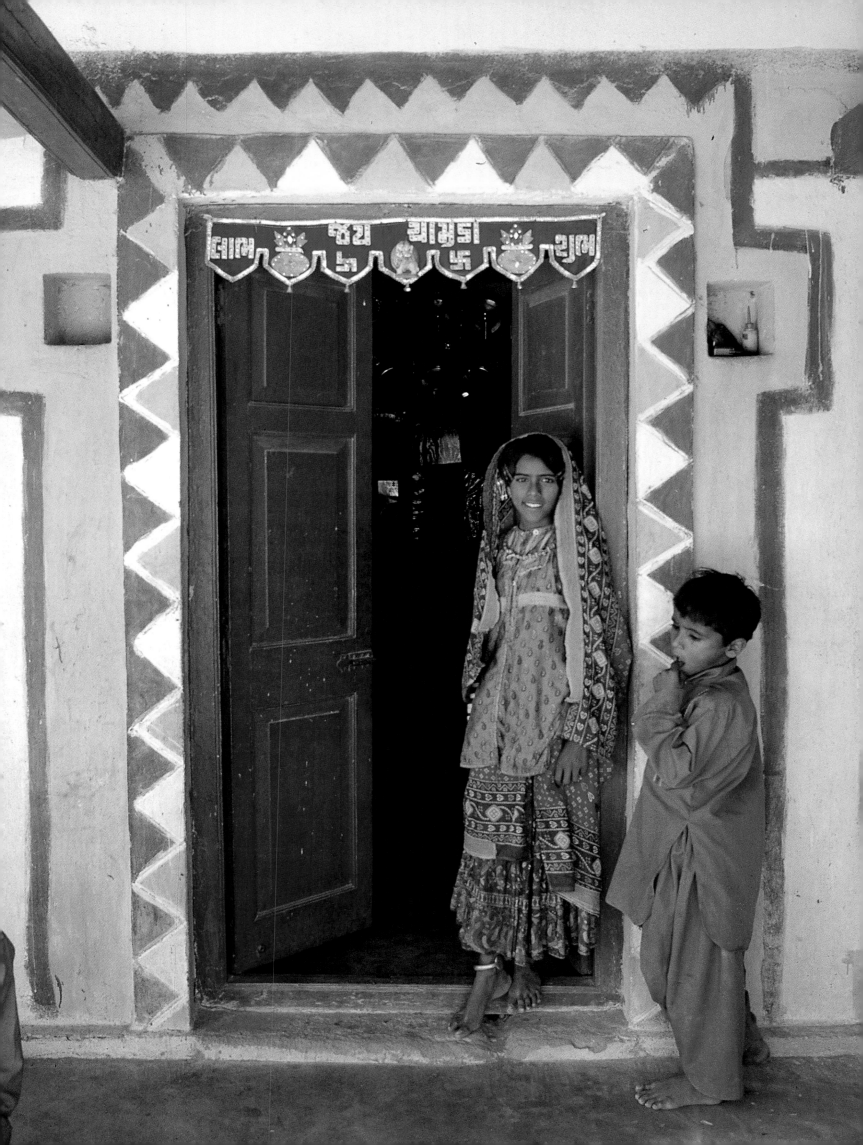

Les années 30 virent la construction des derniers grands palais indiens. A la fin de la Seconde Guerre mondiale, le sous-continent entama sa dernière ligne droite vers l'indépendance jusqu'à ce que, en 1948, les états princiers fusionnent pour former la nouvelle union indienne. Le palais Art Déco de la ville-état de Morvi, dans le Gujerat, représente le dernier flirt de l'Inde royale avec l'architecture moderniste à grande échelle. Les souverains de Morvi furent toujours en avance sur leur temps. A la fin du siècle dernier, le maharaja Waghji fut le premier à bâtir des chemins de fer pour relier la côte aux villes de l'intérieur des terres, à créer des édifices publics et à promouvoir le commerce afin de faire de Morvi un état riche. Son petit-fils, Mahendrasinh, eut moins de chance. Il mourut à l'âge de 37 ans mais laissa derrière lui un palais qui, par les proportions sévères de sa façade et ses intérieurs somptueux, tels que la salle à manger page de droite avec ses accessoires chromés et ses chaises laquées rouge et tapissées de cuir, constitue un témoignage resplendissant d'une période tumultueuse mais débordante d'énergie.

Morvi Palace

The run up to World War II saw the last years of palace-building in India. By the time the war had ended, the sub-continent was convulsed by the final movement towards independence, and by 1948 the princely states had merged into the new union of India. The Thirties art deco palace in the city-state of Morvi in Gujarat, represents royal India's final fling with modernist architecture on a grand scale. Morvi's rulers were always forward-looking: at the end of the last century Maharaja Waghji was the first to link the coast with inland cities by railway, create public buildings and promote trade to turn Morvi into a wealthy state. His grandson, Mahendrasinh, above, did not have the same opportunities. He died at the age of 37 but left behind a palace that, from its severely proportioned exterior to its superbly-detailed interiors, such as the dining room on the facing page with its chrome light fittings and red-lacquered leather chairs, is a testament to a turbulent but high-spirited age.

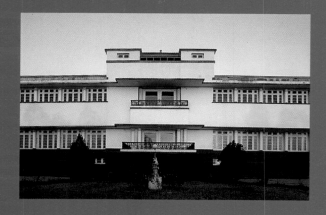

Die letzten Paläste Indiens entstanden in den Jahren vor dem Zweiten Weltkrieg. Nach dem Krieg befand sich der Subkontinent im letzten Stadium der Unabhängigkeitsbewegung, und 1948 schließlich gingen die einzelnen Fürstentümer in der neuen indischen Union auf. Der Art-déco-Palast aus den dreißiger Jahren im Stadtstaat Morvi liegt in Gujarat und ist das letzte Beispiel eines großzügigen indischen Herrschaftssitzes, der von der modernen europäischen Architektur beeinflußt wurde. Die Herrscher Morvis regierten immer schon sehr fortschrittlich. Der Maharaja Waghji war Ende des 19. Jahrhunderts der erste Herrscher, der die Küste mit den Städten im Innern durch eine Eisenbahnlinie verband, öffentliche Gebäude errichtete sowie den Handel förderte und somit Morvi in einen reichen Staat verwandelte. Sein Enkel Mahendrasinh – hier in der Abbildung oben -starb im Alter von nur 37 Jahren. Doch er hinterließ einen Palast, der von seinem strengen Äußeren bis hin zu den meisterhaft eingerichteten Innenräumen – wie zum Beispiel dem Eßzimmer mit seinen Chromlampen und den rotlackierten Lederstühlen – das Zeugnis eines turbulenten und temperamentvollen Zeitalters darstellt.

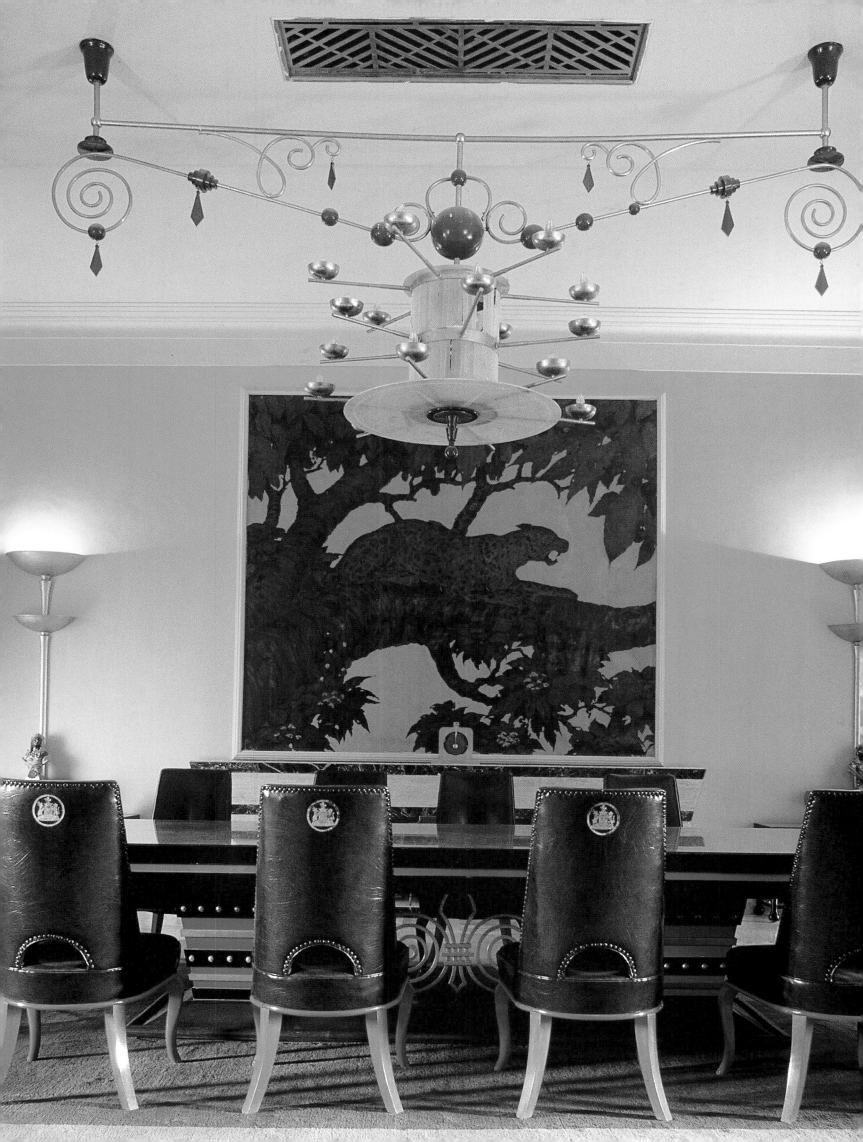

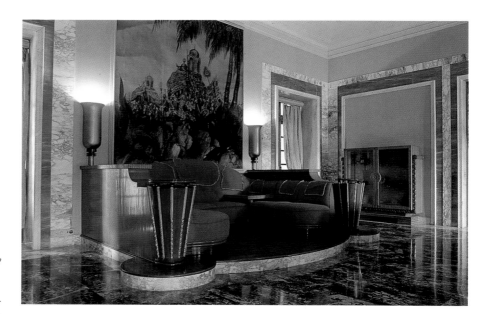

Right: A semicircular seating arrangement with fitted sofas, on an elevated marble platform in the drawing room is lit by specially designed sconces.
Below: Stuffed wild cats in glass cages in the foyer and a pair of oil paintings of Morvi's maharajas flank the entrance to one of the many formal dining rooms in the 42-room palace.

A droite: un petit coin douillet, avec des sofas encastrés et perchés sur une estrade en marbre semi-circulaire. Les appliques ont été dessinées spécialement pour cet endroit.
Ci-dessous: Dans le foyer, un tigre et un lion dans des cages de verre accueillent les visiteurs. Deux grands portraits en pied de maharajas flanquent l'entrée de l'une des salles à manger d'apparat du palais, qui compte 42 pièces.

Rechts: Eine halbkreisförmige Sitzecke mit eingebauten Sofas auf einer Marmorplattform im Salon wird von eigens für den Palast entworfenen Wandleuchtern erhellt.
Unten: Im Foyer flankieren ausgestopfte Wildkatzen in Glasvitrinen den Durchgang, während der Eingang zu einem der vielen repräsentativen Eßzimmer des 42-Zimmer-Palastes von Porträts zweier Maharajas von Morvi gerahmt wird.

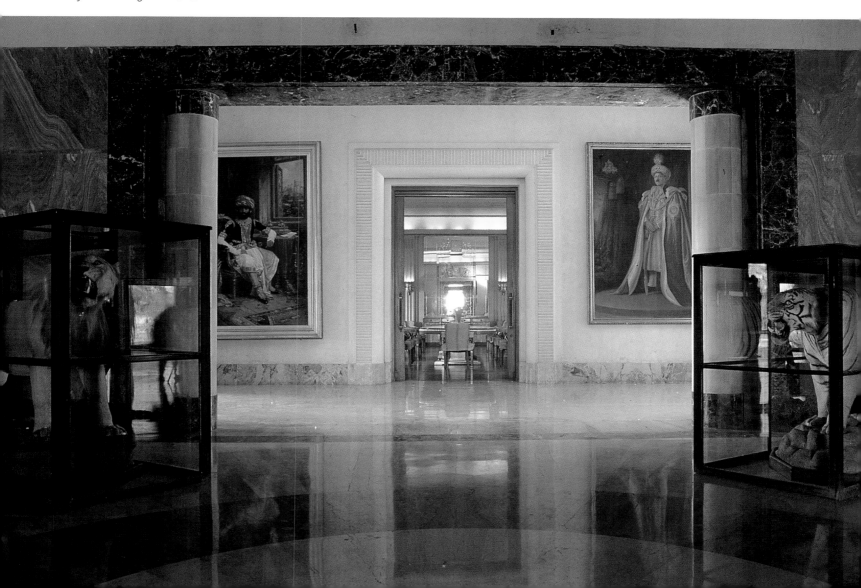

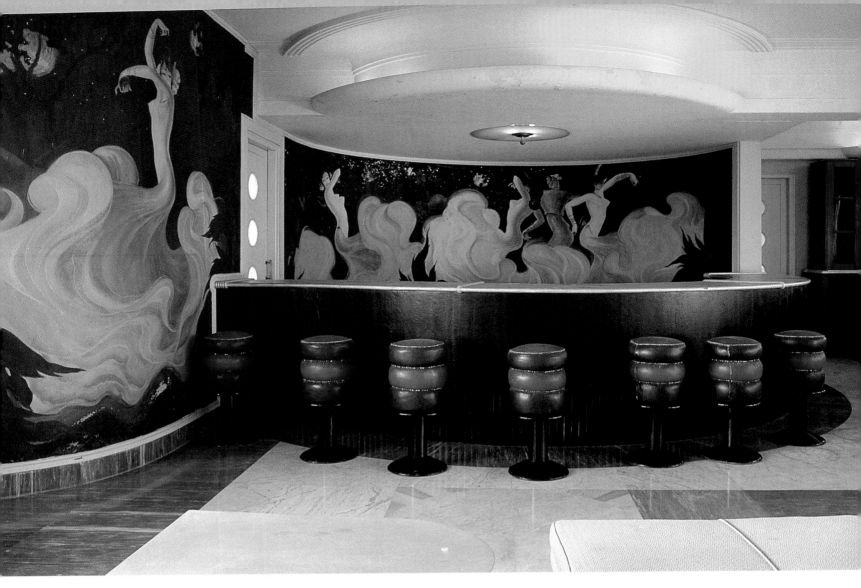

Above: Wall murals of flamenco dancers by the Polish artist Stefan Norblin, who sought refuge in India during World War II, decorate the circular bar. The barstools with triple-decker cushions in blue and red leather indicate the importance of the cocktail hour.
Right: view of the rooftop lounge, with its art deco fountain in pink marble in the centre, individual booths for diners and the bar with Norblin's murals at the far end.

Ci-dessus: Le bar circulaire est décoré de fresques représentant des danseurs de flamenco, réalisées par Stefan Norblin, un artiste polonais qui se réfugia en Inde pendant la Seconde Guerre mondiale. Les tabourets à trois coussins bleus et rouges témoignent de l'importance qu'on attachait au rituel de l'apéritif.
A droite: le salon du dernier étage avec, au centre, sa fontaine Art Déco en marbre rose, des alcôves intimes pour les dîneurs et, au fond, le bar avec les fresques de Norblin.

Oben: Die kreisförmige Bar ist mit Wandgemälden von Flamenco-Tänzerinnen dekoriert. Sie stammen von dem polnischen Künstler Stefan Norblin, der während des Zweiten Weltkriegs in Indien Zuflucht suchte. Die Barhocker mit einer dreifachen Kissenpolsterung aus blauem und rotem Leder sind ein Beweis dafür, wie wichtig man hier die Cocktail-Stunde nahm.
Rechts: eine Gesamtansicht des Salons im Dachgeschoß, mit einem Art-déco-Brunnen aus rosafarbenem Marmor in der Mitte, einzeln abgetrennten Nischen für die Gäste und der Bar mit den Wandgemälden Norblins am hinteren Ende.

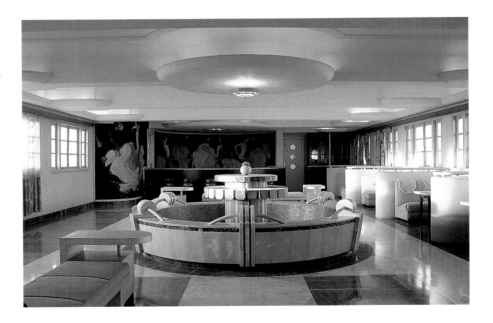

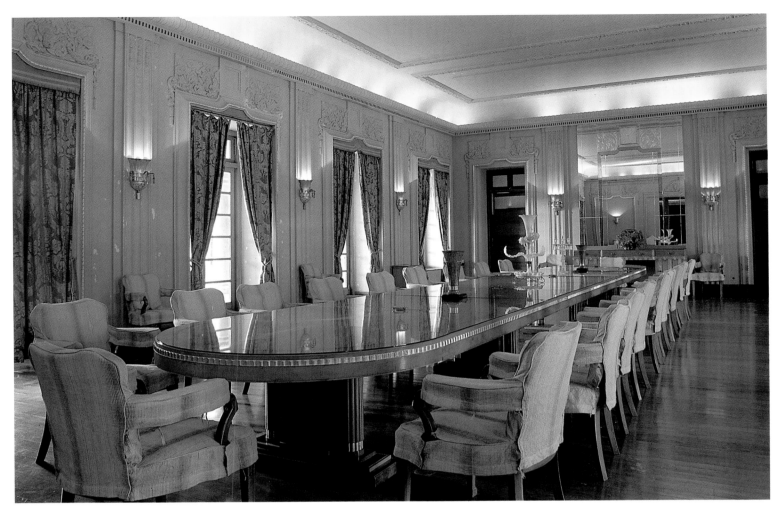

Above: Morvi Palace has several dining rooms, including this formal one, with its glass-topped, chrome-embellished dining table which can seat up to 24 guests.
Right: detail of the cornucopia-shaped lighting fixtures in the formal dining room.
Facing page: The superb bed in the master-bedroom, embellished with chrome and bearing the Morvi crest, is topped with an art deco plaster canopy that holds a concealed rail for curtains. Norblin painted the ceiling-high mural above the backrest.

Ci-dessus: Le palais compte plusieurs salles à manger d'apparat, dont celle-ci, avec sa table en verre et en chrome qui peut accueillir 24 convives.
A droite: détail d'une applique en forme de corne d'abondance dans la salle à manger.
Page de droite: la chambre principale. Le superbe lit chromé portant les armoiries de Morvi est dominé par un baldaquin Art Déco en plâtre dissimulant des rails pour les rideaux. La haute fresque derrière le lit est signée Norblin.

Oben: Der Morvi Palace hat mehrere Eßzimmer, zu denen auch dieser repräsentative Raum gehört. An dem chromverzierten Eßtisch mit aufgesetzter Glasplatte finden 24 Gäste Platz.
Rechts: ein als Füllhorn gestalteter Wandleuchter in dem repräsentativen Eßzimmer.
Rechte Seite: Das herrliche, chromverkleidete Bett mit dem Morvi-Wappen im großen Schlafzimmer hat einen Art-déco-Baldachin aus Stuck, der eine versteckte Schiene für die Vorhänge enthält. Das bis an die Decke reichende Wandgemälde an der Rückwand des Bettes stammt ebenfalls von Stefan Norblin.

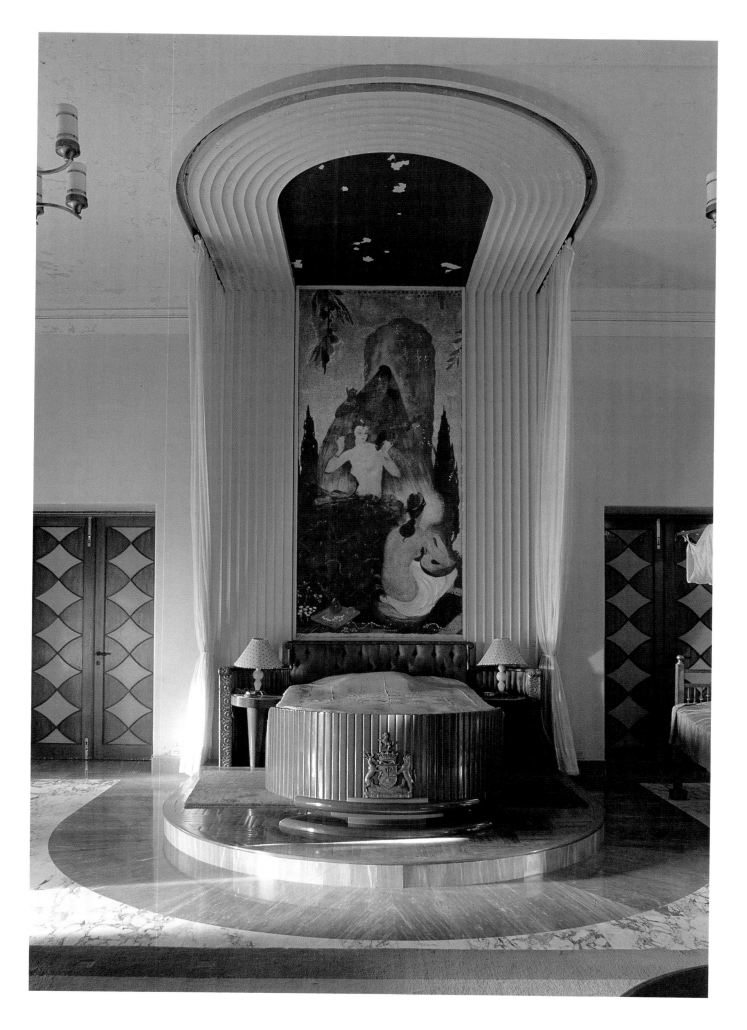

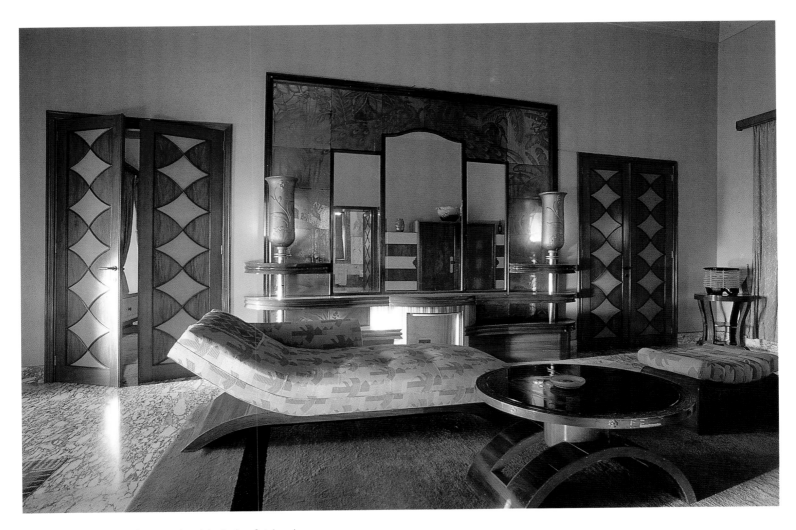

Above: The maharani's sitting room, in subtle shades of pink and gold, has gilt sconces lighting the large art deco cabinet, an elegantly undulating chaise longue and marquetry doors.
Right: The maharani's bedroom continues the colour scheme of pink and gold. A protective gauze of mosquito netting hangs around the bed.
Facing page: A burst of shells forms a nimbus around the maharani's sunken bath. Apart from the metal shower fixture and lights, the entire bathroom is in pink marble.

Ci-dessus: Le salon de la maharani, en tons subtils rose et or, est meublé avec des appliques dorées, un grand cabinet Art Déco, une élégante chaise longue aux lignes courbes et des portes en marqueterie.
A droite: Le thème rose et or se poursuit dans la chambre de la maharani. Le lit est protégé par des moustiquaires en gaze.
Page de droite: Une conque marine forme le décor de la salle de bains de la maharani, avec sa baignoire encastrée dans le sol. Hormis la douche et les appliques, tout est en marbre rose.

Oben: Das Wohnzimmer der Maharani, in zarten Farbtönen aus Rosa und Gold, ist mit einem großen Art-déco-Schrank, vergoldeten Wandleuchtern, einer elegant geschwungenen Chaiselongue und Türen mit Intarsienarbeiten ausgestattet.
Rechts: Im Schlafzimmer der Maharani wird die Farbkomposition aus Rosa und Gold wiederholt. Das Bett ist von einem schützenden Moskitonetz aus Gaze umgeben.
Rechte Seite: Ein muschelförmiger Überbau bildet einen Nimbus um das in den Boden eingelassene Bad der Maharani. Außer der Duschvorrichtung und den Wandleuchtern aus Metall ist das gesamte Badezimmer in rosafarbenem Marmor gehalten.

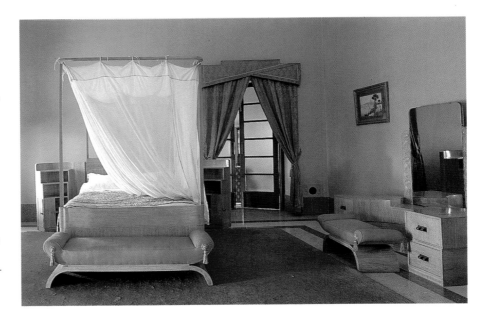

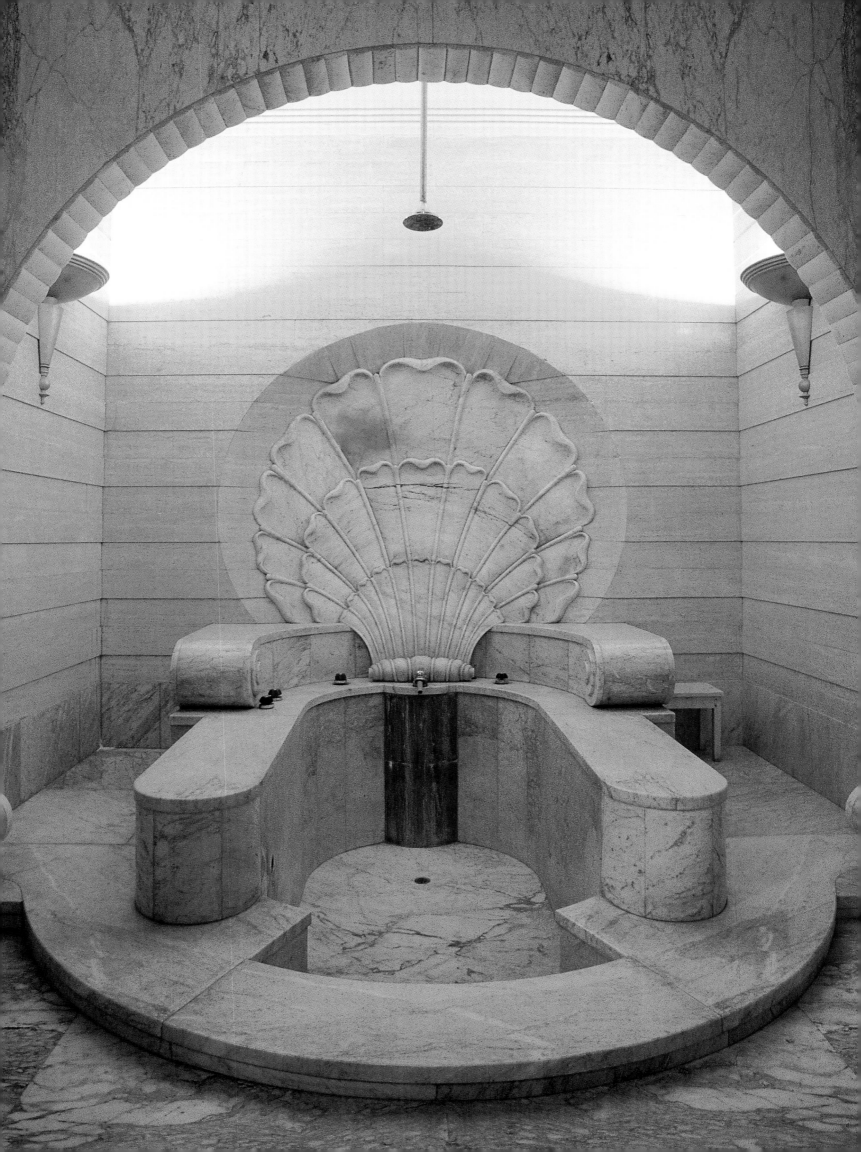

Above: Princess Uma's bedroom is an enchanting fantasy of ebullient child-like humour and art deco materials and style. The inventively designed furniture, such as the cabinet and dressing table, are clad in mirrored shapes that suggest a bunch of blue and silver balloons.
Facing page: The steelframes of the twin beds are hung with mosquito nets and decorated with round mirrors. A blue floral carpet and Venetian mirror of traditional design blend effortlessly with the room's exuberant art deco style.
Following pages: An up-to-date feature of the Morvi Palace was its private gym that includes, among fitness machines of more recent provenance, an electrical horse dummy to improve equestrian skill at full gallop.

Ci-dessus: La chambre de la princesse Uma est un rêve d'enfant plein d'humour et de fantaisie, réalisé dans le style et avec des matériaux Art Déco. Les meubles, comme ce cabinet et cette coiffeuse, sont ornés de miroirs suggérant des bouquets de ballons bleus et argentés.
Page de droite: Les lits jumeaux ornés de miroirs sont dotés de cadres en acier surmontés de moustiquaires. Le tapis aux tons bleus et le miroir vénitien se fondent parfaitement dans le décor Art Déco exubérant de la chambre.
Double page suivante: preuve de la modernité du palais Morvi, son gymnase, équipé, outre d'appareils de musculation plus récents, d'un cheval électrique pour améliorer sa posture au grand galop.

Oben: Das Schlafzimmer der Prinzessin Uma lebt von einem bezaubernden Zusammenspiel aus übersprudelndem, kindlichem Humor sowie Art-déco-Stilelementen und -Materialien. Die phantasievoll gestalteten Möbel, wie zum Beispiel der Schrank und der Frisiertisch,

sind mit Spiegelglasscheiben verkleidet, die an blaue und silberne Luftballons erinnern.
Rechte Seite: Die mit Spiegelglas verzierten Betten sind mit einem Stahlrahmen versehen, an dem Moskitonetze hängen. Ein blauer Teppich mit Blumenmuster und ein venezianischer Spiegel von traditionellem Design verschmelzen mühelos mit dem überschwenglichen Art-déco-Stil des Raumes.
Folgende Doppelseite: Mit dem Fitneßraum befand sich der Morvi Palace damals auf dem neuesten Stand. Zusätzlich zu den Sportgeräten von eher moderner Herkunft verfügt der Raum auch über ein elektrisches Pferd, auf dem man seine Fähigkeiten als Reiter bei vollem Galopp üben konnte.

Peu avant la Première Guerre mondiale, le maharaja Amarsinh, sou-
verain de la petite ville-État de Wankaner, située dans la péninsule de
Kathiawar dans le Gujerat, décida de s'offrir un palais. L'architecture
européenne était alors en vogue et Amarsinh, qui avait voyagé à
l'étranger, l'étudia sous toutes les coutures. Le palais fut construit
entre 1907 et 1914 selon des plans dessinés par le maharaja lui-même,
qui y superposa des styles différents le tout couronné par un beffroi
vertigineux. Les intérieurs constituent un mariage encore plus auda-
cieux entre l'Orient et l'Occident, comme l'atteste le grandiose
double escalier en marbre ci-contre, réalisé de sorte que ceux qui des-
cendent ne voient pas ceux qui montent. Des grilles en fer forgé or-
nées du blason de Wankaner permettaient aux dames de la maison
d'observer les allées et venues dans les pièces en contrebas sans être
vues. Le palais reste aujourd'hui la demeure de Digvijay et de Vibha
Sinh, fiers d'avoir su le conserver pratiquement tel quel.

Wankaner Palace

In the years leading to the outbreak of the First World War, Ma-
haraja Amarsinh, ruler of the small city-state of Wankaner tucked
away in the Kathiawar peninsula of Gujarat, decided to build him-
self a palace. It was the heyday of European-style palazzos and
Amarsinh, who had travelled abroad, left no style unturned. Built
between 1907 and 1914 the palace was designed by the maharaja
himself. Its jostling melange of different styles, are topped by a
soaring clock tower. The interiors are a yet more heady combina-
tion of East and West, such as the grand marble double staircase
on the facing page, built so that those ascending are unseen by
those descending. Wrought-iron grilles emblazoned with the
Wankaner crest were designed for ladies in "purdah" to watch the
proceedings in the public hall below. The palace remains Digvijay
and Vibha Sinh's family home and they are proud that so much of
it is still in its original state.

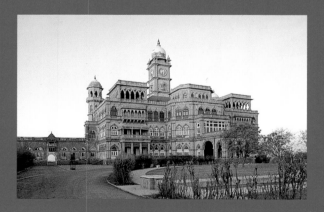

Vor dem Ausbruch des Ersten Weltkriegs faßte der Maharaja Amar-
sinh den Entschluß, sich einen Palast zu bauen. Amarsinh war der
Herrscher des kleinen Stadtstaates Wankaner, der versteckt auf der
Halbinsel Kathiawar in Gujarat liegt. Es war damals hoch in Mode,
Paläste im europäischen Stil zu bauen, und Amarsinh, der einige Rei-
sen ins Ausland unternommen hatte, ließ keinen einzigen Stil aus.
Der Palast wurde zwischen 1907 und 1914 gebaut, wobei der Entwurf
zu dem Gebäude von dem Maharaja selbst stammte. Das bunte Ge-
misch aus verschiedensten Stilen wird von einem endlos hohen Uh-
renturm überragt. Das Innere ist eine noch weit erstaunlichere Mi-
schung aus Ost und West – wie zum Beispiel die prachtvolle Treppe
mit doppeltem Aufgang, die so gebaut wurde, daß diejenigen, die hin-
aufsteigen von den Hinuntersteigenden nicht gesehen werden kön-
nen. Schmiedeeiserne Gitter, die mit dem Wappen von Wankaner ge-
schmückt sind, wurden für die Damen des Hauses angebracht, damit
diese, in »Purdahs« gehüllt, das Geschehen in der Eingangshalle dar-
unter verfolgen konnten. Der Palast blieb im Familienbesitz und ist
heute das Zuhause von Digvijay und Vibha Sinh, die stolz darauf
sind, daß ein großer Teil des Gebäudes gänzlich unverändert geblie-
ben ist.

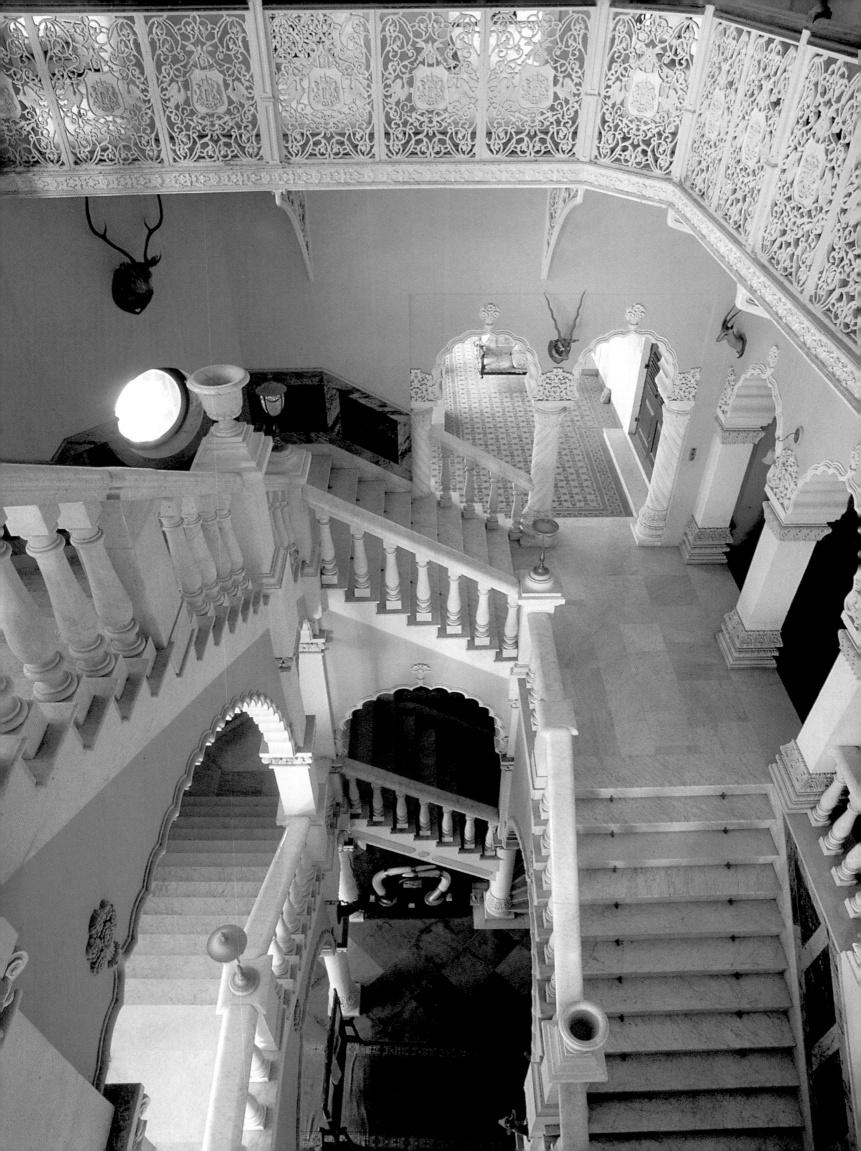

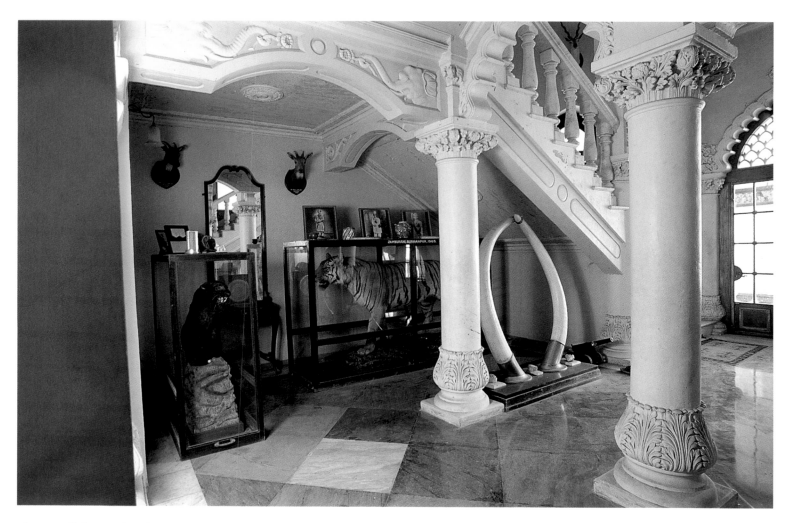

Above: *a stuffed tiger and panther, and a cusped arch of elephant tusks, in the hall of Wankaner Palace amid plasterwork pillars supporting the grand staircase.*
Right: *detail of a rosewood table covered with framed photographs of fellow maharajas and a silver replica of the Wankaner Palace in Bombay which now houses the United States consulate.*
Facing page: *view of the formal drawing room from the gallery, with tigerskin rugs on custom-made carpets and European sofas made in Bombay and covered in gold and blue brocade.*

Ci-dessus: *dans le hall du palais, parmi les colonnes ornées de stucs qui soutiennent le grand escalier, un tigre et une panthère empaillés et une paire de défenses d'éléphants.*
A droite: *détail d'une table en bois de rose sur laquelle sont posées des photos de maharajas et la maquette en argent du palais Wankaner à Bombay, aujourd'hui siège du consulat des Etats-Unis.*
Page de droite: *Le grand salon vu de la galerie. Sous les peaux de tigres, des tapis faits sur mesure. Les fauteuils et les sofas à l'européenne, réalisés à Bombay, sont tapissés en brocart or et bleu.*

Oben: *Ein ausgestopfter Tiger und Panther sowie Elefantenstoßzähne stehen in der Eingangshalle des Wankaner Palace zwischen Säulen mit Schmuckelementen aus Stuck, die die große Treppe stützen.*
Rechts: *Detailansicht eines Tisches aus Rosenholz, auf dem zahlreiche Bilderrahmen mit Fotografien anderer Maharajas stehen, zusammen mit einer silbernen Nachbildung des Wankaner Palace in Bombay, in dem sich heute das Konsulat der Vereinigten Staaten von Amerika befindet.*
Rechte Seite: *eine Ansicht des Salons von der Galerie aus, mit Tigerfellen auf den maßangefertigten Teppichen und Sofas im europäischen Stil, die in Bombay hergestellt wurden und mit einem goldblauen Brokatstoff bezogen sind.*

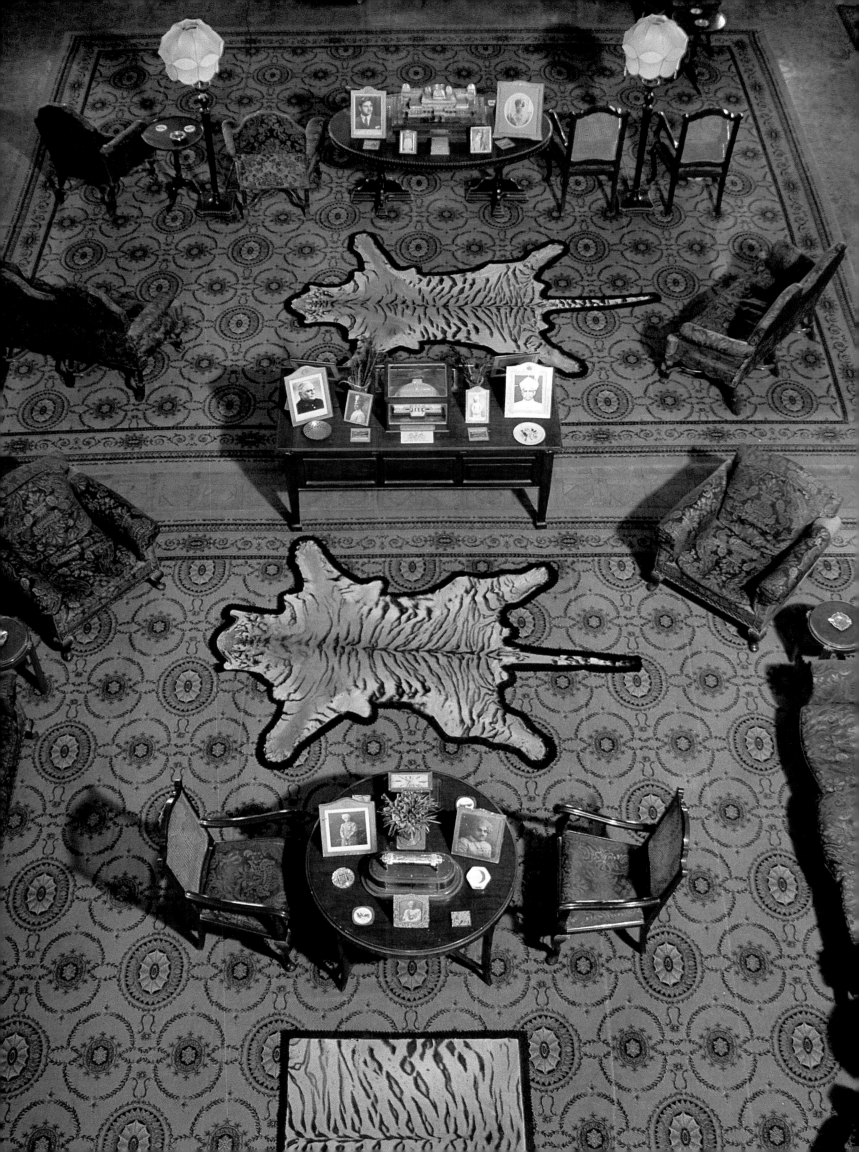

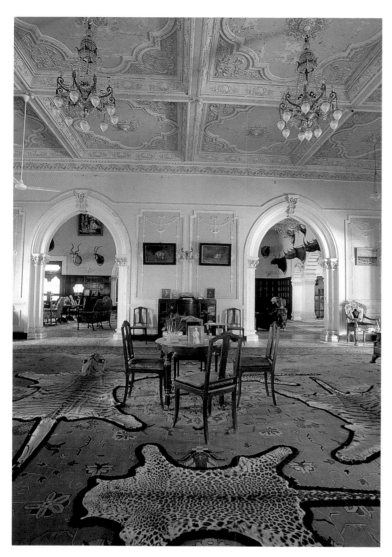

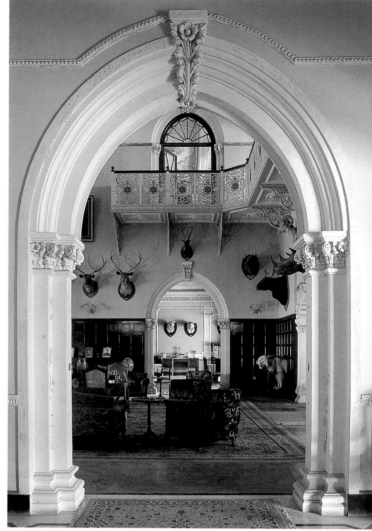

Above: *view from the music room towards the drawing room and dining room, linked by plasterwork arches. The music room, with its Venetian chandeliers and spread of tiger and leopard skin rugs, has walls and ceilings with plaster decoration painted in two shades of Wedgwood blue.*
Facing page: *A filigree ironwork balcony supported by delicate brackets overlooks the teak-panelled drawing room, decorated with hunting trophies. The rows of scalloped arches give on to a wide verandah and the entrance porch to the palace.*

Ci-dessus: *Le salon de musique, le grand salon et la salle à manger sont reliés par des arches ornées de stucs. Dans le salon de musique, avec ses peaux de tigre et de panthère et ses lustres vénitiens, les murs et les plafonds sont décorés d'ornements en plâtre peints dans deux tons de bleu Wedgwood.*
Page de droite: *Un balcon finement ouvragé en fer forgé, soutenu par des équerres ornementales, surplombe la salle à manger. Au-dessus des boiseries en teck, des trophées de chasse. Les trois arches au fond de la salle donnent sur une véranda et le porche du palais.*

Oben: *ein Blick vom Musikzimmer zum Salon und zum Eßzimmer, die durch Türbögen aus Stuck miteinander verbunden sind. Die Wände und die Decke des Musikzimmers mit seinen venezianischen Kronleuchtern und den Tiger- und Leopardenfellen sind mit Stuckverzierungen versehen. Der Stuck wurde in verschiedenen Schattierungen des Wedgwood-Blaus gestrichen.*

Rechte Seite: *Von dem filigranen, gußeisernen Balkon, der von zierlichen Konsolen getragen wird, kann man den Salon überschauen, dessen Wände mit Teakholz verkleidet und mit Jagdtrophäen dekoriert sind. Die Bögen im Hintergrund führen hinaus auf eine breite Veranda und zum Portalvorbau des Palastes.*

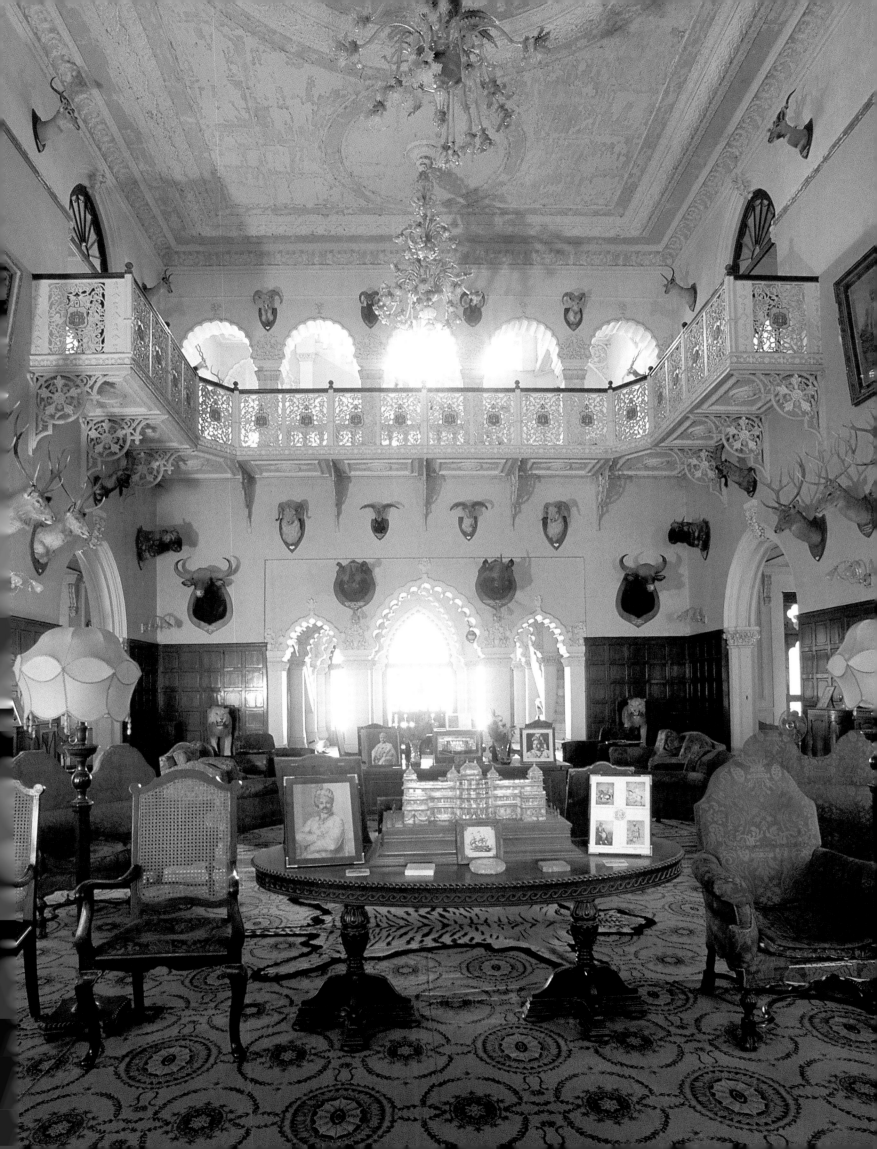

Right: The centrepiece of the maharaja's elegant dressing room is a dressing table with a three-panelled looking glass.
Below: The billiards room, with its English billiards table, adjoins the music room and has its own lounge.

A droite: au centre de l'élégant dressing-room du maharaja, une coiffeuse avec un miroir à trois faces.
Ci-dessous: la salle de billard, avec son billard anglais, jouxte le salon de musique et possède son propre coin salon.

Rechts: In der Mitte des eleganten Ankleidezimmers des Maharajas steht eine Frisierkommode mit einem dreiteiligen Spiegel.
Unten: Das Billardzimmer, das mit einem englischen Billardtisch ausgestattet ist, grenzt an das Musikzimmer und verfügt über einen eigenen Sitzbereich.

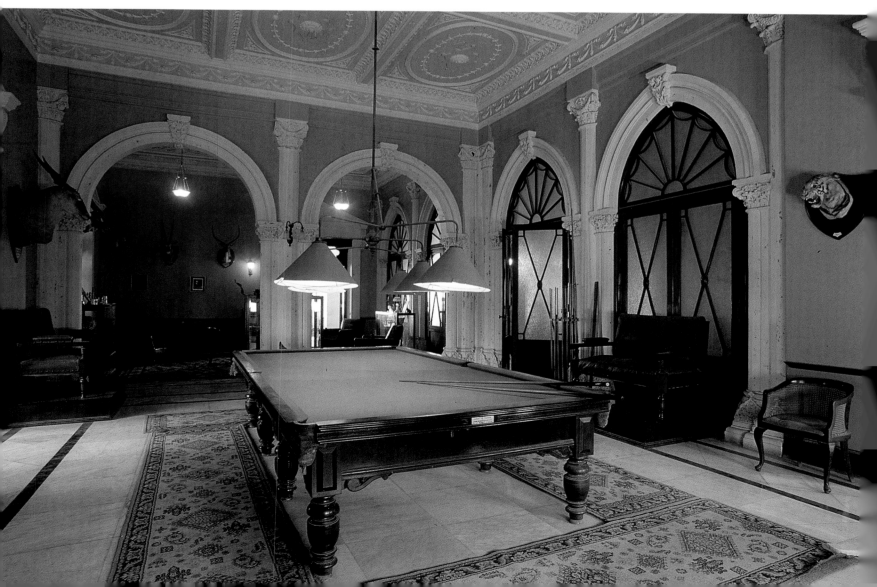

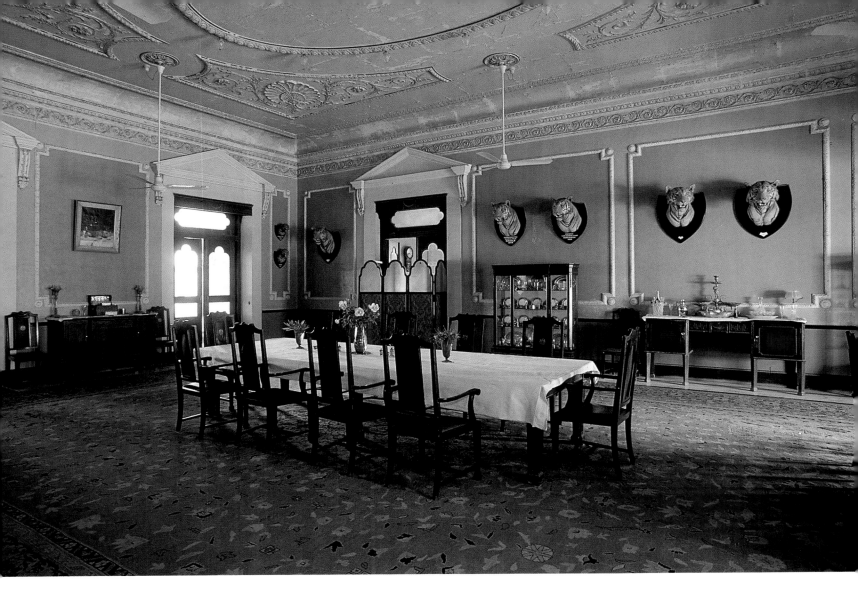

Above: A row of stuffed tiger heads gaze down at dinner guests in the formal dining room.
Right: one of the several armchairs in ornate hand-beaten silver in the palace.
Following pages: Unquestionably the most superb room in Wankaner Palace is a shimmering chamber with its walls, floor and ceiling entirely lined in fitted mirror sheets. In the centre of the room hangs a swing with a seat made of crystal. The glass chamber, adjoining Maharaja Amarsinh's bedroom, was created for his private pleasure but is now used as a room for prayer.

Ci-dessus: Des têtes de tigres empaillées observent les convives dans la grande salle à manger.
A droite: Le palais compte de nombreux fauteuils en argent martelé et ouvragé tel que celui-ci.
Double page suivante: Les murs, le sol et le plafond de cette pièce sont entièrement tapissés de feuilles d'argent miroitantes. Au centre, une balançoire en cristal. Cette «chambre de verre», qui jouxte la chambre du maharaja, était autrefois sa salle de détente privée. Elle sert aujourd'hui de salle de prière.

Oben: Im Eßzimmer schaut eine Reihe von ausgestopften Tigerköpfen auf die Gäste herab.
Rechts: einer der zahlreichen, mit handgetriebenem Silber verzierten Sessel, die es im Palast gibt.
Folgende Doppelseite: ein schimmerndes Gemach, dessen Wände, Boden und Decke zur Gänze mit Spiegelglasscheiben verkleidet sind. In der Mitte des Raumes hängt eine Schaukel mit einem Sitz aus Kristall. Das Glasgemach, das an das Schlafzimmer des Maharajas Amarsinh grenzt, wurde zu dessen ganz persönlichem Vergnügen geschaffen, wird jedoch heute als Gebetszimmer genutzt.

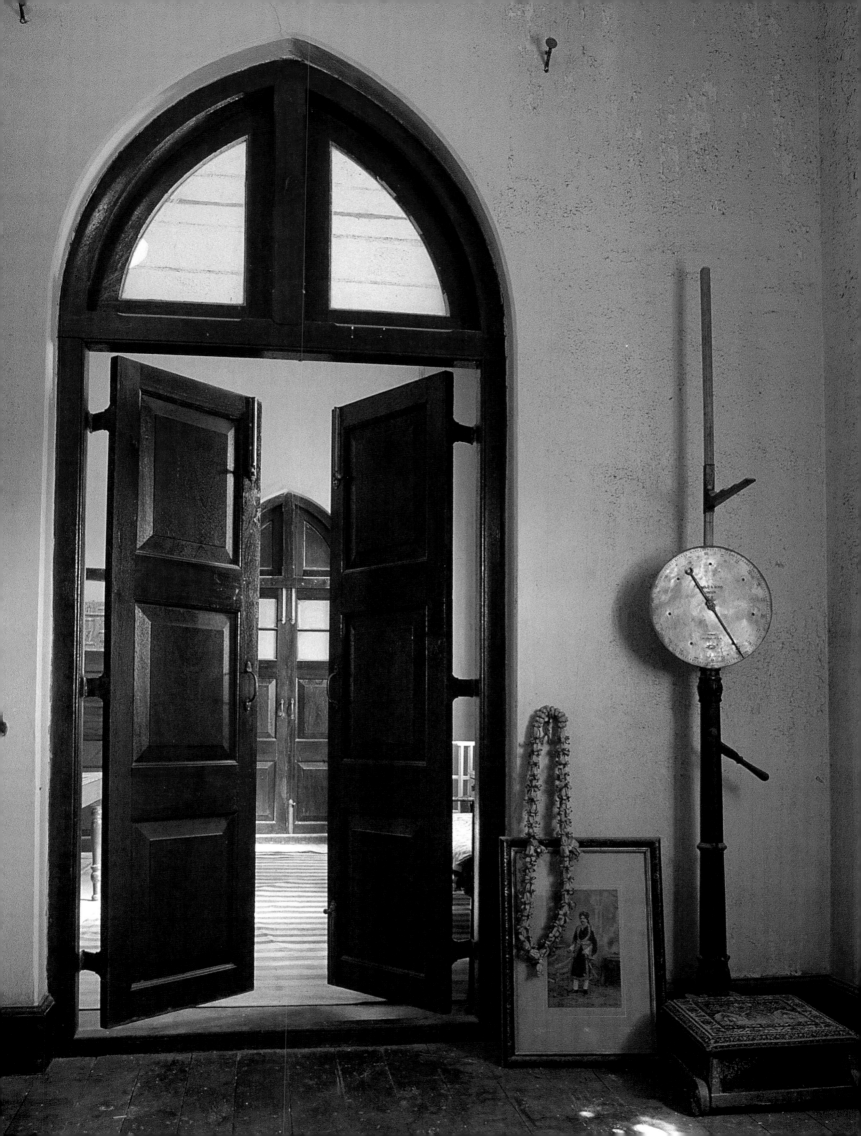

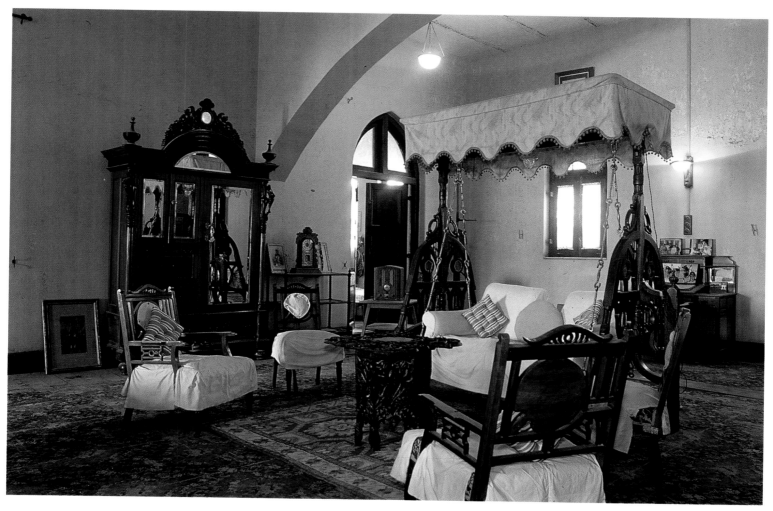

Facing page: A weighing machine from the Twenties with its mother-of-pearl dial stands sentinel by the doors leading to a former maharani's private suite of rooms.
Above: Two large pieces of furniture dominate a former maharani of Wankaner's private sitting room – a large mirror-panelled cupboard and a canopied sofa swing. She brought both to Wankaner as part of her dowry.
Right: two views of the maharaja's luxurious bathroom. Slender pillars with carved capitals in a honey-coloured local stone support delicate marble arches but the wash basin and shower fittings are English.

Page de gauche: Un pèse-personne des années 20 avec un cadran en nacre monte la garde devant les anciens appartements privés d'une maharani.
Ci-dessus: Une grande armoire à miroirs et un sofa-balançoire agrémenté d'un baldaquin dominent ce salon privé d'une ancienne maharani de Wankaner. Ces meubles faisaient partie de son trousseau.
A droite: La luxueuse salle de bains du maharaja. Les délicates arches en marbre sont soutenues par de fines colonnes taillées dans une pierre locale couleur de miel et surmontées de chapiteaux sculptés. Le lavabo et la douche sont anglais.

Linke Seite: Eine Waage aus den zwanziger Jahren mit einer Skala aus Perlmutt steht neben einer Tür, die zu den Privatgemächern einer früheren Maharani führt.
Oben: Zwei riesige Möbelstücke beherrschen das private Wohnzimmer einer früheren Maharani von Wankaner – ein großer Spiegelschrank und eine Sofaschaukel mit einem Baldachin. Die beiden Möbelstücke waren Teil der Mitgift, die die Maharani mit nach Wankaner brachte.

Unten: zwei Ansichten des luxuriösen Badezimmers der Maharani. Schlanke Säulen mit Kapitellen, die aus einem für die Gegend typischen, honigfarbenen Gestein gemeißelt wurden, stützen zierliche Marmorbögen. Das Waschbecken und die Dusche sind jedoch englischen Ursprungs.

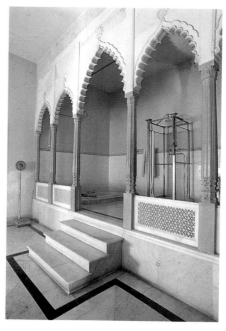

Le palais de Jasdan est un de ces petits trésors encore intacts de l'Inde princière que l'on retrouve ici et là dans le pays, à l'écart des chemins empruntés par les hordes de touristes. Jasdan est situé au cœur du Gujerat, à l'intérieur de la péninsule de Kathiawar, qui doit son nom au clan des Kathis qui la gouvernèrent au 17e siècle. Leur descendant, Satyajit Khachar, un jeune industriel et agriculteur, y habite avec son épouse, une princesse de Baroda. Les intérieurs de Jasdan offrent un contraste saisissant avec son allure extérieure de pièce montée, une charmante combinaison de vérandas ornées de stucs, de colonnes et d'arches. Mais le véritable délice du palais réside dans ses enfilades de pièces, certaines vieilles de 250 ans, d'autres ajoutées par ses propriétaires successifs, toutes ayant résisté au passage du temps. Chaque aile reflète donc le style de vie d'une des nombreuses générations de la même famille qui se sont succédées dans les lieux.

Jasdan Palace

The palace at Jasdan is characteristic of the small, unreconstructed treasures of princely India that lie strewn in out-of-the way places, far from the trail of tourist hordes. Jasdan lies deep in Gujarat, in the hinterland of the Kathiawar peninsula which gets its name from the 17th-century ruling clan, the Kathis. Their descendant, Satyajit Khachar, a young industrialist and farmer lives in the palace with his wife, a princess of Baroda. The interiors of the Jasdan palace are in striking contrast to its wedding-cake exterior – a deliciously creamy concoction of pillared, stuccoed and arched verandahs. But the principal pleasure of the many wings of Jasdan palace lies in the succession of rooms – some as old as 250 years, others added on by later rulers – unchanged by the passage of time. Each wing of the palace, therefore, mirrors the changing lifestyle of many generations of the same family that have lived in the same house.

Der Palast in Jasdan ist ein typisches Beispiel für die kleinen, in ihrem ursprünglichen Zustand belassenen Schätze der indischen Fürsten-tümer, die sich verstreut an abgelegenen Orten finden, weit weg von den Touristenrouten. Jasdan liegt im tiefsten Innern Gujarats, im Hinterland der Halbinsel Kathiawar, die ihren Namen von der Herr-scherfamilie der Kathis aus dem 17. Jahrhundert herleitet. Einer ihrer Nachkommen, Satyajit Khachar, ein junger Industrieller und Land-wirt, lebt in dem Palast mit seiner Frau, einer aus Baroda stammen-den Prinzessin. Das Innere des Jasdan Palace steht in einem erstaun-lichen Gegensatz zu seinem Äußeren, das Ähnlichkeit mit einem Hochzeitskuchen hat – eine köstlich cremefarbene Kreation mit Veranden voller Säulen, Stuck und Bögen. Aber das Schönste am Jasdan Palace sind die zahlreichen Innenräume. Manche davon sind bereits 250 Jahre alt, andere wurden von späteren Herrschern hinzu-gefügt – an allen ist die Zeit spurlos vorübergegangen. Jeder Flügel des Palastes spiegelt die Veränderungen in der Lebensart vieler Generationen ein und derselben Familie wider, die immer im selben Haus gelebt hat.

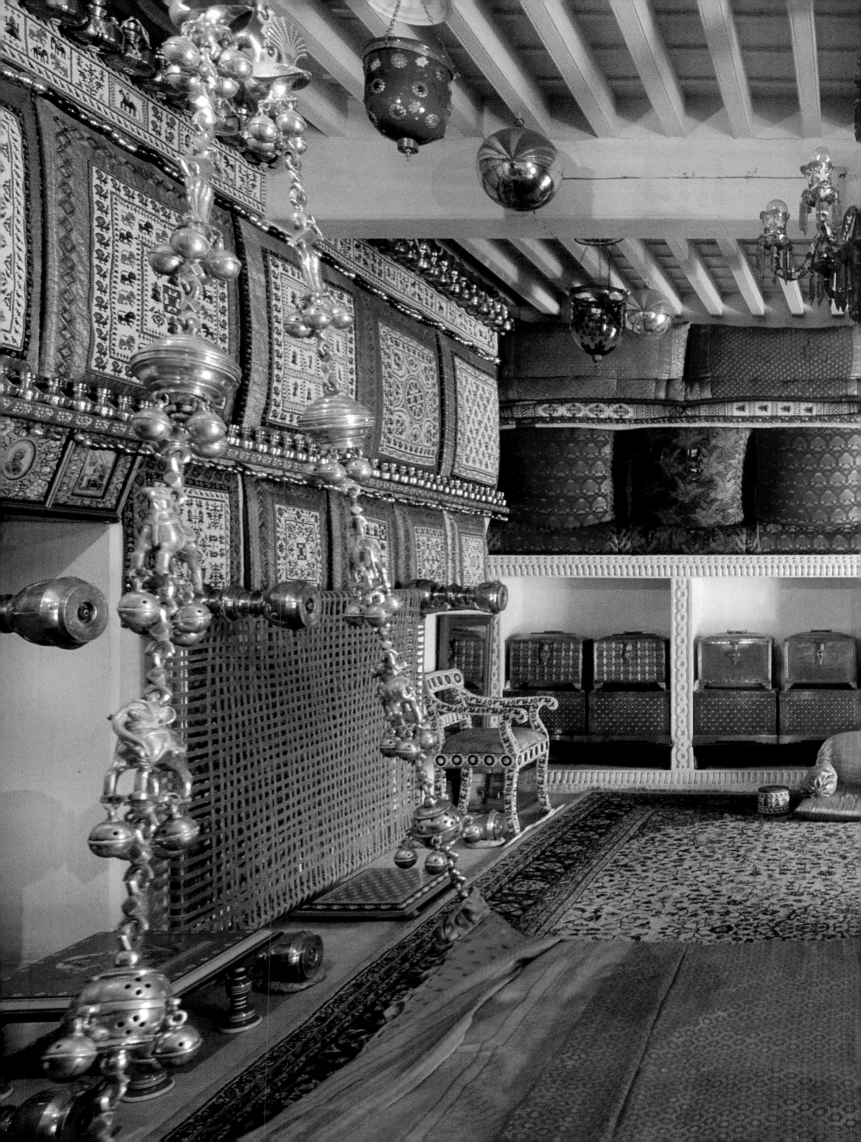

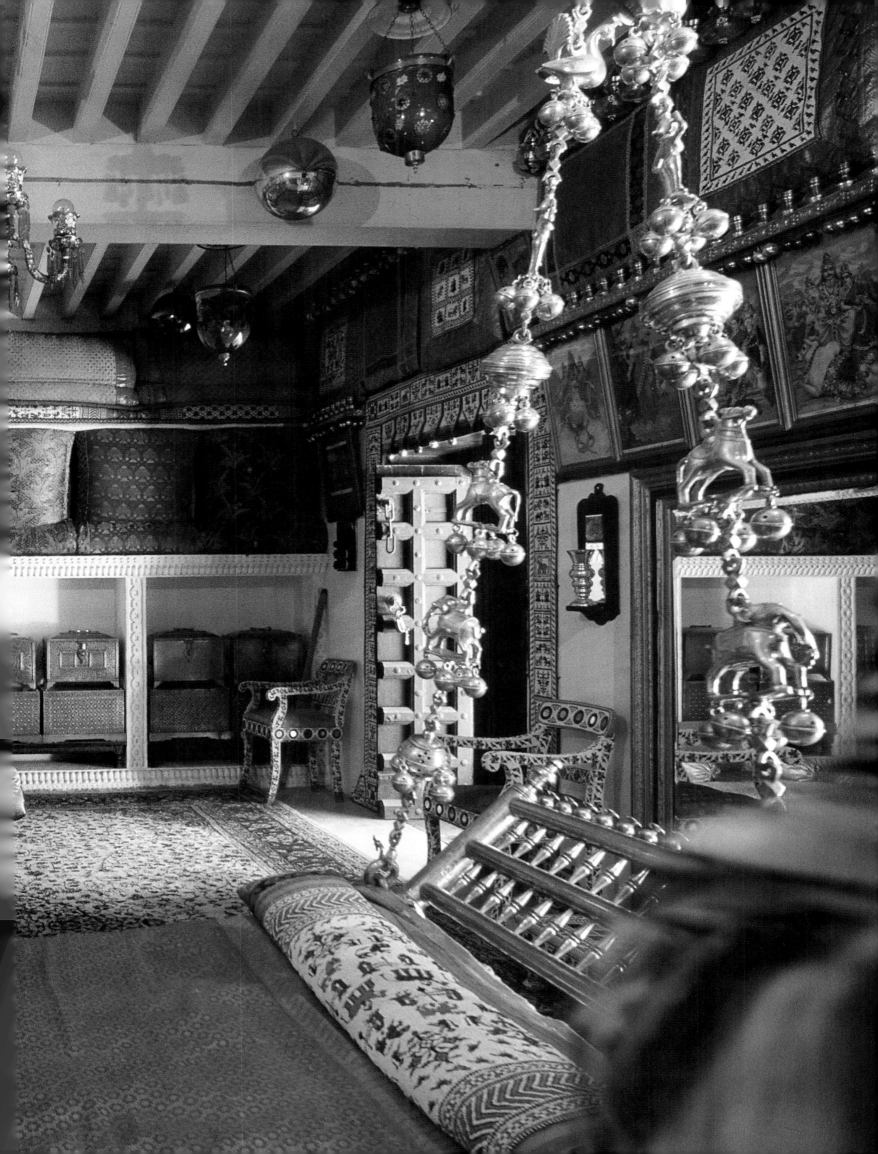

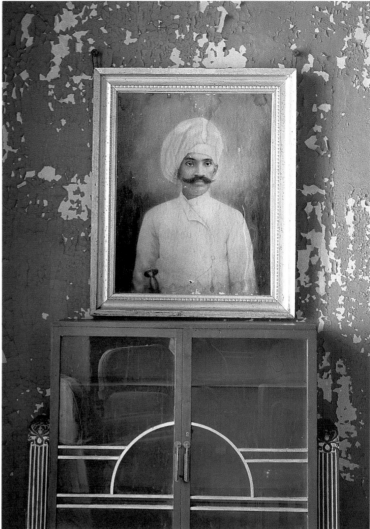

First page: *Deep red terracotta tiles and cane blinds in a ground floor verandah help to keep the harsh light and summer's heat at bay.*
Previous pages: *A sumptuous drawing room done up in traditional style by a maharani of Jasdan about 1880 in the "zenana" or ladies' wing of the palace. The arrangement, known as a "mand", is typical of a formal reception room in Kathiawad homes. The maharani would have sat against the brocade bolster or reclined on the ornamental swing, made of pure silver. Her companions would have used the rich brocade bolsters and cushions stored above. The double row of "pataras", or brass boxes, were her portable wardrobe. The walls and door frame are decorated with panels of fine Kathiawad beadwork.*
Above and facing page: *The blue rooms, originally a porch overlooking the river, were enclosed in 1930, and made into a sitting room for the benefit of European visitors by Alakhachar II of Jasdan. His portrait is company for a stuffed lioness that he shot in 1942. The staircase leads to a room overlooking the river that dried up in the Seventies – and the rooms lost their view as well as their function.*

Première page: *Le carrelage en terre cuite rouge sombre et les stores en rotin chassent la lumière crue et la chaleur de l'été.*
Double page précédente: *un salon décoré à la manière traditionnelle par une maharani de Jasdan vers 1880 dans le «zenana», ou l'aile des femmes du palais. La disposition de la pièce, ou «mand», est typique des salles de réception dans les maisons de Kathiawar. La maharani s'asseyait sur le coussin en brocart ou s'allongeait sur la balançoire ornementale en argent massif. Ses compagnes prenaient place sur les coussins en brocart rangés dans les compartiments. Les doubles rangées de «pataras», ou coffres en laiton, contenaient sa garde-robe. Les murs et l'embrasure de la porte sont décorés de panneaux en perles.*

Ci-dessus et page de droite: *Ces pièces bleu étaient autrefois un porche ouvert sur la rivière. Il fut fermé en 1930 et transformé en salon pour les visiteurs européens d'Alakhachar II de Jasdan. A droite, son portrait et à gauche, la tête empaillée d'une lionne qu'il a abattue en 1942. L'escalier mène à une pièce qui domine le lit de la rivière, asséchée dans les années soixante-dix. Du coup, la pièce a perdu sa vue ainsi que sa fonction.*

Eingangsseite: *Terrakotta-Fliesen und Jalousien aus Rohr halten im Sommer das grelle Licht und die Hitze in Schach.*
Vorhergehende Doppelseite: *ein Salon im »Zenana«, dem Frauenflügel des Palastes, den eine Maharani von Jasdan im traditionellen Stil um 1880 einrichtete. Das als »Mand« bezeichnete Arrangement ist typisch für die Empfangsräume in Kathiawar. Die Maharani saß entweder gegen die Polsterrolle aus Brokat gelehnt oder in der reich verzierten Schaukel aus reinem Silber. Ihre Gefährtinnen setzten sich auf die Kissen und Brokatpolster, die auf den Regalen untergebracht sind. Die »Pataras« – Messingtruhen – dienten ihr als tragbarer Kleiderschrank. Die Wände und der Türrahmen sind mit feinsten Perlenstickereien aus Kathiawar verziert.*
Oben und rechte Seite: *Die blauen Zimmer, die ursprünglich eine Veranda mit Aussicht auf den Fluß waren, wurden 1930 zugemauert und für europäische Besucher durch Alakhachar II. von Jasdan in einen Salon verwandelt. Sein Porträt leistet der ausgestopften Löwin Gesellschaft, die er 1942 erlegte. Die Treppen führen zu einem Raum, von dem man eine Aussicht auf den Fluß hatte, der jedoch in den siebziger Jahren austrocknete. So verloren die Zimmer sowohl ihre Aussicht als auch ihren Nutzen.*

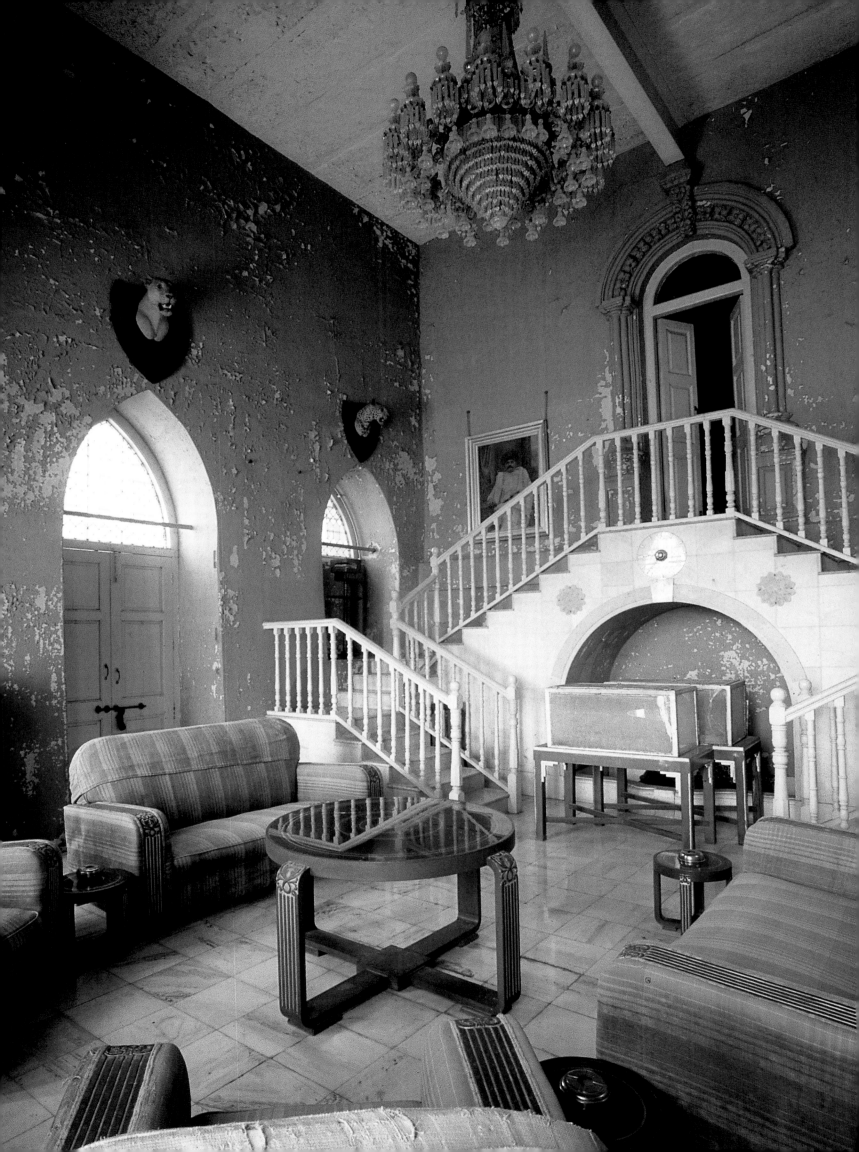

Erik Erikson, éminent biographe de Gandhi, a décrit un jour les Sarabhai d'Ahmadabad comme «les Médicis de l'Inde». Magnats du textile, ils ont contribué à établir certaines des plus importantes institutions pédagogiques du pays et ont toujours été de grands mécènes et collectionneurs. En 1953, Manorama Sarabhai demanda à Le Corbusier de construire une demeure sur la propriété familiale, pour elle et ses deux fils. C'est aujourd'hui une des maisons les plus célèbres et les mieux entretenues du célèbre architecte. Habituée à vivre au sein d'une famille nombreuse et indépendante, Mme Sarabhai, voulait une maison ouverte, sans porte d'entrée ni sonnette. Ses jeunes fils, dont Anand Sarabhai, qui y vit encore aujourd'hui, avaient été marqués par une amusante histoire pour enfants d'André Maurois où des gens menus se laissaient glisser dans des bassins à leur réveil. Ils demandèrent donc une piscine et un toboggan. Le Corbusier exauça leur vœu, fidèle à sa devise: «une maison est une machine à vivre.»

Anand Sarabhai

Erik Erikson, an eminent biographer of Gandhi, once described Ahmedabad's Sarabhai family as the Medici of India. Textile magnates, they helped establish some of the country's premier educational institutions and have remained avid collectors and patrons of art. In 1953 the architect Le Corbusier agreed to build a house on the family estate for Manorama Sarabhai and her two sons – it remains one of his best-known and best-kept private residences anywhere. Used to life in a large, informal Indian family, Mrs Sarabhai wanted an open house with no front door and no door bell. The young boys, including Anand Sarabhai who lives in it today, were much taken by a whimsical children's tale by André Maurois about thin people who tunnelled into swimming pools on waking up. They asked for a slide and a swimming pool. And, true to his axion, "a house is a machine for living", that is what the architect gave them.

Erik Erikson, einer der bedeutendsten Biographen Gandhis, bezeichnete einmal die Sarabhai-Familie aus Ahmedabad als die Medicis von Indien. Sie waren Textilmagnaten, halfen bei der Gründung einiger der besten Bildungsanstalten des Landes und sind auch heute noch eifrige Kunstsammler und -förderer. Der Architekt Le Corbusier erklärte sich 1953 bereit, auf dem Land der Familie ein Haus für Manorama Sarabhai und ihre beiden Söhne zu bauen. Heute ist dieses Gebäude eines der bekanntesten und am besten erhaltenen privaten Wohnhäuser, die der Architekt gebaut hat. Da Manorama Sarabhai an das Leben in einer großen, ungezwungenen indischen Familie gewohnt war, wünschte sie sich ein offenes Haus ohne Eingangstür oder Klingel. Die beiden Jungen, von denen der eine, Anand Sarabhai, das Haus noch heute bewohnt, waren damals ganz begeistert von einer schrulligen Kindergeschichte von André Maurois, in der dünne Gestalten vorkamen, die sich nach dem Aufwachen durch einen Tunnel in einen Swimmingpool fallen ließen. So kam es, daß die Jungen um den Bau einer Rutsche und eines Swimmingpools baten, und genau das tat der Architekt für sie. Das Gebäude dient als Beweis für seinen Grundsatz, daß »ein Haus eine Maschine zum Bewohnen« ist.

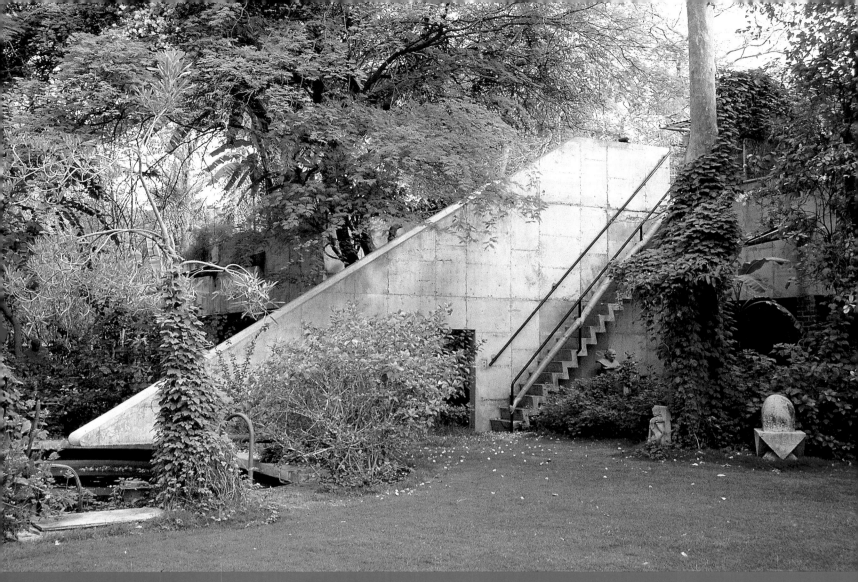

The 25-foot concrete slide, lined inside with smooth terrazzo, sweeps down from the terrace garden on the roof of the house into the swimming pool. A staircase running parallel to the slide leads to the first floor. The poolside is thickly planted with tall trees and lush creepers to give the impression of a magic woodland.

Le toboggan de huit mètres de long, tapissé de granito lisse, part du jardin suspendu sur le toit de la maison et descend jusqu'à la piscine. Un escalier parallèle permet d'entrer au premier étage. Le pourtour de la piscine est richement boisé de hauts arbres et de plantes grimpantes pour donner l'illusion d'une forêt enchantée.

Auf der fast acht Meter langen Rutsche aus Beton, deren Inneres mit glattem Terrazzo verkleidet ist, rauscht man von dem Garten auf der Dachterrasse hinunter in den Swimmingpool. Parallel zu der Rutsche verläuft eine Treppe, über die man den ersten Stock erreicht. Der Pool ist rundherum von einem Pflanzendickicht umgeben, dessen hohe Bäume und üppigen Kletterpflanzen den Eindruck vermitteln, als befände man sich in einem Zauberwald.

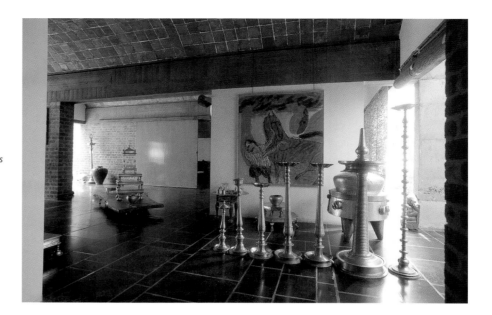

Right: Open bays at either end of the house give on to verandahs. The black stone floors of the living area are truncated by expanses of white and coloured walls. Burnished brass shrines and oil lamps screen a modern painting by the Ahmedabad artist Amit Ambalal.
Below: Sliding wooden doors divide the living area. A row of low brass tables, "bajots" is surmounted by a brass shrine. The neon sculpture on the concrete lintel is by New York artist Keith Sonnier.

A droite: Les baies vitrées de chaque côté de la maison donnent sur des vérandas. Les dalles en pierres noires du sol contrastent avec les murs blancs et colorés. Derrière les objects de culte et les lampes à huile en laiton bruni, une peinture moderne d'Amit Ambalal, originaire d'Ahmadabad.
Ci-dessous: Des portes coulissantes en bois divisent la salle de séjour. Une pile de tables basses en laiton, ou «bajots», est surmontée d'un object de culte. La sculpture néon sur le linteau en béton est une œuvre du New-Yorkais Keith Sonnier.

Rechts: An beiden Enden des Hauses führen offene Erker auf eine Veranda hinaus. Der schwarze Steinboden des Wohnzimmers kontrastiert mit den Flächen der weiß oder farbig gestrichenen Wände. Schreine und Öllampen aus poliertem Messing verdecken zum Teil ein Gemälde des Künstlers Amit Ambalal, der aus Ahmedabad stammt.
Unten: Schiebetüren aus Holz unterteilen das Wohnzimmer. Eine Reihe niedriger Messingtische, die man »Bajots« nennt, werden von einem Messingschrein überragt. Die Neon-Skulptur, die an dem Betonsturz hängt, ist ein Werk des New Yorker Künstlers Keith Sonnier.

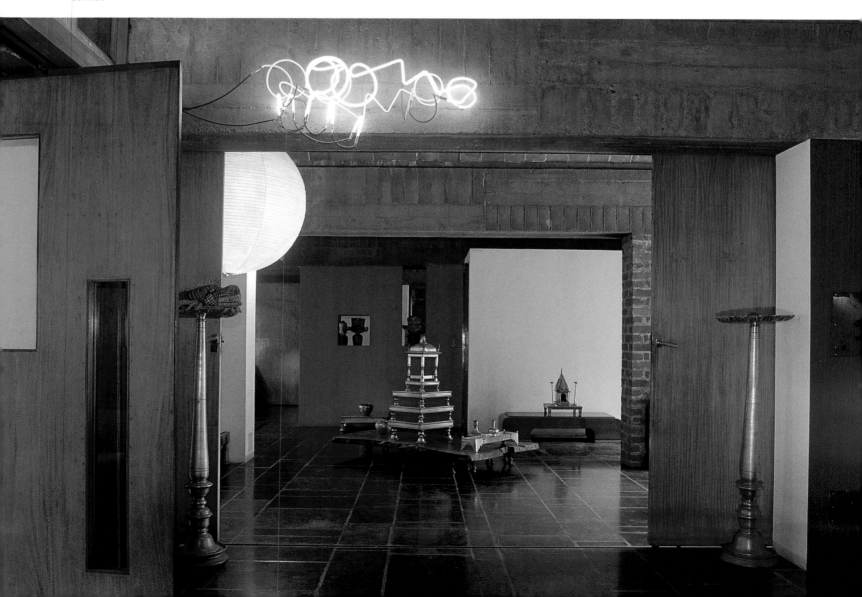

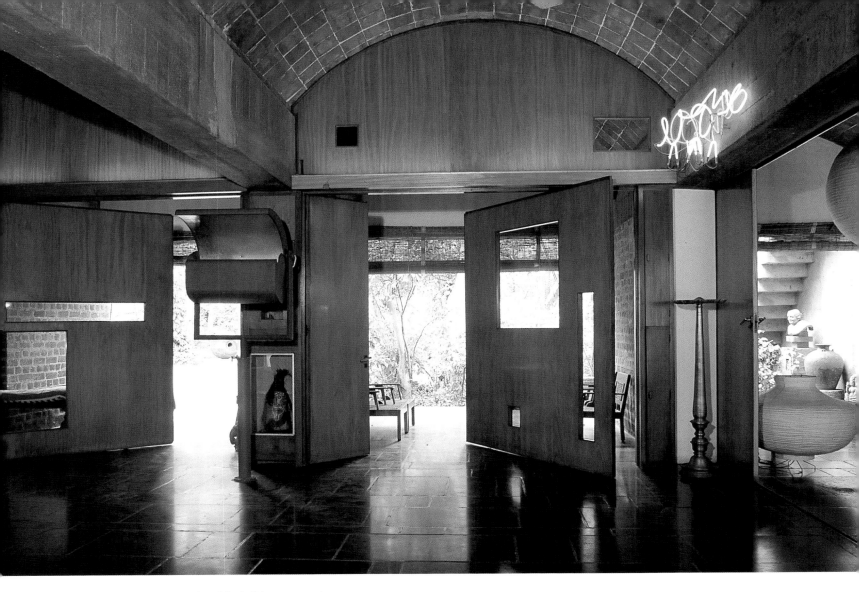

Le Corbusier's prefabricated house in Ahmedabad still has a personal note: A roof of ten concrete vaults is supported on concrete beams. The wooden swing doors on pivots control both light and air flow and are set with panes of plain and coloured glass. Le Corbusier also designed the steel wall-lamp with an aluminium reflector.

Préfabriquée mais néanmoins individuelle, la maison de Le Corbusier a un toit constitué de dix voûtes soutenues par des poutres en béton. Les portes en bois montées sur pivots permettent de contrôler la lumière et l'aération. Elles sont
équipées de panneaux en verre clair et coloré. Le Corbusier a également dessiné l'applique en acier dotée d'un réflecteur en aluminium.

Das Dach von Le Corbusiers Haus in Ahmedabad hat, obwohl es aus vorgefertigten Teilen zusammengesetzt ist, eine persönliche Note: Es besteht aus zehn Betonwölbungen, die von Betonbalken gestützt werden. Die Pendeltüren aus Holz, die auf Drehzapfen aufliegen, regulieren sowohl den Lichteinfall als auch die Luftzufuhr und haben Scheiben aus weißem und buntem Glas. Die Wandleuchte aus Stahl mit einem Reflektor aus Aluminium ist ebenfalls ein Entwurf von Le Corbusier.

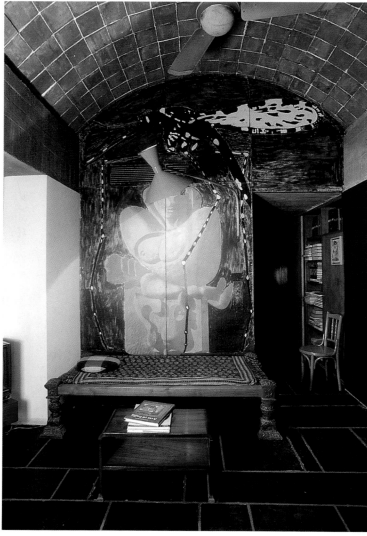

Detail left: The wall on the staircase landing is hung with a sculpture in wiremesh, plaster, fabric and silver paint by New York artist Lynda Benglis. The concrete beam above is mounted with a drawing of a tapestry design, also by Benglis, made for Atlanta airport. The giant, carved stone foot is a ritual Tantric object.
Detail right: Above the traditional square seat hangs a large photograph by Le Corbusier overpainted by Los Angeles artist John Baldessari.
Facing page: A loft-like bedroom on the first floor has ceiling fans painted with cricket bats by John Baldessari. The bamboo-and-paper floor lamp, shaped like an Indian vessel, is by Lynda Benglis. The famous "New Yorker" poster above the bed by Saul Steinberg carries the artist's hand-drawn doodles.

Détail de gauche: Le mur de l'escalier est orné d'une sculpture en grillage, plâtre, tissu et peinture argentée de l'artiste New-Yorkaise Lynda Benglis. Sur la poutre en béton au-dessus, le carton d'une tapisserie conçue pour l'aéroport d'Atlanta, également signé Benglis. Le grand pied en pierre est un objet rituel tantrique.
Détail de droite: Au-dessus du siège carré traditionnel, une grande photographie de Le Corbusier repeinte par l'artiste de Los Angeles John Baldessari.
Page de droite: Dans la chambre-loft du premier étage, le ventilateur de plafond a été peint de battes de cricket par John Baldessari. La lampe en bambou et papier, reprenant la forme d'une jarre indienne, est de Lynda Benglis. Au-dessus du lit, le célèbre poster du «New Yorker» par Saul Steinberg porte les griffonnages originaux de l'artiste.

Detail links: An der Wand des Treppenabsatzes hängt eine Skulptur aus Maschendraht, Gips, Stoff und Silberfarbe von der New Yorker Künstlerin Lynda Benglis. Ebenfalls von Benglis stammt der Entwurf an dem Betonbalken darüber, den die Künstlerin für einen Wandteppich im Flughafen von Atlanta konzipierte. Der riesige aus Stein gemeißelte Fuß ist ein rituelles Kultobjekt des Tantrismus.
Detail rechts: Über der traditionellen viereckigen Sitzbank hängt eine große Fotografie von Le Corbusier, die von dem aus Los Angeles stammenden Künstler John Baldessari übermalt wurde.
Rechte Seite: Der Deckenventilator dieses unter dem Dach gelegenen Schlafzimmers wurde von John Baldessari mit Kricketschlägern bemalt. Die Stehlampe aus Bambus und Papier, deren Form einem indischen Gefäß nachempfunden wurde, stammt von Lynda Benglis. Das berühmte »New Yorker« Poster von Saul Steinberg, das über dem Bett hängt, ist mit Original-Kritzeleien des Künstlers versehen.

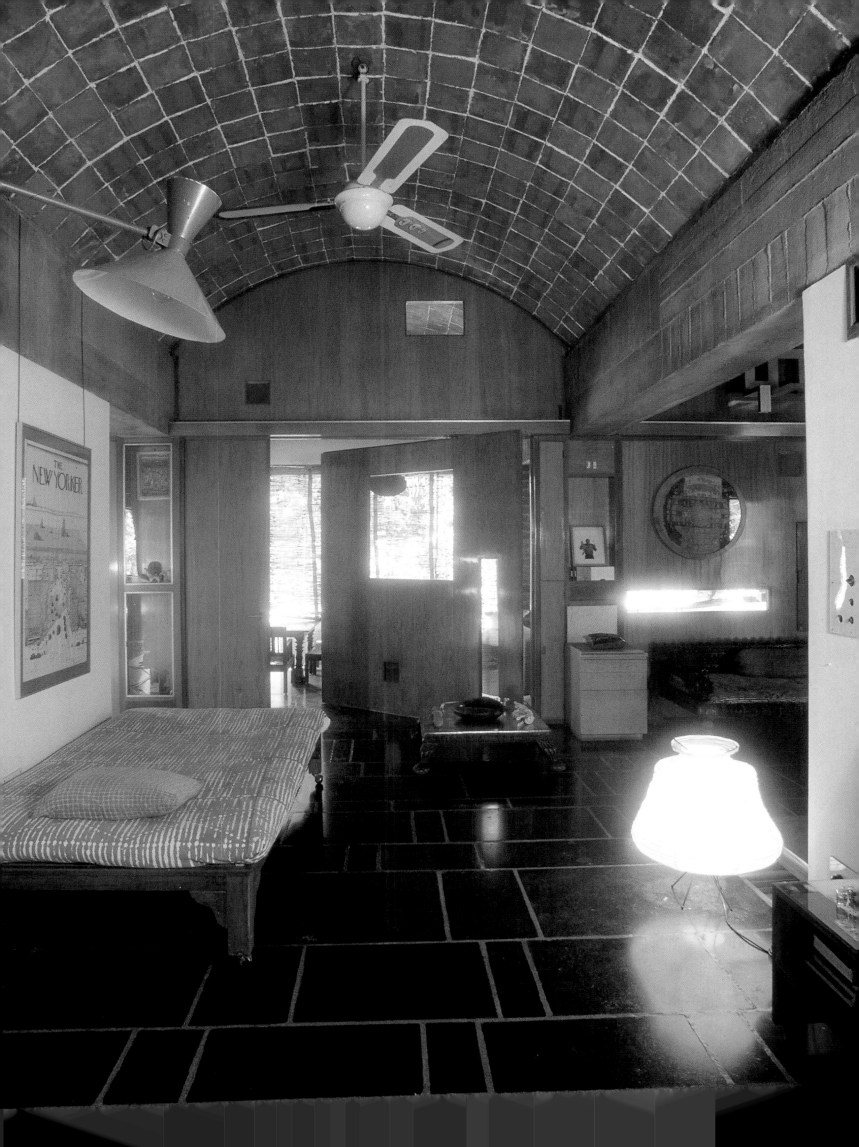

Mohandas Karamchand Gandhi, défenseur de la non-violence et de l'indépendance de l'Inde, fonda son premier ashram permanent sur les berges du Sabarmati à Ahmadabad en 1916. Il était rentré d'Afrique du Sud l'année précédente où son combat contre l'Apartheid l'avait amené à établir des communautés autosuffisantes similaires. Gandhi acheta le terrain avec l'aide d'un commerçant d'Ahmadabad et y planta sa tente. Peu à peu, le terrain fut boisé et les rizières irriguées. Sa famille et ses disciples s'installèrent dans une série de petites maisons blanchies à la chaux, se consacrant à la prière et au renoncement. Ils priaient, jeûnaient, cultivaient leurs champs, filaient et tissaient leurs propres étoffes. La chambre de Gandhi, ci-contre, qu'il a occupée pendant 16 ans, est monacale. Son meuble principal est un rouet, emblème de la résistance à la politique britannique de dumping textile. La photo ci-dessous montre l'ashram de Gandhi à Bombay.

Mahatma Gandhi

Mohandas Karamchand Gandhi, the champion of non-violent struggle and Indian independence from colonial rule, founded his first permanent ashram, or hermitage, on the banks of the Sabarmati river in Ahmedabad in 1916. He had returned to India from South Africa the previous year where his fight against apartheid led him to establish similar self-reliant communes. Gandhi bought the land with the help of an Ahmedabad merchant and pitched a tent on it. Gradually, trees were planted and cotton fields irrigated. A series of low whitewashed huts came up where his family and co-workers, embodying service and renunciation, prayed, fasted, grew their own food and wove handspun fabrics. Gandhi's room, opposite, which he occupied for 16 years, is a cell. Its most important content, his spinning-wheel, is a symbol of the political revolution it unleashed against textile-dumping by British mills. The picture below shows Gandhi's ashram in Bombay.

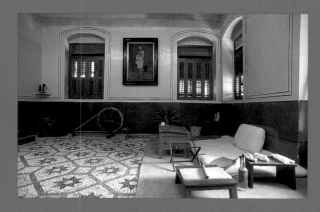

Mohandas Karamchand Gandhi, der Meister des gewaltlosen Widerstandes und der Anführer der Unabhängigkeitsbewegung Indiens, gründete 1916 seinen ersten, dauerhaft angelegten Ashram – was soviel heißt wie Einsiedelei – in Ahmedabad, am Ufer des Sabarmati-Flusses. Im Jahr zuvor war er von Südafrika nach Indien zurückgekehrt. Bei seinem Kampf gegen die Apartheid hatte er dort ähnliche, sich selbst versorgende Gemeinschaften gegründet. Gandhi kaufte zunächst das Land mit Hilfe eines Händlers aus Ahmedabad und errichtete ein Zelt darauf. Nach und nach wurden Bäume gepflanzt und Baumwollfelder bewässert. Es entstand eine Reihe von niedrigen, weißgetünchten Hütten für seine Familie und seine Mitarbeiter. Hier verwirklichten sie die Ideologie des Dienens und der Askese, beteten, fasteten, bauten ihre eigene Nahrung an und webten Stoffe aus handgesponnener Baumwolle. In dem auf der rechten Seite gezeigten Zimmer, das einer Mönchszelle gleicht, lebte Gandhi 16 Jahre lang. Der wichtigste Gegenstand im Raum, das Spinnrad Gandhis, ist ein Symbol für die politische Revolution: der Kampf gegen die den Markt monopolisierende Massenproduktion der britischen Textilindustrie. Die Abbildung links zeigt den Ashram Gandhis in Bombay.

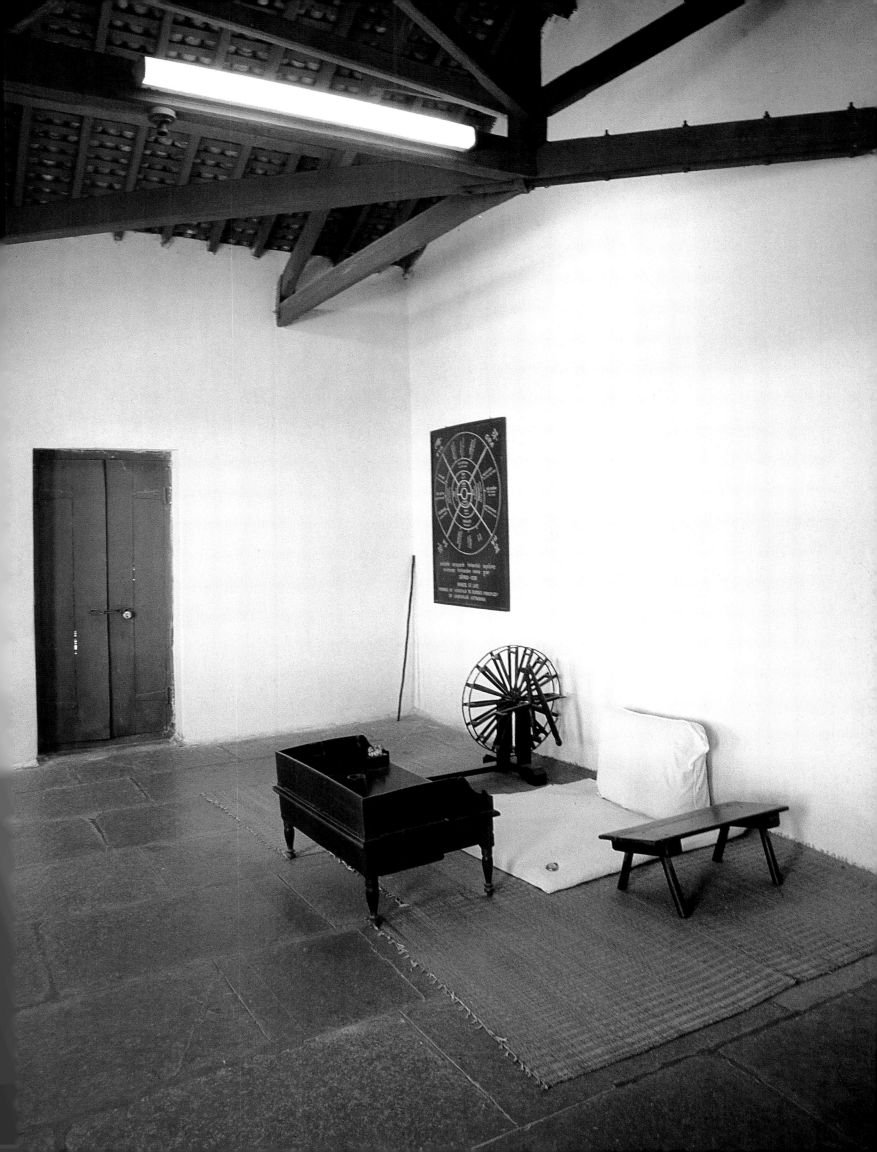

Bombay and Goa

Asha Parekh fut l'une des plus grandes stars du cinéma indien dans
les années 60 et 70, une déesse de l'écran dont la gloire se mesure au
nombre de ses «jubilee hits», de grands succès restés à l'affiche plus
de vingt-cinq semaines de suite dans une des salles titanesques de
Bombay. Des comédies musicales endiablées aux grandes histoires
d'amour chargées d'émotion, elle a triomphé partout. Ne s'étant ja-
mais mariée, elle a consacré toute son affection à ses parents et à une
longue lignée de Lhassa apso. Elle en a élevé jusqu'à onze à la fois
mais n'en possède aujourd'hui plus qu'un. Au début des années 60,
elle a acheté une belle propriété sur la plage de Juhu près de Bombay
et a confié la construction de sa nouvelle résidence à Nari Gandhi, un
architecte renommé, fervent disciple de Frank Lloyd Wright. L'actrice
et l'architecte eurent de nombreuses prises de bec tout au long des
travaux avant de convenir sur l'intérieur labyrinthique de la maison.
Mlle Parekh raconte avec un plaisir manifeste comment un voleur qui
s'était introduit chez elle une nuit n'a jamais pu retrouver la sortie.
Une fois au commissariat, un policier lui a déclaré «Ainsi, tu t'es fait
coincer dans l'hôpital d'Asha Parekh!».

Asha Parekh

Asha Parekh was one of India's top movie stars in the Sixties and
Seventies, a Bombay screen goddess whose success was measured
by the number of "jubilee hits" she gave, blockbusters with
continuous runs of 25 or more weeks in a single Titanic-sized cin-
ema. From dance-studded juvenalia to tear-jerkers laced with heavy
emotion, she breezed through them all. She never married and de-
voted herself to caring for her parents and a string of adored Apsos
– she once owned eleven but is now left with only one. In the early
Sixties she bought an expensive property on Juhu beach near Bom-
bay and engaged Nari Gandhi, an architect influenced by Frank
Lloyd Wright. The actress and architect had furious rows over the
building's maze-like interiors. With delight Miss Parekh relates the
story of a thief who got in one night but could not find his way out.
When presented at the police station, the policeman exclaimed,
"Ah, so you were found in Asha Parekh's hospital!"

Asha Parekh gehörte während der sechziger und siebziger Jahre zu
den berühmtesten Filmstars Indiens. Sie war eine Leinwandgöttin aus
Bombay, deren Erfolg an der Zahl der Blockbuster gemessen wurde,
die 25 oder mehr Wochen in einem einzigen riesigen Kino liefen. Von
Tanzfilmen für Jugendliche bis hin zu gefühlsüberladenen Schmacht-
fetzen hat sie in allen Filmen mitgespielt. Sie hat jedoch nie geheira-
tet, sondern kümmerte sich statt dessen um ihre Eltern und ihre heiß-
geliebten Lhasa-Apso-Hunde. Früher besaß sie einmal elf, heute ist
ihr nur noch einer geblieben. Zu Beginn der sechziger Jahre erwarb sie
ein teures Grundstück am Juhu-Strand bei Bombay. Mit dem Bau ih-
res Hauses beauftragte sie Nari Gandhi, einen Architekten, der von
Frank Lloyd Wright beeinflußt worden war. Die Schauspielerin und
der Architekt hatten wutentbrannte Auseinandersetzungen wegen des
labyrinthartigen Inneren des Gebäudes. Mit großer Begeisterung er-
zählt Asha Parekh die Geschichte von einem Dieb, der eines Nachts
einbrach und dann den Weg nach draußen nicht mehr finden konnte.
Als man ihn ins Polizeirevier brachte, rief der Polizist: »Ah, Sie hat
man also in Asha Parekhs Irrenhaus gefunden!«

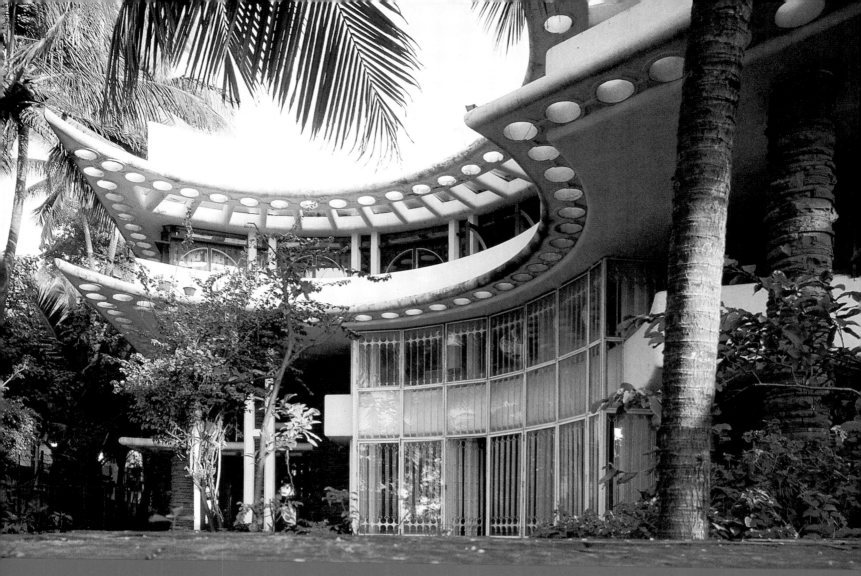

Above and right: The brickless house, set in a garden on the beach, has tall aluminium-framed windows set in an exterior made entirely of concrete. The curved balcony on the upper floor rests on a ledge with a pattern of circular holes. A similar ledge above, with the same design, serves as a pergola. The two ledges end in sharp parallel points, giving the house its futurist air.

Ci-dessus et à droite: Enfouie dans un jardin au bord de la mer, la maison possède de hautes fenêtres aux montants en aluminium et une façade entièrement en béton. Le balcon incurvé à l'étage repose sur une corniche percée d'ouvertures rondes. Au-dessus, une corniche similaire sert de pergola. Tous deux finissent en pointes acérées et parallèles, donnant à la structure un aspect futuriste.

Oben und rechts: Das inmitten eines Gartens am Strand gelegene Haus hat hohe Fenster. Diese fügen sich in eine Fassade ein, die gänzlich aus Beton besteht. Der geschwungene Balkon im Obergeschoß ruht auf einem Vorsprung, der mit einem Muster aus kreisrunden Löchern durchbrochen ist. Ein ähnlicher Vorsprung darüber mit demselben Muster dient als Pergola. Die beiden Vorsprünge enden in zwei scharfen Spitzen, die parallel verlaufen und dem Haus seinen futuristischen Charakter verleihen.

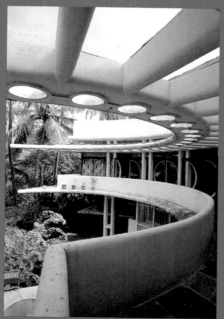
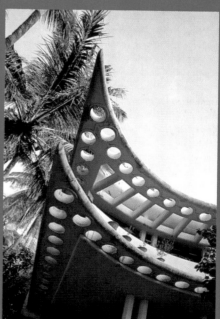

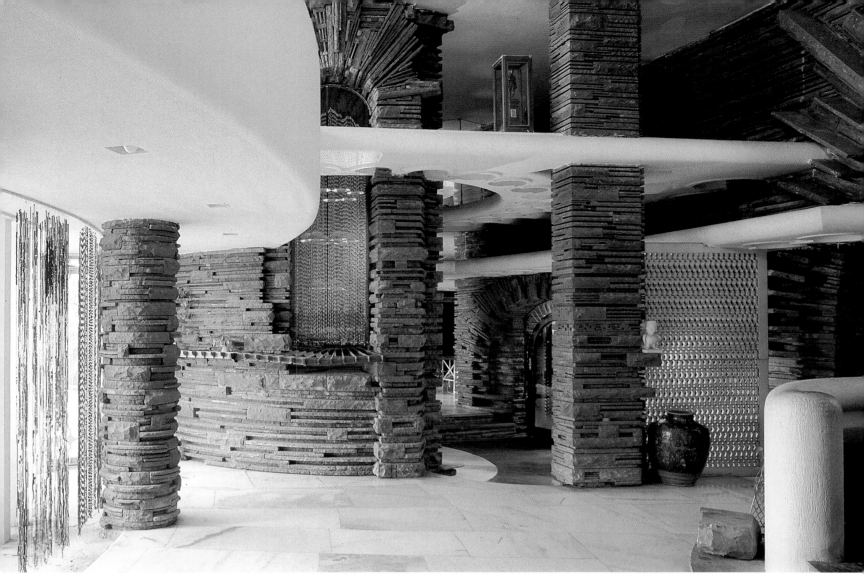

Above: Nari Gandhi carried his exterior theme of horizontal concrete ledges and curved balconies into the reception area of the house. The elaborate supporting columns and walls were made of sandstone blocks and tiles, each piece individually cut on site.
Right: Arches designed in sunbursts of stonework divide the living room spaces. The circular holes on the exterior face of the house are repeated in the interiors. The floors are of white marble throughout.

Ci-dessus: Nari Gandhi a poursuivit le thème des corniches en béton et des balcons incurvés à l'intérieur de la maison, dans la partie réception. Les colonnes de soutien et les murs sont en blocs et tuiles de grès, chaque élément ayant été découpé sur place.
A droite: Le séjour est divisé en plusieurs parties par des arches de grès en forme de rayons de soleil. On retrouve à l'intérieur les ouvertures rondes de la façade. Tous les sols sont en marbre blanc.

Oben: Nari Gandhi übertrug Gestaltungselemente wie horizontale Betonvorsprünge und geschwungene Balkone, die er an der Hausfassade genutzt hatte, auf die Eingangshalle im Inneren. Die kunstvoll gestalteten Stützpfeiler und Wände wurden aus Sandsteinblöcken und Ziegeln zusammengesetzt, wobei jedes einzelne Teil vor Ort zugeschnitten wurde.
Rechts: Das Wohnzimmer wird durch Bögen gegliedert. Die kreisrunden Löcher an der Außenwand des Hauses wiederholen sich im Innern. Die Böden im ganzen Haus sind aus weißem Marmor.

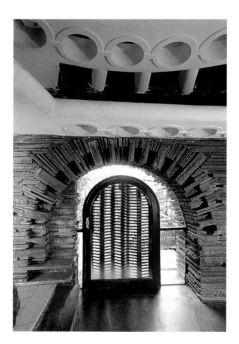
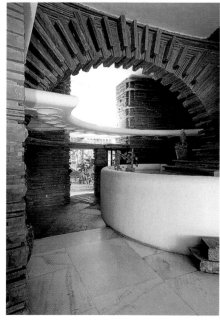

Right: Curved kitchen cabinets are faced in black-and-white masonite in a geometric design and topped with counters of granite.
Below: The floating balcony on the mezzanine floor, cantilevered on stone columns, allows to survey visitors in the living room from the private rooms above.

A droite: Les placards arrondis de la cuisine sont tapissés de plaques d'aggloméré noires et blanches formant un motif géométrique. Les plans de travail sont en granit.
Ci-dessous: Le balcon suspendu de la mezzanine, soutenu par des colonnes en pierre, permet de voir le salon depuis les appartements privés à l'étage.

Rechts: Die in einer Rundung angeordneten Küchenschränke sind mit schwarz-weißen, in einem geometrischen Muster angeordneten Platten verkleidet und mit Arbeitsflächen aus Granit ausgestattet.
Unten: Der freischwebende Balkon im Mezzanin-Geschoß, der auf steinernen Säulen ruht, bietet die Gelegenheit, die im Wohnzimmer befindlichen Gästen von den Privaträumen im Obergeschoß aus zu sehen.

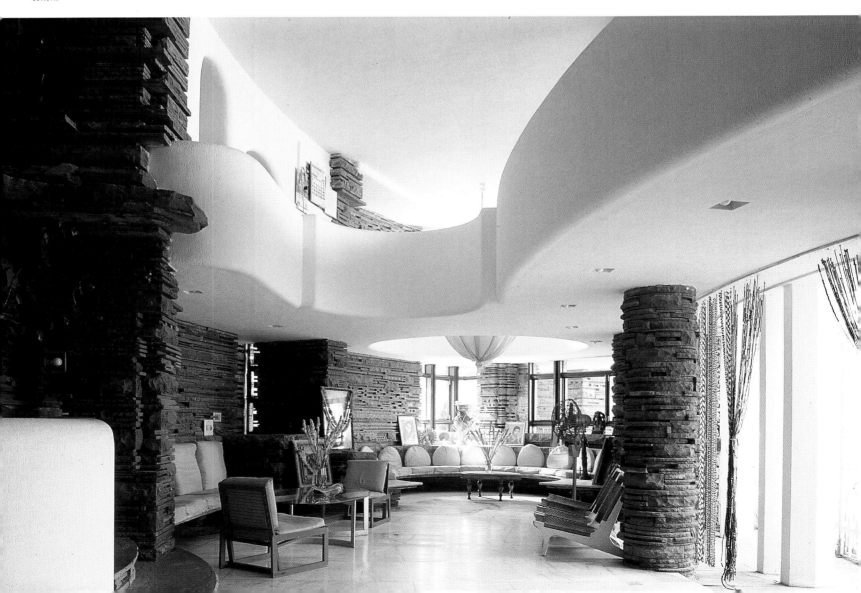

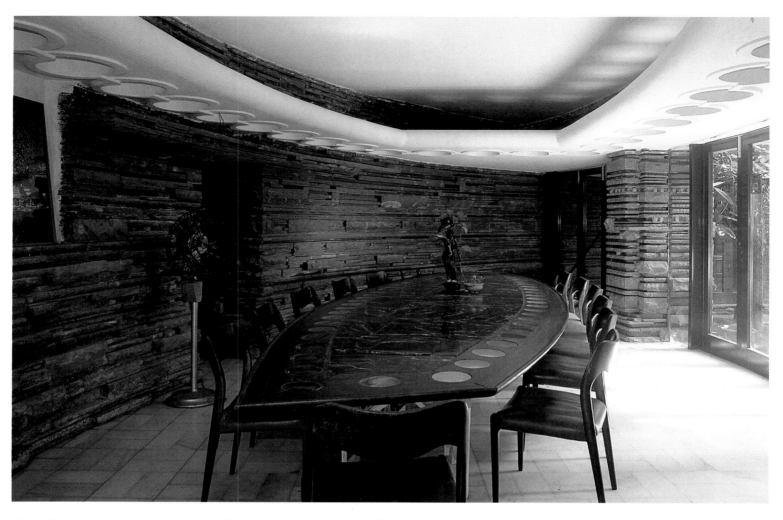

Above: The curved 18-seater dining table, made to Nari Gandhi's design, is inlaid with a centrepiece of Italian marble and circular panels of frosted glass that echo the round cut-outs in the concrete ledge above.
Right: Walls and ledges of stonework tiles form the backdrop to the main bedroom and a seat outside.
Facing page: The circular form of an intimate seating area at the bar is reflected in the round aluminium table designed by the architect. The beaded curtains were made at home but the red-and-white lighting fixture, by Verner Parton, spotted in a foreign magazine, was specially purchased in Denmark by Asha Parekh.

Ci-dessus: La table incurvée, dessinée par Nari Gandhi, peut accueillir dix-huit convives. Elle est incrustée d'un centre de table en marbre italien et de panneaux ronds en verre dépoli qui rappellent les ouvertures du faux plafond en béton.
Détails de droite: Les murs et les corniches en tuiles de grès forment la toile de fond de la chambre principale. Une dalle de grès jaillit d'un mur pour former une banquette.
Page de droite: On retrouve la forme circulaire de ce petit salon intime près du bar dans la table en aluminium dessinée par l'architecte. Les rideaux de perles ont été réalisés sur place mais le lustre rouge et blanc, signé Verner Parton, a été acheté au Danemark par Asha Parekh qui l'avait remarqué dans un magazine.

Oben: Der geschwungene Eßtisch, an dem 18 Personen Platz finden, wurde nach einem Entwurf von Nari Gandhi angefertigt. Er ist mit Einlegearbeiten gestaltet, die in der Mitte aus italienischem Marmor und am Rand aus kreisrunden Milchglasscheiben bestehen. Diese korrespondieren mit den runden Aussparungen in dem Betonvorsprung an der Decke darüber.

Unten: Den Hintergrund sowohl des Schlafzimmers als auch einer Sitzbank davor bilden Mauern und Vorsprünge aus Steinkacheln.
Rechte Seite: Die kreisrunde Form der gemütlichen Sitzecke an der Bar findet sich in dem Aluminiumtisch wieder, dessen Design von Nari Gandhi stammt. Die Vorhänge aus Perlschnüren wurden in Indien hergestellt, die rotweißen Lampen, von Verner Parton entworfen, kaufte Asha Parekh in Dänemark, nachdem sie sie in einer ausländischen Zeitschrift entdeckt hatte.

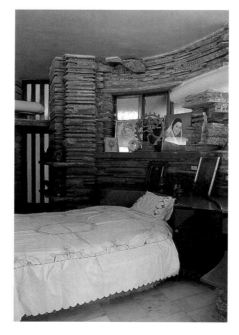
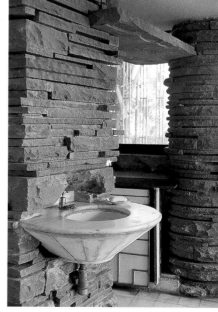

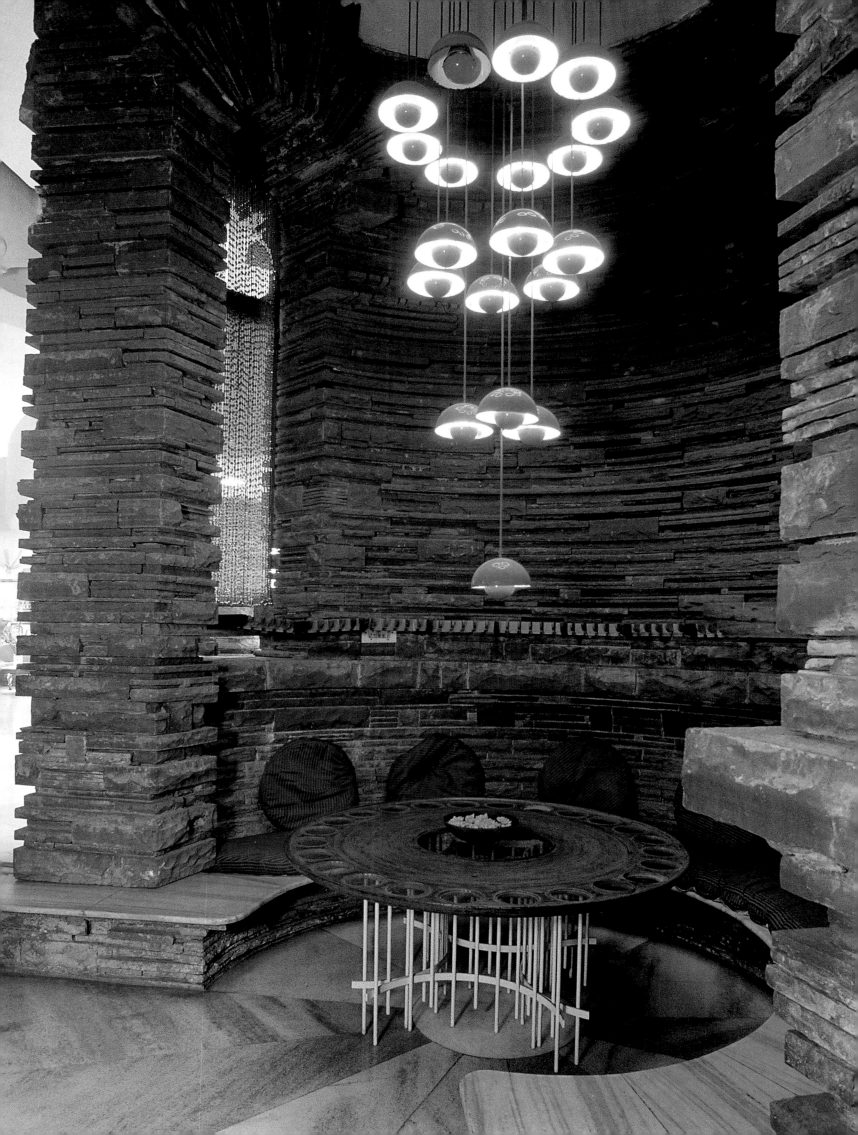

Le plus clair de l'année, Graham et Kay Coward-Windsor habitent dans un cottage baptisé « The Hob » dans un petit village du Cheshire, en Angleterre. Mais dès novembre, telles les hirondelles, ils volent tout droit vers le soleil de Goa. Leur résidence secondaire en nord du Goa est une cabane en bambous et en feuilles de palmier tressées. Chaque année, il leur faut deux heures pour la reconstruire contre un gros rocher qui affleure sur le sable, à 50 mètres des vagues. Après s'être nourris de lotus pendant trois mois, ils repartent, laissant le contenu modeste de leur habitation de fortune dans la hutte voisine du marchand de thé. Graham, ancien steward, et Kay, qui cultive des fraises en Angleterre, ont découvert Goa il y a 20 ans. Bien que leur «squat» soit saisonnier, les gens du coin leur accordent des droits de résidents à part entière: une cloche en laiton est suspendue devant la porte de la cabane pour annoncer les visiteurs et le facteur leur apporte régulièrement le courrier.

A Beach Shack in Goa

For most of the year Graham and Kay Coward-Windsor live in a cottage called "The Hob" in a small village in Cheshire, England. But come November, like homing swallows, they fly off to sunny Goa. Their home in the North of Goa is also called "The Hob" – leaning on a protruding rock in the sand, 50 yards from the breakers, it is a disposable beach hut made of bamboo and plaited palm leaves that takes two hours to assemble. After three months of lotus-eating they depart, leaving their shack's modest contents behind at the hut next door which is the local teashop. Graham, a former airline steward and Kay, a strawberry farmer, discovered Goa 20 years ago. Although their squatters' arrangements are seasonal, the locals accord them full rights: a brass bell hangs outside the hut to ring for morning tea and the postman calls regularly with the mail.

Den größten Teil des Jahres wohnen Graham und Kay Coward-Windsor in einem Cottage namens »The Hob« in einem kleinen Dorf in der englischen Grafschaft Cheshire. Sobald es jedoch November wird, tun sie es den Zugvögeln gleich und fliegen in das sonnige Goa. Auch ihr Heim im Norden Goas nennt sich »The Hob«. Es handelt sich dabei um eine Art recycelbare Strandhütte aus Bambus und geflochtenen Palmblättern, die sich an einen vorstehenden Felsen im Sand schmiegt, kaum 50 Meter von der Brandung entfernt. Der Bau der Hütte dauert nur zwei Stunden. Nach drei Monaten vollkommener Weltvergessenheit fahren sie wieder ab und lagern den bescheidenen Inhalt ihrer Hütte in dem Häuschen nebenan, der Teestube des Ortes. Graham, ein ehemaliger Steward, und Kay, die Erdbeeren anbaut, haben Goa vor 20 Jahren entdeckt. Obwohl sie ihre Unterkunft immer nur saisonbedingt aufsuchen, behandeln die Ortsansässigen sie als vollgültige Nachbarn: Vor der Hütte hängt ein Glöckchen aus Messing, mit dem man morgens nach dem Tee läutet, und der Postbote kommt regelmäßig mit der Post vorbei.

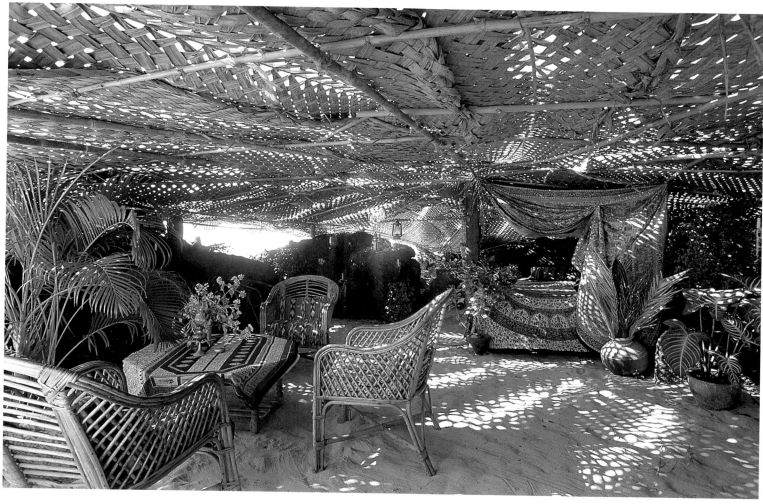

Previous page: A plaited palm-leaf mat hung from bamboo poles forms the bathroom door in the Coward-Windsor beach hut.
Facing page: The bathroom has a floor of sand and a shower connected by a pipe to a water-filled tin drum on the roof. It operates by gravitational pull. Natural cavities in the rock face are used for storing towels and soap.
Above and right: Bright dappled sunlight penetrates the 20-foot circular palm-leaf roof of the beach hut. The bedsit is decorated with potted plants, cane armchairs and a canopied bed covered with a cheerful block-printed cotton fabric. Lit by oil lamps and candles at night, a natural ledge in the rock acts as a makeshift cocktail bar.

Page précédente: La porte de la salle de bains des Coward-Windsor est un tapis en feuilles de palmier tressées.
Page de gauche: Le sol de la salle de bains est en sable. La douche est reliée à un bidon en fer blanc sur le toit de la cabane. Elle fonctionne en tirant sur une corde. Les cavités naturelles du rocher font office de porte-savon et d'étagères pour les serviettes.
Ci-dessus et à droite: Un soleil éclatant filtre à travers le toit, de six mètres de diamètre, rond en feuilles de palmier de la cabane. Le salon-chambre est meublé de plantes en pot, de fauteuils en rotin et d'un lit à baldaquin recouvert d'une gaie cotonnade imprimée. La nuit, l'intérieur est éclairé par des lampes à huile et des bougies. Une corniche naturelle dans le rocher sert de bar.

Vorhergehende Seite: An Bambusstangen hängt eine Matte aus geflochtenen Palmblättern. Dies ist die Badezimmertür der Hütte.
Linke Seite: Der Boden des Badezimmers besteht aus Sand. Die Dusche ist durch einen Schlauch mit einer als Wasserbehälter dienenden Blechtonne auf dem Dach verbunden und funktioniert mit Hilfe der Schwerkraft. Natürliche Aushöhlungen im Felsen werden für die Aufbewahrung von Handtüchern und Seife benutzt.

Oben und unten: Helles Sonnenlicht wird durch das sechs Meter breite, kreisrunde Dach der Strandhütte gefiltert, das aus Palmblättern geflochten ist. Die Einrichtung des Raumes besteht aus Topfpflanzen, Korbsesseln und einem Bett mit Baldachin. Die Tagesdecke auf dem Bett ist aus Baumwollstoff, der mit einem fröhlichen Muster bedruckt ist. Nachts besteht die Beleuchtung aus Öllampen und Kerzen. Ein natürlicher Sims im Felsen dient als improvisierte Cocktail-Bar.

En 1666, un souverain brahmane du sud du Maharashtra dut battre en retraite devant l'invasion des armées mahrates et chercha refuge à Goa. Les Portugais catholiques comprirent donc qu'il était dans leur intérêt de pactiser avec le chef hindou et les territoires de ce dernier vinrent s'ajouter aux possessions portugaises en Inde. Deux siècles plus tard, les Deshprabhu furent élevés au rang de vicomtes en retour de leur administration loyale et avisée sur plusieurs générations, les seuls non chrétiens à jouir d'une telle faveur. Ce titre fut renouvelé par un descendant du roi du Portugal en 1992, 30 ans après que les Portugais aient quitté Goa. Devendra et Jitendra Deshprabhu, les deux principaux descendants, habitent aujourd'hui le palais de Pernem. Ses fondations furent creusées en 1693 mais ses modifications successives illustrent parfaitement le destin d'une famille de la noblesse hindoue qui s'est épanouie sous le règne rigoureux des catholiques pendant des siècles. Le palais du vicomte de Pernem évoque ce passé tumultueux.

Palacio de Pernem

In 1666 a Brahmin ruler in southern Maharashtra was forced into retreat by invading Maratha armies and entered Portuguese Goa in search of peace and protection. It proved useful for the Catholic Portuguese to enter into a treaty with the Hindu ruler. His territories were ceded to create Portugal's new conquests in India. In return for their loyal administration over generations, the Deshprabhu family was raised to the rank of viscounts in the 19th century, the only non-Christians to be so elevated. The title was renewed by a descendant of the King of Portugal in 1992, 30 years after the Portuguese left Goa. Devendra and Jitendra Deshprabhu, the two main descendants, now occupy the palace at Pernem. Its foundations were dug in 1693 but its evolution remarkably chronicles the life of a high-born Hindu family that flourished under powerful Catholic rule for centuries. The palace of the Viscount of Pernem is a reminder of that tumultous age.

Im Jahre 1666 wurde in Süd-Maharashtra ein brahmanischer Herrscher von einfallenden marathenischen Truppen zum Rückzug gezwungen. Er zog daraufhin ins portugiesische Goa, um dort Frieden und Schutz zu finden. Es war für die katholischen Portugiesen von Vorteil, mit dem hinduistischen Herrscher ein Bündnis zu schließen. Er trat seine Gebiete ab, was zu einer Erweiterung des portugiesischen Hoheitsbereichs in Indien führte. Als Belohnung für ihre loyale und geschickte Verwaltung dieser Gebiete über mehrere Generationen wurde die Familie Deshprabhu im 19. Jahrhundert als einzige nichtchristliche Familie in den Adelsstand erhoben. Der Titel wurde 1992 von einem Nachkommen des portugiesischen Königshauses neuerlich bestätigt – 30 Jahre nachdem die Portugiesen Goa verlassen hatten. Heute bewohnen Devendra und Jitendra Deshprabhu, die beiden direkten Nachfahren der Linie, den Palast in Pernem. Das Fundament des Gebäudes wurde 1693 gelegt, und seine Entwicklung spiegelt in bemerkenswerter Weise die Chronik einer hinduistischen Familie von hoher Geburt wider, die unter katholischer Herrschaft jahrhundertelang erfolgreich blieb. Der Palast des Visconde von Pernem ist ein Stück Geschichte, das an jenes bewegte Zeitalter erinnert.

236 | 237

First page: With its smoothly laid black and white marble floor and private upper balcony for the ladies of the house to attend ceremonies, the private temple of the Deshprabhu family has an austerity in marked contrast to the gilded baroque of Goan churches. The temple was built as an adjunct to the palace building.
Below: The sitting room of the palace overlooks running verandahs that give onto garden courtyards. The heavily carved suite of furniture was made in Baroda, Gujarat. The borders on the walls were painted by local artisans.

Première page: Avec son beau sol en marbre noir et blanc et son balcon d'où les dames de la maison pouvaient assister aux cérémonies, le temple privé des Deshprabhu est d'une austérité qui contraste singulièrement avec le baroque doré des églises de Goa. Le temple fut construit comme une annexe au palais.
Ci-dessous: Le salon du palais donne sur de longues vérandas qui dominent des jardins intérieurs. Les meubles sculptés ont été réalisés à Baroda en Gujerat. Les frises sur les murs ont été peintes par des artisans de la région.

Eingangsseite: Mit seinem schwarz-weiß gefliesten Marmorboden und der abgetrennten Galerie, auf der die Damen des Hauses den Zeremonien beiwohnen konnten, ist der Haustempel der Familie Deshprabhu von einer Schlichtheit, die in einem deutlichen Kontrast zu dem üppigen Barockstil der Kirchen Goas steht. Der Tempel ist an den Palast angebaut.
Unten: Der Salon des Palastes grenzt an eine umlaufende Veranda, von der aus man zu den auf der Innenseite des Gebäudes angelegten Gärten gelangt. Die mit kunstvollen Schnitzereien verzierten Möbel kommen aus Baroda in Gujarat. Die Randverzierungen an den Wänden stammen von ortsansässigen Malern.

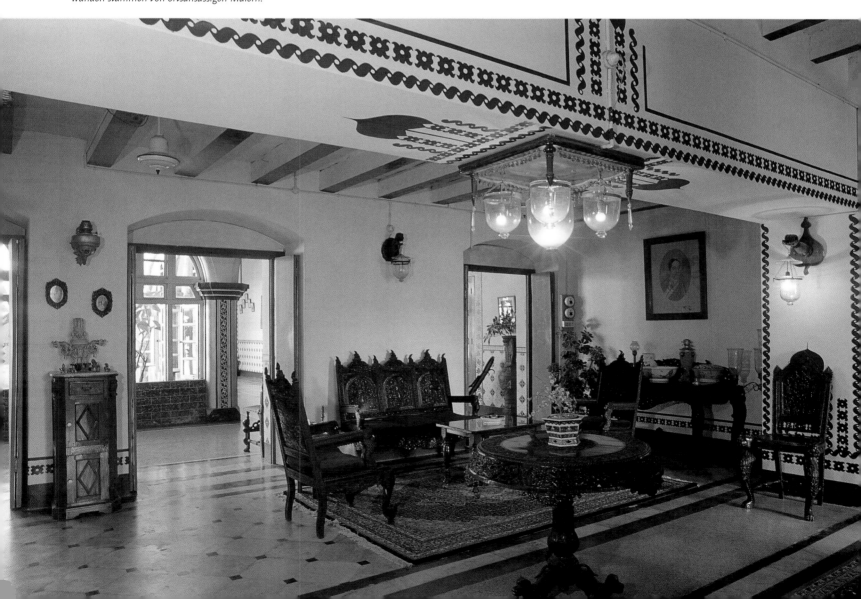

Above: The palace library was created by a forbear, an avowed biblio-
phile. Like most public rooms in the palace it opens on to verandahs
that overlook inner gardens.
Right: A point-to-point telephone, produced by Bell & Co. about
1902, acted as an intercom connecting several Deshprabhu resi-
dences, including a summer house on a hill.

Ci-dessus: La bibliothèque fut créée par un ancêtre, amoureux des
livres. Comme la plupart des pièces publiques du palais, elle donne
sur des vérandas qui dominent les jardins.
A droite: Le téléphone de Bell & Co datant de 1902 environ servait
d'intercom entre les différentes résidences des Deshprabhu, dont une
maison d'été située sur une colline.

Oben: Die Palastbibliothek wurde von einem der Vorfahren der
Familie geschaffen, einem erklärten Büchernarr. Ähnlich wie die
meisten zu Repräsentationszwecken gebauten Räumlichkeiten des
Palastes öffnet sie sich zu einer Veranda mit Blick auf die inneren
Gärten.
Rechts: Dieses Telefon, das um 1902 von Bell & Co. hergestellt wurde,
diente als eine Art Sprechanlage zwischen mehreren Residenzen der
Deshprabhus, zu denen auch ein Sommerhaus auf einem Hügel
gehörte.

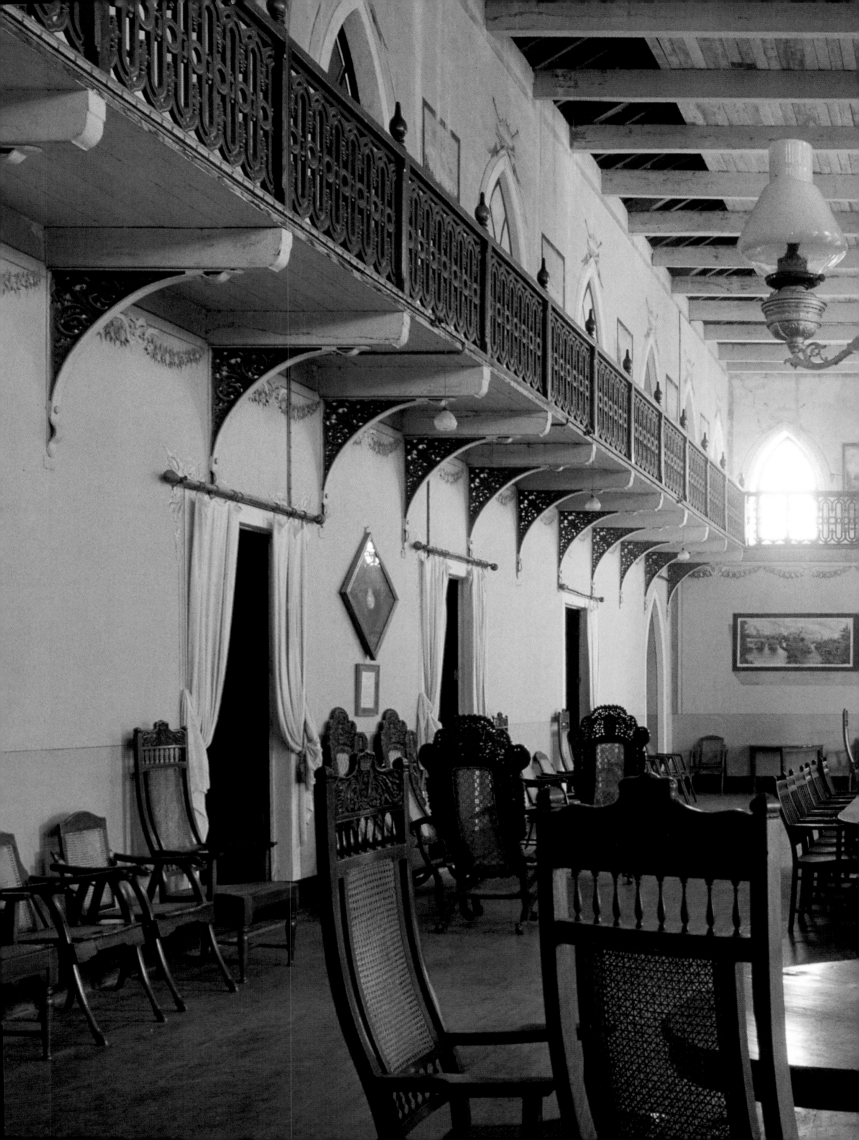

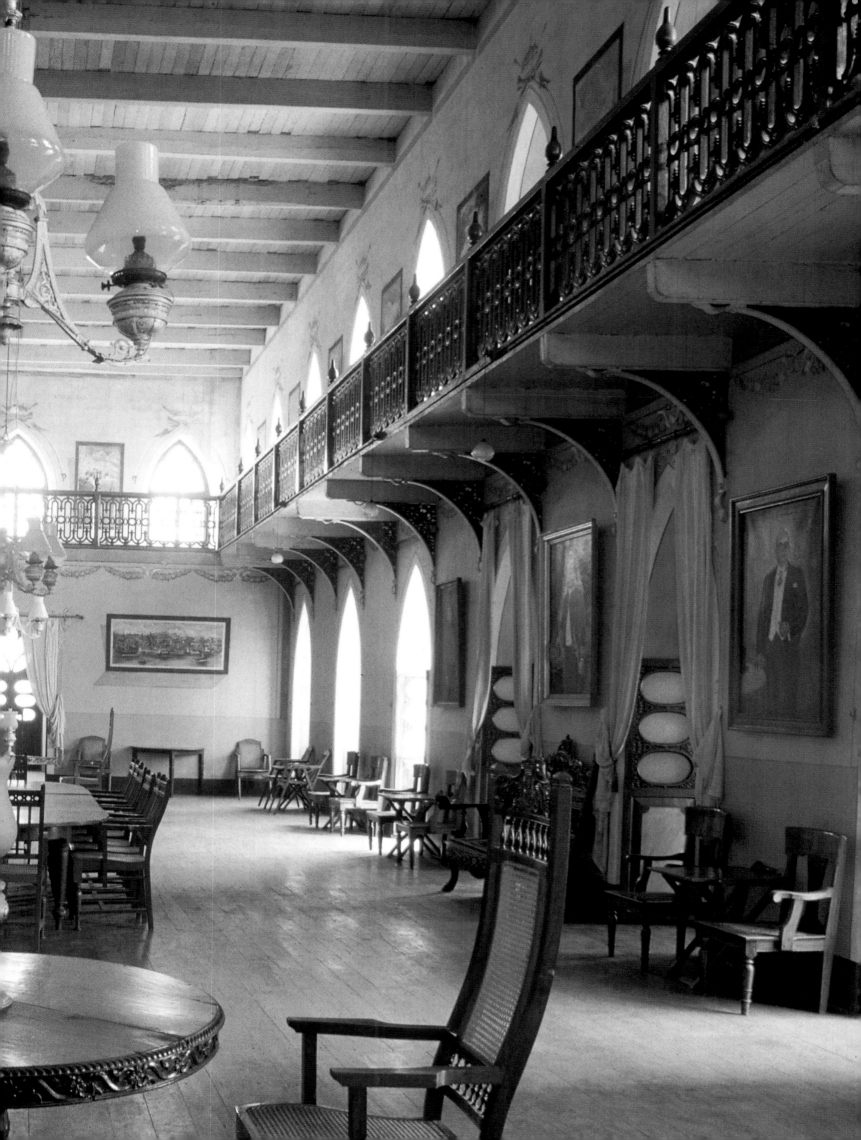

Previous pages: The splendid banqueting hall of the Casa Hospedes, an independent guest house built for European visitors in 1886, has a minstrel's gallery supported by cast-iron brackets. The room is hung with family portraits and lit by kerosene chandeliers.
Below: The entrance hall to the Casa Hospedes with its elegant black and white floor and Thonet furniture is hung with portraits of the first Baron Pernem and the last reigning monarch of Portugal. Delicate frescoes of peacocks and peacock fans around the doors add an inimitably Indian touch.

Double page précédente: la superbe salle de banquet de la Casa Hospedes, une maison indépendante construite en 1886 pour recevoir les visiteurs européens, avec sa galerie pour les musiciens soutenue par des équerres en fer forgé. Aux murs, des portraits de famille. Les lustres fonctionnent au kérosène.
Ci-dessous: l'entrée de la Casa Hospedes, avec son élégant sol noir et blanc et ses meubles Thonet. Aux murs, un portrait du premier baron Pernem et celui du dernier souverain régnant du Portugal. Le thème du paon sur les fresques et autour des portes ajoute une touche typiquement indienne.

Vorhergehende Doppelseite: Der prachtvolle Bankettsaal der Casa Hospedes, eines Gästehauses, das 1886 für europäische Besucher gebaut wurde, hat eine Spielmannsgalerie, die von gußeisernen Stützen getragen wird. Der Raum wird von Paraffin-Kronleuchtern erhellt. An den Wänden hängen Familienporträts.
Unten: In der Eingangshalle der Casa Hospedes, mit ihrem eleganten schwarz-weißen Boden und den Thonet-Möbeln, hängen Porträts des ersten Barons von Pernem und des letzten regierenden Monarchen von Portugal. Zarte Fresken, auf denen Pfauen und Pfauenfächer dargestellt sind, umrahmen die Tür und verleihen dem Raum einen unnachahmlichen indischen Touch.

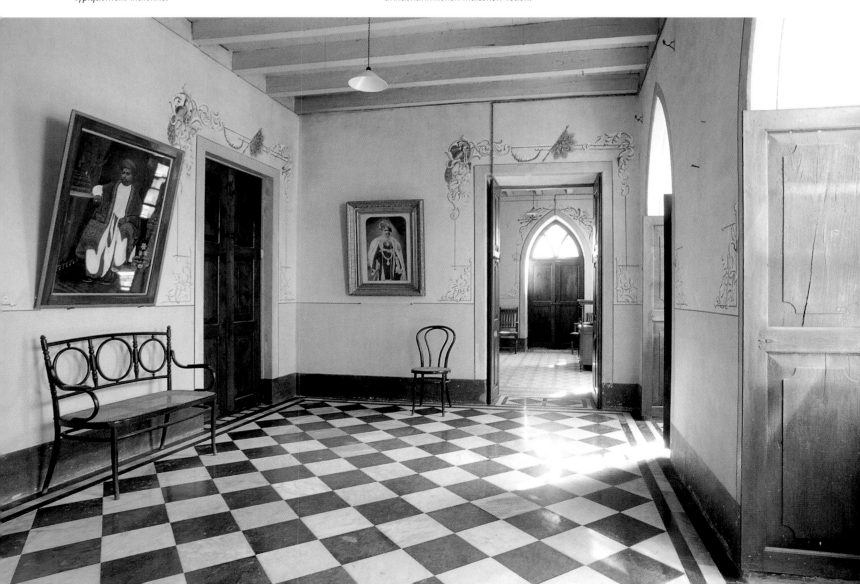

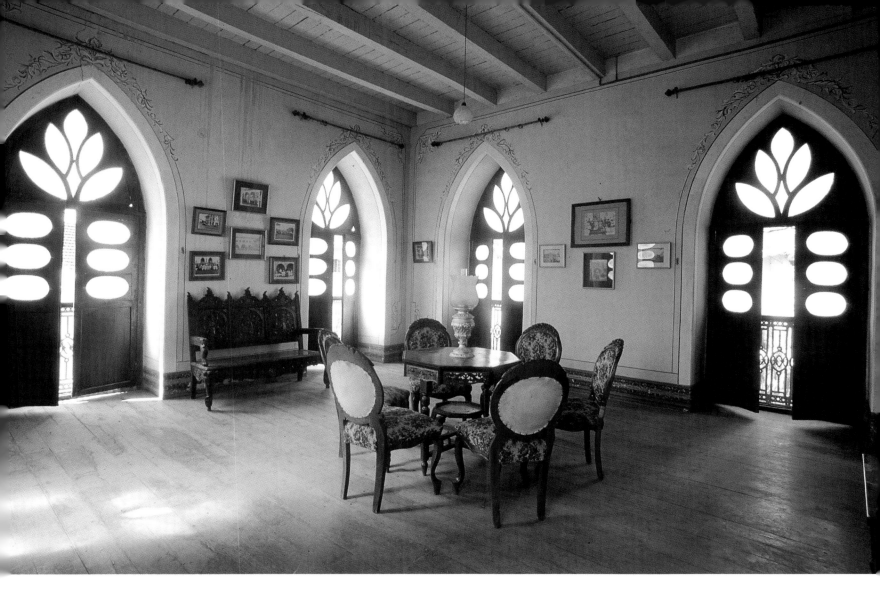

Above: Doors with lotus-shaped skylights devised by Indian craftsmen adorn the ogive arches in the music room near the banquet hall of the Casa Hospedes. The chairs are Chippendale originals.
Right: Idyllic landscapes painted on walls of the mistrel's gallery are the fantasy of local painters. The ogive doors lead to recreation rooms with billiard and poker tables.

Ci-dessus: Des portes aux jours en forme de lotus, conçues par des artisans indiens, ornent les arches en ogive du salon de musique qui jouxte la salle de banquet dans la Casa Hospedes. Les chaises sont des Chippendale d'époque.
A droite: Les paysages idylliques qui ornent les murs de la galerie des musiciens sont sortis tout droit de l'imagination des peintres locaux. Les portes élancées donnent sur des salles de détente avec des tables de jeux et des billards.

Oben: Die Spitzbogentüren des Musikzimmers in der Nähe des Bankettsaals der Casa Hospedes sind mit lotosförmigen Oberlichtern verziert, die von indischen Kunsthandwerkern angefertigt wurden. Die Stühle sind originale Chippendales.
Rechts: Die idyllischen Landschaften, die auf die Wände der Spielmannsgalerie gemalt wurden, sind der Fantasie einheimischer Künstler entsprungen. Durch die Spitzbogentüren gelangt man zu den Freizeiträumen, in denen Billard- und Pokertische stehen.

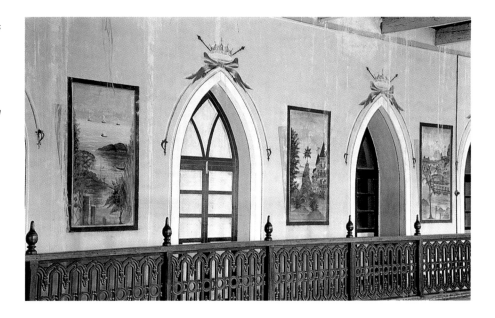

De par sa splendeur, son site, sa taille, et surtout son architecture
exubérante, la villa de Jimmy Gazdar est unique en Inde. D'un style
délirant, elle rappelle la démesure et l'excentricité d'un Randolph
Hearst. Homme d'affaires spécialisé dans le caoutchouc et le thé,
Gazdar passait toutes ses vacances en Méditerranée quand, vers le
milieu des années soixante-dix, il tomba sur une colline à vendre.
Surplombant l'estuaire du Mandovi, ses cinq hectares de terrain es-
carpé tombaient à pic dans les puits de Fort Aguada, une forteresse
portugaise du début du 17e siècle. Las de vivre à Bombay, il décida de
s'y installer et engagea les services de l'architecte Gerard da Cunha,
originaire de Goa. Pour accueillir sa collection de bronzes et de
meubles anciens, Gazdar voulait une demeure entourée de jardins
tropicaux, évoquant l'âge d'or du baroque tout en recourant à la laté-
rite, la pierre locale. Les hauts murs de soutènement et les centaines
de colonnes ornementales créent une vision fantastique de terrasses
et de pavillons que les habitants de la région appellent simplement
«le palais de Jimmy».

Jimmy Gazdar

For splendour, setting and scale, above all for its exuberant archi-
tectural synthesis, Jimmy Gazdar's home has no parallel in India.
Almost Hearstian in style, it is San Simeon come to Goa. Gazdar
is a businessman with interests in rubber and tea who, after years
of Mediterranean holidays, stumbled upon a hillside for sale in
the mid-Seventies that overlooked the Mandovi river estuary. The
steep 12-acre site falls directly to the wells of Fort Aguada, an early
17th-century Portuguese stronghold. Tired of living in Bombay, he
decided to move, and sought the help of Goan architect Gerard da
Cunha. Gazder wanted a building that recalled the gilded age of
Baroque to house his collection of period European bronzes and
furniture, but that also used laterite, the local stone, and was set in
tropical gardens. High retaining walls and hundreds of ornamental
pillars create a panorama of terraces and pavilions that Goans
simply refer to as "Jimmy's Palace".

Was Pracht, Lage und Größe, vor allem aber was seine mitreißende
Architektur betrifft, kann es kein Haus in Indien mit dem Jimmy
Gazdars aufnehmen. Sein Stil erinnert an das Hearst Castle in Kali-
fornien. Es wirkt fast so, als hätte man San Simeon nach Goa ver-
setzt. Gazdar ist ein Geschäftsmann, der hauptsächlich mit Gummi
und Tee handelt. Mitte der siebziger Jahre, nachdem er bereits seit
Jahren seine Ferien am Mittelmeer verbracht hatte, stieß er auf einen
Hügel an der Mündung des Flusses Mandovi. Das fast fünf Hektar
umfassende Gelände fällt steil ab, direkt zu den Mauern des Forts
Aguada, einer portugiesischen Festung aus dem frühen 17. Jahrhun-
dert. Gazdar hatte es damals satt, in Bombay zu leben, entschloß
umzuziehen und wandte sich an den aus Goa stammenden Architek-
ten Gerard da Cunha. Er wünschte sich ein Gebäude, das dem golde-
nen Zeitalter des Barock nachempfunden sein sollte und zu seiner
Sammlung europäischer Bronzen und Möbeln paßte. Gleichzeitig
sollte es aus Laterit gebaut sein, dem für diese Gegend typischen Ge-
stein, und inmitten einer tropischen Gartenanlage stehen. Die hohen,
das Grundstück umschließenden Mauern, Hunderte von dekorativen
Säulen, Terrassen und Pavillons schmücken die herrliche Anlage, die
von Einheimischen einfach »Jimmy's Palace« genannt wird.

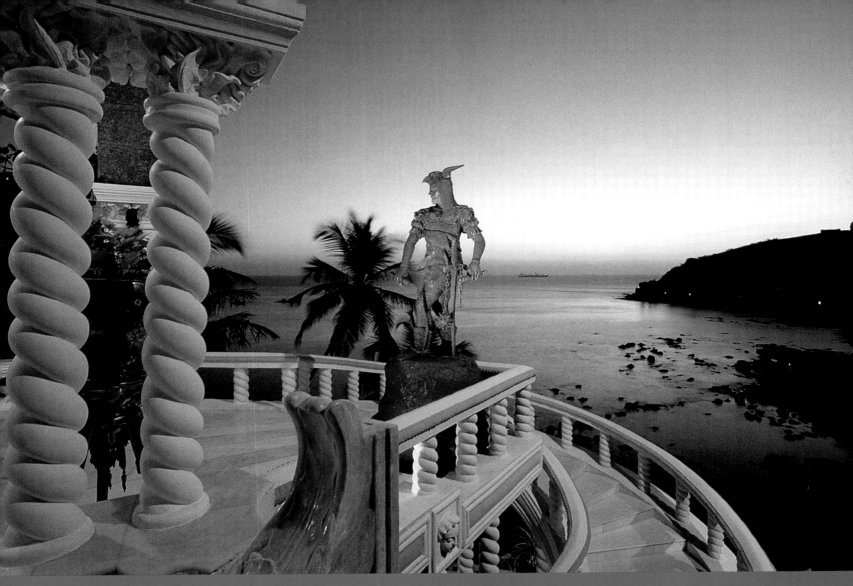

A 19th-century bronze of Thor, Viking god of war, guards the poolside terrace overlooking the private bay. The sweeping pink marble staircase leads to the terrace gardens below. Manueline spiral pillars with seaweed and laterite capitals alternate with gilded columns from Goan churches. Plaster gargoyles and lions decorate laterite walls with scalloped-tile arches of traditional design.

Une statue en bronze du 19e siècle représentant Thor, dieu viking de la guerre, garde la terrasse de la piscine qui surplombe la baie privée. Le grand escalier suspendu en marbre rose mène aux jardins en terrasses plus bas. Des colonnes torsadées manuélines surmontées de chapiteaux en latérite ornés de motifs d'algues alternent avec des colonnes dorées provenant d'églises de Goa. Des gargouilles et des lions en plâtre flanquent des arches en latérite, couvertes de tuiles en forme de coquilles Saint-Jacques.

Eine Bronzeplastik aus dem 19. Jahrhundert, die den nordischen Donnergott Thor darstellt, bewacht die Terrasse des Swimmingpools, von der aus man auf die zum Grundstück gehörende Bucht blickt. Die elegant geschwungene Treppe aus rosafarbenem Marmor führt hinunter zu den Terrassengärten. Spiralenförmige Säulen im manuelinischen Stil mit Laterit-Kapitellen und Verzierungen in Form von Seetang wechseln sich ab mit vergoldeten Säulen, die aus den Kirchen Goas stammen. Wasserspeier und Löwen aus Gips verzieren die Wände aus Laterit. Die Fensterbögen sind im traditionellen Stil gehalten und mit muschelförmigen Kacheln verkleidet.

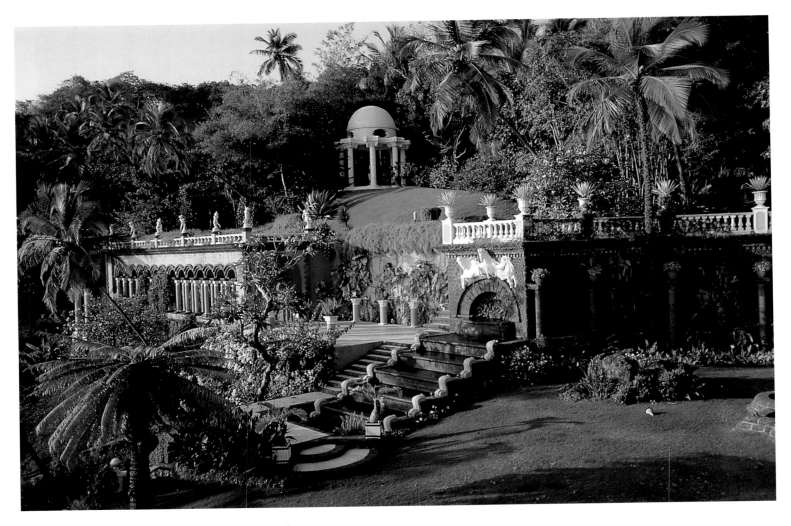

Above: Landscape architect Shashank Vaidya helped to design the terrace gardens, with Italianate colonnades, follies and cascades.
Right: A flight of steps covers a sharp drop of 60 feet leading to the seaside fortification of the 17th-century Fort Aguada. A guest suite with domed roof commands a spectacular view.
Facing page: The freestanding laterite pillar with double capitals and spiral staircase were an inspiration of the architect Gerard da Cunha.

Ci-dessus: Le paysagiste Shashank Vaidya a participé à l'élaboration des jardins en terrasses, avec leurs colonnades à l'italienne, leurs folies et leurs cascades.
A droite: L'escalier monumental à sept paliers descend jusqu'à la mer, 20 mètres plus bas, où se trouve Fort Aguada, datant du 17e siècle. Une maison d'amis ornée d'un dôme et d'un balcon à colonnade domine la vue.
Page de droite: La colonne en latérite à deux chapiteaux et l'escalier en colimaçon sont des idées de l'architecte Gerard da Cunha.

Oben: Der Gartenarchitekt Shashank Vaidya war maßgeblich an der Gestaltung der Terrassengärten beteiligt, in denen es Kolonnaden im italienischen Stil, Ziergebäude und Kaskaden gibt.
Rechts: Eine monumentale Treppenanlage führt den steilen, 20 Meter tiefen Abhang hinunter zu den am Meer gelegenen Befestigungsanlagen des Fort Aguada aus dem 17. Jahrhundert. Oben steht ein überkuppeltes Gästehaus mit Aussicht auf das Meer.
Rechte Seite: Die freistehende Laterit-Säule mit zwei Kapitellen und die Wendeltreppe waren eine Idee des Architekten Gerard da Cunha.

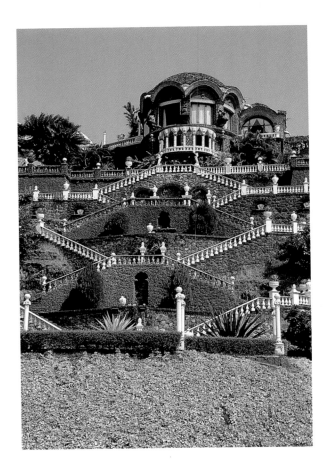

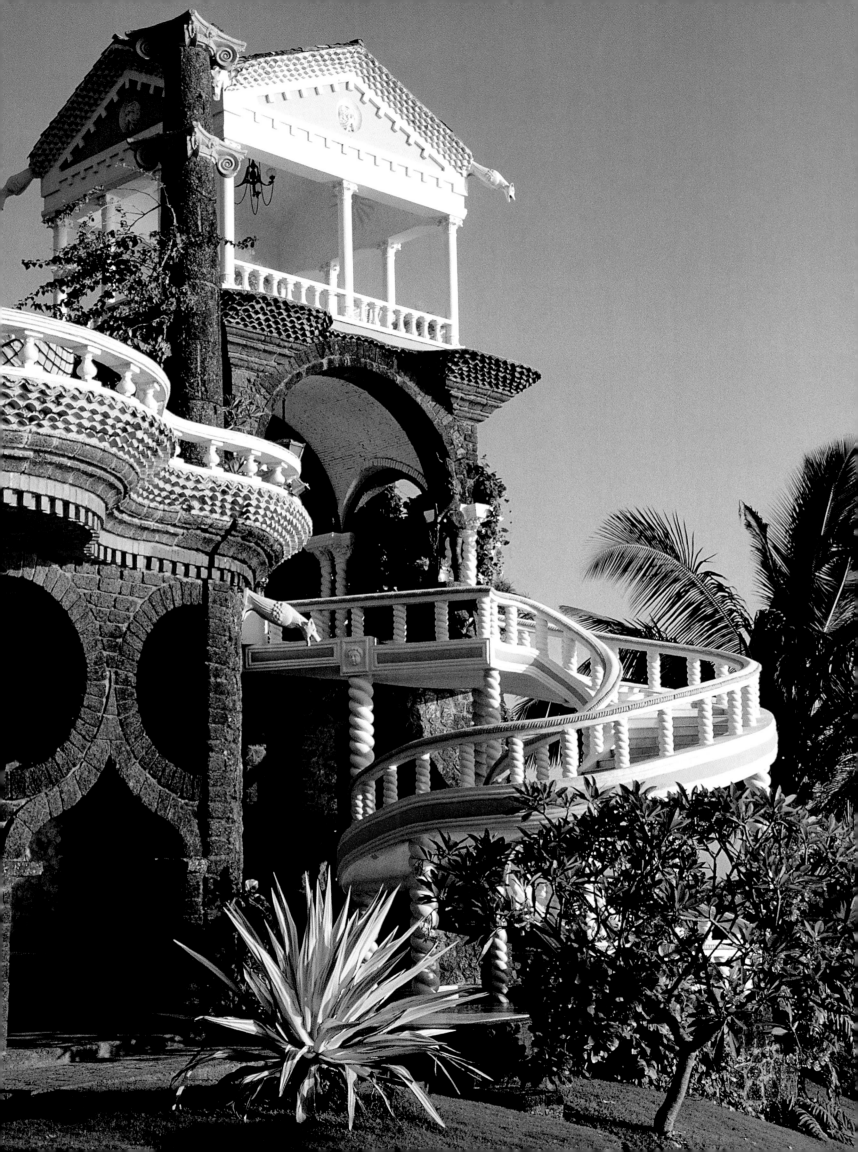

Right: A baroque brass bed from a maharaja's palace, pedimented doors with carved panels from Goan churches, offset by a floor of deep green Italian marble and canary yellow velvet hangings complete the Napoleonic colour scheme of Gazdar's bedroom.
Below: The formal dining room, with its coffered wood ceiling and burnt sienna walls, has French windows with surrounds of giltwood that open on to the swimming pool terrace. The dining table and chairs are 19th-century Indo-Portuguese. The brass chandelier and sconces came from an Indian palace.

A droite: Le lit baroque en laiton provient du palais d'un maharaja, les portes aux frontons en panneaux sculptés, d'églises de Goa. Le sol en marbre italien vert sombre et le velours jaune canari du lit complètent la palette de couleurs napoléoniennes de la chambre de Gazdar.
Ci-dessous: Dans la salle à manger, au plafond à caissons et aux murs rouge de Sienne, les portes-fenêtres bordées de bois doré donnent sur la terrasse de la piscine. La table et les chaises indo-portugaises datent du 19e siècle. Le lustre et les appliques en laiton viennent d'un palais indien.

Rechts: Das Schlafzimmer Gazdars enthält ein barockes Messingbett aus dem Palast eines Maharajas. Die Türen mit Giebelaufsatz, deren Felder mit Schnitzereien verziert sind, stammen aus den Kirchen Goas. Der Boden aus tiefgrünem italienischem Marmor und die kanariengelben Samtvorhängen bringen die Einrichtung zur Geltung und fügen sich ein in das napoleonische Farbschema, das den Raum beherrscht.
Unten: Das Eßzimmer mit seiner Kassettendecke aus Holz und den in Sienarot gestrichenen Wänden hat Verandatüren mit vergoldeten Holzrahmen, die auf die Terrasse des Swimmingpools hinausführen. Der Eßtisch und die Stühle aus dem 19. Jahrhundert sind im indisch-portugiesischen Stil. Der Kronleuchter und die Wandleuchter aus Messing stammen aus einem indischen Palast.

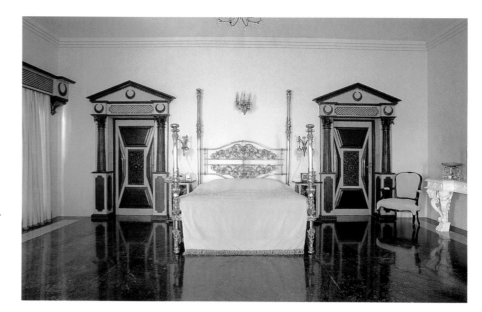

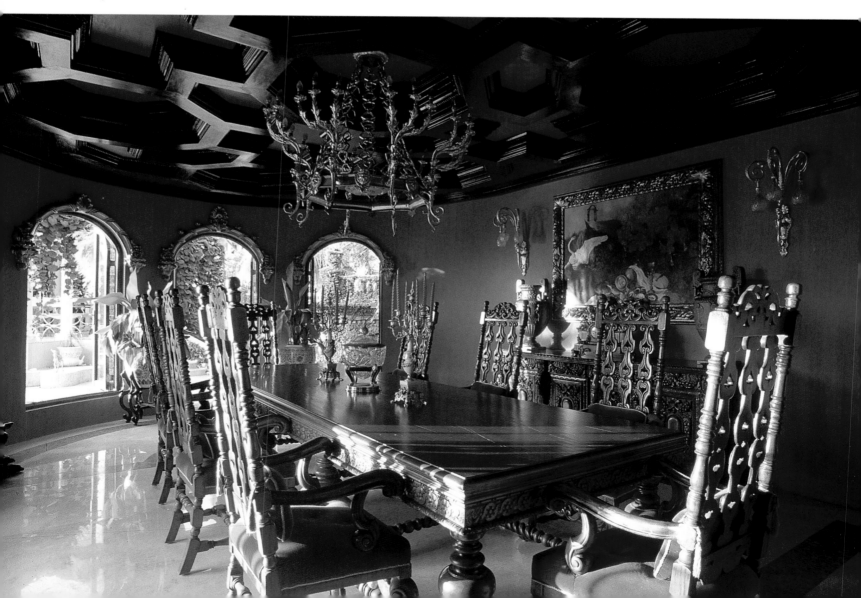

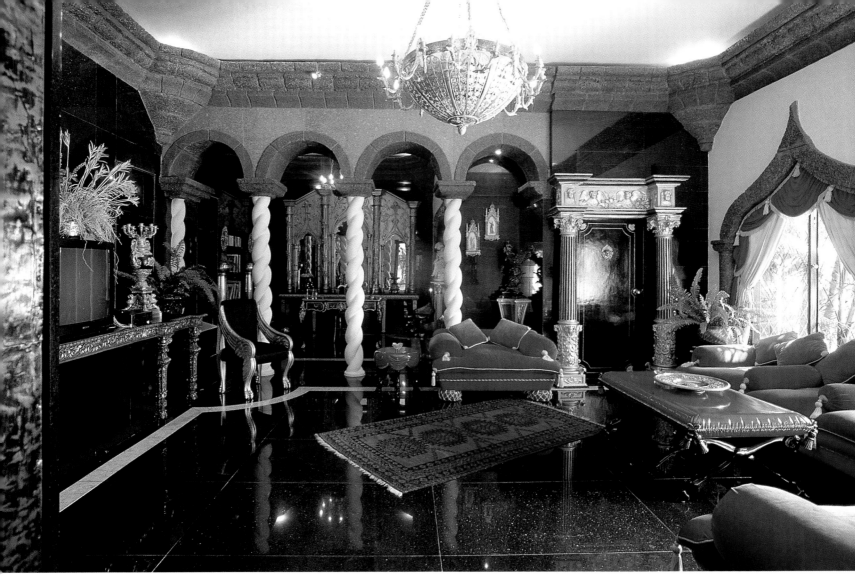

Above: Hand-beaten bronze doors lead into the library, decorated like a pasha's palace, with black granite floor, tasselled divans covered in red velvet and a "cushion" table lacquered in red and black. The room's Ottoman style arch and cornices are made of laterite. The chandelier and candelabrum are Russian.
Right: The master bathroom is set in a rotunda with a floor laid in shades of light and dark green Italian marble. A specially designed green marble basin is surrounded by a gilt mirror and gilded consoles.

Ci-dessus: Les portes en bronze martelé s'ouvrent sur une bibliothèque décorée comme le palais d'un pacha, avec un sol en granit noir, des divans en velours rouge ornés de passementeries et une table basse laquée rouge et noire. Les arches de style ottoman et les corniches sont en latérite. Le lustre et les chandeliers sont russes.
A droite: La salle de bains principale est située dans une pièce circulaire au sol dallé de marbre italien vert clair et sombre. Le lavabo en marbre vert réalisé sur mesure est flanqué d'un miroir et de consoles en bois doré.

Oben: Handgearbeitete, aus Messing getriebene Türen führen in die Bibliothek, die wie der Palast eines Paschas ausgestattet ist. Der Boden ist aus schwarzem Granit, die Diwane sind mit rotem Samt bezogen und mit Quasten verziert, und der »Polster-Tisch« ist rot und schwarz lackiert. Die Spitzbögen und das Eckgesims im osmanischen Stil sind aus Laterit. Der Kronleuchter und der Kandelaber stammen aus Rußland.
Rechts: Gazdars Badezimmer ist in Form einer Rotunde gebaut. Die Schattierungen der Bodenfliesen aus italienischem Marmor reichen von hell- bis dunkelgrün. Ein speziell für den Raum entworfenes Waschbecken aus grünem Marmor wird von einem vergoldeten Spiegel und zwei vergoldeten Konsoltischen gerahmt.

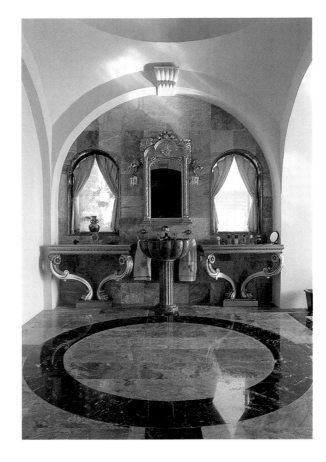

Il y a dix ans, Hari Ajwani, un Indien installé à Berlin, et Claudia Derain, une styliste de mode vivant à Paris, se rencontrèrent à Goa. Ils louèrent alors puis restaurèrent une vieille maison portugaise dont ils firent une maison d'hôtes. Ils rencontrèrent un tel succès qu'ils décidèrent de construire leur propre hôtel «alternatif», Nilaya Hermitage. Hari et Claudia achetèrent une grande parcelle de terre au sommet d'une colline dominant la mer d'Arabie. L'accès difficile du site était compensé par la vue spectaculaire sur les rizières et les cocotiers. Après trois ans de dur labeur et l'aide de l'architecte goannais Dean D'Cruz, le bâtiment aux façades de pierres brutes a enfin vu le jour. Les douze suites de Nilaya sont décorées dans un mélange étonnant de couleurs vives et de sol en granito.

Claudia Derain and Hari Ajwani

A holiday encounter in Goa brought Hari Ajwani, an Indian settled in Berlin, and Claudia Derain, a fashion stylist from Paris, together ten years ago. To cement their new life they first rented and renovated an old Portuguese house and ran it as a guest house. The experiment proved such a success that they decided to build their own "alternative" hotel – and so was born Nilaya Hermitage. Hari and Claudia bought a large plot of land on top of a hill, overlooking the Arabian Sea. Difficult access to the site was compensated by spectacular views of paddy fields and groves of coconut palms. After three years of arduous effort with the help of Goan architect Dean D'Cruz, the rock-faced building materialised. Each of Nilaya's twelve guest suites is decorated in a striking assemblage of vivid colours and terrazzo flooring.

Vor zehn Jahren brachte ein Urlaub in Goa den Inder Hari Ajwani, der damals in Berlin wohnte, und Claudia Derain, eine Modeschöpferin aus Paris, zusammen. Um ihr neues gemeinsames Leben zu festigen, mieteten und renovierten sie zunächst ein altes portugiesisches Haus und machten eine Pension daraus. Das Experiment war ein so großer Erfolg, daß sie sich entschlossen, ihr eigenes »alternatives« Hotel zu bauen. Auf diese Weise entstand Nilaya Hermitage. Hari und Claudia kauften sich ein großes Grundstück auf der Spitze eines Hügels, mit Aussicht auf das Arabische Meer. Die Tatsache, daß das Grundstück nur schwer zu erreichen war, wurde durch die atemberaubende Aussicht auf Reisfelder und Kokosnußplantagen mehr als wett gemacht. Nach drei Jahren mühsamer Arbeit mit Hilfe des in Goa ansässigen Architekten Dean D'Cruz war das Haus mit der Fassade aus unbehauenen Steinen fertig. Jede der zwölf Hotelsuiten des Nilaya zeichnet sich durch eine eindrucksvolle Kombination von lebhaften Farben und Terrazzofußböden aus.

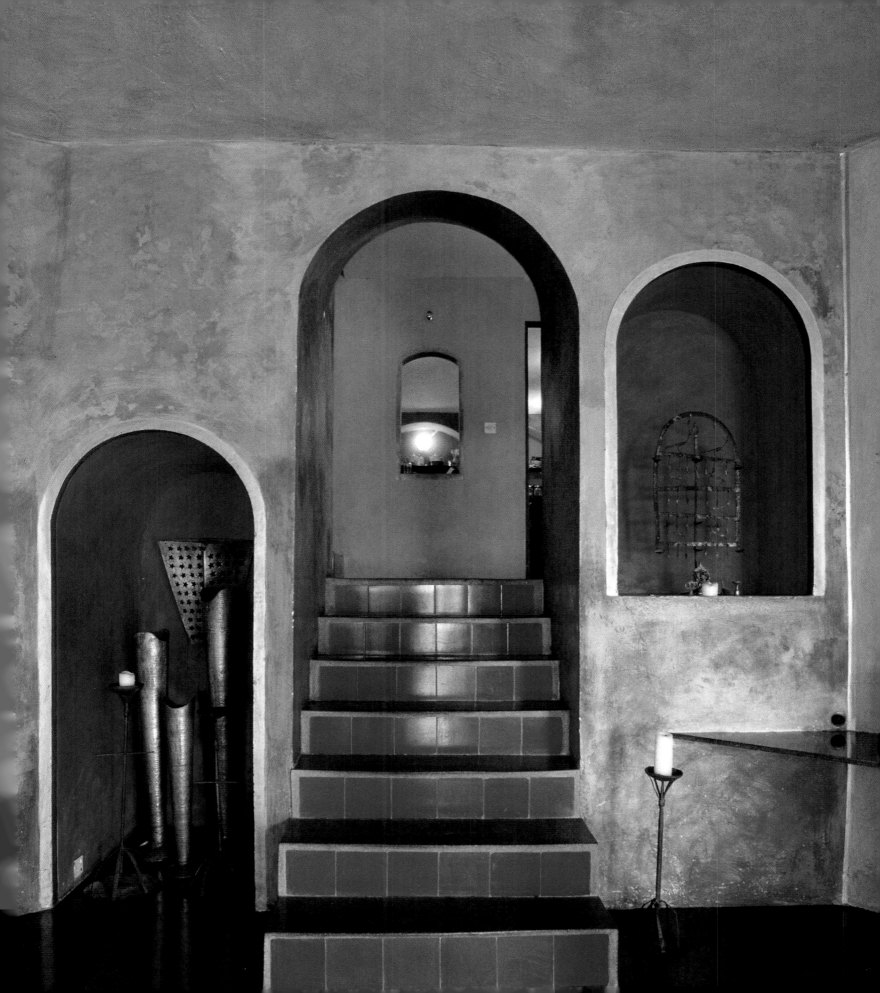

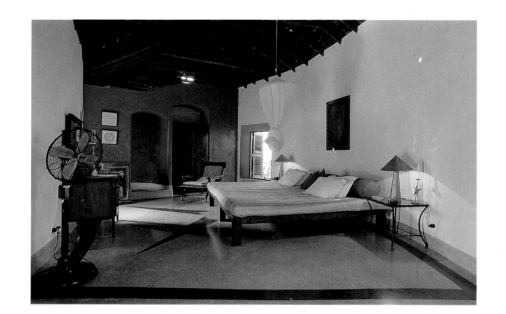

Right: Nilaya's guest suites have names, not numbers. This one, named "Akash" or Sky Room, has a roof made of country tiles supported by beams of coconut wood.
Below: The saffron-coloured "Music Room" is a split-level domed structure with floor seating. It is used for classical music concerts at night or for quiet reading and meditation during the day.

A droite: Les suites de Nilaya ne sont pas numérotées mais portent des noms. Celle-ci, baptisée «Akash», ou Chambre du ciel, a un toit soutenu par des poutres en cocotier et recouvert de tuiles de campagne.
Ci-dessous: Le «salon de musique», couleur safran, est une pièce à plusieurs niveaux surmontée d'un dôme. On s'y assoit par terre. La nuit, il accueille des concerts de musique classique, le jour, on vient y lire ou méditer dans la tranquillité.

Rechts: Die Hotelsuiten des Nilaya haben Namen statt Nummern. Diese, die »Akash«, Himmelsraum, heißt, hat ein Ziegeldach, das von Balken aus Kokosnußpalmen gestützt wird.
Unten: Das safranfarbene »Musikzimmer« ist eine überkuppelte Konstruktion mit Zwischengeschoß, in der man auf dem Boden sitzt. Abends wird es für Konzerte mit klassischer Musik benutzt, tagsüber zum ungestörten Lesen und zur Meditation.

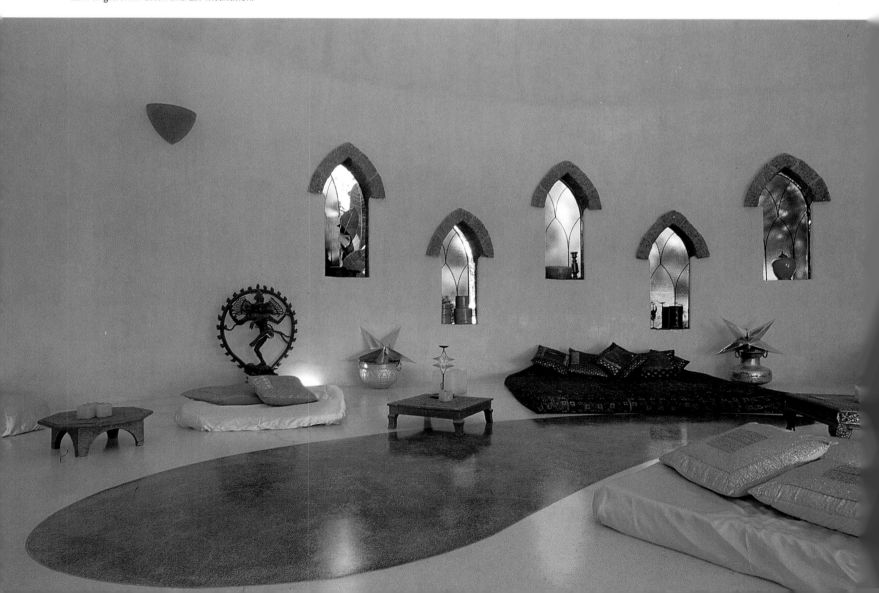

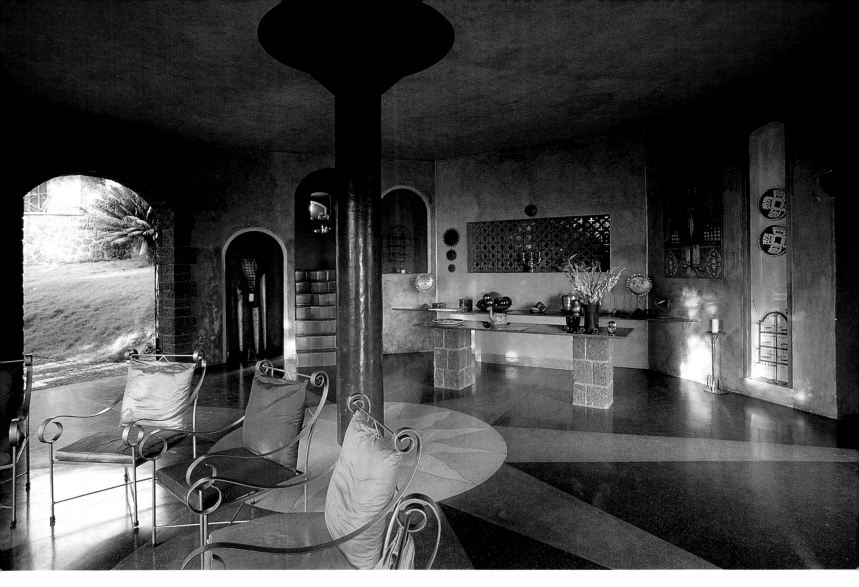

Above: The hotel's stylish circular lobby is a joyous profusion of strong colours, all produced from a secret recipe of Claudia Derain's invention that mixes lime, wax and natural pigments and eschews synthetic paints. The terrazzo floor incorporates Nilaya's logo of the sun within a starburst.
Right: Nilaya's swimming pool is dramatically situated, with a grotto supported by mosaic-tiled columns at one end, and a sweeping view of the Arabian Sea at the other.

Ci-dessus: L'élégante réception circulaire de l'hôtel offre une profusion de couleurs vives, dues à une recette secrète de Claudia Derain à base de chaux, de cire et de pigments naturels. Le sol en granito est orné du logo de Nilaya: un soleil rayonnant.
A droite: La piscine de Nilaya jouit d'un site spectaculaire avec, d'un côté, une grotte artificielle sous des colonnes en mosaïque et, de l'autre, une vue panoramique sur la mer d'Arabie.

Oben: Das elegante, kreisförmige Foyer des Hotels ist mit einer verschwenderischen Fülle kräftiger Farben ausgestattet, die alle nach einem von Claudia Derain erfundenen Geheimrezept hergestellt sind. Sie vermischt dabei Kalk, Wachs und natürliche Farbpigmente und vermeidet synthetische Anstrichfarben. Im Terrazzofußboden findet sich das Wahrzeichen des Nilaya wieder: eine Sonne inmitten eines strahlenförmigen Sterns.
Rechts: Der Swimmingpool des Nilaya hat eine eindrucksvolle Lage. An einem Ende befindet sich eine Grotte, deren stützende Säulen mit Mosaiksteinen verziert sind, am anderen Ende hat man eine wundervolle Aussicht auf das Arabische Meer.

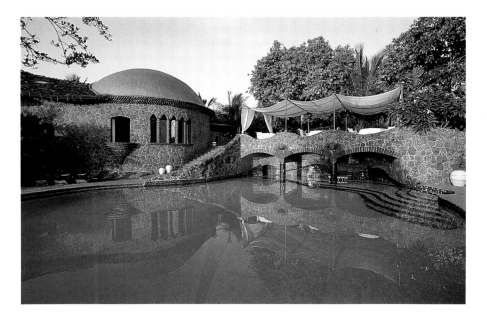

*Au cœur de Goa, là où le littoral sud se fond dans un paysage ver-
doyant de terre rouge et de champs verts, se trouve le vieux village de
Chandor, construit géométriquement autour d'une place. Son monu-
ment le plus splendide est sans conteste l'imposante Casa de Bra-
ganza, un hôtel particulier de deux étages qui occupe pratiquement
tout un pâté de maisons, les 28 balcons de sa façade séparés de la rue
par un étroit jardin d'agrément. La Casa de Brangaza est l'une des
dernières grandes demeures de cette taille subsistant de la période
indo-portugaise. Les Braganza se sont illustrés au 17e siècle comme
une famille d'aristocrates terriens aux penchants intellectuels: elle a
fourni d'éminents avocats, éditeurs et consuls. Il y a plusieurs généra-
tions, elle s'est scindée en Pereira-Braganza et Menezes-Braganza.
Alvaro Pereira Braganza, ci-dessous, occupe une partie de la de-
meure. Bien qu'il n'ait pas beaucoup de rapports avec les Menezes-
Braganza, qui occupent l'autre, il les appelle avec courtoisie «mes
cousins».*

Casa de Braganza

Deep in the heart of Goa where the southern shoreline gives way
to a verdant landscape of red earth and green fields lies the old
Portuguese village of Chandor, built on a grid plan around a
square. Chandor's most splendid feature is the imposing Braganza
mansion, a long two-storey town house that occupies almost an
entire street front, its facade with 28 balconies separated from the
road by a thin sliver of formal garden. Casa de Braganza is among
the last remaining Indo-Portuguese houses of its period and size.
The Braganza family rose to prominence in the 17th century as
landed gentry with an intellectual bent, producing eminent barris-
ters, editors and consuls. Several generations ago they divided into
the Pereira-Braganza and Menezes-Braganza. Alvaro Pereira Bra-
ganza, left, occupies one flank of the house. Although he has little
to do with the Menezes-Braganza who live on the other side, he
refers to them with courtly formality as "my cousins".

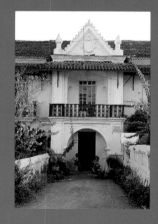

*Tief im Innern Goas, dort, wo die Südküste in eine satte Landschaft
von roter Erde und grünen Feldern übergeht, steht die alte portugie-
sische Stadt Chandor. Sie wurde nach einem schachbrettartigen Plan
um einen zentralen Platz erbaut. Chandors prachtvollstes Gebäude
ist der eindrucksvolle Herrensitz der Braganza, ein langgestrecktes,
zweistöckiges Haus, das fast einen ganzen Block einnimmt. Die Fas-
sade mit ihren 28 Balkonen ist von der Straße durch einen schmalen,
gepflegten Garten getrennt. Hinsichtlich seiner Größe und Ent-
stehungszeit gehört das Casa de Braganza zu den letzten noch er-
haltenen indisch-portugiesischen Häusern. Die Familie der Braganza
nahm bereits im 17. Jahrhundert als Teil des Landadels eine bedeu-
tende Stellung ein. Aber sie hatte auch immer schon einen Hang
zum Intellektuellen: Aus der Familie gingen bedeutende Juristen,
Verleger und Konsuln hervor. Vor einigen Generationen spaltete sie
sich in den Pereira-Braganza- und Menezes-Braganza-Zweig. Alvaro
Pereira Branganza — oben — bewohnt einen Flügel des Hauses.
Obwohl er nur wenig mit den Menezes-Braganza zu tun hat, die in
der anderen Hälfte wohnen, bezeichnet er sie mit höflicher Förmlich-
keit als seine »Cousins«.*

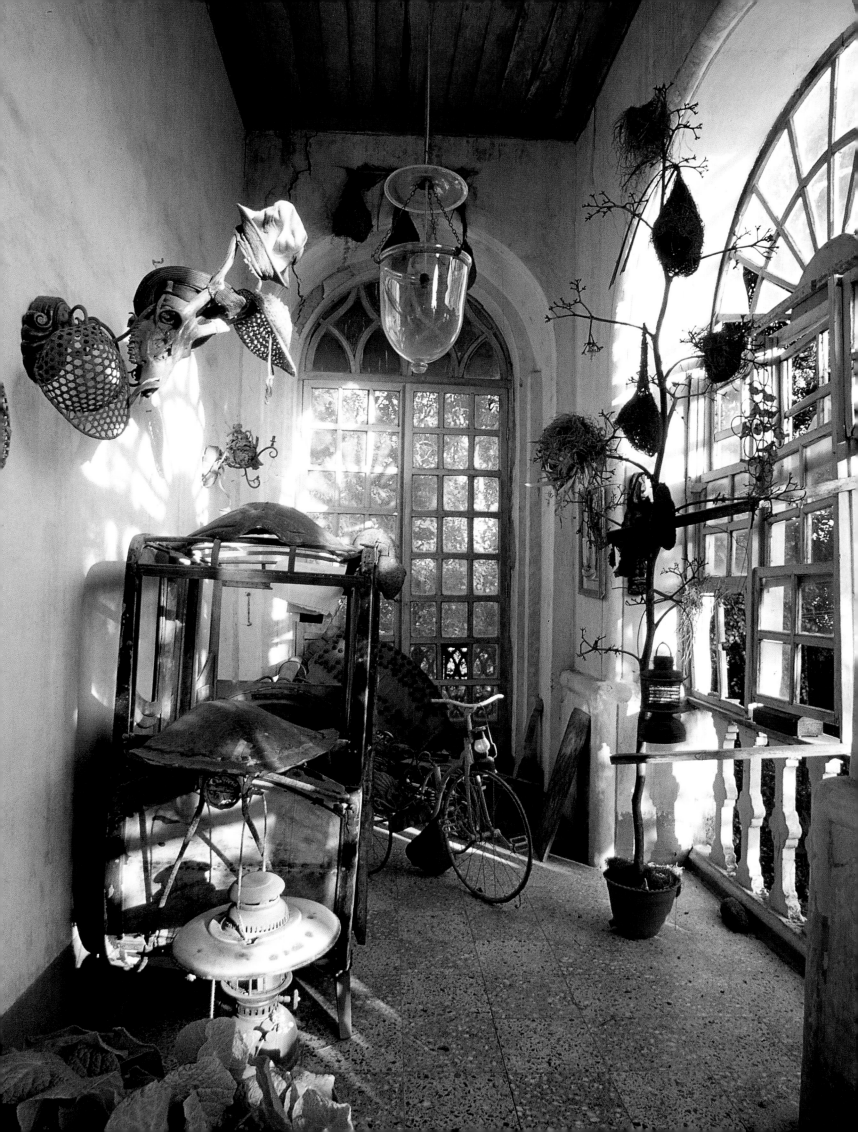

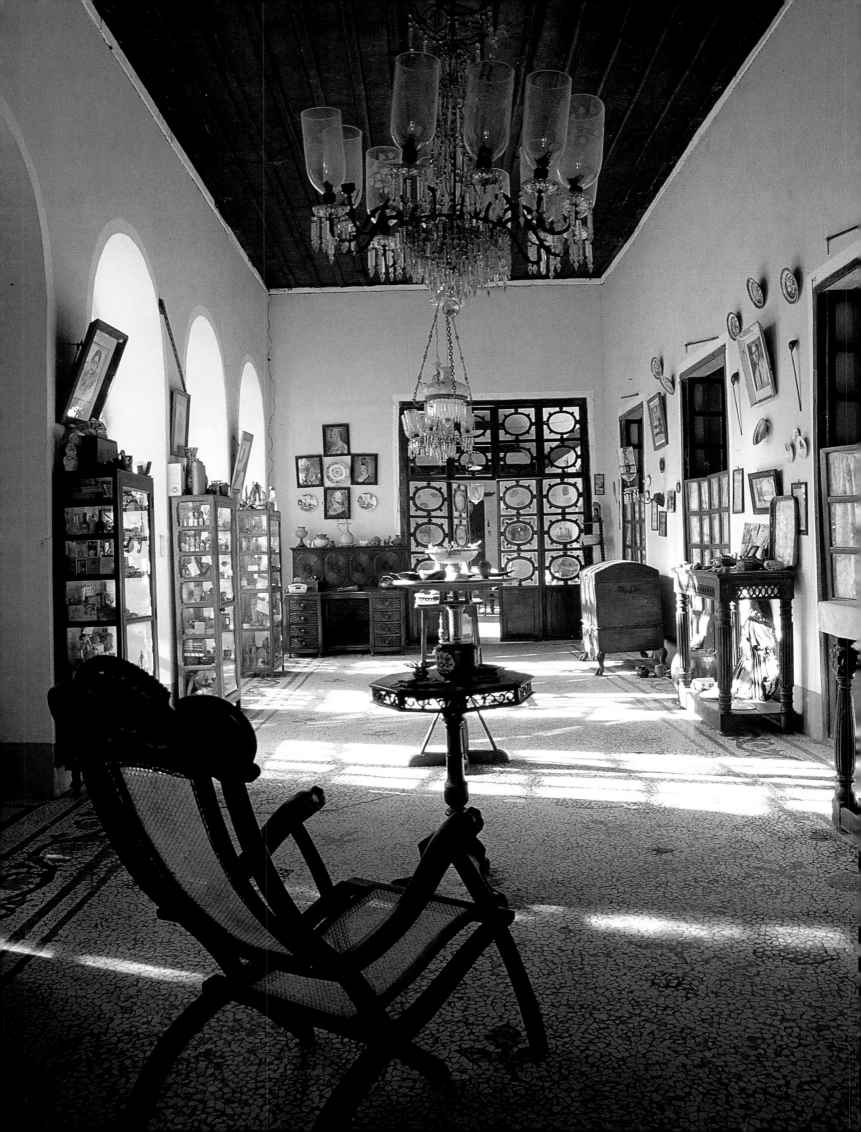

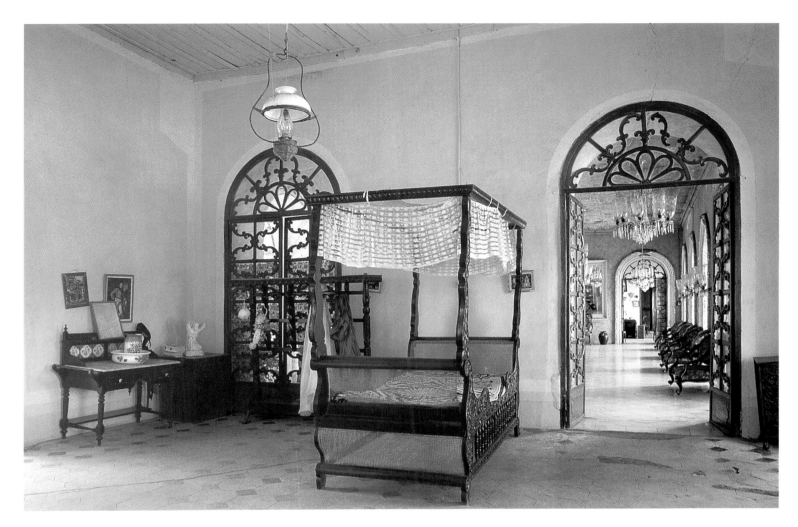

Previous page: The Braganza house is divided into long rooms and sunlit galleries. One such gallery leads to the bedrooms.
Facing page: The Pereira-Braganza parlour has mosaic floors, high wooden ceilings, rosewood reclining chairs and glass chandeliers.
Above and right: A rosewood four-poster with lace fringe and a washstand are a bedroom's main furnishings. Cabinets filled with toy dolls and bric-a-brac stand between French windows overlooking an inner garden.

Page précédente: La Casa de Braganza est divisée en longues pièces oblongues et en galeries ensoleillées. Celle-ci mène aux chambres.
Page de gauche: Le salon Pereira-Braganza possède un sol en mosaïque, de hauts plafonds en bois, des chaises longues en bois de rose et des lustres en verre.
Ci-dessus et à droite: dans cette chambre dépouillée, un lit à baldaquin en bois de rose avec des franges en dentelles et une coiffeuse équipée d'une bassine. Entre les portes-fenêtres qui donnent sur le jardin intérieur, des vitrines remplies de poupées et de bric-à-brac.

Vorhergehende Seite: Das Haus der Braganza ist in langgestreckte Räume und sonnendurchströmte Galerien aufgeteilt. Eine dieser Galerien führt zu den Schlafzimmern.
Linke Seite: Der Salon der Pereira-Braganza ist mit einem Mosaikboden, einer hohen Holzdecke, Ruhesesseln aus Rosenholz und gläsernen Kronleuchtern ausgestattet.
Oben und rechts: Die Einrichtung dieses Schlafzimmers besteht aus einem Waschtisch und einem Himmelbett aus Rosenholz. Ein Schrank, der mit Puppen und Nippsachen gefüllt ist, steht zwischen zwei Verandatüren, die sich zu einem Garten auf der Innenseite des Hauses öffnen.

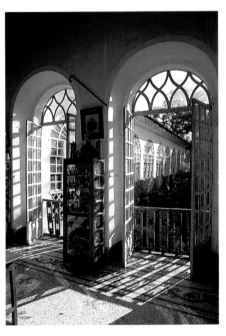

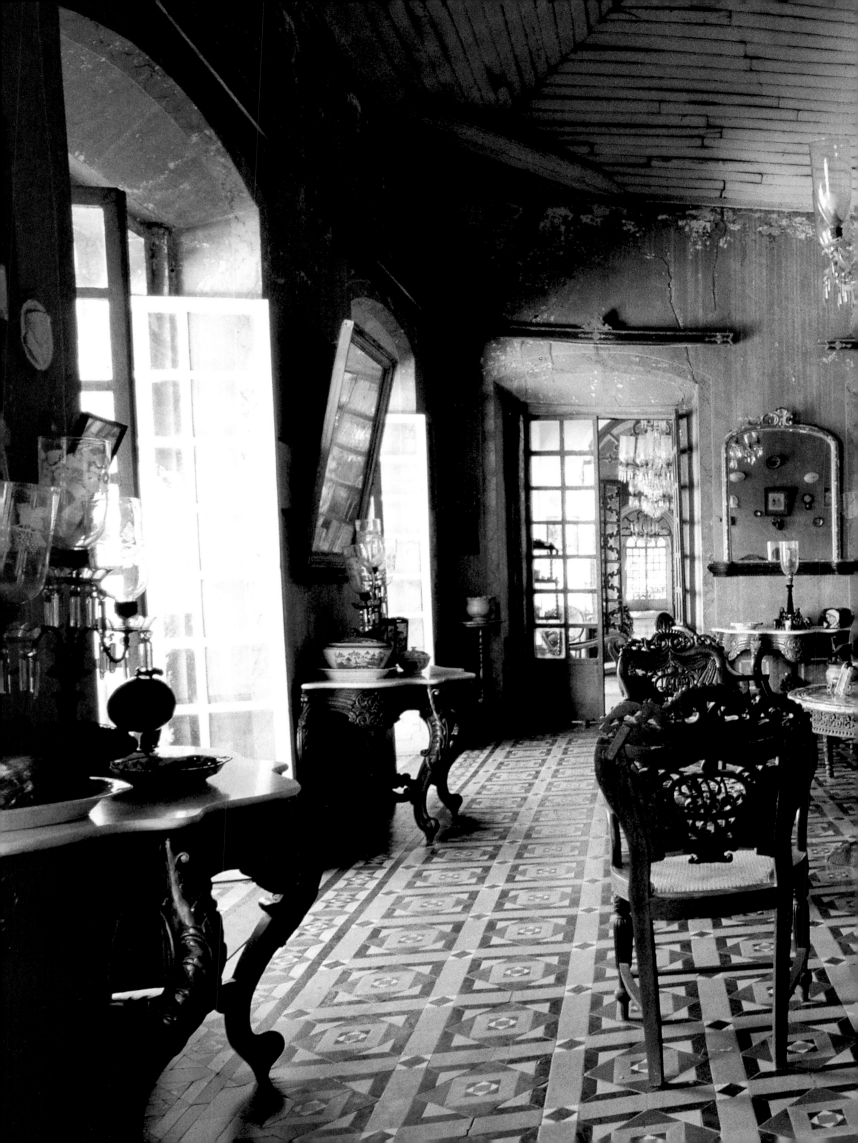

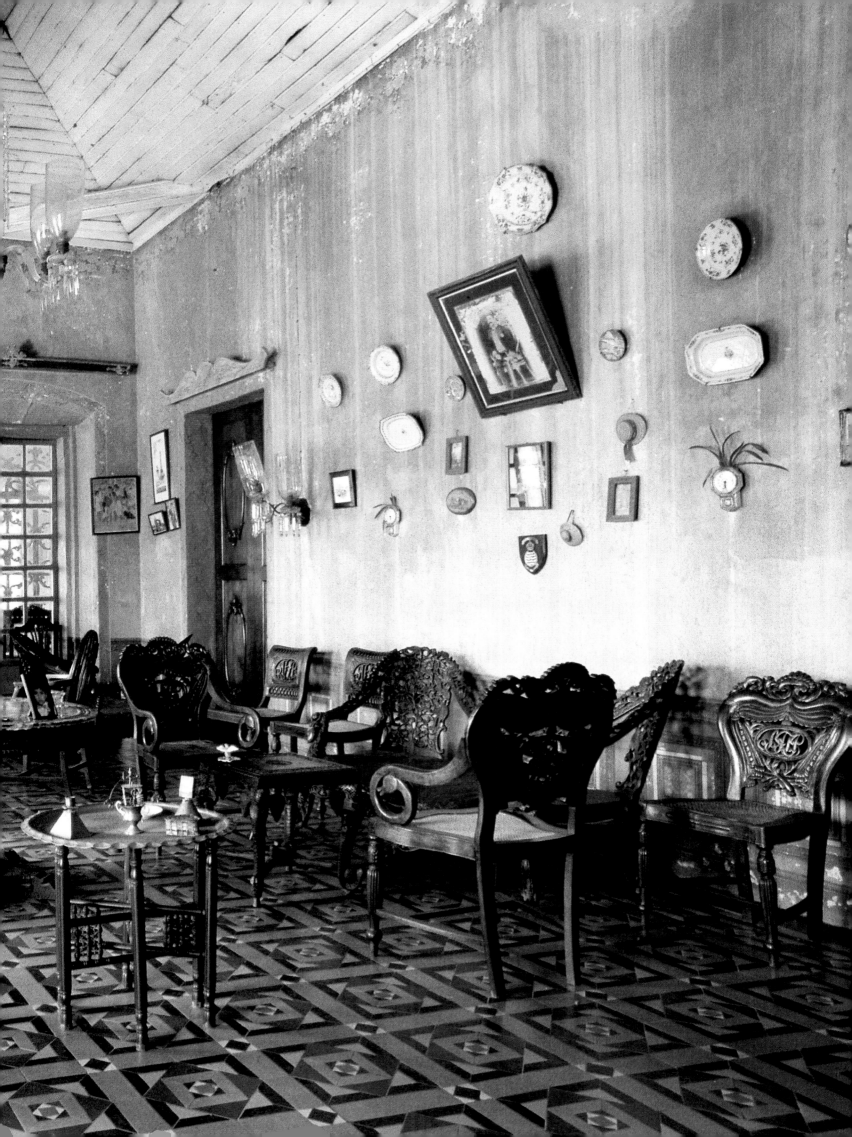

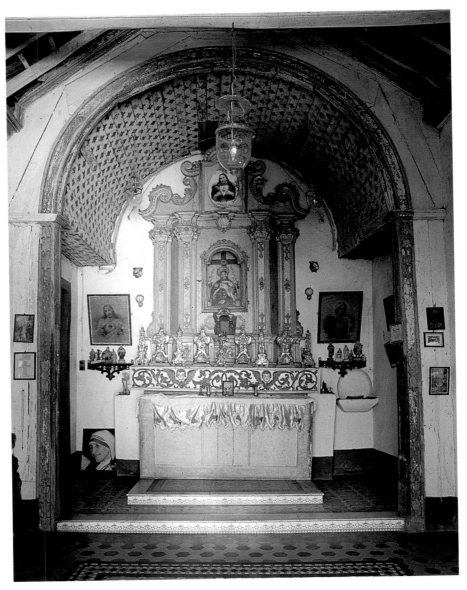

Previous pages: Rosewood furniture of Indo-Portuguese design with a forbear's monogram carved in the backrests of chairs, and hand-painted porcelain decorate the tiled parlour.
Above: The gold-painted altarpiece of the Pereira-Braganza private chapel, of Mary holding the dying Christ. is mounted above a row of silver reliquary-holders and candelabra.
Following pages: A rosewood armchair, carrying the Braganza coat of arms sits beneath a gilt-framed mirror in the grand ballroom of the Pereira-Braganza house. Tiled with Italian marble, the room's deli-cate gold-and-blue stencilled ceiling is lit with Belgian chandeliers.

Double page précédente: dans le salon carrelé, les meubles indo-portugais en bois de rose dont le dossier est gravé du monogramme d'un ancêtre et des porcelaines peintes à la main.
Ci-dessus: Le retable doré de la chapelle privée des Pereira-Braganza, représentant la Vièrge soutenant le Christ, est suspendu au-dessus d'une rangée de reliquaires et de chandeliers en argent.
Pages suivantes: Un fauteuil en bois de rose, portant le blason des Braganza, est placé sous un miroir doré dans la grande salle de bal de la demeure des Pereira-Braganza. La salle est dallée de marbre italien. Sous son plafond peint au pochoir en nuances délicates d'or et de bleu, des lustres provenant de Belgique.

Vorhergehende Doppelseite: Der mit Fliesen ausgelegte Salon ist mit handbemaltem Porzellan und Möbeln aus Rosenholz im indisch-por-tugiesischen Stil eingerichtet. In den Stuhllehnen ist das Monogramm von einem Vorfahren der Familie geschnitzt.
Oben: Unter dem in Goldfarbe gemalten Altarbild der Hauskapelle der Pereira-Braganza, das Maria mit dem sterbenden Christus dar-stellt, steht eine Reihe silberner Reliquiare und Kandelaber.
Folgende Seiten: In dem großen Ballsaal des Hauses der Pereira-Braganza steht ein Lehnstuhl aus Rosenholz mit dem Wappen der Braganza vor einem Spiegel mit Goldrahmen. Der Boden des Saales ist mit italienischem Marmor gefliest, und an der Decke, die mit einem zarten Muster aus Gold und Blau bemalt ist, hängen belgische Kronleuchter.

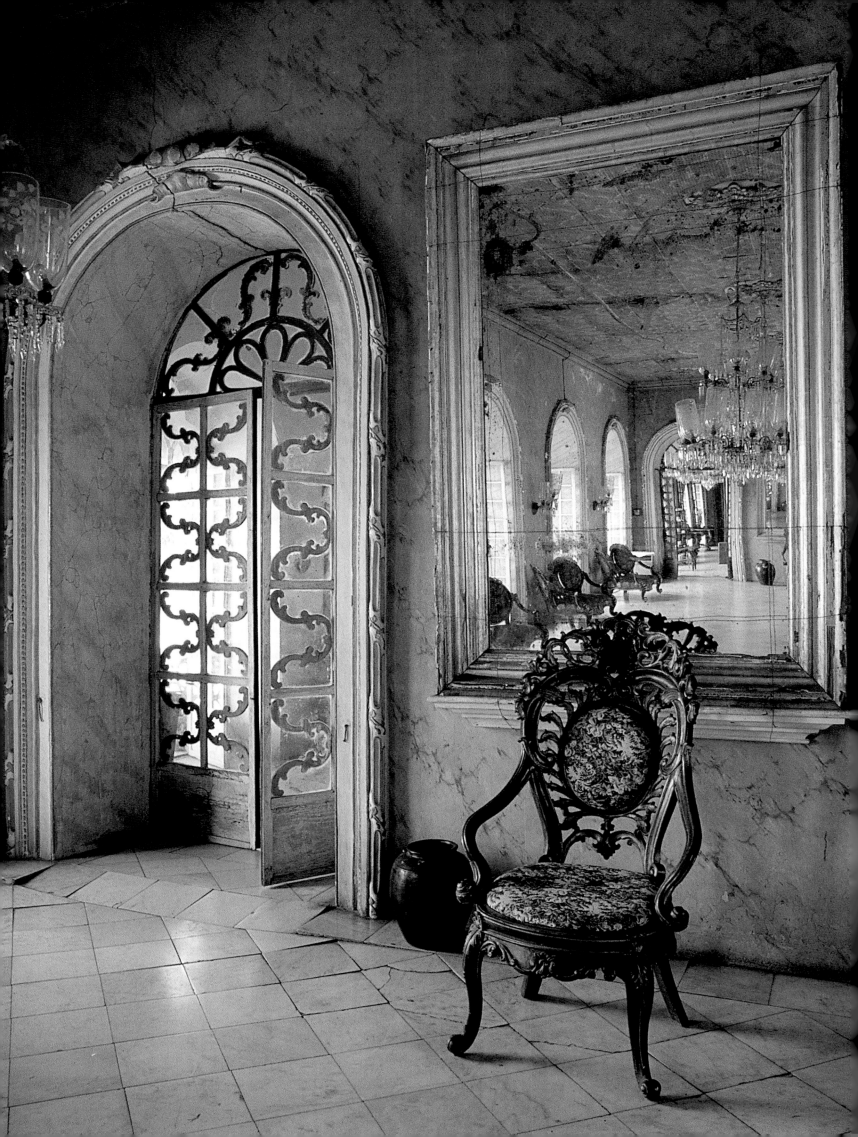

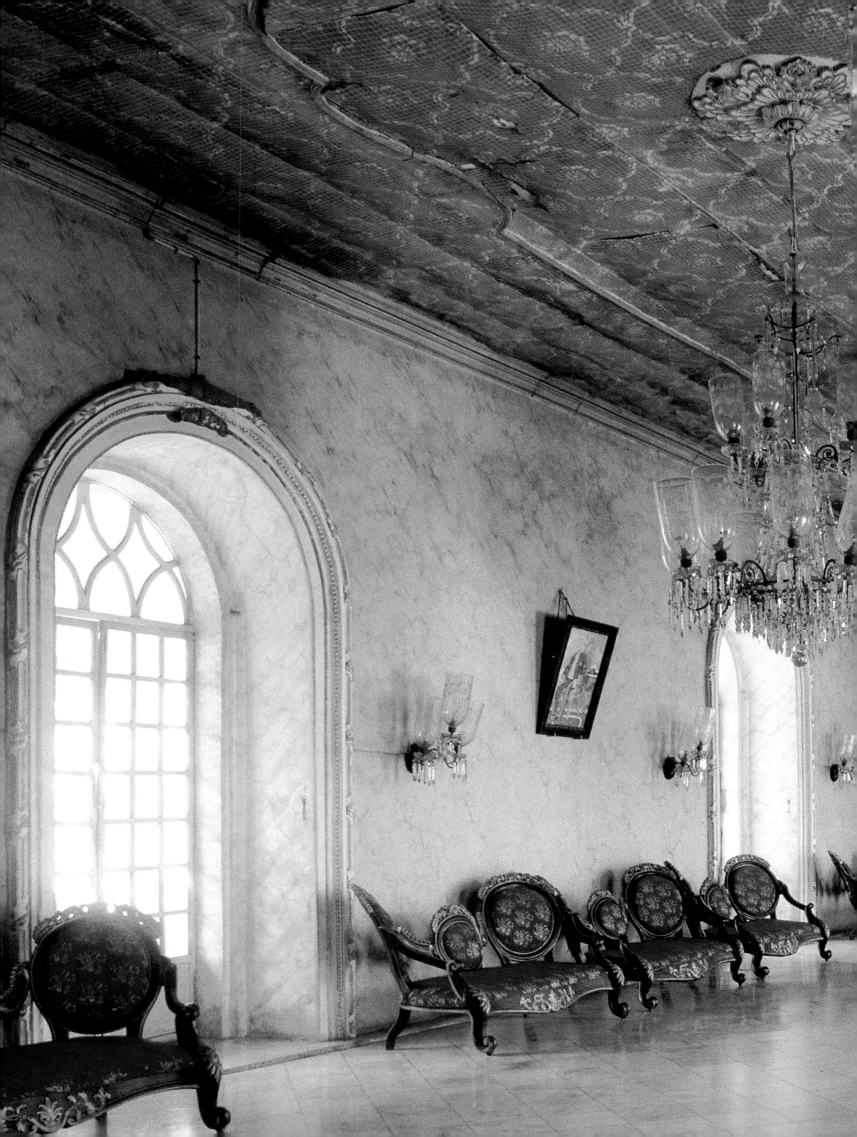

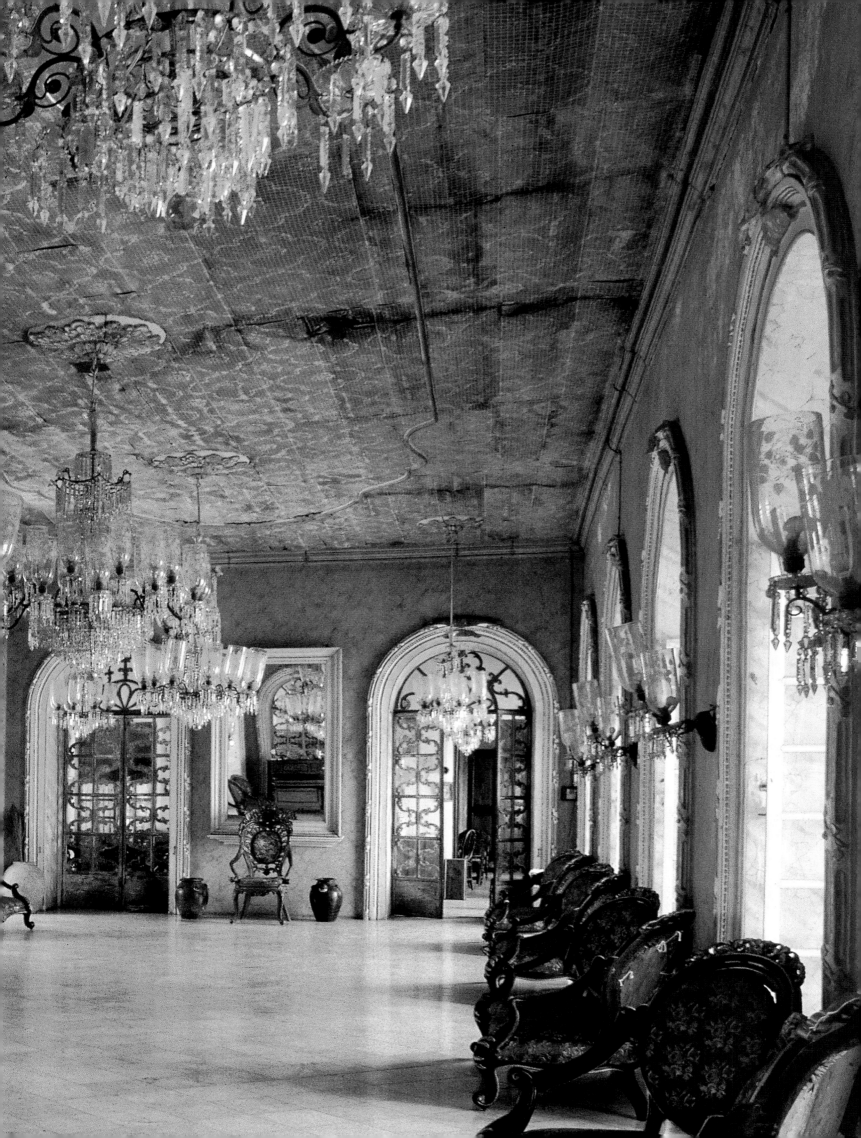

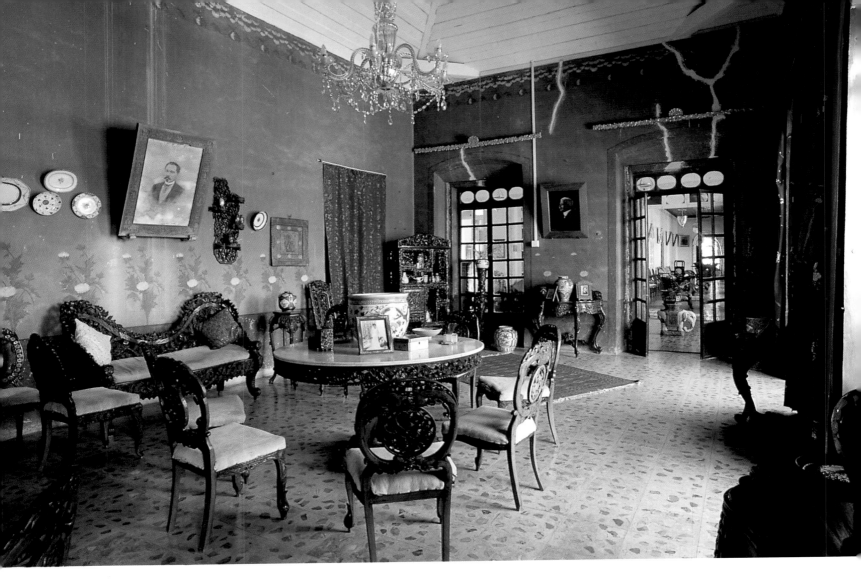

Above: the drawing room of the Menezes-Braganza home, with its faded peppermint walls and painted cornice, gives on to balconies overlooking the street.
Right: Aida de Menezes Braganza, whose grandmother was a Braganza, married her third cousin, who was Brazil's consul in Calcutta in the Thirties. As head of the Menezes-Braganza branch she occupies one half of the Braganza mansion.

Ci-dessus: le salon des Menezes-Braganza, avec ses murs verts fanés et ses frises peintes, donne sur des balcons qui dominent la rue.
A droite: Dans les années trente, Aida de Menezes Braganza, dont la grand-mère était née Braganza, a épousé un cousin au troisième degré, consul du Brésil à Calcutta. A titre de chef de la branche Menezes-Brangaza, elle occupe la moitié de la demeure.

Oben: Der Salon im Haus der Menezes-Braganza öffnet sich mit seinen verblaßten, pfefferminzgrün gestrichenen Wänden und dem gemalten Gesims zu einer Veranda über der Straße.
Rechts: Aida de Menezes Braganza, deren Großmutter eine Braganza war, hat ihren Cousin dritten Grades geheiratet, der während der dreißiger Jahre als brasilianischer Konsul in Kalkutta tätig war. Sie ist das Familienoberhaupt der Menezes-Braganza und bewohnt eine Hälfte des Braganza-Hauses.

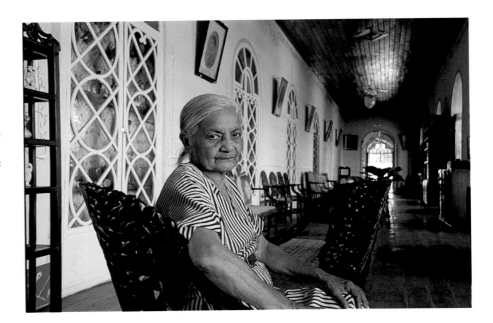

Right: Fanciful Chinese glass paintings of European ladies are grouped above a cabinet with a ceramic collection. A Chinese claw-footed chair rests against a painted dado.
Below: The bedroom of Francisco Xavier Braganza, a distinguished ancestor, is scrupulously kept up. The twin rosewood four-posters are carved with his initials and covered in hand-made lace.
Following pages: Chinese porcelain against a glass painting and a Chinese chair with ornate backrest create a chiaroscuro effect against the finely handpainted drawing room walls.

A droite: Des peintures chinoises sur verre, représentant des dames européennes, sont regroupées au-dessus d'une collection de céramiques. Une chaise chinoise aux pieds griffes devant un lambris peint.
Ci-dessous: La chambre de Francisco Xavier Braganza, éminent ancêtre, est scrupuleusement conservée telle qu'elle était de son vivant. Les lits jumeaux à baldaquin en bois de rose portent ses initiales et sont recouverts de dentelles tissées à la main.
Pages suivantes: Les porcelaines chinoises devant une peinture sur verre et une chaise chinoise au dossier sculpté génèrent un effet de clair-obscur devant les murs délicatement peints du salon.

Rechts: Elegante chinesische Glasgemälde, auf denen europäische Damen dargestellt sind, hängen über einer Vitrine mit einer Keramik-Sammlung. Der Stuhl mit Löwentatzen vor dem gemalten Wandpaneel stammt aus China.
Unten: Das Schlafzimmer von Francisco Xavier Braganza, einem bedeutenden Vorfahren, wird sorgfältig in seinem ursprünglichen Zustand erhalten. In die beiden Himmelbetten aus Rosenholz sind seine Initialen geschnitzt. Die Tagesdecke ist aus handgemachter Spitze.
Folgende Doppelseite: Chinesisches Porzellan, das vor einem Glasgemälde steht, und ein chinesischer Stuhl mit reich verzierter Lehne bewirken vor der mit zarten Mustern von Hand bemalten Wand des Salons einen Chiaroscuro-Effekt.

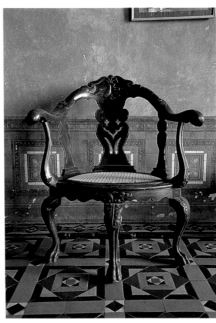

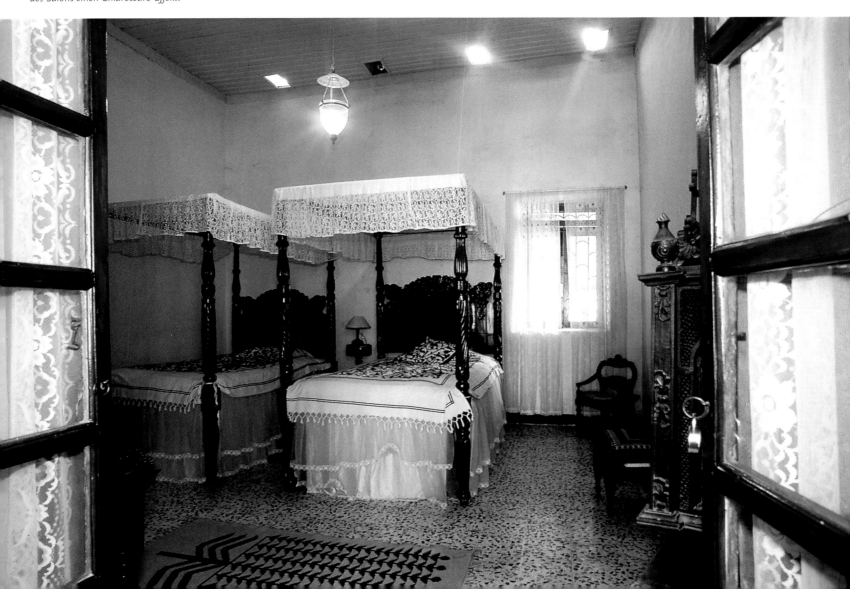

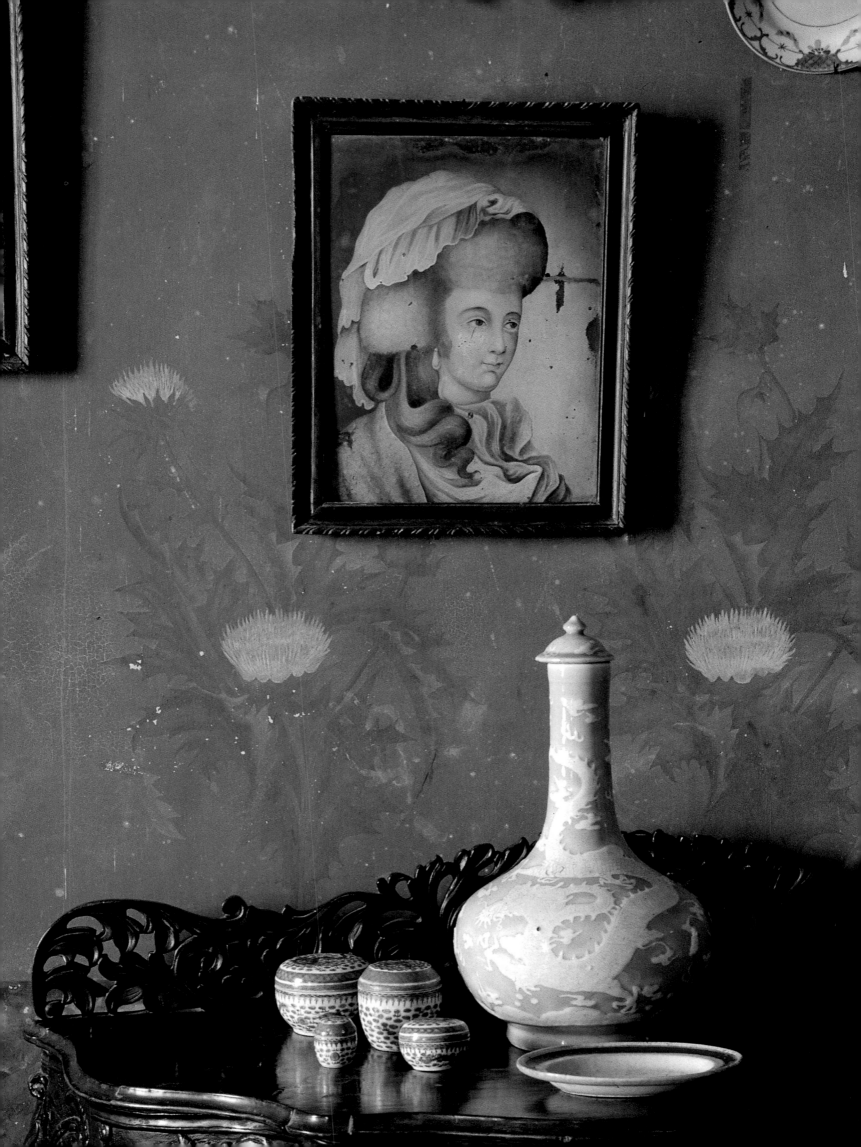

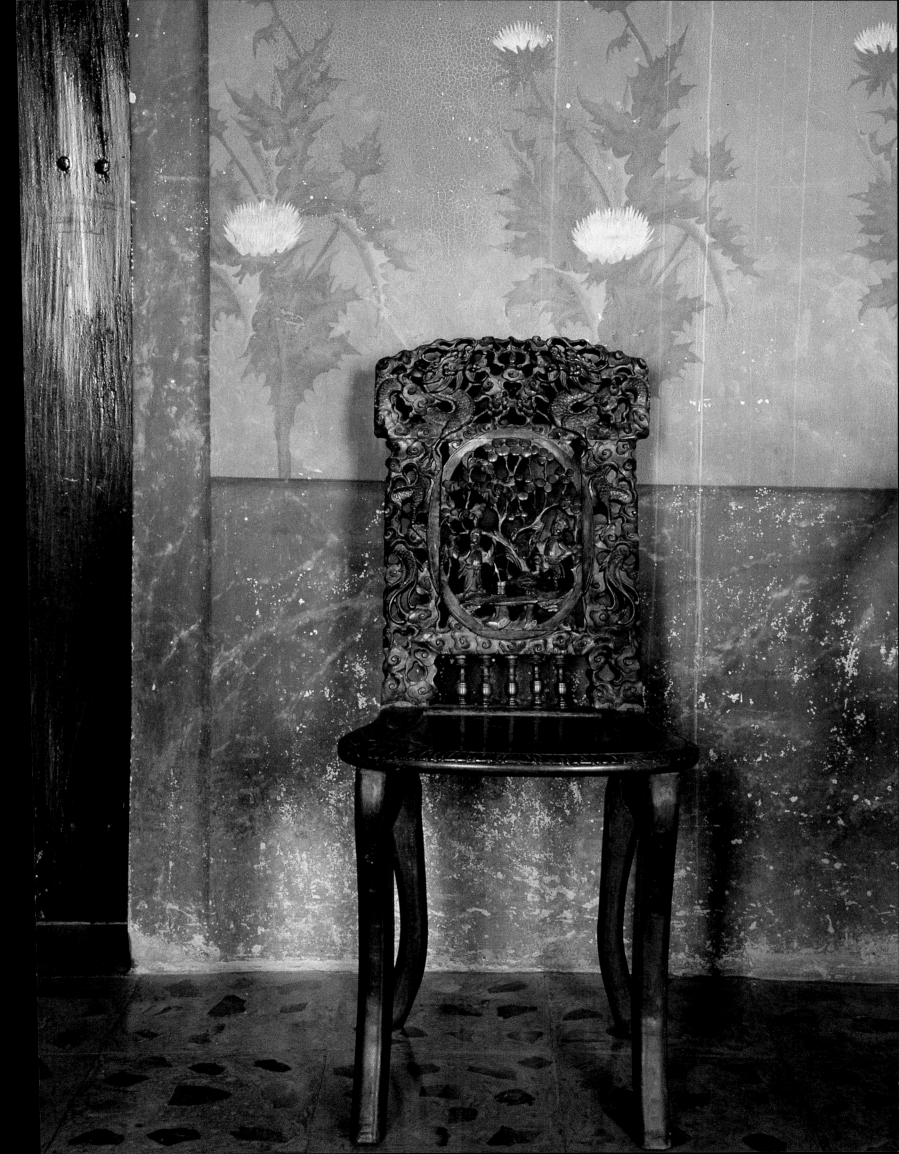

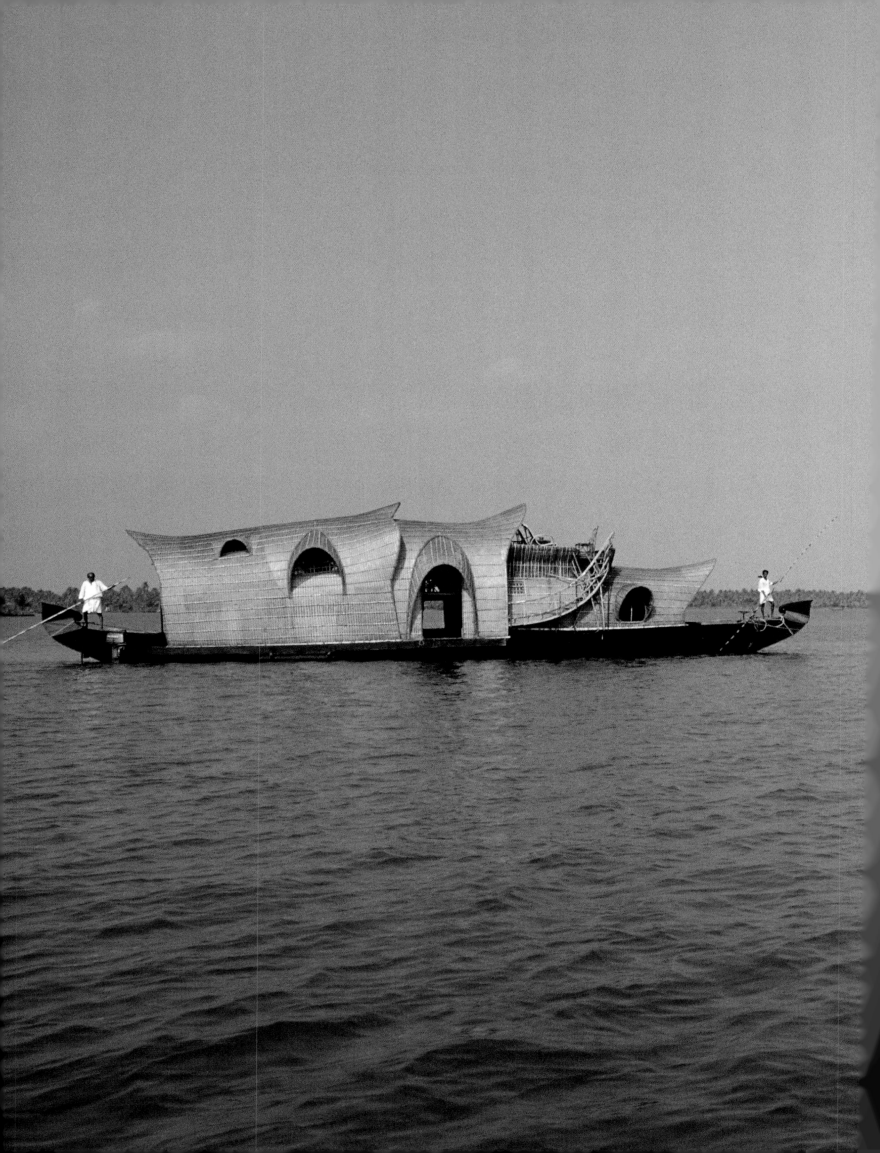

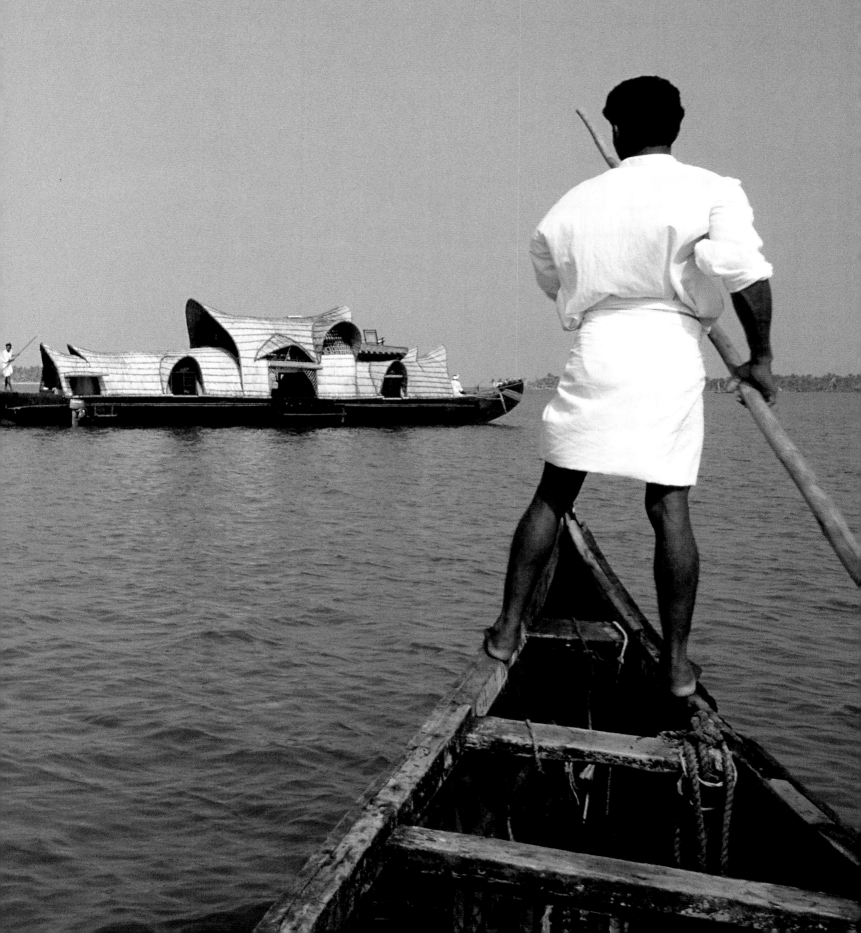

Ces longs et minces bateaux aux toits en fibre de coco et bambou qui transportent des marchandises sur les lagons bordés de palmiers et les eaux tranquilles du Kerala s'appellent des «kettuvallam», ce qui signifie littéralement des «bateaux attachés les uns aux autres». Depuis quelques années, ces embarcations modestes sont souvent modifiées et agrandies pour accueillir des touristes, mais les matériaux utilisés n'ont guère changé: une structure complexe en bambou posée sur des coques de jaques, remplies de paille de bambou et le tout fixé avec d'épaisses cordes en fibres de coco. Babu Varghese, un tour opérateur de Trivandrum, a eu l'idée de les réaménager pour organiser des croisières. Il les a agrandies en maisons flottantes de deux à trois pièces et équipées de toilettes et de douches. Il a été souvent copié depuis, mais il possède la plus grande flotte sillonnant les nombreux ports de la côte légendaire de Malabar.

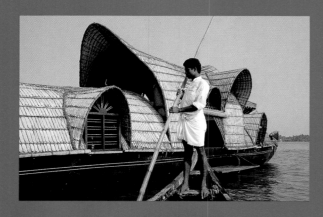

A Houseboat in Kerala

The slender cargo boats, with simple coir-and-bamboo roofs, that glide down the palm-fringed lagoons and backwaters of Kerala are called "kettuvallam". The word literally means boats that are tied together. These modest vessels have been modified and enlarged in recent years to serve as tourist houseboats but the materials used are much the same – elaborate bamboo scaffolding constructed on hulls of jackfruit wood, filled in with bamboo matting, all tied together with thick ropes of coir. Babu Varghese, a tour operator in Trivandrum, hit upon the idea of extended boat cruises along the backwaters. By expanding its proportions, he turned the traditional cargo boat into two- and three-room houseboats with built-in toilets and showers. Although his experiment has been much-copied, he owns the biggest houseboat fleet, plying down the fabled coast of Malabar with halts at many magic towns.

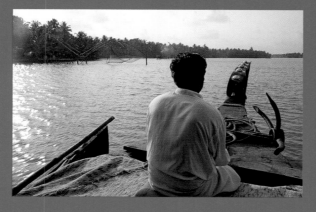

Die schlanken Lastkähne mit den Dächern aus Kokosfasern und Bambus, die durch die palmengesäumten Lagunen und Wasserstraßen von Kerala gleiten, werden »Kettuvallam« genannt. Wörtlich bedeutet dies: Boote, die zusammengebunden sind. In letzter Zeit ist man dazu übergegangen, diese bescheidenen Wasserfahrzeuge zu vergrößern und zu Hausbooten für Touristen umzubauen. Die benutzten Materialien sind jedoch mehr oder weniger gleich geblieben: Auf einem Rumpf aus dem Holz von Jackbäumen wird ein kompliziertes Bambusgerüst errichtet. Das Ganze wird mit dicken Stricken aus Kokosfasern zusammengebunden und mit Bambusmatten ausgelegt. Babu Varghese, ein Reiseveranstalter aus Trivandrum, hatte die Idee, ausgedehnte Bootsfahrten durch die Wasserstraßen Keralas zu organisieren. Indem er ihre Proportionen vergrößerte, verwandelte er die traditionellen Lastkähne zu Hausbooten mit zwei oder drei Räumen, Toilette und Dusche. Obwohl sein Experiment von vielen nachgeahmt wurde, bleibt er der Besitzer der größten Hausboot-Flotte. Die von ihm angebotenen Rundfahrten machen Halt an zahlreichen magischen Städte entlang der herrlichen Malabarküste.

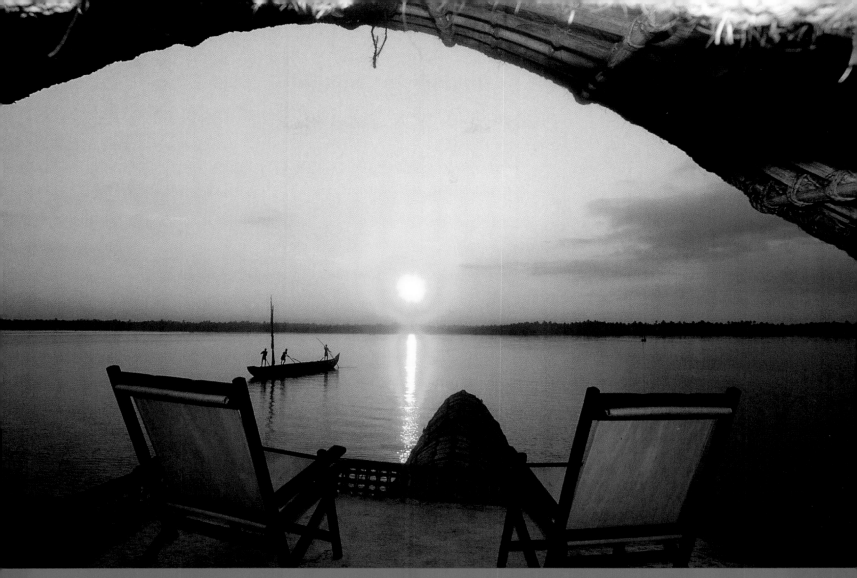

The tapering tail of a Kerala houseboat, fitted with a small deck and folding chairs, is the perfect vantage point for viewing spectacular sunsets on the backwaters. The boat's multiple arches are a skilful construction of palm-leaf matting woven onto a bamboo frame, tied together with yards of coir rope.

La poupe allongée de ce «kettuvallam» reconverti, avec son petit pont et ses transats, est le lieu idéal pour contempler les spectacu-laires couchers de soleil. Les nombreuses arches du bateau sont constituées de feuilles de palmiers savamment tissées sur une struc-ture en bambou et retenues par des cordes en fibres de coco.

Das spitze Heck eines Hausboots in Kerala, das mit einem kleinen Deck und Klappstühlen ausgestattet wurde, eignet sich perfekt dazu, dem atemberaubend schönen Sonnenuntergang in der Lagune zuzu-schauen. Die vielen das Boot überspannenden Bögen sind eine kunst-volle Konstruktion aus Palmenblättern, die auf ein Bambusgerüst geflochten und mit Stricken aus Kokosfasern zusammengebunden werden.

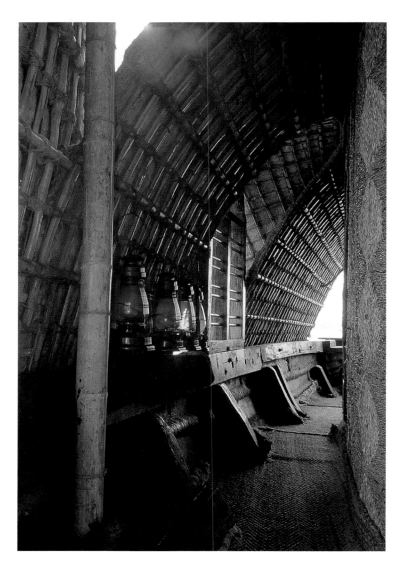
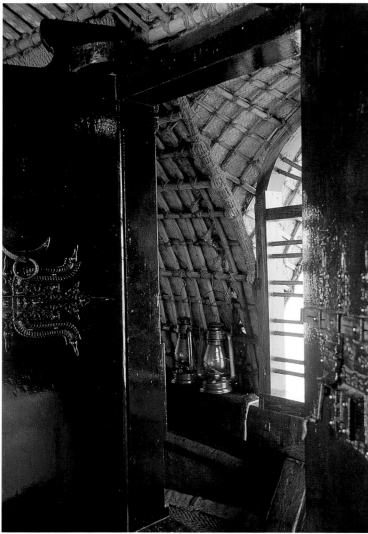

Above: A narrow passage runs down the side of the boat. The entire vessel is lit at night by oil lamps. A wooden door with a traditional Kerala brass lock leads into the bedroom. An average-sized boat is divided into a bedroom and bathroom in front, an open dining space in the middle and a kitchen and storeroom at the back.
Right and facing page: A romantic canopy of mosquito netting is draped over the bed although there are few mosquitoes owing to the constant breeze. Patchwork squares of coir matting line the walls.

Ci-dessus et à droite: une étroite galerie court tout le long du bateau. La nuit, des lampes à huile fournissent la lumière. Une porte en bois ornée de la serrure en laiton traditionnelle du Kerala s'ouvre sur la chambre à coucher. Une embarcation de taille moyenne comprend, à l'avant, une chambre et une salle de bains, au milieu, une salle à manger et une cuisine et, à l'arrière, une aire de rangement.
A droite et page de droite: Une moustiquaire en baldaquin au-dessus du lit pour la touche romantique, car la brise marine éloigne les insectes. Les murs sont tapissés d'un assemblage de carrés en fibres de coco.

Oben: Ein schmaler Gang zieht sich an der Seite des Bootes entlang. Nachts wird das Innere mit Öllampen beleuchtet. Eine Holztür mit den für Kerala typischen traditionellen Messingriegeln führt ins Schlafzimmer. Ein durchschnittlich großes Boot ist gewöhnlich vorne in ein Schlaf- und ein Badezimmer aufgeteilt, in der Mitte hat es einen offenen Raum für die Mahlzeiten und im hinteren Bereich eine Küche und einen Vorratsraum.

Unten und rechte Seite: Ein romantischer, aus einem Moskitonetz bestehender Baldachin breitet sich über das Bett, obwohl es aufgrund des unaufhörlichen Seewinds kaum Moskitos gibt. Die Wände bestehen aus aneinandergereihten Karrees aus Kokosfasergeflecht.

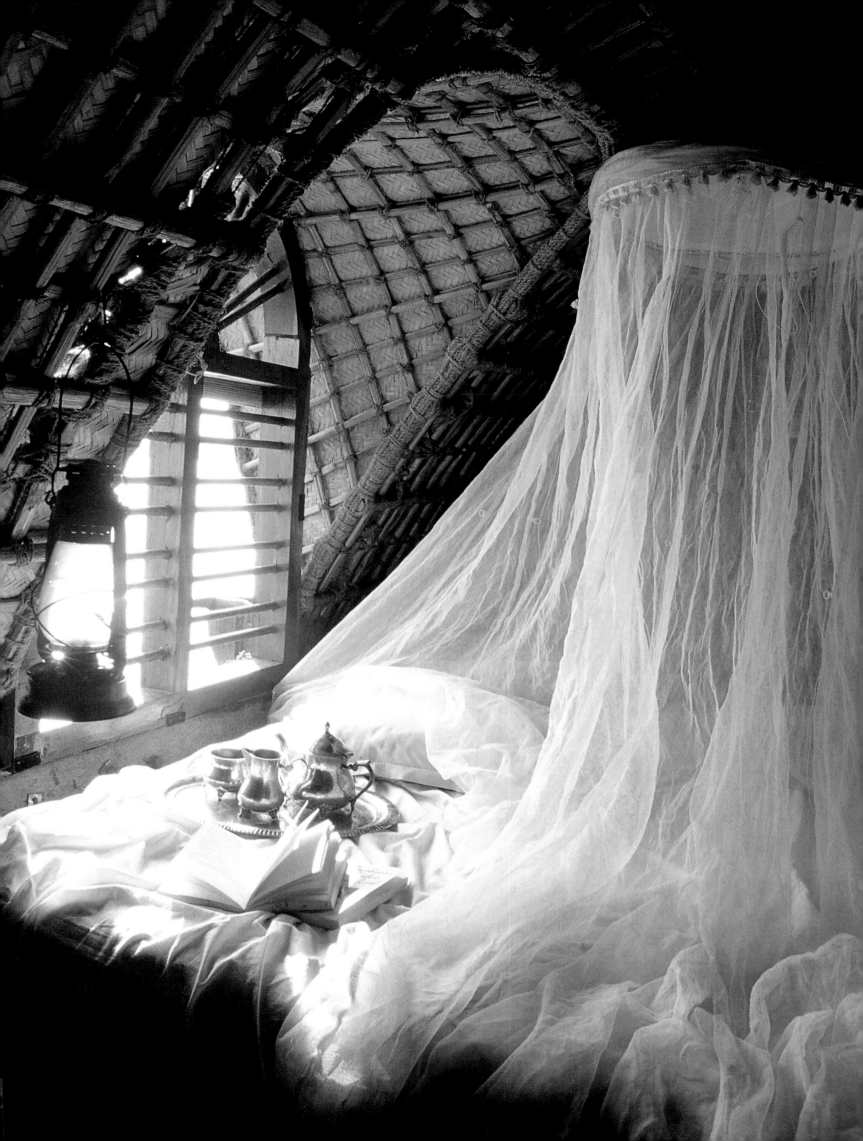

Cette splendide demeure se dresse à 80 kilomètres de Cochin, sur les berges du Meenachil, dans une plantation d'hévéas, de bois de rose, d'acajous et de jaquiers. D'une architecture à la fois simple et sophistiquée, c'est l'exemple type d'une maison 19e du Kerala, ou «tharawad», bâtie selon une technique ancienne sans le moindre clou. Les traverses, les poutres et les cloisons sont maintenues en place à l'aide de chevilles en bois sur des murs de soutien en calcaire. Cette «tharawad» fut construite en 1881 par Thomman Kuruvina-kunnel, le grand-père du maître actuel des lieux, Mathew Joseph. Les origines de cette famille catholique remonteraient, paraît-il, à l'aube de la chrétienté, lorsque que l'apôtre saint Thomas arriva sur la côte de Malabar en 52 de notre ère et commença à convertir la population. Les catholiques du Kerala ont des règles de succession bien à eux: les maisons de famille telles que celle-ci sont transmises au plus jeune fils de chaque génération.

A Catholic Home in Kerala

Eighty kilometres from Cochin, on the banks of the river Meena-chil, stands a splendid Malabar house in a plantation of rubber, rosewood, mahogany and jackfruit trees. Simple yet sophisticated in its design, it is a classic 19th-century example of a Kerala home known as a "tharawad". The construction of a "tharawad" is based on techniques that altogether eschew the use of nails. Instead, the rafters, beams and wall planks are interlocked with wooden pegs on supporting limestone walls. The house belongs to Mathew Joseph Kuruvinakunnel whose grandfather Thomman built it in 1881. The Kuruvinakunnels are Catholics, and claim descent from the very dawn of Christianity when St. Thomas the Apostle sailed to Malabar in 52 BC and made his first conversions among the local populace. Distinct customs govern Kerala's Catholics in matters of inheritance: ancestral homes such as this one pass on to the youngest son in each generation.

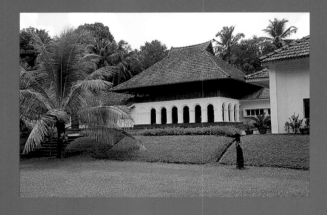

Achtzig Kilometer von Cochin entfernt, am Ufer des Flusses Meena-chil, steht inmitten einer Plantage von Gummi-, Rosenholz-, Maha-goni- und Jackbäumen ein herrliches malabarisches Haus. Es ist einfach und doch von ausgeklügeltem Design, stammt aus dem 19. Jahrhundert und ist ein klassisches Beispiel für eines jener Wohn-häuser in Kerala, die man »Tharawad« nennt. Die Konstruktion eines »Tharawad« basiert auf einer Technik, die den Gebrauch von Nägeln gänzlich meidet. Statt dessen werden die Dachsparren, Balken und Wandplanken mit hölzernen Stiften zusammengefügt und von Kalksteinwänden gestützt. Das Haus gehört Mathew Joseph Kuruvinakunnel, dessen Großvater Thomman es 1881 erbaute. Die Kuruvinakunnels sind Katholiken und behaupten, ihre Vorfahren stammten aus der Frühzeit des Christentums – aus der Zeit, als Apostel Thomas im Jahre 52 an der Malabar-Küste landete und die einheimische Bevölkerung bekehrte. Die Vererbung von Eigentum ist in der katholischen Bevölkerung Keralas genau festgelegt: Ein Stammsitz wie dieser wird in jeder Generation auf den jüngsten Sohn vererbt.

Previous page: A portrait of the family patriarch hangs on the eastern wall of the courtyard next to a receptacle with a cross and plaster decoration for the holy water. The polished pillar and cross-beamed rafters are made of jackfruit wood, locally known as "aanjali".
Right: an elaborate brass lock of traditional Kerala design on the door to the strongroom where the family kept their valuables. The old Chinese jars were used for storing coconut oil and pickles.
Below: A former bedroom now serves as the library. The walls, made of solid wooden planks, are a fine example of traditional Kerala joinery.

Page précédente: dans la cour, le portrait du patriarche, accroché au mur oriental près d'un bénitier en plâtre surmonté d'une croix. La colonne en bois poli et les poutres croisées sont en jaquier, appelé «aanjali» dans la région.
A droite: La superbe serrure en laiton, un travail traditionnel du Kerala, protège les portes de la chambre forte où la famille gardait ses objets de valeur. Les grandes potiches chinoises servaient autrefois à conserver l'huile de coco et les pickles.
Ci-dessous: Une ancienne chambre à coucher a été convertie en bibliothèque. Les épaisses boiseries sont un bel exemple de l'ébénisterie traditionnelle du Kerala.

Vorhergehende Seite: Das Porträt des Familienpatriarchen hängt an der östlichen Wand des Innenhofs, neben einer mit einem Kreuz und Stuck verzierten Aushöhlung, die mit Weihwasser gefüllt ist. Der glatt polierte Pfeiler und die Querbalken an der Decke sind aus dem Holz von Jackbäumen, das in dieser Gegend »Aanjali« genannt wird.
Rechts: Ein reich verziertes Messingschloß sichert den Eingang zur Tresorkammer, in der die Familie ihre Wertgegenstände unter Verschluß hielt. Die alten chinesischen Gefäße davor wurden zur Aufbewahrung von Kokosnußöl und eingelegtem Gemüse benutzt.
Unten: Ein altes Schlafzimmer dient nun als Bibliothek. Die Wände aus massivem Holz sind ein ausgezeichnetes Beispiel für die Qualität des Zimmerhandwerks in Kerala.

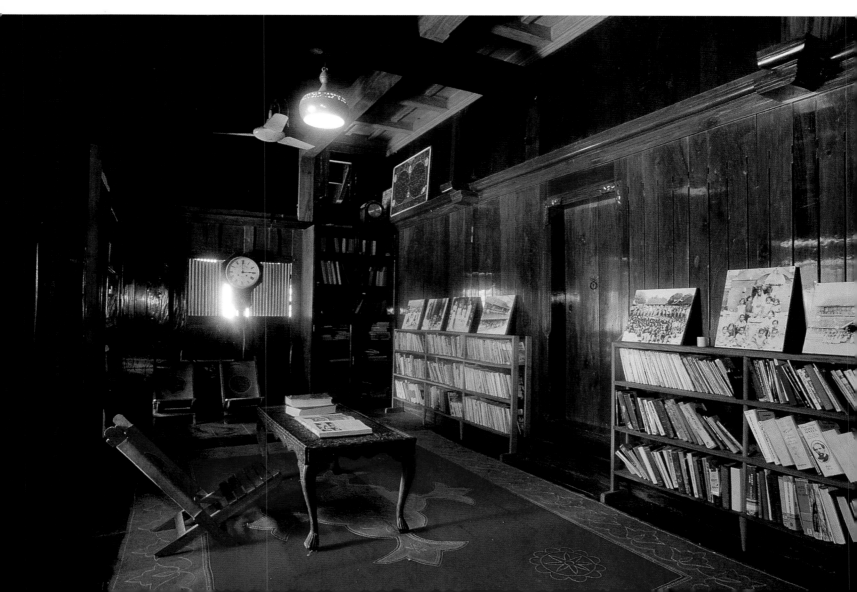

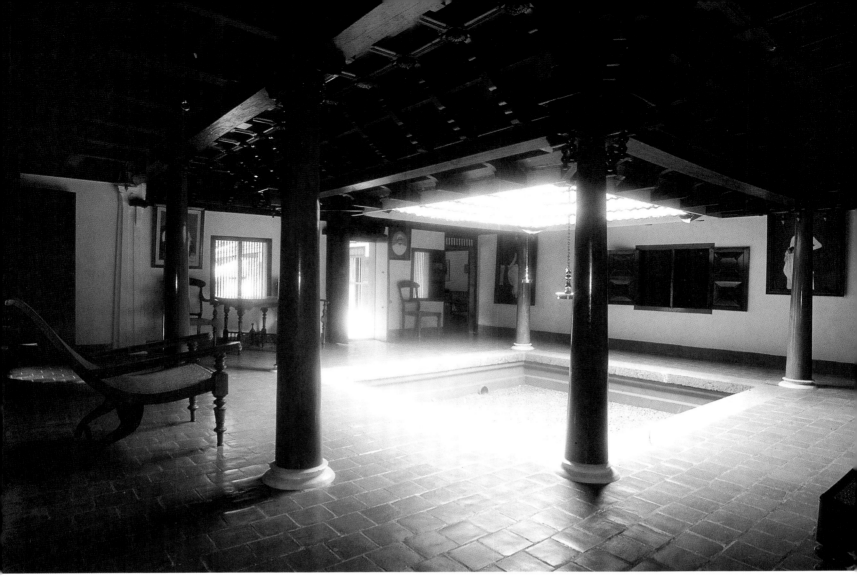

Above: Pillared verandahs overlooking the courtyard, for swift drainage of rainwater, are a central feature of the "tharawad". The entire area, known as the "naalukettu", remains cool throughout the year with floors of mud-baked tiles and excellent cross-ventilation.
Right: The master bedroom in the house has rosewood beds made in traditional style and a high roof of wooden planks cut from jackfruit trees. The floors are of baked tiles. The windows look out onto a land-scaped lawn beyond which lie wooded glades and the river.

Ci-dessus: Les cours bordées d'une véranda à colonnade, qui permet-tent une rapide évacuation des eaux, sont typiques des «tharawad». Cette partie de la maison, appelée «naalukettu», reste fraîche toute l'année grâce à son carrelage en terre cuite et sa ventilation croisée.
A droite: dans la chambre des maîtres, des lit traditionnels en bois de rose et un haut plafond en lattes de jaquier. Sur le sol, un dallage en terre cuite. Les fenêtres donnent sur une pelouse qui descend jusqu'aux berges boisées de la rivière.

Oben: Veranden mit Säulen rahmen den Innenhof, der für den schnellen Abfluß des Regenwassers sorgt. Sie gehören zu den Charakteristika des »Tharawad«. Der gesamte Bereich, den man als »Naalukettu« bezeichnet, bleibt das ganze Jahr über angenehm kühl, aufgrund der aus Lehm gebrannten Bodenfliesen und der exzellenten Belüftungstechnik.
Rechts: Der zentrale Schlafraum des Hauses ist mit Betten aus Rosenholz im traditionellen Stil eingerichtet und hat eine hohe Holz-decke, deren Bohlen vom Jackbaum stammen. Der Fußboden ist gefliest und die Fenster geben die Aussicht auf eine Wiese frei, hinter der ein kleines Wäldchen zum Flußufer führt.

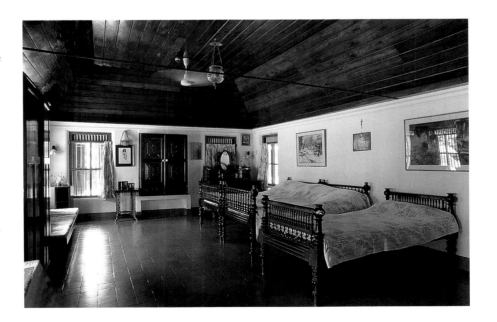

*Mathew Lawrence vient d'une famille d'antiquaires de Trivandrum.
Son grand-père, Mathew Pereira, était marchand d'ivoire, son père,
Lawrence Pereira, un des plus grands antiquaires du sud de l'Inde.
Mathew et son frère Manu ont hérité du commerce familial, qui s'est
à présent enrichi d'une entreprise d'exportation d'artisanat et d'une
galerie d'art située près de la plus vieille synagogue de l'Inde, dans le
quartier juif de Cochin. Ils habitent dans le bungalow familial,
construit il y a 80 ans, avec ses vérandas à colonnade et ses hauts pla-
fonds, en face des bâtiments majestueux de l'université du Kerala. Ces
dernières années, Mathew a entrepris de grands travaux de restaura-
tion afin de le moderniser sans pour autant compromettre ses propor-
tions coloniales ni son lustre d'antan. Il a repeint en blanc ses inté-
rieurs spacieux et les a meublés de pièces indo-victoriennes
soigneusement choisies, assurant ainsi à la vieille demeure familiale
une nouvelle vie pour les générations à venir.*

Mathew Lawrence

Mathew Lawrence comes from a family of antique dealers in
Trivandrum. His grandfather Mathew Pereira was an ivory mer-
chant and his father Lawrence Pereira became a leading antiquar-
ian in south India. Mathew and his brother Manu inherited the
family business which has now branched into handicraft exports
and an art gallery near the oldest synagogue in India in Cochin's
Jewish quarter. They live in an 80-year-old bungalow, with pillared
verandahs and high-ceilinged rooms, opposite the majestic build-
ings of Kerala University. In recent years, Mathew has undertaken a
major renovation of the family house in an effort to modernise it
without compromising either its colonial proportions or its period
flavour. By painting the interiors white throughout and furnishing
the airy, well-lit rooms with carefully chosen pieces of Indo-Victo-
rian furniture, a deteriorating old family home has been saved for
future generations.

*Mathew Lawrence stammt aus einer Familie von Antiquitätenhänd-
lern aus Trivandrum. Sein Großvater Mathew Pereira war ein Elfen-
beinhändler, und sein Vater Lawrence Pereira wurde zu einem der
führenden Antiquitätenhändler von ganz Südindien. Mathew und
sein Bruder Manu erbten das Familienunternehmen, das sich noch
vergrößert hat und nun auch eine Abteilung für den Export von
Handarbeiten und eine Kunstgalerie unterhält, die sich in der Nähe
der ältesten Synagoge Indiens im jüdischen Viertel von Cochin befin-
det. Die beiden Brüder wohnen gegenüber der Kerala University in ei-
ner 80 Jahre alten Villa. Die Räume haben hohe Decken und die Ve-
randen sind mit säulengestützten Dächern versehen. In den
vergangenen Jahren hat Mathew das Haus der Familie einer durch-
greifenden Renovierung unterzogen, wobei er sich darum bemühte, es
zu modernisieren, ohne dabei jedoch die aus der Kolonialzeit stam-
menden, großzügigen Proportionen oder das historische Flair des Ge-
bäudes zu zerstören. Indem er alle Innenräume weiß anstreichen ließ
und die luftigen, lichterfüllten Räume mit sorgfältig ausgewählten in-
dischen Möbeln aus der viktorianischen Zeit einrichtete, gelang es
ihm, einen im Verfall begriffenen alten Familienbesitz auch für künf-
tige Generationen zu erhalten.*

Previous page: A stack of polychrome wooden images of Indian deities, including the blue-skinned god Krishna, find their way into Mathew's shop after being used in religious processions.
Right: Stained glass fanlights and coloured panes were added to the double windows in the parlour to cut down the glare of the south Indian sun.
Below: A collection of European marbles and porcelain pieces are displayed on a Victorian chimney piece, a whatnot and a gilded console in the drawing room.

Page précédente: Après avoir été exhibées dans de nombreuses processions religieuses, ces statuettes de divinités indiennes en bois polychrome, dont un Krishna à la peau bleue, ont atterri dans la boutique de Mathew.
A droite: Les doubles fenêtres du salon ont été équipées de panneaux en verre coloré et surmontées de vitraux en demi-lune afin de filtrer la lumière crue du soleil de l'Inde du Sud.
Ci-dessous: Le petit salon abrite une collection de porcelaines et de marbres européens éparpillés sur une cheminée victorienne, un petit meuble à étagères et une console en bois doré.

Vorhergehende Seite: Eine Reihe bunter Figuren, die indische Gottheiten darstellen und zu denen auch der blauhäutige Gott Krishna gehört, fanden ihren Weg in Mathews Geschäft, nachdem sie in religiösen Prozessionen benutzt worden waren.
Rechts: Oberlichter aus Buntglas und bunte Glasscheiben wurden nachträglich in die Verandatüren eingebaut, um das gleißende Licht der indischen Sonne ein wenig abzuschwächen.
Unten: Eine Sammlung von europäischen Marmorstatuen und Porzellanfiguren ist auf dem viktorianischen Kaminsims, dem Regalschrank und dem vergoldeten Konsoltischchen des Salons zur Schau gestellt.

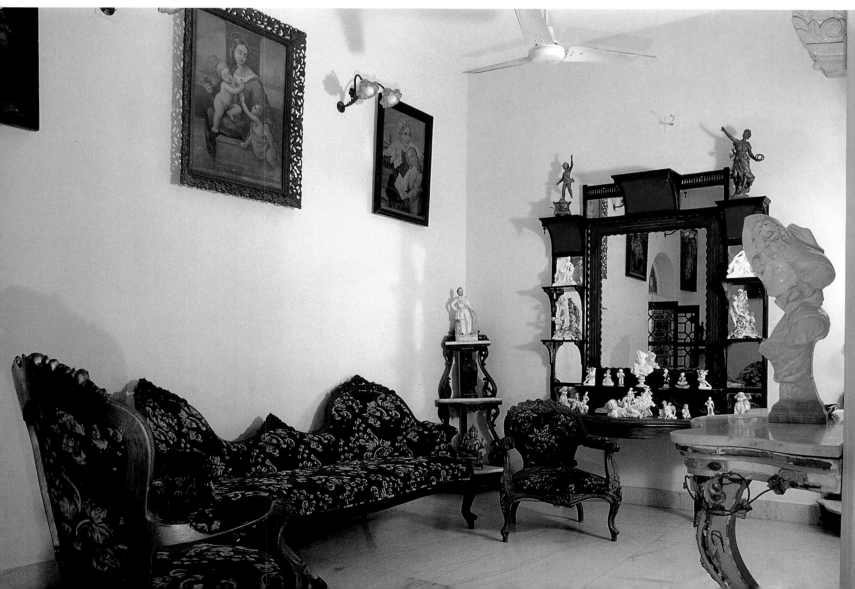

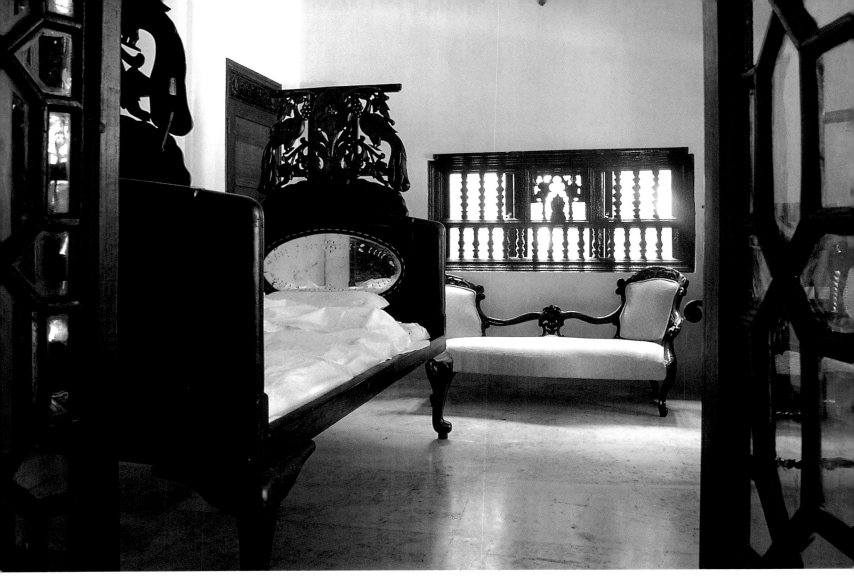

Above: Glass-paned doors open into a guest room furnished with an unusual bedstead embellished with mirrors and carved peacocks.
Right: The long marble verandah with wooden pillars is hung with traditional cane blinds, lowered in the afternoons to provide shade from the glaring light.

Ci-dessus: dans cette chambre d'amis aux portes en panneaux de verre, un lit inhabituel aux montant équipés de miroirs et surmontés de paons sculptés.
A droite: La longue véranda en marbre avec ses colonnes en bois. Les stores traditionnels en rotin sont baissés l'après-midi pour protéger de la lumière aveuglante.

Oben: Glastüren öffnen sich zu einem Gästezimmer, dessen Einrichtung unter anderem aus einem extravaganten Bett besteht, das mit Spiegeln und geschnitzten Pfauen verziert ist.
Rechts: In einer langgestreckten Veranda mit einem Marmorboden und hölzernen Säulen hängen Rollos aus Rohr, die nachmittags heruntergelassen werden, um vor dem gleißenden Licht der Sonne Schutz zu gewähren.

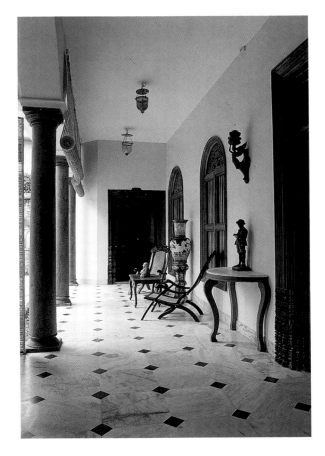

Above: The entrance gate is made from timber carvings, doors and 150-year-old local tiles salvaged from traditional Kerala houses that faced demolition.
Left: A double row of arches protect a shady verandah overlooking a courtyard with a lotus pond, trees and flowering shrubs.

Ci-dessus: le portail, avec ses bois sculptés, sa porte ancienne et des tuiles locales vieilles de 150 ans récupérées dans des chantiers de démolition de maisons traditionnelles du Kerala.
A gauche: Une double rangée d'arches protège une véranda ombragée donnant sur la cour, avec sa mare de lotus, ses arbres et ses arbustes à fleurs.

Oben: Das Eingangstor wurde aus kunstvoll geschnitzten Holzbalken, Türen und 150 Jahre alten Ziegelsteinen errichtet. Letztere stammen aus traditionellen Kerala-Häusern, die dem Abriß anheim gefallen waren.
Links: Eine Arkade stützt das Dach einer schattigen Veranda, die an einen Innenhof mit einem Lotosteich, Bäumen und blühenden Sträuchern grenzt.

Indian Interiors Laurie Baker

Laurie Baker est un architecte qui a consacré sa carrière à chercher des solutions aux habitations bon marché. Pendant près d'un demi-siècle, il a créé des bâtiments peu coûteux et rentables en évitant le ciment, l'acier et le verre, au profit d'autres matériaux disponibles sur place et de techniques indigènes. Au fil des ans, il a conçu des centaines de structures, des huttes de pêcheurs à des églises en passant par des léproseries et des studios de cinéma. Anglais de naissance, il a découvert l'Inde à la fin de la Seconde Guerre mondiale, puis y est revenu pour épouser un médecin indien et s'y installer définitivement. La maison des Baker à Trivandrum fut construite par étapes à partir d'une hutte en bambous et en chaume perchée sur un promontoire rocheux. Elle a ensuite pris de la hauteur, les murs de briques s'écartant en fonction des besoins changeant de la famille. Elle compte à présent de nombreuses chambres et des dépendances rassemblées autour d'une cour agrémentée d'un étang rempli de lotus et d'arbustes à fleurs.

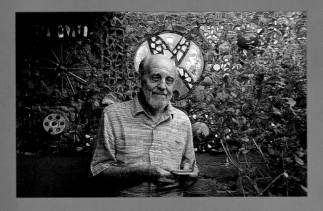

Laurie Baker

Architect Laurie Baker is a man who has dedicated his working life to finding solutions for low-cost housing. For nearly half a century he has created buildings that are cost- and energy-efficient and that avoid using cement, steel and glass in favour of locally available materials and indigenous construction techniques. Over the years he has designed hundreds of buildings, from fishermen's huts to churches and from leper homes to film studios. English by birth, Baker first passed through India at the end of World War II but soon returned to marry an Indian doctor and make India his home. The Baker house in Trivandrum was built in stages, starting with a bamboo-and-thatch one-room structure on a steep and rocky plot of wasteland. Set towards the top of the site the brick house grew according to the family's changing needs. It now includes a series of rooms and cottages overlooking a courtyard with a lotus pool and flowering shrubs.

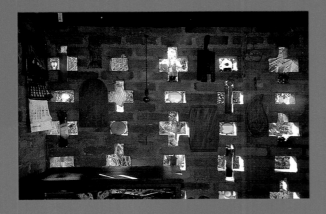

Der Architekt Laurie Baker ist ein Mann, der sein Leben der Suche nach Lösungen auf dem Gebiet des preisgünstigen Wohnungsbaus gewidmet hat. Fast ein halbes Jahrhundert lang hat er sowohl Kosten- als auch energiesparende Gebäude errichtet, bei denen er Materialien wie Zement, Stahl und Glas vermied, um statt dessen lokale Materialien und Bautechniken einzusetzen. Während dieser Zeit hat er Hunderte von Häusern entworfen, von Fischerhütten bis zu Kirchen und von Häusern für Leprakranke bis hin zu Filmstudios. Baker ist in England geboren und durchreiste Indien das erste Mal gegen Ende des Zweiten Weltkriegs. Er kehrte jedoch bald zurück, um eine indische Ärztin zu heiraten und machte Indien zu seinem Zuhause. Das Haus der Bakers in Trivandrum wurde in mehreren Stadien gebaut. Den Anfang bildete eine strohgedeckte Bambushütte, die aus einem Zimmer bestand und auf einem steil abfallenden, felsigen Stück Ödland gebaut wurde. Das darauf folgende Backsteinhaus wuchs entsprechend den sich verändernden Bedürfnissen der Familie und wurde zum Gipfel des Hügels hin ausgebaut. Heute besteht das Ganze aus einer Vielzahl von Räumen und einigen Cottages, die sich um einen Innenhof mit einem Lotosteich und blühenden Sträuchern gruppieren.

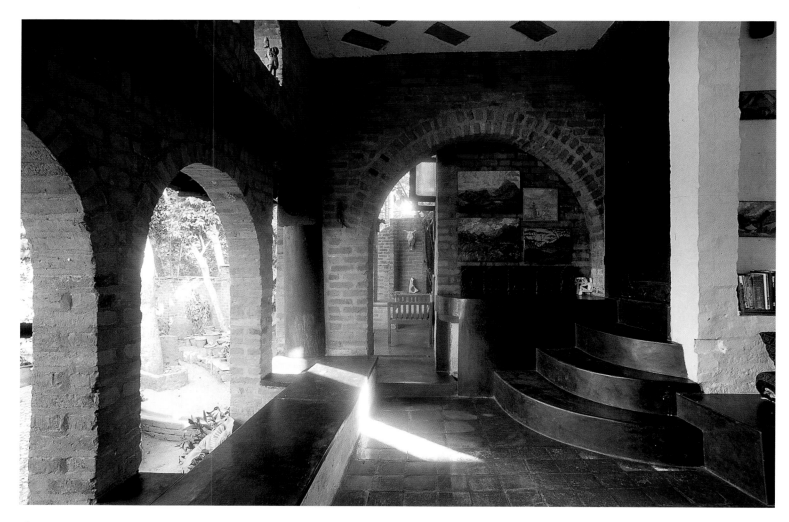

Above: An inner view of the arched verandah with its tiled floor and built-in seating where the Baker family spends part of the day.
Right: The entrance door to the house leads into a small porch decorated with a mosaic of broken plates and dishes.
Facing page: Over the informal living room is an old carved wooden roof rescued from a demolished traditional house. The brick-and-tile divan covers a storage tank for rainwater, made by waterproofing the inner face of the foundation walls.

Ci-dessus: la véranda où la famille Baker passe une bonne partie de la journée, avec son sol carrelé et ses banquettes intégrées.
A droite: La porte d'entrée s'ouvre sur un petit porche décoré d'une mosaïque en assiettes cassées.
Page de droite: Le salon est dominé par une charpente sculptée récupérée dans une maison traditionnelle en démolition. Le divan en brique et en carreaux cache une citerne d'eau de pluie, disponible grâce à l'isolation de la face interne des murs de fondation.

Oben: eine Innenansicht der mit Arkaden versehenen Veranda, deren Boden gefliest ist und die über eine eingebaute Bank verfügt, auf der die Bakers einen Teil des Tages verbringen.
Rechts: Die Eingangstür des Hauses führt in eine kleine Vorhalle, die mit einem Mosaik aus Geschirrscherben verziert ist.
Rechte Seite: Das zwanglose Wohnzimmer ist mit einem alten, aus Holz geschnitzten Dach versehen, das man aus einem abgerissenen, traditionellen Haus gerettet hat. Der Diwan aus Ziegelsteinen und Fliesen verdeckt einen Regenwassertank, dessen Bau möglich wurde, indem man die Innenseite der Grundmauern wasserdicht machte.

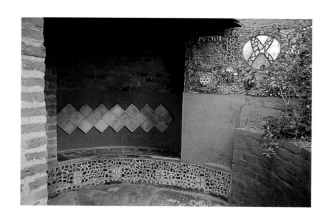

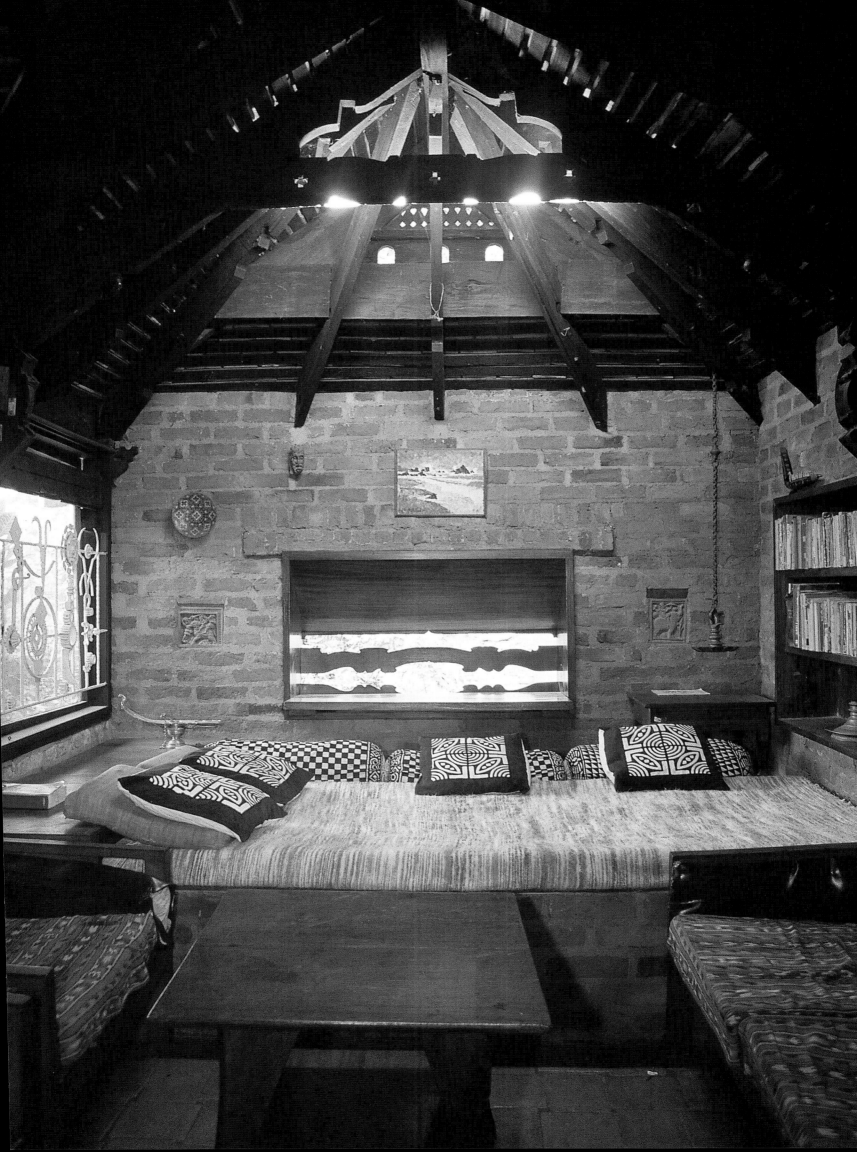

Tamil Nadu and Orissa

Des fouilles près de Pondicherry, à cent cinquante kilomètres environ au sud de Madras, sur la côte de Coromandel, ont révélé l'existence d'un ancien port qui commerçait déjà avec l'empire romain. En 1672, les Français rachetèrent la ville à un roi indien mais le comptoir français se développa de manières inattendue. Sri Aurobindo, un érudit et mystique, y fonda un ashram en 1926. Sa compagne spirituelle, Mira Alfassa, d'origine française, appelée la «Mère», lui succéda et poursuivit son enseignement. Elle fonda Auroville à la fin des années soixante, une série de communautés autonomes, toutes situées dans des villages suffisamment proches de Pondicherry pour pouvoir s'y rendre en bicyclette. L'idéal New Age d'Auroville attira une population bigarrée d'Indiens et d'occidentaux, dont l'architecte français Roger Anger. Cette synthèse entre nature et modernité est parfaitement illustrée par la demeure du Français Jean Legrand et de son épouse Joy.

Auroville

Excavations near Pondicherry, a hundred miles south of Madras on the Coromandel coast, point to the existence of an ancient port that traded with the Roman empire. In 1672 the French bought the town from an Indian king. But Pondicherry's French connection grew in unexpected ways. Sri Aurobindo, an Indian scholar and mystic, set up an ashram here in 1926. His spiritual companion and successor, the French-born Mira Alfassa, known as "The Mother" carried on his teachings. She established Auroville in the late Sixties – a series of self-supporting communities in villages within cycling distance of Pondicherry. Auroville's New Age ideal drew a motley group of Indians and Westerners, including French architect Roger Anger. One example of the synthesis between the natural and modern is the home, on the facing page, of Frenchman Jean Legrand and his wife Joy.

In der Nähe von Pondicherry an der Koromandelküste, 150 Kilometer südlich von Madras, haben Ausgrabungen den Hinweis darauf gegeben, daß es hier in der Antike einen Hafen gab, der mit dem römischen Imperium Handel trieb. Die Franzosen hatten die Stadt 1672 von einem indischen König gekauft. Aber Pondicherrys Verbindungen mit Frankreich sollten sich auf eine ungewöhnliche Weise noch verstärken. Sri Aurobindo, ein indischer Gelehrter und Mystiker, gründete 1926 hier einen Ashram. Seine geistige Begleiterin und Nachfolgerin, die in Frankreich geborene Mira Alfassa, die man »die Mutter« nannte, führte seine Lehren fort. Sie gründete Ende der sechziger Jahre Auroville – eine Reihe von gänzlich sich selbst versorgenden Gemeinschaften in einigen Dörfern nicht weit von Pondicherry. Das New-Age-Ideal von Auroville zog eine bunte Gruppe von Indern und Menschen aus dem Westen an, zu der auch der französische Architekt Roger Anger gehörte. Ein Beispiel für die Synthese von Natur und Moderne ist das Haus des Franzosen Jean Legrand und seiner Frau Joy auf dieser und den nächsten Seiten.

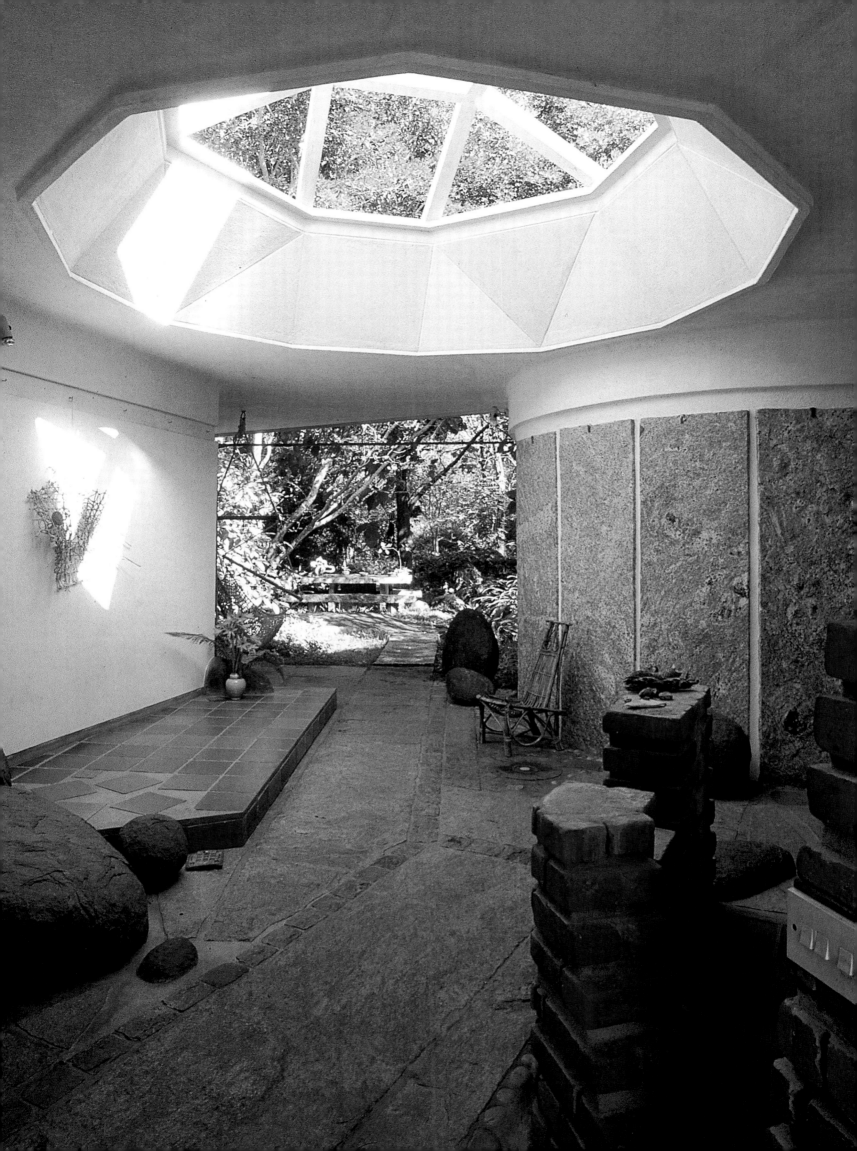

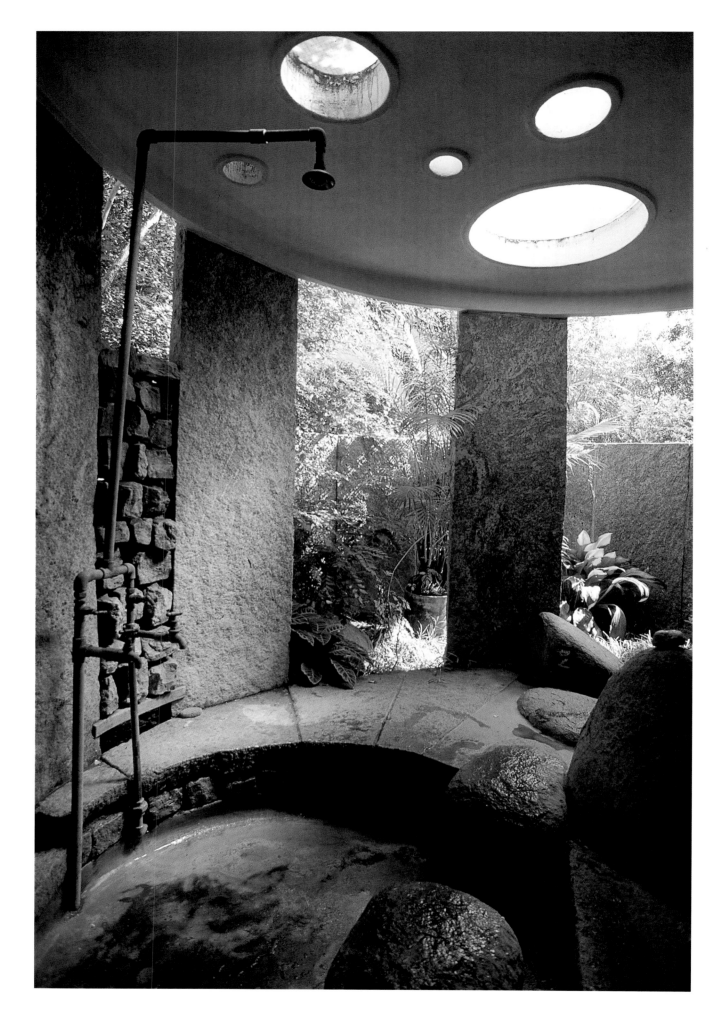

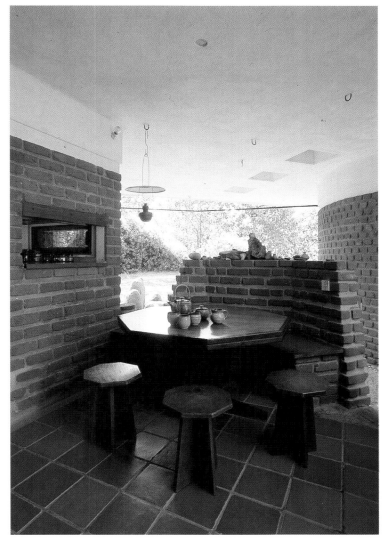

Facing page: Natural rock shapes, vertical slabs of granite and a roof with circular holes create a partially open-air grotto in the bathing area of the Legrand house.
Above: The angular and circular shapes of the kitchen and dining area of the Legrand home in Auroville are carefully designed to modulate light and create open-to-sky spaces.

Page de gauche: Dans la salle de bains des Legrand, des roches brutes, des dalles de granit verticales et un toit percé d'ouvertures rondes créent une sorte de grotte ouverte sur les éléments.
Ci-dessus: Les formes angulaires et circulaires de la cuisine et du salon des Legrand à Auroville ont été soigneusement étudiées pour moduler la lumière et créer des espaces à ciel ouvert.

Linke Seite: Durch Felsgestein, lange, rechteckige Granitplatten und ein Dach mit kreisrunden Löchern wird aus dem Badezimmer der Legrands eine halb im Freien liegende Grotte.
Oben: Die rechteckigen und runden Formen in der Küche und im Eß-zimmer der Legrands wurden so entworfen, daß sie das Licht modulieren und Räume entstehen, die so hell sind, als lägen sie unter freiem Himmel.

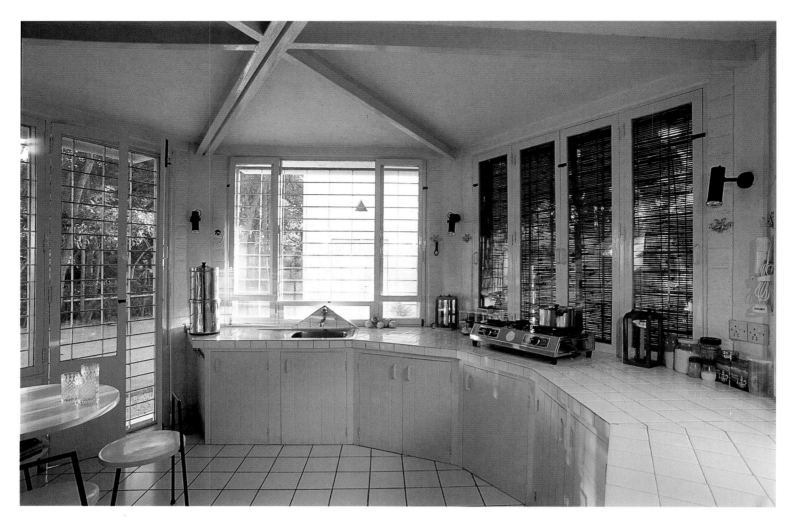

Above: The white-tiled kitchen in the home of designer William Netter, an American spiritualist and follower of Sri Aurobindo, reflects the austere modernism he practises.
Facing page: In minimalist fashion Netter describes the various areas of his house as "A place to pray", "A place to create" and "A place to communicate". The pyramid structure with a spiral staircase on the roof is "A place to look to the future". A votive candle burns between photographs of the Mother and Sri Aurobindo.

Ci-dessus: La cuisine en carrelage blanc du styliste américain William Netter, un spiritualiste et adepte de Sri Aurobino, reflète le modernisme austère qu'il pratique.
Page de droite: A sa façon toute minimaliste, Netter décrit les différentes parties de sa maison comme «un lieu où l'on prie», «un lieu où l'on crée» ou «un lieu où l'on communique». La structure pyramidale sur le toit avec, en son centre, un escalier en colimaçon, est «un lieu où l'on regarde vers le futur». Une chandelle votive brûle entre les photographies de Mère et de Sri Aurobindo.

Oben: Die weißgekachelte Küche in dem Haus des Designers William Netter, eines amerikanischen Spiritualisten und Anhängers von Sri Aurobindo, spiegelt den strengen Modernismus wider, dem er sich verschrieben hat.
Rechte Seite: In minimalistischer Manier beschreibt Netter die verschiedenen Teile seines Hauses als »Ort des Betens«, »Ort der Kreativität« und »Ort des Gesprächs«. Die pyramidenförmige Struktur auf dem Dach, die über eine Wendeltreppe zugänglich ist, wird als »Ort, um in die Zukunft zu schauen« bezeichnet. Zwischen den Fotografien von Sri Aurobindo und der »Mutter« steht eine Gebetskerze.

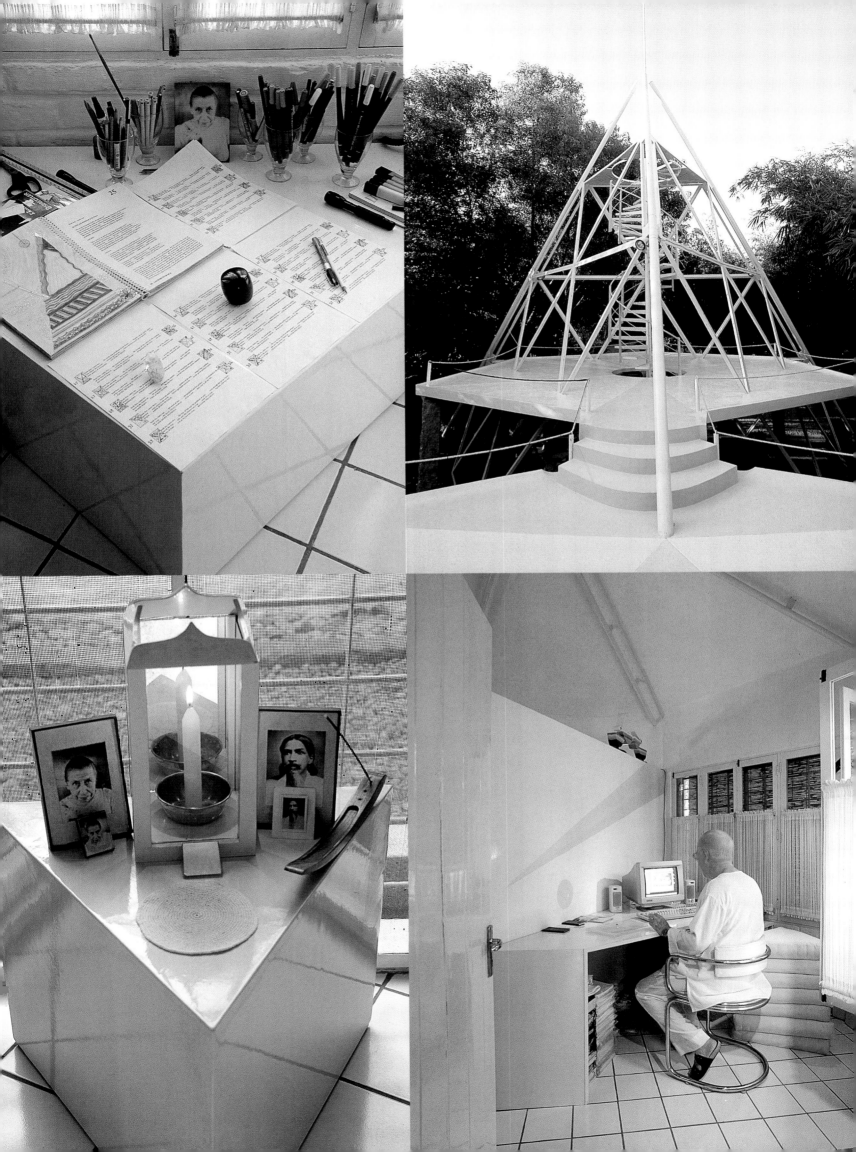

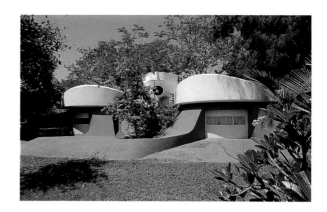

Right: French architect Roger Anger designed the home of Christine Devin and her husband in 1976 as a complex of circular-roofed toad-stool shapes.
Below: A ventilation panel, with moveable slats to adjust light and airflow runs around the circular bedroom of the Devin home. The only adornment on the walls is a portrait of the Mother above a camphorwood chest.

A droite: L'architecte français Roger Anger a conçu la maison de Christine Devin et son époux en 1976 comme un ensemble complexe de champignons aux toits ronds.
Ci-dessous: Un panneau d'aération, avec des lattes amovibles pour régler la lumière et la ventilation, court tout autour de la chambre ronde des Devin. Le seul ornement de la pièce est le portrait de Mère au-dessus d'un coffre en camphrier.

Rechts: Der französische Architekt Roger Anger entwarf 1976 das Haus von Christine Devin und ihrem Mann als eine Ansammlung von pilzähnlichen Formen mit kreisrunden Dächern.
Unten: Ein Ventilationseinsatz in der Wand, mit beweglichen Lamellen, durch die man den Lichteinfall und die Luftzufuhr regulieren kann, umläuft das kreisförmige Schlafzimmer im Haus der Devins. Der einzige Wandschmuck ist ein Porträt der »Mutter« über einer Kommode aus Kampferholz.

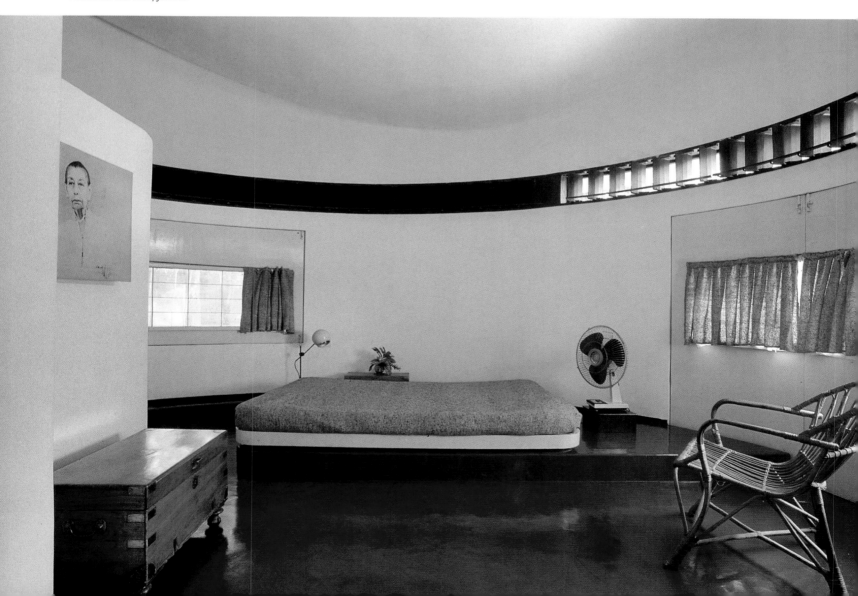

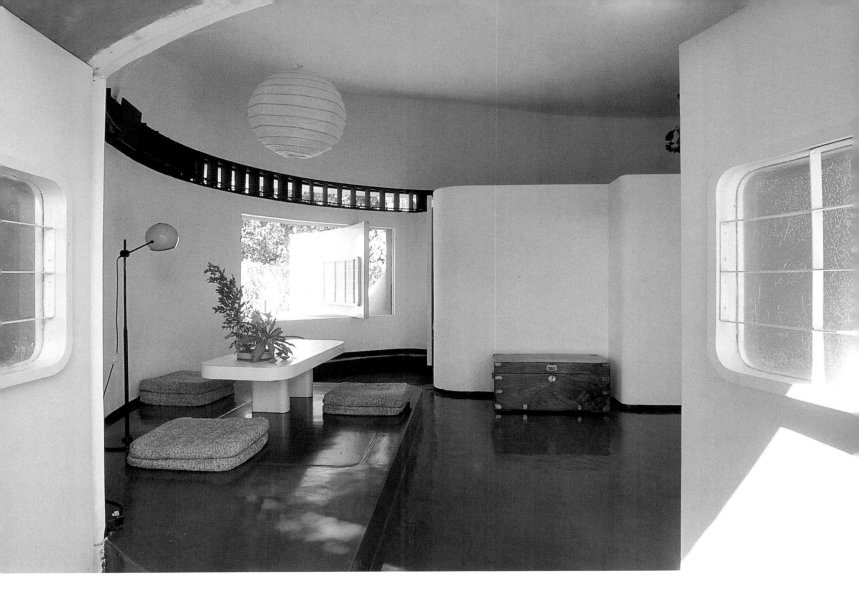

Above: A paper lantern made in Auroville and a standing lamp with a spherical shade echo the curved walls of the sitting room. A low table and floor cushions on an elevated area complete the dining arrangements.
Right: An angled wall with look-outs of modernist design partially screens the exterior of the Devin home.

Ci-dessus: une lanterne en papier, réalisée à Auroville, et un lampadaire surmonté d'un abat-jour sphérique reprennent les formes moulées de la pièce. Une table basse et des coussins sur une estrade forment un coin salle à manger.
A droite: Un mur aux lignes courbes et percé de grandes meurtrières modernistes ceint partiellement la maison des Devin.

Oben: Eine in Auroville hergestellte Papierlaterne und eine Stehlampe mit einem kugelförmigen Schirm korrespondieren mit den geschwungenen Wohnzimmerwänden. Ein niedriger Tisch und Sitzkissen auf dem Boden einer erhöhten Plattform vervollständigen die Einrichtung des Raumes.
Rechts: Eine eckige Mauer mit Durchbrüchen, deren Formen einem modernistischen Design entsprechen, verdeckt zum Teil das Haus der Devins.

Luz House – «La maison de lumière» – se trouve dans la banlieue de Mylapore à Madras. Elle fut construite il y a 150 ans par une famille de connaisseurs et de grands sportifs, dont l'un transforma le jardin en terrain d'entraînement pour les jeunes joueurs de cricket indiens. Lorsque que Jean-François Lesage, de la célèbre maison française de broderie, et Patrick Savouret, restaurateur parisien, arrivèrent à Madras en 1993 pour y développer leur entreprise de textile, ils trouvèrent Luz House en piteux état. Comme de nombreux bungalows situés en ville, elle était condamnée à être démolie et remplacée par un immeuble d'appartements. Emu par l'enthousiasme contagieux des deux jeunes Français déterminés à la restaurer, le propriétaire accepta de la leur louer. Aujourd'hui, le jardin a retrouvé une nouvelle jeunesse et les intérieurs, protégés par des volets à lattes, sont égayés par des détails ludiques tels que la balustrade en trompe-l'œil et les insectes peints dans la cage d'escalier.

Jean-François Lesage

Luz House, "House of Light", has stood in the Madras suburb of Mylapore for 150 years. It was built by a family of connoisseurs and ardent sportsmen, one of whom laid cricket pitches in the garden and turned it into a sports centre for training young Indian cricketers. But when Jean-François Lesage, of the famous French embroidery firm, and Paris restaurateur Patrick Savouret, arrived in Madras in 1993 to expand their textile business and went house-hunting, they found Luz House in a sorry state. Like many bungalows in Indian cities, it was awaiting demolition to be replaced by an apartment block. But touched by the infectious enthusiasm of the two young Frenchmen to restore the property, its owner decided to rent it to them. The garden of Luz House now lives again, and its interiors, screened by slatted windows, are enlivened by playful touches like the "trompe l'œil" balustrade and painted insects on the staircase wall.

Das Luz-Haus – das »Haus des Lichts« – steht bereits seit 150 Jahren in Mylapore, einem Vorort von Madras. Es wurde von einer Familie von Connaisseurs und begeisterten Sportlern gebaut, von denen einer im Garten ein Kricketfeld anlegte und daraus ein Sportzentrum machte, in dem er junge indische Kricketspieler trainierte. Doch als Jean-François Lesage, von der gleichnamigen berühmten französischen Kunststickerei, und der Pariser Restaurator Patrick Savouret 1993 in Madras ankamen, um ihr Textilunternehmen zu erweitern, und auf der Suche nach einer Wohnung waren, entdeckten sie das Luz-Haus in einem erbärmlichen Zustand. Ähnlich wie bei vielen Villen in indischen Städten war auch bei diesem Haus der Abriß geplant, um Platz für einen Wohnblock zu schaffen. Doch der Eigentümer, der sich von dem Enthusiasmus der beiden jungen Franzosen, die den Besitz restaurieren wollten, anstecken ließ, entschloß sich, ihnen das Haus zu vermieten. Der Garten des Luz-Hauses hat heute wieder zu neuem Leben gefunden, und sein Inneres, das durch die Fensterläden abgeschirmt ist, gewinnt durch spielerische Elemente an Charakter – wie zum Beispiel durch das Trompe-l'œil-Geländer und die gemalten Insekten an der Wand des Treppenhauses.

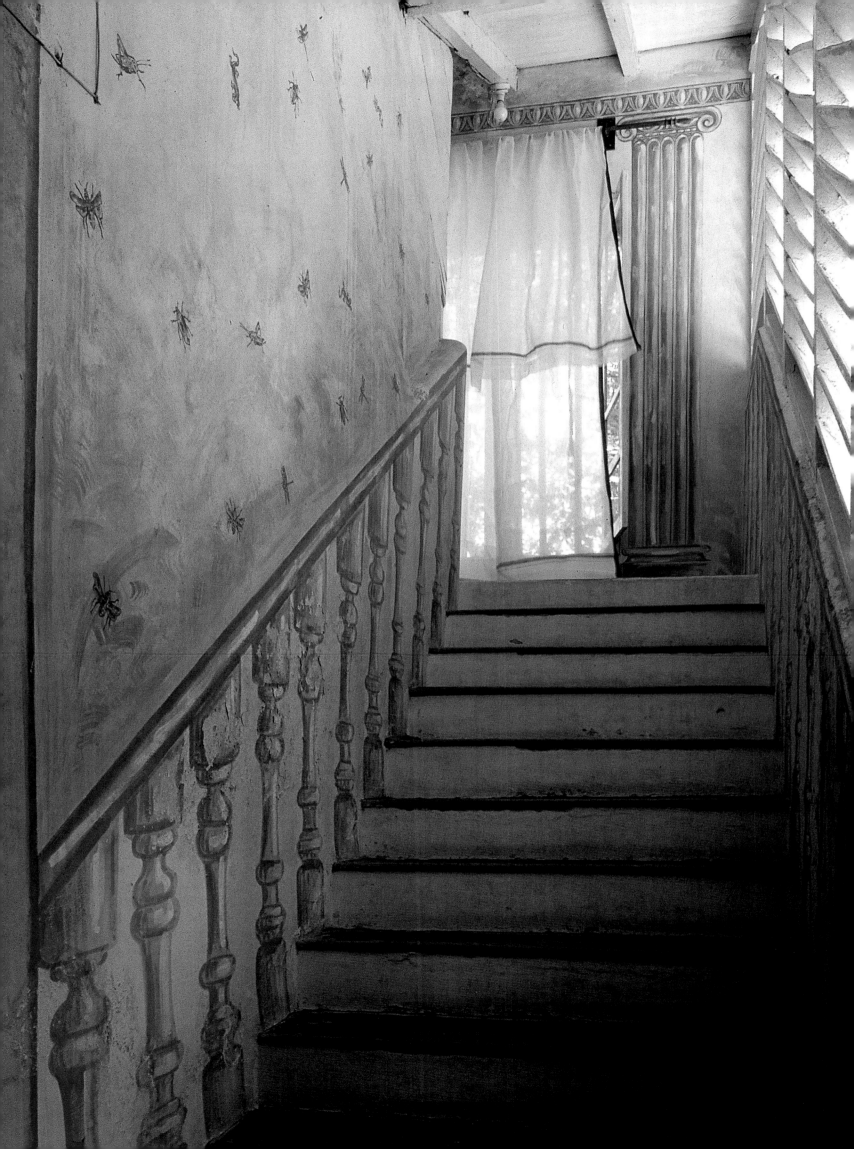

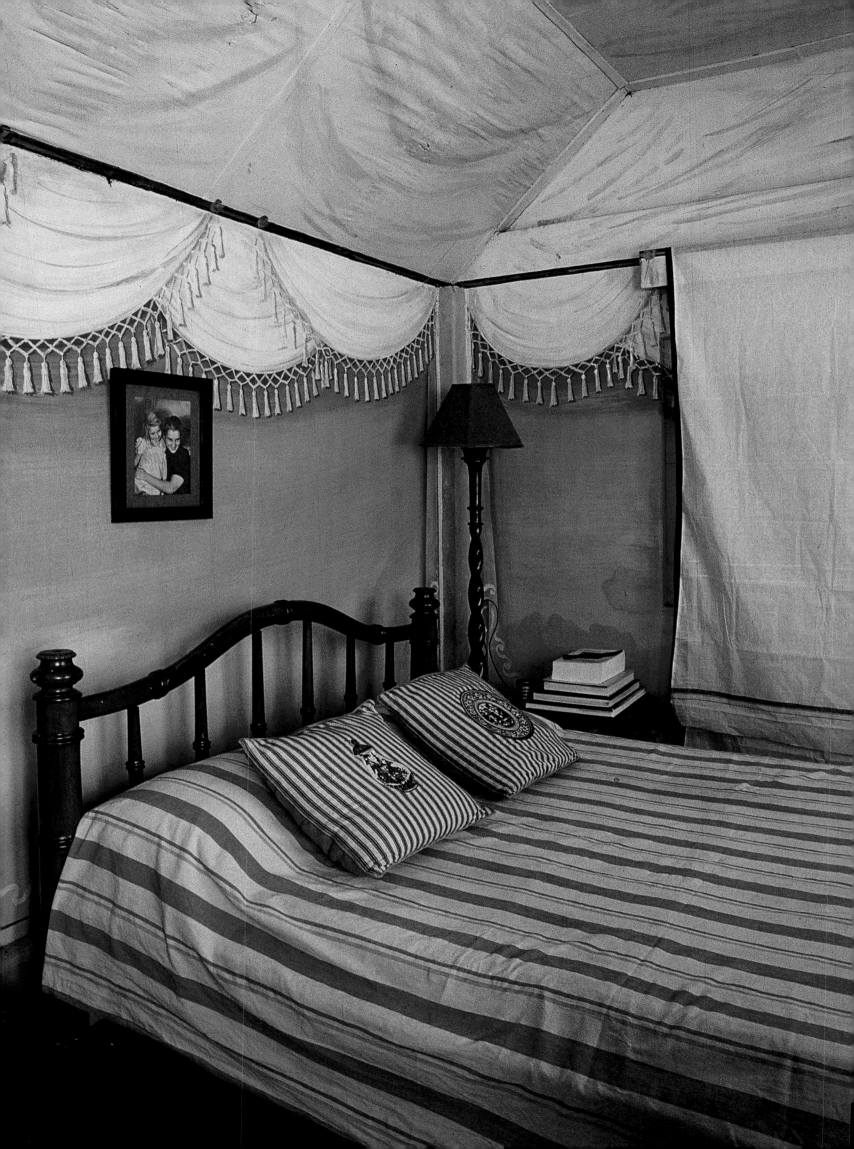

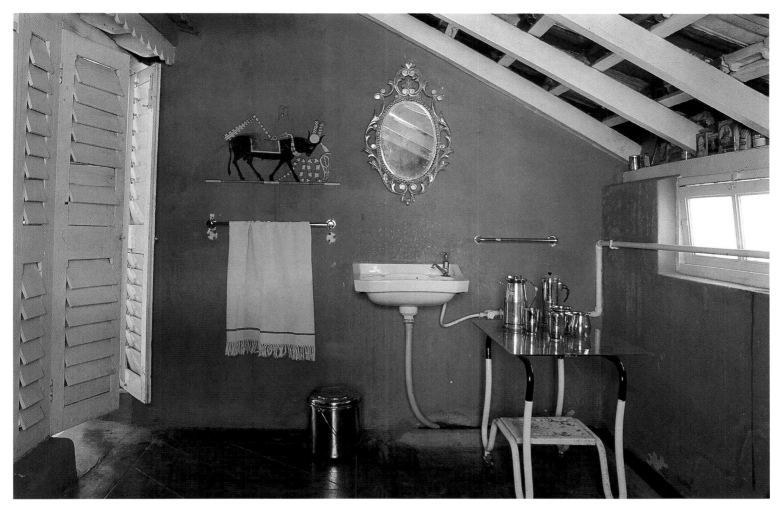

Facing page: A "trompe l'œil" of tasselled swags of white fabric cre-
ate a tented canopy for the old bed in the bedroom. The embroidered
cushions are by Lesage.
Above: The blue wall of the bathroom under the rafters is decorated
with a gold-framed mirror and a hand-painted fresco of an Egyptian
bull.
Right: A period French portrait in its gilt frame hangs above a private
altar in the bedroom. Plumbing pipes are used as towels rail in the
bathroom.
Following pages: An octagonal corridor, faced with slatted windows
runs around the living area. Doors with panes of coloured and etched
glass lead into the room.

Page de gauche: Un trompe-l'œil de pans d'étoffes bordés de glands
de passementerie crée un effet de tente au-dessus du lit ancien. Les
coussins brodés sont de Lesage.
Ci-dessus: La salle de bains mansardée est ornée d'un miroir doré et
d'un taureau égyptien peint à même le mur bleu.
A droite: dans la chambre, un portrait, œuvre d'un peintre français,
accroché dans un cadre doré au-dessus d'un petit autel. Dans la salle
de bain, la tuyauterie sert de porte-serviettes.
Double page suivante: Un couloir octogonal, bordé de volets à lattes,
entoure le salon. Les portes de celui-ci sont ornées de panneaux en
verre coloré et gravé.

Linke Seite: Ein Trompe-l'œil aus mit Fransen verzierten weißen Stof-
fen erweckt den Eindruck, als befände sich über dem alten Bett im
Schlafzimmer ein zeltähnlicher Baldachin. Die mit Stickereien ver-
zierten Kissen stammen von Lesage.
Oben: Die blaue Wand des unter dem Dach gelegenen Badezimmers
ist mit einem in Goldrahmen gefaßten Spiegel und einem von Hand
gemalten Fresko eines ägyptischen Stiers dekoriert.

Unten: Ein historisches französisches Porträt in einem goldenen Rah-
men hängt über einem Privataltar im Schlafzimmer. Die Wasserlei-
tungen im Bad werden als Handtuchhalter benutzt.
Folgende Doppelseite: Ein Gang, dessen Fenster durch Läden ver-
schlossen sind, umschließt das achteckige Wohnzimmer. Den Raum
betritt man durch Türen, deren Felder aus buntem und geschliffenem
Glas bestehen.

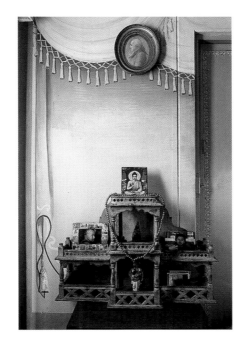

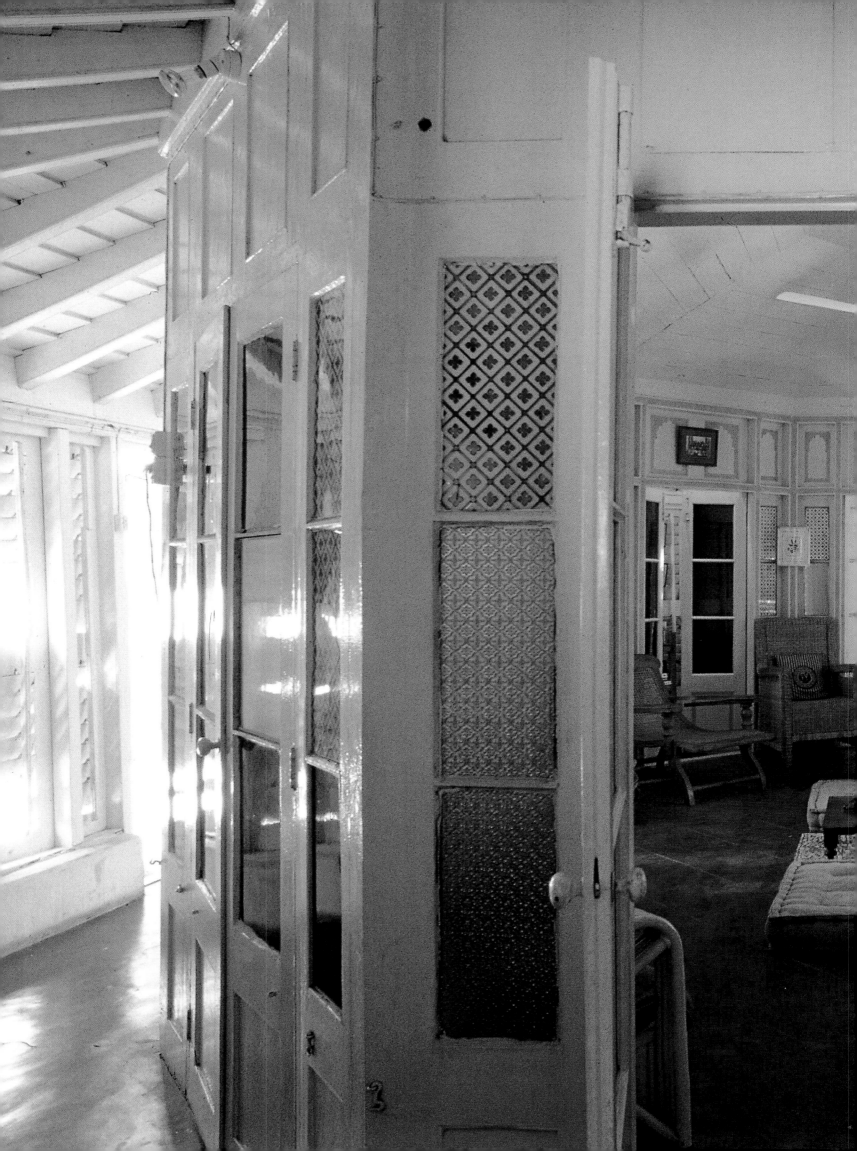

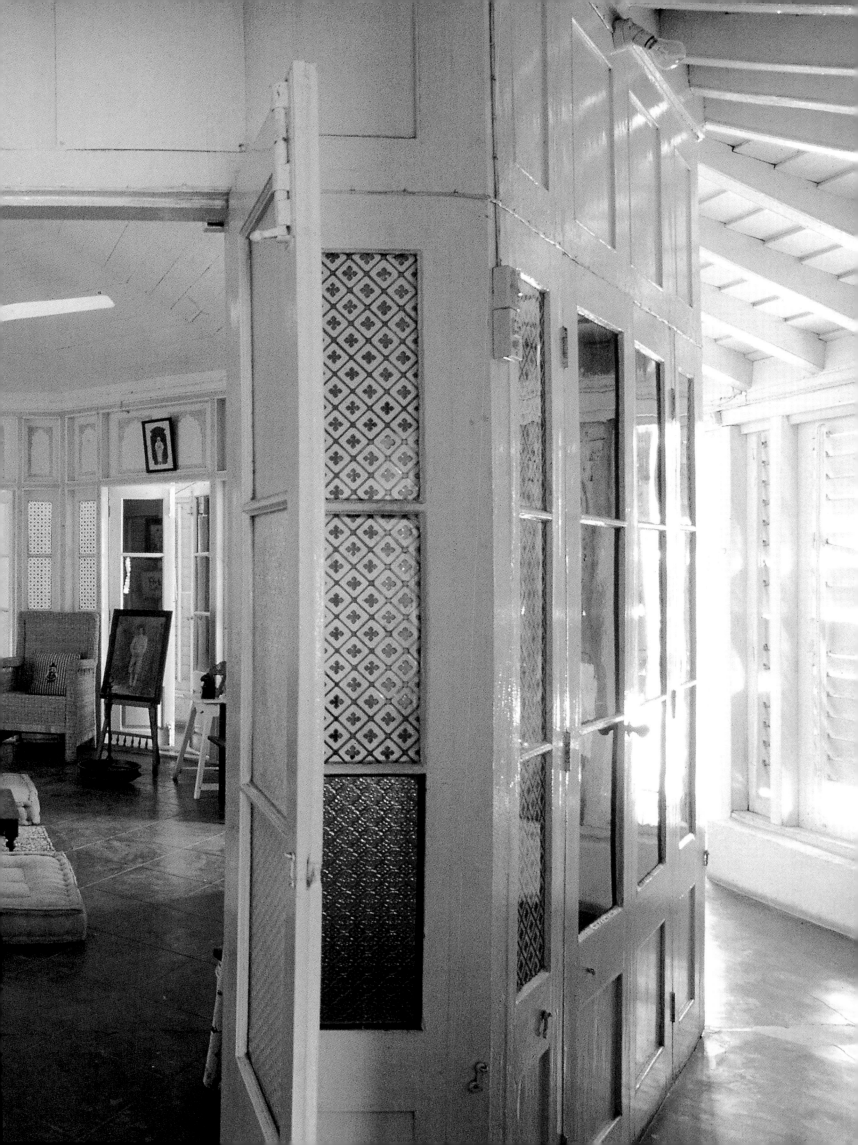

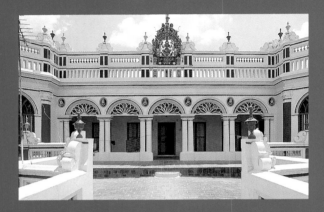

Chettinad est située à l'intérieur des terres de Tamil Nadu. C'est une région chaude, aride et plate qui accueille l'une des communautés marchandes les plus dynamiques de l'Inde du sud, les Chettiars, dont le goût pour la finance et le commerce en ont fait des magnats de l'Asie du Sud-Est. Pendant une grande partie du 19e siècle et le début du 20e, les Chettiars ont contrôlé l'économie de la Birmanie, de la Malaisie et de certaines parties de la Thaïlande et du Viêtnam. Chez eux à Chettinad, ils ont construit de grandes demeures, dont l'architecture, comme leur cuisine, était dominée par les influences étrangères. Annamalai Chettiar fut l'un des marchands les plus riches et les plus puissants, un philanthrope et ardent défenseur de l'enseignement public. Il fit construire ce palais à colonnades près de la ville de Karaikudi en 1912. Son petit-fils, le docteur M. A. M. Ramaswamy, est un magnat d'un autre type. Il est connu en Inde comme le «baron turfiste» pour son écurie de champions.

Chettinad Palace

Chettinad is an inland part of Tamil Nadu, a hot, dry and flat region. It is home to one of the most dynamic merchant communities of south India, the Chettiars, whose penchant for banking and commerce established their supremacy as the titans of trade in southeast Asia. For much of the 19th century and some of the 20th, the Chettiars came to control the economices of Burma, Malaysia and parts of Thailand and Vietnam. Back home in Chettinad they built mansions on a lavish scale, their architecture, like their cuisine, influenced by foreign tastes. Premier among the Chettiar merchant barons was Annamalai Chettiar, philanthrophist and educationist, who built this pillared palace near the town of Karaikudi in 1912. But his grandson, Dr M. A. M. Ramaswamy, who keeps the family home in style, is another kind of baron. Famous for his stables of winning racehorses, he is known as India's "racing baron".

Chettinad ist ein im Landesinnern gelegener Teil von Tamil Nadu – eine heiße, trockene und flache Region. Die Gegend ist die Heimat einer der erfolgreichsten kaufmännischen Gemeinschaften Südindiens, der Chettiars, deren Vorliebe für Bank- und Handelsgeschäfte ihre titanenhafte Überlegenheit im Handel Südostasiens begründete. Während eines Großteils des 19. Jahrhunderts und noch im 20. Jahrhundert kontrollierten die Chettiars die Wirtschaft in Birma, Malaysia und Teilen von Thailand und Vietnam. Zu Hause, in Chettinad, bauten sie prunkvolle Paläste, deren Architektur ähnlich wie ihre Küche von einem fremdländischen Geschmack geprägt war. Der wichtigste der Chettiar-Handelsbarone war Annamalai Chettiar, ein Philanthrop und Pädagoge, der sich 1912 in der Nähe der Stadt Karaikudi diesen mit vielen Säulen versehenen Palast baute. Sein Enkel jedoch, Dr. M. A. M. Ramaswamy, der den Familienbesitz in einem vortrefflichen Zustand erhält, ist eine ganz andere Art von Baron: Er wurde als Indiens »Rennbahn-Baron« berühmt, denn er unterhält einen Stall mit erfolgreichen Rennpferden.

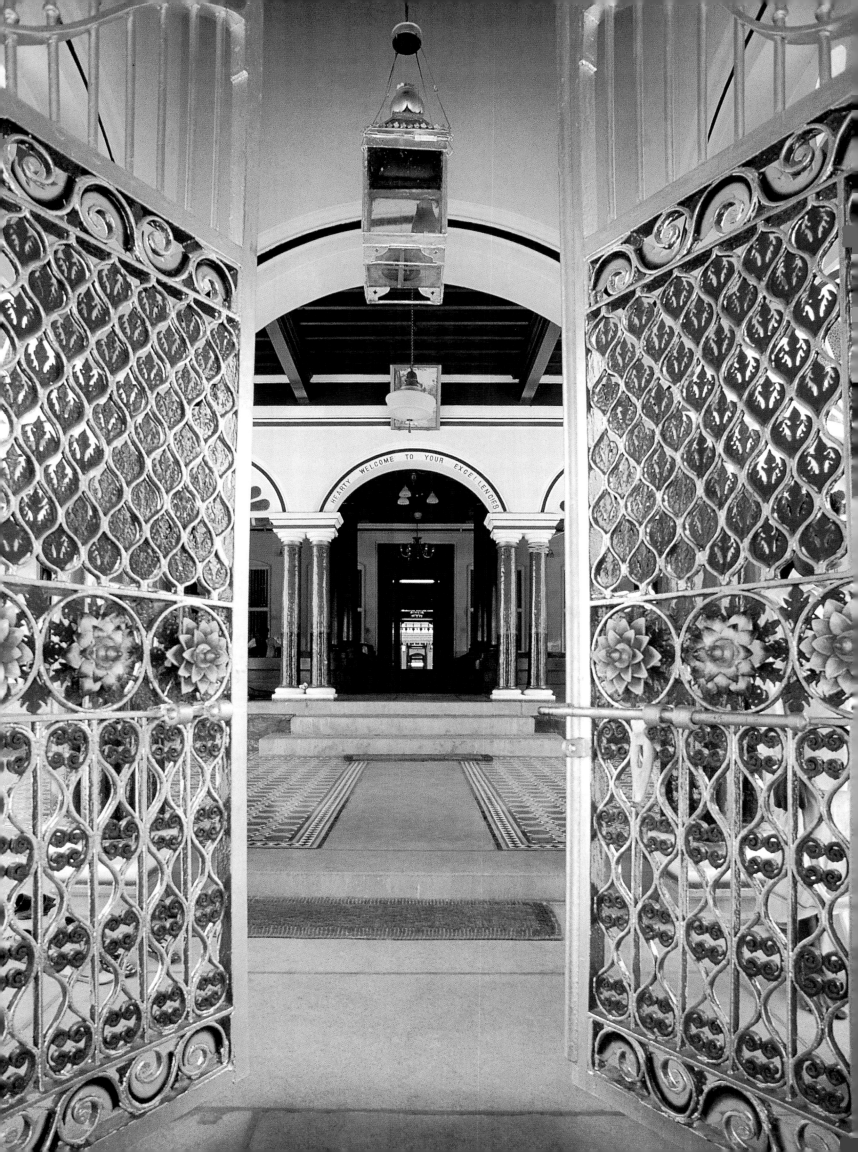

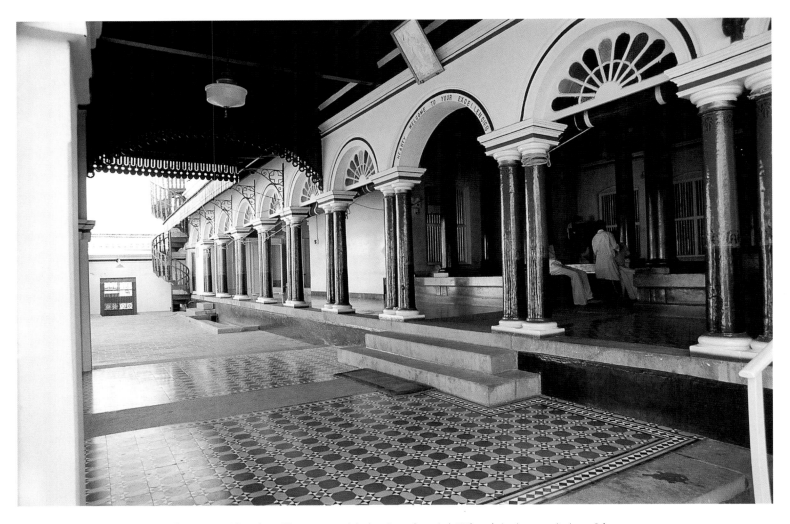

Previous page: Gigantic silver-painted iron gates with embossed lotuses open onto tiled passages leading to the pillared entrance of Chettinad Palace.
Above and right: Built on a linear grid, most Chettinad mansions consist of public rooms set between pillared courtyards. While an inner row of round pillars with stencilled decorations support the verandah, an outer row of elegantly painted stone pillars holds up the courtyard's roof of carved Burma teak.
Facing page: A wide passage with painted pillars is used to seat visitors during the wedding celebrations that are a hallmark of Chettiar family life.

Page précédente: Un gigantesque portail argenté orné de lotus en métal repoussé s'ouvre sur une galerie carrelée qui mène au porche à colonnes du palais.
Ci-dessus et à droite: Construites selon un plan linéaire, la plupart des grandes demeures de Chettinad présentent une alternance de pièces de réception et de cours bordées de colonnades. La rangée intérieure de colonnes rondes, décorées au pochoir, abrite la véranda tandis que la rangée extérieure, élégamment peinte, soutient un avanttoit en teck birman sculpté.
Page de droite: C'est dans cette grande galerie bordée de colonnes peintes que sont assis les invités lors des somptueuses cérémonies de mariage qui ont fait la renommée des Chettiars.

Vorhergehende Seite: Durch riesige, mit Silberfarbe gestrichene und mit einem Lotosmuster verzierte Eisentore gelangt man in einen offenen, gefliesten Gang, der zu der Säulenhalle im Eingangsbereich des Chettinad Palace führt.
Oben und rechts: Die meisten großen Villen und Paläste in Chettinad wurden auf einem rechtwinkligen Raster gebaut, und ihre repräsentativen Räume liegen jeweils um mehrere Innenhöfe gruppiert, die

von Arkaden eingerahmt sind. Während eine innere, mit einem Schablonenmuster dekorierte Reihe von Säulen die Veranda stützt, ruht das aus birmanischem Teakholz geschnitzte Dach des Innenhofes auf einer äußeren Reihe von geschmackvoll angestrichenen Steinsäulen.
Rechte Seite: Ein breiter Gang, dessen Säulen mit Malereien verziert sind, wird als Sitzbereich für die Gäste der riesigen Hochzeitsfeiern genutzt, die im Familienleben der Chettiars eine glanzvolle Rolle spielen.

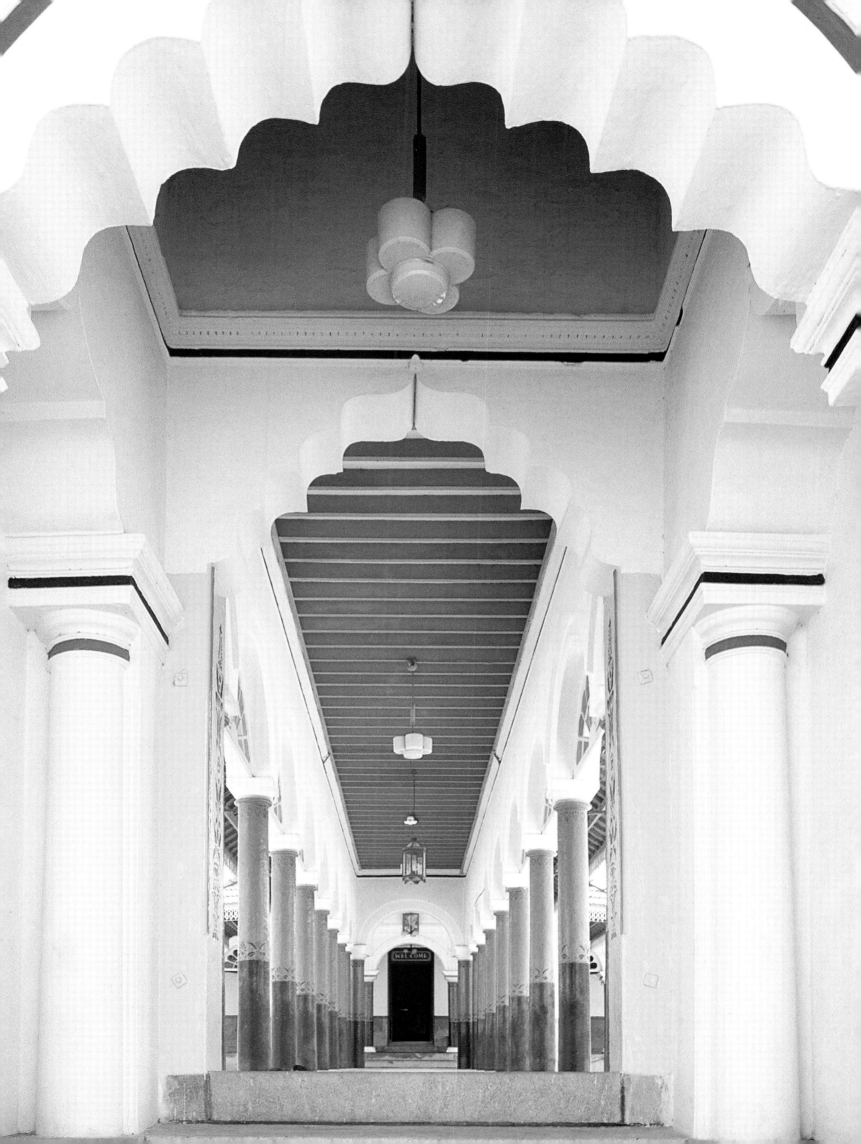

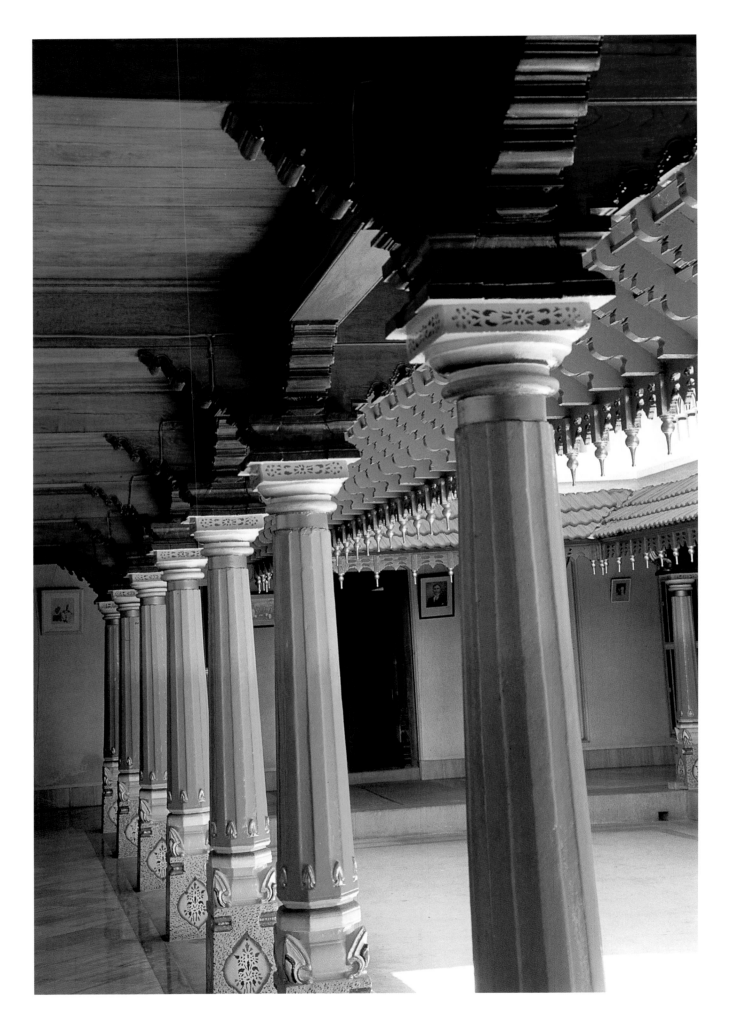

Indian Interiors Chettinad Palace

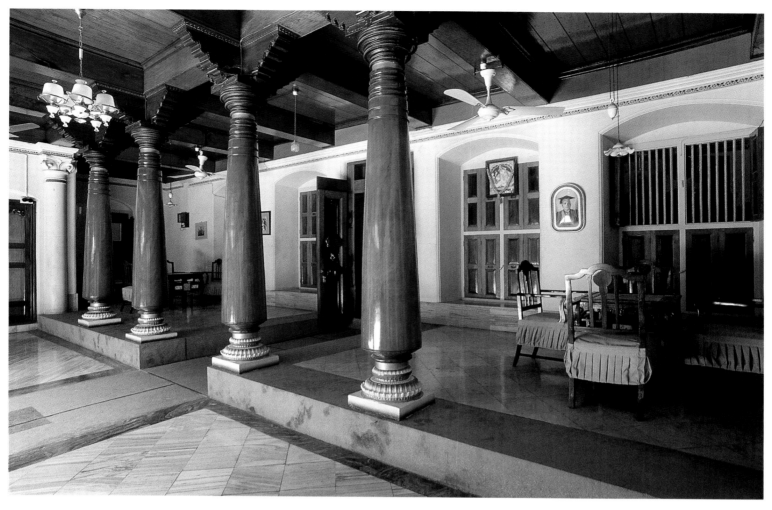

Facing page: The tiled eaves of the courtyard are supported by carved and painted wooden brackets. Delicately carved and painted stone pillars support the roof.

Above: The first pillared hall in a Chettinad mansion is usually reserved for the men of the house to receive visitors and conduct business. In this case, each pillar is fashioned from an entire tree trunk of polished Burma teak.

Right: The vast and sooty kitchen interior with its row of fireplaces is used to cook ceremonial feasts on wood fires.

Following pages: Garlanded portraits of the family's forbears dominate the magnificent reception room, with its marble floors, stained glass windows, painted cornice and ceiling of glazed tiles.

Page de gauche: Les avant-toits couverts de tuiles reposent sur des travées en bois peintes et sculptées. De délicates colonnes peintes et sculptées soutiennent le toit.

Ci-dessus: Dans les grandes demeures de Chettinad, la première cour à colonnade est généralement réservée aux hommes de la maison. Ils y reçoivent leurs invités et y conduisent leurs affaires. Ici, chaque colonne a été taillée dans un seul tronc de teck birman.

A droite: La vaste cuisine couverte de suie comporte une rangée de cheminées où l'on cuit les plats au feu de bois lors des grands festins.

Double page suivante: Les portraits d'ancêtres ornés de guirlandes dominent la magnifique salle de réception du palais, avec son sol en marbre, ses vitraux, sa corniche peinte et son plafond en tuiles de céramique vernissée.

Linke Seite: Die Dachvorsprünge des Innenhofs werden von kunstvoll geschnitzten und bemalten Holzkonsolen getragen, das Dach wird von fein gemeißelten und mit Malereien verzierten Steinsäulen gestützt.

Oben: Die erste mit Säulen verzierte Halle in einem Chettinad-Haus bleibt gewöhnlich den Männern des Hauses vorbehalten, die hier ihre Besucher empfangen und ihre Geschäfte abwickeln. In dieser Halle wurde jede einzelne Säule aus einem ganzen Baumstamm von birmanischem, polierten Teakholz geschnitzt.

Unten: Auf diesen Feuerstellen in dem riesigen, mit einer Rußschicht überzogenen Küchenraum werden zeremonielle Mahlzeiten zubereitet.

Folgende Doppelseite: Die mit Girlanden behängten Porträts von Vorfahren der Familie beherrschen den prachtvollen Empfangssalon des Chettinad Palace, mit seinem Marmorboden, den Buntglasfenstern, dem gemalten Gesims und den glasierten Deckenkacheln.

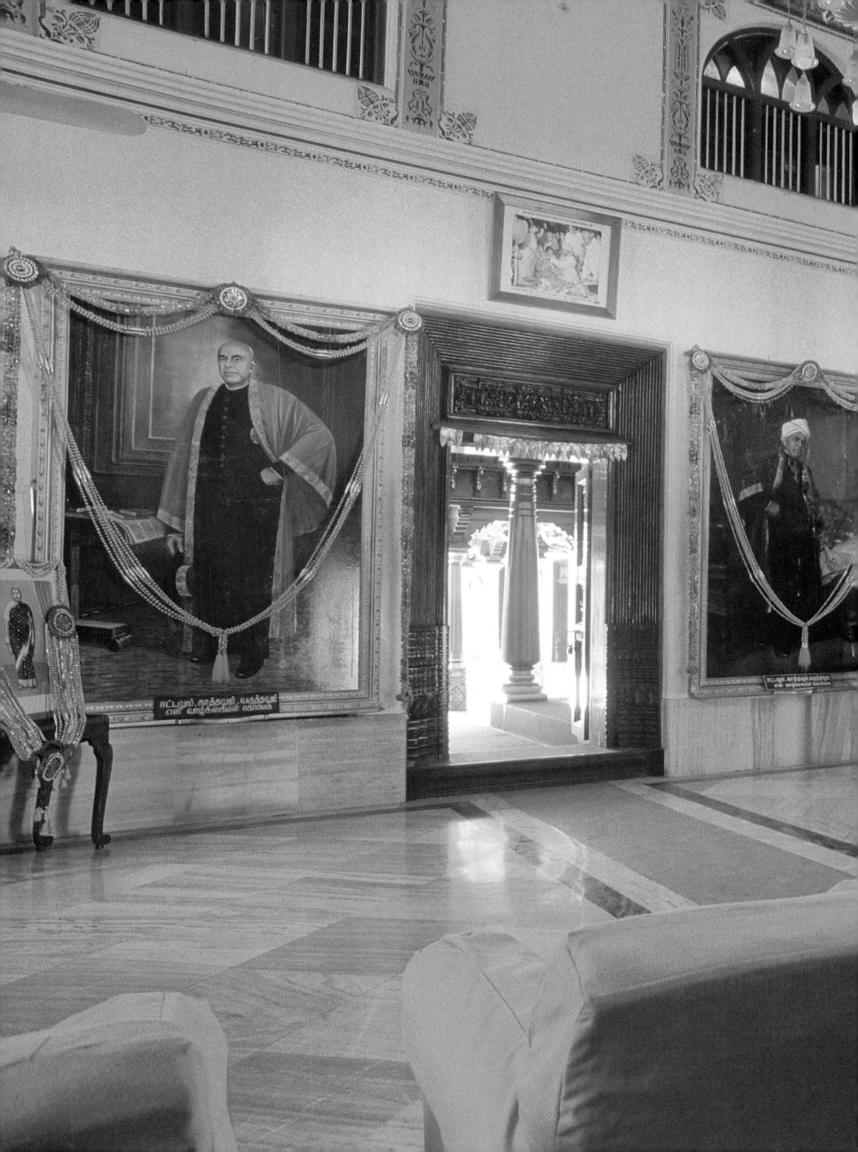

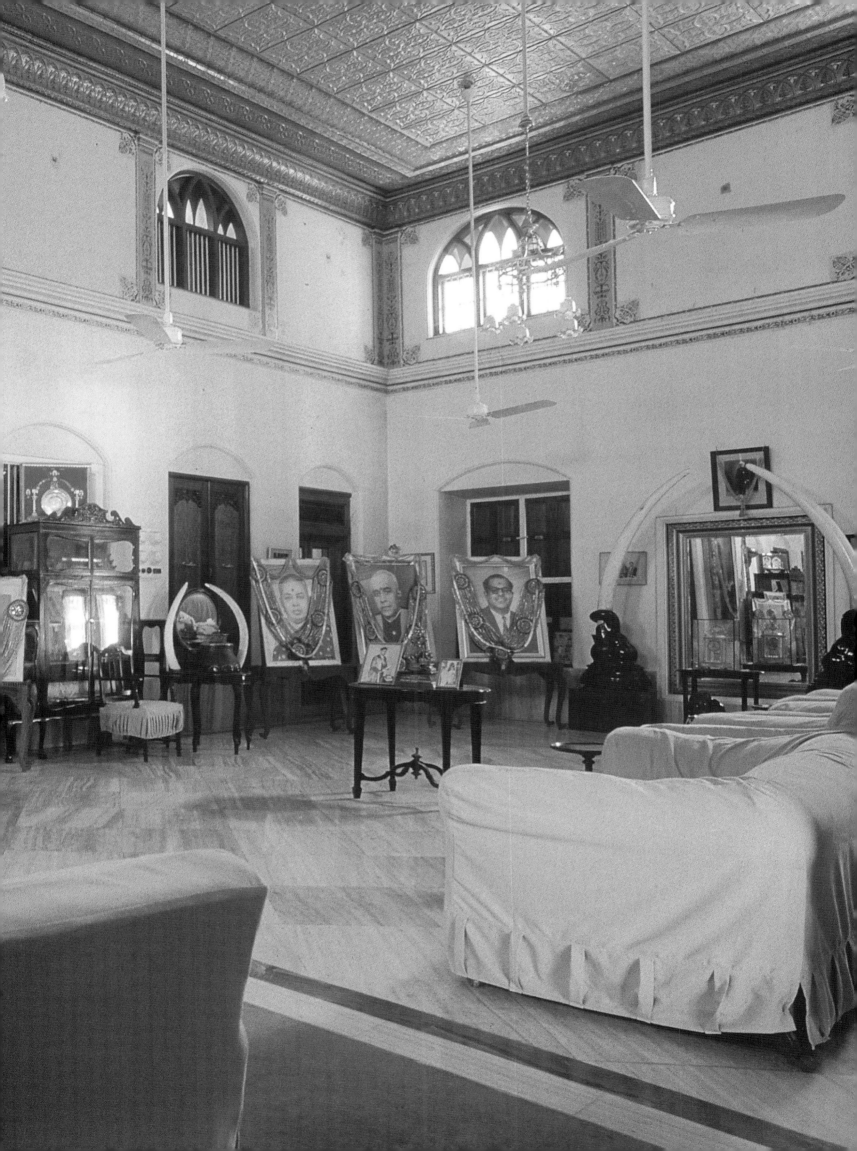

Le Mahanadi – littéralement «grand fleuve» – traverse l'Orissa pour se jeter dans le golfe du Bengale au sud-est de l'Inde. Dans ce paysage côtier de douces collines verdoyantes, on cultive essentiellement le riz. Mais pour les agriculteurs qui vivent dans les villages environnant la ville de Puri et son temple, le riz est bien plus qu'une source de travail, un moyen de subsistance et un symbole de chance. C'est le matériau de base avec lequel ils construisent et décorent leurs simples huttes en terre. La paille de riz est plus résistante que l'herbe séchée et sert à construire les toits. Les grains, moulus avec de l'eau, produisent une pâte blanche et poisseuse avec laquelle les femmes réalisent des décors raffinés. Leurs thèmes, des plantes grimpantes croulant sous les bourgeons et les fleurs, des récoltes entassées en monticules et des rizières stylisées, transmettent tous le même message d'abondance, de fertilité et de prospérité joyeuse.

Painted Huts in Orissa

Mahanadi, literally the Great River, is the name of the main river of Orissa that flows into the Bay of Bengal on the eastern seaboard of India. The crop cultivated in the lush, gently rolling coastal landscape is mainly rice. But for the peasant cultivators in the villages around the temple town of Puri, rice is much more than a source of labour, livelihood or a symbol of good fortune. It is an essential artist's material, used to construct as well as decorate their simple mud huts. Rice straw is longer-lasting that dried grass and is used for thatching roofs. And rice grain, pounded with water, produces a sticky white paste that women use in embellishing their homes with elaborate decorations. But the painted themes of blossoming plants and flowering vines, piles of harvested grain and stylised paddy fields all carry the same message of abundance, fruitfulness and joyful prosperity.

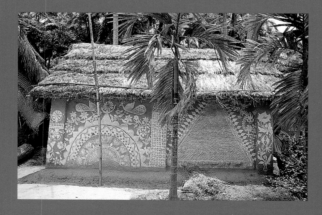

Der Name des größten Flusses von Orissa, der an der ostindischen Küste in die Bucht von Bengalen fließt, ist Mahanadi, was so viel heißt wie »Großer Fluß«. In der saftigen, sanft hügeligen Küstenlandschaft wird hauptsächlich Reis angebaut. Aber für die Bauern in den Dörfern, die die Tempelstadt Puri umgeben, ist Reis mehr als eine Quelle der Arbeit und Ernährung oder ein Symbol für Glück. Er ist ein unentbehrliches künstlerisches Material beim Bauen und Dekorieren der schlichten Lehmhütten. Reisstroh ist langlebiger als getrocknetes Gras und wird für den Bau der Strohdächer benutzt. Und die Reiskörner, die mit Wasser vermischt werden, ergeben eine klebrige weiße Paste, die die Frauen für kunstvolle Verzierungen an ihren Häusern verwenden. Die Motive der Malerei, zu der blühende Pflanzen und Ranken, geerntetes Korn und stilisierte Reisfelder gehören, vermitteln dabei dieselbe Botschaft von Überfluß, Fruchtbarkeit und glücklichem Wohlstand.

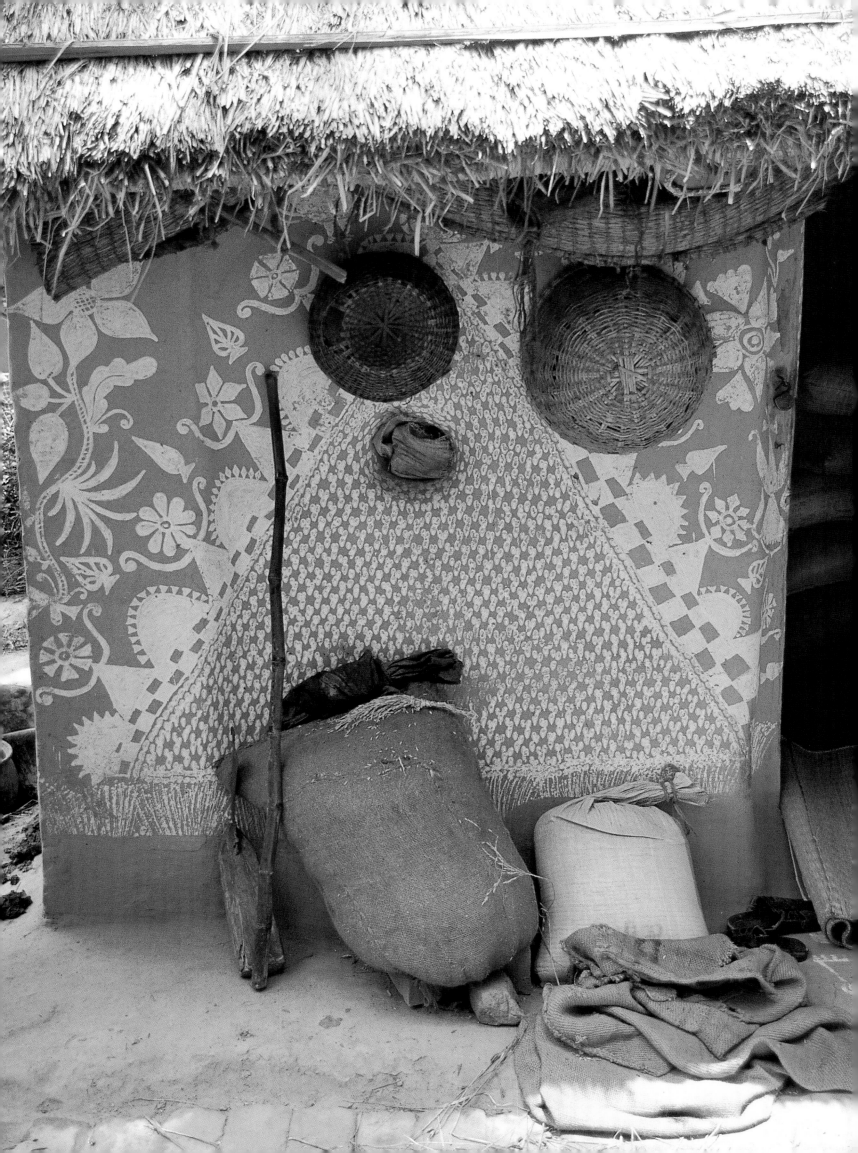

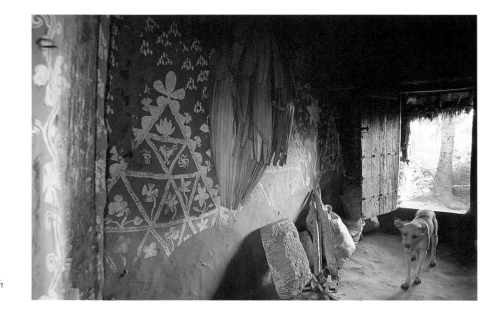

Right: The interior walls of the mud huts are as profusely covered with hand-drawn patterns as the exteriors.
Below: A simple straw mat is spread on a modern wooden bed with posts for mosquito netting. The rice-paste pyramid patterns on the wall are stylised representations of piles of grain.

A droite: A l'instar de ses façades, les murs intérieurs de cette hutte sont recouverts d'une profusion de motifs peints à la main.
Ci-dessous: Le lit est constitué d'une simple paillasse jetée sur un sommier moderne en bois équipé de montants pour soutenir la moustiquaire. Les motifs pyramidaux en pâte de riz sur le mur sont une représentation stylisée de monticules de grains.

Rechts: Die Innenwände der Lehmhütten sind ebenso reich mit von Hand aufgetragenen Mustern verziert wie das Äußere.
Unten: Auf einem modernen Holzbett mit Pfosten zum Aufhängen der Moskitonetze liegt eine schlichte Strohmatte. Die dreieckigen Muster aus Reispaste sind eine stilisierte Darstellung von Kornhaufen.

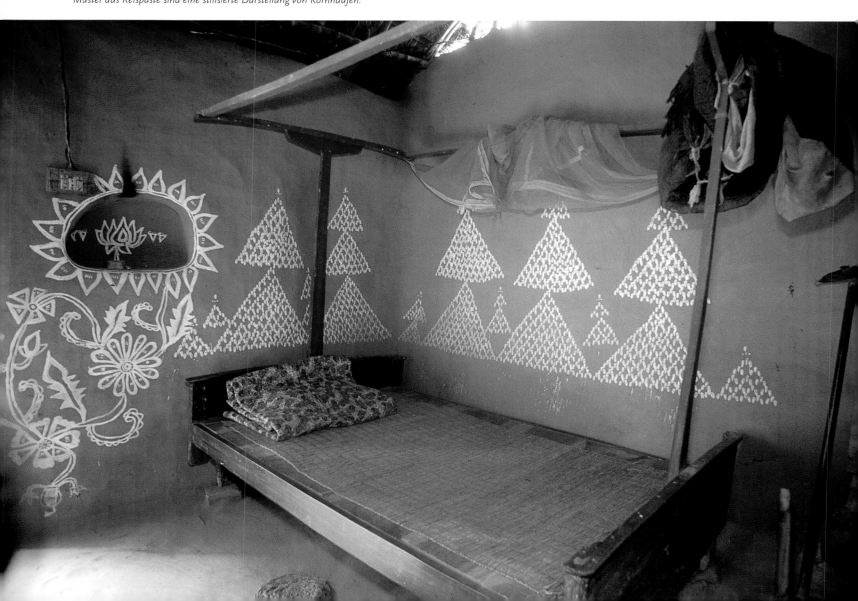

Above: Fresh produce from the front yard, including green bananas, stand against a mud wall decorated with sprays of rice paste.
Right: The wooden door into the grain store, filled with sacks of rice, is painted like the surrounding walls. The room is slightly elevated in case of flooding.

Ci-dessus: les produits frais du jardin situé devant la maison, dont des bananes vertes, adossés à un mur en terre décoré de traînées de pâte de riz.
A droite: La porte en bois du grenier, où sont entassés des sacs de riz, est peinte comme les murs de la maison. La pièce est légèrement sur-élevée afin de protéger les récoltes des inondations.

Oben: Frisch geerntete Erzeugnisse aus dem Garten vor der Hütte, zu denen auch grüne Bananen gehören, stehen gegen eine Wand ge-lehnt, die mit Mustern aus Reispaste verziert wurde.
Rechts: Die hölzerne Tür, die zu der mit Reissäcken gefüllten Korn-kammer führt, ist mit den gleichen Malereien verziert wie die Wände. Der Raum ist leicht erhöht gebaut, um ihn vor Wasser zu schützen.

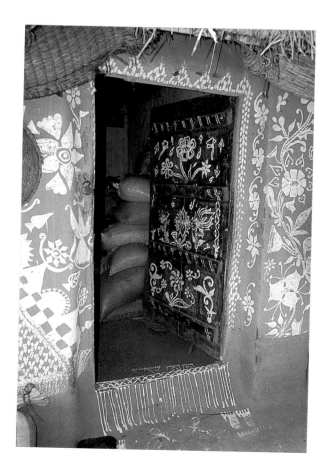

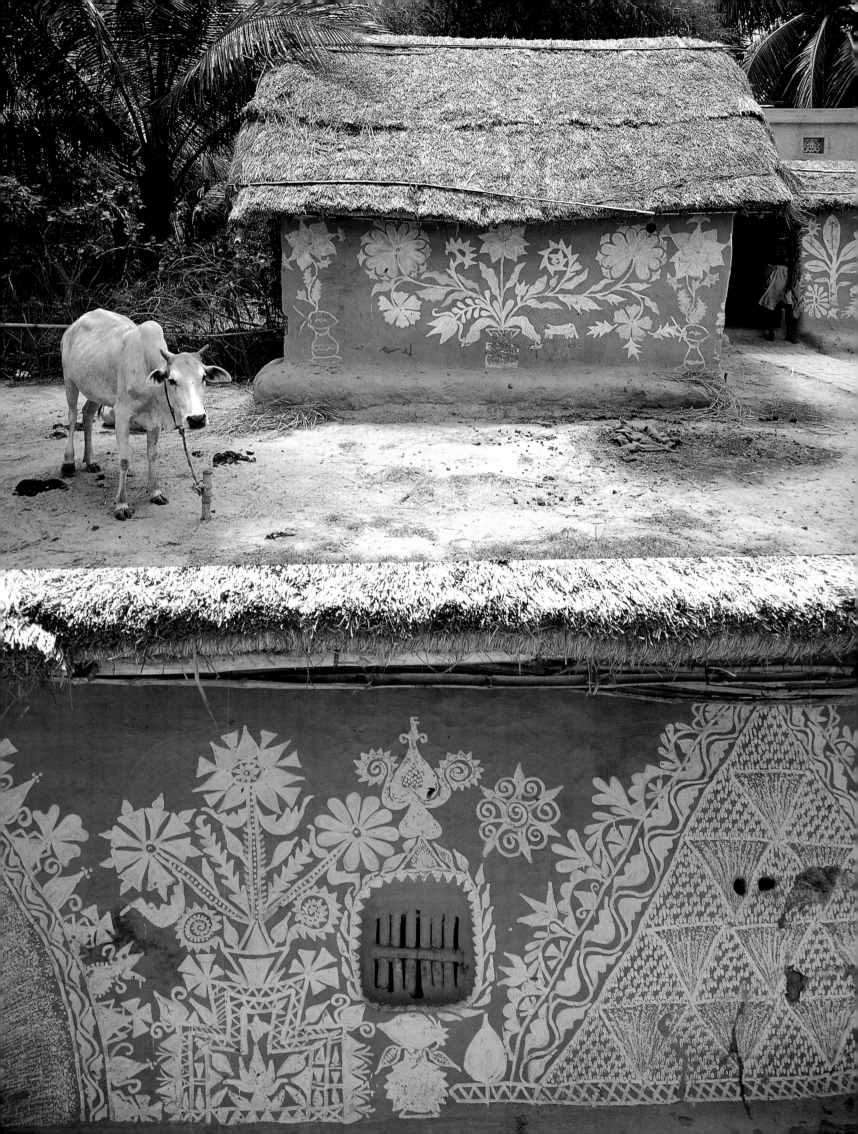

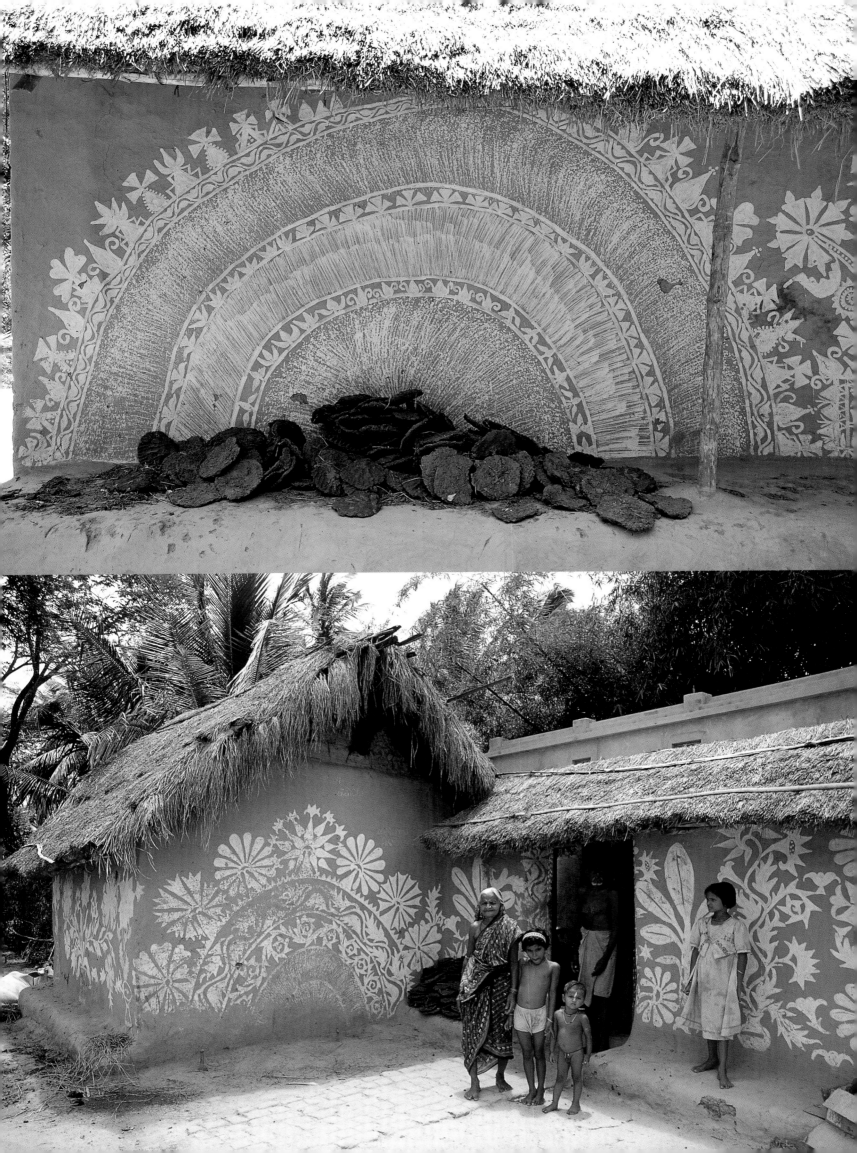

Glossary / Glossaire / Glossar

aam khas
royal apartments or special suite of private rooms in a palace or fort

appartement royal ou suite de pièces privées dans un palais ou une forteresse

königliche Gemächer oder eine Suite von Privaträumen in einem Palast oder Fort

aanjali
a hard fruit-wood used for house-building in Kerala

bois fruitier dur utilisé dans la construction des maisons dans le Kerala

besonders hartes Holz der Jackbäume, das in Kerala zum Hausbau benutzt wird

airaish
a lustrous ivory-coloured stucco, produced from a mixture of lime, crushed eggshells and oil, used to coat floors and walls in palaces and mansions

stuc brillant couleur ivoire à base de chaux, de coquilles d'œufs et d'huile dont on enduit les sols et les murs des palais et des grandes demeures

glänzender, elfenbeinfarbener Stuck, der aus Kalk, zerstoßenen Eierschalen und Öl besteht und mit dem in Villen und Palästen die Böden und Wände überzogen werden

baithak
sitting room

petit salon

Wohnzimmer

bajot
a low functional table

table basse

niedriger Tisch

chang
Tibetan beer made of fermented barley or rice

bière tibétaine à base d'orge ou de riz fermentés

tibetisches Bier aus gegorener Gerste oder gegorenem Reis

charpai
a lightweight bed made of string woven on a wooden frame

sommier léger fait de ficelles tendues sur un châssis en bois

leichtes Bett mit einem hölzernen Gestell, dessen Auflage aus Seilen geknüpft ist

dal-badal
a type of large royal tent made in Jodhpur

grande tente royale de Jodhpur

in Jodhpur gebräuchliches großes königliches Zelt

deodar
a Himalayan cedar

cèdre de l'Himalaya

Zedernholz aus dem Himalaya

dhoti
a single piece of cloth worn as a garment by men, hanging in folds from the waist to the ankles

vêtement masculin d'une seule pièce plissé de la taille aux chevilles

Stoffstück, das von Männern als Lendenschurz getragen wird und in zahlreichen Falten von der Hüfte bis zu den Fußknöcheln herabfällt

dhurrie
floor covering of hand-woven cotton

tapis en coton tissé à la main

Teppich aus handgewebter Baumwolle

doonga, Donga
a river or lake boat in Kashmir

bateau de rivière ou de lac au Cachemire

in Kashmir auf den Flüssen und Seen gebräuchliches Boot

durbar hall
royal audience chamber

salle d'audience royale

königlicher Audienzsaal

dzot
a storeroom or larder for provisions in Ladakhi homes

entrepôt ou garde-manger dans les maisons de Ladakh

Lagerraum oder Speise-kammer in den Häusern von Ladakh

gaddi
throne

trône

Thron

haveli
a town house or mansion

hôtel particulier ou grande demeure

Stadt- oder Herrenhaus

hooka, houka, Huka
a pipe, or hubble-bubble, for smoking tobacco

pipe à eau ou narguilé pour fumer du tabac

Pfeife oder Wasserpfeife zum Tabakrauchen

jaali, Jali
perforated stone screen

paravent en pierre ajouré

gitterförmig durchbrochener Stein

jharokha
projecting balcony or window, often with a domed roof

balcon ou fenêtre faisant saillie, souvent surmonté d'un toit en dôme

hervorspringender Balkon oder Fenstererker, häufig von einer Kuppel überdacht

kail
an Indian pinewood

pin indien

indische Kiefernholzart

kettuvallam
wooden boats, expertly bound by coir ropes, that ply the backwaters of Kerala

bateaux en bois, assemblés avec des fibres de coco, voguant sur les eaux tranquilles du Kerala

aus Holz gefertigte Boote, die geschickt mit Seilen aus Kokosfasern zusammenge-knüpft und in den Lagunen von Kerala gebräuchlich sind

khadi
a paste made from a white clay used to paint and decorate Rabari huts

pâte d'argile blanche servant à décorer et à peindre les huttes Rabari

weiße Lehmpaste, die zum Anstreichen und Verzieren der Rabari-Hütten benutzt wird

Mahabharata
one of India's great mythological epics

une des grandes épopées mythologiques indiennes

eines der großen mythologischen Epen Indiens

Maharana
a title exclusive to the rulers of Udaipur, the oldest ruling clan among the Rajputs

titre exclusivement réservé aux souverains d'Udaipur, le plus vieux clan régnant parmi les Rajputs

Titel, den einzig die Herrscher von Udaipur – das älteste Herrschergeschlecht der Rajputen – führen dürfen

mand
a formal sitting room for visitors in Gujarati homes

salon de réception dans les maisons du Gujerat

repräsentativer Salon für Besucher in den Häusern Gujarats

marusthai
desert

désert

Wüste

Meghwal
an itinerant community of leatherworkers in western India

communauté itinérante de maroquiniers en Inde occidentale

Nomadenvolk in Westindien, das seinen Lebensunterhalt hauptsächlich mit Leder-verarbeitung verdient

naalukettu
an open, four-sided courtyard at the centre of traditional homes in Kerala

cour ouverte au centre des maisons traditionnelles du Kerala

offener, viereckiger Innenhof in traditionellen Wohnhäusern in Kerala

patara
ornamental storage chest from western or central India

coffre ornemental dans l'ouest et le centre de l'Inde

reich verzierte Truhe aus West-oder Zentralindien

pol
gate

portail

Tor

purdah
curtain or veil for the seclusion of women

rideau ou espace cloîtré pour les femmes

Vorhang oder Schleier für Frauen

Rabari
a nomadic community of shepherds, goatherds and camel herders in western India

communauté nomade de bergers de l'ouest de l'Inde

nomadisierende Schaf-, Ziegen- und Kamelhirten in Westindien

raja
king

roi

König, Herrscher

Sanskriti Kendra
cultural centre

centre culturel

kulturelles Zentrum

shikar
hunting

chasse

Jagd

shikara
narrow, oared gondola on Kashmiri lakes

étroite barque à rame sur les lacs du Cachemire

schmale, mit Rudern fortbewegte Gondel, die auf den Seen Kashmirs benutzt wird

shunya
zero or the void of infinity

zéro, dans le sens abstrait du terme; le néant de l'infini

Null, oder im abstrakten Sinne,
die Leere der Unendlichkeit

thankha, Thangka
a Buddhist scroll with paintings of religious deities

rouleau bouddhiste portant des peintures de divinités

buddhistisches Rollbild mit Götterdarstellungen

tharawad
a family home in Kerala, built using a special technique whereby beams and wall planks are interlocked with wooden pegs on supporting limestone walls

maison de famille au Kerala construite avec une technique particulière: les poutres et les cloisons s'emboîtent sur des murs de soutien à la chaux et sont maintenues en place par des chevilles en bois

Wohnhaus in Kerala, dessen Bauweise auf einer besonderen Technik basiert: Die Balken und Dachsparren werden mit hölzernen Stiften zusammengefügt und von Kalkmauern gestützt

traami
a large deep metal dish from which several people eat together at a Kashmiri feast

grand plat profond en métal dans lequel plusieurs personnes mangent lors des fêtes au Cachemire

große und tiefe metallene Schüssel, aus der bei einem Fest in Kashmir mehrere Gäste gemeinsam essen

waza
a master cook specialising in Kashmiri banquets

maître cuisinier spécialisé dans les banquets au Cachemire

Meisterkoch, der sich auf die in Kashmir üblichen Festessen spezialisiert hat

wazwan
a Kashmiri banquet

banquet au Cachemire

Festessen in Kashmir

zenana
segregated living quarters for women

quartiers des femmes

abgetrennter Wohnbereich für Frauen

Bibliography / Bibliographie

Allen, Charles and Dwivedi, Sharada: *Lives of the Indian Princes*. London, 1984

Bayly, C. A.: *Indian Society and the Making of the British Empire*. Cambridge, 1988

Bharadwaj, Monisha: *Inside India*. London, 1998

Bhatia, Gautam: *Laurie Baker – Life, Work and Writings*. New Delhi, 1991

Davidson, Robyn: *Desert Places*. London, 1996
(French edition: Davidson, Robyn: *Mes Deserts: Un Voyage au Rajasthan*. Paris, 1998
German edition: Davidson, Robyn: *Meine Reise zu den Rabari*. Hamburg, 1997)

Davies, Philip: *The Penguin Guide to the Monuments of India, Vol. II, Islamic, Rajput, European*. London, 1989

Fass, Virginia: *The Forts of India*. London, 1986

Fischer, Louis: *The Life of Mahatma Gandhi*. London, 1997

Fischer, Louis: *Gandhi, Prophet der Gewaltlosigkeit*. München, 1995

Fisher, Nora (Ed.): *Mud, Mirror and Thread – Folk Traditions of Rural India*. Ahmedabad and Santa Fé, 1993

Gaekwad, Fatehsinghrao and Fass, Virginia: *The Palaces of India*. London, 1980

Garde, Anne et Raulet, Sylvie: *Salon Indien*. Paris, 1996
(English edition: Garde, Anne and Raulet, Sylvie: *Maharajas' Palaces*. Paris, 1997)

Gascoigne, Bamber: *The Great Moghuls*. London, 1971

Georges, Eliane et Lennard, Erica: *Les Petits Palais du Rajasthan*. Paris, 1996

Ghose, Vijaya (Ed.): *Tirtha – The Treasury of Indian Expressions*. New Delhi, 1992

Huyler, Stephen P.: *Village India*. New York, 1985

Irving, Robert Grant: *Indian Summer – Lutyens, Baker and Imperial Delhi*. Yale and Delhi, 1981

Jain, Jyotindra: *Folk Art and Culture of Gujarat*. Ahmedabad, 1980

Jain, Jyotindra: *Painted Myths of Creation – Art and Ritual of an Indian Tribe*. New Delhi, 1984

Khilnani, Sunil: *The Idea of India*. London, 1997

Michell, George: *The Penguin Guide to the Monuments of India, Vol. 1, Buddhist, Jain, Hindu*. London, 1989

Michell, George and Martinelli, Antonio: *The Royal Palaces of India*. London, 1994
(French edition: Michell, George et Martinelli, Antonio: *Les Palais de l'Inde*, Paris, 1994)

Moorhouse, Geoffrey: *India Britannica*. London, 1983

Muthiah, S.: *Madras Discovered*. Madras, 1987

Nath, Aman: *Jaipur – The Last Destination*. Bombay, 1993

Nath, Aman and Wacziarg, Francis (Ed.): *The Arts and Crafts of Rajasthan*. Ahmedabad, 1987

Nicholson, Louis: *India Companion*. London, 1996

Patnaik, Naveen: *A Desert Kingdom – The Rajputs of Bikaner*. London, 1990

Singh, Dhananjaya: *Marwar Jodhpur – Gateway to the Thar*. Jodhpur and New Delhi, 1996

Slesin, Suzanne and Stafford, Cliff: *Indian Style*. New York, 1990

Tillotson, G. H. R.: *The Rajput Palaces: The Developement of an Architectural Style, 1450–1750*. New Haven, Connecticut and London, 1987

Walker, Daniel: *Flowers Underfoot – Indian Carpets of the Mughal Era*. New York, 1997

Welch, Stuart Cary and Patnaik, Naveen: *A Second Paradise – Indian Courtly Life, 1590–1947*. New York, 1985

Worswick, Clark and Embree, Ainslie: *The Last Empire – Photography in British India, 1855–1911*. London, 1976

Ypma, Herbert J. M.: *India Modern*. London, 1994

Zebrowski, Mark: *Gold, Silver and Bronze from Mughal India*. London, 1998

Addresses / Adresses / Adressen

Heritage Hotels Association
306, Anukampa Tower,
Church Road
Jaipur 303 806
Phone: ++91-141-372 084
Fax: ++91-141-372 084
http://heritagehotels.com

Ladakh
Lakrook Garden Guest House
Sanker, Leh 194101

Rajasthan
Ajit Bhawan Palace
(page/Seite 116)
Near Circuit House
Jodhpur 342 006
Phone: ++91-291-437 410
　　　++91-291-671 410
Fax: ++91-291-637 774

Bhanwar Niwas
Rampuria Street
Bikaner 334 005
Phone: ++91-151-618 80
　　　++91-151-710 43
Fax: ++91-151-618 80

Castle Mandawa Hotel
(page/Seite 80)
9 Sardar Patel Marg
C-Scheme
Jaipur 302 001
Phone: ++91-141-374 130
　　　++91-141-374 112
　　　++91-141-371 194
Fax: ++91-141-372 084
http://heritagehotels.com/
castlemandawa

Fort Chanwa/Luni
Dalip Bhawan
No. 1 House, P. W. D. Road
Jodhpur 342 001
Phone: ++91-291-324 60
Fax: ++91-291-324 60

Mandawa Desert Camp
(Bookings through Castle
Mandawa Hotel)

Narain Niwas Palace Hotel
(page/Seite 76)
Kanota Bagh
Narain Singh Road
Jaipur 302 004
Phone: ++91-141-561 291
　　　++91-141-563 448
Fax: ++91-141-561 045
http://www.fhraindia.com/
hotel/jaipur/narainniwas

Narlai Fort
(page/Seite 122)
Bookings through
Ajit Bhawan Palace

Neemrana Fort Palace
District Alwar
Rajasthan 301 705
Reservation:
Phone: ++91-11-461 6145
Fax: ++ 91-11-462 1112
Email:
neemrana@planetindia.net

Rang Niwas Palace Hotel
Lake Palace Road
Udaipur 313 001
Phone: ++91-294-523 890
　　　++91-294-523 891
Fax: ++91-294-527 884

Samode Palace
Samode 303 806, Dist. Jaipur
Phone: ++91-1423-441 23
　　　++91-1423-441 14 or
　　　++91-141-632 370
Fax: ++91-141-632 407
http://www.samode.com
Email:
reservations@samode.com

Udai Bilas Palace
(page/Seite 150)
Dungarpur 314 001
Phone: ++91-2964-308 08
Fax: ++91-2964-310 08
http://udaibilaspalace.com
Email:
udaibilas@planetindia.net

Umaid Bhawan Palace
(page/Seite 110)
Jodhpur 342 006
Phone: ++91-291-433 316
Fax: ++91-291-435 373
http://welcomgroup.com/
jodhpur/umaidbhawan

Gujarat
Nilambag Palace Hotel
Ahmedabad Road
Bhavnagar, Gujarat 364 002
Phone: ++91-278-424 241
Fax: ++91-278-428 072

**Orchard Palace and
Riverside Palace**
Palace Road
Gondal 360 311, Gujarat
Phone: ++91-2825-245 50
Fax: ++91-2825-233 32

The Palace
(page/Seite 208)
Jasdan 360 050
Phone: ++91-2821-200 29
　　　++91-2821-200 30

The Palace
(page/Seite 196)
Wankaner 363 621
Phone: ++91-2828-200 00
Fax: ++91-2828-200 02

Goa
Nilaya Hermitage
(page/Seite 250)
Arpora
Bardez 403 518
Phone: ++91-832-276 793
Fax: ++91-832-276 792

Kerala
Tour India Houseboats
(page/Seite 270)
P.O. Box No. 163
Mahatma Gandhi Road
Thiruvananthapuram 695 001
Phone: ++91-471-330 437
　　　++91-471-331 507
Fax: ++91-471- 331 407

Acknowledgements / Remerciements / Danksagung

Our heartfelt thanks, first, to each of the owners of the houses featured in this book and also to those whose homes and to our great regret could not be included owing to constraints of space. Without their cooperation and willingness to cope with the intrusions of photographer and journalist, the task would have been difficult to complete. Furthermore, this venture would have been impossible in a country as large as India without the encouragement, support and generosity of a large network of friends, colleagues and specialists. For convenience, their names have been listed regionwise.

In Delhi, special thanks to Patwant Singh, Meher Wilshaw, and Rasil and Romen Basu for hosting the photographer on her numerous trips to India, and to Aman Nath and Francis Wacziarg, whose knowledge and insights were of particular value to both photographer and author. Our thanks also to Vinu and Abbas Ali Baig, Gautam Bhatia, Rupika and Navin Chawla, Uttara Chaudhury, Niloufer Currimbhoy, Achilles and Chantal Forler, Shumita Ghose, Sagarika Ghose and Rajdeep Sardesal, Richard and Sally Holkar, David and Jenny Housego, Jyotindra and Jutta Jain, Samar Singh Jodha, Sonal Joshi, Sunita and Romesh Kohli, Prima Kurien, Momin Latif, Tim and Jan McGirk, Pradeep and Veena Mehra, Ritu and Krishna Menon, S. K. Mishra, Usha and Bhushan Mohindra, Dr Nether and Thilmann Waldraff at Max Mueller Bhawan, Amitabh Pande, Lekha Poddar, Anupam Poddar, Bina Ramani, Sabina Sehgal Saikia, Sanjeve Sethi, Brijeshwar Singh, Martand Singh, Prabeen Singh, Rena Ripjit Singh, Malvika and Tejbir Singh, Hershad Kumari Sharma and former US Ambassador to India Frank Wisner and Mrs Christine Wisner. In Kashmir and Ladakh, we are grateful to Afzal Abdulla, Jagdish Mehta, Pinto and Tsering Narboo, Feroz Khan and A. Rauf, Dolma Shri Sichoi and Gijamat Wangchuk.

In Rajasthan, particular thanks go to Randhir Vikram Singh and the Heritage Hotel Association for their kind hospitality to the photographer; also thanks to Subhash Chaturvedi, A. V. Joseph, Dr Yaduendra Sahai and K. K. Sharma. In Jodhpur, the author is especially grateful to Gaj Singh II, the Maharaja of Jodhpur, Rao Raja Mahendra Singh, Dhananjaya Singh and Mahendra Singh Nagar for solving an intransigent situation with dexterity and tact; our thanks also to Thakur Sunder Singh, Prof. Karan Singh, Maharaja Swaroop Singh and Raghavendra Rathore. In Bikaner, many thanks to U. C. Kochhar, Arvind and Sushila Ojha and Siddharth Pareek, and in Udaipur to Arjun Singh and Sanjay Vyas.

In Gujarat, both author and photographer benefited from the advice and assistance of Balkrishna V. Doshi and Kulbhushan Jain in Ahmedabad, Jyoti Bhatt in Baroda, Kumid Kumari in Gondal, Samita Devi in Bhavnagar and Vanka Kana Rabari in Bhuj.

In Bombay our special thanks go to Abu Jani and Sandeep Khosla: also to Shyam and Nira Benegal, Dimple Kapadia, Silvia Khan, Neeru Nanda, Sunita Pitamber, Nirja Shah, Sheila Shahani and Dr Winterberger. In Goa, we are especially obliged to Jimmy Gazdar, and to Steven Jenkins, Lidia and Alirio Lobo, Habiba and Mario Miranda, Joaquim Monteiro, Bal Mundkur, O. Thomas, Norbert Sequeiro and Babu Varghese. In Kerala, we thank Ashok Adiceam, Radar Devi, Colonel Jacobs, K. V. P. Panicker, Babu Paul and Prameswaran Nair. In Bangalore we are grateful to Mrs Fordyce, Ramu and Roshin Katakam, the late Naomi Meadows and the staff of Nrityagram.

In Madras, Michael and Anjana Hasper, Deborah Thiagarajan and Prema Srinivasan were of special help. In Pondicherry and Auroville we are indebted to Françoise L'Hernault, Veena Lemaire, Françoise Gerin, Ratna and Ajit Kujalgi. In Calcutta our special thanks to Tilottama Das, Sailendra Nath Mullick and Rakhi and Pratiti Sarkar.

The photographer would also like to thank all the drivers who drove her many arduous miles and were such a great help, and the many people who became instant photographic assistants during this project. She also wishes to thank Pam Strayer, Pauline Everts and Ingeborg Cornelius, all excellent travelling companions, and extend her gratitude to Ed Tuttle and Christian Monges, Paolo Arigoni and Nicole Bernard in Paris and to Marion Hauff in Milan.

The author was ably assisted with translations from French by Alexander Housego and by the enthusiasm of Abha Kapoor, research assistant to the project. He also owes a special debt to Shalini Sethi, creator and keeper of beautiful interiors, and equally to Jayati Sethi.

Finally, both author and photographer would like to thank Dr Angelika Taschen and Benedikt Taschen in Cologne for conceiving, nurturing and sustaining such an ambitious scheme, and to Ursula Fethke and Nazire Ergün for their diligent coordination and painstaking editorial skill.

New Delhi/Paris 1999

Sunil Sethi
Deidi von Schaewen